The Complete Book of Personal Training

Douglas S. Brooks, MS

Human Kinetics

Library of Congress Cataloging-in-Publication Data

Brooks, Douglas, 1957-
 The complete book of personal training / Douglas S. Brooks
 p. cm.
 ISBN 0-7360-6694-2 (Hard Cover)
 1. Physical fitness centers--Management. 2. Personal
trainers--Vocational guidance. I. Title
 GV428.5.B76 2003
 338.7'616137--dc21 2003004724

ISBN-10: 0-7360-6694-2
ISBN-13: 978-0-7360-6694-5

Portions of *The Complete Book of Personal Training* have been previously published in D.S. Brooks, 1988. *Program design for personal trainers: Bridging theory into application* (Champaign, IL: Human Kinetics) and D. Brooks, 1999. *Your personal trainer* (Champaign, IL: Human Kinetics).

The Web addresses cited in this text were current as of 6/18/03, unless otherwise noted.

Acquisitions Editor: Michael S. Bahrke, PhD
Developmental Editors: Rebecca Crist and Renee Thomas Pyrtel
Assistant Editors: Sandria M. Washington and Ann M. Augspurger
Copyeditor: Julie Anderson
Proofreader: Erin Cler
Indexer: Betty Frizzéll
Permissions Manager: Dalene Reeder
Graphic Designer: Andrew Tietz
Graphic Artist: Angela K. Snyder
Photo Manager: Kareema McLendon
Cover Designer: Keith Blomberg
Photographer (cover): Brand X Pictures; **(interior):** Tom Roberts
Art Manager: Kelly Hendren
Illustrator: Argosy
Printer: Sheridan Books

Printed in the United States of America

10 9 8 7 6 5 4 3 2 1

Human Kinetics
Web site: www.HumanKinetics.com

United States: Human Kinetics
P.O. Box 5076
Champaign, IL 61825-5076
800-747-4457
e-mail: humank@hkusa.com

Canada: Human Kinetics
475 Devonshire Road Unit 100
Windsor, ON N8Y 2L5
800-465-7301 (in Canada only)
e-mail: orders@hkcanada.com

Europe: Human Kinetics
107 Bradford Road
Stanningley
Leeds LS28 6AT, United Kingdom
+44 (0) 113 255 5665
e-mail: hk@hkeurope.com

Australia: Human Kinetics
57A Price Avenue
Lower Mitcham, South Australia 5062
08 8277 1555
e-mail: liaw@hkaustralia.com

New Zealand: Human Kinetics
Division of Sports Distributors NZ Ltd.
P.O. Box 300 226 Albany
North Shore City
Auckland
0064 9 448 1207
e-mail: info@humankinetics.co.nz

To Mom and Dad—Thanks for standing by me when I entered this little-known profession years ago, and for always being there. Though you still do not grasp the entirety of what I do, I love you and will never go back to having a "real" job!

To my Lord God—Your grace and love, which are always sufficient and unending, humble me. Thank you for giving me the strength for the journey.

To Candice and "my" boys—You make my life complete and full, for *all* the good reasons of which you are fully aware!

Finally, this book is dedicated to the heroes of the world:
John 15:13: Greater love has no man than this, that a man lay down his life for his friends.

CONTENTS

Chapter 4 Getting—and Keeping—Clients 73

Chapter 5 Expanding Your Business 113

Chapter 6 Managing Your Time 137

Chapter 7 Maintaining a Service Focus 149

Chapter 8 Legal and Professional Responsibilities 177

Chapter 9 Control Your Finances—and Control Your Future 187

Part II Foundations Behind Program Design That Works

Chapter 10 Gathering Information (Screening) 207

Chapter 11 Practical Fitness Testing and Assessment 213

Chapter 12 Achieving Goal- and People-Oriented Programming 241

Chapter 13 Periodization: A Model for Planned Results 255

Chapter 14 Track Your Client's Progress 267

Chapter 15 Science Behind Accurate Exercise Programs 277

Part III Program Design: Application That Bridges Theory to Practice

Chapter 24　Training the Cardiac Patient　　475

Chapter 25　Diabetes Mellitus: Types 1 and 2　　483

Chapter 26　Asthma and Your Client　　493

Chapter 27　Arthritis: Osteoarthritis and Rheumatoid　　503

Chapter 28 Working With Older Adults 511

Chapter 29 Training the Pregnant Client: A Special Healthy Population 519

Part V The Final Edge

Chapter 30 Keep Your Personal and Professional Desire Burning Brightly 533

Chapter 31 Bringing Personal Training Back to One on One 539

PREFACE

Everybody could use a hand sometimes.

Whether you're first starting out in your professional life, or you're ready to move in a new direction, or you're feeling burned out doing what you most love to do—at some point in your career, you'll find yourself scratching your head and wondering, "What do I do *now?*"

I hope this book will help you find the answer.

I wanted to write a book that would help all trainers, at any stage of professional development. I hope *The Complete Book of Personal Training* is that book—the comprehensive, authoritative personal training resource I wish I'd had. Whether you're just breaking into personal training, you're a sole proprietor of your business, or you've been training for years and have a staff of trainers, *The Complete Book of Personal Training* can expand, grow, and make your business more efficient.

My own career has given me a lot of chances to learn from great teachers—and my own mistakes. Besides my graduate-level academic background, I've trained an average of 10 clients a day, five days a week, over a nine-year period. I've directed a 5,000-member health club, and successfully managed my own personal training business. I expanded and grew the business by hiring additional training staff and adding locations. Currently, I travel the world lecturing on creating successful training businesses, regardless of the market or global location, as well as showing trainers how to design programming that matches client-training goals.

But, this book goes beyond this author's—one trainer's—successes, failures, and insights. A book that captures the complete picture and scope of personal training could not be illuminated by one author or by a fragmented (edited) collection of essays on the subject.

I've had years to learn from the best in the business. In this book, you'll find accumulated information and personal interviews with other experts who have proven track records with regard to successful personal training businesses. Look at this book as an authoritative, timely, and in-depth resource created by blending usable and time-tested information that has brought trainers across the world success into one complete, contemporary, and practical volume.

The Complete Book of Personal Training answers questions all trainers ask at one time or another. Have you ever thought, "I don't have a life!" or "I need more personal time"? Has a client requested you find another trainer to work them out while they travel on business or for vacation? What do you do? Do you wish you could identify software that could run your business and help you design and periodize client programs? How about life *after* personal training? Have you prepared for your retirement years? Do you know how to leverage yourself financially, avoid personal burnout, and create personal time–freedom that will allow you to keep your sanity and quality of service? Are you looking for that first client? Or, are you just thinking about breaking into the business?

In many instances *The Complete Book of Personal Training* will give you specifics on how to be successful and take the next step. At the very least, it will give you resources to accomplish growth in your business or help you to execute business decisions that move toward what your successful peers, years of experience, and I believe is the right direction.

How to use this book If you're just starting out, welcome to the field! You've got an exciting time ahead of you. While I would advise you to read this whole book (of course!), pay special attention to chapter 2. It covers everything you'll need to know about getting started, choosing the training path that best suits you and your circumstances, and getting your career off the ground.

If you're already an established trainer, congratulations! You've no doubt worked hard to get your business started. You, too, will probably want to read this book from cover to cover, but it's also a handy reference tool that will help solve your daily organizational and business challenges. The reference tips and thorough index will help you quickly locate any topic area you'd like more information about.

This book has enough information packed into it to grow with your expanding and successful personal training business. Today you may be a trainer new to this profession or seeing several clients per day. But who knows? Tomorrow you may oversee a large staff of trainers and own your own training facility.

The Complete Book of Personal Training is concise, yet comprehensive. It delivers timely and current information to keep you fresh, motivated, and moving your business forward. It is my hope that *The Complete Book of Personal Training* is the personal training reference source you can use to find all the information you need to save time and help you run a successful business. You won't need another book on the business or programming aspects of personal training. Whether it's running your business or knowing how to design personal fitness programs, *The Complete Book of Personal Training* will give you the answers and resources to succeed.

Stop running your personal training business by guesswork! Why make the same mistakes top trainers and business owners worldwide have made? I hope you won't have to. This book gives you the inside scoop on how successful personal training businesses are made!

ACKNOWLEDGMENTS

To every client I have ever had the privilege to work with and learn from—thank you for providing the "learning fields." You taught me to listen; you taught me to act; you taught me to empathize; you taught me to care; you taught me to provide for your "wants" and "needs;" you taught me to be a professional; and you taught me to be accountable. All of you have also given me great joy, challenge, and personal reward.

To each of the exceptional personal trainers who helped mold this book through personal interview or through resource material made available to me: this book is about you and the clients we love, as well as a profession you have evolved and taken to a higher standard of care and service. I thank you for you expertise, unique insight, and willingness to invest time back into the personal training field so that our profession continues to leap forward.

Some of the businesses and individuals I have watched, learned from, and admired include Jorge "Mr. World" Briscoe (Argentina), Susan Cantwell (Canada), Matt Church (Australia), Mark Cibrario and Mark Stone (Illinois, USA), Troy Demond (Florida, USA), Gregory Florez (Utah, USA), Maureen Hagan (Canada), Fiona Hayes (United Kingdom), Sherri McMillan (Washington, USA), Mark Madole (Texas, USA), Jose Otavio Mafara (Brazil), David Parise (Connecticut, USA), Beth Rothenburg (Los Angeles, USA), Bob Smith (United Kingdom), Marcos Tadeu (Brazil), Stan Tracht and Mark Colbert (Texas, USA), David Turpin (Georgia, USA), and Pete Twist (Canada) to, quite honestly, name but a few colleagues from around the world—representing Canada, North and South America, Europe, Asia, Africa, and Australia (still waiting for the South Pole)—who have contributed to my expertise and depth of understanding as related to our industry of personal training.

To my peers who have already "gone solo," and to those of you who will join the personal training profession, it is my goal to continue being a part of further raising the standard of competence in our field and helping to spread the revelation about our wonderful profession. It is my hope that every corner of the globe will be touched by the difference a trainer can make in changing lives. It is to these ends from which much of the genesis for this book was established.

To Human Kinetics: Thanks to Scott Wikgren for initially moving this BIG project into the realization phase. Your ideas, support, and confidence are always appreciated.

A special thank-you to acquisitions editor Mike Bahrke who showed an extreme degree of patience, support, and enthusiasm for finishing this project and getting, as it came to be known, *Theee Book* to print. Thanks too, for handing the project into the capable hands of Rebecca Crist. Rebecca, thanks for effectively communicating and reorganizing my ideas! Rainer Martens and Martin Barnard—thank you for your continued backing and belief in this and future projects.

A special thanks to the outstanding models who contributed their talents to this project. They include Amber Bartlett, Bruce Bartlett, Candice Brooks, Kathy Dolan, Melanie Lewey, Brittany Stotko, Stacy Stotko, and Dan Wright.

Thanks to Patti Acton and Snowcreek Athletic Club for allowing us to use SAC for the photo shoot. Thanks too, to Dan Wright and Summit Condominiums for giving us access to photograph the association's workout facility.

To Tom Roberts . . . you've got a great eye and helped to accurately capture the message of this book from behind your camera. Thanks!

CREDITS

"Designing Promotional Materials," pages 80-81

From "What Makes a Marketing Piece work?" By D. Thorneycroft, Jan. 1995. Reproduced with permission of IDEA Health & Fitness Association, 800-999-IDEA, www.IDEAfit.com

Box on page 107

Reprinted from IDEA Personal Trainer, 1998.

Bulleted text on pages 163-164

From "Create Opportunity From Conflict" by J. and N. Gavin, Feb. 1999, pages 35-37. Reproduced with permission of IDEA Health & Fitness Association, 800-999-IDEA, www.IDEAfit.com

Bulleted text sections on pages 178 and 179

Reprinted with permission from the American Council on Exercise (www.acefitness.org).

"Risks Involving the Training Area and Equipment," page 180

"Strategies for Managing Risk" by D. Cotten, March 1998. Adapted with permission of IDEA Health & Fitness Association, 800-999-IDEA, www.IDEAfit.com

"Accident Report Form" section, page 181

"Strategies for Managing Risk" by D. Cotten, March 1998. Adapted with permission of IDEA Health & Fitness Association, 800-999-IDEA, www.IDEAfit.com

"S = Strength (and flexibility)" text, page 353

From R. Sleamaker and R. Browning, 1996. *SERIOUS training for endurance athletes.* (Champaign, IL: Human Kinetics).

Numbered text, page 475

"Training for the Cardiac Patient" by R. La Forge, Feb. 2000. Reproduced with permission of IDEA Health & Fitness Association, 800-999-IDEA, www.IDEAfit.com.

"Safety Considerations" on page 478

"Training for the Cardiac Patient" by R. La Forge, Feb. 2000. Reproduced with permission of IDEA Health & Fitness Association, 800-999-IDEA, www.IDEAfit.com.

"Considering the Refractory Period" on page 497

"Training Clients With Exercise-Induced Asthma" by C. Bryant, Oct. 1998. Reproduced with permission of IDEA Health & Fitness Association, 800-999-IDEA, www.IDEAfit.com.

Figure 11.4 a

Reprinted, by permission, from D. Brooks, 1999, *Your personal trainer* (Champaign, IL: Human Kinetics), 8.

Figure 11.4 b

Reprinted, by permission, from D. Brooks, 1999, *Your personal trainer* (Champaign, IL: Human Kinetics), 8.

Form 11.4

Reprinted, by permission, from D. Brooks, 1999, *Your personal trainer* (Champaign, IL: Human Kinetics), 18.

Form 11.5

Reprinted, by permission, from D. Brooks, 1999, *Your personal trainer* (Champaign, IL: Human Kinetics), 22-23.

Form 7.3

"Staying Motivated" Client Handout, 1998. Reproduced with permission of IDEA Health & Fitness Association, (800) 999-IDEA, www.IDEAfit.com.

Form 8.1

"Do Waivers Work?" by D. Cotton, April 1998. Reproduced with permission of IDEA Health & Fitness Association, (800) 999-IDEA, www.IDEAfit.com.

Form 8.2

"Do Waivers Work?" by D. Cotton, April 1998. Reproduced with permission of IDEA Health & Fitness Association, (800) 999-IDEA, www.IDEAfit.com.

Form 11.6

Reprinted, by permission, from D. Brooks, 1999, *Your personal trainer* (Champaign, IL: Human Kinetics), 25-27.

Form 11.7

Reprinted, by permission, from D. Brooks, 1999, *Your personal trainer* (Champaign, IL: Human Kinetics), 12.

Figure 12.1

Reprinted, by permission, from D. Brooks, 1999, *Your personal trainer* (Champaign, IL: Human Kinetics), 32.

Figure 12.2

Reprinted, by permission, from D. Brooks, 1999, *Your personal trainer* (Champaign, IL: Human Kinetics), 32.

Form 12.1

Reprinted, by permission, from D. Brooks, 1999, *Your personal trainer* (Champaign, IL: Human Kinetics), 33.

Form 12.2

Reprinted, by permission, from D. Brooks, 1999, *Your personal trainer* (Champaign, IL: Human Kinetics), 36.

Figure 12.3

Reprinted, by permission, from D. Brooks, 1999, *Your personal trainer* (Champaign, IL: Human Kinetics), 35.

Figure 13.1

Reprinted with permission. Goss, Keller, Martinez Design: Del Mar, California, 1996.

Figure 13.2

Reprinted, by permission, from D. Brooks, 1999, *Your personal trainer* (Champaign, IL: Human Kinetics), 47.

Figure 14.1

Reprinted, by permission, from D. Brooks, 1999, *Your personal trainer* (Champaign, IL: Human Kinetics), 236.

Figure 14.2

Reprinted, by permission, from D. Brooks, 1999, *Your personal trainer* (Champaign, IL: Human Kinetics), 236.

Figure 14.3

Reprinted, by permission, from D. Brooks, 1999, *Your personal trainer* (Champaign, IL: Human Kinetics), 237.

Form 14.1

Reprinted, by permission, from D. Brooks, 1999, *Your personal trainer* (Champaign, IL: Human Kinetics), 238.

Figure 15.1

Reprinted, by permission, from D.S. Brooks, 1998, *Program design for personal trainers: Bridging theory into application* (Champaign, IL: Human Kinetics), 88.

Table 15.2

Reprinted, by permission, from D.S. Brooks, 1998, *Program design for personal trainers: Bridging theory into application* (Champaign, IL: Human Kinetics), 124.

Figure 15.2

Reprinted, by permission, D.S. Brooks, 1998, *Program design for personal trainers: Bridging theory into application* (Champaign, IL: Human Kinetics), 120.

Figure 15.3

Reprinted, by permission, from D.S. Brooks, 1998, *Program design for personal trainers: Bridging theory into application* (Champaign, IL: Human Kinetics), 127.

Box on page 297

Reprinted, by permission, from D.S. Brooks, 1998, *Program design for personal trainers: Bridging theory into application* (Champaign, IL: Human Kinetics), 116.

Table 17.1

Reprinted, by permission, from D. Brooks, 1998, *Program design for personal trainers: Bridging theory into application.* (Champaign, IL: Human Kinetics), 107. Adapted from McArdle et al., 1991

Form 17.1

Reprinted, by permission, from D. Brooks, 1999, *Your personal trainer* (Champaign, IL: Human Kinetics), 119.

Form 17.2

Reprinted, by permission, from D. Brooks, 1999, *Your personal trainer* (Champaign, IL: Human Kinetics), 119.

Table 18.1

Reprinted, by permission, from D. Brooks, 1999, *Your personal trainer* (Champaign, IL: Human Kinetics), 112.

Figure 18.2

Reprinted, by permission, from D.S. Brooks, 1998, *Program design for personal trainers: Bridging theory into application* (Champaign, IL: Human Kinetics), 193.

Table 18.3

Reprinted, by permission, from D. Brooks, 1999, *Your personal trainer* (Champaign, IL: Human Kinetics), 129

Table 18.4

Reprinted, by permission, from D. Brooks, 1999, *Your personal trainer* (Champaign, IL: Human Kinetics), 129

Table 18.5

Reprinted, by permission, from D. Brooks, 1999, *Your personal trainer* (Champaign, IL: Human Kinetics), 130.

Table 18.6

Reprinted, by permission, from D. Brooks, 1999, *Your personal trainer* (Champaign, IL: Human Kinetics), 130.

Table 18.7

Reprinted, by permission, from D. Brooks, 1999, *Your personal trainer* (Champaign, IL: Human Kinetics), 131.

Table 18.8

Reprinted, by permission, from D. Brooks, 1999, *Your personal trainer* (Champaign, IL: Human Kinetics), 125.

Figure 19.1

Reprinted, by permission, from D.S. Brooks, 1998, *Program design for personal trainers: Bridging theory into application* (Champaign, IL: Human Kinetics), 231.

Form 19.1

Reprinted, by permission, from D. Brooks, 1999, *Your personal trainer* (Champaign, IL: Human Kinetics), 206.

Table 19.15

Reprinted, by permission, from D. Brooks, 1999, *Your personal trainer* (Champaign, IL: Human Kinetics), 202.

Table 19.16

Reprinted, by permission, from D. Brooks, 1999, *Your personal trainer* (Champaign, IL: Human Kinetics), 203.

Table 19.17

Reprinted, by permission, from D. Brooks, 1999, *Your personal trainer* (Champaign, IL: Human Kinetics), 204.

Table 19.18

Reprinted, by permission, from D. Brooks, 1999, *Your personal trainer* (Champaign, IL: Human Kinetics), 205.

Table 21.1

Reprinted, by permission, from D. Brooks, 1999, *Your personal trainer* (Champaign, IL: Human Kinetics), 180.

Form 21.1

Reprinted, by permission, from D. Brooks, 1999, *Your personal trainer* (Champaign, IL: Human Kinetics), 181.

Form 21.2

Reprinted, by permission, from D. Brooks, 1999, *Your personal trainer* (Champaign, IL: Human Kinetics), 183.

Table 21.2

Reprinted, by permission, from D. Brooks, 1999, *Your personal trainer* (Champaign, IL: Human Kinetics), 187.

Table 21.3

Reprinted, by permission, from D. Brooks, 1999, *Your personal trainer* (Champaign, IL: Human Kinetics), 187.

Box on page 121

"Adding On: Hiring Trainers" by G. Florez and J. O'Hara, Feb. 2000.

Reproduced with permission of IDEA Health & Fitness Association, (800) 999-IDEA, www.IDEAfit.com.

Box on page 452

Reprinted, by permission, from N. Clark, 1997, *Nancy Clark's sport nutrition guidebook*, 2nd ed. (Champaign, IL: Human Kinetics), 110-111.

Figure 26.1

Reprinted, by permission, from J.H. Wilmore and D.L. Costill, 1994, *Physiology of sport and exercise* (Champaign, IL: Human Kinetics), 192.

Sample Long Form Medical Questionnaire, page \bb\

Reprinted, by permission, from D.S. Brooks, 1998, *Program design for personal trainers: Bridging theory into application* (Champaign, IL: Human Kinetics), 38-45.

Sample Overview and Consent/Release Form, page \bb\

Reprinted, by permission, from D.S. Brooks, 1998, *Program design for personal trainers: Bridging theory into application* (Champaign, IL: Human Kinetics), 50-52.

PART *I*

STARTING, MAINTAINING, AND GROWING A SUCCESSFUL PERSONAL TRAINING BUSINESS

CHAPTER 1

Personal Training: Then, Now, and Into the Future

To understand where the personal training profession is headed, you need to know its origins and identify how the personal training industry has evolved. This background also helps you appreciate the quantum leap we have taken to move personal training from the dark ages!

Who are we? Trainers around the world tell me that we wear many professional hats. We are not only individual trainers and coaches; we are professionals, educators, supervisors, facilitators, motivators, inspirational leaders, and the "answer people." Oh, yes, and we're still expected to have a personal life!

Personal trainers are highly educated. Eighty-eight percent have a college degree, and 31 percent have a postgraduate degree. Ninety-four percent hold an industry certification, and 68 percent plan to be in the industry 10 years or more (IDEA 1997). We are committed! The average household income of a personal trainer is more than $78,000 (IDEA 1997). We teach general conditioning, resistance training, nutrition and weight management, and sports conditioning; many trainers are involved in various facets of rehabilitation and special populations. We purchase or influence purchases of footwear and apparel, exercise and sports equipment, food and nutritional products, office equipment, and health and beauty products. More than 5,000,000 Americans look to personal trainers for guidance, instruction, and motivation. The number of Americans who hired a personal trainer increased by approximately 32 percent from 1999 to 2000 (International Health, Racquet and Sportsclub Association 2000). Seventy-one percent of us have an established relationship with a retail equipment supplier, and almost 50 percent of trainers maintain a relationship with a manufacturer (IDEA 1997). Ninety percent of trainers recommend products and services directly to their clients. Trainers see more than 250,000 different clients each year and serve clients with an average household income of more than $80,000. Of all the training that takes place, about 66 percent of that training occurs in health club facilities, compared with just 6 percent at home and 6 percent in smaller studios (IHRSA 2000). Our clients constantly ask us for advice (97 percent of us are asked nine times per month), and 75 percent of our recommendations are acted on (IDEA 1997). There are roughly 400,000 personal trainers in the United States (IHRSA 2000), which makes it clear that we are "impact players" in the health and fitness field. Along with this realization—that trainers can have an effect on a person's life—should also come a sense of responsibility to act in the client's interest.

Probably no other professionals in your clients' lives see them as regularly as you do. We have the power of influence and ongoing personal contact. We as a profession can positively affect lives!

Yet, in my opinion, although personal training is growing rapidly, it is in its infancy regarding its potential to influence a majority of society to engage in regular physical activity and healthy eating habits. This holds true for other allied health professions, too. Let's face it—the majority of the population does not engage in regular physical activity, preventive health practices, and healthful eating behavior. This represents a great opportunity for personal trainers

worldwide. Equally true is the fact that one-on-one training is the best way to guide a person to health and fitness results and to develop a program he or she can follow for a lifetime. And, although our ranks are growing mightily, there will always be room for a trainer who possesses a winning personality, the right nurturing qualities, and the required technical competency.

Personal training is no longer the new kid on the block. Personal training is time tested, and its value is certain. Personal training is an established profession that is here to stay!

History of the Fitness Industry

The personal training profession certainly has an early genesis. Pictures on tombs indicate that weightlifting may have been practiced in 2500 B.C. By the sixth century B.C., strength training was predominant in Greece. More currently, professional strongmen appeared as entertainers in traveling shows in the late 1800s and early 1900s in the United States and Europe. The large, awkward look of the strongmen probably did little to encourage this form of training, although their performances may have been quite entertaining.

During the 1920s and Great Depression, Jack LaLanne began to develop programming and fitness equipment that served as the foundation of the modern fitness movement. Although at the time his ideas and methodology were often described as outlandish, or at the least on the fringe of sensibility, history tells us that Mr. LaLanne was very much the cutting-edge health and fitness practitioner for his times. From about 1910 through the 1940s, strength training took on more of a cultist status and was popular among bodybuilders (Dalleck and Kravitz 2002; Reed 1999).

In the 1940s, Dr. Thomas DeLorme helped bring back a degree of respectability by showing the health benefits attributed to strength training done by postoperative patients. He also introduced his 10-repetition maximum (RM), three-set program that progressed from 50 percent to 75 percent to 100 percent of the 10RM resistance. Incidentally, this type of programming is still widely followed today, although it may not be the most efficacious approach for a majority of adults who are looking to maximize their strength gains with a minimal time investment. During and after World War II, Dr. Thomas Cureton spurred another significant development in our field when he began to use research and apply the findings to influence how professionals teach fitness. Next, the Cold War years of the early 1950s marked American concern with statistics that identified about 60 percent of schoolchildren as miserably unfit, when compared with only 9 percent of the children from European countries. These statistics influenced political leaders to promote health and fitness among the nation's youth (Dalleck and Kravitz 2002). The American College of Sports Medicine (ACSM) was founded in 1954 and continues to establish position stands on a variety of health and fitness issues, based on scientific research.

In the 1960s, President John Kennedy promoted fitness and health for all ages and broadened the scope of the President's Council on Youth Fitness. During the late 1960s, Dr. Kenneth Cooper coined the term *aerobics*, and the fitness and health craze had its mainstream start. (In Brazil, Cooper's influence was so great that "doing a Cooper" still means to go for a run!) Cooper's new philosophy focused on disease prevention and stressed the importance of having epidemiological data to support the benefits of regular exercise. Dr. Cooper is widely recognized as the founder of the modern fitness movement.

The concept of periodization, the systematic cycling of intensity and volume of the workout over specific time periods, began to emerge with Tudor Bompa's research (Bompa 1965; Reed 1999). Some professionals also credit noted Soviet researcher L. Metveyev (late 1970s) with championing the importance of periodization. More recently, Fleck and Kraemer (1996) and Bompa (1999) have produced periodization models and texts that are less complex and more usable for fitness professionals. The new millennium will continue to focus on specialized training programs and meeting the needs of an inactive youth and aging population.

History of Personal Fitness Training

The idea of personalized programming, as we define it today, is well over 100 years old. However, the terms *fitness professional, personal*

fitness trainer, and *personal fitness professional* were not associated with this early era of our industry. The mail order programming that Charles Atlas (Angelo Siciliana) hawked in the 1920s may have perpetuated the idea that training consisted of weightlifting and building huge muscles. At the same time, professional strongmen left an image with the impressionable public that reinforced this thinking. Although Angelo and the strongmen may have been way ahead of their time, professionals still fight that "muscle" tag to some degree, even today. And, when talking about personalized fitness programming, one cannot fail to mention Jack LaLanne and his enthusiasm in bringing fitness and nutrition to the public's attention.

In the late 1970s and early 1980s, trainers in New York and Los Angeles began to create, and consumers embraced, the foundation of what personal training is today. Clubs and individual fitness enthusiasts (many now turned personal trainers) jumped on this fitness tidal wave and never looked back. The interest in fitness and health had now grown into a rage. As fitness and health interests flowed into the 1980s, the industry and its participants progressed with almost reckless abandon. Zealous enthusiasts flocked to this get-fit frenzy at all costs, believing that pain was gain, and they trusted personal trainers and group fitness instructors alike who looked the part but may not have had the necessary qualifications to present fitness in a sensible, progressive, and effective manner. Rather than tempering this all-or-none approach, many fitness professionals encouraged it!

Gaining a sense of the early years of personal training involves some difficult questions. Did personal training begin years ago with the privileged rich and famous, in fast-paced and progressive New York City or hip and trend-setting Los Angeles? Were some male trainers really slicksters who preyed on wealthy women? Did other so-called trainers get involved in the trade to bide their time and to earn a few bucks before a big career break (e.g., acting in Hollywood or New York City)? And finally, were some trainers really nothing more than personal gigolos?

You've probably heard it all, and so have your clients. In fact, in the formative years, it is probably not correct to characterize personal training as a profession. In my early years as a personal trainer (1984), I described myself as an exercise physiologist with a university graduate degree and not as a personal trainer! The field was too new and full of trainers of questionable integrity, character, commitment, and professionalism.

Media coverage of personal training seemed to peak in the early to mid-1980s. Many articles pointed to the hotbeds of personal training in Los Angeles and New York City as "the beginning." Media coverage centered on the workouts of celebrities and the wealthy. During this time period, it was a given that coaches (different than personal trainers) trained high-caliber athletes. Much of the media attention was focused on guru-type trainers who understood how television and magazine coverage added to their credibility, whether true or not. Additionally, many of these trainers also thought that who they trained was as important as how they trained, from a marketing perspective. This type of manipulation did little to enhance the image of personal training as a legitimate career track. In my opinion, you begin to have a problem when the client's celebrity status is more important than the workout!

I was fortunate enough to be in Los Angeles during the early 1980s and this amazing period of interest in personal training. But I remember telling reporters and magazine editors that I was a good trainer not because of whom I trained but because of my education and professionalism. They thought I was slightly insane, or at the least odd, because I would not disclose my celebrity clients and because I insisted that trainers are made not by who they train but by how they train.

The 1990s presented a consumer who was more cautious, perhaps because of injury, disillusionment, burnout, or poor training results, and a new participant who demanded that trainers be adequately qualified. Fortunately, a wide variety of media sources—newspapers, magazines, and television as well as various watchdog health and fitness publications and Internet sites—are available to consumers. Access to information like this teaches the consumer what to expect from a personal trainer who calls herself a fitness professional.

Personal Training Today

The rapid expansion and development of personal training into a thriving industry are truly astounding. Personal training is growing at a rate of 25 percent per year (Reed 1999). This is good news for the educated fitness professional who is committed to servicing her clients and growing her business and who possesses a high degree of current and applicable knowledge. The opportunities in personal training are limitless for trainers who possess the necessary foresight, vision, and qualifications to remain on the cutting edge of this rapidly growing profession.

There is no question that the personal fitness training industry is still in a rapid growth period. This is evident by the increasing numbers of trainers who have become certified by nationally recognized personal trainer certification programs. According to the American Council on Exercise (ACE), in 1993 the number of candidates for personal training certification surpassed the number of candidates for group exercise instructor certification for the first time in this organization's history, and the ranks of professional personal trainers have swelled to roughly 400,000 (IHRSA 2000). Many education providers and professional organizations report that personal training courses have remained in demand and membership continues to increase (IHRSA 2000; Hyatt 2002).

In 1994 I wrote that personal training was in its infancy and still evolving. I believe that is still true today, as personal training is still not commonplace and is not always associated with high levels of professionalism. A measure of maturity and respect has been gained, however, and personal trainers have graduated largely from being considered "muscle heads" and into the mainstream status of capable health and fitness professionals. Many personal trainers have made headlines for helping Hollywood stars, professional athletes, and high-profile corporate executives attain the body shape and fitness level they wanted. However, personal training has moved beyond the image that trainers only work with the rich and famous or privileged. In fact, most personal fitness trainers work with ordinary people who lack the motivation or exercise know-how to work out regularly and efficiently on their own. A diverse price structure for personal training services seems to indicate that personal training or coaching is no longer only available to the professional athlete or well-to-do client. Increasing numbers of personal trainers and these varied fee structures have allowed the personal training profession to access a broad range of people and inform them about the benefits and affordability of personal training.

Trainers today are better equipped to meet their clients' needs. Fifteen years ago, many personal trainers were self-taught gym aficionados and self-proclaimed experts. These habitual exercisers knew what worked for them in their own workouts and simply passed on their so-called expertise to clients. Today, trainers have the opportunity for education and certification, which enables them to develop safe, effective, and personalized workouts.

When I started my business almost 20 years ago, the concept of personal fitness training as a professional occupation—or even as a service that was attainable for the average consumer—was given little attention. Today, well over 400,000 trainers on five continents have successfully introduced personal training into their cultures. Consumers are clamoring for information on how to select trainers and now realize that many people can access this great service. A number of colleges are presenting personal training as a career option track for students with, or without, a formal degree.

Simple logic says that trainers starting out today are going to have a tougher time than trainers who established themselves years ago, if we assume that many of the people who want trainers already have one. However, the majority of the world's population has never experienced the difference a trainer can make. About 80 percent (some estimates push this number toward 90 percent) of the population doesn't work out on a regular basis! A huge business opportunity remains and there is not a better service in the world when it comes to positively affecting individuals' lives. Whether you are a seasoned trainer or rank beginner, a wealth of clients are available for you to train.

If training is new to your area or is slowly growing in acceptance and popularity, you are in an exciting position. To meet this challenge, you have to educate people about personal training. The first step is to clarify what services you plan

to offer and how your service is special. Once you can define, in writing, what personal training is and how you could make a difference in people's lives, and when you can identify who you should and should not work with, then you can share this message through newspapers, magazines, radio, and television.

Current Issues Facing the Industry

It is encouraging to know that today's consumer is more discerning when interviewing personal trainers and more demanding of legitimate credentials. It is also comforting to note that the majority of trainers place their clients' agendas and needs first and fiercely protect the client's right to privacy. Personal training is about service, service, and more service. If you base your business on the question, "What can I do for my client?" your business will thrive and your personal satisfaction will soar.

Unprofessional Behavior

Our industry is still threatened by unscrupulous behavior. Erratic or unprofessional behavior hurts any business, whether growing or established. Unprincipled practitioners in any field, whether doctors, dieticians, physical therapists, athletic trainers, chiropractors, or massage therapists, hurt anyone involved in that profession.

Even though the personal training industry has come a long way, remember that your every action as a fitness professional is being watched, scrutinized, and evaluated. What you do reflects on anyone who is involved in personal training as well as on you and your business.

We still hear stories about lack of professionalism in our field. This type of negative association makes me cringe. I'm proud of what the majority of trainers do for people, and it hurts when anyone draws the profession down. On the bright side, it reminds me that if these types of personal trainers who reflect our industry poorly can have some degree of success, just think what can be accomplished when you set the standard of care, service, and professionalism at the highest limits! Trainers provide a list of wonderful services to dramatically improve individuals' lives for the better.

Certification Versus Licensure

A key issue facing trainers today is whether the industry needs a comprehensive qualification program. As is true in any industry that grows quickly, not all trainers are credits to the field. Many in the industry are concerned about the lack of consistent professional guidelines and the sometimes less than adequate competence level exhibited by so-called professional personal trainers. Some industry leaders believe that this lack of quality control and consistent standards hinders efforts to further professionalize the field. Bringing consistency to our profession might require a certification or licensing program that blends theory and science with practical application of the information.

Whether a standard certification or licensing program would serve or set back the field is an ongoing and heated debate. Until such a program is developed and adopted, or rejected by the fitness industry, there is no better substitute than a constant hunger for new and updated training theory and ways to apply that theory in day-to-day training. Obtaining a formal degree in a related field, obtaining various recognized certifications, and most important, constantly updating your knowledge at least guarantee a certain base level of competency that can keep personal training safe for the consumer. Trainers should have an insatiable appetite for professional journals, industry conventions, and other educational opportunities. As part of your professional presentation, education does not stand alone but rests next to personal conduct, of which you must set the highest professional standards.

In the meantime, we are a self-governed profession. Anyone can claim to be a personal trainer. This cannot be said for other health professionals, such as licensed physicians, osteopathic doctors, chiropractors, physical therapists, and registered dieticians. All must fulfill rigorous entry requirements as set forth by their profession and pass state licensing exams to practice.

In an article regarding certification for exercise physiologists, Carl Foster (1992) noted the feelings of many professionals in this field by stating that government regulation is a way to improve the quality of care in the medical and exercise industry and enhance professional status—in this case, for physiologists. The same

argument has been put forth for personal trainers, although certainly this is not a consensus view in personal training.

Dr. Foster pointed out that to justify such a licensing requirement, we need data that document a demonstrable risk to the public when staff are unqualified. Licensure and government regulation could ensure that businesses hire staff with documented qualifications. Creating clear guidelines regarding qualifications of exercise staff is an important step in providing more consistent regulation of the personal training industry. Regardless, if you own a business or manage a facility, you must ask, "Can I afford not to hire qualified staff when liability is considered?" People who support licensing or some type of increased regulation believe that regulatory control and consistent standards not only would be good for the exercise participant in terms of safety, quality of care, and effective programming, but also would represent a marketing advantage to qualified trainers.

Finally, most of the licensed health professions regulate at a single or, at most, double level of licensure. If the profession is regulated by a single level, this usually is the lowest common denominator of practice. A double level is represented, for example, by a physician who is licensed to practice general medicine and, if specially trained, medicine and surgery. From Foster's discussion with various professionals, he concluded that they support licensure at a level somewhat below that of exercise physiologist. Relative to personal training, this equates to some level above minimum competency but below the most stringent requirements. Many fitness professionals believe that current certification requirements represent this level, but there is no consistent industry standard and numerous certifications are available. This fact makes it difficult to identify a certified personal trainer's minimal competency level. Without a doubt, future discussions will attempt to define the lowest common denominator, or minimal standard, with regard to competency. For example, is competency represented by no relevant academic degree and certification, a relevant bachelor's degree without certification, or a relevant bachelor's degree with certification?

Consider that some professionals question whether a health- or fitness-related degree is of value if not updated regularly with continuing education. This feeling seems to support certification or licensing requirements from the standpoint of accumulating continuing education credits or units to keep a trainer's knowledge current. As can be seen, there seem to be as many questions as answers and a variety of potentially valid scenarios. The issue of certification and licensure, combined with a mix of formal education experiences, is likely to be a hotly debated topic for some time. Although the verdict is not close to being final, we all must become involved in the process and ongoing debate. The standard of care and educational requirements in the field of personal training need to be evaluated, and from this study recommendations should clearly identify whether the system needs an overhaul.

Fitness-related businesses (i.e., certifying organizations or health clubs) and trainers who oppose government regulation because they believe it will limit their ability to run a cost-effective business may complicate or thwart the examination of our field. Actions and opinions like these are not good or bad but are appropriate and part of the process of due diligence. Additionally, the path through government bureaucracy is slow and is generally unique to each state or country. Even if the industry agreed on a single strategy, implementing a licensure process would probably take several years. Regardless of what you believe, do your homework and become involved. Organizations that provide membership services, training and education, or certification should become involved in these proceedings as well as individual trainers.

Currently, there is no coordination among the many certifying organizations and hence no single, impartial voice from the fitness industry in the area of certification and standards for personal trainers. As mentioned, licensure should not be characterized as good or bad, although many professionals support the concept and others think it is a potential fiasco. Would increased regulation lift personal training's credibility to new heights and provide additional opportunity to work more closely with insurance companies, licensed health care practitioners, and preventive health care? Or would we be faced with government officials controlling an industry they know nothing about, increased cost of doing business, and

bureaucratic red tape? Your professional involvement in this topic is essential. Because few of us would like to be dictated to in regard to standards in our profession, involvement—not apathy—is the rule.

The Future of Personal Training

What will the future hold for personal training? Although it's difficult to say with absolute certainty, you can be confident that the following issues are going to be important for the industry in the coming years.

Education

Education leads the way with regard to the future of personal training. Continuing education is a must for all in this profession. Participation in formal education, certifications, workshops, other educational events or conferences, and distance education courses has brought personal training out from under its sometimes deserved stigma of being a fly-by-night occupation. A large segment of the medical profession now recognizes qualified personal trainers as an important adjunct to their patients' treatment (Ashton 1998; Couzens 1992; Gesing 1990; Molk 1996). A qualified personal trainer can work with an asymptomatic individual, a sedentary population, or a myriad of special needs populations, including medically referred postrehabilitation patients.

Like almost every service business today, personal training has entered a specialization phase. For a personal trainer, this means that the more audiences the trainer can confidently work with, such as cardiac or postinjury rehabilitation patients, diabetics, asthmatics, children, and older adults, the more marketable she will be. The trainer who is diversified and well rounded in terms of education has an opportunity to develop a professional and trusting relationship with licensed health care providers who will put their outpatients' care in her hands.

Health Care Reform

How personal trainers will work with medical and insurance companies in terms of preventive care and reimbursement for services is still uncertain and will continually evolve. However, our aging population, an increased awareness of how fitness positively affects health, and the world's current push to change the availability and types of health care management are all working in the trainer's favor.

Fitness research analyst Ralph La Forge, MS, predicts that insurance companies will become more and more reluctant to pay for the use of advanced technology and that primary care physicians will rely increasingly on independent health promotion specialists (i.e., personal trainers) to supply various preventive services to their patients (Brooks 1994).

Fitness careers expert Linda Pejchar of H & F Solutions adds, "Greater emphasis on self-care, prevention and outpatient treatment implies continued work for fitness professionals, nutritionists, and other health promotion and education specialists—and for greater referral opportunities from physical therapists, orthopedic surgeons and cardiac rehabilitation specialists. However, this emphasis would also bring increasing pressure for fitness professionals to be credible, experienced and well educated" (Brooks 1994).

Opportunities for personal trainers in the health care field are partially based on the possibility of reimbursement by health management organizations (HMOs), according to Daniel Kosich, PhD. Although Kosich believes that personal trainers will have a role to play, he also adds, "At the moment it is impossible to make an accurate statement defining this role because no one knows the actual details of health care reform" (Brooks 1994, pg. 29).

Regardless of the eventual details of health care reform, the well-prepared and -educated trainer will be in a strong position to work with various allied health professionals, including those who are licensed. Kosich encourages trainers not to wait for health reform to create opportunity but, instead, to get involved now and create their own opportunities. Links with allied medical professionals should be established whether health reform evolves into an opportunity, self-destructs, or reinvents itself each time a new governing body is introduced to a particular region of the world. Personal trainers will always need, and should desire, to work with licensed health care providers.

This liaison embodies professionalism, helps to bridge the two disciplines, creates a business opportunity, and most important, is critical to offering the client or patient complete care.

Since the health reform opportunity is partly based on reimbursement, reimbursement issues will be tied to health care organizations, which historically have associated reimbursements with licensed professionals. A license ensures the third-party payer (insurance company) that the person with the license falls within certain standards to qualify for reimbursement consideration. According to Kosich, this establishes who is an approved provider. If we consider this aspect of industry history, it makes even more sense to ally ourselves with licensed health care providers. In the foreseeable future, there is a good chance that reimbursement for the non-licensed professional will continue in the same manner as exists today. Generally, the licensed professional will hire the trainer for patient care, bill the insurance company for appropriate services rendered, and pay the trainer directly. Reimbursement for personal training services will likely continue to best be served by affiliating with licensed professionals.

Many signs indicate that the current direction in health care reform will be a bonanza for personal trainers. However, I believe its effect will be less than revolutionary. Furthermore, if you are going to be a significant part of health care reform, it is critical that you have appropriate credentials and technical depth. Most encouraging, and having little to do with health care reform, is the increasing acceptance and awareness by medical professionals of how qualified personal trainers can provide outstanding "aftercare" for patients.

Dr. Michael O'Shea predicts that personal trainers "will have to learn subspecialties and learn to market themselves in a proactive way." Fitness business advisor Jeffrey Bensky, PhD, believes that personal trainers will be a part of health care reform. He thinks the "winners" will possess the following qualities:

- An ability to provide quality service
- An ability to provide cost-effective service
- An ability to manage information (Brooks 1994)

Dr. Bensky believes that personal trainers can deliver on all of these issues. He explains, "As part of health care reform, there will be a huge focus on prevention and early detection of disease." The implication, according to Bensky, is that the personal trainer is in the position to gather a wealth of information the insurance companies can use to reduce their costs (Brooks 1994, pg. 30).

For example, you can discover high blood pressure in a client who is not being seen by a doctor regularly. Bensky says, "To decrease costs you have to manage information and act on the information by treating and preventing further escalation of the discovered health risk" (Brooks 1994, pg. 30). Trainers often have this type of information at their fingertips, because properly educated trainers assess their clients' health status regularly. Trainers have the ability to pass on the information to the appropriate practitioner so that she can carry on continued evaluation.

The horizon is ripe and exciting for the personal trainer. As discussed, a growing portion of the medical community already considers personal trainers as a viable solution to ongoing health needs of their patients. The educated personal trainer will play a continued and increasingly important role in providing specific services as part of patient treatment in conjunction with licensed health care professionals and venturing into the area of insurance company billing, especially when collaborating with licensed health care providers.

Expanding the Scope of Personal Training

According to health trends analyst Ralph La Forge, MS, health promotion and personal wellness represent the big picture as far as consumers are concerned. La Forge also contends that, "Unquestionably, interest in health promotion including wellness or primary prevention programs (which promote general health rather than treat disease) will continue to rise as interest in health care reform and worksite health promotion programs escalate" (Brooks 1994, pg. 33). Additionally, many consumers would like to feel and look better with a minimal and realistic time investment. Trainers can maximize exercise returns by using efficient training, which could be termed "smart training."

Being aware of current exercise interests (i.e., trends and consumer needs) is important. Identifying and tracking trends can motivate

you to learn new skills, advance old skills, and improve your marketability as well as help you spot new opportunity.

There are numerous opportunities for the personal trainer who stays abreast of new information and research in the many diverse areas of health promotion. But the fitness professional also must understand how the average fitness enthusiast thinks and must deliver the program in a way that is nonintimidating and attainable to the prospective fitness enthusiast. Widening your service scope not only broadens your market but also keeps your business current and interesting.

Expanding Service by Selling Products

Another way to leverage income earning potential is by selling products. Personal training, by its nature, helps you establish a trusting and professional relationship with your clients. Statistics support the fact that clients will look to you for advice and counseling when they want information about health or fitness products (IHRSA 2000). But, you still need to ask yourself, "Why am I thinking about offering products?" Your business, personal standards, and ethics will determine what types of products you will sell and under what circumstances you will recommend, offer, or promote them. If you choose such a direction, the products must be in the best interest of your clients or other outside markets that you target, as related to need or safety concerns. Do not forget this fact. Your personal training business success is centered on training clients, not selling exercise equipment, apparel, or nutritional products. Never compromise your commitment to service. This area of your business should not be taken lightly with regard to its ability to generate profits or undermine the trust and confidence you have earned from your clients. Approach this option carefully and with the highest degree of integrity. Refer to chapter 5 for additional discussion.

Specialization: The Emphasis of Today and the Future

Think specialization when contemplating the type of clientele with whom you can work. For example, providing services to high-need or higher-risk clientele is an exciting option, can be very rewarding, and is important for business growth. Today's personal trainers are generally more qualified, and as discussed, trainers have become more credible and attractive to physicians and other health care professionals. Because of this, incredible opportunities have already opened up in this area for the personal trainer.

Sooner or later, all trainers will have the opportunity to work with a higher-risk client. This expands your market potential for prospective clients and increases your positive impact on the lives of others. Don't discount the immense personal reward that awaits you when you make a difference in the life of a person who has special health and fitness needs. The gratitude and respect that emerge over time are, to say the least, powerful.

Looking Beyond Physical Activity to Program Design

Personal trainers must look beyond "activity only" to broader health issues. For example, assessing and addressing coronary risk factors is a first step in increasing your perceived value to your client. Do you help your client implement lifestyle behavior changes related to stress, a family history of coronary heart disease, obesity, lack of regular exercise, smoking, high blood pressure, high cholesterol, or high-density lipoprotein-to-cholesterol ratio? If you can help your client improve in any of these areas, you have gone beyond serving as an exercise mechanic or becoming a trainer who only can herd your clientele through a workout. Stated another way, physical activity should not be your only approach to encouraging a healthy and balanced lifestyle for your clientele.

The Most Important Issue Will Remain the Client!

Business success could be characterized by a healthy, happy client as well as a thriving bottom line. Most people do not want to exercise hard. People exercise to feel better and have more energy for daily living and recreation. To meet the needs of your clients, you need to venture beyond your own thinking and understand

what your clients want. Most of your clients would not plan their exercise programs like you plan your own. Consider this thought seriously and you're on your way to personalized and effective program design as well as a thriving business.

The most important issue will always remain the client, independent of whether you are a business conglomerate or sole proprietor! Eye-to-eye communication, care, and follow-through are the key markers for personal training businesses that endure and thrive. I have had professional relationships with some of my personal training clients for many, many years. Many still do not perform with perfect exercise technique. Some do not include all of the ideal components of a balanced fitness program in their daily schedule. Although the majority of clients are not the perfect models of textbook programming and theory, their individual improvement is great. Their lives are better. I engage my training with limitless energy and follow through with a focus on service delivery. I use methods that are specific and individualized to my clients' goals, physical abilities, and readiness to learn. This approach convinces a client that our program works and allows for personal success. This is personal training that listens to the client, involves the client, and acts on feedback from the client. Ultimately, this is personal training that meets clients eye to eye in terms of their needs and wants, on their own emotional turf, and at their current level of readiness to move in new directions!

Breaking In: You (Yes, You!) Can Be a Personal Trainer

If you're just starting a career in personal training, this chapter will help to give you the motivation and a practical foundation from which you can move forward with confidence. Whether you're new to training or trying to make your business work better, you'll find principles and philosophy in this chapter that have become standards for successful training businesses. Other chapters will expand on the numerous options you have as your business evolves and your programming becomes more sophisticated. "Breaking In," along with chapter 3, highlights everything you need to know about starting or continuing to grow your business without overwhelming you!

What it takes to start your own business or enter the personal training field and work for an established business is neither easy, obvious, nor risk free. However, nothing will stimulate you more than putting pressure on yourself to create a successful business. With that comes a desire to excel as well as a sense that passion drives you. Owning your own business has a simple bottom line. All of your hard efforts and risk taking will come back to directly reward you. There is no middle person here, no one to take your profits and no one whom you can blame for your failure. The necessity to balance business, technical programming issues, and people management skills, in addition to managing financial pressures, provides some insight into why most people never own their own business.

On the other hand, working for a top-notch personal training organization has an upside, too. Doing so promises you a peer learning experience, educational opportunities, a diversity of programming challenges, relatively little financial risk, and flexible scheduling options. In a sense, you're running your own business and creating your own schedule within a business while simultaneously having a guiding hand.

The personal training arena can offer enough possibilities to satisfy the wishes and personalities of most individuals interested in offering personalized training. Some people are self-starters and thrive under change, risk, and leadership demands. Others do well under the guidance and care of a sensitive and progressive boss or mentor. This variety in the field of personal training means you can choose between owning your own business or working as a trainer for another organization. There are many possible matches and career options, none necessarily better than another.

Sole Proprietorship: Owning Your Own Business

Sole proprietorship (having your own business or owning or leasing the required space) begs the question, Do you really want to own a business?

Owning a business requires you to brave uncharted waters. It is a journey that commits you and can be laced with questions, uncertainty, and insecurity. But there is also no adventure that burns as bright with the hope of success and personal fulfillment as building a successful business.

Several key points should be highlighted. First, don't assume that your first steps are obvious and basic. This is so far from the truth. None of your questions are simple or stupid. You need answers. Get them. No apologies necessary. It's part of doing your homework. If a particular source you tap ridicules you or questions your reason for even asking a question with "such an obvious answer," move on quickly to another source. It's only after you look back, years later, that the right choices are obvious and seemingly mundane. Even when you're on the road to success, the need for self-evaluation and the hunt for answers to business challenges will be ever present.

If you're new to personal training, you need confidence and must know that you are making wise career decisions. I can't think of a better way to find proper direction than by looking at what seasoned pros are doing in their businesses. I have a system that works and have already made mistakes you can avoid. Whether it's information you get from *The Complete Book of Personal Training* or from other credible written or human resources, it makes sense to implement the ideas that work for your situation. No one wants to reinvent ground floor basics. You cannot ask too many questions. Asking questions and getting answers will help secure and define your business direction. This requires time, forethought, relentless diligence, and thick skin! Don't be discouraged when many of the "doors" you knock on don't open or the person behind the door doesn't receive you with open arms. Continue to knock! Do your homework!

Second, there are many ways to both run, and define, a successful business. However, it's less risky when your choices can be taken from within boundaries established by successful trainers and businesses worldwide. My way, or another trainer's successful blueprint, is not the only avenue to adopt. However, you should consider the inherent principles since they are tried and true. Carefully evaluate whether the idea can be successfully integrated into your business.

Third, it might be comforting to know that most people who start their own businesses are scared to death. This usually motivates the self-starter to do her homework (ask questions and dig for related reference material) and helps her overcome the paralysis of fear that leads to inaction. By performing the requisite "due diligence," you can replace uncertainty and anxiety with confidence, clarity, and action. It is interesting to note that around the world, it is not the norm to be self-employed. Many individuals would like to own their own business but don't know how or where to begin. The fear of the unknown and risk sets in, and the reality of owning a business never materializes from this starting point. Years from now, it will be fulfilling for you to look back on your successful business accomplishments. With a grin, you might slowly shake your head with disbelief when you consider that the real fears you feel today almost derailed your promising personal training career!

The Making of a Personal Trainer

Personal training's lasting strength lies in professional standards, ethics, and conduct. This is followed by the intangible, human variable—your special touch. So much of personal training is based on three simple things: Believe in yourself, care about people, and establish yourself as a fitness and business professional. These are the key features of a successful personal training career.

The following is a snapshot chronology of the beginning of my personal training career. In 1983, personal training was not well defined. Please read this haphazard evolution with a smile and don't make the same mistakes! Today's trainer has the advantage of proven know-how, and the field continues to professionalize and grow in sophistication.

I didn't start out wanting to be a personal trainer. The idea never even crossed my mind until I moved to Los Angeles in 1983. I had just completed my graduate work in exercise physiology and was excited about working in a sports medicine clinic. Although it wasn't that long ago, personal training was not seen as an occupation or legitimate career track.

Today, personal training is a viable professional option for someone with a formal degree or those with specific accreditations or certifications. By 1987, some universities offered personal training certification programs and

courses that focused on day-to-day personal training concerns, and the number of organizations that certified trainers continued to increase, as well.

Although there are now more than 400,000 personal trainers across the United States (IHRSA 2000), in 1983 personal training was still uncharted territory. At the time, I worked for a health club where I trained staff, oriented new members to equipment, trained clients one on one, and—to my consternation—simultaneously sold memberships. The club I worked for had a unique policy. It offered all of its members personal training, at no additional charge. Demand quickly outstripped the club's ability to deliver on this promise. Soon, it became apparent that the club had abandoned its intention of fulfilling its promise and of expanding into a full-service sports medicine facility. The club was not going to live up to the promises it had made to its members and me. Although this reality first hit me as a stinging disappointment, it also was a positive driving force in my career. This setback motivated me to start my own business and set high ethical standards. I never looked back! Honesty, follow-through, and service would become my trademarks.

As the club gained more members, club owners were unable (and unwilling) to hire adequate numbers of qualified staff to service the demand. It didn't take the members long to figure out what was happening. Anxious to get their workouts back on track, a few asked me to train them privately, at their expense. (Although the members were outraged at the club's broken policy, it's interesting to note their willingness to pay extra for personalized training. It reinforces the idea that once someone gets a taste of the difference personal training can make, it's hard to return to working out alone.) Even the club, which had its back to the wall over this issue, encouraged staff trainers to take the clients on so that the members weren't completely left out in the cold.

At that point, I was working 50 to 60 hours a week at the club and taking home less than $1,500 a month. It didn't require a sharp mind to figure out that I could better that amount by working out with three clients, with as little as three hours per client a week (nine total hours at $50 per hour). Even though that sounded terrific, the thought of losing a steady paycheck

made me very nervous. I was so uncertain, in fact, that I continued to work for the club until my work schedule ran me ragged. Today, I reflect on these memories with sheer amazement. You would think making a choice like this would have been easy!

While trying to increase the number of paying personal training clients, I did something I don't approve of and don't recommend: I didn't hold firm to my hourly rate. Because I was just starting, I would quote a fee to prospective clients which was at the high end of the going rates in my geographic area. If they indicated that my fee was too high and countered with a lower rate, I said yes, thinking I was still coming out ahead, compared with the club job. However, changing fee structure to accommodate someone's ability or willingness to pay is very unprofessional.

Fortunately, I quickly got five or six clients who unhesitatingly agreed to my rate, so I stopped cutting my price. But, I didn't stop expecting the bottom to fall out of my business and spent that year training anyone who expressed interest, even if it meant sacrificing my personal life, weekends, or nights. Before I knew it, the gaps in my day when I could study, read, and do my own training disappeared. Instead of working out a few people several times a week, I had six to seven clients each Monday through Friday and three on both Saturday and Sunday.

After several more months had passed, I realized that I had unknowingly bought into what I coined the "greed/ego syndrome." This is the circuitous rut that occurs when you cannot say no to additional clients even when your schedule is full. Why? More clients mean more money, and it is flattering to the ego that you are in demand.

In my case, it got worse before it got better. I had booked 65 to 70 one-hour training sessions per week. I would get up at 5 A.M., work through the day, go for a run at 10 P.M., fall asleep around midnight, and then do it all over again. It was incredibly draining, but it also had a momentum that I couldn't immediately control.

By then, I couldn't even pretend the money was worth it. I wasn't having fun. I was too tired to keep up with my paperwork. I wasn't as discriminating in terms of choosing clients with whom I would work, and I let some clients

get behind in their payments. Not surprisingly, these clients were the same ones who canceled at the last minute, came late, and didn't take training seriously. Some of them didn't even bother to explain or apologize. It put me in an awkward position and made me realize that I was lowering the level of service that was being provided. Additionally, I wasn't running my business properly.

Many aspects of my life had gotten out of hand. I was not in tune with my business, my personal instincts, or my clients. I forced myself to relax about my career a bit and admitted that I had been so unsettled about the potential of clients going on vacation, or quitting entirely, that I had gone overboard in an attempt to cover myself. I had taken on all comers and it had ground me down.

I wasn't the only trainer in town who had too much work, too fast. Some other professionals were also lucky enough to be in the right place at the right time. The interest in personal training was erupting. In the space of several months, the club's clientele was supporting more than 10 trainers. Most were even newer to the field than I was and had less or no technical background. Other entrepreneurial trainers specialized in at-home workouts or had vans in which they transported a variety of equipment. At one time personal trainers were an oddity, but soon local magazines began running articles about how to choose them and ran a listing of trainers that covered two full pages.

At this point I decided to take control of my career and my personal life. Although the club was a great starting place, as I became increasingly clear about my personal and business directions, I decided to take the risk and establish my own training facility.

In the process of getting my studio opened and operating, I discovered how exciting and frightening it can be to make all of the decisions regarding equipment, policy, and business procedure. There was so much to learn. Besides running my business, I still had to give the same quality workouts to my clients and find time for a personal life. Over a period of time, I learned to carve out at least an hour per day for my own training and another hour to deal with business and client concerns. I was still busy but at least felt like I was running the business instead of the business running me. Plus, I realized I was once again providing the superb service to my clients for which I had become known.

One day when I was out for a run, I saw a billboard that said, "Be All That You Can Be." This made me think about why I love personal training. It allows me to challenge myself and grow in many areas. I think personal training is one of the most diverse professions in the health and fitness field in terms of career options. I've learned business skills, improved my communication skills, and continue to study scientific research and stay abreast of changes in our fast-growing industry. Finally, the most rewarding aspect of personal training for me is the day-to-day challenge of renewing my relationships with my clients and helping them move their training programs forward.

Why Personal Training?

I would guess, and hope, that you love the idea of helping people in a personalized setting and are impassioned with the entire area of health, fitness, and wellness. Personal training is a wonderful vehicle to leverage yourself financially and can allow you to become a full-time professional. Many group exercise instructors have taken advantage of this opportunity. Obviously it is not a sensible idea to teach 25 to 40 group exercise classes per week, yet the group exercise instructor who has the technical knowledge to teach groups of people safely can easily transition into a career of personal training, without giving up one for the other.

Personal training can provide the leverage, from both a physical and a financial perspective, so that you can become a full-time professional. Although you can't teach 40 classes per week, if you're well prepared, you can facilitate a number of personal training sessions and command a fee that is well above minimal or average wage standards compared with many other occupations. For many individuals, personal training has become the right step toward financial freedom and toward being involved 100 percent in a profession they love and want to work in around the clock.

How Do I Start?

Fear, insecurity, doubt, and lack of confidence result in status quo: no movement! This is a type of career paralysis, stemming from lack of preparation and inadequate background work. How do you overcome fear and inaction? Attorneys might call it "due diligence." Information is power. Preparation is power. When you access, understand, and apply information related to an area of interest, and you can add a dose of experience, the concoction represents confidence and clarity that lead to success.

I like to mountaineer and climb rock. Some view these recreational habits as a death wish. I also used to think these were sports for extreme thrill seekers—until I started to do my homework. First, I read a lot about these sports. In fact, I became quite an armchair mountaineer, accumulating a substantial library of related material. The physical endurance, tenacity, and intellect these sports required fascinated me. I watched climbing videos, visited specialty climbing stores, and talked to and asked questions of anyone who would listen. I was amazed by the warm response to my often naive and novice questions. Next, I needed to mix in a little experience under watchful guidance. It wasn't long before I was climbing at a local rock climbing area and joined a mountaineering club. I became more and more skilled. Understanding the intricacies of protecting the climb, setting or placing protective equipment, and knowing how to belay with a rope changed my impression of climbing. The risk of climbing became very calculated. Far from being a death wish, mountaineering and climbing have become a passion that fuels my soul, challenges my mind, and often pushes me to the limits physically and mentally.

Erase fear, inaction, and lack of information from your list of reasons for not initiating a career in personal training. Entering the field of personal training or creating your own business is not much different from my journey that led me to discover what mountaineering and climbing were all about. I discovered a passion; I had to do a little homework; I gained some insight and asked a few questions of the pros; and finally, I needed a little practice. Whether your framework of reference is sport or business, find your passion and get your homework done!

Right now, you might be working in an unrelated profession, working for someone else in the fitness field, or teaching group exercise classes part time. But perhaps you'd really like to start your own personal training business and be a full-time fitness professional. Information gathering will give you the security, confidence, and clarity to move your career off the starting blocks. You're already in the process. Reading *The Complete Book of Personal Training* is a step in the right direction that will move you from inaction to action that will jump-start your career and dreams. Not only should you read applicable books, attend industry conventions and workshops, and take home-study courses to expand and update your knowledge base, you should also attempt to gain valuable experience from hands-on learning experiences.

In the process of gathering more information—doing your homework—you'll reach a point of clarity. You'll choose to dip your toe into the vast waters of personal training to experience the possibilities and lessen your risk. Or you might jump into personal training with commitment and conviction that raise the water level up to your neck. Find your readiness level. Regardless, spread the word about what you are doing.

When people find out you're going into the business of personal training, they may think you're crazy or a genius, or they may label you "entrepreneur." I think many of my associates and family were shocked when they learned I was leaving behind university teaching and my position as fitness director of a 5,000-member fitness facility to enter the field of personal training. Even today a fancy title with a big desk and nameplate on your door rates higher in the eyes of people who do not know or understand the greatness of this profession.

Now, it's time to "embarrass yourself into success." In other words, tell the world. By telling everyone you know that you're going into the business of personal training, you'll place yourself in a situation where you're in too deep to back out. In the near future, your doubting friends or friendly supporters will want a progress report. This positive pressure to succeed can backlight your desire to succeed so that you'll be able to give a thumbs-up report on your business' development, and it will help you sustain the required diligence to stay on the path of success.

First, your success in establishing a personal training clientele and flourishing business will lie partly in your ability to define personal training. Key media sources, including written media, radio, and television, are your best friends with regard to getting the word out. If you can't define personal training, it's pretty hard to establish what service you're offering, why a client would want to hire you, and what difference—as perceived by the prospective client—your service can make in her life. See appendix, "Client Introductory Packet Overview," for an invaluable tool to create a very useful business "calling card" that will help to define your business direction and identity.

Second, realize that the service you provide is tied directly to your success. If in doubt, recite service, service, and more service.

Third, it's important to discover the needs and wants of clients. It is unlikely that your client will work out like you do. Personal training is the perfect environment to personalize workouts that can match each client's style. A client may think you're an exercise zealot, especially if what you consider a warm-up for your workouts equals your client's entire aerobic session, or your idea of fun revolves around an endurance event that highlights you on ESPN being airlifted to an emergency room with an IV draining into your arm! We need to remove ourselves from our biased perspectives and consider our clients' perspectives. How? Find out by asking, listening, and acting on the information. You didn't "get it" if the program you develop doesn't reflect your client's comments, feedback, and needs.

What Qualifications Are Required?

The personal training industry is currently a self-regulated service business. Anyone can claim to be a personal trainer. To add to the confusion, someone who possesses a formal degree in an area of health and fitness isn't always an effective trainer. What exactly do you need?

Education and Certification

A college degree in a related health and fitness field is an excellent plus for any trainer and quickly establishes credibility. Formal education can also open doors for you as you attempt to expand career options. Do you want to write a book, be featured in a video, manage a training facility, or represent yourself as an expert consultant? Someone who has a degree will probably be considered before someone who doesn't, or, at the least, doors of opportunity will open more easily. Although the degree may not prepare you for the exact job in which you find yourself, I believe a college graduate knows how to find information. If you can locate information and are disciplined in study, you can become expert in any topic. Not only have you acquired knowledge, but you have learned a process with which to uncover information. Information is power. Accessing it is the key!

It is highly probable that as many as 25 to 50 percent of the trainers in the field do not have degrees. Clients who hire trainers, and who are well-educated themselves, generally prefer the degreed over the nondegreed trainer. So, there are advantages to formal education.

Having said that, I must restate that the most important professional marker for any trainer is to have an updated certification that is nationally recognized. What a certification discloses to me, or to a potential client, is that the trainer is involved and up to date in his or her respective health- and fitness-related fields. I would prefer a certified instructor with no degree over a PhD who has not updated the degree he or she earned 15 years previous. The issue, of course, is updated versus outdated information. Living on past rather than current accomplishments is unacceptable.

At a minimum, I believe that certification is a requisite, although this type of training is not legally required in the personal training profession. Today's legitimate personal trainers are certified or have degrees, and they carry liability insurance. It is worthy to note that it is almost impossible to get liability insurance unless you're certified.

Are all certifications created equally? Absolutely not! To date, several hundred certifications are available, and this number does not include a variety of "certificate-type" programs. Pick a certification that is demanding. Fitness consumers are beginning to discern between fly-by-night operations and programs that set admirable and challenging standards. (Refer to chapter 1 for additional discussion of licensure and certification.)

Is CPR Training Necessary?

Like certification and liability insurance, possessing a current cardiopulmonary resuscitation (CPR) card is not mandated legally. But the true professional would not be without one. Also, many certification organizations and liability insurance carriers require that you maintain current CPR status to renew certification or to obtain insurance coverage. A specified number of continuing education credits over specific time frames is another key requirement. Most likely, you will never have to lead a rescue effort using CPR or help clear a blocked airway in a choking victim. But, legal matters and self-protection aside, whether it was your child or a client who needed this lifesaving skill, could you ever forgive yourself for not acquiring this simple and easily obtainable expertise?

Keep your client's best interest at heart, and many questions about the qualities you should strive for, and the skills and services you should provide, answer themselves. A reasonable and prudent trainer will carry a current CPR card, and this dovetails with legal and industry standards in most communities.

Establishing Credibility

There are four keys to establishing credibility. First of all, you need communication skills. Good communication skills allow you to make a favorable initial impression on the client. Second, you must act as if you are constantly being observed, evaluated, and scrutinized. Doing so ensures that your mannerisms, energy, and performance are always professional. Third, you must use honest business principles. Shoddy business practices turn off clients, erode credibility, and eventually chip away at your ability to deliver top-notch service. Fourth, it's important to demonstrate limitless energy, commitment, and enthusiasm without necessarily being outwardly frenetic. You should develop your own style, and it should match nicely with client expectations and personalities.

Setting Up Shop for Your Client's Home Gym or Your Training Facility

If you have a modest budget for equipment but don't want to compromise training result, consider these equipment basics:

- Exercise mat. Cho
firm resilience and c
easily cleaned. This
and safety on any
work can be difficu.

- A stationary cycle. Cy
nonimpact, and effective. The
a smooth, solid feel and a good u.
record. Don't be tempted by an inexpe.
brand, since they generally fail rather qui
Find an equipment distributor who gives professional discounts.

- Elastic resistance. Elastic resistance is commonly referred to as surgical tubing, bands, or tubes. This simple piece of equipment can provide limitless exercise possibilities for resistance training and stretching. Include several thicknesses so the load can be progressed, and purchase a door-strap or step-strap attachment for increased diversity. It's easily carried and affordable.

- Fixed-weight dumbbells. At a minimum, purchase three to four pairs of fixed-weight dumbbells in increments appropriate to your clientele. Fixed-weight dumbbells are preferable to dumbbells with removable collars, because they are safer to use. It is virtually impossible for well-maintained fixed-weight dumbbells to come apart on the client.

- Bosu Balance Trainer. Best described as a half ball, this incredibly effective and portable balance training device can train functional movement and core stabilization regardless of fitness or skill level.

- Stability ball. This air-filled ball has been used by physical therapists for years to condition and rehabilitate patients. It's very diverse and lends itself well to abdominal and back conditioning and functional and balance training.

- Adjustable step and lateral training slide board. Can't afford a bike just yet? This item provides two diverse pieces of cardiovascular equipment, and the step can double as an adjustable bench.

Add the following equipment when you can:
- A rowing machine with manual pull arms. This can be used for strength training and cardiovascular work and can easily be inserted into a circuit training workout. Be certain that the rower moves smoothly, is adjustable, and has a seat that locks.

Wireless heart rate monitor. You can use a wireless heart rate monitor to teach your clients how to use the rating of perceived exertion (RPE) and heart rate ranges for targeted training. Clients can also use monitors to guide their efforts when they are working out by themselves. I instruct some clients to wear the monitor during resistance training sessions so they can more readily understand the physiological difference between increased heart rates during cardiovascular conditioning and those during resistance training.

- Set of fixed dumbbells. A complete set of fixed or nonadjustable dumbbells or Power-Blocks (these store easily and take up little wall space), from 5 through 60 pounds or greater, in five-pound increments, will add challenge to a variety of exercise movements and will enhance strength levels.

- Microweight loads. Magnetic microweight increments that attach to dumbbells or other equipment (see chapter 16) allow small and appropriate weight increases as your clients increase strength.

After these purchases, I would consider buying a treadmill or multistation exercise machine. Whatever you buy, make sure the machines require minimal adjustment and maintenance. Several of the better known multistation machines take too much time to adjust and the mechanics of the machine do not work with the body. Not only does a poor investment like this interfere with the efficiency and rhythm of the workout, it can lead to injury and poor training results.

To compensate for my time when designing and purchasing equipment for a client's home gym or corporate setting, I generally charge the client 10 to 20 percent of the cost of the equipment. I make sure the markup is clearly indicated on the bill and communicated before I take on the job. Because the purchase price plus any markup is still less than the client could have negotiated on his or her own because of my professional discount, everyone is generally pleased with the arrangement. If the transaction only takes a quick phone call, for example, I may provide the service as a professional courtesy to a regular client.

Business Pitfalls: Why Trainers Fail

How do you keep a business up and running? More than 77 percent of businesses fail within five years of their start-up dates. Only about 18 of 100 businesses will make it to a 10-year anniversary, which means 82 percent of businesses fail (Hallo 1999). Service is the cornerstone of your business and can be compromised by five common mistakes.

1. Overhead. Take the pressure off by keeping your costs low. Don't make the mistake of accumulating unnecessary debt. For example, is it best to start your career training for someone else, partnering in a business, or assuming a large building and equipment lease? There is not a right or wrong answer. Instead, identify what allows you to develop professionally before you take on huge financial risk and mounting business pressures. Many businesses fail because trainers create a huge financial burden related to their cost of doing business. Pressure like this creates a situation where the trainer desperately needs clients and income immediately. Choosing to start a business in this manner clashes with the reality that most businesses require at least three to six months to be up and running (this means up and running as a solid business, not necessarily wildly successful on a profit or loss basis). Your net income—how much profit your business generates—is more important than your gross income. Unnecessary, inappropriate, and high expenses eat profit and discourage many new business owners, setting them up for failure. Too much overhead, especially if you can't support a negative cash flow for an extended period of time, is one of the leading causes of business failure.

2. Lack of follow-through and service. Pay attention to detail. This includes following up on unanswered client questions, maintaining sensitivity toward individual client needs, keeping personal energy levels up, and, in general, sustaining professional behavior.

3. Lack of personal depth. Need more be said? You can never have enough education. Your professional knowledge and ability to

apply it to improve your client's training program and quality of life directly affect your value, your versatility, and the services you can provide.

4. Improper expansion and unrealistic time allocation. This sets the stage for the greed/ego syndrome. Can you maintain quality of service to your clients and a balanced lifestyle if you are working around the clock? A mature trainer who does not have the time or capacity to take on new clients can say no! and refer the potential client elsewhere. If service is compromised, your business is expanding too fast. Do you have more clients than you can handle? Saying no is preferable to haphazard expansion and hiring practices. Well-run businesses capture income without compromising service.

5. Creating inappropriate workouts in relation to client needs. It is especially important during the initial stages of training not to create workouts that are too hard. Although any type of misguided workout is usually well intentioned, nothing will undermine your credibility and destroy your business more quickly. See the section in this chapter, First Meeting, for an approach to working with new clients.

These potential pitfalls welcome you to the world of the self-employed and the responsibility that comes with owning your own business! They are ever-lurking, waiting to pull your operation down. You can look at the considerable challenge of owning your own business as overwhelming and intimidating or as demanding and exciting. The successful trainer will choose the latter characterization. Your comfort and success will be in line with the amount of preparation you have done.

Developing Your Training Style

Every trainer evolves his or her business image and personal style over time. I believe that both the style and the image that you project should originate from a scientifically valid viewpoint. This type of foundation indicates physical programming based on science and acceptable professional behavior. Science and professional business behavior may seem like a strange place to turn for style and image, but they are the underpinning theme on which the trainer's authority and integrity rest. Clients become involved in your organization because they trust you and are able to experience results because of the sound direction of your training.

From that base of science and professional business behavior, you then add the human element. This is where your unique personality becomes very evident. Style is what makes you special and differentiates you from other trainers. Your style, along with grounded expertise and professionalism, is often the key reason why people want to work with you. Your style may underscore special traits that, for example, allow you to smother a client with unrelenting focus and attention, and service like this can begin to set your approach apart from other trainers. Spotting and positioning the body can be another acceptable hands-on characteristic that personalizes your training approach. Or, maybe you're gifted at tuning into a client's emotional needs to make him feel like he is the only person in the entire world who matters during the time you are with him. These are good examples of how style develops and is recognized.

I also believe that trainers must project unlimited energy and enthusiasm but must differentiate between frenetic behavior and unguided emotional intensity versus directed and focused attention. You don't have to go overboard to convey sincerity, dedication, attention to detail, enthusiasm, commitment, and total involvement with the client. Find your style! When you do, the match will fit like a glove.

There is no quick or magical manner to evolve style. As you become comfortable dealing with clients on physical, emotional, and psychological levels, you will gradually develop a personal style that is all your own. Chances are, you won't even realize you have a style until a client or peer mentions it. I didn't think I had a style until a client told me I was "firm but easy." I took that to mean that my goals and plans for the client were firmly grounded in scientific information. As long as the training does not stray from that long-term direction, I am reasonably flexible. I remain caring and sensitive, but I am also firm with regard to session direction and I don't let the client get too

far off track. This combination of setting and achieving specific goals and being flexible to the client's mood and physical condition on a particular day makes perfect sense to me and is one aspect of my style of training.

Where Do You Go With Your Training?

When all is said and done, this is an exciting time to be a trainer because the field of personal training is still developing by leaps and bounds. At the forefront of these changes is the demand for increased depth and diversity of education for health and fitness professionals and an increasing push worldwide to get the inactive population involved in fitness. The profession will continue to distinguish between fitness and health versus performance-oriented activity, because these two approaches to training are very different.

Along with theoretical education will come a further integration of practically applied information and training techniques. Core education, based on scientific principles and proven training methodology, will continue to lead the way in program development.

A sensible and moderate approach to exercise continues to be the watchword in fitness, especially when you are working with individuals new to exercise. Self-punishment and the "no pain, no gain" insanity are long gone. The profession continues to focus on and encourage smarter, kinder, more diverse, and gentler workouts. It is hoped that this type of approach will allow the personal training profession to involve a larger segment of the nonexercising population. A huge number of potential clients exist in this market for the trainer who can identify and meet this population's needs. Looking for clients? About 80 percent of our population doesn't exercise regularly. Many of the individuals who fall into this category state that part of the reason they don't exercise is because "no one understands me."

The no pain, no gain mentality burst onto the scene years ago. Back then, many individuals interested in a health and fitness program turned to coaches who trained competitive athletes or former athletes. Assuming that the same programs would work for adults who had been sedentary, many pseudo-professionals placed the general public on similarly intense, inappropriate regimes. The one-size-fits-all approach to fitness is out. Education, combined with "in-the-trenches" experience, dominates the training scene today.

I hope that progressive fitness professionals, armed with new information and balanced by an informed public, will break this cycle of abuse, guilt, misinformation, and misdirected intentions. As the fitness revolution and growth of personal training continue, the no pain, no gain philosophy, which can be both injurious and intimidating, is being replaced by a more moderate, more enjoyable brand of exercise that brings fitness within everyone's grasp—and creates an experience that can be enjoyed for a lifetime.

Because fitness should be a permanent part of daily life, most people are insisting—and with good reason—on programs that are moderate, safe, and enjoyable. Progressive fitness professionals, therefore, no longer make people feel that they have to pound their bodies into submission day in and day out with an unvarying, intense routine. Instead, fitness professionals now encourage many of their clients to hike through a park, cycle around the neighborhood, or walk along the beach at an enjoyable pace. This new sensibility can help trainers to tailor workouts to their clients' temperaments and fitness levels. In addition, because people benefit from and take pleasure in these low-intensity workouts, they will more likely continue the commitment for a lifetime. Consistent and sensible workouts will burn calories, decrease the risk of coronary (heart) disease, improve health, and help one to feel better. And that is why most people want to work out in the first place.

How Do You Create Success?

Trainers who can provide a multitude of appropriate workouts, depending on the needs of their clientele, will be the trainers of the future! To gain this insight and advantage, you must be a good listener. Personal training success, whether you're a sole proprietor or a personal training mogul who oversees numerous trainers and facilities, comes from an ability to meet clients' needs at a one-on-one, personal level.

Common Traps That Trainers Fall Into

It is helpful if you can avoid common mistakes that even master trainers and top business owners have made. Avoiding these oft-repeated mistakes requires that you focus on key aspects of high-level service delivery.

Neglecting overhead and the bottom line. Your net income, or bottom line, influences who you are as a business entity and provides a picture of your business. Whether new to training or seasoned, you cannot be reminded of this truth too many times. If you're overextended financially and don't have the staying power to make it through the roller-coaster nature of income flow or if you have an overhead that is too high, you've created a condition of need: a need to get more clients, generate more income, and work longer hours. These types of need move your business away from customer care and service.

Imagine an actor who is desperate for work. As the actor auditions for a part, spontaneity and confidence are replaced with pressure and anxiety. Rather than being relaxed and inspired, the actor gets distracted by thoughts of needing this job to pay expenses or to further a career.

Your focus should always stay fixed on delivering a service that is people focused and inspired to meet the needs of your clients. Financial pressure will take away your relaxed and confident delivery of the service system you are trying to build.

Lack of follow-through and service. Failure to follow up on client requests and provide services to your clients in a consistent and professional manner will mark a business for failure. Computers, cellular phones, day-planners, the right staff, and personal attention to detail are your allies in safeguarding this important aspect of your business. The cornerstone of a personal training business is service, service, and more service!

Lack of personal depth. I believe you can never have too much knowledge under your belt that is application oriented, accurate, and in line with current industry standards. Personal training has evolved, as have most service-oriented businesses, to a specialty era. The more skilled you are at working with special needs clients or high-risk situations, the broader your target market.

I don't believe you should put undue pressure on yourself to wear too many hats. After all, if the majority of the world's population does not exercise regularly, this means that a whole lot of people need a basic program and a caring trainer to progress them to an acceptable level of health and fitness. Most trainers have this capability.

However, I strongly believe that the future of personal training belongs to the trainer who has a variety and depth of education and to businesses that can service the growing needs of specialty markets. Sports conditioning, the older adult, diabetes, youth fitness, asthma, and pregnancy are just a few of the many specialty markets that are emerging. This demand for specialized service and knowledgeable trainers creates a market niche that you may be able to enter.

Becoming proficient in a number of areas does not occur overnight. All trainers evolve their skills and abilities over a career. Embrace change and learning. The ongoing quest for knowledge opens the door to a career that is full of opportunity, reward, and the personal satisfaction that emanates from giving clients their money's worth! The well-educated trainer is a valuable resource for clients.

Lack of adequate people skills. All the education, certifications, and advanced degrees in the world will not bail out a trainer who does not have the requisite people skills. The best combination, of course, is a trainer who understands how clients best respond to her encouragement and has the education to back her methods. Most people look to a trainer as a source of information who can guide and motivate them toward productive workouts and personal goal accomplishment.

While maintaining professional conduct, the trainer is expected to nurture, educate, support, coax, influence, wheedle, and demand as well as exhibit fairness, caring, and excellent listening skills. The ability to coax the best out of a client within an environment that is fun, motivating, filled with anticipation, and realistic is a large part of the subtle art of personal training.

Allowing the quality of your services and products to become diluted. Delivering quality service and products ties directly into time management and ethics. Are you realistic with your time allotments? Are the products you recommend in the best interest of your client or your pocket? If your ability to deliver service is sliding downhill because you've taken on too much, reverse this trend quickly. The principal product you are selling is your service.

Never forget that the basis for a successful personal training business always comes back to the trust, respect, and service delivery centered around the one-on-one relationship. Your business is never bigger, nor is any other service or product, than this foundational relationship. Preserve the integrity and trust of this ever-growing relationship and you will be successful for the long haul.

The greed/ego syndrome. Greed (more money) and ego (can't say no to new business) that are excessive take you away from the nucleus of a successful business—which is to spotlight the client. Making money and expanding your business are inevitable by-products of a well-managed business that understands the impact of client service. But if you focus exclusively on generating more money, you lose your ability to focus on what makes a personal training business successful. Patience, which includes a wise and realistic use of time, sets you up for success and allows you to stick with a personal training career for a lifetime.

Unrealistic time allocation and scheduling. Which comes first, the greed/ego syndrome or unrealistic time allocation and scheduling? The two are so closely intertwined that it is not important to differentiate. Be realistic and considerate of yourself and your clients when scheduling your finite available time.

Improper expansion of services or facility. With success often comes a desire to expand your operation to include additional trainers or even a number of new training sites. Growth and change are fine. However, expansion and business growth can probably never occur too slowly, especially if your plate is already full. I have witnessed a number of successful personal training businesses fail because of unchecked, incautious expansion that was not backed by a well-thought-out plan; the corporate world is full of failed businesses that expanded too quickly.

Concentrate on what you want to accomplish, evaluate whether you have the time or resources to do so in a professional manner, make sure you have the financial staying power as well as the necessary time to see it through, and don't be distracted by every opportunity. Set your goals and put a realistic plan of action into play. Establish your business plan and see it through to completion, or if you find that it makes good business sense to cut your losses, move in a new direction. In the process, maintain the business procedures that made you successful!

Developing inappropriate workouts. Occasionally, you might lose a client's interest because he or she thinks the introductory workout should have been harder. More often, however, clients lose trust in their trainers because of workouts that are too hard for the client physically or mentally. If you're a good listener and ask questions, you can avoid this disconnect. The hard workout is usually well intentioned but doesn't always match the client's readiness. Most people want a workout that is fun, is progressive, doesn't hurt, and still gets results. Putting aside the issue of hard or easy, and how you might work out yourself, here's the bottom line: The program must meet the client's expectations, wants, and needs.

Making a First Impression

Your first conversation with a client and the subsequent workout are the most important contacts you will ever have with a client, particularly with regard to establishing a long-term relationship. Expect the client to be a little nervous in both cases, and realize that this is your chance to show off your professionalism and service orientation.

First things first—unless clients hire you, the workout remains purely theoretical. To move those clients through your doors, you must make a powerful first impression to potential clients who have expressed an interest in your services. A client who is attracted to your business quickly forms an impression as to whether you can provide the service she needs, whether she would click with you, and whether you run

your business professionally. All of this "impression feedback" is constantly being formulated by people who might use your service or refer someone to it. Because you don't know who is watching, or when an impression might be imprinted on someone's memory, never let up when it comes to displaying professionalism and an upbeat attitude.

Frequently, that first opportunity to display high standards will be on the phone. During a phone conversation, and as quickly as possible, I ask broad questions about the individual's background, availability, and current exercise program and goals. I listen carefully and take notes. I mention that I have an advanced degree in exercise physiology and that I'm certified, and I explain why this might be advantageous. Like it or not, you have to sell yourself! I let the individual know I will present a balanced exercise program that meets his or her wants and needs. I state my rates, make sure I've listened and responded to all questions, and then move to close the deal. Don't cringe at this idea of closing the deal. After all, the individual is interested in your services, too! You have to ask people for their business.

If nothing we discuss, including my rates, prematurely ends the conversation, I cap the chat, which takes anywhere from 10 to 30 minutes, by emphasizing the importance of getting together. In a face-to-face meeting, my personality, enthusiasm, and sincerity, as well as professional demeanor, can work for me. Suggesting a meeting allows me to plant the idea that we both will have a chance to decide whether we'll make a great team.

I also point out the openings that are available in my schedule, because I may not be able to accommodate the prospective client's schedule. Believe it or not, even if you don't have a single client, you still have a limited number of openings because you need to preserve your personal life. Limiting the hours you are available creates a sense of urgency toward commitment by the potential client; in addition, your time is precious and you need to be efficient with its use. It may be tempting—and it's a big lure, especially if you're in great need of clients or new to training—to take on all comers, regardless of when they want to work out, even if it means throwing away your personal time. Do you really want to work from 4 A.M. to 10 P.M.

and be at anyone's beck and call, any time of the day? Discipline yourself to maintain balance in your personal life. Don't fall into the greed/ego syndrome like I did early in my career.

On the other hand, starting a new business sometimes requires you to do whatever is necessary, as long as it is morally and ethically above board, to establish a strong business. Strive for balance and use common sense or you'll bury yourself and have to dig out.

First Meeting

Finally, you're meeting face to face. Verbal and written screening procedures are important to minimize your risk of being sued, and they increase your chances of being able to deliver a fantastic program to your new client. Why? The more information you gather, the more accurately and safely you can direct the program. Refer to the appendix for medical history questionnaires and other forms that will help you gather useful information.

I try to keep the first meeting to a half-hour and usually have it at my studio. Don't meet at a client's home. Instead, choose an appropriately public place. My place of business works because it allows me to show off the facility and other trainers and because other clients are present. If you're meeting for the first time regarding training in the client's home, you might suggest a restaurant or other suitable public meeting place. Reasons for doing so are related to privacy, harassment issues, and professionalism. In other words, you don't want to place either yourself or your prospective client in an uncomfortable or threatening situation. A neutral and public meeting place protects your client and you.

During this meeting, the client and I talk and complete the necessary paperwork. Policies and professional expectations are discussed. I give the client a chance to ask about the training program and my qualifications as well as those of other trainers. At the same time, I ask questions about the client's lifestyle and interests and how he or she might benefit from a program like this.

Does this sound like a time-intensive hassle? It will pay off. I believe that this thorough and sensitive approach is the reason why a majority of my clients have trained with me for years and

years. It's important to start the relationship on the right foot. Countless clients have told me over the years that my approach made it obvious to them my priority was not to get them in the gym as soon as possible so that I could start generating income but, instead, that I was interested in them as individuals and in their safety. I wanted to form the foundation for our relationship to grow. How did they know? I was and I'm still willing to commit the time necessary to establish a caring and service-oriented relationship. Do I waste time? Sometimes, but it is obvious when a client is not going to commit to your services. You can politely thank these people for their time and interest and quickly cut your losses. The rewards of this approach far outweigh the time spent. This process also lets you interview and assess the client. It's not necessary, or even appropriate, for you to work with every client who solicits you, even if the client is ready to commit! It takes discipline and professional maturity to say no to a client who wants to hire you. If you choose not to work with the client, explain to the client why you've made such a decision and try to provide a referral that can better meet his or her training needs.

As we talk about workouts and diets, I listen and watch carefully for red flags that indicate unhealthful habits or behaviors. I later compare these notes with the written information I have from the medical history questionnaires and other forms. It's not always easy to get an accurate picture of a client's health and fitness. For example, most people significantly overstate the amount of exercise they engage in and underestimate the amount of food they eat.

In addition, because it's a fresh relationship, new clients are sometimes on guard and, intentionally or not, may not completely disclose information at this meeting. Your personality plays a huge role in helping clients to be comfortable and honest. Paying attention to body language, listening closely to what is being said between the lines, and asking simple but leading questions sometimes allow me to get a clear sense of the person's health and fitness needs.

No matter what potential or new clients tell me, I don't argue, make judgments, or otherwise intimidate them. Instead I accentuate the positive changes that training will make in their lives. It is only later and after I am asked that I talk to them about healthful alternatives to any negative or potentially harmful behavior. By waiting until they want to change and invite my suggestions, I can meet them where they are today and invade more intimate space when they are more receptive and encouraging. Maintaining this sensitivity will have a great impact and open many doors related to your client's overall health, if you're willing to move at the client's own timing, when he or she is ready to make changes in these areas.

I do not charge the client for this introductory meeting. I believe it is time well spent. However, if the person insists on a sample workout, I offer my services at my normal, per-workout fee. I draw the line here with regard to giving away too much time without compensation. Prospective clients sometimes expect or demand this as part of their investigative process, but it's not necessary that you offer it. Can you imagine an orthopedic surgeon cutting into your knee or a hair stylist cutting your hair at no charge? At this level, I don't believe in giving away professional services. Risk is a two-way street, and some will have to fall onto the shoulders of the prospective client.

At the end of the introductory meeting, I hand out an appropriate medical history questionnaire (short or long form; see appendix), which the person is instructed to fill out at home. Some prospective clients who are aware of this requirement ask me to send them the necessary forms to fill out before our rendezvous so I have the information in hand at the time of the meeting. This allows the client to start training sooner, because all of the preliminaries are taken care of. At this time, or soon after the meeting and after reviewing all of the paperwork, I have an accurate picture of obvious health risks and a good sense of any areas in which my client may have special needs. I have a good idea of his or her attitudes toward health and related knowledge as well as an overall profile of what motivates the client and what training approach would best connect to his or her personality. In other words, I'm starting to understand what makes the person "tick" and how I can best work with him or her.

If any information given to me indicates a high risk of imminent injury or death because of exercise, I follow up these caution flags and

insist on talking to a qualified health care provider who is familiar with the client. All of this occurs before I decide whether to train the person. My clients appreciate this thoroughness when they understand that it is in their best interest for me to evaluate and follow up on all information at hand. It costs them nothing and gives us a better chance to create a program that is safe, personal, and results oriented. If there are no apparent risks and the screening process is complete, let the training begin!

Client Introductory Packet

In addition to being able to carry yourself well in conversation, you should also create an excellent image of yourself on paper. This paper trail should culminate in a presentation that I call the client introductory packet. You might also refer to this as a press kit, and the packet is an invaluable marketing tool that will help you get new clients and promote your business (see appendix).

This packet should include your biography, resume, philosophical outlook, and approach toward training as well as information about the basis of your program, the scope of your program, specific services to be offered, and areas of expertise. If you have written articles or have been written about, add these. I also include pictures of facilities I have designed because this encourages clients to hire me to design their home or corporate gym or refer me to their friends. Finally, a medical history, activity, and eating habits questionnaire should be a part of this initial presentation. Complete, professional, and organized information further enhances anyone's credibility.

Putting your goals and services in writing does more than give the prospective client a clear and concise look at you. Just as important, creating this introductory packet helps you to clarify what your business can offer. It helps you flesh out your business plan and identify what services you can expertly deliver. This will serve you when you sell your program to prospective clients, because it gives your business purpose and makes it easier to impress others with your conviction, expertise, and professional approach.

An integral part of my presentation packet is the medical history, activity, and eating habits form that each client fills out. This kind of evaluation is a necessity by any professional and liability standards. Plus, it communicates loudly that you're interested in learning about your clients and intend to create the safest and most specific program you can, based on their current situation.

The packet consists of personal information and business philosophy. Include in the packet copies of degrees, certifications, and liability insurance (I include a copy of my professional liability insurance, not to let my clients know I've protected myself, but to let them know I've protected them!); an 8- by 10-inch picture of you, which could be a head shot or other action photo; an essay on training philosophy and approach to training; necessary business policies; an overview and consent form; and the medical history, activity, and eating habits forms when appropriate.

The long-form medical history questionnaire I designed is purposely repetitive so it can more likely pinpoint red flags or areas related to my client's health that may require further investigation or more information before a program is started. Similar questions, asked different ways, assure me that I have gotten accurate and meaningful responses about my client's health. In addition, the questionnaire gives me an idea of my client's knowledge concerning basic exercise, weight loss, and nutrition principles.

How the Client Introductory Packet Works for You

The client introductory packet (see appendix) is a fantastic marketing piece that works! It clarifies who you are and what you have to offer (sell), helps you communicate why someone would want to hire you, and gives you confidence because you have all of your bases covered.

1. It says you are a qualified professional. You've done your homework and taken the time to put it in writing. You are a professional and in the business for the long haul.

2. It serves as your business card. I hand out my packets right and left. The packet leaves a much stronger impression with potential clients or the media compared with a business card introduction. It gives you a competitive edge, whether you're working by yourself or

within a personal training organization. What would impress you more, a business card or a professionally prepared introductory packet?

3. The introductory packet is your press kit. The media, and even people who might have an interest in referring your services to a friend, will ask you for information about your business and training approach. You'll be asked time and time again, "So you're a personal trainer. Can you provide me with information about your organization?"

I have two sets of introductory packets. The introductory packet I put together for these marketing situations doesn't include the medical history, activity, and eating habits forms. The more complete packet is appropriate for new clients who are ready to commit to training.

Overview of the Client Introductory Packet

Place the information in a clear binder with a plastic, slide-on spine. This creates an inexpensive presentation that looks pulled together and is easy to edit when information needs to be changed or added to the packet.

This is how I organize my client introductory and press kit packet (see written sample in the appendix):

1. Cover page: training logo and other contact information
2. 8- by 10-inch head shot or action-type photo
3. Personal biography
4. Resume
5. Copy of degrees and certifications
6. Copy of professional liability insurance
7. Brooks . . . The Training Edge philosophy
8. What to expect during your first visit
9. Basic program and business policies
10. The Training Edge approach: balanced fitness
11. Medical history, activity, and eating habits questionnaire and forms (This is an optional insert, depending on who will receive the packet. New clients get the whole packet, whereas the media or those interested in my services get the shortened version.)

12. Books written by Douglas Brooks (including copies of book covers)
13. Informational articles written by, or about, Douglas Brooks or The Training Edge (Insert list of titles; if you've written just a few articles, include part or all of the articles.)
14. Personalized gym design in commercial, corporate, or home settings (Insert pictures of gym designs.)
15. Character and service references (List a number of people or organizations that would bolster your credibility and confidence in your service, if contacted. Be sure to request permission if you print contact phone numbers; you can also simply state that the references are available on request.)

Included in this packet is a map detailing The Training Edge business locations.

First Workout

Finally, after all the preliminary phone conversations and the first meeting and when the client screening is complete, the day of the first workout arrives. The client is probably somewhat apprehensive, and rightly so, although a well-designed client introductory packet in combination with a sensible workout will put him or her at ease.

Perhaps to establish their role, many trainers spend this first workout putting their clients through a battery of tests, including submaximal cardiovascular testing, flexibility tests (e.g., sit and reach), strength and muscle endurance tests, blood pressure assessment, body fat composition, and the like. Last, and often with good intention, the trainer annihilates the client with an intense workout that was supposed to showcase the trainer's abilities. I approach initial workouts differently.

Fitness assessment administered by personal trainers who don't possess advanced degrees or specialty training in medical testing and evaluation does nothing more than create test data you can refer to over time to show personal improvement. Generally, the tests have absolutely no diagnostic value unless the professional is appropriately trained. Your screening

process (i.e., medical history questionnaire and appropriate consulting with licensed practitioners when needed) will determine when your client is ready to begin a program that requires him or her to be physically active. Any trainer who believes the measurements are anything more than a motivational tool is mistaken.

Premature testing undermines the basic focus of my training, which is to take the average, health-conscious client and help him to become physically fit without pushing him to exhaustion or into a state of performance anxiety. Rather than ease clients into the training process, these tests tend to coerce clients into working at their maximal level immediately. They want to perform well on the tests. Not surprisingly, clients who want to do well get nervous and competitive and tend to push hard. Although there is no rationale for it, the client ends up in a potentially high-risk situation.

Because the client is still largely an unknown entity, I would much rather keep the first workouts mild enough to be virtually injury and heart attack proof. Even clients who are adequately screened could have undiagnosed heart disease, for example. During initial workouts, I reassure the client, who may be intimidated by the concept of working out, and establish a supportive role. Many people, especially those who have had a negative personal history and impression of physical experiences—couldn't do a single pull-up in gym class or got mauled in dodge ball—have to be handled carefully.

Instead of trying to impress them with quick results and a hard workout—which can lead to injury, extreme soreness, and lost clients—I spend the time emphasizing proper breathing and good exercise technique as well as talking shop about nutrition and other fitness topics. I also begin to teach basic physiological principles. This might include discussions on the myth of fat-burning exercise or information on how to use heart rate or perceived exertion to find the right level of effort for their cardiovascular workouts. Because accidents and injuries can happen at any time, and because many experienced trainers will tell you that you can never approach the workout from too conservative of a standpoint, I am confident that my actions are in the interest of my clients and a long-term professional relationship and could be documented as prudent in court. The clients also like it—they actually are relieved—because they realize health benefits and fitness can be gained without having to be beaten. Clients who are indoctrinated to the workout process like this get outstanding results and are more likely to stick with the program.

At these first workouts, I concentrate on creating an environment that is receptive to body positioning by touch or spotting. Even though it may not be comfortable for some trainers at first, physical manipulation is very effective in communicating your message of correct body alignment. If you are not confident in this method, however, your clients certainly will not be either. Ask your clients whether you have their permission to place your hands on them so that you can assist them with alignment and proper exercise execution. The touch or spot should be completely asexual, meaning the hands-on technique is not personally invasive, sexual, or to be construed as an inappropriate sexual advance. Where and how you place your hands will determine appropriateness. The spot should be geared to safety and proper body alignment. If a client is unsure or resistant, use mirrors and video footage, which are excellent tools that can be used in combination with hands-on technique to communicate the intended information.

Whose Workout Is It, Anyway?

As prepared as you are, as good as you and your business plan are on paper, there is no way to anticipate some aspects of personal training. Perhaps the first of these surprises is finding out that personal training, often glamorized, is a difficult, emotionally draining, and labor-intensive job. Although there are many wonderful upsides, personal training is a demanding job!

No matter how intensely a trainer likes to work out and independent of how many hours the trainer works each day, the workout belongs to the client. This means that you don't structure the workout to get your run in or to crank out a few ab curls on your client's dime. Trainers should facilitate the client's workout to optimize enjoyment, training result, and compliance. Period!

It is your clients' expectations, perceptions, and needs—not the trainer's—that count and must be met. If they don't want to push

extremely hard, and few do, the workout must reflect that yet still help them achieve their goals. Your screening and evaluation process should uncover your clients' desires and abilities.

Much like the Little League coaching nightmare, where coaches sometimes try to live an unfulfilled sports career through their little protégés, it is sometimes very hard for many trainers to let clients work at a pace that fits their mentality and physical readiness. Too often, it's easy for trainers to think that their clients' performance—running faster, lifting more weight, completing a marathon—reflects their own ability and success. They may be tempted to force clients into workouts that are not suitable. Why would a trainer move in this misguided direction? This might occur because a trainer wants to create clients who become walking advertisements for the trainer, or because that's what the trainer would do if it was her workout, or because the trainer just "knows" the client can give more. You must remember that it isn't your workout and your client doesn't think like you! Commend the client for his or her best effort, and your awareness will reward you many times over by minimizing frustration and injury.

How Hard Should That First Workout Be?

This point is worth repeating. Trainers should not make the mistake of thinking that a hard workout and extreme muscle soreness or discomfort create anything close to a positive training experience or that this situation impresses the client. What the trainer actually has accomplished is injury. Microscopic muscle fiber and connective tissue tears are the result. Many inexperienced or uninformed but well-intentioned trainers try to conduct the first workout from a boot camp mentality. Simply, training a client too hard is one of the top reasons for a client to stop training. It constitutes a loss of trust and confidence and also contributes to many personal training business failures. Don't take this lightly.

Many of your new clients won't want, much less need, a "hard-core" workout. By the trainer's own workout standards, many of the clients' workouts may seem easy, but the client probably has a different perception. Become confident and knowledgeable enough to educate your clients about the need for progression, safety, and adaptation and to allow this transformation to occur over time. Hard workouts are best introduced late in the workout regimen, months down the road, after the client is prepared both mentally and physically. By having a client work too hard initially, the trainer is more likely to end up with a client who is burned out, is injured, or quits instead of one who is grateful.

I believe a trainer will have more success by forgetting how the workout might look to an observer and, instead, by listening to and watching the client carefully. By letting the client's perceived exertion level determine the intensity of the workout, the trainer can keep the client motivated, safe, and having fun.

This philosophy does not mean that the client totally controls what is and isn't done in the workout. Maintain a balance of accommodating your client and directing the program. After all, your client is not the fitness expert. Many clients, for instance, only want to lift weights in the training session. If the client is in good shape and sufficiently motivated to perform the cardiovascular training by himself, his workouts with me, for example, can be limited to resistance training, stretching, and trunk work. But, before that can happen, the trainer must be absolutely certain that the client's program is balanced.

A trainer who does not make this balance a prerequisite willingly becomes little more than a client's workout puppet and is continually jockeyed around at the client's whim. This is not a professional personal trainer's role, it cheapens the industry, and there is not an hourly fee in the world that would justify continuing a relationship like this.

Let's return to fitness testing and assessment for a moment. (Also, reference chapters 10 and 11 for additional screening, testing, and assessment information.) I feel much more comfortable administering fitness tests after at least several weeks of progressive workouts. Even though I have spent thousands of dollars over the years on testing equipment and software, I make these tools available to my clients, not mandatory. I also use them on a client's request or when I believe they are of value to the spe-

cific client. I recommend a pair of top-of-the-line calipers, and at some point in the client's training, I may regularly take calibrated body fat measurements (skinfolds) on seven different anatomic sites: the subscapula, the midtriceps, the axilla (under the armpit), the chest, the iliac crest (taken on the diagonal), the abdomen (taken on the vertical), and the midthigh, so that I have a baseline for later comparisons. Although three sites are adequate, you can see how I use this information in part II of this book. Body composition and blood pressure measurements are perfectly safe for the client. However, make sure the body composition test is appropriate for the client. For example, an obese client doesn't need to be told the caliper jaws will not open wide enough to allow for a measurement.

The medical history information and physician's diagnostic interpretation, if required, are crucial to have when establishing a new program. Physical fitness testing may not be necessary or even desired in the early stages of a fitness program, but gathering information about your client's well-being prior to exercise is essential.

Fitness Testing and Evaluation

In a complete physical fitness program, testing and evaluating participants before, during, and after prolonged participation are considered important by most professionals. There are several reasons to test and assess a client's status:

- Assess current fitness levels
- Identify training needs
- Select training regimens
- Evaluate the participant's progress
- Evaluate the success of the program
- Motivate participants

The evaluation phase of a physical fitness program can be divided into two parts. The first part is the medical or diagnostic evaluation of the participant, which usually is performed by the client's physician. (A diagnostic evaluation may or may not be required, or possibly your client may have such an evaluation regularly, which makes the information potentially available to you.) The second part, which is most common with regard to fitness evaluations, simply compares your client's current level of fitness to future changes and is often used to motivate the client. This is considered a nondiagnostic procedure and does not evaluate the health status or readiness of your client to participate in a fitness program. Of course, before nondiagnostic protocols can occur, the client should be evaluated and cleared for any type of fitness or activity program.

Personal Burnout

It is imperative that you maintain professional and personal balance. If you are going to preserve a balanced approach to life in general and ensure a healthy self-preservation, you have to separate who you are as an individual from your work. Who you are is probably best represented by your personal growth, friendships, family ties, and values and beliefs. This is in contrast to the number of clients you work with per day or the number of hours you work in a day or the number of miles you fly per year. A decision to be consumed by your work, and allowing your very soul to be identified as your work, speaks loudly about your beliefs and priorities in life. A one-dimensional approach to life and work is a quick way to a dead-end. A trainer may be able to survive on training and business alone, but he or she will not thrive.

CHAPTER 3

Starting and Refining Your Business

This chapter is a tome unto itself and answers many of the questions that new trainers have. But, the information contained in this chapter is also useful to veteran trainers who want to mature, sharpen, and evaluate business practices. Even if you oversee many employees, you should never get too far away from the day-to-day realities of the training floor.

A successful business considers the perspectives of both client and trainer or business owner. Clients require special care, relationship maintenance, and nurturing. But the trainer needs to be cared for, too. This holds true whether you're the only trainer in your organization (sole proprietor) or you supervise other trainers. Ultimately, the success of the business comes back to whether the trainer is accomplishing the job for the client.

As you consider the following statistics about business failure and success, it might be wise to focus on the following important points. I have drawn on these points time and again during my career, and their message still has relevance today.

- Define your direction in writing (i.e., client introductory packet in the appendix).
- Acquire education and contacts that allow you to follow your direction.
- Concentrate on your destination by maintaining focus and following through in every aspect of your business.
- Keep an eye on trends so that both you and your business remain fresh and cutting edge.

Frightening is one word that describes statistics about new businesses. More than 77 percent of businesses fail within five years of their start-up dates. The next five years see the end of another 22 percent of the remaining businesses. (See box on page 34.) Only about 18 out of 100 businesses will make it to a 10-year anniversary. In other words, 82 percent of businesses fail (Hallo 1999). Anyone can go solo, but can you stay in business? Operating a successful personal training business and sustaining its success for the long haul are not easy, and the solutions required to thrive are not always apparent. Success relies heavily on what you are doing, not on what you want to accomplish or think that you are doing. The bottom line is that your actions must satisfy your customers.

Create a Professional Business Image

Although you might characterize your image as a basic aspect of your business, it is no less important to your business success. In fact, many successful trainers have taken a second look at both their business name and image and found them less than optimal. If you have any questions about your professional image or direction, develop a client introductory packet like the one in the appendix. In chapter 2, I discussed essential steps that are necessary to build a solid personal training business. From this foundation this chapter begins.

Ten Reasons Businesses Fail

1. Lack of vision, purpose, or principles. You need goals, vision, direction, and passion. Define what your business will deliver as its products. Identify a niche that will set you apart from other businesses.

2. Lack of financial planning and review. What you hope to happen will not materialize unless you plan to make it happen and reevaluate your budget regularly.

3. Too much dependence on specific individuals (this could be you). Do you want to work at a business or run a business? If a key employee leaves, will this leave your business in shambles?

4. Poor marketing strategy. Hard work and expertise in a given area do not replace marketing. I know people who have worked their businesses into bankruptcy. Marketing is about numbers and getting your product or service known to potential consumers.

5. Failure to establish or communicate company goals. This affects potential customers, employees, and company growth.

6. Competition or lack of market knowledge. In the personal training field, competition from other trainers is a weak argument for failure. No one is training the more than 80 percent of our population who doesn't exercise on a regular basis. You can avoid failure by knowing how the services and product you offer can meet several market niches.

7. Inadequate capital. Often times, the major reason behind business failure is inadequate start-up or expansion cash. Do you have the financial staying power to stick through slim times, a business disaster, or changing economics? Plan for this!

8. Absence of standard, quality programs. A specific level of expertise that falls within accepted industry standards and practices is required. The fitness consumer today is more savvy and informed than ever before.

9. Focusing on the technical rather than strategic work at hand. For example, the success of your business is not wholly dependent on you placing all of your time and effort into becoming a biomechanics expert. If you focus on only one area of technical expertise, for example, resistance training, you're no longer running a business. Instead, you're working at a business. Myopic focus rarely meets all of your customer needs. Running a business requires you to focus on the big picture.

10. Inability to place management systems in place. In other words, you do all of the work. Management systems include organizational schemes as well as using people effectively.

Adapted from FitPro (1999).

Creating a comprehensive client introductory packet or press kit will go a long way in helping you to avoid many of the mistakes cited previously that are associated with failed businesses. Being aware of potential stumbling blocks allows you to go in with your eyes open and will give you a chance to prepare for these pitfalls, thus avoiding the nightmare scenario of business collapse.

Companies like Mercedes-Benz, Vuarnet, McDonald's, International House of Pancakes (IHOP), Microsoft, and IBM, to name a few, have created an image directly tied to the product and services they provide. Their business logos are distinct and are immediately identified by millions of people worldwide, and their marketing message is clear. On the other hand, have you ever driven by a restaurant with a neon sign flashing "Eat"? What kind of service can you expect from a business called "Eat"? You may have one of two immediate impressions. First, this could be a cut-rate diner where you expect poor service, crummy food, and filthy rest rooms. Or maybe it reminds you of the time you chanced on a poorly lit, mom-and-pop operation called "Eat" where, to your pleasant

surprise, the server was friendly and sociable and the food was homemade, delicious, and inexpensive.

Here's my point: To achieve success, you must think about your business identity, establish a well-thought-out business plan, identify your target audience, and use effective marketing techniques. If, for example, your business has a slant that communicates bodybuilding, corporate fitness, or a women-only specialty, you need to evaluate whether this message reflects your true intention. Do you wonder how people will identify your business and what services they think your business offers? If you are not certain of public reaction, ask several people for their impressions. The response could surprise you and help get your business on track. A training colleague of mine once expressed puzzlement and dismay that his business was not attracting a nice cross-section of the available market in our area. It became obvious that one of the reasons was his business name: Executive Care. If you choose to specialize in a target market like bodybuilding, corporate or executive fitness, or women-only training, understand the limitations with regard to market size. Having said that, I'm aware of numerous successful businesses that enjoy prosperity in their chosen specialty. Of course, this discussion is not an issue of right versus wrong but one of planned direction.

Assembling the aforementioned presentation packet, media kit, or client introductory packet (it can be used for all three situations) is paramount in helping you clarify your business direction. Creating such a packet will also further solidify your business and professional image (see the appendix).

Advisory Boards

The development and use of an advisory board are essential to your business. (Note that this is not a board of directors, which votes on company issues and often has a stake in the decision-making process and financial gains.) A diverse advisory board can strengthen your credibility with clients and potential clients. An active board—versus a figurehead board that looks good on your letterhead but whose counsel you don't really use—can help you establish a solid business plan and avoid decisions based only on your limited experience or biased perception of a given circumstance.

A balanced advisory board includes individuals from both the business sector and health and fitness fields. Think of your advisory board as a group of experts available to help you better serve your clients. It's in your best interest to have a working board in place as soon as possible. This group's influence on your business and programming decisions can be invaluable.

Where do you get help for a client who has a special problem? How do you locate health professionals to whom you can refer? Whom do you tap when you have a business question? This, of course, is where your advisory board comes in.

Part of the success of your program design and of your business development depends on expertise you can access. An advisory board is a step in the right direction. Thoughtfully selected advisory board members can provide an expert and professional referral system, business management team, and wise counsel for your daily and long-term operational goals. Your advisory board members should not expect you to send business to them, nor should you expect the same. If such a referral does come about, it should be in the best interest of the client.

Setting Up Your Advisory Board

Why would someone want to serve on your advisory board? I am asked this question quite often, because the underlying question that begs to be answered is, what's in it for the nominee?

I serve on boards for a variety of reasons that range from enjoying the prestige I receive by being recognized as a contributing expert to a worthy organization, to having a desire to be involved with a top-notch organization whose philosophy dovetails with mine. I serve because the cause is worthy, or I want to give back to a specific enterprise, or I appreciate the guidance I have received over the years with no strings attached.

Will an individual serve in an expert capacity for you? The fact that successful people are busy is a given, but you'll never know unless

you ask. Every person you seek is not looking for financial gain or weighing how the position will serve him or her. There are many genuinely concerned people who love to help a just, good, and organized cause; these are the people you need to find. Here's a reality: Most people love to share their expertise. Don't you love to talk about what you do well? Think of the various ways you volunteer your time. Understanding why you donate time may help you get into the mind-set of others who would consider the appointment. Making a difference, sharing expertise, or moving a business or project forward is personally gratifying and rewarding.

Planning Advisory Board Meetings

Although most trainers agree, in theory, that an advisory board is a good idea, a majority of trainers don't actively use one. Actually setting up a board and taking the steps necessary to put it to work for you are not easy. It does take some time and effort to present yourself as a professional who runs an effective business. That's easy to do if you've already created a presentation or client introductory packet and your personal communication skills are up to par.

You need to consider, in advance, the areas of expertise in which you need resources. After you compile this inventory, ask what can be reasonably required of the people who serve on your advisory board if they are to fulfill your needs.

How often will you meet? Are meetings necessary at all, or are e-mail contacts and phone conversations sufficient? Is it necessary to have all advisory members present or just those who have expertise in the area being discussed? Let the candidates know who else serves on your board. This can influence a decision if they recognize a peer who, for example, is highly regarded and very busy.

Many potential top-notch consultants you have your eye on are concerned with being able to make a maximal impact with a minimal time investment. Most, quite honestly, want to help you if for no other reason than they like you. However, if you appear to be disorganized, unprofessional, or unclear on what you desire from the person, and it seems that the board

appointment will result in a huge, nonproductive time requirement with no specific direction, you can bet any prospective candidate will run for the nearest exit. I let the person know that meetings, if called, will be infrequent and will be organized with a specific agenda that will be mailed to them ahead of the meeting date; I tell them that if lunch is required it's on me, and we'll finish in 45 minutes.

Acknowledge your board members by letting them know you appreciate their efforts. Identify the impact they have had on your growth and decision-making process in hand-written thank-you notes, voice mail, and e-mail messages. An annual gift or other special gesture is appropriate.

Include a diverse representation of business people that could include, for example, an attorney, an accountant, a real estate broker or developer, and a financial planner or investment banker. You're looking for individuals who can help move your business forward and help you make smart, informed choices. Consider including licensed health professionals such as a registered dietitian, physical therapist, physician, osteopathic doctor, chiropractor, or massage therapist, along with other qualified fitness professionals. Much to the surprise of several colleagues, I like to include at least one other personal trainer who owns her own business as well as another trainer who works for a club.

I suggest a maximum of 10 advisors to represent both the fitness and business fields. Communicate regularly, although judiciously, with board members. Keeping board members apprised of movement and decisions in your business is not only a necessary professional courtesy, but it indicates that your sincere and organized efforts justify the person's involvement. Review appointments annually and add members when an area of need presents itself and you do not have expert representation in that domain.

Consider asking qualified clients to serve in an advisory capacity. If appropriate, I often query my clients about my impending program and business decisions as a courtesy to them, and sometimes I also pick up valuable insight. It makes sense to ask your clients, "What do you think?" and investigate whether they are interested in serving on your board. If you

anticipate that an appointment would compromise the professional relationship in some way, obviously, it is prudent to leave the business relationship as is.

Use of an advisory board can keep you from becoming myopic, stagnant, and complacent in your approach to running your business and in your program design. This group of people can also keep you from making costly or irreparable mistakes. Bad decisions cost you money and time and can ruin a business. Representation from the business community and the health and fitness sector gives you direct communication to the pulse of the real world. An advisory board can help you solve your business and programming challenges in an efficient and effective manner and keeps you fresh and challenged by a constant introduction to cutting-edge ideas that may take you beyond your comfort zone or familiar routine.

Successful and savvy leaders of today surround themselves with excellence. They absorb personality qualities and information from knowledgeable sources by observing behavior, listening, and asking questions. Part of their strength lies in the people they hire and depend on. An openness to learning, an ability to use another person's creativity and expertise, and a desire to give a personal best effort propel services and businesses to the top.

Deciding Where to Train

Of the many decisions to make, few are as important as where you will train. At some point you will have to consider the pros and cons of hiring on as a paid employee, working for a club or established personal training studio as an independent contractor, or starting an independent business where you travel to homes or have your own facility. All three scenarios have benefits and drawbacks.

Club or Personal Training Facility

Unless there are unusual circumstances, probably the best place to begin a training career is an established health club or personal training facility. Both provide an easy place to cultivate a clientele and learn a successful training approach. You can make some mistakes and

test the water. Also, because these facilities already have equipment, this choice minimizes, if not eliminates, the bulk of any start-up costs. Fortunately, this option is realistic and very available. At one time, major cities like Los Angeles, New York, Toronto, London, Sao Paulo, and Buenos Aires were among the few areas with clubs that offered personal training employment opportunities. Today, clubs all over the world use trainers in their facilities who are either employed as a salaried staff member or hired on an hourly basis. Trainers also may be hired as independent contractors to service the club membership, and some type of mutually beneficial agreement is worked out.

Besides being the least risky way to begin, working at an established facility that offers personal training lets you experiment with your methods, techniques, and people skills. Although the facility may negotiate for a percentage (and it is not unusual for them to ask for up to 60 percent of the trainer's fee), they provide the facilities and a preselected pool of potential clients. Although the better clubs and personal training facilities do not always have openings, they lose trainers from time to time and therefore are worth investigating. Your resume and client introductory or presentation packet can have a tremendous impact on whether you'll be hired for one of these sought-after positions. First impression and initial presentation are very important.

If you can generate your own clientele and can avoid the substantial start-up costs of developing and leasing your own studio space, consider using a training facility that charges you a flat hourly fee or fixed monthly charge. Most of these facilities will have specific guidelines you will be required to follow, such as obtaining liability insurance. Keep in mind that clubs that personal train only—that is, they have no general membership—and rent space to trainers are not always good places to find clients because the clients working out will, obviously, have a trainer. Still, it might be possible to generate some income and develop relationships that could benefit you by substituting for established trainers when they are out of town or sick. Or, maybe the trainer has more clients than he or she can handle and you might receive a referral. Regardless, it is always smart business to initiate personal introductions and establish professional relationships.

An even better place to start your training career might be one of the many health clubs that don't offer personal training. With the right business proposal, a trainer may be able to convince the organization to provide personal training service for the club members.

The easiest way to successfully push through such a proposal is to detail how bringing in a personal training service is in the club's financial interest. Before you launch the plan of attack, do your homework. The club didn't seek you out; therefore, it is important to impress your audience with a professional, thorough, logical, and conservative business plan. That means you must realistically assess the clientele and show the club owners that the members want, need, and can afford what you have to offer. Point out that people who work out with personal trainers are more likely to stick with their programs. An important factor in creating a win–win situation is related to your training fee. It must be high enough to justify your investment of money and time but low enough to generate clients. Additionally, you may or may not have to offer a portion of your income production to the club. Every aspect of the deal is negotiable and depends largely on your presentation. Start with a competitive fee for that area. It is easy to raise prices once you are established and producing a cash flow.

When working with clubs or personal training facilities, never try to train a client on the sly. You should not take money from a client unless you have an agreement with the owner or management. You are a professional trainer, not a workout partner in disguise or dishonest business person. Rather than risk humiliation and cheapen our profession, obtain the club's approval first, or negotiate a deal, and begin to establish a solid business foundation of honesty and integrity.

Training in Homes

People value the privacy, convenience, and time savings that training in the home can provide, and they are willing to pay a premium.

Although I have commented a great deal about working in clubs or personal training facilities, they are not the only venue available to the trainer who is just starting out. On entering the personal training field, many new trainers imagine themselves training out of clients' homes. This is understandable, because television and print media often focus their coverage on trainers who travel to the homes of the rich and famous with a van full of equipment or are fortunate enough to train in a home that has an elaborate workout room, containing $50,000 or more worth of equipment. It is unlikely that the majority of trainers will have access to these kinds of neighborhoods and social circles. However, every town, regardless of size, has its power brokers and social elite. Although this demographic represents an important part of a market you would like to access, it is not your only target. Busy and time-conscious people, independent of fame and wealth, know what working out in the home delivers.

Don't let the issue of a client not having a complete gym detour your confidence. Many people don't have the space, money, or desire to turn a room into a gym. Additionally, your average client is not going to expect the traveling trainer to arrive with or supply an elaborate home gym. On the other hand, the client who chooses to train in his or her home is rarely put off by paying top dollar for this specialized service to a trainer who brings in minimal equipment that is easily transported and doesn't compromise workout results. Trainers must be creative and knowledgeable and have the ability to work with minimal equipment, while simultaneously creating an effective and varied program.

In my experience, many of the clients you train in homes, while understanding that this is a premium service, will probably dislike being charged your full hourly fee for travel time, especially because personal training fees tend to be on the high side compared with other similar services. I add approximately 20 percent of my hourly fee for travel time of 20 minutes or less. Regarding home training and fee structure, consider these three points: (1) The additional fee of 20 percent, for 20 minutes or less of travel time, is less than charging them a flat fee based on hourly rates, for 20 minutes of travel to and from their house. In essence, this is a 50 percent discount of your time because you're only charging a travel fee one way. (2) If you work in a studio or club, you need to carefully weigh whether it is a wise use of your time to train in homes if you have a

clientele who will come to you. Obviously, being compensated for your finite time is the issue. (3) Limit one-way travel time to a client's home to 20 minutes. The outer limit is 30 minutes. The exception might be for a client who is willing to pay your training session fee and fully compensate you for travel time, based on your full training fee.

Because traveling to and from homes can take as long as the workout itself, the trainer usually has to absorb at least part of the travel time. If you're just starting a business, taking on almost any home workout opportunity makes sense. Once your business is thriving and available time is at a premium, it might be wiser to decline in-home training options or, at the least, to be very selective. From a business standpoint, your decision should rest on fair compensation and how you want to use your time.

Training in clients' homes requires careful scheduling of clients so that you make the most efficient use of your time. Because personal training is labor intensive—most trainers generate income by the hour—it's easy to dilute earning potential if excessive and uncompensated travel is required to reach in-home clients. Poor scheduling results in late arrivals or unproductive gaps in your daily schedule.

Training From Your Home

Some trainers try to get around the challenge of leasing space by converting an extra room in their house or apartment into a makeshift studio. The idea, of course, is to entice the client to come to you. On paper it looks like an answer from heaven. But somehow, the idea's appeal usually collapses once the plan is implemented.

Problems you will encounter include inadequate parking and approved business zoning, the lack of privacy for both you and the client, and whether you can create a professional environment. You can imagine the issues that surface regarding showers, dressing, and clients coming and going. This type of training choice can open your entire life to the client. Because the bed always has to be made and the rest room spotless, depending on how clients enter and exit your living space, many trainers who go this route soon feel like prisoners in their own homes.

To make matters worse, the high start-up costs of the equipment, furnishings, and upkeep are frequently beyond the means of most beginning trainers. Because there is limited foot traffic on residential streets, the trainer is fairly isolated when it comes to generating new business, and an irritated neighbor may put you out of business if you have not thoroughly checked zoning ordinances with regard to operating a business in a residential area and obtaining the proper operating permits.

I will add that there are exceptions to the rule. Several trainers I know have created excellent businesses based out of their homes. With this type of setup comes the convenience of minimizing travel time, operating out of the comfort of home, and minimizing costs by not having to lease a separate building space. Success usually stems from a building design that allows private entry and exit into the training area, as well as showering and dressing in a bathroom adjacent to the designated gym area—none of which requires the client to ever enter private areas of your home. Client privacy and uninterrupted training are other commodities that must be preserved. No interruptions from family, phone calls, and personal emergencies must be allowed. If you have a spouse or child who is home during the majority of your training hours, for example, this can create some logistical problems with regard to maintaining a professional training environment.

Banding With Other Trainers

Occasionally a group of new trainers will try to band together and pool resources by sharing a common space or going into business together. The concept plays out well on paper and sounds great over dinner but self-destructs when one trainer becomes more successful than the others. Troubles also can occur when the partners squabble for the same studio space or the same client. One way to avoid this competition and self-destruction is to create a legal partnership. Know your partners well before entering into this binding agreement, and set the group on target with the same long-range business goals.

Sole Proprietorship

Once you've done your homework and made your decision to set up a training facility—whether you own or lease the space and whether you own or lease the equipment—you have to assemble and organize the workout gear and create an appropriate business environment.

When I first started my personal training business, I wanted to play it safe. Instead of immediately launching out on my own, I dreamed of creating a workout space that my clients and I would want to come back to over and over again. Because of this conservative thinking, I remained at a health club until I could afford what I thought was a state-of-the-art studio.

While I was saving money, I also was on the lookout for potential studio space. By chance, I discovered that one of my clients had an office building under construction. I found a large room adjacent to the building entrance that he was going to use as storage. I convinced him to build the space out a bit and this became the genesis for my stepping out and going solo. We raised the ceilings, worked around the problem of no windows (I wanted some natural light), and installed two showers and bathrooms. I negotiated a long-term lease that included utilities and three accessible parking spaces. Additionally, it was my option to renew each year's lease. I had negotiated the deal in my favor. Together, the building owners and I converted otherwise unusable space into income-generating space, which increased the value of their building and gave me the means by which to open my training facility.

By the time the space was ready, I had saved about $30,000. That sounded like a small fortune to me, but even with comparison shopping, dealer discounts, and careful planning, the majority was earmarked for expenditure. Besides purchasing and leasing equipment, I included amenities such as a stereo system, video recorder, television, towels, pictures and framing, and custom painting and mirror installation. The investment, though substantial, paid off because I was ready to open a first-class facility. If you choose to go this route now, or in the future, make certain that you have the finances and resources to finish all preparations before you open. Nothing is more unprofessional than having to work out in half-finished quarters with ongoing promises of completion. Understandably, this is probably not avoidable if you are remodeling after the business is well established.

Despite being pleased with the equipment and layout of my studio, I have never considered the physical aspect of my business as essential to my success. But I had the space and the finances, and I appreciated, as did my clients, the options that The Training Edge has given to them and me. Even so, if you understand how the muscles move the skeletal structure and the basics of programming for balanced fitness, you don't need the most expensive or sophisticated equipment to train people and accomplish goals. If you have limited finances and space or are buying equipment for a client's home gym and have to be more selective, you still have a variety of choices that are affordable and space efficient, and having to make choices like this should not compromise the training result.

Basic business essentials when you are setting out on your own include promotional expenses (business cards, promotion packets, graphic artist or design fees, advertising costs); telephone and answering machine and service costs; liability insurance; accounting costs, even if you keep your own financial records; office supplies; and any legal and consulting fees.

Mobile Units: Fitness on Wheels

Fitness on wheels is the perfect solution for a world that demands service at your door. Essentially, this concept requires a large van (although you can choose smaller vehicles and still make it work) that holds numerous pieces of space-efficient, versatile equipment. The van arrives at the client's place of work or residence and literally provides a fully equipped workout facility. Wise equipment choices and appropriate vehicle selection are necessary for optimizing space use and programming options. You'll have to choose between a minivan (portable fitness equipment that can be transported to the home or office and must be transported in and out of the vehicle at each training site) and a large cargo van (the exerciser can actually work out in the cargo space). With requisite planning and thoughtful equipment selection, several diverse strength-training exercises and cardiovascular workout options are possible. When you are considering a van in which

the client will actually work out, consider the weather. Cold climates can be tricky to deal with when hustling your client to the mobile unit, and you'll have to heat the unit during the session. On the other hand, warm climates can present dangerous temperatures that require the mobile gym to have a sufficient cooling system and insulation. Sensibility to the client's comfort and safety is a must.

A City Within a City . . . Potential Client Gold Mine

Any area with a highly concentrated population is a potential business gold mine. An apartment complex or office building offers such an opportunity, or what I call a "city within a city." A trainer can develop a clientele and business around any complex. Great opportunity exists

Ten Marketing Tips That Work

Following are 10 no-cost or low-cost marketing tips that will get your business in the news, enhance your business image, increase your credibility and profitability, and get you clients.

1. Host or be part of a job or career fair.

This enhances your community image, and people can learn about what a personal training service has to offer. You may generate potential clients and potential employees.

2. Establish a community fitness award or recognition.

Host the event at your training facility or other community location.

3. Donate training services to a community auction or other charitable event.

This allows your services and business to be "discovered." Even if the individual chooses not to renew the training, he may refer your services.

4. Serve on community boards and other benevolent or worthwhile projects.

Contributing to the community is a powerful statement of your local involvement.

5. Participate, volunteer, and get involved!

Coaching youth sports, participating in chamber of commerce activity, and joining local service organizations expose you and your business to important contacts.

6. Sponsor or help organize community events.

As a show of community support and interest, take part in fund-raisers, benefits, charitable luncheons and auctions, and other social events in your community.

7. Give fitness and health-oriented lectures, write fitness articles, or host a fitness radio or television show.

This provides more opportunity to promote your business, polish your presentation skills, or "do a good deed."

8. Host a thank-you party for your clients.

This provides a professional time-out for you to personally thank your clients. Encourage your clients to bring a guest to the gathering.

9. Offer complimentary fitness assessment.

Provide blood pressure screening or body composition assessment and hand out complimentary passes or brochures detailing your services.

10. Create a client introductory or presentation packet or media kit.

Update this introductory packet (appendix) regularly and use it as a powerful promotional tool.

in areas of new construction. Pitch the idea of offering training and a workout facility as an amenity to entice tenants. As a prospective tenant, if I were given the choice between two similar facilities and one offered training and a gym, I would take the one with the workout area. As I mentioned earlier, once I decided to go solo, I examined a building that a client was constructing. We looked for and found unused space that the building owners would have otherwise been unable to rent, and I negotiated a reasonable long-term lease. With a little imagination and a bit of dreaming, and because I dared to ask, it was not long until I had my own, thriving personal training business.

Because personal training is well ingrained in our society today, trainers may have an easier time selling the idea of personalized training to building owners or managers and developers. Trainers today have more leverage because the service they provide is an amenity that leasing agents can sell to prospective renters. You may be able to convince the building supervisor or owner to turn open space into a luxurious workout space. For many prospective tenants, having a workout area could be the defining reason for leasing in a particular building. The same holds true for hotels. When a given rate for a room is comparable to the rate for a room in a different hotel, many travelers will choose to stay in the hotel that provides workout or spa options and personal training services.

Propose a variety of arrangements to make the deal work. You might purchase the equipment in exchange for rent-free space or in lieu of a lease that is favorable to your situation. If this investment seems too steep, you might offer one-time or discounted orientations to new tenants or guests of the hotel. As an additional incentive and to compensate the building or management group for its risk and for providing a space that gives you access to its tenants, you can negotiate a percentage of your revenue, or propose a fixed fee you will pay monthly, which would be your rent or lease.

If your proposal has been accepted at a new construction site, at the same time the building is going up and your workout space is being built, create interest and excitement that are centered on the services you will be offering. If you keep your expenses in line and charge a fee that is realistic for the people in that demo-graphic area, you should be able to pick up several new clients immediately. Serve them well, and these first clients will be enough to start you on the road to success. This referral base will continue to grow as long as you provide an impeccable and valuable service.

Getting Your Business Running Confidently

Personal fitness training can require relatively little start-up expense and minimal business registration requirements. Setting up your business requires you to take simple but important steps to safeguard your business and your clients' well-being and to minimize your exposure to unnecessary liability. Many of these issues are discussed in more depth in later sections, but this will help you get the ball rolling and give you step-by-step instructions.

Is a Business License Required?

Local and federal laws generally require any business to undergo specific registration steps before starting to serve customers. Obtaining a business license usually fulfills this obligation. Governmental regulations allow your state, county, province, or municipality to generate income by taxing your business. Additional obligations to the government may include business franchise taxes or sales tax if you sell products, and some areas require you to file a fictitious name certificate. When a business operates under a name other than that of the owner, that business is using a fictitious name. This document states that, for example, The Training Edge is owned by Douglas S. Brooks, an individual, or if incorporated, The Training Edge is owned by DSB, Inc., a corporation doing business as The Training Edge. If you choose to use a fictitious name, you'll probably be required to file a fictitious name statement with, for example, the county clerk. This prevents any other business from using your name. You also may be required to publish a fictitious name statement in a local newspaper of general circulation. This announces your intention of opening your business to the public.

Although these steps may sound confusing, their fulfillment generally only requires you to pick up a phone book and search the white

pages for the listing of county government offices. A few phone calls should get you the information you need. Additional help may be found through contacting Small Business Administration offices, which are located in nearly every major metropolitan area. You can also question people you know who have opened service businesses of their own. Good examples might include a dentist, hair stylist, massage therapist, registered dietitian, or your family doctor. This would also be a good time to network and share your new business intentions as you seek to properly register your business. If you question the legality and completeness of your actions, by all means, consult with a competent business or legal advisor.

Should I Incorporate?

Incorporate is to form, or form into a legal corporation. Most corporations are formed to shield business owners from personal liability, and the decision to incorporate, or not, may be less important in the early stages of your business. My opinion, based on anecdotal conversation and solid investigation, is that most personal trainers need not be overly concerned with this issue, especially when starting a business. Two of the most common arguments for incorporating a business include an attempt to shield yourself from personal liability and to gain tax advantages. Let's dispel the myth of incorporating in an attempt to limit all personal liability. Whether you incorporate or not, if you provide service that is injurious or incompetent compared with industry standards of care, you can and probably will be sued. If a corporation is sued, the successful litigation brought against the corporation would be termed by attorneys as "piercing the corporate veil." The veil, obviously, does not protect you from lawsuits or absolutely limit personal liability. If liability is your concern, purchase liability insurance and take all of the necessary steps you can to provide service that is the cutting-edge standard in our industry.

As your income increases or you hire one or more employees, it's appropriate to discuss incorporating with an attorney, a certified public accountant (CPA), or a competent financial advisor. I have found input from all three sources to be of incalculable value, since three very different expert perspectives shaped my final decision. If incorporation doesn't seem like a good business decision today, don't shelve the concept forever. Down the road, it might be an appropriate decision that matches your changing business.

Should I Carry Liability Insurance?

Every trainer should carry liability insurance! No matter how skilled or professional you are, a client could get hurt or judge you to be at fault in a given situation because of an action you take, or do not take, that results in injury or loss of any kind. Right or wrong is not the issue here. Your client can sue you. So, the obvious response is to protect yourself from personal liability claims and lessen the financial and emotional stress created by litigation against you. However, I want my clients to know that I carry liability insurance to protect them. Something can go wrong during training, and I want them to feel that their well-being is ensured. To deny the possibility of ever erring or being involved in a groundless lawsuit is naive. Liability insurance is a strong statement of your professionalism, it is a friend in court when you are required to document prudent steps you have taken to ensure your clients' well-being, and it indicates that you have your clients' best interest at heart.

Affordable liability insurance is available through a number of certifying or member organizations. This coverage is often available to professionals who possess the requirements of the organization but aren't necessarily certified or belong to the group. Check with the insurance provider to determine whether the package offered covers your training situation. It may or may not. If you work as an independent contractor at a club or personal training facility, you'll probably be required to have liability insurance.

Omission and Commission: Legal Matters

It is cliche, but we live in a very litigious world. You can be sued for doing too little (omission) or for taking action that is beyond your training (commission). Both words, from a legal sense,

can be tied directly to liability, which means being responsible for your actions or omissions. Trainers are obligated to use "ordinary care" when training clients. If you follow an acceptable standard of ordinary care, you will be taking action to avoid injuring a client by using training methods that are consistent with those that a reasonable and prudent trainer would use. This idea represents the legal concept of standard of care. Any state or geographical area in the world that does not require trainers to be licensed will judge you by (1) a standard of care that is often based on criteria set by leading educational and certifying organizations and accepted by the industry as evidenced by its adoption and (2) expert witness testimony that testifies as to what a careful, prudent, updated and professional personal trainer would have done in the same training scenario.

Lawsuits can best be prevented by adequately screening your clients, developing safe programs that meet industry standards of prudent progression and correct exercise technique, and being careful to closely supervise the entire workout—from equipment setup and maintenance to hands-on spotting where appropriate. In other words, you need to be in control of the workout from start to finish. Proper instruction and supervision are the message here. Accurate and updated record keeping is also essential. Using waivers, informed consent, and health history questionnaires is expected. If you train away from your regular training site or outdoors, for example, visit the area ahead of time, be sure your insurance carrier covers this training situation, consider using a specialized waiver form that informs the client about any inherent risks, and take along a fully charged cellular phone in case an emergency arises. Finally, don't play doctor. Common sense says you should not misrepresent your expertise, and most countries have laws that mandate severe penalties for those who practice medicine without a license. It's tempting to offer advice when asked our opinion. If you have the expertise and qualifications, it's acceptable to give an opinion. But generally, when asked about treating injuries or taking medications, limit your general recommendations to standard first aid procedures. Recommend that clients seek expert counsel from a licensed health care practitioner when the situation calls for such counsel. Keep comprehensive records and modify the workout in accordance with professional guidelines.

Now, it's time to stop worrying about legal stuff. Although this next point may seem very subjective and anecdotal, I believe that the genuine concern I have for my clients may be a leading reason why I have never been sued. I have made mistakes. But, it is evident to my clients that I have their best interest at heart, and this fact is obvious by the business and programming decisions I have implemented. I believe that if you keep your clients' needs, wants, desires, and personal well-being in the forefront and you have built a strong professional relationship, your chances of being sued are greatly lessened. A healthy relationship and a policy that represents the interests and well-being of a client will likely cause that client to give you a margin of error, the benefit of doubt, before wanting to proceed with a lawsuit.

Policy: The Foundation for Running Your Business

Nothing is more important to your business than forming business policies that both you and your clients understand and follow. A business plan could be described as a written summary and ongoing evaluation of your business ideas. The client introductory packet in the appendix goes a long way in helping you to determine your business direction and accomplish this goal of clear vision. A well-written policy is a useful reference when conflicts with clients arise or an operating procedure needs to be clarified. When you put the plan in writing, you will be forced to carefully work through all aspects of your business.

Policies set the foundation from which you run your business. Clear and professionally presented business parameters give the client confidence that you are capable, skilled, learned, and trained. Without a doubt, your professional image is enhanced. You reduce the risk for conflict and make the most of your time and money.

Policies are best developed after you've identified common challenges every business will face sooner or later. In fact, many trainers who started businesses years ago, before reference books existed for professional trainers,

simply made policies based on need and crisis. Policies represent a planned course of action, much like periodization is a planned and well-thought-out approach to training. You need to give your business planning as much thought as your physical programming.

Policies create a standard from which to operate, yet common sense says the rules should be flexible. A company without well-thought-out written policies has no basis from which to gauge and check recurring policy abuses.

Client-Friendly Policy

Policies should be developed in client-friendly language. Rather than bluntly state, "You broke the rules and this is the consequence," I write the regulations so that clients understand that both they and the trainer are held to a standard. For example, I have a cancellation policy that applies to the client, trainer, and business and that clearly outlines consequences not only if the client breaks the rules but also if the trainer breaks the rules. This is fair policy, and the underlying theme is that we must have rules, but we care about the client and will accommodate the client if at all possible. A philosophy like this, in fact, strengthens your policy and your ability to enforce it.

A clearly defined policy gives you a strong foundation from which you can make reasonable choices and decisions. Here's an example. My company has a "black and white" cancellation policy. Let's say one of my trainers was working with John, a client who has missed three scheduled sessions in a row, without giving the trainer the courtesy of a phone call. Quite happily, from his financial perspective, my trainer intends to bill the client for the missed workouts. I ask the trainer some questions: Has the client been called? Is the relationship strained? Is this common behavior on John's part? The answer to all three questions is no, so I suggest that the trainer call John before sending the bill. On doing so, he finds that John's mother passed away unexpectedly. John, who is exhausted and burdened with grief, appreciates the phone contact, apologizes for not contacting his trainer although the reasons for his oversight are obvious, and indicates he's anxious to work out as soon as he can. Feeling sheepish and more than a bit greedy, my trainer has the good common sense to tell John that his three

missed sessions will be rescheduled at his convenience and apologizes for not contacting him sooner. The trainer also follows up with a sympathy card and, at his own expense, sends a bouquet of flowers. Later, I insist on reimbursing him for doing the right thing (sending the flowers) and let him know I also appreciate his kindness and empathy. Ethics, values, morals, and fairness—part of the complex dynamic of doing the right thing—are an important aspect of maintaining and developing healthy, long-term relationships and policy that works for and is fair to all.

Written Policy and Agreements

Thinking about your policies and formulating them in your mind is a start, but they will not have teeth until you put them in writing. Without a doubt, written policy and agreements create commitment, avoid misunderstanding and ill will, and become a foundation on which your business is built.

Written policy and client agreements command mutual obligation between the customer and your business. Written procedure helps to avoid unclear policy and unrealistic customer expectation that can lead to client dissatisfaction.

Clear and consistent policies help you avoid losing clients. Written policies that are effectively communicated and fair provide a quick and impartial solution when conflicts arise. A well-written client introductory packet (see the appendix) will serve this purpose. Take the time to construct this invaluable packet.

Letter of Agreement (Client or Training Contract)

A client service or training contract also can be viewed as a letter of agreement between a client and your business (form 3.1). It usually states the services to be provided, cost of said service, payment arrangement, and contract length or number of sessions the client is willingly entering into. Although semantics are at play, I prefer the personal and nonintimidating nature of a letter of agreement, compared with a contract, which might contain intimidating legal language that details theoretical consequences for noncompliance.

Whether you agree with the idea of such letters or contracts, I believe they have merit and

F O R M 3.1 Sample Letter of Agreement

This letter of agreement details the client–trainer business relationship between The Training Edge and said client. The client agrees to abide by The Training Edge policies and regulations as presented in writing to the client. The client acknowledges receiving, reading, and understanding the stated policies.

Payments are overdue and the client is in breach of agreement if payment is 14 days past the due date. Invoices are due and payable on receipt. A prepaid training package may be transferred or sold to another person for a period of 1 year from the purchase date. Any prepaid purchase is nonrefundable. The Training Edge may immediately cancel this agreement or stop providing training services for nonpayment of fees. The client agrees to pay any balance owed for services rendered, even if future services are not hired by the client or offered to the client, by The Training Edge.

Client Payment Plan and Training Session Schedule:

_____ _____
Client initials and date Training Edge representative's initials and date

Per-session charges can be increased and will be reviewed annually but do not affect any services purchased before the review.

The Training Edge works on a scheduled appointment basis. Any session canceled with less than 24 hours notice will be billed at a normal session's full rate or will be deducted from a client's prepaid block of training sessions. Cancellations received inside of the 24-hour courtesy period allow the client to reschedule the missed appointment within 7 days from the date of the missed appointment. If the client fails to make up the missed workout in this time period, the canceled session will be billed at the full session rate or will be counted as a used session to be deducted from a client's prepaid purchase of training sessions.

Training Edge policies were developed and continue to evolve in hopes of creating a mutually respectful relationship between client and trainer. Clear and fair policy helps build strong, long-term relationships. The Training Edge is here to serve you, and our service commitment is strongly stated in the Client Introductory Packet you have received.

I, _____ (the client) have read this letter of agreement, fully understand the information presented here and in the Client Introductory Packet, and accept these policies as they apply to the relationship I have willingly, and in a fully informed manner, entered into with The Training Edge.

Training Edge Client (Signature) _____ Date _____

Training Edge Representative (Signature)_____ Date _____

Author's Note: To avoid having a number of forms for each possible arrangement, I have designed the agreement to be flexible enough to accommodate a number of different scenarios. Simply fill in the details as they relate to each individual agreement. Input this form into a computer, and it's simple and quick to customize the form to meet each client setup and to update information. It's always a good idea to have an attorney review your contract, especially if your intent is to create an agreement that is legally binding and if you fully intend to pursue litigation through the legal system.

should be an option you consider. But, without a doubt, many people do not like the idea of signing on the dotted line. Don't pressure your client into signing an agreement, and be sure that you explain all aspects of the letter or contract. Too many individuals have been pressured into signing contracts they didn't want to sign or found out too late that the fine print revealed a very restrictive contract that was not disclosed in an honest and open way. Even if you think the contract was disclosed honestly, if a client believes that it wasn't, you've got a problem.

I have always thought that if it takes a contract or threat of litigation to keep a client coming to me or to make the client feel obligated to me, then the relationship is over and is probably best let go. Can you imagine clients using your personal services when they no longer desire them and to do so under legal threat? The issue of right and wrong aside, most trainers do not have the time or money to pursue a lawsuit and make it stand up in court. Create a strong professional relationship and the contract takes a less important place.

Do not convey an impression that the agreement paperwork and requisite signature are more important to you than the potential client's well-being. Don't think that once you've got a signature you're guaranteed a committed client and a stream of income. You have to earn both of these with service. Here's another reality. No contract is truly binding, and at the least it can be challenged and opposing sides can argue personal perception and intent. Even if the contract is upheld in court, what has become of your relationship with the client, and will you ever actually collect any money?

Having said all of that, I believe it is smart business practice to spell out the details of the agreement and restate your key business policies. Written policy is the glue that holds your business and relationships together.

What should you include in the contract? Whatever you and the client have agreed to as far as price, payment, and services offered. Since your cancellation policy directly relates to money exchanged between the client and you, state your cancellation policy in the letter of agreement, even though it's already stated in your client introductory packet. Your clients can't see your policies in writing too often.

Spell out the terms of payment. My clients have an option to be billed for services after they receive training. As long as they follow my business policies and pay promptly as detailed in my program policies, this courtesy remains available to them. However, as an additional convenience to my clients, I offer several payment plans and workout packages so that I am better able to work with their specific needs and to provide them a discount incentive. This planned flexibility, which keeps me from scrambling on the spot for a solution, has helped me close the deal with a number of clients over the years who were looking for a personalized business agreement that met their demands. At The Training Edge, for example, a client might have the options of paying after services are rendered, purchasing a prepaid block of training sessions, or entering a group training session.

As you offer payment options such as pre-paid purchases of discounted sessions, a contract or letter of agreement detailing the arrangement takes an increasingly important position. The letter of agreement is valid, if for no other reason than preserving the client relationship should a conflict or misunderstanding arise surrounding the administration of such a plan. Any agreement or business policy that is in writing provides a neutral ground from which my client and I can begin when disagreement arises. We can objectively see what we originally agreed to as we entered into our business agreement and, I hope, proceed to an amicable solution.

One of the most important goals I strive to accomplish in my personal training business is to preserve the client–trainer relationship rather than antagonize and stress the relation and lose all of the positives that come with an intact, long-term association.

Personal Agreement or Self-Contract

A personal agreement or self-contract is not legal in intention and essentially is a client goal sheet (form 3.2). Responsibilities to be carried out by the client are listed with the intention of helping the client accomplish goals. Self-contracts symbolize a personal commitment the client makes with himself. The form should be signed by both the trainer and client; the trainer serves as the witness and friendly enforcer.

Although a trainer plans and leads training session content and direction, there are a lot of hours in a week during which the client is not under the trainer's watchful eye. Therefore, it is important to set goals and establish expected outcome not only for your clients' training sessions but also for the time outside of the training session. After all, action, follow-through, and consistent behavior—not good intention—deliver results.

A client who trains three 55-minute sessions per week with you can have a program that fails, or is not optimal, based on what they do with the other 165 hours in the week. Ultimately, the personal agreement puts the impetus of responsibility on the client to be successful. I want my clients to know that they can succeed, with or without my assistance, if they make a commitment and take responsibility for themselves, their actions, and their choices. They have the knowledge and power to be successful, independent of a trainer. Most of your clients will, of course, choose to continue the relationship for many reasons, but it is important to me professionally and ethically to instill this confidence and can-do attitude in every one of my clients so that they are capable of determining their own path, with or without my services. This personal agreement outlines the client's current responsibilities, documents his or her long- and short-term goals, and provides a snapshot of fitness- and health-related assignments that should occur outside of training session time.

Review Policy on a Regular Basis

At a minimum, policy should be reviewed yearly. If a particular procedure is not adequately working to solve problems or creates additional problems, it needs to be rewritten to fit your changing business or client needs.

If you have unsolved problems that recur in your business, you need to immediately create a policy that fixes this weakness. Day-to-day operational and personnel relationship difficulties need to be solved quickly, before these issues affect your ability to deliver top-notch service. Swift policy making on an as-needed basis is important.

Following are two common scenarios most trainers face sooner or later. Tribulations like these rank as many trainers' biggest daily frustrations. This is especially true for busy trainers. Don't let this dangerous virus infect your business.

Case Study: Policy Virus 1—Client Tardiness

A new trainer who's working for you has five clients scheduled back to back in the morning, followed by a one-hour lunch break, and three more clients back to back after lunch. The day starts with the first client arriving 15 minutes late. Flustered and eager to please the trainer moves the session along quickly but still runs overtime by 10 minutes. Client 1 thinks he should have gotten another five minutes, and client 2, who has to leave at the scheduled end time, is visibly irritated. The trainer puts her best face forward and tries to make up for the inconvenience by playing super trainer and begging her client to stay a few extra minutes. Client 3 begins her session five or six minutes late, but 3 is used to this tardiness by now, which occurs regularly. At this point the trainer is irritated and emotionally drained. It's more difficult for her to give 100 percent effort to a less demanding client. However, client 3 has noticed the moodiness and lack of enthusiasm exhibited by her trainer for the past few months and is thinking of leaving the program. Client 4 shows up 20 minutes late, but the trainer isn't worried because she can run client 4 into her lunch hour, and this client doesn't seem to mind as long as he gets his full session. This behavior repeats itself after lunch. The virus has infected the whole program and is dismantling the very core of this trainer's business, which is founded on service and professionalism.

I hope the trainer will identify the issue at hand and realize she needs to correct the situation before it destroys her business. Her first step is to communicate her concern to all of the clients and to apologize for letting the situation get out of control. Next, she needs to present a written policy that is client-friendly and fair and that states the importance of all training sessions beginning and ending on time. If a client arrives late, the session will still end at the scheduled time.

What is the outcome of such a strong policy? The trainer's late-arriving clients know the free ride is over, and those clients who were inconvenienced by the domino effect of sessions starting and ending late will applaud the new

FORM 3.2 **Personal Agreement and
Goal Sheet (Sample)**

Self-improvement and personal best cannot be realized without commitment and action. I (the client) pledge to commit myself to achieve a balanced physical, mental, emotional, and spiritual self. I understand that I should set goals that are realistic yet challenging. Success partially lies in personal effort, time commitment, consistency, and planning. Goals are accomplished through acting, not good intention.

Short-term (six- to eight-week) goals **Goals achieved?**

Date goals set: _____

1. _____ Yes No
2. _____ Yes No
3. _____ Yes No
4. _____ Yes No
5. _____ Yes No

Reevaluate short-term goals every six to eight weeks with trainer!

Notes: _____

Date new goals set: _____ **Goals achieved?**

1. _____ Yes No
2. _____ Yes No
3. _____ Yes No
4. _____ Yes No
5. _____ Yes No

Midterm (three- to six-month) goals

1. _____ Yes No
2. _____ Yes No
3. _____ Yes No
4. _____ Yes No
5. _____ Yes No

Reevaluate mid-term goals every three to six months with trainer!

Notes: _____

From *The Complete Book of Personal Training,* by Douglas S. Brooks, 2004, Champaign, IL: Human Kinetics

Continued ➤

Date new goals set: _____

Goals achieved?

1. _____	Yes	No
2. _____	Yes	No
3. _____	Yes	No
4. _____	Yes	No
5. _____	Yes	No

Long-term (one-year) goals

1. _____	Yes	No
2. _____	Yes	No
3. _____	Yes	No
4. _____	Yes	No
5. _____	Yes	No

Reevaluate goals every year with trainer!

Notes: _____

Date new goals set: _____

Goals achieved?

1. _____	Yes	No
2. _____	Yes	No
3. _____	Yes	No
4. _____	Yes	No
5. _____	Yes	No

 I believe that what I do outside of the training session is as important as the session itself with regard to my personal success and achievement of my health and fitness goals. Additionally, I understand that I lead the march toward a more balanced and healthier lifestyle, and that I am ultimately responsible for my success. Therefore, I agree to and will carry out the following responsibilities on a consistent basis, as set forth by myself and in conjunction with my trainer:

1. Training goals will be reevaluated with my trainer within one week after the accomplishment date has passed.
2. Training sessions will be prioritized as important appointments—not to be missed—in my weekly schedule.
3. Activity sessions that are scheduled on my own will be prioritized as important appointments—not to be missed—in my weekly schedule.
4. I am aware of and will carry out necessary lifestyle changes. These choices are in line with my overall commitment to keeping fit and attaining a healthier lifestyle.

From *The Complete Book of Personal Training,* by Douglas S. Brooks, 2004, Champaign, IL: Human Kinetics

Continued ➤

➤ *Continued*

5. As part of my commitment, I will
 a. gradually add additional activity into my life that goes beyond my training sessions.
 b. over time, modify or change my eating behavior and food choices as appropriate to my need.
 c. consider making lifestyle changes in areas of my life that will contribute to a more healthful lifestyle.
6. I believe that I am responsible for reaching my goals and can reach my goals.
7. My actions and behavior that are consistent with attainment of my goals will greatly determine my success.

Other: _____

Signature: _____ Date: _____

Trainer or Witness Signature:_____

Author's note: If these guidelines are not followed, the personal agreement serves as a basis from which you can review the self-contract. This examination should serve as a strong reminder, motivation, or enforcement to help your client stick with his or her promises and commitments. This dialogue should motivate the client toward being responsible for self-action and follow-through. At this time, it is also wise to ask the client for feedback regarding his or her disappointments or frustrations, if any, regarding your professional responsibilities. Be sure to ask why the client thinks some or all of the goals were not accomplished. Ask what you could do better to assist the process. Practice being a good listener before you respond with solutions, and acknowledge your responsibilities for any lack of goal accomplishment.

From *The Complete Book of Personal Training,* by Douglas S. Brooks, 2004, Champaign, IL: Human Kinetics

policy. The pressure, stress, and emotional drain on the trainer will disappear, enabling her to provide a more enthusiastic, helpful, and professional service to all of her clients.

Case Study: Policy Virus 2—Enforcing Policy

Your client Warren talked you into 45-minute sessions, rather than your usual 55-minute standard. He also insisted that the per-session fee be adjusted to reflect the 45-minute duration. You agreed to both requests, but it wasn't long before you were working with Warren for 55 to 60 minutes, at the reduced rate. Warren is a very likable, wheeler-dealer, personable man. You're not sure you can trust him and you can't really pinpoint what he does for employment, although he has a cell phone in his ear all the time and usually seems rather animated. You have to be honest, however; you like this guy. He's intriguing and he really depends on your assistance. In his own way, he even conveys a message that he appreciates how much you've contributed to his health and fitness improve-

ments. Warren talks a lot about "deals." You've noticed he always gets the best deal for himself and holds onto his money as long as he can.

That brings up the second problem. Not only is the 45-minute session now running at an hour, but Warren owes you $1,200 in overdue training fees. Even though you explained your payment policy to Warren and presented it to him in writing, Warren is slick. He's a fast talker. When his oversight is pointed out, he laughs, slaps you a high-five, and says he'll have the cash, emphasis on cash, at the next workout. True to his word, he has the cash. But, it's only a couple of hundred dollars.

You could give him a receipt and deduct $200 from the $1,200 owed. You could tell him you will not meet him for his next workout until you are paid in full. Or you could just ignore it and get used to his always owing you money. What do you do? Obviously, this situation has escalated beyond your control. Warren has the upper hand. However, because you have business policy detailing your billing expectations, you

have recourse. The sooner you apply the policy, the better. Your policy should state payment time frames and ask for payment at the time of invoice, but you should also state consequences of late payments.

What is the outcome? Although you genuinely like Warren, his ongoing saga has worn you out. Quite frankly, you're irritated that he doesn't respect your business policy or you. Warren may like you, but if he is noncompliant with stated policy, he doesn't respect you. It's time to reestablish authority with policy application. Warren may react flippantly, but you must tell him that his account must be paid in full before any future sessions will take place. Are you willing to lose this client with strong policy implementation like this and possibly the money he owes you? I hope your answer is yes. Most likely, after you show Warren the policy again and let him know full payment is required to continue the relationship, he will become punctual with his payments and continue to be the otherwise great guy that he is. Oh yes, don't forget to tell him that the session starts and ends on time, unless he wants to graduate to a full-fee session.

Present Your Policies Effectively and Hold to Them

All of your policies should be introduced to your clients verbally as well as presented in writing. An introductory meeting, during which there is no training, is an excellent time to present your client introductory packet (see the appendix) and to communicate your policy in a caring, sensitive, and clear manner. I love to share policy with new clients because it is in their best interest to understand how it serves them and it conveys how excited I am about our program. This presentation also gives me a chance to share with them how policy is structured so that it not only helps me run an efficient business but also is fair and simultaneously holds The Training Edge and the client accountable. I believe I communicate this positive thought: *If you (the client) think this is great (policy), just wait until the training starts.*

Make sure your clients understand and agree to the policy, and answer any questions. My clients appreciate the effort I have taken to present clear and concise parameters from which we can build a mutually beneficial relationship. A strong, straightforward presentation of policy gives clients a chance to say no before training is initiated. Concise policy is best presented verbally and in writing, but don't scare off your clients with excessive business bureaucracy, paperwork, and complicated legalese. If your clients are to believe that your business policy and regulations are positioned to serve their best interests, they must be able to comprehend the policy and regulations.

Although a letter of agreement and personal agreements or self-contracts are two great steps in the right direction, you're not finished writing and clarifying policy. You also need to know how to discuss issues with your clients when they, or you, break the rules.

Consider a number of factors when applying your policies: common sense, individual circumstance, length of the relationship, number of times the policy or others have been broken, number of times you have excused and allowed your client to take advantage of you, the personal relationship you developed with the client, as well as intangibles like truth, integrity, fairness, and doing the right thing.

Pricing Your Services

A diverse price structure for personal training exists internationally. Fees vary greatly depending on whom you are training, where you have established your business, and the particular arrangement between you and the client. Fees can range from $10 or less to well over $100 per 55-minute session. (Note that all prices in this chapter are stated in U.S. dollars.) Big cities across the world—Los Angeles, Chicago, Detroit, New York, Buenos Aires, Sao Paulo, and London, to name a few—have comparable pricing structures and higher than average fees.

With such diversity, how do you get a sense of what you should charge? What will a particular area support? You have to consider three issues: your cost of doing business, the supply of available trainers, and the demand for them. Keep these points in mind as you set your rates.

Do Your Homework

Your first step is to investigate the demographics or characteristics of the population in your area. This is an ongoing process because

demographics can change over the years. Unfortunately, many trainers take little time to investigate supply and demand in a particular region when opening a business. And the few who do undertake this research often fail to monitor and anticipate changing demographics. It is difficult to evolve a business and keep it on the cutting edge unless changing demographics are taken into account. Once you have a grasp of who lives in the area you've chosen, as well as mean incomes, you can effectively market to this target audience.

It is important to perform this demographic investigation if there isn't a personal training reference fee to compare with because training is not established in your locale. What's your area like? What's the average income, population density, and ratio of blue-collar to white-collar workers? What sustains the economy? These and other questions need to be answered so you can create a targeted business and marketing plan as well as a sensible pricing system. You can capture this type of information in several ways: Look in the yellow pages for health and fitness-related advertisements. Scan local papers for health-related advertisements (or those of any other service industry related to personal health and fitness). Initiate contacts with sport equipment, athletic shoe, and apparel retail outlets, or use chamber of commerce or other small business development assistance.

Find out how much other trainers in your area charge. If your rate is double that of local trainers, you'll definitely have the highest priced personal service business in town, but you may not have any clients either! How much do you need to worry about your competitors? I look at other trainers in my area as peers, not competitors, and we learn a lot from one another. Actually, the more trainers in an area, the easier it is to sell personal training, because more people are familiar with the concept. Whether there are many or few trainers in your territory, I hope you believe that you can hold your own with regard to top service. At least 80 percent of the population still doesn't exercise regularly, so excellent businesses will always have a huge market of inactive people who are waiting to exercise and get fit.

If training is new to your area, or if you need additional information to verify that you've appropriately priced your fee, find out and compare what sports professionals and other health care-related services are charging. What do sports pros who teach golf, tennis, or a personalized sport conditioning program charge for private and group lessons? Look at related medical services provided by licensed physical or physiotherapists, nurses, in-home health care and management, massage therapists, and chiropractors. It won't take long to find out what people are accustomed to paying for specialized care and health and fitness services. This information will give you a realistic impression of acceptable pricing and services that are in demand in your geographic area.

Finally, take a look at your qualifications. Trainers in your geographic area may have similar or dissimilar qualifications. A trainer can have advanced degrees, loads of practical experience, certification, an established business with strong word-of-mouth referral, and a winning personality. If so, he or she will probably be able to charge a premium for services.

Regardless of what you find out, focus your business plan on what you do well. Do not try to fill niches that are not your passion or area of expertise solely because you have identified a market that exists and has not been serviced. However, if while investigating these local services—whether related to health, sport, or personal training—you find a market that has been overlooked and you have capability in this area, by all means fill the void by providing the appropriate service.

Don't Undersell Yourself

Although there are exceptions to the rule, most trainers will fall into average pricing ranges. It's obvious that you can make a mistake if you set your fee too high, but new trainers are often tempted to set their fees too low. See the box on page 55 for tips on setting your rates.

Significantly undercutting your price sticks out as sorely as significantly overpricing when compared with your peers' similar services. A fitness consumer who comparison shops may perceive the price cut, when compared with other personal training services, as a possible reflection of poor service, unhappy clients, a business that needs and can't keep clients, or a business that doesn't offer quality service, to name a few. The question that begs to be answered is, "What's wrong with your business?"

Substantially underpricing your services, on the other hand, may get you a full schedule, but your earning capacity will be greatly diminished for at least a year. If you decide this is acceptable, your concern is securing clients quickly, and you don't believe your business will be viewed negatively, then by all means proceed. At some point, possibly when there is a strong demand for your company's services, it makes sense to slowly raise the fees of your faithful, first clients as well as your base rate for new clients.

When setting rates for the first time, focus on setting a reasonable, fair, and competitive fee. Be patient. If you have laid the groundwork—they will come!

The key to presenting fee structure, when a prospective client asks how much you charge, is to have a clear-cut and confident answer for any training scenario. You do not want to be viewed as a deal-maker or one who determines your fees based on immediate circumstance. Your business policy related to fee structure needs to be set before you start soliciting clients. Once you've established your rate, review price structure annually and reserve the right to add annual increases.

Billing and Pricing Options

Creative billing options can be an attractive marketing tool to meet client purchasing preferences. A single billing and pricing plan is not the best plan for all of your clients. My goal as a business owner is to capture all possible client business that comes my way with attractive programming and a flexible business and pricing plan that meets the client's needs. A variety of billing plans and pricing structures will best serve you and your clients and could be one of the reasons the client says yes.

Although I'm not suggesting that you offer every imaginable plan—this can be an administrative nightmare to track—it's a good idea to have several in place or to be aware of a plan that might provide a solution in a given situation. Pick the plans that work for your business and clientele. But first, you need to firmly establish your standard session length, establish your individual session fee, and decide whether you will offer any discounted rates.

Step 1: Establish Your Standard Session Length

I base my pricing system on a 55-minute session. A 55-minute "hour" makes it easy to transition from client to client when they are scheduled back to back in one location. The 55-minute reference session is also the foundation on which all other fees are based.

Step 2: Establish a Flat Fee for an Individual Session

A flat session fee is the basis from which all other fee structures evolve. Your flat per-hour fee positions you in the marketplace relative to other training businesses, and the fee you set will create an impression with new clients who check your standard per-session rate. Setting your base fee also will help you to forecast income generation for the fiscal year. Discounted or prepaid training packages and other creative pricing options are all based on the individual session fee.

Payment in Advance, Discounted Service, Retainers, Contracts, and Pricing Schedules

If payment in advance (prepay) is required, do you discount the prepaid sessions or is this simply your way of operating your business? Many clients who prepay for service not yet received expect a discount. If you don't offer a discount incentive and you require your clients to pay first, your business policy must be stated strongly and clearly. What is your minimum, if any, up-front fee requirement? What is the client's recourse if he or she doesn't like your service?

Most trainers work by the hour, so discounts can cut deeply into income generation and affect bottom-line profits quickly. Forced prepay (the client doesn't have a choice), if unprofessionally presented, can concern new clients who might wonder about your integrity or professionalism because your capability to deliver acceptable service has not been established.

Typically, I see 5 to 10 prepaid sessions as a starting point for trainers to begin offering discounts. Incidentally, I would not have a client sign a contract for a specified period or number of training sessions. Instead, I offer volume purchasing or a retainer agreement as better alternatives, mostly because of the headaches contracts often cause. Contracts can

Ten Points That Will Help You Set and Review Your Rates

1. **Going rate.** Find out what other trainers or similar services charge in your area. In other words, what is the going rate?

2. **Market demand.** Is training new to the area and an unknown entity? Is training the current trend or well established in your location?

3. **Trainer demand.** Does everyone want a trainer, or are people hesitant and conservative when hiring this type of service?

4. **Quality and depth of your education.** Are you in a different league? Do you have advanced degrees or specialty training and certification?

5. **Training experience and services (your product) you offer.** How are these services special or different? Are your qualifications exceptional and above the norm?

6. **Training location.** Do you have your own gym? Is it private? Will your clientele come to you? Are you training in clients' houses or from a public facility? If you are an employee, is your percentage of the training fee enough to compensate you for your training services?

7. **Session location.** Is significant travel time required to meet your client? If so, how much of your session fee are you going to bill for travel time? Some people hate to hear it, but time is money, especially when you're working by the hour.

8. **Training session length.** Establish your reference training hour at 55 minutes and base all other training fees on this standard.

9. **Number of people trained.** You can charge less per person trained if you consider training small groups, which generates more income per hour for you and can make training more affordable for some clients.

10. **Common sense.** Understand what your area can support in terms of training, and focus on markets that match your expertise and business plan.

be problematic regardless of whether you can, or even would want to, enforce a contract that a client wants to break.

Although I don't use restrictive contracts, following is information that will help you choose your direction. Generally, this type of contract states an agreement between the client and trainer for a specific number of sessions to be used in a given week, month, or year for a specified dollar amount. The client is usually billed on a monthly, prepaid basis.

With contractual arrangements you must consider all details. For example, your client may want to train three times per week with you for six months. That's 72 workouts. Do the client's absences count toward the 72 workouts? Is the contract over at the end of six months and due to be paid in full even if only 50 of the 72 workouts have been used? Do you bill a fixed-fee per month and do you discount the 72 workouts? Is the client required to prepay any portion of the amount?

In theory, contracts may result in greater commitment, but I doubt it. In fact, contracts probably sour more relationships than they help. How many clients do contracts scare away, especially if they are mandatory? What if your client wants to break or change the contract? To say the least, this would not develop a positive and committed relationship.

Retainer Agreement

A retainer agreement reserves your services at a specific time on a recurring basis. Many of my clients love what my retainer agreement offers. Clients who want to develop or continue a committed workout schedule, have their workout time reserved on a permanent basis, and are looking for a rate reduction find a retainer agreement as the perfect fit. This option works with new clients as well as those who have been training with you for quite a while. I believe retainers simplify bookkeeping, create steady cash flow, make it easier to project earning, and save you time.

Here's how it works. Let's say Ken works out three times per week at $100 per hour and he averages 12 workouts per month. When Ken makes all of his workouts you earn $1,200 per month from him. However, this client travels a lot and might miss two to three workouts per month. Since about 50 percent of the time he lets you know of cancellations ahead of the scheduled session, you lose income because your cancellation policy hasn't been violated in these instances. An attractive alternative for Ken might be for him to pay you a retainer or fixed fee per month. Note that this is not a long-term contract, but the relationship remains intact as long as Ken so desires. I trust that my skills and other services at The Training Edge will ensure my client's commitment and involvement in the training program. Retainers keep your relationship fresh. Your clients keep coming back for more as long as you deliver services they value.

The retainer system guarantees Ken his three time slots per week, and he pays the same discounted fee regardless of his attendance or when he cancels. In this case, I might offer Ken and any of my other clients the same option, a 15 percent discount, which brings Ken's bill to $1,020 per month. Since Ken often misses sessions and has to pay for half of them anyway because of my cancellation policy, a win–win situation is created. My bottom line is only slightly affected, especially if I take into account the canceled workouts with acceptable notice.

About 10 years ago, I regularly had between 8 and 10 clients who thought the retainer system was a wonderful idea. While I was located in Los Angeles, I charged $100 per hour for home visits within 20 minutes of my training facility (about 30 percent above my base rate of $75 per hour). I knew that if I maintained these clients on the retainer system, I would generate between $8,160 and $10,200 per month, or between $97,920 and $122,400 per year. I could operate my business on that base easily and even with expenses still receive a good wage. Of course, I had other revenue streams from clients on different payment plans, related fitness services, and trainers who worked for me, but this income was more difficult to project. Many of my clients stayed on this financial plan from 1984 to 1993, until I moved my operation from Los Angeles.

All of my established policies apply to every pricing plan, including the retainer system. I review package and session rates for current clients annually. I have had many years of success with this option, and you should consider offering it to your clients.

Step 3: Do You Discount Your Standard Fee?

Many businesses do not offer a discount for any of their services, for any reason. Here's the principle behind thinking like that. The value and quality of the session or service do not change and are independent of the number of sessions the client purchases. Generally, personal training is labor intensive, meaning that there are only so many hours in the day that a trainer can generate income. Do you want to dilute your earning capacity? The other side of the coin is that you need to attract clients to your business.

Often, companies that do not discount are well-established businesses with a dedicated clientele and a long list of clients knocking at the door. The operation may not have started this way, but when you reach a point where you have more clients than you know what to do with, it makes sense to adopt slightly more restrictive policy. Ultimately, time is the premium commodity.

Many trainers offer discounted services based on the number of sessions purchased per week, month, or year or the type of service provided. High-volume training session purchases are common as well as discounted rates for small group training and team sports conditioning. What is high volume? Many experienced trainers tell me that client commitment is exhibited by a client who averages two to three workouts per week, totaling 24 to 36 workouts over a three-month period. If you choose to offer discounts for volume purchases, I suggest starting significant discounts at 24 sessions.

A lower per-session fee may be charged by trainers with less experience than by veteran trainers in the same facility. Some trainers award discounted or free sessions to clients who refer individuals who become paying clients.

If you're opening a business and want to offer a discounted fee that is well below the average going rate in your area, consider running the

bargain as a limited time offer only. This will attract client interest, it will limit suspicions concerning the quality of service you can provide because it is a short-term promotional offer, and you can focus on selling your training services. Base your selling points on qualifications, experience, and customer service. If the only selling point of a business is a bargain price, it's probably in trouble. Even if the entity survives, the trainers eventually will not make a reasonable wage and when it comes time to raise fees, existing clientele might resist mightily. An image of low value can permanently be created by the use of ongoing bargain prices. It doesn't work to hang a "going out of business" sign all the time! If you're intent on undercutting the going training rate, present it as a short-term opportunity that will help you to initially attract interest in your business without undermining it.

Regardless of your decision, put your pricing scheme in writing and explain to your clients why it is to their advantage. Remember that it is wise to use the discount approach in a discerning manner because it can cost you a significant amount of money and can lose its marketing effectiveness.

Setting Up a Volume Discount Pricing Structure

When you set up your volume discount pricing structure, you need to determine four things: (1) the least amount of money you are willing to earn per hour, (2) the minimal number of sessions that merit discount status, (3) the largest number of sessions you're willing to offer at a discount, and (4) the progression of discount as the package increases in number of sessions.

Be careful not to discount any package so heavily that you earn less per hour than you can afford. After all, you will be providing the same quality service at every session. Generally, no per-session fee, regardless of quantity of sessions or length of time commitment, should be discounted more than 20 percent. What is your time worth? You need to be compensated adequately!

Following is a pricing plan for facility-based and in-home training. Pay close attention to the percentage reduction as the number of sessions purchased increases. At no point does the deduction exceed 20 percent.

The package of 144 sessions includes three workouts per week for 12 months. Significant reductions start at 25 prepaid sessions (table 3.1). Although my clients are not required to use all of the sessions in one year, you might want to place expiration dates on the discounted packages. (Read more about expiration dates in the following section.)

Notice in table 3.2 that as you progress the percentage of reduction, your per-session fee for in-home training begins to resemble your per-session fee in your training location. In fact, my per-session fee would be only $5 less in the studio—and I don't have to travel—when compared with the 20 percent discount package of 144 in-home sessions, where I have to travel. It's not an issue of right or wrong, but you need to decide whether the per-hour fee is really what you want to earn.

Expiration Dates

I never place an expiration date on a prepaid package, and I give the client the right to transfer the package to another individual. I feel I owe the service to someone once it is paid for. However, the package is nonrefundable.

TABLE 3.1 Volume Discount Purchase Plan for Sessions at Facility

Number of sessions	Cost at facility	Cost per session	Percentage reduced
Single session	$75.00	$75.00	None
Package of 10	$712.50	$71.25	5
Package of 25	$1,687.50	$67.50	10
Package of 60	$3,825.00	$63.75	15
Package of 120	$7,380.00	$61.50	18
Package of 140	$8,400.00	$60.00	20

TABLE 3.2 Volume Discount Purchase Plan for In-Home Sessions

Number of sessions	Cost in-home	Cost per session	Percentage reduced
Single session	$100.00	$100.00	None
Package of 10	$950.00	$95.00	5
Package of 25	$2,250.00	$90.00	10
Package of 60	$5,100.00	$85.00	15
Package of 120	$9,840.00	$82.00	18
Package of 140	$11,200.00	$80.00	20

The flip side is that expiration dates prevent a client from starting and stopping over long periods, and end dates can encourage commitment and accomplishment of short-term goals. Think about your schedule, too. Let's say a client bought a prepaid package and hasn't trained for a year. Your schedule is booked, and out of the blue the client calls and is ready to recommit himself to training and using up all of those sessions. What do you do? It can be hard on relationships and schedules.

If you think your business location is not permanent, you may want to put a limit on how long the package is valid. To me, that's an ethical issue. If I chose to relocate my business and it was impossible for my customers who had purchased discounted packages to attend, I would offer full refunds for all unused sessions.

When you set expiration dates, it is important to be fair and realistic with regard to your client's ability to use the sessions within the stated time frame. For example, a client who is working out regularly two times per week can easily use 10 sessions in a six-week period. I base prepaid fees on the client averaging two sessions per week, and the expiration dates in table 3.3 reflect this fact. Bring this logic to the client's attention. Explain that such an agreement is your effort to fully disclose information so that your clients can make an informed and smart decision. It's also part of being upstanding and doing the right thing.

Small Group (Semiprivate) Training

The whole idea of small group or semiprivate training can be boiled down to financial lever-age from both the client's and trainer's perspective. The client would like to reduce her cost of training, and the trainer can multiply her earning power per hour, even though each person who is part of the small group is charged a reduced rate compared with a regular session fee. Additionally, many people, although they may not like to train in a busy club environment, genuinely prefer some company when working out.

A small group can range from two to, well, who knows? If you have the ability to teach group exercise, you could take a committed group of 10 to 15 people and teach them a step, sports conditioning, or circuit class or take the group on a fitness walk or outdoor hike.

When small group training is viewed from a traditional approach to personal training, where hands-on attention and personal contact are the rule, I don't like to see the group get any larger than five people. Ideally, I prefer two to three people per small group. My most common request for small group training usually involves two people—often a husband–wife team or a couple of exercise buddies.

Fewer group participants result in less compromise to individual attention and logistics. For example, do you have enough equipment and space to keep more than two individuals busy, safe, and productive? It is important to differentiate between individualized small group training and group exercise instruction. Small group personal training should still offer specialized attention and personal, hands-on instruction.

People who work out together should be as homogeneous as possible with regard to health histories and physical ability. It's too easy to fall

TABLE 3.3 Realistic Expiration Dates for Training Packages

Number of sessions	Cost at facility	Per session	Percentage reduced	Expiration
Single session	$75.00	$75.00	None	NA
Package of 10	$712.50	$71.25	5	5 weeks
Package of 25	$1,687.50	$67.50	10	13 weeks
Package of 60	$3,825.00	$63.75	15	30 weeks
Package of 120	$7,380.00	$61.50	18	60 weeks
Package of 140	$8,400.00	$60.00	20	72 weeks

victim to helping a group member who needs more attention. Other clients can quickly feel they are not receiving their just due of attention. Be selective. I have often counseled higher need clients, including diabetic and cardiac patients who do not have well-managed solutions to their health problems, to enter into an individualized program until their medical situation is stable and controlled.

Group size will determine what each person can expect. Honestly discuss the difference when this type of training is compared with one-on-one attention. Frankly, being in a group sometimes feels like a cattle call. It can be a bit frenetic, there's lots of energy, and often the attention of the trainer is spread thinly across the room as she herds the group through its paces. Does the client want to be spotted all of the time, engage in private and informative health fitness conversations, and attach to you like Velcro? Then group training is not for her. If the client is looking for excellent guidance, a planned approach to activity, exercise correction, enthusiasm, and lots of motivation and if she likes people, group training is probably the right choice.

What does the business side of small group training look like? There are numerous issues to consider:

- Attendance
- Missed sessions
- Payment in advance
- Who pays
- Start and end dates, or no termination date
- Scheduling mutually convenient time for the group and trainer

A strong business policy can answer these and other questions and erase a potential conflict before it has a chance to arise.

My policy reflects the following train of thought. Group training is a special privilege I extend to my clients as a courtesy. I do this because it can make training affordable or more enjoyable to certain clients. My concept of group training is that it is efficient and cost-effective. I don't want it to become a logistical nightmare or a bottomless pit that requires a lot of my attention to administer, schedule, collect fees, and resolve conflict. Of all my policies, and for the reasons stated, my small group policy is the most restrictive and gives my clients very few choices.

Small Group Policy
I choose the dates, time of day we'll meet for the session, and how many weeks the group session will run. I do my best to coordinate client interest in group training and have it materialize into a scheduled reality. It's important to have an ending date to reevaluate commitment and how the environment and scheduled time are working for all who are involved. If enough of the people involved react with a thumbs-up, you can schedule another block of classes or consider scheduling additional times and allowing other interested clients to partake.

I don't offer volume discount purchase packages for group training for a variety of reasons. It would be too easy to end up with clients who have paid for group training when I can't pull together a schedule that works for everyone. Or, maybe there are not enough people interested in small groups of two, three, four, or five people. How do you accommodate someone who

has prepaid you for a package of group workouts priced for a small group of four? If you don't have enough interest to put together a group of four, you may have to train that person individually, although the sessions he or she bought are priced at a group discount. Even if you refund the money because of lack of interest, both you and the client have wasted a lot of time and, ultimately, you have reneged on an agreement.

Although small group training sounds like a great way to generate additional revenue, scheduling is difficult. A busy trainer has enough challenge scheduling individual clients! That's why I control this option with a precise hand.

Each person in the group is accountable for paying his or her training fee unless, of course, the individuals are a family unit. I strongly disagree with policy that requires one member of the group to collect and be responsible for the entire group's payment of fees. I know the thinking behind this policy: If conflicts arise or someone drops out, let the group figure it out and resolve the issues.

Whether these people are friends or not, this is my business and these people are my clients. I do not want my clients pointing fingers at one another and attempting to resolve my business problems. Letting your clients deal with your business conflicts will eventually place you right in the middle of the mess as mediator and you will no longer control your business direction. A situation like this can erupt and, if it does, will cost you time, money, emotional stress, and maybe even a client or two.

Besides being responsible for their own fee, each member must, in advance, (1) pay the small group training fee; (2) agree to the scheduled time, number of days per week, and number of weeks the small group training class will meet; and (3) understand that class times will not be rescheduled or made up if missed. (This policy needs to be stated strongly. However, a trainer always has the option to consider any extenuating or unusual circumstance; I prefer to give my clients the benefit of the doubt.)

The small group class will be offered at a discount based on (1) the number (2, 3, 4, or 5) of people signed up and (2) a minimum of two or three workouts per week, over a four-week period. The fee is nonrefundable and is only applicable to this scheduled, small group session that runs for one month.

Pricing the Small Group Option Right

I only offer four pricing options, based on the number of people training, and whether two or three workouts are taking place in each of the four weeks. Your per-hour group fee should be substantially higher than your single-session fee. Your client receives a (1) 30 percent discount off of the standard per-hour price when in a group of two, (2) 40 percent discount off of the standard per-hour price when in a group of three, (3) 50 percent discount off of the standard per-hour price when in a group of four, and (4) 60 percent discount off of the standard per-hour price when in a group of five. Small group training offers a unique business opportunity where you can discount your per session fee by as much as 30 to 60 percent and still make more money per hour training. This works for both the client and you!

At my facility, the small group pricing plan is based on a per-hour, single-session fee and eight (two workouts per week) or 12 (three workouts per week) workouts over a four-week period. If travel is required to a client's home or other preferred site, base your costs on your per-hour in-home training fee and apply the percentages as shown in the pricing plan sample (table 3.4). As the small group grows in numbers, note how much the training fee per hour increases and the per-hour session fee for clients decreases!

Quite honestly, I don't encourage group training. I believe that personal training is only at its pinnacle in a one-on-one relationship. But, because some clients like the concept, my pricing reflects the compromise that occurs with regard to personal attention when personal training transitions to small group training. Regardless, the group training scene can be a win–win scenario.

I encourage clients to solicit family members, friends, or acquaintances if they are interested in group training, and I put the word out to my clients via newsletter, bulletin board, billing statement, and personal contact. I place small group training sessions on my schedule as need dictates and as my schedule allows. My role is to coordinate schedules of clients or potential clients so a workable meeting time and place can be scheduled.

TABLE 3.4 Small Group Pricing Plan (Sample)

No. in group	Percent discount	No. of workouts	Client cost	Client cost per hour	Trainer's fee per hour
2	30	8	$420.00	$52.50	$105.00
2	30	12	$630.00	$52.50	$105.00
3	40	8	$360.00	$45.00	$135.00
3	40	12	$540.00	$45.00	$135.00
4	50	8	$300.00	$37.50	$150.00
4	50	12	$450.00	$37.50	$150.00
5	60	8	$240.00	$30.00	$150.00
5	60	12	$360.00	$30.00	$150.00

Note. Based on a per-session fee of $75.

In-Home Training

In-home training is romanticized on many levels. Training clients in the comfort and privacy of their home can be a labor-intense and time-consuming strategy.

From the client's perspective, the home is safe, convenient, and familiar. Training in the home appeals to time-crunched people or those who don't like the crowds and hum of public facilities. These clients understand that this is specialized service that has inherent value, compared with training elsewhere. Of course, the price will be at a premium. A trainer's time is important, too.

I recommend charging 30 to 35 percent more than your base rate per-hour fee for travel to a client's home that is 20 minutes or less driving time. When I explain my in-home fees or list them in my rate plans, I let these clients know they are being charged for my travel going only one direction. My ride back is on me!

Let's say your base rate for clients who meet you at a workout facility is $75. Thirty-five percent of $75 comes to $26.25. In this example, I would round off the charge per hour for in-home training to $100. This moderate 35 percent increase partially compensates you for about one third of a "wasted" hour in travel time, but remember that you have to travel to your next destination, which may or may not be closer, or to your training facility.

Seriously consider not taking on clients that require more than 30 minutes of travel time because of distance or likely traffic congestion. When I first was getting started I did what I needed to do to procure clients, but as my business matured I became much more selective. Even if you're paid for your travel time, it isn't rewarding; toiling as a road warrior is frustrating work. While in your car, you can only do so much in terms of being productive. After all, did you enter this business to train clients and change lives or to be stuck in your car racking up miles!

Note, too, that training in the home may not be the tranquil experience that clients imagine. Most clients want to train in the home because they see it as efficient. They can spend less time away from family, sleep longer, take care of personal business, avoid traffic, and so on. But training in the home has its pitfalls. Business and commitment are often not honored the same as in the workplace. Family and household priorities regularly come first. That last sip of coffee, sending the kids off to school, and finishing a phone call can replace the starting time of a scheduled in-home session. You might even slap your client on the wrist with a good-hearted admonition, but this delinquency will happen again. I arrive and leave on time, maintain my energy, and keep the efforts focused and moving forward. Many of your clients will be warmed up and ready to

take advantage of this training luxury. Other clients will regularly and literally have to be awakened and dragged out of bed every session. Sometimes I feel like a glorified baby-sitter, but regardless, I know I can place all of the disorder and lack of discipline aside and still improve this individual's life.

Payment Plans

Should your clients pay at the end of the day, week, or month? If your clients are not prepaying for service or purchasing volume discounted packages, will you bill your clients after services are rendered? My preferred method of billing is to invoice clients after services are rendered in a given month (see figure 3.1 and form 3.3). Invoices are mailed immediately after this billing period and are due and payable on receipt. They are overdue if not received two weeks from the billing date. All services stop until the overdue invoice is paid in full.

Of course, I'm at risk to lose four to six weeks of training fees if the client does not pay. If this concerns you, consider requiring prepayment of sessions until you determine the client's credit is secure and his intentions are trustworthy. After a trial period of two months, for example, the client may be offered the courtesy of receiving invoices for services rendered. Payment after service is rendered should always be viewed as a client privilege, not a right, which means it can be revoked.

Billing or collecting fees daily or weekly is cumbersome and time consuming, and you might begin to feel like a 12-year-old paper boy or girl collecting money from your subscribers. It's no fun to hound clients for money that is owed to you. What do you think about payment after each session? Don't even consider it! Collecting at the time of service—cash or check—is the weakest and least professional of all options. However, I do know trainers and clients who prefer this type of business arrangement. Some clients will insist on paying just before or after the service is delivered. If the client is consistent, payment terms are enforced, and no problems are encountered, it's hard to say that this payment option is wrong or inappropriate. Although I don't advertise this option, I remember one of my clients who asked whether it was okay for her to pay me each session, after our workout. Knowing this was what she preferred, I said yes. But, I also explained that

my cancellation policy was still intact—meaning if she failed to cancel within the time frame established by my policy, her next postworkout payment would be double. She agreed.

This client trained with me for more than 10 years. She never failed to deliver a check or cash immediately after the workout, and she presented the payment discretely in an envelope with my name on it. Several times, payments were presented for two workouts because she missed sessions. I never had to badger her for missed or late payments. I have policies that I prefer, but I am not so inflexible that I can't identify a win–win situation when it's presented to me. However, believe me when I say that this pay-as-you-go scenario is not always so positive.

Prepayment, invoices for services after they are rendered, and the retainer system are the top options to consider. Regardless of the billing plan or plans you choose to use, records and billing statements must be updated regularly and must always be accurate. Send out monthly statements, even if no money is owed. For example, it is important to deduct sessions from prepaid blocks so clients know how many sessions remain. Remember to check in your state, province, or country whether a particular billing plan, like advance payment, is legal.

Most businesses would consider invoiced services, where payment is required after the service is rendered, to be high risk compared with advanced payment for service. I agree, but I still prefer billing my clients via an invoice after I deliver the service. After all, most services and utilities we hire or subscribe to invoice after the product is delivered or used.

All payment options carry risk. Will your clients pay you money owed on a timely basis? The real answer to this lies, in part, in your ability to create clear, concise, and fair business policies while simultaneously using common sense to mediate conflicts. The other element is to maintain a fair and positive relationship with your clients. Your policy and your attitude will communicate where you stand. Preserving an outstanding relationship with each client is the key to business longevity, keeping clients, and getting paid.

Before you decide how your clients will pay, consider the following. I believe the higher risk pay options actually work well for small or single-ownership companies. I've always used payment after service is rendered as a selling

Invoice for Services Rendered

Client name: _____ Payment plan: <u>$75 per session</u>

Client account number: _____ Terms: <u>Payable on receipt</u>

Invoice or statement no.: _____

Month	Workout dates and notes regarding product purchase, equipment billing, misc. services	Session charges or session deductions or cost of misc. service or purchase	Date cost billed or date session deducted from prepay purchase	Amount of payment received or number of sessions deducted	Balance due and no. of sessions remaining	Billing date
	Balance due from previous page or invoice, or no. of sessions remaining				$900.00	
June	1, 3, 5; training sessions	$225.00	6/30		$1,125.00	NA
June	8, 10 (late cancellation—full charge), 12; training sessions	$225.00	6/30		$1,350.00	NA
June	9; payment received			$900.00; invoice no. 111	$450.00	
June	12; equipment purchase: heart rate monitor; bill end of month	$119.00	6/30		$569.00	NA
June	15, 17, 19; training sessions	$225.00	6/30		$794.00	NA
June	22; ordered motorized treadmill; payment due immediately	$1,500			$2,294.00	6/22; invoice no. 153
June	22, 24 (late cancellation—no charge), 26, 28; training sessions	$225.00	6/30		$2,519.00	NA
June	29; received treadmill payment			$1,500; invoice no. 153	$1,019	
June	29; training session	$75.00			$1,094.00	NA

Continued ➤

FIGURE 3.1 Sample invoice for services rendered.

➤ *Continued*

Month	Workout dates and notes regarding product purchase, equipment billing, misc. services	Session charges or session deductions or cost of misc. service or purchase	Date cost billed or date session deducted from prepay purchase	Amount of payment received or number of sessions deducted	Balance due and no. of sessions remaining	Billing date
June	30; billing for June sessions and heart rate monitor				$1,094.00	6/30; invoice no. 182
July	1, 3; training sessions	$150.00			$1,244.00	NA
July	6, 8, 10; training sessions	$225.00			$1,469.00	NA
July	12; payment received			$1,094; invoice no. 182	$375.00	NA

Author's note: This billing ledger works for payment after the service is rendered and prepayment plans. This form helps you keep a running tabulation of your client's current balance due, as well as any money owed resulting from equipment purchases or other optional services. If the balance due is not received 2 weeks from the billing date or as agreed upon, training services should stop until the balance is paid in full. This will limit the accumulation of debt. Each client should be sent a monthly statement; payment is due on receipt and overdue if not paid within 2 weeks of the invoice date. Timely, organized, and accurate statements will keep the client apprised of his account status and keep money flowing to you.

FIGURE 3.1 *(continued)*

Invoice for Services Rendered

Client name:_____ Payment plan: _____

Client account number: _____ Terms: _____

Invoice or statement no.: _____

Month	Workout dates and notes regarding product purchase, equipment billing, misc. services	Session charges or session deductions or cost of misc. service or purchase	Date cost billed or date session deducted from prepay purchase	Amount of payment received or number of sessions deducted	Balance due and no. of sessions remaining	Billing date

From *The Complete Book of Personal Training,* by Douglas S. Brooks, 2004, Champaign, IL: Human Kinetics.

point. As a small company, I can develop professional relationships with my clients that are personal and private. I believe this develops trust and commitment. On the other hand, larger—less personal—operations don't have this advantage, and it makes a lot of sense to have clients prepay for services, use preauthorized bank account debits, or use preauthorized credit card transactions that allow automatic billing of fees.

Payment in Advance

Although advanced payment is arguably the lowest risk option, if advance payment is your only payment option, you will lose a few potential clients because this plan is not affordable or right for them. Figure 3.2 shows a sample prepayment statement (see form 3.4 for a blank, reproducible version), but it's wise to consider at least one other payment option.

What kind of company requires this type of payment exclusively? Several of my colleagues' businesses come to mind that are huge, employ lots of trainers, have several locations, are well run, attract high-income clients, are established as a company you can trust and that will be around for a long time to come, and are known for delivering incredible service. These types of companies are in demand and believe in their services and abilities to continue to attract high-end clients. When demand outstrips supply—you have more business than you know what to do with it—you're in a good position to be more restrictive with any policy. However, most companies that are trying to grow, and even those that are wildly successful, should strive to meet potential clients' needs, which indicates that you need to offer more than one option.

Alternative Forms of Payment

Alternative types of transactions—which include postdated checks, credit card authorized payment, and electronic bank transfer—add an arsenal of diverse payment options for your clients. Although they take a little time and research to set up, initial setup time is quickly rewarded with a relatively hassle-free method of collecting money owed to you.

Postdated Checks

Recently, I used the concept of postdated checks to negotiate a deal to translate a book I had written. The organization accepted the terms of a contract that would give them the Spanish language and distribution rights to my fitness book. But, the organization was short on cash at the moment because of recent projects and business expansion. I offered a quick solution because I had done business with this company before. Obviously, I trusted them. I wanted the deal to go through, and the contract was not considered activated—meaning the rights were not legally transferred—until all money was paid in full.

At the signing of the contract (via fax and courier mail), I required one third of the total payment. One month later a second payment totaling one third was due, and the following month the final payment was due.

Similarly, there are many clients you might like to work with but the payment plan stands in the way. On occasion—I don't advertise or promote this option—it might make sense to consider postdated checks.

When allowing someone to pay you with postdated checks, follow these rules. Treat the postdated check as payment in advance. For example, if a client purchases a prepaid package of sessions that he or she cannot pay for in full, require at least one third of the fee to be paid in advance. The next payment is dated one month later, and the final payment is dated two months later. All three checks are physically in hand at the beginning of the agreement period, with, of course, the second and third checks postdated accordingly. This arrangement still ensures that you will receive payment for services before they are given.

Postdated checks may make the plan affordable and a realistic option for a client since payments can be spread over the life of this short-term agreement. If the agreement becomes a nightmare to manage, or if checks bounce or are canceled, this privilege should immediately be taken away. Billing options that are flexible and work with client needs are a courtesy you provide to clients who honor the agreement.

Preauthorized Bank Account Debits or Preauthorized Credit Card Transactions

This form of payment can be used to prepay for services or to pay for services already rendered. The beauty of this option, once you set it up, lies in its automation.

Preauthorized bank account debits come from a client's bank account and are transferred and credited to your business' bank account. Contact the bank you use to see whether this business

Prepayment Statement

Client name:_____ Payment plan: <u>Prepay 144 sessions</u>

Client account no.:_____ Terms: <u>Payable on receipt or prepaid sessions</u>

Invoice or statement no.: _____

Month	Workout dates and notes regarding product purchase, equipment billing, misc. services	Session charges or session deductions or cost of misc. service or purchase	Date cost billed or date session deducted from prepay purchase	Amount of payment received or number of sessions deducted	Balance due and no. of sessions remaining	Billing date
	Balance due from previous page or invoice, or no. of sessions remaining				$0.00/122	
June	15, 17, 19; training sessions	3	6/30	3	$0.00/119	NA
June	23, 25 (late cancellation—full charge), 27; training sessions	3	6/30	3	$0.00/116	NA
June	27; equipment purchase payment: heart rate monitor	$119.00	6/27	$119.00; invoice no. 52	$0.00/116	NA
July	3, 5, 7; training sessions	3	7/31		$0.00/113	NA
July	3; ordered motorized treadmill	$1,500	7/31		$1,500/113	7/3; invoice no. 87
July	10, 12 (late cancellation—no charge), 14, 15; training sessions	3	7/31		$1,500/110	NA
July	18, 20, 22; training sessions	3	7/31		$1,500/107	NA
July	25, treadmill equipment payment received			$1,500 invoice no. 87	$0.00/107	
July	25, 27, 29; training sessions	3	7/31		$0.00/104	NA

Author's note: This billing ledger works for both prepayment and payment after the service billing plans. This form helps you keep a running tabulation of your client's remaining prepaid sessions as well as any money owed. As the session number dwindles toward zero, you can advise your client to purchase a new package. Each client should be sent a monthly statement, even if no additional charges have accrued. Doing so will keep the client aware of his account status.

FIGURE 3.2 Sample prepayment statement.

Client name:_____ Payment plan: _____

Client account no.:_____ Terms: _____

Invoice or statement no.: _____

Month	Workout dates and notes regarding product purchase, equipment billing, misc. services	Session charges or session deductions or cost of misc. service or purchase	Date cost billed or date session deducted from prepay purchase	Amount of payment received or number of sessions deducted	Balance due and no. of sessions remaining	Billing date

Author's note: This billing ledger works for both prepayment and payment after the service billing plans. This form helps you keep a running tabulation of your client's remaining prepaid sessions as well as any money owed. As the session number dwindles toward zero, you can advise your client to purchase a new package. Each client should be sent a monthly statement, even if no additional charges have accrued. Doing so will keep the client aware of his account status.

From *The Complete Book of Personal Training,* by Douglas S. Brooks, 2004, Champaign, IL: Human Kinetics.

arrangement is an option. The procedure to begin this type of service usually requires your client to provide a canceled or voided check, complete a form provided by the bank (which you should have available), and sign the form. You may or may not be able to deliver the paperwork directly to the bank for the client. If allowed, I do all of the legwork I can for a client who is interested in paying for services this way.

Preauthorized credit card purchases made by the client through your business are charged to the client's credit card account and credited to your company's bank or merchant account. Merchant accounts reflect your agreement with your bank, or other credit institution, with regard to the percentage of the transaction the bank receives for handling credit card transactions. Generally, the charge to you for credit card transactions is a fixed percentage of the transaction—usually about 2 to 3 percent or less if you negotiate a deal that is favorable to your business.

Preauthorized bank drafts usually cost your business a fixed fee per transaction that is independent of the amount transferred or a minimum payment charged monthly for the service. After the minimum payment is exceeded, some bank draft systems charge you an additional amount per transaction when the base allowed has been exceeded. If a fixed payment per month is required for bank drafts, and if the amount is not surpassed each month, you usually don't receive a refund.

Since business setups like these vary greatly, contact the financial institutions you deal with, like your bank or an investment brokerage firm, and ask them how these business tools might work for your business. Be careful to factor in the costs of using these types of services. If you don't do enough business to justify the fixed fees per month, you may not want to choose an option that requires fixed monthly fees. Run the numbers; if the bottom line makes financial sense, this can be a wise, useful, time-saving, and productive business choice.

Preauthorized payments or credit card transactions make it easy for clients to pay for invoiced services or renew prepaid training packages. These payment options give a client one less reason for dropping out!

Final Thoughts on Getting Paid

Some of your clients will turn out to be crooks or will try to take advantage of you. If, for example,

the bank returns a client's check because of insufficient funds, you must take immediate action. If it's a second occurrence, stop training the client until you have a specific remedy in place for the policy infraction. Credit card transaction, money orders, and cash are good alternatives, if rubber checks are the problem. Additionally, the cost the bank charges for processing a check that is deposited without sufficient funds should be billed to the client to cover your administrative costs. Paying by check is a privilege that can be rescinded.

Here's an ugly aspect of business. Sooner or later, you may have a client who owes you a good sum of money and won't pay. When I am convinced the client has no interest in paying off the debt, I enlist the services of a collection agency. If I have made every attempt to communicate with the client and fully believe I am being ignored and the client has no intention of honoring his debt, I go forward with this accepted method of delinquent payment collection. Don't worry about harming the good standing of your relationship with the client; it probably is already destroyed. The collection agency receives a percentage of all outstanding invoices it successfully collects. The percentage is negotiable, although it often is as high as 50 percent of all revenue collected. My perspective on these fees is that I would rather receive something than nothing. Investigate the agency you think you might want to employ to ensure that the methods they use to gain payment are legal, ethical, and morally acceptable to you. Ask your advisory board members how they would proceed. The actions of a collection agency reflect you and your business.

Another option to collect money that you believe is owed is to pursue monetary award through the legal system and litigation.

Managing Your Business for the Long Term

Where can a once successful business go wrong? Take another look at the opening of this chapter and revisit the 10 reasons businesses fail (see box on page 34). Indifference to clients and lack of service are two points that immediately come to mind. It's time to change careers if you are no longer passionate about service or caring for clients.

Managing a business for the long haul is all about having a clear vision of your goals. You have to be able to see where your business is headed

and have an action plan in place to accomplish this direction. Lack of clear direction and goals and failure to execute said direction can quickly lower personal spirits as well as bring a business crashing down. Realize too, that your original vision will change and most plans do not go exactly as you anticipated. But having a plan keeps you in tune with who you are, what you want, and how you are evolving as a person.

It's your business, so ultimately you need to move in a direction you strongly believe in and want to go. Sound simple? It is! Before you start thinking about what other businesses are doing and what would be right in the eyes of a peer or other professionals, focus on your personal vision and passion. I have kept my vision and passion close by my side throughout my career. I am willing to stray from it if I believe the journey will serve my business and personal life and if outside counsel (like family, advisory board members, and others I respect) has supported my change of direction. But, I return to personal goals and vision often for my grounding. Personal vision does not rule by itself but is an important part of the big picture.

Without question, feeding your business and feeding personal vision are a fine balancing act and if poorly managed can cause conflict or result in poor choices. When a particular situation arises, ask yourself, Does this option serve me? Does it serve my business? Does it reflect my personal passion and desire? This introspective process will help you align your decisions with what is really important to you and your business.

Your business goals should line up with your personal goals and vision, or you have a recipe for disaster. For example, if your business choices require you to work around the clock and yet personal time with your family is important to you, you have a dilemma.

Clear, accurate, and current business direction is never more important than now. If you established your business plan long ago, be sure to revisit and evaluate your business direction and personal vision regularly. Doing so creates hope and results.

Strengthen Your Weaknesses

It is human nature to get stronger where we are strong and to ignore our weaknesses. Physically, that is why some people perform an unbalanced routine of biceps curls and chest press exercises only. They are good at both exercises and familiar with both. They are also in a rut. The same

could be said of many businesses. A combination of fear, the effort it takes to change old ways, and insecurity often leads businesses to operate the same, day in and day out. This method of running a business can continue year after year if the business is not first forced to close its doors.

Trainers new to the business of personal training, veteran trainers included, often agonize and procrastinate over such issues as setting policy and making policy changes. They struggle dealing with difficult clients, collecting money, enforcing late cancellation policy, and—bottom line—changing with the times. Whatever you are battling, acknowledge the area of need, get help if needed, and make the necessary changes. You cannot wear all of the hats, nor should you.

Making Mistakes and Moving Forward

It's hard to be perfect. In fact, if your goal is to be perfect, you will fail. Much of your fear of moving forward or being paralyzed by the thought of making a mistake or bad decision can be minimized with planning and research. Clarity, confidence, and belief in your ideas come, at least partially, from due diligence. You can wallow in a poor choice and call it failure or look at it as a brave attempt and learn from it. Give yourself some room to fail with business decisions and employee handling. Not only will the way you handle these situations affect your self-esteem, but your clients and employees will watch you and learn to admire you, or despise you, by the example you set. How will you deal with stress, difficult decisions, and admitting that you made a mistake?

As long as you have employees, family, and vision and as long as you lead others, you will second-guess yourself and have fear. Having tempering qualities like these should ensure that you deal with your business and interpersonal shortcomings appropriately and sensitively. Failure is an opportunity to learn humbleness and humility, to learn how to treat people fairly and with respect regardless of the pressure you're under, and to learn from your mistakes.

Personal Training Management Directions for the Future

You may be thinking, How can I find out what the best trainers and businesses are doing to

be successful and remain cutting-edge in their approaches? Here's how you find that answer.

Several colleagues of mine have businesses that I have observed and admired over the years. The business direction is very different for each one of these businesses. But more important, each business is a perfect match for the person running the business, and these individuals have reevaluated their goals and personal visions regularly.

How can you learn from successful business entrepreneurs? A good idea is to observe the businesses of other trainers and communicate with them.

Observe the Businesses of Other Trainers

All of the businesses I am referring to are hugely successful operations, yet you can still learn from their successes, missteps, and failures. Of the individuals or businesses I have admired professionally, all have been able to be competitive and fiscally productive for the long haul. Personal vision is a trademark of each business, but all of the individuals involved with a thriving business were also smart enough to balance vision with changing times. The capabilities to recognize mistakes and poor choices and quickly change to a new and positive direction, and to anticipate industry trends and customer need, are hallmarks of businesses that sustain themselves.

I have seen many businesses come and go, whereas others accomplish remarkable achievements and maintain business longevity. Through personal contact via various media that include phone calls, e-mail, and personal correspondence, in addition to worldwide business travel and staying updated on industry news from Internet and written sources, I have gained much insight from numerous individuals and businesses.

Information is free if you seek it. Why learn by trial and error when most top training businesses and their owners willingly, and in fact are often delighted to, talk about what they are doing well as well as what they have done wrong? Sharing information is a two-way street and a learning process for both parties. Proceed with confidence, be ready to learn, offer your insight, and don't forget to offer an appropriate thank-you.

Timeless Principles

Some truths never change, and it's important to identify solid principles you can count on to help you successfully run your business. But, although each ideology represents a timeless and consistent force, the information within is usually dynamic and ever changing.

The success of any personal training business lies in its trainer. Of course, you also need to know how to run a business and work with people. Following are several important steps that shape success stories and will hold true in the future:

- Hiring highly educated and skilled trainers who possess versatility and depth with regard to education and managing people
- Creating a business that is specialized, reaches a broader client base, and reaches beyond familiar ground
- Educating the consumer in a sensitive and caring way
- Defining personal training and the difference it can make in an individual's life
- Understanding the power of word-of-mouth referrals and how to cultivate this type of referral to grow a business
- Providing outstanding and consistent service
- Offering people sensitive and progressive programs that meet individual needs and wants and focusing on highly individualized programs versus a one-size-fits-all approach
- Working with health care professionals and creating business partnerships
- Understanding how to expand and increase income earning potential without compromising the highest standard of ethics and fairness
- Preserving a personal life for owners and employees

Managing a personal training business is not inherently complex. But to grow steadily, you probably cannot do the job alone forever. You may train all of the clients in your business, but many hats remain that you can choose not to wear. It is intelligent to delegate some responsibilities, regardless of the size of your business, to outside services or other sources.

Running a business is very personal. Regardless, proven business principles and sound programming that is backed by science should provide the framework from which you operate. An underlying theme of fairness, trust, honesty, and high moral and ethical standards must be ever present. Ultimately, the process of building a successful business must be meaningful to you.

Getting—and Keeping—Clients

This chapter may be the most important one you read if success matters to you, because the information here can help you adhere to an important business mantra: "Keep and service the clients I already have." The ability to capture a prospective client's business is as important as keeping clients because both situations reflect how effectively you have marketed yourself and whether your business is growing or stagnating. You cannot hope you are taking the right steps—you must know!

Health and fitness trends are important to fitness professionals. Anticipating the next trend can help you identify business opportunities. If your business doesn't recognize new shifts of interest that are driven by consumers and fitness equipment companies, you could miss that next big business opportunity.

Trends can help you focus marketing efforts and decide what new services you should offer. Foreseeing trends is both art (some people have an innate sense about such change) and science (i.e., market research—or doing your homework to ascertain specific steps to meet market opportunity). Regardless, if you can't accurately anticipate the future, marketing efforts will be fruitless. Also, trainers who are active industry watchers will know what personal skills and knowledge need to be improved and expanded.

But, don't put the cart before the horse. If your business is already founded and you have clients, forget—just for a moment—market research, anticipating trends, and procuring new business. Any business can fail to recognize the importance of taking care of existing clientele when trying to enlarge a client base. This issue alone—successfully servicing existing clients—will have the biggest impact on the prosperity of your personal training business and is independent of any other effort to increase your client base.

Marketing Yourself

Marketing involves many factors. Let's start with your business identity.

Naming Your Business

Either before or while you set up your basic business policies, consider the public presentation of your business, including its name. Many trainers choose generic names such as Executive Fitness or personalize the business by using a first or last name. Initially, when I was considering names for my business, I wasn't sure if I wanted to incorporate my family name or not. Also, I didn't want to limit myself to a specific type of fitness (e.g., executive fitness or bodybuilding) or possibly deprofessionalize my approach with a name that sounded too much like a mom-and-pop operation (i.e., Douglas' Workout). Instead, I considered the pros and cons of including my name as part of the business name. My reasoning was based on the fact that early on you are the business, and your name is often what you sell.

However, I wanted the name and logo to reflect my general approach to training and keep open the doors for future business opportunity and expansion. There is probably not a

right or wrong name if you have thought out how you want that name to reflect your business or accomplish your intent.

I liked the name I came up with almost 20 years ago—Brooks . . . The Training Edge—the first time I heard it (figure 4.1). The name was right for me because it had several levels of meaning. It conveyed my feeling that people who are fit are better equipped to handle life's challenges. It seemed to capture the advantage my education gave me relative to other trainers who were starting out at the same time. It also indicated my enthusiasm for remaining on the cutting edge of changes in the health and fitness field through continual updating and education. Finally, it would come to describe the goal of the workouts, which are individualized for maximum effectiveness in relation to the client's specific needs. Also, Brooks could be deleted from the logo, shortening it to The Training Edge, if my name no longer offered a marketing advantage or if I wanted to franchise the business.

You should brainstorm and experiment with names and logos until you come up with the ones that fit your plans. Run your ideas by anyone who will give you an opinion. Don't give up or be discouraged. Independent of the positive and negative feedback you will receive in relation to naming your business, remember that this is your business and no one knows what you have to offer better than you.

Sort through all of the feedback and realize that you make the final decisions. Since your decision will give you a name and identity that you will probably use for a long time, it is worth waiting until you have the right match for your business.

FIGURE 4.1 Choosing your business name and logo is of great importance. Do your business name and logo communicate what services you have to offer?

Creating the Right Paper Trail

Once you have a name, hire an experienced graphic artist to design a distinctive logo and oversee the printing of your signs, brochures, business cards (include development of a client introductory packet or press kit; see appendix), letterhead, envelopes, and notepads. This step may seem expensive and time consuming, but besides being fun, it is critical to help you further establish a professional image and clarity of direction. It also speaks of professional commitment. Because this is a one-time expense, don't compromise by hiring someone just because he or she is available and will work cheap. On the other hand, early in my career cash flow was tight, so I traded training for graphic design work with an up-and-coming designer who was professionally in the same place as me.

Don't second-guess yourself and worry that you are wasting money you don't have, or trading your limited time, for a frivolous business expense. I know what you're thinking. Many trainers will tell you that all you need to get started is a business card. Although there is some truth to this statement, I've discussed in chapter 2 and the appendix why this isn't your strongest option. You can't afford not to invest in these printed supplies! When I finally saw the finished client introductory packets, stationery, business cards, and signs with my logo and name, I felt proud because I was sending my business out into the world well dressed. On paper I looked very professional and thorough, and my confidence soared. Having done my homework made me confident of my direction. Although it seemed like a lot of money and time investment at that point in my career, I have never gotten tired of the logo, and I think it has paid for itself many times over.

As important, and more tangible, was the business return I received from my investment. I believe the rocket-start my business experienced in terms of client interest, referrals, and my ability to successfully liaison with licensed health care professionals was partially built on this paper trail I developed. It was also easy to get my business in the news via magazine, newspaper, and television because I presented myself professionally on paper. Many clients and trainers had positive comments about our professional look. Being professionally

prepared via a smart paper trail gives outsiders looking at your business and services confidence that you can provide the service they are looking for.

If you are working for someone else, you may not need a logo and business name, but I would still create my own identity by developing a client introductory packet. The business name and logo are more important to trainers who are opening their own studios or truly working as independent contractors. If you work at an established facility, your exposure and visibility are guaranteed, but you can still distinguish yourself from other trainers by thoughtfully developing an introductory packet. If you were hiring a trainer, what would you rather pick up: a business card or a professionally prepared introductory packet?

Creating a Successful Web Site

For many people, the World Wide Web is a big mystery. Although the majority of people believe a Web site would benefit their company, they are unsure where to start, how much to pay, or what to expect. The Internet is like exercise: Most people know that exercise and eating healthfully are good for them but let obstacles prevent them from proceeding successfully.

Placing your business on the Web can be simplified into a three-stage process: do the research, build the page, and launch the site.

Research. This discovery step may be the most crucial. Before you start your research, decide on the purpose of your site. Web site strategies include supplementing your advertising brochures or client introductory packets, exposing and defining your services, emphasizing sales, or extending customer service. The best way to decide how you want to set up your Web site is to browse other sites that provide similar services. Make notes on what you like and don't like. Many people who surf the net like photos, video clips, and other graphics as well as interactive sites. Compile a complete list of what you want on the site. This wish list might include interactive games, online sales of personal training services and related products, video clips and photos of exercise technique, and educational articles.

Build the page. This phase begins with the selection of a domain name. Larger companies often prefer a domain that uses their company name, whereas individuals who own businesses may wish to use their personal name. After all, you are selling yourself and your name. Whatever is memorable and will draw people to the site is the key. Ask whether the domain is in line with your marketing efforts and the purpose of the site. If you promote beyond your business contacts and clients, a more general term might be appropriate.

For example, when I operated Brooks . . . The Training Edge in Los Angeles, a good domain name would have resulted in the Web address, www.Brooks-TheTrainingEdge.com. I was selling and marketing the quality of service that had begun to be associated with my training business, and the site would have served my immediate clients' needs. My name was well known on a local level and starting to be recognized on a national and international level. "Brooks" and "The Training Edge" were not only my products but my calling cards as well.

Moves International Fitness (MIF) is the name of my company today. My products and services have moved beyond personalized training alone. My home page is www.MovesIntFitness.com and through advertising has become known as a provider of distance education and other health and fitness products. Regardless of how someone finally arrives at your Web site, there is a good likelihood he or she will be exposed to the products and services you offer at little expense to you. Any business owner would like that!

Once you select a name, you need to register. The easiest way is to have the Internet service provider (ISP), which is the service that will host your Web pages, register it for you. Here's the catch. You must have a host before registering the name. This is similar to having office space before ordering new phone service.

Your ISP is more or less your host and server, too. These terms are often used interchangeably. Choosing a host is an important decision in getting on the Web. When people type in your Web address—let's say http://yourdomain.com or www.yourdomain.com—into their browser or search engine, a host computer "serves" the pages so that people can see your pages. If the host is out of service, a message will post that reads, "Server is not responding."

Whether you argue that a local provider or a national brand name is the best hosting option,

the key is that your provider or host must have a proven track record of dependability. Otherwise, if the provider goes down and does not quickly rectify the situation because of lack of money or skilled technicians, you will lose business, money, and exposure. Because online service is fairly competitive—and in many instances can be obtained for nothing—reliability and stability are the watchwords. If your server goes out of business, that's a nightmare too, because you might have to change your e-mail address, which can be costly if you have to modify letterhead, business cards, or other printed material. Names you know offer stability. However, I use a local service in my region that has provided outstanding service. Because quality and dependability vary greatly, word-of-mouth recommendation is a smart place to seek information.

Will you build your page or have an expert design your Web site for you? There are persuasive arguments for both. Building your own site saves you money and gives you complete control over updates. If you truly love to tinker with new software and consider design work fun,

you probably have the right temperament to develop a small site. Web design programs like Adobe's PageMill and Microsoft's FrontPage get good marks for their features and ease of use. If you're like me and don't have the time or inclination for this type of work, contract a Web page designer. If you can't do a trade-out (your time for his or her time), expect to be charged a fixed fee of $500 to several thousand dollars or $40 per hour and up. If you design your own Web site, you might be able to keep the cost down to several hundred dollars. Major sites can cost tens of thousands of dollars. Many companies have Web sites in which they have invested seven-digit figures in development and maintenance costs. I recommend getting a fixed bid so the costs don't overrun, and I suggest that you request an exact blueprint of what will be included in the page design when the final product is rendered. Also, decide who will update and maintain your site and what the cost will be, or ask the Web page designer to teach you how to maintain your own site. The box on this page lists the key steps for creating a Web site.

Key Steps for Creating a Web Site

1. Select an easy to remember Web address or domain name that reflects or identifies your business. If you aren't set to launch your Web site, register your domain name so it is not taken by someone else.

2. Early in the process, choose an Internet service provider (ISP). The acronym ISP is used interchangeably with the terms host or server. Find a host that is dependable and has a proven track record.

3. Use photos, video clips, and interesting graphics. Pictures, images, and movement make for fun, interesting, and eye-catching Web sites. One warning, however, is that video clips and large photos may take too long to load, or view, by someone who is surfing the Web. This is especially true of computer users who don't have updated modems or other services (DSL or wideband) that allow them to open sites quickly and to view data-dense material quickly. Therefore, make sure your pages are quick and easy to view.

4. Create an interactive site. Fitness quizzes, body fat calculators, nutritional score cards, and opinion polls are good examples.

5. Frequently update your site. Add new information, such as timely articles, newsletters, or product specials, regularly so you tease people to return for another visit.

6. Visit other Web sites and cross-promote. You can get good ideas you can incorporate on your Web page from other addresses and you can discover opportunities to link (promote) your site with others or to be listed on search engines. A top ISP company can effectively register you on search engines so you are easy to find by someone who is seeking the types of services you offer.

7. Secure your site. If you provide a retail opportunity online, let your customers know the site is secure.

Launch the site. The launch is your payoff. Search engines play a key role in exposure because they function as a jumping-off point for Web surfing. Ensure that your site is listed in the most popular places by having your Web page designer or ISP help you.

Exposure, or getting people to your site, is the single aspect that will lead you to Internet success or failure. People have to know about your business or products and want to visit your site. Second, take the time to launch a site that best reflects your company. Although fast is good in the digital world, excellence is better when it comes to Web page design.

Do Web sites really pay off? Yes, no, maybe. It's not always easy to tell.

When asked if their business is online, most business owners mumble something like, "Not yet, but at some point in the future we plan to be online." The implication is that all businesses should be online. But the average business owner doesn't know how much it costs to set up and maintain a site or how much time and financial commitment are required to keep the site current and producing, even if they believe the site will result in business growth and an increased bottom line. There is good reason not to have a Web site and, conversely, many good reasons to get your business, services, and products online.

Many small businesses have finally turned to computers because they make daily business tasks easier, quicker, and more efficient. But can the same be said of Internet connection? Does it pay for itself, or is it simply a status symbol?

Web sites can increase business through increased e-mail contacts and can create new business opportunities from sources that were not previously accessible—if your page is designed to generate this type of business response. It's also easier to inform, market to, and otherwise serve your existing clients through e-mail and Web site information. The Web has greatly increased the number of research tools and amount of information available to you without ever leaving home.

Certainly, hooking into the Internet takes some time—there is a learning curve—before you can e-mail and otherwise navigate it efficiently, and Web sites take time to manage. Not only do they have to be updated, but you also have to respond to inquiries, purchases, and e-mail correspondence generated by your site. It would not be unusual to spend 8 to 15 hours per month to service a busy Internet site, even if your site represents a small business.

No matter how you look at it, the Internet will continue to affect fitness professionals worldwide. The number of Internet users is expected to surge to 716 million by 2005 (Internet World 1999). Profits and success with its use are not guaranteed. Keep open to the opportunities and grow with this rapidly expanding area of technology. It is always easier to expand with a growing field than to enter after it is well established.

Market Research and Marketing

Don't let the words *market research* scare you. Effective market research is not complex and doesn't require a huge time or dollar investment or a degree in business marketing. Simple market research, on the other hand, can keep your business growing and current. Because it can help your business, you need to use it as one of your growth tools. A comprehensive marketing plan, although not necessarily expensive or complex, can help you detail your strategies for identifying, reaching, acquiring, and keeping clients.

What is marketing? Marketing involves six key steps:

1. **Identify needs.** Recognize needs in the marketplace that are unfulfilled.
2. **Conduct research.** Do your homework or gather the facts related to those needs.
3. **Satisfy.** Create a product or service that satisfies the need or market demand.
4. **Promote.** Expose the service or product to consumers so that they know how your business can help meet their needs.
5. **Distribute.** Advertise and let everyone know what you have to offer and how you can help. Distribution allows you to get the product or service in front of customers so they can view it, ask questions about it, and try it.
6. **Acquire new business.** Make the sale and ask for a potential client's trust and commitment.

Effective marketing requires knowledge and predictions about the future. Trends speak of need, desire, and interest. Are you in a position to service evolving consumer demand and need?

The key to a simple marketing plan is to talk with others and search for opportunity that is untapped or ripe for action. Phone your peers and ask them what they are marketing successfully and what has flopped. Share your views as well, so that professional networking is a two-way street. Consider visiting competing facilities, not as a spy, but to get a sense of what drives that particular business and to maintain a friendly, open communication with your competitors. Reciprocate the same offer to your peers.

Local business agencies can be used, such as the chamber of commerce, which can provide you with demographics of a particular area. If you're in a position for a full-blown market research project, you could subcontract to a university, college, or research firm that has expertise in this area. Expanding to a 50,000-square-foot facility might necessitate this kind of expense and exacting information before you make a financial commitment.

Good marketing research is always followed by superb promotional strategy. In other words, where do you advertise? Where and to whom do you mail your promotional pieces? Will the response to the promotion be successful or acceptable? How do you track effectiveness? How do you get the word out in a cost-effective and focused manner?

Marketing a Personal Training Business

How do you get your business in the news? How do people find out about your services? You can pay advertising fees or use a variety of methods to publicize what you are doing at no cost.

But again, before we jump too quickly ahead, you must provide outstanding customer service and expertise and present a corporate image that communicates professionalism, fairness, enthusiasm, and empathy toward the customer. Your corporate image is everything, and it is directly reflected by everything you do and say. How you are perceived by your clients, potential customers, and the community at large—not what you think your message is—will determine to a huge extent the success of your business.

Simple, Effective, and Cost-Effective Marketing Strategies

1. Develop a Web site (as discussed earlier in this chapter).

2. Publish a monthly or quarterly newsletter. Distribute this information and promotional source via mail, fax, e-mail, or Web site. Feed business-related promotional information to sources (i.e., newspapers, magazines, local television) that might be interested in creative health and fitness programming and other appropriate news.

3. Provide fitness tips for radio and television talk shows or for Internet sites.

4. Profile client success stories (with the client's permission) in your newsletter or on your Web page or in business or airline magazines.

5. Speak in corporate or other institutional settings (such as hospitals or service organizations) on health, fitness, and wellness.

6. Offer gift certificates.

7. Offer promotional, complimentary workout invitations to selected or referred personal training candidates.

8. Send introductory letters to selected individuals and follow up with a phone call.

9. Mail postcards to promote interest in your business.

10. Record a message on your answering service in a manner that promotes your business.

11. Send personal, handwritten thank-you notes to acknowledge business referrals.

12. Mail unique items (i.e., T-shirts or an exercise band) with your company name, logo, and phone number to people who are likely candidates for personal training, or distribute thank-you notes to your existing clientele for continued support.

13. Develop and distribute a signature line of products that might include T-shirts, gym bags, baseball caps, socks, gym shorts, or other exercise apparel or equipment.

14. Ask your clients and other professionals for referrals, and give these people an incentive to do so.

15. Maintain exceptional service.

Public Relations: Put the Word Out

Public relations involves putting the word out about your business. People have to know your intent. Are you committed? Once you're committed, you have to follow through. Do you have a plan in place that enables you to advertise the services your business offers?

The best way to create interest in your business and to establish a clientele is to set goals and define the services you plan to provide. Not only will your client introductory packet help you to effectively introduce your business to prospective clients and the media, but as you develop the packet, you'll become clear and confident about what you have to offer and how it is different than other services in the marketplace. This packet is part of your public relations delivery vehicle and will help shape your business image as well as create an impression of professionalism (see appendix).

Publicity: Getting Your Business in the News

The exposure through publicity is outstanding and there is usually no cost. The news media include newspapers, magazines, radio, and television. Don't forget to consider public speaking to various community and corporate groups, and promote any news story that involves your business. This could include charity events, volunteer work with local athletic teams, new programs at your business, or staff training updates. This kind of publicity associates your name with good causes, creates familiarity with your name and services, and attaches a degree of credibility, expertise, and professionalism to your organization.

To get your business in the news, introduce yourself to the local media sources in your community. Media coverage that targets local events is where you'll find new clients. Develop a story you want to tell, add photos, and you're ready to sell the story. Explain your business and why your story is of unique interest. I court the media as I would a client. In other words, find out what an editor or news director wants and figure out how to provide the information in a timely and professional manner.

Media Advertising

This will cost you, but it can be productive and may make it easier to get free press or other media coverage in the future. Whether you're using radio, television, newspapers, or magazines as your marketing vehicle, all require you to budget, target audiences that are likely to hire or at least consider your services, and advertise frequently. Rather than make a big splash with a concentrated radio blitz of costly commercials or blow your entire budget on a costly one-page ad, use your budget to have the greatest impact. I prefer to trickle information to the public with a consistent and frequent message communicated in small doses. Any type of local media advertising costs will be fairly inexpensive compared with national media coverage.

Business Cards, Letterhead, and Business Stationery

Consistency and repetition are key to name recognition. These marketing pieces—business cards, letterhead, and business stationery—should tie into one another. The same distinctive logo, color, and design should appear on any printed advertisement materials, so that over time, these elements stand out and consistently identify your business.

Enough information should appear on the business card to represent your professionalism and detail your qualifications, without turning it into a mini-resume requiring a magnifying glass to read. Some trainers like to provide space on one side of the card to schedule workouts or counseling sessions or offer complimentary consultations. This business or appointment card projects a professional image and helps people commit to and remember appointments. It provides another tool to move the client toward the fitness programming you have to offer.

Company Brochure

Your business card or company brochure may be the first tangible piece of information that a potential client sees when considering your services, and it literally introduces the individual to your business. The brochure should clearly define what your business offers, what a personal trainer can do for a potential customer, why the interested person can trust you, and how your business services differ from similar services (figure 4.2).

A well-designed brochure is a great promotion piece that can be mailed to potential clients who inquire about your business over the phone. It is less costly to produce and distribute than the client introductory packet. The client introductory packet is more appropriate to give out during your first face-to-face contact with an interested client or top prospect. Remember that these brochures are advertising pieces. Don't hoard them because they cost several pennies to produce. They are meant to be given away like candy during a holiday. If in doubt, hand them out!

A brochure by itself is not worth much, but when combined with a stellar reputation, documented professional credentials, comments or testimonials from satisfied customers, and a description of your business services, the brochure is another piece of the marketing puzzle that helps to spread the word about your business. Brochures are a cost-effective and efficient method to promote your business.

If you employ trainers, print your credentials, experience, and training objectives on the folding brochure. Print single-page inserts that can be easily slipped inside the folded brochure for other trainers and employees. This will save the cost of reprinting the brochure when employees are hired or leave your business. If new programs are added to your services offered, this same idea can be used to update your brochure.

Designing Promotional Materials

If image is everything—at least until people discover your professionalism and substance for themselves—what makes a marketing piece work? Darren Thorneycroft (1995) identifies seven key points to keep in mind to design effective promotional materials:

1. Clarity wins over cleverness and between-the-lines information. Hidden information or a secret and deep meaning that is disguised in a logo or tag line is of little use from a business perspective. Many prospective clients do not know what personal trainers do and how they can affect their clients' lives. Although you want to differentiate yourself from other businesses with an inventive logo, tag line, or business name, don't forget to define who you

About the director or owner:	**Back of brochure:** What people are saying about The Training Edge	**Front page of brochure:** Logo: Brooks logo here
Professional qualifications		Name of business: Brooks . . . The Training Edge
Experience	Name of business and logo; contact phone numbers, Web site, e-mail	Name of proprietor, credentials: Douglas S. Brooks, MS, Exercise Physiology and Certified Personal Fitness Trainer
Professional objective and training goals	Enticement or promotion: for example, "Call for a complimentary consultation."	
About the company		Contact information: business phone, fax, e-mail, mobile phone, mailing address
Board of advisors		
Meet your trainer (insert trainer profiles)		
What is a personal trainer?	Training Edge session costs and package/pricing options	What to expect:
How can a trainer make a difference with regard to your personal well-being and fitness?		Training Edge mission statement
Individual programs and services to help you		

FIGURE 4.2 Trifold brochure design content sample.

are, what your business does, where you train, what services you offer, and why the person should choose your business.

2. Recognize the limitation and power of emphasizing "you." Although it is important to present your business professionally by detailing its outstanding attributes, be sure to tailor the information to a reader's question, "What's in it for me?" Focus the emphasis of "you" on what the reader will receive. *You* will receive the guidance and care of a professional. *You* will feel better, look better, and achieve the result *you* have always dreamed about. Emphasizing "you" toward the reader's perspective properly focuses the power of this three-letter word.

3. Carefully target your market. If a written communication is to be powerful, it should speak specifically to the audience you are targeting. Use appropriate photos, language, and graphics to hone in on your desired target market. For example, a photo of you scantily clad in your best bodybuilder pose will affect who will and will not be attracted to your business! This is not an issue of right and wrong but a matter of appropriateness with regard to the clientele to which you are marketing.

4. Use clean, clear, and easy-to-read layout and type. Use a professional to help you zero in on these qualities. Effective brochures offer benefit-oriented headlines or headers and compelling logos, graphics, or photos that speak to the clientele you are trying to draw.

5. Aim for quality, quality, and more quality! As location is to real estate value, quality is to marketing pieces. Grammatical and typographical errors, excessive verbiage, unclear statements, incorrect facts, and self-inflating fluff detract from your message and professionalism. Images, photos, and graphics should be clean, vivid, eye catching, and professionally integrated into the piece.

6. Use testimonials. What are people saying about your business? Nothing is more powerful than real-world results. Testimonials tell about who is using your services and what benefits are being received, and they communicate that your clients are so satisfied with what you have to offer they are willing to tell the world about you. Testimonials that are printed in your clients' own words are compelling and powerful.

Canned testimonials—ones that proprietors write or edit to target marketing efforts—are easy to spot as fakes: "Real" wins over "invention."

7. Design multiuse promotional materials. Advertising and promotional pieces should be designed with more than one use in mind. This will save you money and time. You should be able to mail a brochure in addition to handing it out at clubs or distributing it to retail businesses (running specialty stores, equipment retail outlets, spas, hair salons) that are likely to result in client referrals. Attractive letterhead can be printed on and used for price sheets, fliers, promotional offers, and client introductory or media packets.
From D. Thorneycroft 1995

Direct Marketing Pieces (Mass Mailings)

Before you spend a substantial amount of money mailing advertisement pieces (letters of introduction or brochures), realize that this common technique is not very productive. A 3 to 5 percent response is the best you can hope for. Trainers have sent out several thousand pieces and received no replies. On the other hand, a few replies can help jump start a business and create a swell of future referrals based on the success and happiness of just one client. Don't be disappointed if your response rate is low, and be realistic when using this method to attract clients.

Personalize direct mail. A mailing addressed "Resident" or "Addressee" is not likely to be read. Just like your client introductory packet, this advertising piece may be the first measurable representation of your business that a potential client sees. It must simultaneously define who you are and what you do! See figure 4.2 for help in designing a superb brochure.

If you work in a club, take full advantage of the club's mailing list. The club's roster is a great example of a targeted demographic that will be interested in personal training services.

Network With Other Health Care and Fitness Professionals

How do you make the medical connection? Not all medical professionals know what personal trainers do and may question an individual's level of technical competence. Licensed professionals, whether medical doctors, physical

therapists, registered dietitians, or athletic trainers, are used to working with individuals who possess an easily documented standard of education and training. A certified personal trainer, at his or her best, represents a minimal level of competency in the eyes of many licensed professionals, because certification is not standardized in the personal training industry. In other words, medical doctors, chiropractors, physical therapists, athletic trainers, and osteopathic doctors within a state, country, or province usually have the same stringent requirements in each of their disciplines and are required to successfully fulfill all of the standard requirements to attain and maintain their degree, professional status, and license. Because this standardization does not exist to a large degree in personal training, it is imperative to establish your credentials and credibility from the start as well as educate the medical community about how a personal trainer can work with patients. Professionals in both the medical community and fitness arena are now realizing the merits of aligning their services to benefit the overall well-being of their mutual customers. Education opens doors to this liaison. If trainers want to access this market, they will need to receive training in subspecialty areas and learn to market themselves to doctors and other licensed health care professionals in a proactive manner. Fitness and health care can be a great match! (See chapter 1 for additional discussion and part IV.)

What are the best ways to collaborate with other health and fitness professionals? Here are some tips I've picked up.

Accumulate education and formal training. If you're serious about building professional ties with the medical community, it is essential to accumulate formal training (i.e., certifications and degrees) and other continuing education. You will need to understand the conditions for which patients are referred as well as the medical treatment or therapy that typically is administered. As your knowledge base and experience grow, so will the opportunities to market yourself to and effectively work with a growing variety of special populations.

Identify your role. Earn the respect and trust of physicians and other health care professionals by defining the boundaries between what the trainer does and what the licensed professional does. The trainer's role is not to diagnose disease, illness, or orthopedic problems but to understand the basic pathology, causes, and management of common disorders or specialty needs. These include heart disease, hypertension, diabetes, blood lipid abnormalities, obesity, asthma, pregnancy, osteoporosis, arthritis, and a host of other diverse and challenging health management scenarios. An approach like this will forge a fitness partnership that is a win–win situation.

Establish credibility and professionalism. When you have correctly identified your role, have accumulated sufficient education and formal training, and continue to expand your knowledge base, you have established a position that is credible and professional. It's easy to present yourself and your services with confidence, and it's not long before many professionals will desire to take advantage of what you have to offer.

Initiate the partnership. The most effective way to approach the physician is through your client who already has access to that professional. Your clients can effectively introduce you to their licensed professionals.

Don't be intimidated when you make contact. When you use a client to make the introduction, you have an advantage. Credibility is established via your client, and you can further this with appropriate materials that you will forward at a later date. Additionally, you have the permission of the client to contact the doctor for the client's best interests, which include developing the safest, most effective program possible. You also have the business clout of the client, since the attending health care practitioner sees the person not only as a patient but also as a paying customer. Licensed practitioners are particularly concerned with service too, especially in the face of a competitive market.

If a physician is reluctant to communicate or meet with you, continue to be a polite nuisance, exhibiting a professional and well-mannered persistence that will eventually gain you the contact. Never criticize the physician's lack of interest in your client but, instead, ask the client to help you get a meeting with the doctor so that you can move the client's program forward in a safe, efficient manner.

The common interest that you and the licensed practitioner share is the well-being of the patient. When this motivation is made clear and it becomes evident how both the trainer and licensed professional can advance the patient's personal well-being, the relationship moves from tentativeness and a questioning of motive to something more like a team approach. It's in your client's interest to have a team working to develop the best possible approach to optimize her personal fitness, health, and well-being.

Target direct marketing to the medical community. Although this approach can be difficult, your success may be minimal, and rejection may run high, reaching out to the medical community with a concerted marketing effort can be productive. Try to identify doctors and other professionals in your area who are interested in wellness and preventive medicine. Obviously, you don't have the personal introduction via the client in this instance, so your presentation must be overwhelmingly professional, your role and what you have to offer must be expertly spelled out, and you must specify how your expertise complements the health care professional's practice.

"Cold" mailing can be a waste of time because physicians can receive 30 pounds of mail each week. It is likely that your advertising piece will end up in the trash. Personal visits reap a much higher success rate compared with mailing campaigns. Personal visits to registered dietitians, physical therapists, orthopedic surgeons, chiropractors, osteopathic practitioners, and medical doctors are an excellent way to sell your services and convince these professionals to use your training services with their patients. As mentioned, visitation is especially successful when you have a personal connection or introduction via a client, or other acquaintance, which can help you to get a foot in the door.

Create an exercise prescription pad for licensed medical professionals. Try cultivating business with doctors by providing a gentle reminder in the form of an exercise prescription pad. These tablets should be emblazoned with your company logo, name, and contact information. Each sheet has a list of varied medical conditions patients might have with a small check-off box next to

each category. Provide space to explain the condition and preferred activity choices of the referring professional, and have an "other" category for unique conditions. After introduction to a licensed health care provider, most likely through one of your client contacts, provide an introductory packet that details your business and personally encourage the referring party to use the exercise prescription pad. After you've canvassed, for example, physicians, physical therapists, and registered dietitians your current clients are seeing, you can target other licensed professionals with this same approach.

However, I would introduce myself first via a written introduction and follow this with a personal visit to the office. At this time, it would be appropriate to personally deliver the prescription pad. Prescription pads left without this personal touch will, unfortunately, make for quality scrap paper. Can you imagine a physician referring you a patient without an introduction and without scrutinizing your credentials and personality?

Make efficient use of people's time. It is crucial that you are concise, accurate, and efficient when dealing with busy medical and health care practitioners. If your client is meeting with his or her doctor regarding clearance for an exercise program, it is ideal if you can attend the consultation. At the meeting between the doctor and patient, regardless of whether you are there, the client should have (1) a brief cover letter introducing you and, if you're not in attendance, an offer to meet and discuss the program and further introduce yourself; (2) a brief resume and biography outlining your qualifications, certifications, and formal education; (3) a brief sketch of your proposed program, welcoming any questions or suggestions; and 4) a brief questionnaire asking for the physician's comments regarding any perceived limitations the patient may have.

Time is the busy physician's most precious commodity, as is true for busy trainers and most adults in the world! Keep your communications as brief and succinct as possible, while simultaneously being thorough.

Before your first contact with the professional via phone or in person, prepare questions and concerns related to your client and the doctor's patient. Preparation minimizes

the time investment by you and the doctor, as well as the patient, and maximizes your time spent with the allied health professional. Be thorough and organized during any contact. Avoid groundless or otherwise unproductive and irritating calls. While you don't want to wear out your welcome, you still have to accomplish your mission.

Follow up. After initial contact with a licensed health care practitioner, follow up with appropriate background material or answers to questions posed. A thank-you is proper on receiving a referral or any type of helpful information from the practitioner.

Finally, supply any necessary progress reports. Regardless of what the physician requires, you should always maintain updated records. Offer the information to referring professionals before they ask! Strengthen the bond with continuous and appropriate communication between you and the physician, as it relates to the client's needs.

Once you've established relationships with other fitness and health professionals, other questions may arise. The first among these: Should you refer clients to the health care provider who refers patients to you?

The answer is yes, no, and maybe. Just because a health care provider refers patients or clients to you does not necessarily mean you should refer your customers to him or her. The reverse scenario holds true as well. The referral should be focused on the needs and betterment of the patient; it is not a philosophy that if "you take care of me, I'll take care of you."

Money or referral favors should not be exchanged in lieu of client or patient referrals between health professionals. In fact, many professionals might be quite offended if you mention referral fees. The referral can hardly be objective and in the best interest of the patient if this bias poisons the motivation for the referral. On the other hand, if you have carefully checked out the licensed professional's credentials and the services offered are in the best interest of your client, a referral is appropriate. This is a two-way street. Trainers need to investigate the credibility and professionalism of professionals to whom they refer clients, too.

Whenever a patient is referred to you, an immediate thank-you is warranted in the form of a card, phone call, or e-mail. This is also a good time to include introductory materials about yourself and your business if you have not already done so.

Concentrated Population Areas

Condominiums; high-rise and apartment developments; planned community developments; mixed-use residential and commercial buildings; and commercial, retail, or office settings are excellent targets. These little cities within a city can provide you a steady base of clients.

In many such buildings, a workout area already exists but is underused as an amenity and the owner might be motivated to lease or otherwise optimize the usage of the space. The win–win approach is to create a plan that offers personal training and direction to the potential users (inhabitants of the facility or building) and allows you to train from the existing space. The entrepreneur can meet with the building owner or manager and show how a gym could be profitable and useful to the site.

Identify the more stable and larger projects in your area. Developments occupied by owners are generally better prospects than those occupied by renters. Also evaluate commercial company stability (how long has the leasing company been in business and located at this site?) and office occupancy turnover. Does the demographic profile of the occupants match the profile of your expertise and target market?

Most large projects are operated by a management company or board of homeowners. Develop and present a concise plan that outlines your intentions. Point out how your plan serves management, not how it benefits you. You may have to mail this proposal with a cover letter, but attempt to get a personal introduction to the management team via a tenant who knows you or some other contact. Try to get your plan placed on the agenda of the board's next meeting.

Your approach during the board meeting should be as follows:

■ Provide a copy of your professional liability insurance and explain its coverage.

■ Provide a copy of your resume and biography. Emphasize your education and professional affiliates.

■ Outline your plan and how the financial agreement will work.

■ Provide a list of references.

At the meeting, offer to give a brief presentation of how personal training can be a no-added-cost (especially if the gym space and equipment are already available) selling tool for management to use when leasing space.

To reach the residents, offer a complimentary orientation at a prescheduled time to current and new tenants or residents. Schedule an orientation every month to introduce new residents to the facility and your services. The complimentary orientation might be followed by a promotion that offers a program setup package, such as three sessions at a discounted rate. Offer shared or group sessions and network the offering by getting marketing information to personnel such as security staff, doormen, leasing staff, and the concierge. It is a smart idea to provide a complimentary session to individuals who you think would be effective in promoting your service. The options and creative marketing solutions are unlimited.

Established Health Clubs

Generally, space is leased by the hour or at a fixed fee per month, or the management receives a percentage of the trainer's profits while at the club. The club usually requires the trainer to have specific credentials and professional liability insurance. A roadblock to this relationship is when the club requires you to become an employee instead of an independent contractor. Employers generally take anywhere from 30 to 60 percent of the income generated by the employed trainer. Commonly, the split averages closer to 50-50. Advantages to being employed can include insurance coverage, health insurance, and retirement benefits, and a steady stream of client referrals generated from the club. Refer to chapter 2 for more information.

Working With an Established Trainer or Larger Personal Training Business

Many training businesses are looking for trainers to work for them or to lease space by the hour from them to lessen overhead. Trainers new to the field can advance their careers and personal knowledge quickly by working with a credible and successful organization. Less money per client will be generated when you're employed, but the real-life experiences and peer learning opportunities can be richly rewarding. A smart organization will take care of a productive trainer so that turnover is limited and the trainer becomes committed to the group.

Trainers who have an established clientele often look for facilities that will allow them to train clients in particular geographic areas. These training satellites are convenient and allow them to efficiently service a clientele that is scattered across a general locale. This benefits the traveling trainer and the trainer who is trying to minimize fixed costs and other overhead. Refer to chapter 2 for more information.

Rehabilitation or Sports Medicine Facilities

See the section in this chapter on working with licensed health care providers.

Corporate Fitness or Wellness Programs

Approach this setting with a combination of advice from sections that focused on concentrated population areas, established health clubs, and working with an established trainer.

For other inexpensive yet extremely effective marketing tips, check out the special "Ten Marketing Tips That Work" box on page 41.

Success in Small Markets

When you're training in a small market, you have to find the right mix of service and marketing strategies. Sometimes the service delivery package for a small market needs to be very different from that used in a big city populated with several hundred thousand or millions of inhabitants. Not only are fees generally lower, based on what the economy will support, but the trainer often faces the challenge of being the jack of all trades. In other words, the more skilled you are at working with a variety and diverse set of clients, the more successful you will likely be. For example, it is improbable that you would be successful in a small town if you chose to train obese women only. However, I know of a colleague who successfully markets

to that niche in a city with a population of seven million.

It's a good idea to approach specialized small-town markets with comprehensive and diverse service capabilities. Be willing to customize packages and workouts, and offer a flexible schedule. For example, if a client lets you know in writing that he will be gone, use a membership freeze to encourage him to stick with the program on returning.

Think of small-town training as a comprehensive service that provides one-stop shopping for personal fitness and health. The trainer must inform people how they can benefit from the services offered. Potential customers must understand how they could afford such service and justify the expense. The small-town trainer must be very visible and accessible to the community. Word-of-mouth referral is potent and can work for you or against you depending on the type of service you provide and your reputation. A haughty, insensitive, uncaring image cultivated in a small town is often the deathblow for a service business like personal training.

What makes the small-town approach work? The service must be friendly and useful, and everyone should feel special. This has been called the "high touch and comfort" approach. Any personal training business, regardless of location, could apply this tender, caring, and nonclinical approach. It's all about service, followed by more service. Add to this a touch of community involvement and commitment, and you're starting to develop the right mix for successful business in small markets.

Although the essentials of creating a successful business are not entirely different than running a successful operation in larger markets, you cannot absorb too many image-related mistakes in small markets. Before long, you will be branded with a poor reputation. Gossip or any behavior that leads to a lack of trust and ill will not only can harm your business but may quickly destroy it. Keep the following 10 points in mind when you are developing a personal training business in any small town.

Lynne Greer, a successful small-town personal trainer in northern California, cites 10 points as essential for helping you thrive in smaller markets:

1. Get your name known and create a need or desire for your services. Involvement in your small community is a requirement, not an option. Donating even a few hours per month will get you connected to potential clients or create client referrals. Produce a fitness show for local radio or television, or write for the local paper. This exposure to you and your business is critical to your success.

Implementing fitness in your small community requires you to create a need for your services by explaining what you do and helping people understand that they can access this life-changing service. You must educate without pontificating; inspire; change lives; and provide unyielding, top-level service. And above all, you must be in the business of changing minds. Share with people what personal training can do for them!

2. Develop long-term relationships. Relationships are all about creating trust. The trust and respect of your community are earned by giving back and being involved on a personal level. This means time commitment on your part to serve the community. Keep visible as a professional and as a member of or volunteer in the community. People will less likely be intimidated when they think they know you on a personal level.

3. Provide service, service, and more excellent service. Service-oriented businesses must go beyond the usual if they are to stand out. Going beyond the call of duty can make the difference between a thriving and a surviving business. Service that is off the charts of excellence will also result in a strong word-of-mouth referral foundation. Even if people choose not to use your training skills, if they like and trust you, they will refer acquaintances who could benefit from your services. The message is to provide outstanding service and go the extra mile.

4. Focus on what people want and also give them what they need. Incorporate what people tell you they want to accomplish into a well-thought-out, comprehensive program that targets all of their fitness and health needs. Paying attention to what a potential client wants sends a loud message that you are actively listening and involving him or her in the planning process to create the best program approach.

5. Share your passion but don't forget to listen. When people hear me speak about personal training, they know that I am passionate and care deeply about what I do. People feel my enthusiasm when I talk with them about personalized fitness programs. But I also have tried very hard to constantly improve my listening skills. Nothing speaks more strongly for indifference than not hearing people when they express their views. Bluntly put, know when to silence a potentially lethal weapon, the mouth!

6. Budget and prepare for slow times. The fitness business can be very fickle, is sometimes seasonal, and can change widely around holidays. Your schedule might be completely full and you might be begging for a break, yet months later your quiet schedule might lead you to think your business is crashing down around you. Many small towns, especially those that are resort or holiday towns, can have a very transient local population as well as a migratory tourist influx. Budget both your time and money during the busy season, and when your business runs into slow times, you'll be glad you planned ahead.

7. Hire and keep excellent employees. Superb trainers and other employees who support your business are hard to find anywhere, and this is especially true in small towns, where the pool of qualified candidates is often extremely limited. Noncompete contracts (discussed later this section) are a good idea in small communities where competition for a client base is limited by small population numbers. Unprofessional squabbles that result from less than clear-cut agreements are very undesirable.

Noncompete covenants work nicely when the employer lets the employee know that he or she is valued in the operation and when the person is properly and progressively compensated. Take care of emotional and financial needs. Since money is often the dividing issue and usually small budgets are in order, if you can't reimburse for educational expenses or pay a fair salary, personal touches like baby-sitting, cards and letters of appreciation, or an invitation to lunch or dinner can work wonders. Everyone likes to be appreciated and also values someone who genuinely cares for his or her well-being.

8. Tailor your services to what the community wants and what the demographics support. If you teach small group classes to a predominantly older community, funk classes may not go over well. (Then again, maybe they would!) Your personal training brochure should reflect what is marketable and in demand. Although diversity is important, don't overwhelm the potential customer with a confusing array of possibilities. Focus on the mainstream needs and diversify your offerings from that starting point. If you are going to wear all of the hats and be all that you can be for every possible training scenario, your information must be believable and, ultimately, you have to possess the skills to deliver what you say you can!

9. Network, network, and network some more. Networking is all about establishing relationships with people. Trusting, positive relationships will ensure future business growth and keep your business' name circulating throughout the community. Introduce yourself and your services to the local medical community, principals and teachers in your area, and police and fire departments, as well as any local organizations that promote commerce and business development in your area. The Internet is useful to access a wealth of information, and you'll find that instructors worldwide graciously share their expertise and experiences. Make sure you're connected at both the community and world level so you can learn and continue to grow.

10. Guard, protect, and develop a positive and trusting reputation. Reputation is everything to your business. Flaws are not acceptable in any circumstance, but a character flaw or unprofessional act of any kind is magnified and quickly circulated in a small town. Not only do you work with your clients, but you run into them at every imaginable gathering place in town!

Bonus tip: follow up! Procrastination can be your worst enemy. If procrastination were the norm, most highly personalized service businesses, like personal training, would be out of business. Any prospect should be followed up quickly. Don't wait for someone who has expressed interest to initiate the process. Follow-up phone calls and letters are in order

to thank the person or group for their interest, to answer any questions, and to ask for their business. More times than not, the interested party will thank you for your professionalism, admire your commitment, and become your client!

Finding and Keeping Clients

Many trainers don't understand why people hire them. If you don't know why people would pay for your services, how can you confidently sell yourself? Also, nagging questions can linger in the back of your mind: "Will my client continue to train with me?" "Will my business one day collapse?"

It is essential that trainers take a journey into the minds of their clients so they can understand how clients think. Perspective is tainted by personal bias. Do you really understand that the service you provide has value? Your client does!

Why Clients Hire You

Consider other professional occupations—lawyer, accountant, hair stylist, carpenter. We recognize that all of the services these professionals provide have value. That is why we continue to hire them. In addition, we probably like the person and appreciate a job well done. Personal trainers can provide a valuable, lifesaving service. But because we are so close to what we do well every day, we sometimes lose perspective of our worth. We lessen our perception of our inherent value. Why? The answer is simple. We do it well (personal train) every day and begin to question why someone would continue to desire our services. Every professional occupation is vulnerable to this type of insecure thinking. Here's a helpful perspective. You probably don't cut your hair well, wouldn't file a sophisticated tax return accurately, and wouldn't represent yourself well in court or perform surgery on a friend. In other words, you are not expert and skilled in these areas. As a personal fitness trainer you are highly skilled! Most people do not know how to plan a sensible, safe, balanced, progressive, and results-oriented fitness program. We live in a time where service businesses are highly specialized and no one can simultaneously be an expert in all. That's why professionals from all walks respect one another and continue to hire each other.

If you don't know what your customer is thinking, it is very difficult to provide top-notch service that meets his or her viewpoint and expectations. In fact, this is a leading factor that contributes to failed businesses.

Consumers expect expertise and technical competence from their trainers or from any other professional service they use. Beyond that, there is a multitude of reasons why a person hires a personal trainer.

1. An individual may be uncomfortable joining a group of experienced exercisers or may have had many negative encounters with exercise since childhood. Personal training might seem like an attractive and hopeful alternative to past experiences, with the individual investing one last effort in an attempt to integrate exercise into his or her life.

2. Constant supervision is highly motivating and provides a means to exercise safely.

3. People who have reached plateaus in their fitness levels sometimes want specialized coaching for sport skills or want to upgrade their workouts safely.

4. Fitness consumers realize that one-on-one training fits easily into their schedules and is efficient, providing optimal results in a minimum amount of time.

5. Special needs populations who have physical limitations or have concerns about injuries or chronic health problems want a trainer who can design a special program to meet their needs.

To meet these and other requirements, consumers look for the following standards:

■ A personal trainer who can articulate a philosophical viewpoint and design a physical program that reflects a complete approach to health and fitness and who encourages a preliminary one-on-one interview.

■ Professional credentials summarized in, for example, a client introductory packet, which should include your resume, copies of diplomas, certifications, licenses, and any previous experience in personal training or health-related fields.

■ Certification in cardiopulmonary resuscitation (CPR) and basic first aid and lifesaving procedures.

■ Membership in one or more professional organizations. Professional involvement, like

certification, indicates the trainer's desire to keep up with new information that can be applied to a client's program.

- A trainer who can assess readiness to safely partake in a physical program through medical history questionnaires and optional fitness evaluations and who can set goals before designing a program. Fitness testing and assessment should be based on the client's need, appropriateness, and your abilities.

- Presentation of a complete medical history questionnaire and development of a working relationship with the client's physician or other primary health care provider.

- A trainer with the knowledge to discuss sound nutritional policies as established by industry guidelines.

- A trainer with the ability to realize when she is challenged beyond her area of expertise and who knows when to refer these situations to appropriate personnel.

- Charting of progress, as necessary, in written form. Periodic retesting is expected in, but not limited to, cardiovascular conditioning, strength, flexibility, posture, blood pressure, and body composition.

- Provision of and adherence to business policies regarding billing, fees, liability insurance, and cancellations.

- An emphasis on safety, including warm-up and cool-down, instruction about equipment use, and the modification of exercises to meet the client's special needs as well as safety standards.

- A trainer with the ability to listen to client's concerns and questions and explain concepts clearly.

- A sense of invention, creativity, and adventure in each session and over the long term.

Finally, both the trainer and client will benefit when the trainer has an eclectic background. Experiences of life, both physical and otherwise, play a key role in a trainer's ability to motivate and serve clients and keep interest levels high. Trainers who use new opportunity and fresh ideas can pull from a varied bag of tricks. Therefore, trainers with varied backgrounds and enthusiasm for new experiences are in a better position to offer a variety of solutions for business and client challenges.

The number one reason people hire personal trainers is to obtain and maintain a level of general fitness (Davis and Davis 1999). However, an unofficial, close second—according to many clients—is a written commitment to an appointment they will not schedule out of the day. Know why your clients train with you and what they expect!

Establishing a Clientele

Each time I talk with prospective trainers, which is generally before they establish their business direction and identify what they are selling, they inevitably ask, "How do I get clients?"

First create your client introductory packet (see the appendix). This preparation alone may not get you clients, but it's a foundation from which to work. After you've done this homework, it is time to figure out who your market is and how to reach them. To figure out your market, honestly evaluate your abilities and limitations. This will define the variety of clients that you can train. This is not just a matter of personal preference, but, more important, an issue of your expertise. Are you qualified to work only with asymptomatic low-risk clients, or do you have the background for more difficult situations? When answering this query, be very realistic. If a client's history or other problems throw you even the slightest bit, you would be better off not training that client until you have more experience. It takes time and specialization in a variety of health-related areas to take on high-need clients and maturity to know when to say no. Your reputation and financial future are constantly at stake, as well as a client's well-being. There is never room in any business for a mistake at the client's expense.

Once you know whom you are trying to train, the problem becomes the more practical one of finding clients. Unless you work in a club or for an established trainer, the traditional way to get clients is through referrals from professionals in related disciplines or from satisfied clients. But your source of clients is only as good, and as big, as your network. Introduce yourself to registered dietitians, physical therapists, doctors, chiropractors, attorneys, spa directors, retail health and fitness equipment outlets, and hair stylists. Any professional working with customers who are concerned with personal appearance, health, and well-being is a potential networking star.

Your success with any group of allied professionals may be directly related to your credentials. You need a solid background that is recognized by medical practitioners and other highly trained professionals (see pages 81-84, this chapter).

It's OK to refer clients if the referral is in the client's best interest. I acknowledge referrals with short, sincere thank-you notes or phone contacts, rather than with referral fees or monetary kickbacks. If one is motivated purely by financial concerns, it is not likely that this service is objectively chosen and solely serves the needs of the client. The exchange should be motivated by respect and trust and a commitment to giving the client the best care possible. When I refer my clients to other professionals, I have two expectations—that the service rendered is professional and that my client is pleased with the service.

In addition to bringing in clients, the network can become a terrific professional support team. It can help guard against the isolation that results from working on your own with a relatively small number of people and also can help you keep abreast of the new developments in related health fields.

Although referrals generated by other clients will probably be the mainstay of your business after you are established, it can be difficult to build a business strictly from referrals. To speed the process, some trainers use direct marketing techniques to attract new clients. They blanket high-concentration areas—fraternities and sororities, apartment complexes, medical facilities, weight loss centers, high-rise complexes—with flyers or brochures. Some even use mass mailings, although the costs are high and the rate of return very small (see related sections in this chapter).

There are many books and resources in libraries or on the Internet that can help you make the campaign more effective. You can also consult marketing consultants, although that can get expensive. Still, with the right approach and perseverance, you may get a few new clients from these types of campaigns.

Until you are solidly established, you also might barter your services with people who can help you professionally. Your list of potential prospects might include a bookkeeper, an attorney, a publicist, or other allied health professionals. Although this system of doing business can be cumbersome when you get more successful, when you are launching a business this system

is useful from a standpoint of both economics and experience. You will also get referrals from those professionals satisfied with your service.

Trainers who are just getting started often consider training someone free for several months. Doing this showcases your talents, personality, and training style, especially if it is in a club where your abilities and people skills will be immediately visible. For example, consider training a radio talk show host so the progression and personal results of the program can be highlighted on the radio over a period of time. If you go this route, be direct and honest with your "freebie" client about your motives. Make sure the person will not betray your confidence and reveal your financial arrangement. No one likes to pay for what someone else got for free, so that information should remain strictly between you and the client. Even if the client doesn't continue to train with you after the free sessions, he or she may become your best referral source. Other bartering-type strategies include offering complimentary workouts to individuals or organizations in exchange for word-of-mouth advertising, lecturing to various organizations, or offering your services through charity raffles.

Key point: Marketing is about exposure. No one can hire you until they know about you!

Regardless of which strategy you choose, it may take three to six months to get several steady clients. If you do not have the financial cushion to support yourself during this period, consider training part-time during this interim. This substantially reduces financial risk, especially if you continue to earn money from another sources, and it enables you to gradually ease into full-time training. This direction may take longer but will not force you to compromise your integrity because you are pressured into getting clients at any cost.

Additional Ways to Generate and Keep Clients

Mass mailings and advertising are relatively expensive, yet you can expect only one or two responses from a 3,000-person mailing list. If you attempt to get your first clients this way, focus your efforts on populations that are representative of the clientele you seek. If your business is new, securing only one client could be the seed from which your business will grow to incredible success.

Promotional brochures (figure 4.2) are another way you can broadcast your services. These are less involved than the client introductory packet, are inexpensive, and serve as a professional presentation if prospective clients request more information. Your brochure should outline what you can do for your clients and specific services you provide. Accent your academic strengths and program philosophies succinctly. Use conservative pictures (people are attracted to graphics), unless you are, for example, trying to capture a bodybuilding clientele. Competitive athletes tend to like coaches who excelled in their sport. However, more and more competing athletes are realizing that well-rounded, educated trainers can be as effective. Education and experience lend the best balance. A gold medal or buffed body does not ensure teaching abilities. The general fitness consumer is especially wary of this paradox. Be sure to communicate your sensitivity and interest in people's individuality. Distribute brochures in public places where likely clientele will frequent, or consider a mass mailing.

Even after you've become an established trainer, you will need to generate new clients and maintain a service focus to keep the ones you have. To accomplish this, you must continually sell and reinvent yourself. The best way to do that is by never losing sight of the unending service that you must provide to your clients. If your turnover is low and your work schedule is full, this validates your service and serves as your best advertisement. If you give poor service, client dropout will increase, and lack of word-of-mouth referrals will make it difficult to replace anyone who leaves your business.

Client Turnover Related to the Program

Once you've established a successful start, keep your guard up so you can avoid common pitfalls that can undercut your business. If clients drop out regularly from your program, it may be attributable to a lack of follow-through and service. Unanswered questions, poor scheduling, a lack of punctuality, and a distracted attitude reflect poorly on the trainer. The client senses that the trainer is not fully committed to the program and becomes disenchanted.

Another explanation of why many new trainers lose clients is the trainer's perceived lack of personal depth, as seen through the eyes of the client. Trainers who have a limited amount of knowledge and who are not actively trying to plug those gaps eventually run out of new directions to take the client or can't answer the client's questions. If the client gets bored or injured or reaches a point where the workouts no longer seem effective, he will move on.

Another major trap that successful and veteran trainers fall into is related to inappropriate expansion. As the trainer becomes more successful, she has to juggle many demands. Because it is hard to say no to work, the trainer tries to squeeze even more into her schedule. A logical scenario is to hire associates or, as I did, open a second studio and hire additional trainers.

Expanding too fast has hit many businesses very hard. Usually, and after it is too late, the business owner must come to grips with the limitations of time and financial expenditure. It seems that there are never enough hours in the day to oversee more than one facility or to supervise new trainers at a level that meets your business and technical standards. If you're simultaneously running an expanded business and still training clients, you can become a bit ragged around the edges, to say the least. Suddenly, even if it hasn't been an issue before, the trainer or business owner may be faced with a client turnover problem and an inability to keep dedicated employees. At this point, philosophical questions arise regarding your role and business direction. Do you continue with hands-on, hour-to-hour training, become a full-time administrator of a growing business, or combine the best of both worlds?

Warning: Getting New Clients May Be the Wrong Focus

If you're constantly preoccupied with the pursuit of getting clients to replace ones who regularly depart, you might concern yourself first with keeping your existing clients.

Service that anticipates and meets the changing needs of clients is the glue that holds any business together, regardless of its size. Losing sight of the importance of consistent, high-level service means being out of touch with what initially brought success. Poor service and inadequate client care will bestow, at the least, mediocrity on your company, or at worst, business failure.

Looking for Clients?

If you're looking for clients, identify what the fitness consumer is looking for in a personal trainer.

Take a close look at desirable characteristics of professional trainers. Consumers who are considering hiring a personal trainer believe these to be important. This understanding will help you market yourself and define what you are selling.

1. Who needs a personal trainer? This is what you are selling, so you should be able to answer this question through the presentation of written materials and verbal communication with the prospective client.

2. Does the trainer have a solid education background as evidenced by a degree in a related field or certification through a nationally recognized organization? Your introductory packet should detail your credentials.

3. Does the trainer have experience in fitness training and keep current with research through professional association membership, journals, and educational events? A top professional is current with industry standards.

4. Is the trainer certified in CPR and first aid, and does she carry professional liability insurance? Professionalism and industry standards make this point mandatory.

5. Does the trainer require a health screening or release from your doctor? Protocol dictates one or the other as mandatory.

6. Can the trainer provide references from other clients or established industry professionals familiar with the trainer's knowledge and abilities? Experience and a proven track record establish instant credibility and trust.

7. Will the trainer keep a record of the client's workouts with an organized tracking system and update medical history information periodically? Pros maintain professional standards and maintain client records.

8. Does the trainer ask questions about the client's lifestyle? Master trainers are outstanding listeners.

9. Does the trainer hear what the client wants to accomplish and provide a balanced approach that provides what the client needs in regard to health and fitness? Interaction like this helps to create a relationship between trainer and client.

10. Does the trainer help the client set safe and realistic goals without promising unattainable results? Setting clients up for success, rather than failure or disappointment, is the mark of progressive trainers.

11. Has the trainer cultivated a network of professionals that will help serve the client's needs? This is not limited to an advisory board and may include licensed professionals like doctors, physical therapists, and registered dietitians.

12. Does the trainer exhibit good listening skills and communicate well? Top trainers act on what they hear!

13. Is the trainer willing to explain his workout methods and the principles and reasoning behind exercise program decisions? The client introductory packet will serve the trainer well.

14. Are the trainer's business and technical skills adequate? For example, are cancellation policy, billing procedures, and other administrative responsibilities clear-cut and in writing, and is the training program progressive and results oriented?

15. Does the trainer exhibit unlimited enthusiasm, passion, respect, and authentic care for the client as well as his profession? Individualism is a must as top trainers set the standard for service delivery.

Before you get off track and hustle new clients with new programming, new equipment, state-of-the-art sales strategies, and aggressive marketing campaigns, pay special attention to your current client base. Are you directing attention toward areas of your business and related service deemed important by the client or toward yourself? Referrals from your existing client base will always be your best bet for getting new clients and maintaining your current level of success. Obviously, your existing clients' well-being and satisfaction should be your top priority.

If your clients are fleeing your business because they're dissatisfied with the service, look at the trends all you want but you'll continue to have problems. If you're struggling to keep clients, you need to visit some core issues related to top-level service at the one-on-one, interpersonal level. People skills and technical competence cannot be overemphasized! Remember, it costs a business much more in time and dollars to acquire a new client than it does to keep a client through excellent service. Keys to keeping clients include providing safe, effective, and results-oriented training; having a program that is enjoyable and fun; producing an atmosphere that is nurturing, positive, and safe; and sustaining a consistently high level of service. These staples of service must be supplemented by going beyond the obvious and ordinary to meet your clients' expectations. This extra measure of service begins to define service excellence and should include the following:

1. Leave the training environment to learn more about your client. Talking with a client's health care specialist or watching her tennis or polo match lets the client know you're interested in knowing her better. It takes time, but it's time well invested because you deliver a nonverbal message that you are committed to the client and personally interested in her well-being and in creating an individualized program.

2. Become the renaissance trainer. The world, especially your client's, does not usually revolve around physiology, science, and fitness. Make it a point to read magazines, newspapers, and other current event literature. When I trained in Los Angeles, I made it a point to read two trade magazines for the entertainment industry because many of my clients were actors, directors, producers, and entertainment lawyers.

Many of my clients love to chat about their work. After all, it is what they are very good at and they often like to share this type of information. Here's the point. It's okay to talk about subjects other than fitness and evolve your intellect beyond fitness-related matters. You could metamorphose into the renaissance trainer and might become more dynamic and interesting to talk to, in and out of the training facility! However, other clients make a special effort to keep chit-chat directed away from what consumes them during, and often beyond, normal business hours. Be sensitive to a client's desire. Don't hesitate to ask about his preference. I am careful to honor this time as my client wishes. If the client wants to use this time as an oasis from incessant workday concerns, it's appropriate to talk about fitness, eating right, his favorite book, or any number of other topics unrelated to work.

3. Train off site. If it's fitting and time allows, attempt to place your clients in new training environments. A cross-training workout outdoors, tennis, outdoor volleyball, or an in-line skating session are possibilities. At the least, consider getting your client off of the indoor treadmill if she usually trains inside and encourage her to go outside for a walk, run, or jog.

4. Know your client. Discover what music she likes and find out what she likes to read or what activities she participates in over the weekend. Incorporate personal preferences into the workout and use them to help create a training atmosphere that matches your client's interests.

Cultivating Your Existing Core of Clients

Now that you're keeping your existing clients satisfied and happy, the timing is right to ask, "How do I get more clients?" The answers include service, trust, results, and personal referrals.

Part of your marketing campaign is grassroots and ongoing in nature. Because a majority of new clients will result from client referrals,

expand this word-of-mouth gold mine. A personal referral implies an implicit trust and confidence in your services.

Satisfied clients are usually very enthusiastic when it comes to recommending a service that has had a significant impact on their personal well-being, health, and fitness, but you have to ask for business. Let people know that you have openings for clients. Many of my clients know that I am very busy and were often surprised to find that I had openings for additional clients.

Although many clients express an interest in referring new business, most never follow through. Reasons range from forgetfulness to lack of incentive. What will remind and entice clients to refer people to your business? During special holiday seasons, or on a quarterly or semiannual basis, it's a good idea to contact clients and thank them for their business. Remind them that if they refer someone to your business and that person becomes a client, they will receive a complimentary session. Additionally, cards and flyers should be available at the training site and regularly sent with invoices or other business mailings.

Persistent, yet tactful and appropriately timed reminders—plus incentives—work very well at cultivating referrals from your clients. Your clients may need just a little nudge to follow through on those good intentions.

At the risk of sounding a bit repetitious, your satisfied clients are your best marketing tool. Through them, you will most quickly and efficaciously expand your client base.

Making the Most of Personal Referrals

Personal referrals occur when clients tell a friend, family member, or business associate how much they enjoy your service. Give people something to talk about—as long as it is positive—and you'll never need to advertise. This is especially true of personal training. It is essential to preserve positive word of mouth about your business and training skills. This kind of client testimonial will always be your best marketing tool. Successful trainers repeatedly affirm that personal referrals are their primary, if not only, source of new client referrals. Suc-

cessful businesses that provide excellent service can derive 80 to 90 percent of their new business from satisfied customers.

Personal referrals are powerful because they are, well, personal. An immediate confidence is established in prospective clients because someone they trust has suggested your service, and obviously, the person who recommended you has also shared his positive experiences.

Quite simply, it is much easier to get clients who have been referred to you than to close a deal that stemmed from a cold contact with a person to whom you had not been personally recommended. Since warm and fuzzy referrals are much easier to close, it makes good business sense to concentrate on generating this type interest in your business. An additional benefit regarding your most effective marketing tool is that it's free!

When you have this built-in referral advantage at your disposal, how do you encourage and capture these referrals, turning them into new business? To maximize and encourage referrals from people who already believe in your business, you must ask for and nurture this kind of referral, as discussed earlier. But, you must first believe that rounding up referrals is the right thing to do.

Asking for Referrals: Does It Tarnish Your Professional Image?

Most personal trainers work hard to exhibit a professional image. Many trainers think it cheapens or lessens professional representation if they solicit clients for referrals. Will your clients think you are too self-promotional, too focused on self-interests, rude, or pushy if you express an interest in referrals? The answer probably depends on how they are approached and whether they are pleased with the services you are providing.

Move forward with confidence. Clients who are using your services are happy with your program and the personal benefits that come from participation. Many clients see training as a gift they would like to share with others. A pleased client is already telling family members, friends, and acquaintances about how fun, interesting, and motivating the sessions are, not to mention the great impact they have had

on her life. Simultaneously, many associates or family members of your client may have already noticed the physical and self-esteem changes that have occurred, leading them to ask the question, "What have you been doing? You look so great!" As is evident, the referral machinery is already set to be placed in motion just because you are providing outstanding service to a very satisfied customer.

Here's the hard part for most trainers who struggle with the referral issue. Personal training is a business, and if you have something great to offer in terms of a product, it is fitting to ask for business. Asking for referrals is not overstepping your bounds. Realize that some people will respond to this request and become your best cheerleader, and other clients will not. The choice to act on the referral request is your client's. Many service businesses provide referral cards for clients to share their great find with people they think would benefit from a service they hold in such high regard. Have you ever told a friend he *has* to read a particular book, subscribe to a health and fitness newsletter, or purchase a useful piece of training equipment? It is natural to desire to refer people to legitimate products or services that have a positive impact on our lives and that can enhance someone else's life. People like to help people, and all of us love to spread the word about positive experiences that have greatly affected us. Get over your concerns about unprofessionalism and take advantage of this marketing tool.

Differentiate Between "Asking" for Business and "Soliciting" Clients for Business

Uninvited solicitation is, to say the least, irritating and sometimes outright intrusive, rude, and grossly unprofessional. Can you ask for referrals without soliciting your clients in a rude or intrusive manner? The answer is yes. The key is to listen for openings or inquire in subtle ways.

For example, one of your clients may have mentioned a close friend who has diabetes. You might suggest that you're available to meet with the person and could probably help him or her. If a client says she is concerned about the lack of fitness activities her children

partake in, an opportunity is presented for you to offer your services.

You can also ask questions that encourage referrals. For example, you could inquire how a male client's wife is doing postpartum and ask if she has developed a postnatal exercise plan. Or, you might ask if your client's spouse engages in a regular fitness program. A client may share with you how stressful his job is and comment that he couldn't handle the pressures without his regular workout. This is an opportunity to ask whether his corporation has an on-site workout facility or whether the business offers any incentives to employees if they engage in a fitness program. If there is interest, you could give a presentation on the importance of fitness activity to his associates and follow this with a formal business proposal to management.

Who knows where any of this banter may lead? At the least, you will become more familiar with your client, and this information is invaluable in that respect. Once the seed is planted, more times than not the client suggests the next step that would enable you to reach a new client. Yet, asking for business in these examples was accomplished with a subtle, soft-sell approach.

Make sure the conversation does not become an interrogation based solely on your hope of procuring more clients. The conversation, questions, and responses should flow naturally and should stem from the fact that you care about people and are available to assist them. Rely heavily on your intuitive feeling. This will keep you on track professionally and inform you whether your advance is obnoxiously opportunistic or professionally suitable.

As mentioned previously, newsletters, billing invoices (use this mailing to also send other information about your business), and printed flyers placed at the training site are subtle and consistent ways to trickle information to your clients and make your intent known. If this aspect of your business is going to be successful, your clients need to know that you are interested in receiving client referrals.

The key to avoiding irritating and unprofessional solicitation is to first develop a relationship with the client. The relationship should be based on trust and excellent service and allowed to mature. If you dive in too soon, your request for referrals may seem inappropriate.

Referral Compensation or Incentive for Your Clients

Although you may want to provide an incentive for clients who refer individuals who become paying clients, you don't have to give anything away. Most referrals will come your way because people promote a business they really believe in and especially one that offers superb service. People love to play matchmaker and derive a great deal of pleasure and satisfaction when they believe they have created a win–win relationship. They understand they have helped a friend or loved one and benefited a trainer whom they admire and respect. Your demeanor and professionalism will serve you well in this area of referral business.

Offering incentives can cut both ways. The positive is that incentives can remind people of something they have said they would do but have failed to follow through on. Going overboard on giveaway incentives can indicate a condition of need. It may raise a question, "Why does she need new clients all of the time?" Pushing this edge of your business to extremes doesn't present a professional image. A successful business often projects an image that is discerning and selective or has a waiting list of clients. In your hunt for clients, don't destroy the quiet confidence your business should emit. A desperate and over-the-top search for clients—if it's all you talk about—does not portray a busy and successful trainer. By all means, use incentives if you need to and have the time (i.e., complimentary workouts cost you time and income). All trainers and businesses need new clients from time to time, but ask for client referrals in a discriminating, sensitive, and professional manner.

Referral Payment or Incentive to Other Professionals

I believe referrals from other health and fitness professionals should not result in compensation or an automatic referral to the referring professional, unless the services to be rendered reflect the client's needs and the services can be rendered in an expert manner. This keeps the referral objective and in the client's best interest and removes financial motivation from the picture. When I refer my clients to other professionals, I expect the service to be given in a professional and competent manner and that the services rendered reflect me well. In other words, although no compensation or incentive is appropriate (a thank-you is enough professional acknowledgment), my good name is on the line. Attached to that is the trust and credibility I have established with my client. There is nothing I would do to jeopardize this foundation. Therefore, excellent service and customer care are required, because any service I refer my client to directly reflects me. Recommend your clients to other services and products carefully and with great discernment.

Closing Strategy That Keeps Referrals Coming

After you have been in touch with the potential new client, make immediate contact with the referral source. This could be in the form of a verbal thank-you in person, on the phone, or via voice mail. Follow this up with a hand-written thank-you card to the referring client after you have met with the new client. Keep the referring party in the loop as to how things are going with the family member, friend, or coworker, as long as you don't violate privacy issues. Although client conversations are confidential and the privacy of any client must be carefully guarded, an occasional thumbs-up with regard to how the client is doing might be appropriate and it gives you a chance to thank your client once again for the referral. If you have a particular client who is especially enthusiastic about your services and he or she has given you multiple referrals, small gifts expressing your appreciation are appropriate.

New Client Closing Strategy

Some personal trainers place the burden of introduction on the referring individual. I think this is a big mistake. If you ask the referring party to contact the referral, it requires more time and effort on her part and may actually kill the deal and future referrals. Assume a client has already spoken to the person about your services and communicated this to you. A more subtle closing strategy is to say, "If you happen to talk to John, let him know that I'll be calling." This kind of response is very open ended and does not require your client to give information to the prospective client. Because

you have this inside connection, immediately request the contact information from the referring client and use your client's name as your "password" for entry. After taking control, follow these 10 steps to turn business opportunity into new clients.

10 Steps to Turn Referrals Into New Clients

Now that you have the referral information in hand, focus on converting the prospect into a long-term, committed client.

1. Mail the referred prospect information about yourself and your business. It's beneficial to mail a client introductory packet, which describes your background and business operation. I believe it is a good idea to make a quick phone contact, even if via voice mail, and let the individual know he will be receiving a packet in the mail detailing your service. Don't forget to tell the person who referred him to you.

2. Set up the introductory meeting. Initiate contact by phone once you believe the client has received the information you mailed. The operative word is "initiate." Most people don't work out because they need your motivation and guidance, so what makes you think they would call you if the responsibility to set up a meeting time was dumped entirely on their shoulders?

3. Conduct personal inventory and observation. Carefully observe the prospect's physical self, social skills, and any other mannerisms or history that will help you tailor the discussion to excite her about training and indicate that you can deliver what is necessary in a comfortable, nonthreatening environment.

4. Listen and connect. Pay attention! Connect visually to the person with good eye contact, but don't wither or intimidate the interviewee with an unrelenting laser gaze. It is more important that the client be heard than for you to dominate the conversation. If you don't first listen, you will not be able to respond in a way that assures the client you offer a personal and caring approach.

5. Inquire about the prospect's goals. This further personalizes your intent. If you don't hear what the client wants to achieve and don't under-stand why he wants to train, how can you personalize the approach and help the individual accomplish goals? A prospective client will become a paying client when he chooses you to help him accomplish personal health and fitness hopes, dreams, and aspirations—his, not yours!

6. Provide an overview of your general plan. It is appropriate to give an overview of what the client can expect after she commits to training. Information about health status, previous or current exercise experience or participation, and nutritional background will help you better plan her program progression. Create an anticipation of expected positive outcomes that could result from the client's committing to a training program that is individualized to her special needs.

7. Discuss policies and fee structure. No surprises here: Present your policy in writing. If you mailed information, the individual perhaps has reviewed the material. Discuss the value and identify what plan best fits your prospect's situation, as well as how the policy benefits the client. Discuss any questions or concerns.

8. Ask for the potential client's business. Your prospective client may not give you his business, even if he wants to, unless you ask for it. This requires asking the client for a commitment and necessitates a discussion about when the first appointment can be scheduled. A number of trainers agonize over this aspect of closing the deal. If you aren't excited and confident about taking the next step, your potential client won't be either.

9. Close the deal. An easy way to close the sale, and this is closely tied to asking for your potential client's business, is to reiterate what the client has shared with you about her personal goals and aspirations and explain how you will help accomplish these results. Sometimes during consultations you can assume the sale is done based on the client's reaction and willingness to readily move to the commitment and scheduling stages. If there is hesitation based on scheduling logistics, it is appropriate to state the times that you have open and ask the client if the stated times are convenient. This combination, asking questions and providing solutions, is what is meant by asking for the sale.

10. Follow up, follow up, follow up. If you haven't already closed the deal, this step can be your closer. This step is like a relief baseball pitcher who enters the game in the late innings to save the day. You should have mentioned in the introductory meeting that you would follow up, and you should do just that. Following up after the client meeting can help the individual decide to move forward with training, and it exhibits your professionalism.

If an interviewed client has already committed to training with you, touch base before the first official workout. Let the new client know via phone or e-mail that you're looking forward to the first official meeting, and remind her of the time and date. Thank her for her commitment and assure her that the decision to improve her health and fitness with a planned and progressive program will result in rich personal rewards.

10 Ways to Maximize Client Referrals and Keep Them Coming

1. Give people something positive to talk about. Develop trust and respect, and provide consistent service and progressive training results. This will give people something to talk about and share. Satisfied clients are quite willing to extol your virtues and share their success stories with others.

2. Listen for and create a referral opening. Clients regularly talk about friends, business partners, and family members who are not taking care of themselves; their children and friends' children who are not getting enough exercise or eating right; or other specialized needs related to pregnancy, asthma, diabetes, obesity, or sport-specific conditioning. This is the opening you are listening for; follow with questions that encourage conversation and give the client a chance to share further information.

3. Communicate your current situation. Let people know that you have openings for clients. Many of my clients recognize that I am very busy and are often surprised to find that I or other trainers have openings in our schedules. Most react enthusiastically to the opportunity to refer clients to a business that has had a positive influence on their life.

4. Offer trial, gift, or workout certificates that you or your clients can distribute and advertise beyond your current clientele. Many trainers report a very high renewal rate from clients who started training because of a gift certificate or trial offer coupon (this is a "freebie," or complimentary) they received from you, a family member, or a business associate. Once people experience the difference a trainer can make, they usually continue the service. Renewal rates often average between 80 and 90 percent.

5. Grease the referral machine. After receiving a referral, request the name, phone number, and mailing address of the individual. Contact the referred client directly. As a professional courtesy, even though you've taken command at this point, let your referring party know how you'll be handling the situation. Directly thank the client for the referral, and even if the prospect doesn't sign on, let the individual know that you appreciated the referral and enjoyed the time with the prospective client.

6. Try public speaking. Speaking to appropriate groups that might consider your services can help establish credibility, trust, and a personal relationship with various audiences, as well as introduce your business to the community at large. Many individuals who view your presentations might not consider hiring you, but there is a high probability that they would recommend your services to associates or family members.

7. Publish a monthly or quarterly newsletter. Distribute this information in person or via mail, e-mail, or fax to current clients and potential clients. Profile your business and client success stories and provide useful fitness information. Don't forget to include a section for client referral, and if you are offering an incentive, outline the details.

8. Send out press releases for newspaper coverage. Use this technique to expose your business and to entice local newspapers and television stations to profile your business. Client success stories, unusual or new training approaches, and consumer education stories interest the media. Update your client introductory packet or press kit with current information and news stories that reflect the current state of your business.

9. Network with licensed health care practitioners and other associated health and fitness professionals. See "Network With Other Health Care and Fitness Professionals," this chapter.

10. Give thank-yous where thank-yous are due. You should ask prospective clients how they found out about your business, if you don't already know who the referring party is, and send an appropriate thank-you note or make a quick phone call to let the referring person know that you appreciate the new business as well as the confidence and trust that are exhibited by the personal referral.

Stealing Clients

Is your business losing clients to former employees or to trainers whom you have partnered with, assigned clients to, or shared clients with from time to time? "Stealing" clients is an age-old complaint and a major annoyance to trainers worldwide. The possibility of clients being stolen raises issues of trust and professionalism and prompts reactions of fear, anger, and feelings of being taken advantage of.

Generally, the offended trainer or business plays the role of victim and rarely asks, "What could I have done to prevent this from happening?" I don't condone unscrupulous and unprofessional behavior from trainers, who should be able to be trusted and should exhibit the highest degree of professionalism in an area as touchy as stealing clients. But, I ask, "Are you acting proactively to prevent this problem?"

Trainer to Trainer: Stealing Clients

Client commitment that wanes often culminates in the person's switching to another trainer. This can occur when numerous trainers work from the same location or when a trainer is introduced to clients of another trainer with the intent that clients will be able to maintain uninterrupted workouts if their prime trainer is ever sick or out of town. But, the reason why a client switches trainers is because the client views the current service as having less value than when the service was begun.

Let's stop here and ponder client loyalty for an instant. Loyalty, from a business sense, is really related to the service and care that are provided, not the client's innate faithfulness, devotion, or attachment to the trainer. The client should not be made to feel guilty when this uncomfortable situation arises. Clients may like you, but if you aren't delivering the service they desire, there's a good chance they won't retain your services. Many times, poor service and personality conflicts explain client departure. It's easier to blame another trainer or the client for the departure than to focus on the cause of the problem.

Look closely at the current services that are being delivered and honestly ascertain whether the client's needs are being met. This provides you feedback if you care to honestly evaluate the relational dynamics that are being exhibited and simultaneously presents an opportunity to learn during difficult circumstances.

Looking at how a trainer could avoid losing clients or why a client shifts allegiance and commitment doesn't transfer professional responsibilities away from the accused trainer. Even if problems existed with the client's former trainer, the trainer who may gain a new client does not have the right to undermine an organization or trainer for whom she has subbed or the right to engage in any other unprofessional or dishonest behavior.

Did the trainer who stood to gain a client fully apprise the current trainer of the existing client attitude and displeasure with the training situation early on? If a situation arises with regard to a client wanting to switch trainers, the trainer who stands to gain the new business should, as a matter of professional courtesy, discuss the present client attitude with the other trainer or business.

Most of the time, dealing quickly, honestly, and directly with controversial issues will keep them from growing into a disproportionately huge problem that drains the trainer of time and emotional energy. A problem like this does not remedy itself. If you sense this type of situation starting to simmer, act quickly by communicating openly to both the involved trainer and client. This type of precedent sets up strong, trusting relationships with other businesses, trainers, and clients. Furthermore, taking proactive steps like this will create an image that says you are a pro and can be trusted.

Noncompete Contracts

Many clubs or training studios have concerns about employee-trainers leaving the business and taking clients with them. Generally, the company tries to combat this fairly common occurrence by having the trainer sign a contract stating that he or she will not work with clients if employment is terminated with the company. Companies that rely on "noncompete" covenants to control and motivate their employees to stick with the company are off track legally and relationally.

A contractual clause may intimidate a few trainers and keep them away from the business' clients, but most trainers know that these contracts don't hold much weight in court and are usually not legally binding, or at the least are extremely difficult to enforce. In addition, this clause would limit a client's free will in choosing whom she will train with and could lead to ill feelings between the client and the business. The situation can escalate quickly to a sticky and complex business quagmire.

Here's the heart of the issue. From a business standpoint, do you want a client or trainer working for you who really doesn't want to be there? Usually, you can avoid this situation by nurturing, giving back, and developing the relationship between the business and the trainer.

You have to give away something quite substantial to keep your top employees. This includes stimulating them professionally, developing a personal relationship with each one, and offering adequate and fair compensation. See the box on page 101 for more tips on how to keep your clients and employees.

It is difficult to repair relationships and trust that have been damaged. Prevention and personal care win over restrictive and largely unenforceable contracts. Even if the contract might be upheld in court, most businesses don't choose to take legal action, because litigation is costly and drains emotional and time reserves. Ultimately, it doesn't make a whole lot of difference in terms of long-term business if both an unhappy client and an unhappy employee don't want to be involved with your organization. In fact, long-term business can be hurt if a client and trainer think they were not treated fairly and let people know about it. Customers and employees who are satisfied are keys to business success. You really don't want unhappy people around your business. Proactive relationship building is the solution here. It's easier to prevent relational problems than to fix them. The relationship is the foundation on which to build, not an impersonal contract. (See figure 5.1, page 124, for sample noncompete contract.)

Keeping Clients and Employees: What Could I Do Differently?

1. Develop relationships.

Business owners and program managers must actively pursue relationship building with not only the personal trainer but the client as well. Management must take a personal interest in individual clients. Walking the floor and introducing yourself is a start. Next, call clients and listen to their feedback. Encourage positive and critical responses. This contact serves as a customer satisfaction survey and lets them know the business owner, not just the trainer, is listening and acting on their input. Communicate at every chance. Send out letters from the organization indicating how the business is meeting the needs of its patrons. If the client only hears from the trainer, allegiance will naturally be biased toward this personal relationship. In other words, without this kind of relationship-building effort, the loyalty of the client is with the trainer, and if the trainer leaves, the client is likely to follow.

2. Trainer partnering.

If you oversee one or many trainers, you must incorporate trainer partnering, which means client sharing. This is a win–win idea. It frees up the primary trainer for guilt-free personal time away from the training floor and gives the client more options. If a trainer is sick or goes away for a holiday, clients should be trained by another trainer who has already been introduced. This way, the client's program is uninterrupted, cash flow remains, and the trainer can be away from the training premises without concern for a client's well-being. Mandate and facilitate trainer partnering. (This means require it as part of operating policy, not just encourage it!) Clients should have relationships with at least one and preferably several trainers who can serve as a back-up when the primary trainer is absent. Of course, as a professional courtesy, let the client know as far ahead as possible about any impending substitution, and in the event of sickness, provide the client with choices. Finally, if the primary trainer leaves the organization, a client who has relationships with several trainers and management will be more likely to continue with the group's services.

3. Develop a two-way street of loyalty between management and the trainer.

Loyalty develops between trainers and management when you spend time with them and take a genuine interest in who they are outside of the training environment, what they like, what values they hold, what motivates them, and what their goals are for the future. Listen to their ideas on how to train clients and improve service delivery. Act on useful feedback, and acknowledge ideas in a positive manner even if you don't agree with or use them. Convey that you are a good listener and a fair person. If you are viewed as a mentor, friend, and role model, mutual respect will develop (however, keep a professional edge).

Preserving a strong working relationship will depend directly on fair compensation, treating your trainers with respect, keeping the trainers developing professionally, and creating a training environment where trainers trust and respect one another. Fair compensation will keep trainers from looking at other businesses or from wanting to open their own businesses. Developing friendships at meetings, parties, dinners, and group outings creates a sense of family and belonging. Teams are less likely to put personal interest first if this would harm a business or individual who they care deeply about. Trainers who are not growing professionally or are not otherwise stimulated will start looking elsewhere for career opportunity or for a career change (resulting from burnout). If your trainers have not been told how they make a difference to you (management) and the clients they serve, you have not communicated your respect for and appreciation of them. Thank your trainers for their efforts, and let them know that you value them as people as well as expert trainers.

Although a client's preference determines who he will train with and where he will train, a buyout solution may provide a win–win for all involved.

In any negotiation, don't forget to factor in the client's best interest. It is unfair for the client to be ruffed up emotionally in this conflict, and it isn't right to target a client as the problem just because he would rather train with another trainer. It is well within a client's rights to follow a trainer who is leaving a business.

Trainer Leaving an Established Business

If a trainer is intent on leaving your business, a previously signed noncompete clause or contract can make her seriously consider whether this is a prudent step. However, if she is determined and the client is firm on following the trainer wherever she goes, I advise the departing trainer of a number of outstanding issues. I let her know I am not pleased by the circumstance and think she hasn't honored a legal agreement and has taken unfair advantage of what I've offered professionally. Because the client wants to retain her services (contact the client and discuss the situation), I let the trainer know she can avoid being sued by agreeing to a buyout option. Since my noncompete contract (see sample on page 124) is for a year, if she is going to continue to work with any of "my" clients (all clients at The Training Edge are my clients, even if I don't train them), she is required to pay 50 percent of all income generated from Training Edge clients for one year, from the date of termination. This figure is a negotiable starting point. Sometimes I will accept a lump sum of a lesser gross figure. I believe this to be fair and actually quite gracious on my part. Consider that I stand to lose a full year's worth of income from the client who is switching camps, not to mention income that won't be generated via other clients working with this trainer, and I have to eventually hire and train a new employee. If the trainer accepts this or a negotiated buyout, she can go her way and the client continues with the trainer of his choice.

This scenario is business, not a personal war. I understand that relationships don't always work out for the best, and when this situation is handled professionally by the departing trainer, I genuinely wish him or her great success. If the departing trainer maintains stellar and ethical professional standards throughout this transition, it is not unusual that I would assist the person in any way that could benefit his or her business. The transferring client will appreciate not being included in the political battle. Two honest, upfront professionals should be able to come up with a workable solution that leaves the client out of the negotiations and any turmoil.

A Client Wants to Train With Another Trainer in the Same Facility

First, although your clients may have a primary trainer they work with most of the time, each should have at least one other trainer they are comfortable working with (this is the partnering concept). Second, the choice of trainers is dependent on the client's needs and preferences. A client should not have to stay with a trainer who is not meeting his training needs or does not match the client's personality, simply because the client started with a particular individual. Switching trainers occasionally or even regularly is actually a good idea, especially from the client's perspective. Variety brought on by different training styles can keep the client interested, fresh, and progressing.

What about the trainer's outlook related to lost income and self-esteem? A trainer must believe that it is natural for some clients to shift interests and have an interest in experiencing other trainer approaches. There will always be some clients who prefer you, too.

The client should never be made to feel wrong or intimidated because she wants to change her primary trainer. Clients who are not allowed to switch trainers may leave a business because they feel uncomfortable with the climate that has been created.

Since the loss of a client does affect a trainer's income, it might not be a bad idea to put into place what I call a "client transfer fee." Essentially, the trainer who becomes the primary trainer pays a token, fixed fee (e.g., $100) to the trainer who lost the client, after the client has trained with the new trainer regularly, for

one month. The new trainer should encourage the client to train with the old trainer when she is on vacation or sick, if no existing personality conflict precludes this. This is part of developing teamwork for a group of employees. You get the idea. Change and newness are good as long as egos are preserved and upstanding professionalism is exhibited throughout the process.

If the client stealing scenario involves trainers who are not part of an employee group (for example, the trainers lease the same space to train their clients), the answer lies in using a combination of information presented previously. The key is to come up with an equitable solution that provides a win–win for the involved trainers and clients.

Preserving Current Business and Anticipating Future Opportunity

Once you know you're maintaining high-level service to existing clientele, then of course you should turn to generating new business and clientele with innovative and cost-effective approaches. The best trainers and businesses in the world lose clientele for any number of reasons that include death, illness, relocation, personality conflicts, service inadequacies, and financial issues.

Without exception, businesses must generate new business to grow and maintain their bottom line. If you're tending your existing business well, it's time to look at a number of marketing and programming choices that can take your client load to the next level or change how you run your business. If you're not looking to take on more clients or change your business approach, it's still critical to maintain quality, freshness, and progression with your current clients.

Being able to predict future directions that fitness will take gives you the chance to adjust your business accordingly. Avoid fads if you think they will be here today and gone tomorrow or if the fad points toward activity that is not well founded in science. Going with solid and accurate shifts in our industry keeps clients interested and progressing, but the forces that shape change must be weeded out to preserve the good.

On the other hand, rejecting every new or trend-setting idea simply because it is different than traditional approaches does not serve the interests of our industry, individual clients, or your business. Take, for example, recent trends like step, slide, stationary cycle, or functional training, as well as aggressive yet scientifically sound nutritional advances. A fair look is warranted. Scrutinize new programs and equipment with a critical and objective eye, but don't jump to a biased and premature judgment. Change and growth require effort and risk, as well as adequate investigative time, but the payoff is worthwhile.

Forces That Shape Consumer Health, Fitness Choices, and Interest

What does the next decade hold for fitness professionals? In a word, specialization. Technologically speaking, there is an incredible wealth of information available to us that can seem overwhelming at times, and the specialized needs of a changing society are both a challenge and opportunity. If a specialization trend is the rule, then diversity is important to businesses that want to capitalize on this reality.

Specialized services that will be in demand include exercise programs for the older adult, kids, and the entire family; relaxation, yoga, stretching, integration of mind–body approaches, and lifestyle management; "aftercare" exercise, a concept that will grow as the medical community embraces the idea of referring patients with medical conditions like arthritis, diabetes, and cardiac disease to qualified trainers; weight management; and sports conditioning and group personal training, which provides affordable personalized service for many clients. Finally, a broader definition of acceptable exercise standards from a health, fitness, and personal wellness perspective has emerged from scientific literature.

Businesses and individuals who want to be successful in a rapidly changing world not only must constantly assess the direction in which they would like to head but must be prepared to alter the direction based on knowledge or reasonable predictions of what the future holds.

Future Trends You Cannot Afford to Miss

Personal training. Specialized services will continue to increase, and sophisticated skills and superior education will be required to work competitively in this market. Matt Church, a personal trainer and top motivational speaker from Australia, once told me that, to paraphrase Ann Landers, "There are three types of people (or businesses) in the world: Those who make things happen; those who watch things happen; and those who say, 'What happened?'." Which type of person (or business) will you represent?

General programming. Successful programming will include approaches that meet special needs and ongoing needs of a general, seemingly healthy population. Strength, cardiorespiratory, and flexibility training will still be mainstays. Lifestyle management, general sports conditioning, functional training, mind–body fitness, indoor cycling, outdoor training, cross-training, periodization, healthy child and young adult fitness programming, nutrition and eating guidance, group personal training, and water fitness will continue to be recognized as approaches in any balanced personalized fitness training program. Rather than being the exception, this balanced and comprehensive approach will be the rule.

Special programming and medical needs. Specialized programming requires experienced and highly educated trainers who can meet the needs of clients who are challenged by asthma, diabetes, heart disease, cardiac disease, stroke, hypertension, obesity, multiple sclerosis, osteoporosis, HIV infection, and pre- and postnatal conditions. Programming will be needed that addresses specialized sport training needs, fitness approaches for the older adult, physical reconditioning, postrehabilitation or aftercare fitness, and weight management.

It is obvious that the market for trainers with superior knowledge and superb people skills is wide open. Clients are looking for trainers who can help them accomplish individual goals or work with their special medical or physical needs.

In Search of Clients: Diversify Your Business, Make Plans, and Take Action

Diversify your business by providing a range of services and exposing these services to people who are looking for you. Here are the nuts and bolts of moving a marketing approach forward from good intention to results.

Overcome the obstacles of fear, time constraints, and inaction. How do you beat these formidable foes? You accomplish it by doing your homework, planning, and preparing. As I stated in chapter 2, overcoming fear and inaction comes with clarity of direction. Clarity of direction comes from planning strategies that empower you with confidence because you know the groundwork has been laid and you will succeed.

Identify what you are doing well. Compile a list of the successful services you offer now, such as fitness and postural assessment, in-home training, or home and corporate gym design. List the distinguishing features of each service and how you make the service known and accessible to your clientele, as well as people outside of your current client base.

Identify where you want to go with your services and business. Be realistic with client-load limitations. The number of clients you work with daily has a significant impact on your time availability and physical stamina. Planning and preparation requirements for a one-person business are quite different compared with a multiple-trainer, multiple-staff operation.

Identify opportunities that exist in the marketplace. Study trends and identify market niches that are created because no current service is adequately being provided to fulfill the consumer demand. You can also discover a need and create a market to fill that need, before the demand is present. If you see the need and create the demand and interest, your vision is far ahead of others who are watching and waiting for trends to appear.

Who is the potential customer? Your type of service, rates, location, and personal training style

should appeal to this target group. Market to the demands of the consumer when you can provide services that meet these requirements. In other words, don't take on an area that is outside of your expertise and capabilities.

What type of customer do I want to attract? Market and promote according to what you can deliver in excellent fashion. You want a customer who identifies with what you have to offer. This potential client should naturally align with the services you plan to offer. Marketing to and attracting clientele outside of your expertise and interest can be a big mistake.

What is this customer looking for with regard to service and type of trainer? Potential clients who are looking for trainers repeatedly mention professionalism, honesty, straightforwardness, trust, good listening skills, a balanced approach, outstanding service, and sincerity as qualities they hope to notice on first impression.

Focus your advertising. Create an unmistakable and appealing business image as well as a message that clearly communicates the service you offer and for whom this service is appropriate.

Go directly to your clients for help. Let your clients know that you appreciate referred business. Earlier sections of this chapter discussed referral promotion among existing clients.

Go directly to and follow up personally with clients you contact professionally. Cold call solicitation, in any form, is unproductive. However, if you're going to take the time to contact people who are not personally referred to you, send them a professional proposal in the form of a letter or brochure, for example, and follow with a phone call after you are sure they received the materials so that you can introduce yourself and find out whether any interest exists.

Use the media. Free press, whether written or televised, is your best ally. Develop contacts with several media sources and offer your services. You could provide fitness and health tips for radio, television, or print media. Don't forget the power of the Internet. Press releases can be sent that detail new training you've received or some type of unique approach to fitness that you are implementing with your clients. Put your name out so that you will become known as the fitness source or resident fitness expert.

Get your name out. Helping to get your name out and marketing your business, as well as preserving a positive public image, are the reasons that public relations firms exist. You are your own best public relations firm. It is critical to expose your business and talents as well as the business image you have created.

Preserve outstanding service. The most effective way to retain and obtain clients and generate a steady stream of referrals is by providing outstanding customer service.

Looking for Clients? Remember, They're Looking for You, Too!

Trainers around the world ask, "How do I find clients?" at the same time that fitness consumers ponder, "How do I find a trustworthy, reliable, and expert trainer?" People want to know who you are and what your reputation is, so they can quickly evaluate whether they would be comfortable working with you.

Expanding Your Client Base and Keeping Your Existing Clientele

What programming should you offer to attract clients? What market needs can you fulfill? What does the person want who is looking for a personal trainer? What are some unique training or programming approaches that will attract new clients to your business? What marketing and promotional schemes can you use that will be cost-effective and efficient and that will produce results?

As you consider a range of services, different paths to business growth, and how you will go about developing a loyal and expanding client list, answer these 10 questions to help you target your direction and keep on a successful course:

1. Who is your typical client?
2. What new client niche would you like to target?
3. What is the geographic range or target area of your business?

4. Where is your business operated (i.e., in a health club, in a facility owned or leased by you, in the client's home, or some combination)?

5. How would you compare your level of service to other similar businesses in the area?

6. What is your client retention rate?

7. How is your business different from other personalized fitness training businesses?

8. What is your marketing edge?

9. How do you currently find clients? Where do your referrals come from?

10. Is expansion or new growth realistic when current profitability, physical space requirements, and available time are honestly evaluated?

Cultivating Referral Opportunity

Ever heard this? "I got my first client by going to an office party." Always be ready to professionally present what you do and turn a chance encounter into new business. Act as though your behavior, demeanor, attitude, and professionalism are constantly being observed. You never know who that referring party might be, who is watching and listening, the direction a social conversation may take, and what impact leaving a business card with someone may have.

Selling Your Services, Professionalism, and Image

It cannot be stated enough in this chapter and the theme is evident throughout many other sections in this book: Professionalism, service, and image are everything to a successful personal training business. But, you also have to ask for and secure business commitment from interested clients.

Training Your Sales Skills

Although service, image, and professional relationships have been mentioned repeatedly, you also need to improve your sales skills. You have to sell to get people to experience your wonderful, life-changing services. Selling should be embraced from the standpoint of believing in yourself and the services you have to offer. You can't share what you love to do if you can't make a living from personal training. Many trainers are highly educated and skilled, but most don't have an extensive business or sales-oriented background. Technical and programming competence alone may help you keep clients but may not assist you in getting clients initially or help you maintain a successful business.

Selling is easy if you can do the following:

- Project a successful image.
- Project a professional image.
- Project a confident, yet friendly demeanor.
- Listen to, hear, and respect what the prospective client has to say.

The Art of Closing the Deal

Focus on these selling points and closing arguments: results, safety, knowledge, enthusiasm, motivation, mutual respect, and value.

Often, the best way to move a conversation forward with a client is by asking this simple question: "What is our next step?" Many times, the prospect will close the sale for you. Let the potential client provide the answer. Usually the response sounds like this: "Well, I guess I should pick a payment plan, complete your screening process, and schedule a workout!"

Objections to commitment or starting a training program can be overcome by being ready to answer your prospect's questions and address her reservations. Focus on your strengths, stick to your policies and prices, and remain positive, citing the value and advantages your program has to offer.

Finally, you will not obtain every client to whom you present your business. That is reality. Don't let rejection diminish your self-esteem. Skilled business negotiators actually target any weakness they see and try to take advantage of this opening. Believe that the objection is not personal and stand by what you know is a valuable service. If the stall reaches a stalemate and no resolution is foreseeable, look

for other possibilities. Even in the face of rejection, remain positive and enthusiastic and keep the door open for future follow-up or potential referrals by the person who chooses not to use your services at this time. You can train your sales skills by avoiding the common mistakes listed in the box on this page.

Image, Professionalism, and Service

Your business and personal image are an accumulation of everything you do and say. Each decision or choice is available for review by your patrons, peers, and competitors. You should be fully aware of how you present yourself and your business. Professional standards and genuine care for people should lead the way. Perceptions of others, and not your intention, will define your corporate image and reputation.

Marketing specialists are fond of saying that customer service is the only sustainable market advantage. Education, new programs, pricing packages, complimentary workouts, client appreciation day, free T-shirts, and other promotions or services can take you only so far. Your marketing advantage can be made with a thorough and painstaking effort toward consistent and outstanding customer service. Satisfied customers are the key to future referrals and new business, and they minimize client turnover.

Establishing a competitive edge results from approaching service excellence from the customer's perspective. Remain sensitive to requests and demands by walking in the customer's shoes. If you were the client, how would you feel? If you lose this sensitivity, you will be unaware of problems and incapable of turning poor customer service around quickly. Without awareness, there is no possibility to correct a situation where the client is unhappy. Correction requires awareness and an immediate response to ensure the situation is remedied to the client's satisfaction.

Answer the following questions to see how you would rate your own business and service:

Train Your Sales Skills by Avoiding These Common Mistakes

1. Misunderstanding objections.
Get potential clients to talk so that you can find out why they are hesitant to commit to training.

2. Being poorly prepared.
Anticipate what questions prospects will likely ask. How will you answer these questions? Provide supporting material, like a client introductory packet or brochure and, most important, provide solutions.

3. Not asking enough questions.
Find out what the particular client is interested in and position your services accordingly.

4. Misusing screeners.
When trying to make connections with, for example, a medical practitioner, don't look past the receptionist or secretary. Treat administrative staff with as much respect as you would the licensed professional.

5. Not performing postmeeting reviews.
After your first meeting with a potential client, ask yourself what you liked about how the meeting went and what you wish you had done differently.

Reprinted from "IDEA Personal Trainer," 1998.

1. Do honesty, integrity, caring, enthusiasm, motivation, and sincerity describe your image in your client's eyes?

2. Do your clients view you as an answer person who can answer all of their health- and fitness-related questions?

3. Do your clients trust that if you don't know the answer to a question, you will research the matter and will always come back with an answer for them?

4. Is the information you share reliable? Are you a trustworthy clearinghouse for health and fitness information?

5. Do you encourage critical feedback of your services and business and promptly handle complaints to the satisfaction of your clients?

6. Are most of your clients pleased with your services? Do your clients continue to benefit from your services?

7. Would your clients continue to work with you if a competitor solicited them with a training offer that cost a little less per hour? Do your clients regularly refer business to you?

8. Can you differentiate the service you have to offer from competitors or other similar services?

9. Do you have the client's best interest at heart in all of your business and program design decisions?

10. Would you hire yourself?

Customer loyalty, repeat business, and word-of-mouth referral come from paying careful and exacting attention to every aspect of customer service. Customer service involves hearing what the customer wants and providing the level of service he or she expects. Image without service is useless. Take care of your clientele, and exceed client expectation. If you can provide all of this, your demand will soar.

Retaining Clients

Finding new clients is meaningless if you can't keep them interested in your services. It's critical to keep your existing clientele happy while you're looking for new prospects. But how do you do that? The first step is finding out how your clients feel about your services.

Client Survey Equals Quality Control

Quality control relates directly to establishing a high level of service and monitoring whether this aspect of your business is being sustained. You should know how to design various types of surveys such as verbal, written, and phone surveys as well as how to create a safe environment that encourages your clients to provide honest and direct feedback. If you can create a relationship that encourages criticism of your services and your clients can feel uninhibited with such a response, you will receive a lot of useful feedback.

Can you afford to assume that your current clients are satisfied? The obvious answer is an emphatic no. To find out what your clients really think and feel, survey them periodically. Not only do surveys help to maintain current service quality, but the information and insight gained can help to position your business for growth.

The Art of Surveying Your Clients

Ask specific questions in your surveys. Vague or overly broad questions confuse your clients and require too much time to answer, and they lead to responses that are not helpful to your business. Surveys can be written from the perspective of a facilitator overseeing other trainers or a sole proprietor and should encourage candid responses.

These are some good questions: "Are you finding that the sessions meet your original goals as discussed before starting your training? Have your goals changed since you started? Have your program and progression been reevaluated? Is your training meeting your expectations? Is the trainer on time for your sessions? How important is starting and ending your sessions on time? What do you like best about your training? Is there any area of service you think that we might be able to improve on? Are there any other needs related to your health and fitness goals that we can assist you with? Is there any matter you'd like to share that could help us to better serve you?"

If any area of a client's program needs attention, be sure to let the client know that you

will address the problem fully and remedy the situation to the client's satisfaction. Then, be sure to carry out your promise!

The following points will help you to create an atmosphere that is conducive to free-flowing, honest feedback:

1. Listen! Full attention to comments is essential. Avoid interrupting or attempting to defend or remedy the situation before the client has fully expressed herself. Allow for silence between thoughts. Your client may simply be pondering the stressful situation or concern and how to best share it.

2. Encourage candid feedback. If you sense a hesitancy or reluctance on the client's part to fully disclose the entire situation he is not happy with, ask, "Can you tell me more?" This indicates how important his direct feedback is to you.

3. Offer solutions. If your client presents issues that need to be improved on, be prepared to offer a specific solution that will satisfy your client. Changes may be needed with your or another trainer's approach to training and working with this client, or you might be able to appease a client by sharing your views about, for example, a business policy that is in place and you may not be able to or want to change.

4. Follow up. Ask the client if it is okay for you to follow up in the near future, and encourage her to initiate contact if at any time she has other questions or concerns that are not being addressed.

Here's the golden rule: Do not survey your clients unless you are committed to using their input and acting on their concerns.

Written surveys, although less personal, often get you more honest and direct feedback compared with an in-person interview or person-to-person phone contact. Clients generally like their trainers and are reluctant to jeopardize their relationship with the trainer or get the trainer into trouble. Although many clients like their trainer as a person, many are less than satisfied with the service being provided. This is a big problem and needs to be remedied or the client will eventually terminate the training. Written surveys remove the personal nature of critiquing current service and the trainer. Keep the survey simple and you'll generate a high number of responses (see chapter 7, form 7.1, Client Service and Satisfaction Survey).

Client feedback allows you to create a customer-driven business. You know what your clients are happy with and what areas of service need improvement. Surveying clients for feedback indicates that you take a personal interest in your clients, desire to learn more about them, and actively listen to their concerns. Of course, all of this holds true if you act on the information and follow through with corrective steps.

Using Feedback to Improve Your Service

The most important aspects of using customer feedback are to look for an overall pattern of response and to act on the responses. Although patterns of response tell you which concerns are valid for the majority of clients, don't view esoteric or fringe comments as unimportant. Personal training is, by nature, personal! Each client needs to know that she is being heard, even if you do not agree with her. This scenario—acknowledging a client you don't agree with and preserving a positive relationship—is one aspect of the art of training and managing client associations.

Feedback has to be viewed as positive. Of course, it's easy to view complimentary feedback as positive. But it takes considerable maturity to constructively use positive critiques or steaming criticisms to improve service. If you own your own business, don't be too hard on yourself. This is not a personal attack, so you shouldn't take it personally. Remember, you invited the feedback so you could improve your business.

If you oversee trainers, use the gathered information as a learning opportunity for all of the staff, independent of who a particular critique was levied at. Staff should know that surveys are not covert and should not be considered as spy tactics to rout out poor trainers. This is an ongoing process that trainers should know about and be part of because correction takes place, generally, at the trainer or client level.

Don't Forget the Trainer's Feelings

Although feedback must be used to constructively address client concerns, be kind to your trainers. No one wants to be beaten up with feedback that implies they're wrong or less than perfect. We all have egos and feelings that need to considered, yet it's still necessary to move forward so that you end up with customer-oriented service.

Change that is necessary on a trainer's part, based on feedback received, not only allows the business to be more successful but also can keep the trainer from failing. Let staff hear both positive and negative feedback. Help trainers to see the feedback as valid and understand why defensive posture is out of line as well as nonproductive. The focus should be on improving customer service while staying sensitive to how you share the information with trainers. Support and acknowledge areas in which the trainer excels and then pointedly discuss areas that need improvement. (If you own your own business, you have to address these concerns with yourself!) Look at patterns of response. Ask whether the trainer thinks the feedback is accurate. Listen to her full response. Explain why, regardless of the reasons, this pattern of behavior is unacceptable. Detail consequences that will result if the behavior continues. Often, you may lose a client if the situation is not fixed. Follow up with a review in the near future.

Client surveys that are properly handled can be a growth tool that helps a business keep customers and deliver service pointed at client needs. Because most personal training clients are seen on a regular basis, take this opportunity to capture their comments about personal satisfaction and whether your business is doing a good job. After all, a customer-driven business is one that really knows and understands what the client wants. Surveys allow business owners and trainers to get in touch with this driving force (see chapter 7 for more information on surveys and sample survey forms).

Is Your Business in Trouble?

Speaking of feedback, if you are not receiving or encouraging any, look for trouble down the road if your intention is to stay in business for the long haul. You may not be looking for feedback of any kind—which I think is a big mistake—but you might be getting nonverbal feedback whether you want it or not.

How does feedback present itself? Are referrals from existing clients largely nonexistent? Are you always looking for new clients to replace clients who have left you? Or, look no further than your appointment book or calendar. If your no-shows and late cancellations are consistently running higher than 30 percent, and the client isn't making an effort to keep the relationship intact, it's time to find out what is wrong. Make the effort. This client is ready to walk, and your business may be set up to take a fall. Find out where the divide is between you and your clients and why it exists. At this point, you still have a chance to rectify the situation before your business implodes. Review the "Six Key Qualities That Are Closely Tied to Business Success" box on page 111.

Know Yourself and You Can Know Your Business

Getting to know and understand yourself can be rigorous, demanding, and humbling. However, if you can take this honest look, it will serve you, your clients, and your business. Part of stepping back and looking at your values, morals, and ethics and getting a sense of who you are requires you to be receptive and open to feedback.

Regard enlightenment—whether the truth is hard to swallow—as an opportunity to change and improve a given situation or personality trait. Imperfection and a willingness to improve compared with who you were yesterday highlight anyone's humanness. Most people embrace and respect humbleness or someone who can acknowledge that he or she was wrong or can improve. Anything that humanizes makes you more approachable and real to most people you encounter daily.

Honest feedback gives you a chance to evolve the person you are with regard to ethics, morality, and other personality traits. Straight-shooting feedback can help you (1) define what you value, (2) appreciate your talents and strengths, (3) understand how you keep and continue to

Six Key Qualities That Are Closely Tied to Business Success

1. Commitment to clients

Clients are business priority number one. Commitment is exhibited by providing excellent, dependable, and consistently high-level service.

2. Initiative (anticipation)

Take a proactive stance in progressing and developing your client's program. Can you anticipate a client's need before the question is asked?

3. Follow-up

Even if your client forgets about an information request or other query, you shouldn't. Client feedback must also be acted on when received and action is warranted.

4. Adaptability (personalities and equipment)

Put in a situation of limited or no equipment, a knowledgeable and creative trainer can provide an effective solution. Most successful trainers can "change colors" to match the client's mood or need on a given day without compromising a professional approach.

5. Business development skills

Successful businesses must have trainers, or the individual proprietor must be able to generate new business, maintain mature business and existing service levels, collect money owed in an efficient and professional way, and tactfully communicate business policies that help to establish professional parameters from which to run a business.

6. Professional presentation

How you dress, communicate, speak, and interact with clients; your professional presentation of business policies and fair enforcement of these procedures; and how you actually run your business and manage clients and staff greatly affect your overall professional presentation. You are what you present.

draw clients to your business, (4) understand why you have been able to develop personal and business boundaries that are fair and respected, (5) know how to enhance the lives of your clients in the most effective and caring manner, and (6) continue to run a successful business and have a rich personal life.

This introspective and nakedly honest look allows you to step back and make adjustments where necessary or acknowledge and appreciate a job well done. Combine this ongoing insight and feedback with a productive personal life and a willingness to make change where change is warranted. With these abilities in hand, you know that you're moving toward business success and growth, and you're on your way to becoming a master trainer or business owner.

CHAPTER 5

Expanding Your Business

American business consultant Michael Gerber says, "If your business depends on you being there, you don't have a business, you have a job." A problem that is inherent to the typically labor-intensive, hour-to-hour nature of personal training is that little, if any, revenue is produced unless you are training clients one on one. My idea of a successful business is one that progresses from income generated by hourly client visitation to income generated even in your absence. This opinion is in no way critical of sole proprietors who generate all of their income by training clients on an hourly basis. One colleague and friend has trained individual clients for more than 25 years and is still as enthusiastic as she was when she began her career. Instead, this message is for trainers who are looking to leverage their income earning potential by taking a step in a different direction, away from hour-to-hour income production.

Why Should I Consider Expanding My Business?

Although I don't believe any business will run itself successfully for very long without hands-on involvement, it makes sense for many trainers to develop a business that uses services and products that leverage time. If all the work and money making are accomplished by you and you alone, rather than employees or services that can free up more of your time, then you're stuck doing all of the work.

You cannot leverage your time efficiently if your operation requires you to do every task. Eventually, you realize you have very little freedom. Hourly workouts can grind you down. Taking care of every detail as a sole propri-

etor takes its toll. From a business expansion perspective, taking care of everything yourself limits your future by limiting flexibility in your schedule and limiting your ability to generate more income.

Don't believe that expansion just happens. Initially, it requires hard work, time, risk taking, and an amazing amount of focus and energy, and it can create feelings of fear and insecurity. However, after the initial excitement and turmoil have passed, you'll wonder what took you so long to see the light and expand your business. As was true for breaking into personal training (chapter 2), researching your subject well will provide you with clarity and confidence to move past the stages of "paralysis from analysis," second-guessing yourself, and fear.

If a sole proprietorship business or working hour-to-hour suits you, I certainly don't want to criticize that choice. But, if you want to free yourself from a business that can drain your energy and spirit, either limit your number of training sessions per day, or increase your freedom and financial opportunity by running a business that frees you from delivering every aspect of your business. Maybe you can have it all, but you shouldn't be doing it all if you want to build a diverse and leveraged business.

If you're relatively new to training, probably your main focus right now is setting up your business and getting clients. Your hands are full. It's an exciting period of growth, and you have little time for much else. Or, if you've been training happily and passionately for years, you're right where you need to be.

If you're a seasoned trainer and looking for more out of your business, or if your business has boxed you in professionally and personally, you're ready for this chapter, now! There is no

need to convince the time-crunched veteran about the importance of time and financial leverage.

Partnering Trainers and Personal Training Businesses

Partnering or teaming is a training strategy that sets your business up for success. Although mentioned in chapter 1, this cutting-edge approach merits additional discussion.

Partnerships occur when trainers and their businesses group together in a formal and businesslike fashion. Partnering can be integrated as part of a standing business policy among trainers in one organization or can be set up between separate personal training companies. Partnering means that a client does not rely exclusively on one trainer to be present at all of his or her training sessions. Partnering of personal training businesses is not yet happening in a big way. But, you might want to consider the partnering concept if you are looking for an option to leverage yourself financially (you can only earn so much money working by the hour) or avoid trainer burnout. Partnering also may be the key business choice that keeps the personal training industry growing and sustainable. Professionals drop out of personal training after many years in the field because the demands of the business will always rest squarely on their shoulders if they don't implement the idea of partnering. Partnering can create a breath of fresh air and more hours available to you. Potentially, partnering makes it easier to better use human resources and the finite time available to individuals (both trainer and client) daily as well as to provide a better service to clients.

Take Care of Yourself and Your Staff

Taking care of your staff, or yourself, is a simple concept that is often overlooked as businesses expand. Don't fall prey to taking on more clients than you can handle or fail to appreciate your dedicated and productive clients. Your approach to life and training needs to be balanced, and you cannot hear this enough. Most trainers need to be reminded that it's easy to focus on becoming successful. This myopic focus causes the trainer to be unrealistic with personal time allocation. If you manage other trainers, take care of your staff by guiding and tempering their enthusiasm, instead of seeing how much you can get out of your trainers before they break. Busy schedules always look good on paper, but life doesn't run without any glitches. Why put undue pressure on yourself or staff and compromise service? Restraint, realism, discipline, and balance are the watchwords here.

Taking care of employees goes beyond making them feel good and having genuine concern for their well-being. You also have to come up with fair and progressive financial rewards. As an employer, I am of the mindset that you have to give away a little to get a little. When I have an outstanding employee I cannot afford to lose because he or she makes my customers happy, generates income, and simplifies my life with his or her dependable and consistent work—I work hard to take care of this employee. Compensation takes many forms, but a fair wage that increases with time is essential. Other perks you offer to dedicated employees that let them know you value their contribution include health and disability insurance, expense accounts, business-related cell phone reimbursement, dollar allotments for continuing education, in-house training and continuing education credit workshops, and retirement contributions to an employee's IRA or SEP retirement plan. Anytime you can put money in employees' pockets or cut their expenses related to doing business, you're taking good care of them.

Taking care of your employees means fairly compensating them, expanding their business skills and knowledge, and nurturing their mental, emotional, and spiritual selves. Balance cannot be emphasized enough. Money and kind words are not enough if your goal is to develop a lasting and fruitful employee–employer relationship.

Businesses that have a lot of employee turnover usually could be described as low paying or cheap and show little personal appreciation of productive employees. Customer service is absent, and a high standard of ethics in management positions is often lacking. Former employees might say they enjoyed their work but management didn't treat employees with

respect and rarely thanked or let them know their work was appreciated and made a difference. In this last instance, even if the employee is well paid, emotional and verbal abuse, or indifference, will send the employee packing.

Seems simple to run an effective business, doesn't it? It doesn't cost money to compliment people for a job well done, and one of the costs of doing business is related to fairly compensating your outstanding employees. When you evaluate employee care in your business, ask, "Would I want to work for this company?"

One of the reasons that I own my business today is that I never met an employer who really was concerned with my emotional well-being and compensated me adequately for the work I performed. Rather than play victim to an unappreciative employer or paltry pay scale, I instead turned my belief and strong feelings toward creating my own business.

When Employees or Hired Services Don't Get the Job Done

Should you patronize someone who is not getting the job done? Of course not. When you believe an acceptable work performance is not going to happen, you need to terminate the employee by using a fair and considerate approach.

How do you know an employee or hired service is no longer meeting your needs? You realize this is the case when the person you have hired is costing you money, not servicing your clients, or not accomplishing duties related to his or her job description. The person or service for hire is costing you more time than it is saving you. Employees and hired services are supposed to make your life easier, free up your time, enhance your product presentation (which is represented by service) and increase your profits. Employees who require high maintenance and detract from client service don't last long on my team.

How to Fire or Release an Employee

Many employers are concerned with lawsuits when it comes to terminating employees who are not delivering the standard of service required by the employer. The fear of ending up in court over employee termination is well founded. The trend in employee lawsuits being filed exploded in the 1990s. Today, employee complaints are second only to product liability cases. The Americans with Disabilities Act, sexual harassment cases, and loss of union protection by many workers have increased the emphasis on individual workers' rights (Handley 1997).

Anyone can sue you, for any reason, so you should be prepared to defend your actions in a court of law. Anger and emotions lead the way in many termination cases. To follow are several ways to limit your chances of being sued and avoid successful litigation against you.

1. **Develop a good employee manual.** Your policies and stated expectations determine the parameters from which your employees work. A policy book implies that the business promotes a uniform, fair, and consistent work ethic for all employees.

2. **Be honest, thorough, and objective in performance reviews.** Praising employees who are struggling to meet employee standards seems contradictory if you later inform them of impending termination. The announcement will be met with shock, disbelief, and anger if they have regularly received positive reviews and salary raises. In court, this would be a contradiction and would make it more difficult to justify a termination. Two performance reviews per year are a must. Honest critiques let the employee know where he or she stands. It gives the person an opportunity to change based on stated critiques and expectations. You must have the employee and the reviewer (you in most cases) sign the performance review sheet. Signatures can be likened to sending a registered letter; the employee cannot claim he or she was never made aware of any shortcomings.

3. **Document all warnings or performance reprimands.** Written memos are the strongest evidence to document this action. Some people think this approach is too harsh, so they prefer spoken warnings. I incorporate both. I verbally inform the employee that we have a situation that could jeopardize his or her employment. I give the employee a written summary of the performance inadequacy and also note the delivery in the employee's file.

4. Apply employment policy consistently. Policy and expectation with regard to employee performance and dress must be strictly adhered to across the board. Don't allow any favors here. Do some of your staffers skip mandatory meetings with no consequence, whereas others are reprimanded? Inconsistent application and enforcement of policy could set you up for a charge of discrimination or unfairly targeting some staff who are less favored.

5. Be aware of your state or country laws as they apply to employment. Some state, province, or country laws are very liberal when it comes to firing an employee. In many instances, an employee can be fired for what amounts to any legal cause. Other areas have more stringent policies that favor the employee, and regulations like this put the burden of responsibility on the employer to demonstrate cause for termination. Keep records and document all of your actions.

6. Don't create an inadvertent contract. This can be done in writing or verbally. For example, on the day of hiring, where positive emotions and the likelihood of a bright future for the new employee run high, you might say, "You'll always have a job here!" This statement is a promise and does not reflect your true policy. Employees must perform at expected standards of service. Offhand comments like these can be interpreted as legal agreements. Be honest and sincere when you interact with your employees.

7. Leave a paper trail. You cannot have enough documentation of your policy, fair and consistent administration, and reviews of employees. Take the few minutes required to make performance notes on employee files, and if you intend to communicate verbally, back it up with a written statement that the employee receives and that you file for later reference (Handley 1997).

Becoming an Effective Administrator

You might already be thinking that there are a lot of duties associated with running a business. This is especially true when compared with a sole proprietorship business, where your biggest time demand is training clients on a per-session basis. Deciding whether to become a business administrator or stick to daily per-

sonal training in the trenches is a decision you may face now or in the future. Even if you continue to train clients and administer other trainers, all training businesses, regardless of size, still juggle billing, taxes, communications with health care professionals, and soliciting new business, to name a few.

As your business expands, you will find yourself besieged with increasing demands on your time. Administrative and management tasks will mount, especially if you hire employees. Time that once was spent doing your own workouts and planning your clients' training sessions is now spent returning phone calls, rescheduling clients, training and motivating staff, and designing promotional pieces.

If you identify with this, and your list of time management challenges is increasing steadily, then your business is successful enough that you must move beyond unplanned, unfocused business administration. It is easy to formalize and organize an efficient approach to these necessary tasks. Identify the key administrative tasks that are essential to client service, constancy, and growth. These include the following:

- Record keeping, client follow-up, communication with client's health care specialists as needed
- Client billings
- Accounts receivable (money due your business)
- Accounts payable (money you owe to businesses or individuals who provide services)
- Budget planning
- Marketing and promotions that lead to new business
- Responding to new business interest
- Phone calls and business-related follow-up
- Quarterly tax planning and preparation
- Tax documentation and record keeping related to annual tax filing
- Education and staff updates and employee training
- Policy enforcement, formulation, and reevaluation of existing policy for staff and clients
- Personal time management; caring for self and employees

Partnering With a Retail Business for New Client Referrals

Finding new clients remains the biggest challenge for growing personal training businesses, especially when owners want to keep new staff busy and expansion financially viable. If you have one or more employed or independently contracted trainers, or if you plan to hire trainers, new client referral is essential to keep expanding and to adequately compensate employees.

Partnering with a retail group, for example, is a great opportunity to create new relationships and new client referrals that come from outside of your current business and usual contacts in the personal training industry. Businesses that cater to a clientele who might have an interest in personal training are good starting points to develop such a strategic and mutually beneficial relationship.

Potential Partnering Matches

Good examples of retail partnering matches include specialty stores that sell fitness or outdoor equipment and athletic footwear as well as sporting goods stores. Partnering with such a business provides the chance to offer your services to a clientele you would not have accessed via your current resources; from the store's perspective, you represent an added value that increases the likelihood of retail sales because you are available to teach the purchaser how to properly use the equipment.

Sole practitioner physicians or physician groups, osteopathic doctors who are often oriented to all aspects of wellness and prevention, chiropractors, physical therapists, dietitians, weight loss clinics, day spas, any allied health care professionals, hair salons, or other beauty and personal wellness treatment centers are excellent prospects. Any business that has workout facilities, such as management leasing or selling groups, condominium owners, and apartments or other real estate, is also a prospect. Market and consider partnering matches based on the services you provide and what your local business community has to offer.

The concept of partnering can be used with any retail or service group that has a potential clientele who could be interested in training services, as long as your personal ethics are not compromised in any way. For example, getting involved with local running, triathlete, and hiking clubs can help expose your services. It makes perfect sense to target your services to clientele with whom you have a special interest or expertise. Use your business goals, background, athletic history, and passion to locate and identify potential new markets.

What's in It for Them?

Although mutual goals, needs, and expectations must be met by any parties entering into an agreement, my perspective with new business partners is, "What can I do for them?" In other words, I define how my new partner will benefit from the relationship.

My selling effort focuses on asking key questions. Doing so helps me sell the project based on understanding their needs and motivation. For example, physicians need to know that you won't compete with their services, demand too much of their time, or present any headaches, and they need to know what is in it for any patients they refer. Determine what potential partners want to accomplish. Are they treating patients who have rehabilitated a knee or finished medical treatment? Do they want to add value to a product (e.g., fitness equipment instruction) or service (e.g., office space or residential on-site training) they are selling? If so, you can provide an invaluable and complementary service to whatever a particular business already provides.

Here are some of the questions that need to be answered with regard to developing a partnership strategy:

1. How would my service (e.g., new fitness equipment instruction or teaching someone how to run and progress their program after purchasing a new pair of jogging shoes) benefit the potential partner's company? Which of the partner's markets would benefit my company?

2. What is my definition of success and what is the other party's definition of success, from a business and ethical standpoint? This question often creates a deal breaker or non-negotiable breaking point if your definitions of success and

how to achieve it do not perfectly align. If your business operating procedure and your way of treating your customer do not match those represented by a potential new partner, don't question your intuition. Look elsewhere!

3. How will you and your new partner cooperate regarding sales, customer exposure, and marketing efforts? This step requires a team effort, honesty, and an objective plan. Specifically define the roles played by each partner to maximize effectiveness. For example, many times an agreement may be nothing more than leaving business cards or flyers at a retail outlet. This is a sloppy and haphazard approach. A win–win situation could be created by printing a formal award certificate that details your consulting services and provides a complimentary introduction to the equipment just purchased. This could be handed out upon purchase. Compared with the first approach, this adds value and importance to the offering.

4. How will this strategic relationship measure and evaluate success? This may be as simple as being introduced to new or potential clients or having the opportunity to be part of an added-value package. There may be no hard guarantees, but at the least, exposure provides the possibility of new business. It may be necessary to set a number of referrals required per week for the deal to meet your business goals. Every item is negotiable. Remain realistic and be sure that the other side's needs are also being met. An equipment retailer, for example, who promotes a complimentary consultation with you when a specified dollar amount of equipment is purchased may need to track returns. In my experience, returned fitness products are significantly reduced when a professional trainer orients the buyer to the equipment. The more clearly and accurately the partnership can track results, the more likely this mutually beneficial relationship will continue.

5. How do the client lists match up between the partners? Not only must you gauge the list in terms of interest and likelihood of the customers' interest in using your services, but the client must have access to you or you must be able to travel to him or her. Does the customer travel all the time or live outside of your geographic area, or is he or she otherwise difficult to contact?

Don't forget to analyze, based on demographics of where customers are based and mean incomes in the area, how many potential customers are realistically available to you.

If questions one through five withstand your scrutiny and present glowing possibilities, you might have the right union, a "match made in heaven" (Florez 1999).

➤ Questions 1-5 on pages 117-118 adapted from Florez (1999).

Making Contact and Working Together

Think about what you would like to accomplish in your business and identify your biggest challenges. Once compiled, the list might include getting more clients, minimizing client turnover, differentiating your business in the marketplace compared with other similar services, exposing your business and the type of services you provide, having an exemplary customer satisfaction level, maintaining cutting-edge service, providing new programming, and marketing your business in a cost-effective manner that maximizes local exposure.

The best contact is personal contact. To say the least, it can be challenging to gain an audience with a prospective partner. Retailers and equipment manufacturers are busy taking orders, making sales, and contacting distributors. Allied health professionals, especially physicians, are always time-crunched. Use "buffers," the people who are the first obstacle in making a personal connection with your desired prospect. Receptionists, office managers, personal assistants, physician's assistants, physical therapy assistants, athletic trainers, nurses, and your client or doctor's patient or the customer herself can be of great assistance in helping you to get a formal and personal introduction. Find something that puts you on common ground with the person you'd like to meet.

Partnership Compensation

Should you get paid for this service or any service you provide? That's negotiable. If you're just starting a business, it might make sense to offer complimentary service. (But, for example, limit the service to specific and significant equipment purchases.) This is a perfect way to establish or

grow a client base. Another idea is to provide a number of complimentary visits each month to the store but charge a fee for any visits that exceed the agreed upon total. As an established trainer I always try to get paid for any service I provide, unless it is specifically directed toward charity service. Time is a premium.

In the preceding scenario, I would present my service as an added value that will give salespeople an additional tool to close the sale. Support your case by documenting additional sales or giving evidence of repeat buyers who return to the store for another purchase because of your recommendation. Also note your record regarding returned goods. Of the many equipment orientations that I have done over the years, the return rate of the purchased piece of equipment is close to zero percent! That is a statistic that talks to retailers!

Making the Retail Partnership Work

Always keep the retail business owner's needs in mind. When you approach the business owner or manager, you must communicate your understanding that it is a business' intent to sell products and encourage repeat business by providing outstanding service and follow-up. Beyond that, establishing your professionalism is crucial to high-end, specialty retail outlets because your service will represent the store and extend the store's image.

Next, visit the stores and take inventory of what they sell. Talk to the salespeople and find out what questions are most often asked by customers and what are the biggest roadblocks to equipment purchase. Most of the time customers are intimidated by the thought of learning how to use the apparatus and how to plan a safe and progressive program. A personal trainer is a perfect fit to fill this need. Do your homework! After visiting the outlets and accumulating the requisite information, formulate a basic proposal that outlines how you can provide a service that is cost-effective and service oriented, will decrease returns, and will increase sales and repeat business at the store. Now you've got their attention!

Once the relationship and working guidelines are established, you can choose from two proven methods of furthering this mutually beneficial relationship and having it culminate in desired results for the partners.

Present a Clinic, Lecture, or Question and Answer Period

The store can promote this informational talk as part of a preplanned sale or other promotional event. It should be promoted externally via flyers or brochures and internally within the store by posting in-store signs and distributing your brochure and flyers. At the clinic, give the participants take-home materials that support your talk, further establish who you are and how your services can help them, and give them a means by which they can contact you.

Offer a Complimentary or Fee-Basis Consultation

Customers who purchase a piece of home fitness equipment from a retail outlet might receive a complimentary or low-fee consultation. Designate a minimal purchase amount that warrants the complimentary consultation and orientation to the purchased piece of equipment. You do not want to visit every person who buys a pair of ankle weights or dumbbells. Generally, focus on significant purchases like treadmills, steppers, elliptical trainers, stationary bikes, multistation strength training machines, and complete sets of free weights.

Schedule the consultations where the equipment will be used and, of course, after it is delivered to the site. This ensures that you will have an attentive potential customer. An atmosphere like this is very conducive to showing the person how to use the equipment to maximize his or her personal benefit, and it gives you an opportunity to introduce and showcase the benefits of personal training.

Selling to the Potential Client or Store Customer

Keep a few points in mind when selling your services during the orientation. You must provide the customer with the information and expertise that were promised at the point of purchase. This will satisfy your partner and the customer. After building that foundation, you need to gain the customer as a client. You will have to establish the right feel with regard to your sales approach, but you must define what a personal trainer does and discuss how your

service can help the customer achieve his or her personal fitness goals, in addition to maximizing how he or she uses the new equipment purchase.

As incentives, you can discount initial sessions. At the least, leave a professional informational brochure (chapter 4) or your client introductory packet (appendix). Finally, if your session does not result in the customer's purchasing your service, follow up. People generally procrastinate about any purchase decision and it is appropriate to initiate movement in this area. Your call may be the driving force that this person needs to start using the equipment that is now collecting dust. Your call may help the customer recommit to using the equipment and staying on a regular program.

Partnership Agreement: Get It in Writing!

Although a partnership in terms of the agreement is usually straightforward, you still must put it in writing. (However, if a hair stylist or skincare outlet lets you place brochures in their store, it may not be necessary, and could be intimidating, if you suggested a written agreement.) Language should be concise and avoid complicated terms or legalese. Your agreement does not have to be written in Greek to be legally binding, and you don't want to frighten away potential partners. Document what you will provide and what is expected of your partner. Use language and tailor each agreement to the type of strategic partnership you are forming. The language and intent of the agreement will be very different for physicians, physical therapists, spa directors, running clubs, or equipment or shoe retail outlets.

Hiring Additional Trainers and Staff

Hiring additional trainers is often a natural first step when you're looking to expand your business. In fact, it occurs almost by default. The first time you think about hiring additional trainers probably will come when you realize you cannot take on any more clients and have more requests for your time than you can manage. What do you do with this waiting list of clients who want to use your services? Successful sole proprietor businesses can quickly grow to a point where they have more clients than they can work with, and the ability to capture this income is lost.

Take Advantage of Your Client Wait List

If this is your situation, you might expand your single-trainer business and direct this overflow of potential clients to independently contracted or employed trainers. Not only will this help you to capture a lost income stream, you can free yourself from the immediate and day-to-day tasks of running a successful business entirely on your own.

Is Adding an Employee or Employees Realistic and Cost-Effective?

Hiring staff is a step that should not be taken lightly. Many trainers have created a number of personal, emotional, and financial nightmares because they went about it entirely wrong. They did not do the necessary background work and were not fully committed, or they were naive as to what business expansion really entails.

Be clear about your resolution to follow through and identify the steps necessary to make your business expansion successful. You'll have to develop a whole new set of business skills and be ready to face very different challenges in this new venture. You have to find the right employees and keep them; generate clients and other new business; administer billing, pricing, client, and staff policies; stay in contact with your clientele even if you don't train all of them; and continue to personally train a core of existing clients. Considering all of this, you might think expansion is an impossible task. After all, this significant change in your business operating procedures initially will require more work, time, and juggling on your part, in what is already a full schedule.

You'll be tempted to stay in the groove you've settled into. A trainer can create enough income via a single-person training business to live quite comfortably and so avoid the challenge and the stress that come with business expansion and staff. However, the new opportunity,

diversity, professional challenge, personal stimulation, gratification, and freedom that eventually come with this type of growth are not always available to the single-trainer operation. Because this choice will dramatically alter how you earn a living in the field of personal training, be absolutely certain that this decision aligns perfectly with your goals and personality!

The self-evaluation checklist in the box below will help you decide if hiring more staff is right for you.

Is there financial risk? Yes. Can you lose money? Yes. Could you lose your business? Yes. Could you lose your existing client base? Yes. Will you earn more money and have more personal freedom? Maybe. Is there a chance you could be successful beyond your wildest dreams and affect clients' lives in ways that you never thought possible? Yes. There are no guarantees. Are you ready or not?

Now, you've made a decision and you're either committed or not. If you're moving the investigation forward, it's time to start objective analysis, time to really start doing your homework.

Independent Contractor Versus Employee

Weighing the advantages and disadvantages of each possibility will help a business owner and the prospective trainer appreciate what each brings to the table.

Personal training within a health club or personal training company, compared with being self-employed, can have both advantages and disadvantages for employer and prospective employee. Keep the following in perspective when negotiating compensation plans or hiring employees (tables 5.1 and 5.2). You may have to point out what the business brings to the negotiating table.

Independent contractors (self-employed) require less hands-on management and personal involvement, and they lighten the administrative and financial burden. Many large or franchised fitness clubs that offer personal training find it cost and time prohibitive to shoulder the administrative burden of managing a few to hundreds of trainers. This could interfere with other marketing, operational, and sales campaigns. Independent contractor status places the burden of professional preparation, taxes, insurance coverage, marketing, scheduling, and money collection on the self-employed individual. Many trainers thrive on the independence and trust placed in them as independently employed trainers. However, I prefer employees because I know what I want to accomplish and how I want it to be done. Control is a big issue to me, which ties directly to maintaining professional consistency and quality of service.

Hiring Trainers: Self-Evaluation Checklist

Ask yourself the following questions to evaluate whether hiring trainers or other staff is the right step for you.

❏ I am able and willing to handle conflicts with trainers and clients.

❏ I can face rejection when asking for new business.

❏ I can trust others to represent me without constantly supervising them.

❏ I am willing to have others work with my personal training clients.

❏ I am willing to risk my reputation and rely on other people's expertise.

❏ I can comfortably delegate key responsibilities.

❏ I am certain that my goal is to grow beyond my own personal training.

Adapted from Florez and O'Hara 1997.

TABLE 5.1 Advantages and Disadvantages of Being Employed

Advantages	Disadvantages
There is a waiting list of client referrals, and the employee's services are actively marketed to clientele.	Income generated must be shared, so the trainer doesn't have the capacity to earn the highest dollar amount per client trained compared with self-employed trainers.
Business expenses and associated costs are minimized; these include secretarial support, answering services, rent or lease, utilities, health insurance, liability insurance, workman's compensation insurance, taxes, and legal and accounting fees.	If travel is required, associated expenses increase, but oftentimes top organizations will provide expense accounts or allow certain work expenses to be reimbursed.
You receive professional training, support, and mentoring; personal evaluation; and growth opportunities—you are not alone.	You are not the "captain" of your own ship; you must become a part of a team generated effort.
You receive business perks such as continuing education, health benefits, uniforms, team get-togethers, and other incentives like discounted equipment and apparel purchases, milestone awards, and outstanding service recognition.	
You have flexibility in scheduling clients and creating balance between work and personal life.	
Administrative duties are almost nonexistent; there are no advertising, marketing, or budget duties. Fee collection is usually done by the employer; client conflict and resolution issues often end up in the lap of management.	

TABLE 5.2 Advantages and Disadvantages of Being Self-Employed

Advantages	Disadvantages
You receive the highest dollar per client compensation, although you need to factor in the cost of doing business and ascertain if you really are earning more money compared with working for someone else.	Associated expenses are significantly higher and recurring. After you assess any start-up costs, factor in the costs of lease or rent; utilities; advertising; marketing; continuing education; secretarial services; office equipment, paper, and other supplies; business cards, brochures, and client introductory packets; answering service; hired outside services; liability, health, and other insurance; taxes, liability, and preparation; transportation; legal and accounting fees, to name a few.
You own your own business; you are self-employed, which is unique and special in all societies. Every reward that results from your hard efforts, commitment, and individual successes comes back to you 100 percent—you share what you want to when you're the boss. You experience immense personal satisfaction and pride.	Perks and benefits come entirely from your pocket, not to mention retirement plans.
You have personal freedom and more career options.	Your business requirements can consume you; you can become a workaholic.
You are the "captain" of our own ship; you must parlay your energy so that your business becomes a team effort; your business sinks or floats because of you.	Some "captains" find that they sink under the relentless pressure of performance, financial risk, possible failure, and being the "go-to" person.
Significant business expansion and increased income earning potential are very viable options.	

Understanding Exclusivity Contracts

The most common exclusivity agreement is referred to as a covenant not to compete. Employers have a variety of reasons for demanding exclusivity. The most obvious purpose is self-protection. This type of contract reflects the concerns of the employer and is written to favor the employer's best interest, if not challenged by the signing employee. This is good from the employer's perspective and bad from the employee's.

The contract can be a single page or a legally verbose maze of paperwork. Employees need to know that the contracts are legally enforceable, although the employer should realize that gaining a judgment is costly and time-consuming. If the decision goes in your favor, it's not always easy to collect the monetary award, if one is awarded. Even more difficult is enforcing issues that pertain to trainers working in a certain proximity to your business, working for another business, divulging trade secrets or training methods, or taking clients from your business. Monitoring and enforcing such agreements can consume a significant amount of time and energy that should be directed toward your growing business.

As an employee, know that the contract is initially written to favor the employer's best interest; negotiate and tailor the contract to suit your needs and be prepared to honor the stated principles or be prepared to be sued. Seek legal counsel before you sign so an attorney can explain what you are agreeing to.

Although exclusivity can enhance teamwork and create a sense of unity, this holds true only if employees are satisfied with compensation and personal growth opportunities. Exclusivity agreements also can create an ugly wall of division. There are many reasons to enter into agreements, and if the pros (experience, a "foot in the door") outweigh the cons (a restrictive contract with few employee options), it makes sense to enter into the deal. Generally, this type of contract is worded to favor the employer's best interests but can be negotiated if you feel uncomfortable with any area. A contract need not be restrictive, limiting, or unfair.

Very restrictive contracts can be written to prevent the employee from working anywhere else for a specified period of time or to prohibit an employee who is leaving the business from working within a specified proximity (e.g., 30-mile radius) for a certain amount of time (e.g., six months to a year). Some contracts hold former employees to this covenant regardless of whether they choose to leave or are fired. Employees should be aware of what they are signing, and employers should fully inform the prospective employees what they are agreeing to.

An overly restrictive clause can result in excellent employees choosing not to sign with an organization. Quite often, the place of employment is no longer the primary source of training education, so this perk is not as attractive to trainers today. Our industry has evolved to include certification, workshops, conventions, home study courses, and a multitude of other educational opportunities. Rigid exclusivity may be an unrealistic and unfair request unless adequate compensation is provided. A long-term and binding commitment is much easier to swallow when potential employees feel they will be taken care of.

Many clubs or personal training businesses require exclusivity only while the individual is employed, because teaching at competing facilities could be a conflict of interest. If there isn't enough work at one facility to cover full-time employment, then exclusivity will not be in the employee's best interest.

My noncompete clause is not meant to limit an employee's ability to make a living at a competing business in my immediate geographical area if the employee leaves my business. Instead, I want to ensure that clients of Brooks . . . The Training Edge do not become clients of the breakaway entity! The contract's focus is to keep the former trainer from soliciting or working with any Training Edge clients for up to one year after termination of employment. Securing client records and maintaining privacy of the records is part of this process, and it's important to me that all Training Edge property be promptly returned. The sample noncompete contract is a reasonable demand of commitment and loyalty and covers issues that are of biggest concern to me (figure 5.1).

If pushed to the limit, I will sue the offending trainer, although I would prefer not to. I know the contract is legally binding. The noncompete contract may intimidate a trainer or at least

Noncompete Contract (or Agreement)

The purpose of this agreement is to protect DOUGLAS S. BROOKS/DBA as Brooks . . . The Training Edge (BTTE) time and energy expended over the past years in developing his BTTE training program. The fitness program and the subscribing client list are considered trade secrets and proprietary information developed and accrued by DOUGLAS S. BROOKS.

In this agreement, DOUGLAS S. BROOKS shall hereinafter be referred to as "Employer" and you, the associate trainer signing this agreement, shall be referred to as "Employee."

Therefore, as additional consideration for Employee's employment by Employer, Employee agrees to the following:

1. Soliciting Customers After Termination of Employment

 The Employee shall not for a period of one (1) year immediately following the termination of his or her employment with the Employer, either directly or indirectly

 (1) make known to any person, firm, or corporation the names and addresses of any of the clients of the Employer or any other information pertaining to them, or

 (2) call on or take away, or attempt to call on, solicit, or take away, the clients of the Employer with whom the Employee has become acquainted during his or her employment with the Employer, either for him- or herself or for any other person or corporation.

2. Return of Employer's Property

 Upon the termination of his or her employment or whenever requested by the Employer, the Employee shall immediately deliver to the Employer all property in his or her possession or under his or her control belonging to the Employer.

3. Ownership of Client Records

 All records of accounts (i.e., any records, books, or electronic data relating in any manner whatsoever to the clients of the Employer), whether prepared by the Employee or otherwise coming into his or her possession, shall be the exclusive property of the Employer regardless of who actually purchased the original book or software used for recording purposes. All such books, records, or computer data provided by Employee as a hardcopy printout will immediately be returned to the Employer by the Employee on termination of employment.

 If the Employee purchases any such original book or record-keeping software, he or she shall immediately notify Employer, who upon Employee's approval shall immediately reimburse Employee. Generally, Employees are required to track client progress on BTTE-approved forms or software provided by BTTE.

I, the undersigned Employee, have read the agreement and fully understand the reasons for its implementation, as well as the demands to which this contractual agreement binds me. I understand that the contract is legally binding and enforceable. I agree to abide by, follow, and honor the agreement as stated.

Agreed and accepted this _____ day of _____, 2_____.

(Employee signature)

Note: Make sure the contract you use is specific to and satisfies your state or country's laws so that it is legally enforceable.

Author's note: Have I ever used a noncompete contract? Yes. Would I use one today? Yes. Although I understand the contract's limitations, signing the contract indicates the degree of loyalty I am looking for in trainers who work for me. They understand that I will award loyalty with fair monetary compensation and will help stimulate their professional and personal growth. I work hard to develop a personal relationship with a trainer and take a genuine interest in him or her as a person, not just an employee who can generate income for my business. I take this relationship seriously.

FIGURE 5.1 Sample Noncompete Contract.

make him or her think twice if considering an unjust action. If I am upset enough to sue, and the trainer is disenchanted enough to undermine a business and relationship that I believe was nurtured, the void caused by such disparate views is probably not fixable. When all else fails, I like to have my noncompete clause as a backup. Note that it is not my first line of defense. Building relationships is number one on the agenda and can help avoid such a crisis.

Generally, I do not want an employee working for me who doesn't want to be there, doesn't think his or her needs are being met, or is otherwise unhappy. However, I prefer to keep every client training at my business or be compensated for those who leave under this situation, and usually I accomplish this goal. This especially holds true when the client is satisfied with the organization and understands that the business ultimately serves his or her best interest, not the individual trainer's.

Savvy business owners invest a lot of time, effort, and money toward employee development. Client referrals are generated from the business and turned over to the trainer, which expands the trainer's personal business. Although it is critical to limit employee turnover and dissatisfaction, this type of agreement provides just recourse and levels the playing field with trainers who think they can have their cake and eat it too.

How Do I Find the Right Candidate for Employment?

It's tough to find someone to replace your talents because you believe in yourself and your services, but the right person can complement what you have to offer and ease the time demands that your business places on you. If your clients have never trained with another trainer, they will probably resist change, but the positive aspects of expansion can be sold to existing clientele as an added value to an already superb training situation. If you position the change as positive and understand what you are trying to accomplish, it's easy to sway any negative opinion or resistance.

Keep this in mind as your business grows: Besides taking a financial risk, you initially take on more work because you have to train the new trainer, too. (This is not necessarily true if the trainer is an independent contractor, but you should establish some measurable and minimal competency level if you don't directly oversee the trainer's training.) On the other hand, the right trainer or trainers can eventually take some of your workload and help your business prosper. Find employees who are trustworthy and whom you respect. Do they take initiative and pursue new opportunity that can help your business grow? They can train new clients, get to know and train the clients who swear by your philosophy and approach, and take over administrative tasks.

So when do you hire? Not only must you look at economics, credentials, and experience, but you must be disciplined and patient and trust in your subjective intuition. Wait until you find the right person. The perfect employee is not always the one who looks squeaky clean and academically outstanding on paper. This employee becomes an extension and reflection of who you are and the services you provide. Proceed cautiously and make sure the fit is right for your business!

Hit List for Recruiting and Hiring Candidates

1. Contact other trainers in your area, allied health and fitness professionals in related fields, medical professionals, colleges, and universities and offer internships and job opportunity postings. Place ads in professional journals and local newspapers. Post positions at university and fitness conference job boards, and use the Internet to get the word out. Guest lecture at community colleges, high schools (graduation time is often effective), local gyms and clubs, certification programs (e.g., community college extension courses), and fitness conferences or workshops so that you establish credibility and visibility and communicate the opportunity you have to offer. Ask colleagues, clients, advisory board members, and any current staff or independent contractor (fitness related or not) for employee recommendations.

2. Develop a specific interview process that differentiates between employment and intern opportunities. If you have bottom-line qualifications, be sure they are met before offering an interview. This step saves you and the individual valuable time.

3. Offer a compensation package that meets your needs, is flexible and fair to the recruit, and can grow with a trainer who develops professionally and who shows increasing commitment to your business. Initially, I suggest that you hire trainers, whether as an independent contractor or employee, on an hourly basis. This way, the trainer's paycheck that is written by you is matched by income generated from client training sessions. When the trainer establishes a steady clientele she has maintained over a period of months and your lead or referral sources continue to increase, consider offering the trainer a salary or full-time employment that provides specified benefits.

Turn-Key and Farm-System Candidates

In your search for top trainers, you'll identify candidates who have proper and adequate credentials and look good on paper. These are what I call potential "turn-key" prospects. If they have the necessary people skills and philosophically match my training approach, they might be ready to integrate quickly into my business.

"Farm-system" candidates—the words are taken from the training grounds of professional baseball players who are being honed for the highest level of professional play, the Major Leagues—are less qualified based on credentials and experience. However, they have raw abilities, enthusiasm, and great demeanor and personality, and during an interview they appear very trainable and anxious to improve their professional skills; this makes them prime candidates for my business.

How Will Adding Employees Improve Your Business?

Staff who are selectively chosen and trained and who are motivated to stick with your organization will greatly free you to market, pursue public relations, and support and direct your staff, as well as to see and seize new business opportunities. Minimizing staff turnover, learning to let go, and learning to delegate responsibility are aspects of business expansion. Your business dimension and depth will increase greatly because ideas and expertise will no longer rest entirely on your shoulders. Most successful leaders surround themselves with talented people who can complement an organization's direction or goals. Good leaders are willing to listen, follow and lead, detach their egos when necessary, and make decisions for the good of the team. A company led by a single person is obviously more limited than one led by a multitude of talented and expert staff.

Do you have the capacity to administer, manage, baby-sit, encourage, and cajole employees to be their best? Increased paperwork, new organizational skills, increased taxes, staff meetings, and trainer development are but a few of the new challenges you will be required to undertake. Take another look at "Hiring Trainers: Self-Evaluation Checklist" on page 121, as well as tables 5.1 and 5.2, which compare the pros and cons of being employed or self-employed. Your passion, interests, and personal talents should match the job description you choose.

Training the Trainer

There is no better way to advance the career of a new employee and increase his or her professional skills than by offering a strong mentoring program. The only downside is that mentoring is time consuming and requires a substantial commitment from both parties. Consider group mentoring, so that you can more effectively leverage your or another mentor's time.

When an employer takes a personal interest in developing a new employee, a mentorship training experience—although labor intensive—provides an incredible foundation from which to develop a long-standing, loyal, and productive relationship. Mentoring takes place when you, or some other seasoned pro, takes a promising professional under your leadership and guidance and shows him or her how to successfully navigate the profession of personal training. This means sharing your business acumen as well as in-the-trenches experience and insight that you have accumulated over time while training at the one-on-one level.

Mentoring is not a one-way street, either. Serving as a mentor is good for your business

and the clients you help. Personal reward gained is astronomical when you gauge the impact you have had on helping to develop a special individual's passion, dedication, and professionalism toward a business to which you are devoted. Businesses that provide a mentoring program ultimately generate dedicated employees who are more satisfied, are more productive, and love what they do. Ultimately, your business will be marked by the people who stick with you year after year!

Mentoring can be combined with more traditional training approaches that include enrollment in certification courses, instructor training courses, fitness-related education through formal institutions like community colleges and universities, and ongoing continuing education courses.

Integrating the Trainer Into Your Business

After you've settled on a trainer, have the new trainer shadow you or other accomplished trainers, if appropriate. (An independent contractor may not be interested in how you train! Before you hire an independent contractor, review his or her training skills and during the interview ask key questions that expose his or her training approach and methodology.) Get the client's permission before inviting this third party observation. Assign the new trainer to clients who are easygoing and pleasant and who have no special training needs or risks. The trainer can fill in for sick or vacationing trainers, too. Advertise the new trainer's presence via e-mail and newsletter and by handing out copies of his or her client introductory packet to other staff and current clients. Get the word out!

Observe the trainer during training sessions and schedule meetings to discuss areas of excellence and those that need improvement. Continue to supply training, mentoring as needed, and other educational resources that will further the trainer professionally. Schedule a performance review after six to eight weeks. Supply resources and practical direction to help the trainer improve in areas that need improvement. Continue the nurturing and growth process from this point and forever! If the prospect is hopeless—information retention is lacking and personal improvement is small to nonexistent—see the section in this chapter on how to fire or release an employee.

Compensating Trainers: How Do You Fairly Split Up Trainer-Generated Income?

Is it efficient and cost-effective to take on additional employees? The numbers will tell the story, and you need to take a close look at the costs of doing business and projected income before you offer any type of compensation package.

Various Ways to Divide the Money Generated Per Session

What is the best and fairest split between owner and trainer? Management has its interests at heart in view of overhead and profit, whereas the trainer deserves fair compensation, too. If profit is the main driving force behind the decision of how much management gives to employees, employee turnover will be management's worst nightmare. Employers have to find the balance between being financially solvent and awarding enough of the pie to retain, motivate, and encourage top trainers.

Ultimately, the division comes down to the net profit or percentage you want to derive from hourly or net revenue. If a large club views personal training as a retention center, rather than a profit center, it will offer a greater split. If the training organization relies heavily on profit generated per training session, the split will favor the employer. Two of my favorite options appear next.

Straight percentage split. The most common split is the traditional, straight percentage split. Trainers are paid a set percentage of revenues generated, so the percentage can be applied per session or to overall income generated by the trainer. Typically, the split can range from 30 to 70 percent of the per-hour fee. For example, if your organization charges $50 per training session, an inexperienced trainer may be pleased with earning $15 per hour (30 percent of $50), whereas a savvy and popular trainer

can command as much as 70 percent of the fee, or $35 per session. National averages hover between 40 to 60 percent.

Sliding scale. The variability discussed in the straight percentage split naturally leads into a sliding scale pay arrangement, based on what your employment and financial scenario demands. A sliding percentage works particularly well for specific circumstances:

- When your budget requires you to vary the split between top performers and part-time or less successful trainers
- When you reward trainers a higher percentage based on the number of workouts they execute each week
- When experience, credentials, and longevity are assigned a premium percentage

This plan provides a built-in diversity that will meet the changing needs of deserving trainers.

Many business owners who hire staff report that an employee needs to quickly top 20 training sessions per week to make the employment situation work for them. Because 20 billable sessions seem to offer a profit point for many training organizations, some businesses offer significant percentage increases for client hours that are billed by the trainer in excess of 20, 25, and 30 billable client sessions per week.

Compensating Trainers Beyond the Paycheck

Although hourly or salary compensation must be fair and competitive, you also need to develop employee loyalty by taking care of your employees with adequate employee benefits and by nurturing them emotionally. When salaries you can afford to pay are not as high as they should be, consider alternatives to cash incentives to let your employees know you appreciate them.

Offer employee benefits that affect the individual's quality of life or have a significant monetary value.

Health care plan. When selecting, for instance, an employee health care plan, consider several factors:

- Your costs.
- How much of every premium dollar spent on the plan is directed toward providing health care versus profits and administration—the top plans spend closer to 80 cents.
- The flexibility with which you can choose a doctor.
- Whether the plan offers access to specialists.
- Coverage limits.
- Whether the plan has a good reputation in the community and with local doctors. Don't shop for a policy based on price alone. You'll end up spending a significant amount of money for a plan that doesn't provide the service you desire for yourself and employees, and your employees will quickly rate the value of the benefit as minimal if it does not adequately cover their health care needs.

Other fringe benefits. Although it may seem obvious, dental, life, and disability insurance are important employee benefits. Most employers shy away from offering these types of incentives because of the cost. However, you may not have to pick up all of the cost. Carefully investigate and determine how much of the tab you'll have to pay and how much a state or government program, for example, may provide. Also, employees may be required to pay a portion of monthly premiums. Fringe benefits will help you retain and attract quality employees.

Retirement plans. Company-supported retirement plans help focus employees on their future and also help you attract and retain quality employees. With many plans the employer matches employee contribution. A company-sponsored retirement plan quietly communicates that the employer has an interest and financial commitment in the trainer's future.

Training staff. Require staff to attend educational events. Professional certifications or licenses should be kept current, and the employee can help with this financial and time burden. You can award the staff paid time off to attend such an event and pay for the training outright, or you can create a noncompetitive incentive program for staff to earn points toward attendance at educational enrichment events. For example, you might give credit for

time accrued as a full-time staff member, for billed hours, or for retaining a specified number of clients. Use common sense to reward staff. You own the business and can make decisions that are outside black and white policy lines.

Supportive Employee Compensation . . . Beyond Significant Monetary Value

Once you've got hourly and salary dollar compensation under control, don't ever believe that is enough to keep a committed employee. Every human craves attention and adulation and likes to think that his or her efforts are deeply appreciated. Going the extra mile to let your employees know that you value their efforts, friendship, and professionalism is of paramount importance. If recognition is predetermined and evenly distributed across the board via a formula—whether the employee is deserving or undeserving—you might as well not offer it in the first place. There is no sincerity in such an offering. It will be seen as fake, the value will be minimal, and at worst, it will offend dedicated employees. Keep the recognition special, sincere, individualized, and in line with what has been accomplished by the employee.

Say thank-you often. Don't forget to say thanks and offer spontaneous, meaningful, and heartfelt acknowledgment for a job well done. In my opinion, employee-of-the-month programs are often not well tended, and since everyone is usually eventually cited, these programs lose their clout. If you preserve the significance of these programs, they can be effective. A simple thank-you via voice mail, e-mail, and hand-written notes will go a long way. Include a personal touch in your communications. You might add an inspiring quote that reminds you of the deserving employee or relay a story from a pleased client. Letting an employee know that you are delighted with his or her performance and demeanor via this personal expression of your pleasure sets the employee and his or her actions apart and recognizes the trainer as a unique individual.

Designate special and personalized rewards. Do you have an employee who is diligent, trustworthy, and always willing to go the extra mile? Let this person know that you take notice of the extra effort and surprise him or her with the unexpected. If an employee always loads and folds the towels or cleans the locker room and changing facilities without grumbling, give a gift certificate at the local dry cleaners for cleaning of his or her own clothes or offer the services of a cleaning business to clean the employee's home or apartment. Do you have an employee who faithfully opens your club or personal training studio early every morning and greets the clientele with unrelenting enthusiasm? If so, reward that person with a gift certificate for a week's worth of free coffee from his or her favorite coffee house. For the employee who always posts fitness and nutrition tips on the bulletin board or helps write the monthly newsletter, provide a subscription to a professional journal or other health and fitness magazine.

Host special recognition events. Group events, parties, or outings not only support teamwork but encourage peer recognition. Staff parties can boost morale and build team spirit while simultaneously thanking employees for their individual efforts. Special awards can be given to recognize outstanding service.

Assist with an employee's professional growth. You can pay for your employees' education by sending them off site to gain new knowledge or you can bring the educational event to them. Support your employees' professional growth and networking efforts with other fitness professionals by hosting educational programs and workshops at your facility. This sends a clear message that professional growth and development are expected and backed by management. It also lets employees know that management knows what is valued by top fitness professionals who like to stay on top of new information about the personal training industry. You might also offer to pay for an employee's professional membership dues. Benefits like these not only improve the individual but also strengthen your organization and build employee loyalty.

Provide access to member services or product discounts. Everybody likes a deal, freebie, or complimentary service! Membership and access to your facility are positive for most staff. If the membership is not currently extended to family, consider offering that bonus. If you have access to ancillary services, like discounted tennis court or golf privileges, attendance at wellness

seminars, or discounted theater tickets, you can offer these perks to your staff. If you run a pro shop, have another retail outlet, offer food services, run clinics and lessons, or provide child care, give employees a substantial break on purchases or services. Allow all employees, not just the fitness staff, complete access to professional or discounted services you offer so that they feel part of the service delivery team. Employees should not expect this sort of generosity to be a right. In fact, most deeply appreciate this type of courtesy extended by the employer and usually, at some time during their employment, let the employer know they appreciate these employment advantages. Most employees really like these quality-of-life benefits and attach quite a bit of value to them.

Award paid time off. Realize that time is money, and time off is mental and physical recovery for a busy trainer or other employee. In fact, for most employees, paid time off is more rewarding for a balanced life than a direct cash reward or paid overtime. Overworked personal trainers prefer paid time off when compared with more money in their paycheck as a result of working out one more client. Time off is required to nurture oneself, to mature, and to recover and maintain passion for training. Not only is this type of compensation a coveted prize, but it also lets the hardworking employee know that down-time is part of a well-rounded approach to work and personal life. People cannot excel through work alone, although many hard-working trainers believe this. Awarding paid time off is a strong statement communicating that you care for the trainer's personal well-being, you note her extreme commitment and hard work, you don't expect or want the individual to work around the clock, and you want her to practice what she preaches to her clients. Balance wins over an all-or-none approach that will eventually crush both emotional spirit and physical capacity to endure.

Recognize and honor employment anniversaries. This doesn't have to be an annual event, although most businesses offer annual salary or hourly reviews. You can recognize outstanding service and commitment to your business on a quarterly or semiannual basis. This is very appropriate during the first year of employment, especially if your first offer of compensation

was on the low side, so that you were able to maintain plenty of margin to reward great service with significant wage increases during the early months of employment.

Reward employment milestones with specific privileges, rewards, or benefits (e.g., life insurance, retirement plan, dental or eye insurance coverage) not available to most staff. The message is that you value and compensate employment longevity and outstanding service.

Compensate for exceptional performance. Cash always speaks loudly and certainly goes beyond "feel-good" recognition. Outstanding and consistent service justifies a cash reward or a permanent increase in hourly or salaried compensation. At some point, a dedicated and hard-working employee wants and deserves a cash reward. If one of your employees has earned this type of remuneration, find a way to take care of that person. You also can set up a performance bonus pool for special employees based on number of hours billed, success of a department, or success of the business as a whole. Profit sharing is also a possibility if the employee greatly affects your bottom line. Objective and subjective compensation awards make good business sense.

Allow and encourage evaluation of management! Employees love this perk and "payback" opportunity. All joking aside, employers should encourage this invaluable feedback opportunity. If you promote critical review of your own performance, you will receive many pats on the back as well as criticism that will help you to run your business more effectively and remain sensitive to individual employee needs. This will help both employee and employer to succeed.

You have to decide if your goal is to believe that you are perfect or to run a better business and keep your employees satisfied. At least once a year, let your employees anonymously evaluate you. Create a form that allows them to candidly evaluate your people and management skills, your ability to motivate and lead, and your organizational skills and professionalism.

Formal evaluation once per year is a good first step but is not enough. Encourage the same kind of ongoing evaluation that you get from paying clients regarding your staff and

services you provide. It's essential to encourage employees to evaluate owners or other management regularly. Then, you must acknowledge all feedback and act on relevant feedback. Some information is appropriate to present to staff and can lead to productive staff discussions as you choose or choose not to implement various suggestions or change company policies or approaches to employee needs. Staff involvement like this leads to employee loyalty and creates a sense of business ownership in the employee's mind. Without a doubt, this feedback tool will help you to become a better manager of a business and people, and you'll be branded as a sensitive boss. As important, your business will likely succeed.

It's your family. Maybe now you get a sense of why I prefer employees over independent contractors. Yes, control, quality, and consistent service are important issues, but when push comes to shove, employees can really become committed family members if you do the right things! Maintaining a mentoring and sensitive environment for employees is rewarding and a sound business stance.

Product Sales: Moving Toward Full-Service Business

Offering a full range of products and other non-training-related services could be your competitive edge—or your downfall. The caveat here is distraction. Don't forget what you do best—working with your clients individually. Never lose sight of this business foundation. If you do, your business will crumble.

Your product offering should be motivated by meeting individual client health and fitness needs, not advancing the profit margin of the trainer. Additionally, it is nice to offer the product at a value below retail or at a lower cost than the client could procure by him- or herself. It's okay to make a profit for your time and effort, although some trainers offer this as an additional service, recognizing that their personal training fees are what really drive their business. Regardless, making a profit is appropriate if you fully disclose the financial matters and choose a legitimate product to recommend.

Product sales allow you to leverage your time to maximize earnings and service delivery to your clients. Your clients' interests should dictate your product offering, evidenced by their requests for information, recommendations, and insistence on product purchases. By being honest and keeping product choice in the client's best interest, you can move toward a full-service business. Many of your clients see you as the answer person, a credible and knowledgeable clearinghouse and informational source for all their health and fitness questions. It's logical and perfectly natural to become the supplier for many of their other health and fitness needs. Whether you receive compensation for playing this role or not will depend on how you manage this aspect of your business, but you will be asked and expected to provide guidance!

Every product you recommend should be truly helpful to your clients, and you should feel good about standing behind it. In fact, would you use the product? Although simply using a product is not a reason to sell it, your personal use can say a lot about your belief and confidence in what you are promoting. Before you ever consider any aspect of selling products, honestly answer this question: Is this in my client's best interest?

Most trainers express an interest in selling products. However, many are concerned with ethical questions, as they should be, and what impact selling will have on the integrity of the core services that they offer.

Trainers are asked regularly for recommendations about health and fitness products, equipment, shoes, apparel, and related services like massage therapy or spa services. Why? Because trainers are trusted, they often best know the individual who is asking for personal guidance, and they can provide a confidence-building nod of approval. Everyone prefers a personal referral over an educated guess or intuition.

There is a special bond between trainers and their clients. Because of this, manufacturers are eager to take on trainers as their distributors for items ranging from athletic shoes and apparel, to multiple-mineral and -vitamin combinations, to water purification systems and gym equipment, and everything—good and bad—in between!

When should you expand your business by selling products? I think it is crucial to establish a core of dedicated clients who trust and

value your service. Trainers new to the business should not blitz their clients with an array of products aimed at generating more money. Prove yourself as a reliable provider of personal training services, and product expansion will come off as though you're trying to provide another great amenity that is in the interest of your clients and is a direct result of their requests.

Client interest and individual requests drive how I choose products to market to my clientele. Training and nutrition aids like heart rate monitors, fat content calculators, and resistance tubing and reading resources like nutrition newsletters are good examples. Home gym design and equipment purchase are also high on the list, as well as requests for guidance and direction in the confusing area of nutritional supplementation. (I encourage multiple-mineral and -vitamin supplementation but insist that my clients seek expert counsel from a licensed registered dietitian, too.)

My goal is not to be a fitness product and health services retail provider. You will see companies listed at the back of this book that provide this service. In fact, these are companies with whom you may want to partner. I don't want to overwhelm my clients with a catalog of options. I stick tightly to client interest and request and home or corporate gym design and layout, and I coordinate equipment purchase for the facility design aspect of my business. I also take note of what I bring to clients' homes. Most clients eventually want to purchase the same equipment for traveling purposes or completing workouts on their own.

Remember the business side when you sell products: customer service and other administrative duties. Selling costs you time, so weigh profitability and balance that with a break-even or profitable service versus a nonprofit value-added service.

Don't forget to look into state or country tax assessment on goods that are purchased and resold. Legally this is important, but it also will help you price products. What do you do with damaged or defective goods? Will the product be shipped directly to your clients or to you? Who pays the manufacturer, you or the client? If you pay, what's the process for the client to reimburse you for the purchase? Do you disclose any markup beyond what you paid or discuss commissions that you receive?

If your goal is to generate revenue and create an aspect of your business that goes beyond an added amenity or convenience for your clientele, you need to be able to purchase product wholesale. That means you should be able to mark up the product or create profit margins that are 30 to 100 percent above your wholesale purchase price. For example, the wholesale cost on a video might be $9.95. It is acceptable to sell the video for twice that amount or a 100 percent mark up. More common markups range from 30 to 50 percent.

Trainers who do very little with wholesale purchasing often pass any savings onto their clients and probably don't yield much buying leverage since they have not cultivated these partnerships. But, if you're seriously into developing this end of your business, you will be able to pass outstanding savings to your clients compared with a retail purchase and still generate substantial income for your business. That's a win–win!

Alternative Revenues

My idea of a successful business is one that progresses from income generated by hourly client visitation to one that generates income even in your absence. Fortunately, personal training offers several options for nontraining revenue generation.

Lease Your Facility to Other Trainers

Many trainers are looking for training facilities where they can train a clientele that is dispersed over a wide geographic area. Business operators who own or lease workout facilities are often looking for other professionals to share their cost, as are smaller, established general fitness clubs. On one hand, many business owners value the option of hiring only employees or being the sole trainer at the facility because all aspects of influence on their business and clients can be controlled. Other owners invite reputable trainers to share space so that they can cut costs. It's a good idea to require some type of technical competency and retain the right to refuse use of the facility for any behavior that voids your agreement.

Charge Clients to Use Your Facility

Consider offering unsupervised workout privileges to clients if the space you work in allows for the extra traffic. Trainers or business owners who pay for or own a lot of square footage sometimes find that offering an optional gym membership to training clients is smart business. Increased earnings can be realized with virtually no additional expense. Your facility cost is already fixed and doesn't cost you less just because you don't maximize its use.

Some owners also offer memberships to non-clients to help defer overhead or may limit the times at which training members or nontraining members can work out unsupervised. Unsupervised workouts may be designated during slower times of facility operation. The key is to preserve the personal and intimate aspect of training in a private facility—if this is not a large, public sports club—as well as providing high-level professional behavior by all who train on the premises. Substantial and consistent monthly income can be generated, which helps a proprietor project earnings and budget accurately. It also moves the owner away from generating income entirely as a result of hourly labor.

Fitness Facility or Home Gym Design and Layout

This business service is not limited to private residential settings and corporate facilities. Apartment buildings and hotels present facility design opportunities. See chapter 16, "Right Workout Environment, Right Workout Equipment." I include photographs, sort of a portfolio, of gyms I have designed in my client introductory packet to promote this aspect of my business.

It is amazing to see workout facilities where substantial money has been spent purchasing equipment yet little thought has been paid to equipment selection, equipment layout, and training environment concerns, like natural light and adequate heating and cooling. These are laughable at best and outright incompetent at worst.

What is your time worth? Generally, I charge per hour for facility design, the same rate I charge to personal train or do other consulting work. Depending on size and whether the site exists or is being built, design and layout can take two to five hours. If a substantial amount of equipment is being purchased and you receive a percentage of the gross purchase, you might want to provide design and layout at no cost. Bottom line: Ask whether it is worth your time. This question will lead you to ask for and receive adequate compensation.

Equipment Purchases and Sales

If you are going to offer a gym-design service, your clients usually will expect that you recommend and be able to purchase equipment at below retail costs. Equipment purchase, delivery, and setup are the aspects of design and layout that many customers desire. You will need to choose equipment that is appropriate to the designated space and individual requirements (see chapter 16) of the people who will use the equipment. Additionally, the equipment should be chosen so that it is aesthetically pleasing and complements the workout atmosphere without compromising function. The package you offer regarding gym design should include access to top equipment and purchasing power that allows you to offer the customer a price well below retail, even if you mark up the equipment to make a fair profit for your time and effort.

Arguably, the easiest way to create this type of arrangement with an equipment manufacturer or equipment retailer is on a local level. This relationship may limit equipment choices if the local retailer can't offer you a competitive price on any piece of equipment you desire. Regardless, it's also a good idea to create personal relationships with equipment product salespeople on a national level. Most commercial-grade equipment companies also offer quality home versions of their top-selling equipment or are eager to refer you to companies that do. You can use the Internet to shop for equipment, too. Any of these contacts can give you information about different types and lines of equipment—an important factor, because the information available changes rapidly. It's essential to attend training sessions that equipment manufacturers offer at major conferences and for local equipment retailers. Your expertise will help you differentiate propaganda and company bias and what is in your clients' best interests.

Looking at various equipment choices on the market increases the likelihood you will receive the best price for your customer and get the right fit. If you think you're stuck with what a local retailer offers or can obtain, you are not representing your clients' best interests. You should be able to explore many options and purchase the equipment that best meets your clients' needs. Since you probably won't want to inventory or carry the equipment because of cost and space concerns, make sure the company or store you've partnered with will "drop ship" the product or inventory the equipment until you can place it in the facility or home gym you are designing. See chapter 16 for more information on how to choose the right equipment and the questions to ask before you engage in a business relationship or purchase a product.

Professional Speaking

Professional speaking can produce revenue, but for most trainers it is more helpful in generating credibility, business visibility, promotion, self-confidence, and new clients and helping you to become a better teacher and communicator. Consumer talks (where you meet the consumers on their own turf) and presenting to other professionals (acting as a trainer's trainer) usually come about when you have a gift for gathering information and presenting it in a new and interesting way or for taking complex information and bringing it to life for the end user. Speaking requires you to speak to an audience on an emotional, mental, and intellectual level. Although you can animate and demonstrate physically, lecturing often requires you to move from demonstration mode to dynamic information delivery. Expert and effective speaking requires practice and training. You know the feeling when you've given the perfect workout or entered the zone during athletic performance. Expertise and top performance do not happen by chance.

When you're ready to break into speaking, start with familiar, nonintimidating territory so you can progress your skills and gain confidence. Consider team presenting—it takes the pressure and focus from you and lends two experiential and expert viewpoints. Potential venues include corporate clients who see this service as valuable to employees, community service and business groups, business associates, and local workshops and conventions for health and fitness professionals.

When presenting workshops to other fitness professionals, consider offering continuing education credits or units to those who attend. This adds value to the presentation from a practical standpoint because professionals are required (licensure) or encouraged (certifications) to keep industry credentials current by accumulating education credits over specific time periods.

Choose topics for which you have interest, passion, and expertise and that you've identified as an interest of your target audience. I question whether professional speaking is lucrative for most who pursue this career, but the promotional and credibility possibilities as well as development of excellent communication skills hold strong. It is not an easy road, but if you have desire and the ability, financial reward looms for the best; top speakers can earn thousands of dollars per speech or workshop day. But for most, personal satisfaction and growth are the prize.

Should you always be paid? You might think that lecturing doesn't cost you anything, but your education, expertise, and time represent cost. If you're new to training or relatively inexperienced as a speaker, a no-pay tradeoff may be acceptable. This tradeoff will help you gain experience and start to build credibility, and you may receive new client interest. If you charge and your name is known, fees should fall within averages in your area unless you are exceptional or you speak on a national level. Find out what other speakers charge. I always ask, "What is my time worth?" I know what I need to earn to book an event. I am happy to fax or e-mail my fee structure and other requirements (e.g., airfare, ground transportation, meals, and lodging) to any interested party. Eventually, you may book lectures and other presentations and require a contract to be signed as well as a nonrefundable deposit to reserve the date in your schedule. Remember, if the event is canceled, you have given up personal or training time for which you are not compensated.

Speaking grows like any career. It is a process that matures with time. If making money is your first thought, don't jump. It was only after years of speaking that I realized the career possibilities.

Working with a speaker's bureau (see the following resources section), which generally is reserved for more experienced or established speakers, has its advantages even though the organization may charge you 20 to 30 percent of your speaking fee. Speaking and its associated duties can become a full-time job. The bureau does all of the footwork; it has contacts and networks that you don't, and it gets the word out. This saves you valuable time and lets you do what you do best.

Speaker Resources

Toastmasters International™

Web site: www.toastmasters.org

E-mail: tminfo@toastmasters.org

Phone: 949-858-8255

National Speakers Association (NSA)

Web site: www.nsaspeaker.org

E-mail: nsamain@aol.com

Phone: 602-968-2552

Informational Sources: Articles, Books, and Videos

Another option is to broaden your base by writing a book or producing a video. But go in with your eyes open. Many published books don't break even or reach very many people; a handful make a lot of money and are effectively distributed to the author's or distributor's desired audience. Most hugely successful books or other information projects are bankrolled by established publishers and producers who already have the capital and advertising or distributing machinery in place. Talent is usually either a well-known and entertaining fitness professional or a celebrity.

The other choice is to publish the book or produce the video yourself. The biggest challenges for self-publishing are sufficient up-front capital, advertising, and distribution. Before you try this, test the waters by writing articles for local newspapers and fitness magazines that provide exercise advice and other credible information to consumers or fitness professionals. This

type of entry into writing may not earn you a lot of money but will give you credibility and practice. Forget the *New York Times* bestseller list, although to dream is admirable, and some dreams do come true! Writing at the national level takes hard work and focus. Develop it as you would your business or speaking skills.

Telecommuting, Telecomputing, or Phone Coaching

A lot has been written about telecommuting and the possibility of running a complex and full-time business from your favorite ski resort or second home because of recent advances in technology. The thought goes something like this: "Wouldn't it be desirable to run your business from a location where you'd really like to be!" Using the phone or Internet, which doesn't require you to be physically present with the client you are counseling, certainly provides additional options that can leverage your time and ability to generate income efficiently. Plus, it can be a valuable service to the fitness consumer.

Phone coaching or Internet coaching is not for everyone, and many professionals are in fact concerned about the negative side of advising clients via the phone or Internet. The question that is often raised is, "How thorough, complete, and safe can phone coaching be?" This is a fair and relevant question, but I believe that when the information comes from a competent professional who carefully words and qualifies his or her recommendations, this guidance is better than a consumer trying to figure out programming direction alone via Internet surfing or consulting other sources that may not be reputable.

Many times the consultation serves as a great motivator, check-in, or update. It creates a sense of accountability, fosters commitment to goals and schedule, and encourages progression. At the least, it can serve as a powerful guiding and mentoring avenue available to anyone, independent of location. It leverages the trainer's and the client's time! The limitation is personal contact and correction. However, with the increasing use of digital cameras, e-mail photos, and video streams, it is possible to create the next best thing to being there!

The trainer can more effectively use dead time in his or her schedule to administer this

part of the business. Neither trainer or client needs be present as information and questions are passed back and forth. Phone coaching also creates a stimulating challenge for many trainers who must research information, organize it, and deliver it to their off-site client. It really is fun, stimulating, and challenging.

Business logistics require that you set specific parameters and costs for involvement. This part of your business is no different than the business policies discussed in chapter 3. Using the Internet, designing a Web page, and using e-mail win over using the phone, in my book. I limit time on the phone to necessary personal contacts and consulting conversations. Using the Internet is more efficacious for everyone involved.

Insurance Company Billing and Reimbursement for Services Rendered

Is it possible for a personal trainer to receive reimbursement from a client's insurance company for training services? Historically, reimbursable service was set up for licensed professionals. Trainers do not have a right to expect collection of money from insurance companies because the contract is between consumers and the insurance company with stated services covered. Most insurance companies only reimburse covered services provided by a licensed practitioner.

More often than not, the services provided by nonlicensed health or fitness education specialists will not be recognized by insurance companies for direct reimbursement. In most cases, it is easiest to receive indirect compensation from insurance companies when the health care or allied exercise specialist is employed directly by the physician or physical therapist and is performing under the guidance of the licensed individual. If you can align yourself to work with licensed professionals in their practices, you will be in the best position to receive compensation for claims that are reimbursable by insurance companies, and you'll be in the best position to grow with this changing area of medicine, fitness, and preventive health care. (Refer to chapter 1 for more information on this topic.)

Special Populations

Think specialization when contemplating expansion of your service. Working with high-need or high-risk clientele is an exciting option and important for business growth. Today's personal trainers are generally more qualified, and, as discussed, trainers have become more credible and attractive to physicians and other health care professionals. Because of this, incredible opportunities have already opened up in this area for the personal trainer.

All trainers eventually will have the opportunity to work with a higher risk client. This expands your market potential for prospective clients and increases your positive impact on the lives of others. Don't discount the immense personal reward that awaits those who make a difference for people with special needs. Their gratitude and respect are immense. A huge market segment exists that simply needs a basic, consistently performed exercise program (see part IV, "Working Safely and Effectively With Special Populations," for additional discussion).

A Final Word

Most trainers generate the majority of their income by working with clients. Don't let other revenue possibilities jeopardize what you do best and what is the mainstay of your business—which is offering personalized training service.

Personal training always comes back to, and success depends on, the trainer–client relationship. Your money, business, success, and personal reward of making a difference in clients' lives depend on this one-on-one connection.

Whether you're overseeing a business empire, contemplating expansion and new revenue streams, or working as a sole proprietor, you must keep the trainer–client relationship in mint condition. Businesses go nowhere if this insight is not adhered to tightly. Independent of what you choose to do with your business, always keep in mind the client's best interest and focus on providing outstanding service—service that goes beyond the norm or what might even be described as great service. Move client care to the next level and keep it there!

Managing Your Time

Now that you know how to get your business off to a great start and keep it successful, let's take a look at how to manage what none of us have enough of—time. After all, how can you care for, nurture, and serve your clients and staff and maintain a balanced personal life if you're maxed out to the point of breaking? You and your business are probably off track if you hardly have the time to take a breath, let alone a rest room break, and you don't even like being around yourself! Awareness that a problem exists is the first small step toward change. Periodization, program planning, and running a business require time. To thrive, you have to manage time through smart and disciplined planning and by using the age-old practice of delegation.

Do you control the clock or does the clock control you? Businesses are built on scheduling and service, and nowhere is scheduling more important than personal training. One-on-one training, by its very nature, is a labor-intensive session-by-session endeavor. Training daily and overseeing necessary business operations can consume all of your available time. Add the requisite hours of educational updates, planning, and follow-up phone calls, and you've got the ingredients for a personal or business meltdown. The relentless and time-consuming nature of personal training can wear you down.

10 Tips for Effective Time Management

Any business, especially a single-ownership business, is vulnerable to time mismanagement. Whether you are a sole proprietor or an owner who oversees a larger operation, some-

one has to micromanage the day-to-day reality of personal training. A few simple steps will help you use the finite amount of time you have to your best advantage (Durrett 1994).

1. Set the hours you are willing to work. When I started working with clients one on one, and then later as my personal training business began to grow quickly, I worked whatever hours were required of me. My business ran me. I was proud of my ability to "handle it" and could usually one-up someone else's story of overindulgent business endeavor. Without a doubt I had forgotten who controlled the clock—who could say yes or no to more business and commitment. I fell into the greed/ego syndrome that I mentioned in chapter 2.

If I were opening a business or starting a new career working for someone else today, I would still probably commit endless energy and time toward that end. However, as soon as the business was operating smoothly, I would regain control of my schedule. (If you've been saying that you are going to slow down and make a change for years, you're in trouble!) The problem lies in the following. Once you have set precedent, people resist change. Your 10 P.M. client may not care whether you've been on the go since 4 A.M.; he or she just wants a convenient schedule. Sometimes you do whatever it takes to launch a dream, but don't let it evolve into martyrdom. It's not always easy or comfortable, but you can untangle messes (schedules and commitments) that you have created. For one, give incentives, be honest, and be direct.

Today, I set definite parameters from which I am willing to schedule business. I reserve most evenings for family and personal time. Most trainers need at least one full day away from the "office" per week. There is always work to be done. To compound the problem, business

associates or clients can page, e-mail, leave voice mail, call your cell phone, and otherwise drive you to total distraction and insanity at their pleasure—if you let them. It is essential to practice disciplined scheduling, say no to unfinished work and new opportunities when necessary, be selective about responding to demands, and understand the value of time away from work and how all of these elements contribute to overall well-being and productiveness.

2. Plan your business time within specific hours. Set the hours you are willing to work. Investing a small amount of time in organizing will save time in the long run. It's wise to choose an organizational tool to assist you. You'll need a day planner that contains a weekly planning option, a monthly calendar, and a yearly planning calendar. You need to be able to record phone numbers and addresses as well as have a section or space that accommodates to-do and reminder lists. Follow-up and attention to detail are very important. Why clutter your mind with details you need to attend to and that you'll probably forget unless they are recorded?

Remember to schedule not only your business day, which might include studying new fitness information, training clients, following up on client requests, billing, record keeping, and recording client progression, but also your personal schedule. Personal commitments will include designated time for your family, friends, and self.

As much as I depend on computer and software technology to run my business and to help me record and plan workouts, I prefer a daily planner that requires me to commit my schedule to paper. The particular planner that I like is small, about five by eight inches, and lets me see my schedule with a week-at-a-glance format (two pages show my entire week), rather than a day-per-page look (seven pages for the whole week). If your handwriting is large, or the week-at-a-glance setup is too cramped, by all means find a format that works for you.

Using small data-based computers that fit in the palm of your hand is another great way to organize your schedule and appointments, make notes, and keep important addresses and contact numbers at your disposal. Voice pagers are also a useful tool because a client can contact the pager and leave a message

about a cancellation or schedule change and you don't necessarily have to call the client back immediately.

I use a cellular phone that functions as a minicomputer. It has a number of functions that allow me to make notes and has a virtual address book of personal and business contacts contained within its microchip memory. I can easily stay in touch with my clients via e-mail and voice mail with the cell phone as I travel or otherwise use potentially nonproductive business time. The use of a cell phone increases my availability (I can turn it off when I don't want to be available!) and ability to deliver timely customer service, not to mention the time it saves me.

I effectively use my laptop computer as a time-saving machine, too. My laptop is my entire office on the go with regard to information, technology, and ability to contact my clients (if I interface it with my cell phone). If my laptop is with me, I can always accomplish work that is waiting for me back at the "office" or I can visit the Internet and access a wealth of information. Because "homework" is always waiting for me, I also need to know when to shut off the communication and information highways. This plot to undermine balance in my life—ever lurking in a variety of forms—is why I schedule my days and stick to that schedule most of the time.

The key to keeping your business operating within your stated business hours is to efficiently use the time you have available to you during these hours. This often limits the need to work around the clock.

3. Set and preserve personal time. Guard personal time like a lioness would her cubs. Commitments to family and spiritual beliefs, personal workouts, and personal quiet time or downtime fall into the category of can't-miss "appointments." When it comes to keeping these appointments, I am the least flexible with regard to change. Personal time promises should be etched in stone.

Personal priorities should require a regular time allotment, so schedule them! This type of scheduling does not happen on its own, and in fact, if given the chance, a majority of trainers will schedule business agenda before self-time. Disciplining yourself to honor appointments

that are scheduled for your well-being will pay huge dividends with regard to balancing your life and increasing personal productivity.

On your deathbed, you will not agonize about not having had enough time to train just one more client or make one more business call or deal.

4. Review short-term daily goals, determine the next day's focus, and plan for each week. Stick to your daily, weekly, and monthly plans. At the end of the day, take a quick look at what you have just completed and make any minor adjustments to the next day's schedule. At the end of each week, assess what you have and have not accomplished and plan for the following week.

5. Prioritize to meet your goals. If you are not accomplishing your daily goals, differentiate between goals, busywork, activities, and accomplishments. Prioritization rules here, in relation to the goals you want to accomplish. In other words, was what you completed during the day written on the schedule? If not, you're getting off track. There's a good chance that what you are doing is somewhat easy, mindless, or fun rather than productive. Anyone can keep busy or engage in distractions for an entire day. But it takes discipline and focus to organize your time directly around goal attainment.

Distractions and activity not related to goal accomplishment should be labeled time wasters. This is not to say that your desk should never be cleaned or that you shouldn't learn how to use new software, call family members you haven't spoken to in a while, surf on the Internet, or play with that new training "toy." The question that you need to answer is, "Do the day's activity and work choices pay off in results that keep my business growing and successful?" Is your personal freedom preserved? Fill your day with accomplishment, rather than busyness! Schedule it and do it!

6. Stay on schedule. If you start and end sessions on time, falling behind in your daily training schedule should not be a problem. Professionally communicated, this policy states that you are a busy professional yet still care deeply about the client. To honor your clients and other personal as well as professional commitments, it is critical to begin and end sessions on time. Or, for example, instead of running sessions

over or "wasting" time during sessions, follow up on a client request by doing the necessary homework and reporting back to the client during the next session.

Falling off schedule can have a disastrous, domino impact on your daily schedule. Not only is it unprofessional, but it also will frustrate and anger your clients who expect to start sessions promptly and leave on time. You'll begin to feel the mounting dissent and stress, which will take an emotional and physical toll on you. It's simple. Stay on time and you can avoid that feeling of always being behind, being in a defensive posture most of the day, and not delivering high-quality, professional service.

7. Use technology to save time. As I mentioned previously, technology plays a huge role in my ability to use time efficiently. Technology helps me to complete work in a specific time frame yet still have a quality personal life.

Although I could not get along without a computer and requisite software, cellular phone, e-mail, the Internet, various phone systems, and voice mail, any professional must maintain control over technology. Are technological advances controlling you, or are you wisely using this technology to move your business forward and make better use of your time? If technology is requiring all of your time, it has the upper hand and you need to learn how to shut it down. Don't let technology overwork you and control your life. I would guess that no businessperson would truly want to hang out a sign that says, "Open 24 hours per day." Yet, the temptation is to do just that. Remember the schedule you have created and stick to it. Shut off technology and power down on a regular basis.

8. Avoid downtime during business hours. During scheduled business hours, be prepared to maximize the use of any unplanned downtime. A client may cancel at the last minute, and even though you're probably being paid for the late cancellation, why not take advantage of this time by knocking out some administrative work or by working out? Here's the point: If you prepare for the unexpected, you can take advantage of any opportunity presented. Nowhere is this more true than as related to my air travel or client schedules. Airline delays and cancellations are rampant. I never feel victimized because I always travel with my

laptop, cellular phone, and copious professional reading materials. When I'm in the car traveling to clients' homes or the airport, I listen to educational cassettes, designate the time as personal or meditative, or make business or personal phone calls.

When I shut down, I shut down. When I work, I work. When I am operating in my scheduled blocks of business time, I want to accomplish the most amount of work possible so that I can weigh this accomplishment with the good feeling I have when I engage just as whole-heartedly in my scheduled personal time.

If you travel quite a bit to meet your clients at their homes or other locations, try to schedule appointments that are consecutive and in the same vicinity. Consider limiting your travel time from 20 to 30 minutes and learn to eat while on the run. Water, juices, fruit, bagels, cereals, yogurt, and other healthful, low-fat foods are a must to keep you fueled and productive.

Whether you are traveling or dealing with schedule changes or cancellations, or you have the odd half hour between clients, be sure to have your workout clothes with you as well as the technology or other resources available that allow you to use every scheduled business minute to your advantage. Expect the unexpected!

9. View delegation as a time management necessity. As your business grows, you cannot train every individual who desires your services, nor do you want to. Eventually, if you'd like to capture this business and leverage your income earning capacity, you will need to consider hiring other trainers. At some point, you will ponder the dual role of trainer and business administrator. As discussed in chapter 5, delegating is a critical part of effective business administration.

Delegation will at some point in your career provide personal freedom and give you a balanced approach that helps you to effectively manage time in your business and personal life.

10. Realistically allocate time to your personal and business life. Years ago, I honestly believed that I could train 10 clients per day, handle any other unforeseen emergencies or tasks, and maintain a personal life. I think what fooled me was that this type of schedule seemed to work on paper. But, as I found, overcommitment was the beginning stage of the greed/ego syndrome and indicated a dire need for a reality check.

It is doubtful that a nonstop schedule focused on making money and taking on all business opportunity can serve you or your clients optimally. Before you take on more work, consider creating a waiting list (Or, raise your rates so you don't feel compelled to take on more clients!). Either choice represents a good time management strategy and allows you to focus more energy toward the clients you have as well as providing the necessary time for you to create a sane plan of action. Don't spread yourself too thin, and recognize when it's time to hire other trainers.

Bonus tip: Take good care of yourself. Take good care of yourself and you can take good care of your business, clients, and family. If you don't have symmetry in your life, your business cannot be on track. Training clients daily and running a business can be brutal work from an emotional and physical perspective. Time management is part of what permits you to stay in top mental, emotional, and physical shape.

Notice Where Your Time Goes

Closely monitor the efforts you put forth for your clients. Are you spending endless hours on the phone counseling, encouraging, and motivating your clients? Try to limit most of your interaction with clients to training hours or a scheduled counseling session.

Although the client receives your expertise, insight, and program design capabilities as part of the training package, unlimited and frequent access outside of training hours is unacceptable. You will spend copious amounts of time on your client's behalf researching and answering client queries, designing and periodizing programs, talking to his or her health care professionals, keeping records, and sending medical and progress reports to doctors or insurance companies. (Incidentally, reports required by insurance companies take time, and you can bill for the time you spend. Make sure you are compensated for this time even if the billing occurs through a licensed health care professional.) These duties are attached to a personal training job description that is client centered and service oriented.

How do I deal with requests from clients that I anticipate will require a lot of my time? If I need to read something to gain perspective, I ask them to drop off the information, send it by mail, fax, or e-mail, or bring it to the next session. If the issue seems to require a counseling session, I ask the client whether he or she wants to schedule a time in addition to regular workouts or would prefer to replace a regularly scheduled workout with this information session. I also suggest that we can discuss the issue at one of our future training sessions as we work out. In any event, I always note the query in my appointment book, do any necessary background work regarding the question, and follow up on the request, even if the client forgets!

Scheduling can be a potentially huge time waster. If you do a lot of scheduling weekly, you're wasting not only your time but your client's too. By the time niceties and chit-chat are exchanged and you've traded several voice mail messages with the client you're trying to schedule, you can waste numerous hours every week. Encourage your clients to commit to fixed appointments on a regular basis. Convincing a client to commit to specific days and times involves letting the client know why it is to his or her advantage. Not only does it save time, but the client can (1) reserve the time that is best suited to his or her schedule, (2) prevent being pushed off of the schedule because someone else takes that appointment time, and (3) ensure regular attendance—all of which move the program forward. I strongly encourage all of my clients to reserve preferred times in my schedule. Otherwise, I can offer no guarantees that the time will be available. Prescheduling is part of client–trainer commitment to one another. It makes perfect sense.

Delegate

The obvious question to answer next is, "How do I accomplish time-intensive tasks?" *Delegate* is the first word that comes to mind. I could try to do it all, but I don't want to, nor do I have time, nor is this the wisest use of my time. Most self-starters have trouble with delegating. Delegating requires that you identify people you can trust who will act as good representatives of you. These individuals will carry out any assigned duties as completely as you would. There's the catch. Can anyone do as good a job as you could? The answer is probably, yes, and better. You'll never know until you let go and commit to people who can and want to do the job. The more quickly you get comfortable with handing off tasks, the quicker you'll be on your way to running a business, instead of the business running you down.

Two options that optimize your time include delegating work internally in your business and hiring outside services.

Trainers often tell me that it's hard to give other individuals authority and equally difficult to not try to do everything themselves. When a business grows, however, this inability to let go predestines you to a fast track that can lead to burnout. Delegation is easy, and once you experience it, you'll never go back. Ask yourself, "Do I want to work at the business or have the business work for me?" In other words, you must learn to run your business or you'll always be tied to daily tasks required of the business. The second option controls you, whereas running your business liberates your time and maximizes your earning capacity.

Use Internal Delegation

If you're what I call seriously busy—you can't take on any more clients because your schedule doesn't allow, you wake up with training on your mind, and your administration tasks have overwhelmed you—then you've probably already considered hiring another trainer. As you add trainers to your payroll, consider hiring trainers who also can provide administrative assistance.

A trainer who can function in a dual capacity has increased value from your perspective, and the arrangement may be an advantage to the trainer as well. This dual role not only allows the trainer to earn money from working with clients one on one but also allows the trainer to draw a base pay for business-related tasks. Many trainers thrive on the diversity of an appointment like this. It doesn't limit them to a relentless grind of one client after another as the only means of earning income. Numerous trainers I have hired over the years have had an outstanding array of business skills that

I have used to help run my business. I have interviewed trainers who have accounting and certified public accountant (CPA) credentials, law degrees, business administration skills, marketing and advertising expertise, and design capabilities. Most are excited about combining these skills with a career in personal training.

Generally, I have found that potential candidates who are new to the field are most likely to be interested in and excited about such an arrangement. Simultaneously, they are able to receive "trainer training" and further their training experience under a mentoring situation as well as help in other aspects of my business. Besides fostering commitment from the employee, this situation can make the trainer feel a part of my business. The trainer quickly realizes there is more to training than working out clients. A person who is employed in this capacity gets to experience the big picture of training and can appreciate the employer's perspective. This, in turn, can foster a mutual respect and appreciation for the details of running a personal training business. A relationship like this can lead to an ongoing business partnership.

A personal trainer who also works as an administrative assistant can take care of business tasks during nonpeak hours or when the trainer has an opening in his schedule. But if you assign only administrative tasks to him, it might not be long before he leaves. Your agreement should be based on furthering his personal training skills while taking advantage of a business-related specialized skill. Consider this as a basis from which to evaluate whether the trainer will play a significant role in the growth and operation of your business. I make no promises but plant the seed regarding my desire for long-term, committed relationships. Delegation is good for both the business owner and employee. I embrace the concept and love to surround myself with talented, confident people who want to be responsible and have some sense of ownership in my business. If I can foster in my employees a sense that my business is their business, then I've done a good job of hiring, nurturing, and compensating these individuals.

The base pay can reflect a set retainer fee per week for the expected number of hours the employee will involve him- or herself in administrative tasks, or you can pay a flat hourly rate for any administrative work. The hourly fee (or retainer salary) should be lower than the personal training rate and in line with temporary office or secretarial help.

Don't pressure someone into a role he or she doesn't want to play. Keep your covenant with trainers who are willing and excited about this diverse employment option. Train the people who accept this responsibility and spend time with them. Treat them with respect and let them know you appreciate their work. Tell them how they are important to you and your business. Trust them, thank them, hold them accountable, and then let go!

Use Outside Services

Do what you do best. For everything else, consider using outside services. Hiring outside services, when it is cost-effective, saves you time, allows you to use your time more effectively, and results in a better product and service.

A number of services for hire can substantially ease your burden and take the pressure off of you. Think of these services as hired guns to do tasks you don't want or have time to do.

One of the first services I hired was a CPA. This person prepared my annual tax filing and estimated quarterly taxes for the next tax year. Soon after, I hired a part-time bookkeeper who kept my billing statements going out on time and made sure they were accurate, kept my accounts receivable up to date, notified my clients of any delinquent accounts, and paid my business and personal bills. These two services saved me precious hours per week.

You can control costs when hiring outside services by specifically stating what you need accomplished. Most of these services require payment by the hour. If you want to control costs, find out what you can do ahead of time to minimize time involvement by the hired service. Additionally, if you live in an area where you can hire college students for part-time administrative work, this can be cost-effective.

Consider hiring services to accomplish chores that include housecleaning, janitorial and towel services at your training facility, cleaning the car, and others. Should you hire a service? If doing so saves you time, provides a better result than you could provide, and costs you less than the income you could generate by doing what you do best, the answer is an obvious yes!

Without question, hiring outside services or delegating tasks to employees is frightening to the entrepreneur who has carefully cultivated a business that is his or her "baby." Probably, you are where you are today because no one else could or would do the job that you do with the same completeness and commitment. This is a common concern and belief of many successful small business owners.

Are you trying to move your business to the next level or preserve a personal life? If so, hiring outside services or delegating tasks is a critical and absolutely necessary step. You'll later question why you took so long to embrace this freeing concept. Using outside services will free you to engage in what you do best, which is training clients, mentoring other trainers, maintaining and generating new business, and providing a high quality of service. Delegation makes perfect business sense, and your personal life will thank you, too.

How do you find competent outside services? Identifying these services is accomplished in the same fashion by which most of your clients find you. Using word-of-mouth referrals is the best way to find an individual or service that you can trust and rely on. Ask your clients, advisory board members, and other business acquaintances for referrals; then, thoroughly investigate the service or individual.

Hire Help With Taxes

I often see trainers struggle with taxes. If you are thinking you should pass this burden on, you're on the right track! Filing your own taxes involves quite a bit more than just owning accounting software. Although financial software can help you stay on top of your business' profit and loss statements or minimize costs when hiring a certified expert to file your annual tax return, such software alone won't let you take advantage of every tax write-off. I'm not encouraging you to ignore your financial status. But, few trainers have the time or expertise to take advantage of ever-changing tax laws. Not hiring an accountant will cost you money if you don't know every tax write-off available to you or if you spend time on taxes that could more profitably be used training clients or growing your business.

Accountants can save you time and money. They can help you organize your approach to record keeping and educate you about what you can and cannot deduct. If you want to save money, ask the accountant in advance how you can organize your receipts and record keeping to save the accountant time in preparing your tax return.

Your expertise is personal training, not accounting and tax return preparation. Besides allowing you to focus on your business, using an accountant will give you peace of mind knowing that your taxes have been filed correctly and professionally. In the event of a financial audit, having a tax professional on your side from the beginning will make the audit less emotionally trying and ultimately will save you personal time as well as money.

Choose an Accountant

Choosing an accountant is part of building your team. Although it's prudent to have a relationship with a banker, an insurance broker, a stock broker or investment manager, an attorney, and an accountant, it is not always easy to find or afford an individual who understands your business needs. As is true in any situation that requires you to gain new knowledge and insight, you must be able to speak the language of the professional from whom you are seeking help and ask the right questions. However, an accountant who is sensitive to your needs and understands you are not the expert will help you appreciate the difference between bookkeeper, accountant, and CPA.

Start the search by asking your clients, other trainers, or acquaintances who they use. When you interview, ask these key questions:

- What is your background?
- What is your knowledge of my business?
- To which professional organizations do you belong?
- What is your fee structure?
- Will you provide business-related referrals?

➤ Adapted from Piccone (1997).

When you're ready to enter into an agreement, have the CPA or accountant prepare an "engagement letter." This letter references the agreement between you and the accountant with regard to services to be rendered, your responsibilities, and the fees and payment terms.

Use Computers to Ease Time Burdens

A lot of what you do in your business should be based on shrewdly using your finite amount of available time. Personally, the worth is incalculable when I consider lost time that could be time spent with my family and friends or recreating.

Part of the solution to easing time burdens is enlisting the help of technology. You can't make choices on how to use available time if you're using all your time trying to keep up with your business. If you find yourself thinking that there is never enough time in your day to accomplish tasks, consider embracing technology that will work for you.

Affordable computer technology can help you do the following:

- Minimize the cost of training clients
- Design, plan, and keep records of client progress
- Send out invoices and billing statements
- Develop and update business policy and client introductory packets
- Solicit new business and find new revenue streams
- Evaluate and train your staff
- Keep business expense records and tax files
- Access educational updates
- Identify and evolve your business-related services
- Create advertising brochures
- Communicate with staff, family, and clients

A computer, printer, and necessary software are musts for growing businesses and business owners who are looking to operate their businesses most profitably and efficiently. If cost is keeping you from moving in this direction,

realize that computers and printers can be purchased used. If learning to use a computer intimidates you, affordable computer classes are available through adult education programs and colleges. Technology plays a huge role in preserving personal freedom. User-friendly and application-oriented technology is part of any growing and proficient business.

Make Technology Work for You

I know from experience that learning to use new technology can make you want to heave your computer right out the window. However, after the initial setup and once the necessary data have been entered, you're ready for smooth sailing. I can assure you that once you're up and running, you'll wonder how you ever survived without computer technology or a particular software package.

Use consultants or toll-free hotlines, online help, or written manuals to speed up the learning phase. There is a time cost, not a time savings, in the initial learning phase. If you believe technology is the right idea but you're still struggling with the "beast," consider the following: Most trainers' strengths lie in running a personal training business and giving specialized attention to clients. Do what you do well and hire outside consultants to speed you along in other areas, like getting software to run or using computers to make your life easier.

I ride my mountain and road bikes; I don't tune them. I ski and snowboard; I don't wax and sharpen edges. I use my computer; it works for me; I don't try to understand it. I could probably do it all, but I don't have time, and these tasks don't ignite my passion. When it comes to technology, I find qualified consultants and tell them, "Just make it work, tell me what to do, and I'll use it." It's all about time management.

Use Effective Business Software

Using computer software like Quicken, Quick Books, or Microsoft Money allows you to handle fiscal data once, not several times, and the software has the capability of printing out just about any kind of cash flow report you want. Once data are entered into the computer, calculations and financial updates occur automatically. These programs require some computer

know-how, but anything can be learned. Not only is computer software like this very helpful when it's time for you to file your annual tax returns, but the current financial data available to you at the click of a mouse can assist you in obtaining loans and figuring estimated quarterly taxes as well as projecting expenses and profit and loss statements. Without a doubt, computers and software save precious time by streamlining your business operations.

Use Fitness Programming, Testing, and Record-Keeping Software

Personal training program software can help run your business and ease programming administration and planning burdens. Many packages are available to help you plan and periodize your clients' workouts, assess client fitness and nutritional status, keep records, evaluate medical history questionnaires, schedule appointments, and print customized plans and performance charts and graphs. To receive all of these services you will probably need to buy more than one software program, but the time that you save by using this software makes it a worthwhile investment.

Not only can software packages provide all of the benefits mentioned, but technology in the form of slick program printouts and graphs will impress clients with an air of professionalism and ultimately will help you retain clients. Because software programs have different application emphases, one is not necessarily better than another. Instead, determine what the software package needs to accomplish for your business. Does it offer too much or too little? Is it just right with regard to content, or do you need two programs? Is it easy to use and logical compared with how you run your business?

Try It Before You Buy It

When you are considering any software purchase, try before you buy. Often, versions of the software you're interested in are available to test for a limited time. You may be able to download the software from the company's Web site. This will give you an idea of how the program operates. The download or demo disk you receive from the company usually has an expiration date that is activated once you use the freebie, or the sample provides a limited selection of the software's features. After a short period of time, usually from a few days to a week, the demo disk program will automatically be erased. Generally, you won't receive a demo version that gives you the entire program, but you get enough information to figure out whether the program fits your needs and whether it is user friendly.

Ask acquaintances whether they run one of the programs you are interested in. Query them as to what they like and don't like, and ask for a personal demonstration at their convenience. "Try before you buy"; no matter how enticing the software offer is, if I can't try, I usually won't buy. The exception to this rule might be an unconditional guarantee from a reputable and trusted company, although this type of offer is not common. If an offer looks too good to be true and offers no trials, demo disks, returns, or guarantees, you need to look elsewhere.

Use Software for Personal Trainers

The software listed next have received favorable reviews from various professional organizations, publications, or other trainers. None of the programs are perfect. Do your homework and investigative each carefully. Try before you buy. Two software programs that I have found to be extremely helpful are BSDI's Fitness Analyst–Personal Trainer Edition and Summit's Personal Trainer Assist. Companies are listed alphabetically. All costs are approximate and subject to change.

Biometrics Inc.

Developer of PC Coach software. This software is especially effective at tracking runners' and other endurance athletes' programs.

System requirements: Windows®/PC or Macintosh

Cost: $24.95 to $295.00

Web site: www.PCCoach.com

Phone: 800-522-6224; 303-442-1818

Brittingham Software Design Inc. (BSDI)

Developer of the Fitness Analyst™ software. This software provides a wide variety of fitness reports as well as programming and record-keeping or tracking options. Although the software's strength lies in these areas, it offers much more, including programming that looks at the business side of your personal training business.

System requirements: Windows®/PC

Cost: $399.00; Personal Trainer Edition allows you to track up to 100 clients. Another version provides single-station usage for an unlimited number of clients, whereas the club version has capacity for use by an unlimited number of trainers to track their clients. Networking features are available.

Web site: www.BSDIFitness.com

Phone: 888-273-4348; 908-879-4991

SporTRAC Fitness

Developer of SporTRAC software. This software includes fitness and nutrition components.

System requirements: Windows®/PC

Cost: $39.99 to $99.99

Web site: www.SportTrac.com

Phone: 614-261-6030

Summit Training and Education

Developer of Personal Trainer Assist™ software, an outstanding program that can help you plan and periodize your fitness programs. The program gives you ready-to-use periodized program recipes for a variety of activities or allows you to customize the approach to periodized training.

System requirements: Windows/PC

Cost: Approximately $150.00

Web site: www.the-summit.co.uk

Phone: 44 (0) 114 224 2624 (United Kingdom)

UltraCoach

Developer of UltraCoach software, which is especially helpful to triathletes and other endurance performers. Versions are available for multiple- and single-sport endurance athletes.

System requirements: Windows/PC

Cost: $19.95 to $79.95

Web site: www.FitCentric.com

Phone: 800-400-1390; 909-625-0463

Willow Creek Publications

Developer of Personal Trainer Business Manager for Windows software. This software edition is best used by trainers or business owners who are already familiar with computers and are running Windows programs. This program can facilitate scheduling as well as help you record income and expenses.

System requirements: Windows/PC

Cost: $69.95 to $249.95 for club version

Web site: www.FitBuy.com

Phone: 800-823-3488; 303-823-3488

For accounting and invoicing purposes, I run the Quicken program for personal computers (PCs). In my company's office we have switched from Macintosh computers to a networked system of desktop PCs and laptops. With the advent of Windows for PC users, I recommend PCs for new computer buyers or computer system upgrades, unless you have a specific need for Macintosh that is related to desktop publishing or photography. Windows now makes PCs as user friendly as Macintosh. Because much of the available software is compatible with PCs, this makes good sense.

Capture the Power of the Internet

Learning to use the Internet effectively begins as a labor of love. As with attainment of any new skill, there is a serious, although short-lived learning curve. You will not become proficient unless you spend time and roll with the speed bumps.

First, make sure your phone service is in line with your business needs. A majority of business operations still rely on a single line to do business. If you use one line for voice mail, faxes, and Internet access, reconsider this arrangement. Having a single phone line can cause you to lose business if you miss calls, or it can generate an unprofessional image (if you're never available) to callers. Additionally,

call waiting, for example, is eminently unprofessional and irritating, not to mention stressful to the person trying to juggle multiple calls.

Small business owners can maximize their phone systems with multiple lines, DSL (allows more than one user to simultaneously use a single line for the Internet, faxes, and voice mail), distinctive ringing, voice mail, and call forwarding. These features will limit office expenses but, more important, will eliminate missed communications with clients or potential customers and will present your business as efficient and professional.

Electronic Mail (E-Mail)

If for no other reason than e-mail, purchase a computer and get online! Having e-mail capability requires an address from which you can post and receive messages at any time, anywhere in the world, from other individuals who also have e-mail capabilities. Generally, your e-mail address should incorporate your business name or personal identity. You must have an Internet service provider (ISP) to access the Web and to send e-mail. Check with providers in your area to ascertain whether any restrictions apply to "customizing" your e-mail domain name. For example, some ISPs require their domain name to be part of your site's name.

E-mail has to be one of the most efficient and cost-effective means with which to communicate. I save hundreds of dollars, especially when communicating internationally or across the country, as well as saving countless hours related to nonproductive chit-chat. With e-mail you can eliminate the initial introductions and casual conversation that often occur during a phone conversation. E-mail is virtually free, it requires no long-distance charges, and you can focus on the task at hand. Type the message, send it, and you're done. Because it only takes a few seconds to send or receive a message and costs little or nothing to have the service, e-mail is an amazing communication tool to have at your disposal.

Accessing Information on the Internet

Is the Internet shackling and frustrating you, or have you learned to unleash its power and have it work for you? If you've spent any time "surfing the net," it's probable you have been overwhelmed by the sheer volume of information available. My own initial experiences with surfing resulted in information overload. But once you learn to effectively navigate the Internet, what it has to offer is, indeed, quite astounding.

How can you separate the junk from useful information? Several useful tools can help you navigate the World Wide Web (www) and the Internet.

Search tools like Navigator, Dogpile, Yahoo!, Alta Vista, and Google hold the keys to opening information doors. But still, sometimes these "search engines" find too much. After you type in a word or phrase, the search engine retrieves all available information on the topic you've selected. You may have thousands of possible sites to search. For example, key words like *fitness* and *aerobics* can yield several hundred thousand hits. The more specific your subject request the better, because this will reduce the number of irrelevant hits that the search engine discovers. Proven address sites will help you to separate gold from garbage.

Bookmarks (like an address book) allow you to store specific sites you visit often and find useful. When you click on the bookmark command, the computer will store the site of this location for easy access and future use. It's irritating and time-consuming to type in addresses time after time, not to mention that it's easy to enter the wrong address.

I have found that the key to effective information access on the Internet is to accumulate a list of Web site addresses that are specific to your needs and interests. Time is money and wasted time is frustrating.

Ask colleagues about the sites they visit often and find useful, and request the addresses if the sites seem to apply to your needs. Keep your eyes peeled for Web site addresses that come highly recommended in various media sources, too. You will find helpful information that can serve your business and meet your physical programming needs as well as health and fitness interests. The resources and addresses listed at the back of the book are worth examining.

Being organized, having the ability to access information, and using time-saving devices in your personal and business life can help you deliver the "goods" to demanding clients. You need to know what you want to manage in your business and personal life and, in this case, that relates directly to time commitments. Use this finite amount of available time carefully; it will shape your business and reflect who you are!

Maintaining a Service Focus

A successful business considers the needs and feelings of both client and trainer. Clients require special care, relationship maintenance, and nurturing. The trainer needs to be cared for, too. This holds true whether you're the only trainer in your organization or whether you supervise other trainers. Ultimately, the success of any business comes back to whether the trainer is accomplishing the job for the client. Although it's a challenge, the success of your business depends on your professionalism and your commitment to providing the best possible client care.

Being a Professional: 12 Commandments

Even though personal training is self-governed, we should demand of ourselves certain minimal standards of ethical and professional conduct. To follow are some tips—let's call them the 12 commandments—I learned in my early years of training.

1. **Share ideas and innovations.** Too many trainers, clubs, and studios believe they must guard operational or program information to survive. Actually, this attitude is more likely to contribute to the downfall of a business. Honesty and sharing upgrade the entire profession. Instead of being insecure and threatened by competition or evaluation, we should share our trade secrets. A trainer who shares gains in two ways: new knowledge and new perspective. Personal growth occurs when you seek engagement, look for new ideas, and risk positive critique. I have learned much over the years from speaking engagements by chatting with my audience before, during, and after the lecture. I always take home several outstanding

pearls of wisdom, tricks of the trade, and wonderfully different viewpoints. The same holds true regarding my interaction with other personal training business owners. Trainers who live in your vicinity are your peers, not your competitors or the enemy. Stretch your mind a little by sharing. Everybody wins.

2. **Practice what you preach.** Live a lifestyle that centers around what you teach. Then it is much easier to influence your clientele. You should make lifelong commitments to health, fitness, and personal well-being. Your clients should know this by your example, not by words alone. That means simple things, like eating sensibly in restaurants, limiting your intake of alcohol and sweets at social gatherings, and maintaining a regular training program regardless of your workload. Trainers are human and don't have to be perfect, but we also are role models and should always set an excellent example.

3. **Dress appropriately and exhibit good hygiene.** For example, skin-tight or revealing clothes will not put a client at ease who is self-conscious about his or her appearance. You'll see no uniform recommendations here, but leather, lace, and loafers are examples of unprofessional attire. Dress in a way that your clients perceive as professional and personally acceptable. What do I wear? Generally, you'll see me in tailored shorts, a polo-type shirt, and fresh athletic shoes. I brush my teeth often, chew sugarless gum, and take several showers throughout the day if I'm jogging with clients or squeezing in my own workouts. It's your business, and your success floats or sinks with decisions like these!

4. **Always be punctual.** Emergencies occur, of course. Depending on the circumstances and

frequency, the client will usually understand, but you should do what is humanly possible to be on time, such as taking a cab and dealing with your broken-down car later. If the trainer has to cancel, the workout should be rescheduled at the client's convenience and the trainer's expense, meaning the missed workout is rescheduled at no charge (for more information on policy, see chapters 2 and 3). If the trainer respects his or her client's time, the trainer is entitled to demand the same in return. Run your business like a business and be prompt!

5. **Follow up on the client's needs or requests.** This point is closely intertwined with service. The trainer should make notes about any requests that have to be followed up, write down appointments, solve scheduling conflicts, note special occasions and accomplishments, and be on top of anything else that deserves the trainer's attention. If the client asks a question the trainer can't answer, he or she should research and be prepared to answer the query before the next session. Don't waffle on an answer you don't know. Your client will know you're being less than honest. Let the individual know you'll do the detective work and get back to him or her when you have the answer. Even if the client has forgotten about it by the next workout, you should be ready with the answer.

6. **Draw a strict line between personal and professional relationships.** Many clients want to become friendly with their trainers. Many trainers reciprocate because they genuinely like a client, or are physically attracted to the client, or are intrigued by the client's power, wealth, or sophistication. Maybe the trainer believes that attendance at a social event is owed or that he or she is indebted to the client or, conversely, that attendance might create an allegiance that is owed by the client. In any case, the trainer is probably better off by drawing a firm professional line. This does not imply that you should never accept a social invitation offered by the client (I have honored many of my clients by attending fund-raisers or making a quick stop at their child's birthday party). But, be very selective, minimize your involvement in these situations, and avoid any possible scandal. Minimizing social contact out-

side of the personal training session doesn't mean the trainer doesn't care about the client but that he or she has carefully considered and defined proper professional conduct. Trainers who fail to set this standard of behavior often struggle with clients who can't differentiate between friendship and a business relationship. When the line is crossed, it becomes difficult to provide professional service and uphold business policies. If there are enough of these engagements to constitute a pattern, you should reevaluate your priorities: Do you want to compromise your business for social or other reasons?

7. **Actively listen to clients,** because that is the best way to find out about their personal health, needs, wants, and idiosyncrasies. The trainer also must be able to use this information to develop a realistic, safe, effective, and personalized program. It is as if the trainer is empathetically saying, "I hear what you want. This is what I think you need and this is how we are going to mesh those two to match your personality." Active listening, which means taking action on what you hear, lays a good foundation that gives you a chance to recognize each client as an individual.

8. **Never gossip or talk about clients.** Although the issue of privacy seems obvious, many trainers can't resist a little bit of "harmless" gossip or aren't aware of inappropriate slips. Remind yourself that the client relationship and your business are too important to put at risk with a simple slip of the tongue. Where and who you train truly are a very small world! Furthermore, the key client referral source available to you is your existing clients. Many future clients will come highly recommended to you from clients who trust you and value your professionalism. Keep your conversations and interactions with each client private and safely guarded.

9. **Refrain from selling or advocating products that are not in the client's best interest.** Trust and ethical behavior form the basis of this point. Anytime a product is recommended that is questionable—whether the trainer is trying to fatten his wallet or he is well intentioned but not well informed—these products often perpetuate myths and cheapen the profession, not to mention undermine the

credibility of the trainer. I'm not saying you should never sell or recommend fitness equipment, apparel, shoes, or nutritional products. There are some very honorable ways to create alternate cash flow other than training hour to hour (more on this in chapter 5). To determine whether your intention is ethical, ask yourself, "Is the product legitimate and is the recommendation in my client's best interest from a health and financial perspective?"

10. **Remember that the workout is the client's, not the trainer's.** As trainers get busier and busier, they have less time for their own workouts. It is tempting for some trainers to compensate by turning the training session into their own private workout. But your function as a trainer is to serve the needs of your client. Your actual participatory role is simply one of support, companionship, and expertise. Although there will always be instances where you actually exercise with the client, try to minimize these occurrences so you can be free to facilitate the workout rather than being directly involved in the physical effort. The trainer's job involves guiding, spotting, and educating the client. To do that, you must be totally focused on the client's needs, ready to serve the client at a moment's notice.

11. **Run a legitimate business.** For example, instead of taking cash payments under the table, declare your income. Operating above-board alleviates many of the headaches pertaining to business improprieties. It also helps establish your credit, which will be important when you want to buy a house or get a business loan. Your business policies should be written and clearly stated. Clients should know what your cancellation policy is, how your billing system works, and when payments are due. Consequences of late payments or appointment cancellations should be clearly defined (more on policies in the appendix and chapters 2 and 3).

12. **Be in complete control of your schedule.** It's hard to say no when you have an opportunity to increase your income, and it's hard to say no when your services are in demand. Being realistic with your schedule can be extremely difficult, because it seems there never is enough time in the day to get everything done. Effective and efficient use of time quickly becomes essential to any busy trainer. Organization, computer

and communications technology (more on these topics in chapter 6), professionalism, honesty, integrity, and diligence help, especially if held together by focus, planned direction, and enthusiasm for preserving the equilibrium between professional and personal life.

Keeping Your Clients Motivated

An ability to motivate and direct your clients toward results is critical to the success of your business. It keeps your clients excited about you as an individual and develops a desire within them to continue their fitness program. The techniques used by trainers, combined with their personalities, reflect and help define training style. Some trainers are domineering and aggressive, whereas others are firm yet supportive. The most important skill is to be able to change your dominant temperament so that you are compatible with any client. Can you be encouraging, a good listener, patient, caring, firm, and demanding when appropriate with individual clients? Simultaneously, do clients find your efforts motivating? Success lies in this ability to "chameleon," to change personal color or temperament to blend with the emotional and physical needs of your client on any given day. This capability separates trainers who are great motivators from those who struggle keeping their clients excited about their training.

Trainers who are excellent motivators demonstrate a concern for education, cooperation, good listening skills, sincerity, enthusiasm, caring, and a limitless energy directed toward the client.

Being able to recognize what drives a particular client at a particular time is at the heart of any effective motivational effort. The trainer needs to discuss clients' goals, figure out what clients want and need, and design reasonable programs that give clients a sense that they are part of an effective, planned process. Create client ownership, a client who has a vested interest in what you are doing, by using the ideas and feedback you receive in written and verbal form from your client. This not only makes the client believe he is part of the process but also tells him that you are listening.

More than 50 percent of individuals who begin exercise programs quit within the first 6 to 12 weeks. Yet, many seasoned trainers have clients who have been with them for years. To follow are 10 "tricks" that trainers use to keep their clients coming back for more. The tricks, of course, are common sense and using techniques that fit your clients' personalities.

1. The establishment of accurate, realistic goals is one of the most powerful motivational tools at your disposal. People like success and are willing to continue programs that work. If the goals are realistic in terms of genetics or personal ability and in line with health history profiles, clients will see measurable progress and will likely forge ahead.

2. Because goals change, formulating them should be an ongoing rather than a static process. You must stay in tune with a client's current physical, mental, and emotional status if you are to move him toward his goals in a purposeful way. One of the most exciting aspects of personal training for me centers around this ever-changing challenge to remain "connected" with my clients. This makes my days interesting and different and, when I succeed, encourages my clients.

3. Pleasure is also a powerful motivating force. "Fun," however, does not necessarily mean a loosely structured, directionless play period or informal social hour. An approach like this does not result in clients sticking with you. Clients actually enjoy structure and guidance as well as results. Your efforts let them know you have their best interests at heart. Temper this with a pleasant personality and they'll have a good time. Cross-training, periodization, and progression (planning with intention!) will please a client who is looking for variety, injury-free training, and results.

4. Change (cross-training and periodization) is a necessary part of a fitness routine because it is the only way you can continue to overload the muscles and energy systems of the body and thereby produce additional fitness gains. Changing the routine regularly is also a great way to stamp out boredom and prevent clients from dropping out of your training program. Trainers regularly replace old exercises with new ones, use different combinations of exer-

cises, and introduce new equipment or change whole programs over specific time periods (periodization). However, be careful not to put too much pressure on yourself to always be creative and vary the routine. You don't have to bring a three-ring circus to your clients each day. Physiologically this is not sound, and many of your clients will be perfectly comfortable with a familiar routine. Constant change can frustrate and intimidate clients. Too much change and too little change are the extremes you want to stay away from if effective programming is your goal. The real key is staying sensitive to your client's moods and needs and incorporating change when the client is both physiologically and psychologically ready. Make certain that your client is excited about any impending changes in her program. In other words, make sure the client wants and is ready for the change!

5. A change in environment also can be effective. Cross-training lends itself well to this. For example, I might have a client who usually walks or runs on a treadmill indoors change to an activity such as hill walking or cycling outdoors. You can cross-train between components of fitness (i.e., aerobic, strength, or flexibility training) or within a component of fitness (e.g., running, walking, bicycling, or swimming). Another good change is to create workouts that include circuit training. This style of training gives you variety while still allowing your client to perform exercises she is familiar with.

6. A unique way to liven up the training session involves dynamic and thoughtful use of the spoken word. What you say and don't say, and how you say it, can have a huge negative or positive impact. Simply, you must "language up" specifically for different clients and keep your spoken word sensitive, sincere, and honest.

Various training scenarios warrant a change in the verbal imagery you create during the workout. Predictable verbal encouragement is not motivating or sincere. If every effort of your client results in a rapid-fire string of thoughtless superlatives like "great," "really great," and "great job," your client will not believe you.

Here's another way to change scenery and help your client exercise more effectively. In an

exercise such as a chest fly with dumbbells, I sometimes tell a client to feel as if he is wrapping his arms around a barrel as he executes the movement. On another day, I might tell the same client to initiate the movement by contracting the muscles in the shoulder and upper chest area to help draw the arms toward the center of the body.

Paint the picture, whether instructional or motivational in intent, with an ever-changing mosaic of verbal imagery that is pertinent to each training situation.

7. Sincerely acknowledging your client's progress also keeps the client going. I always provide plenty of honest feedback about technique and form as well as general progress. I remark on intangible improvements, such as positive attitudes, good attendance, and enthusiastic attitudes. I remind long-term clients who may be mired on a "result plateau" how far they have come since their first session, and I explain that maintenance of fitness levels is very different than regression or loss of results. Comments like these let my clients know that I am watching and that I am still connected! I let my clients know that I notice their behavior as well as personal improvement.

8. Periodic fitness testing, posture and flexibility assessment, and other measurements can provide motivation, document measurable improvement, and help set new goals for your clients. Simultaneously, assessment bolsters credibility. On the other hand, remain sensitive to your client. Fitness assessment can be a double-edged sword. Testing can put undue pressure on some clients and can be discouraging if their test results are compared with norms. Many of my clients have enough competition and pressure in their daily work. Because of this fact, I am very discerning as to whether assessment and what assessment procedures are appropriate for each of my clients. I am careful to make this element of their program nonthreatening, an encouraging rather than a discouraging experience. It is not appropriate to use evaluative tests with all of your clients. Fitness testing and assessment are not required to ascertain whether your client is healthy and whether he can safely participate in physical training. Differentiate between diagnostic testing that takes place most often in a medical setting and assessment that has the potential to motivate your client (more on assessment in chapters 10 and 11).

Before I assess clients for whom testing is appropriate, I convey the idea that maintenance is positive. Clients who maintain fitness and health have achieved their goals. Setting a goal of constant improvement and attainment of new levels of fitness is not only unrealistic, but it also destines your client to fail in her fitness program. Ultimately, maintaining a desired state of personal well-being is the ultimate pursuit for your clients.

9. I have found that motivation often comes down to a matter of providing a lot of positive encouragement, rather than negative reinforcement, even when correcting. Instead of saying, "You're not reaching," I'll say, "That's better. Now on the next effort, reach just a little higher." And, the next time, the client will. I have discovered that reinforcing and appreciating even small steps in the right direction can reap large rewards. One warning: Your client will know when you're patronizing him and not being honest.

One type of motivation that does not work for me is the aggressive boot-camp mentality. In my opinion, a training style that uses insulting, loud, and intimidating language and pushes people far beyond appropriate physical capacity not only courts exhaustion, injury, and burnout but contributes greatly to the failure of many training businesses. It is the rare person who would be encouraged by and return for more of this type of abuse. I believe most individuals who want to enhance their personal well-being want to be nurtured, encouraged, gently pushed, and motivated while simultaneously being cared for and listened to.

10. Maintaining a personal training service focus involves staying in tune with your clients and staying current in the industry. Ultimately, these skills will help you meet your client's fitness needs and can create a long-term relationship that benefits everyone involved. Ultimately, this type of union sustains businesses.

Keeping Yourself Motivated

Personal burnout is probably the least of your worries if you're new to training. More than likely, your enthusiasm is fresh and running rampant as you forge headlong into your new career. However, keep this perspective in mind now and you might be able to avoid the syndrome that many personal trainers and other professionals have experienced.

Perhaps the biggest problem facing successful trainers is maintaining the enthusiasm and excitement that first attracted them to the business and that first attracted clients to them. Even the most caring of us have to deal with the frequently tedious, physically and emotionally demanding, and time-intensive nature of the job.

Trainers eventually develop their own methods of self-motivation and self-checks to ensure consistent service. I use a variety of approaches to keep me sharp, enthusiastic, and sensitive to my clients' changing needs and interests.

1. Keeping professionally updated is very stimulating. I read as many professional journals as I can, attend seminars and lectures, and watch instructional videos in an effort to keep both my own and my clients' training sessions current, relevant, interesting, and productive.

2. Being able to identify the client's emotional and psychological needs also keeps me involved and relevant. I approach each training session knowing what I want from the client, but I make a game out of working around the mood and energy of the day to draw those efforts out. To do that well, I have to be very tuned into or sensitive to the individual I am working with at the moment. Realize that your client is not the same person every session. Clients change with a dynamic world that robs them of sleep, applies work and family pressures, and rewards them with the victories of life. I think of each workout session as a chess match in which I attempt to match theoretical programming strategy with optimizing individual client involvement. When the client's victories are plenty it's easy to motivate, but when a business deal fails or a newborn child keeps your client up all night, can you change strategy to match the client's mood and still accomplish goals that are appropriate and in line with client capability? Changing strategy helps make the workout different and therefore not only more interesting from day to day but results oriented. It could be a huge reason why many of my clients have trained with me year after year.

3. Optimizing client focus and care requires personal discipline. To get this kind of focus, I have to take care of my personal needs. Although I'm human and still struggle with this balancing act, I know it is essential for me to have a personal life outside training clients and other professionally related events. It's ironic that a nonobsessive approach is what frees you to become a better role model, to love what you're doing, and to serve your clients' best interests. It is critical to a trainer's long-term professional survival and success to preserve a personal life.

If there are no meaningful breaks from the business of training, your life begins to feel like one long workout. Your clients will notice, too. There is no time to recharge. Instead, you become a machine and, like all machines, eventually you'll wear out. Part of the management of your business is a stewardship of your own time!

4. Then, there is the occupational hazard of wondering what you will do when you grow up. Training is not always considered a "real" job in many quarters. I've been asked repeatedly, "Do you have a day job?" or "When you're done with personal training, what are you going to do?" Repeated exposure to that sort of attitude can lead to a lack of self-confidence and a feeling that other people do not take you seriously.

When I start feeling that way—maybe somewhat defensively, yet with an inner peace and knowing smile—I remind myself that personal training not only is lucrative but also allows me to thrive as an individual. Then, I consider the following: Instead of being a personal trainer I could be sitting in some office, getting fat, and breathing my boss's cigarette smoke, and an artery could slam shut at any moment. Sincerely, I realize I have the ability to change and positively affect lives by doing something that is good and having a career that I love. Thoughts like these usually bring me right back to a wonderful reality. I am blessed to be a fitness professional. A little self-analysis goes a

long way for me and will probably do the same for you, too.

5. I try to give limitless energy to my clients. I don't expect my clients to entertain me. Instead, I want to capture their interest, trust, and commitment. A blasé, indifferent attitude does not convey a great enthusiasm for health and fitness or for client care. When I'm tired or life's events have overwhelmed me and I'm struggling to motivate myself to a higher level of service delivery, I remember that I took this client on of my own free will. Professionalism is reflected in service that can be repeatedly delivered par excellence, independent of outside or extenuating circumstances. Your clients deserve nothing less.

Asking for, Getting, and Using Client Feedback

The only way you can make client feedback work for you is by (1) creating a safe environment where your client is comfortable critiquing you, other trainers, and your business; (2) receiving criticism openly; and (3) acting on honest and well-founded feedback. You should want to measure your customers' satisfaction level. You can't hope that you're performing adequately: You have to know.

Taking criticism in a positive manner and using it wisely are difficult. However, client dissatisfaction does not go away by itself and if glossed over may explain why clients leave abruptly without explaining why. Clients who can't communicate their concerns see no reason to hope for any type of change relative to their issues. Say good-bye!

Over the years my clients have rated, judged, taught, condemned, encouraged, and praised me, because I have solicited their comments so that I can better serve them and improve on areas of weakness. I am better for it. Still today, it is a hard pill to swallow. Professionally, I speak in many cities and countries over the course of a year and it's easy to focus on one scathing criticism—to take it personally— rather than balance the whole of the information received from the evaluation forms. Hard as it is, you have to focus on the rich opportunity that constructive criticism provides.

Although not everyone loves filling out evaluation forms, you stand a good chance of having your clients participate if the forms are brief and encourage honest feedback that will be acted upon. I also motivate my clients to return the form by offering a free T-shirt or other gift to those who sign and return my evaluation form (see form 7.1). If your clients think that you are not open to change or that you might react personally or defensively to constructive criticism, then they will give you lip service—tell you what you want to hear—because they may not want to sour the relationship or have you angry with them. Or, you might not be so lucky and they could choose not to use your services any longer.

Ask clients to sign surveys, because this gives you a chance to correct a simmering situation at a personal level. Putting a name on a survey takes away the safeness of anonymity, and if you are to receive this kind of trust from your clients, you must not put the client at personal or emotional risk. How you handle such feedback will indicate to your clients whether it is worth the effort or risk to give you honest feedback. Inappropriate reaction or no action will quickly dry up this invaluable feedback mechanism. On the other hand, a nondefensive posture (even though criticism can sting), a willingness to listen and change, and gratitude for the opportunity you have been given to improve will let your "feedback machine" flourish. Getting information from your clients is an important part of managing a successful client–personal trainer relationship and helps to maintain a service focus.

Verbal Surveys and Feedback

Because the nature of one-on-one training is verbal, verbal communication is very valuable to trainers who work with clients daily. It shouldn't replace written surveys but adds to the overall picture of how your business is doing or how the one-on-one relationship is developing. Person-to-person feedback is just that—personal. Many clients find it difficult to be honest with critiques that take place in this up-close and personal format. That is why I use the written survey as well as the inevitable information a trainer receives from day-to-day client contact.

F O R M **7.1** **Sample Client Service and Satisfaction Survey**

At The Training Edge it is important for us to know how you rate our services. We want to regularly measure your satisfaction level. We don't assume that we're performing adequately. We have to know what we are doing well and what we could do better so that we can provide "over-the-top" service to you. We appreciate and openly receive both your praise for a job well done as well as your direct and honest criticism concerning areas where we could better serve you.

We will never be defensive or angry toward you for expressing your opinions. We thank you for the chance to improve and better serve you. We want you to know that we are listening and acting on your invaluable feedback.

Thanks for taking a few minutes to fill out this satisfaction survey. Although optional, please consider printing your name legibly at the bottom of this form so that we can make corrections and direct follow-up where needed on a personal level.

FREE T-shirt! Because this feedback is important to us, we want to encourage you to return this form. When you sign your name and turn in the satisfaction survey, we'll be happy to give you a Training Edge T-shirt. Thanks for your time and participation!

In general, what could we be doing better at The Training Edge to enhance your training experience?

List your top three complaints related to Training Edge programs, service, or personnel.

1. _____

2. _____

3. _____

List your top three positive comments related to service at The Training Edge.

1. _____

2. _____

3. _____

Is there a particular staff member you would like to comment about? "Thumbs-up" or "thumbs-down" is okay here!

Is The Training Edge giving you what you want from personal training? Please explain your answer.

Who is responsible for what in your training? Does the trainer dominate or are responsibility and accountability shared by both the trainer and you?

Continued ➤

➤ *Continued*

Do you think your trainer plans your program in advance and adequately follows up on your questions or other training needs?

Training Edge Facility Patrons Only:

(Please rate the following categories on a 1-5 scale, with 5 representing excellent, 3 adequate, and 1 a need for improvement.)

Category	Rating	Comments
1. Facility cleanliness	_____	_____
2. Shower and changing areas	_____	_____
3. Equipment	_____	_____
4. Water and towel supply	_____	_____
5. TV, stereo, headset use	_____	_____
6. Courtesy: other trainers and staff	_____	_____
7. Overall training environment	_____	_____

Your input and feedback are valuable to us. Thank you!

Name (optional): _____ Date: _____

(Please print legibly.) (FREE T-shirt!)

Author's Note: The survey can be mailed, e-mailed, faxed, or personally delivered by trainers to clients. I prefer hand-delivering it to the client. This encourages an open, direct, and honest relationship. Ultimately, change will take place on this personal, one-on-one level. Clients may return the form directly to the trainer, to other staff, or via mail, e-mail, or fax. Clients should understand that some comments will be viewed by the entire organization, whether it's one or 80 employees. The information solicited can help any business improve, whether a sole proprietor or a team of employees. Everyone learns from feedback, even if the information is not directed at them or their performance.

Verbal surveys, like written ones, whether performed in person or over the phone, are only going to be as effective as the degree to which you ask for, encourage, accept, and use feedback! Nothing will dismantle this feedback mechanism quicker than a negative, defensive, or angry response or failure to act on feedback that requires an apology or correction.

Feedback gives you the opportunity to respond to a situation that the client believes needs improvement. You may not always agree, but you should always thank the client for her directness and openness. Action is required but not necessarily immediately. If you hear the complaint enough, logic says that your clients are on target and change should be quickly made. If feedback and positive criticisms are not encouraged to flow freely, the first symptom of unhappiness might be a client who simply leaves. At that point, it's too late for any corrective action.

Phone Survey

I don't love the idea of a phone survey unless I am playing the role of employee administrator and following up on another trainer's relationship with a client for quality control reasons. Of course, the trainers know about these follow-up surveys and that the intent is to provide a higher level of service to the client, not to check

clandestinely on the trainer's performance. However, this type of administrative follow-up can be used to help trainers minimize client turnover because customer care moves to a higher and personal level. In other words, with feedback in hand, the trainer will have a chance to improve where improvement is needed.

Day-to-Day Training "Survey"

Remember, the survey does not have to be formal. Too much paperwork and clinical questioning can wear your clients out. Regularly and sincerely questioning your clients about their satisfaction is effective for daily training. Clients quickly accept this as evidence that you listen and are interested in their personal well-being, if you act on the feedback.

Weekly workouts provide a trainer regular contact with the client. Continually pepper clients with questions before, during, and after the workout. Questions should be oriented toward personal and general topics and might include these:

- Is there anything I can do to meet your program and workout needs better?
- Did that exercise irritate your shoulder?
- Do you like the direction of your program?
- Did the change we made on that shoulder exercise eliminate your discomfort?
- What does that effort feel like?
- In what area of the body do you feel this strength training exercise?
- Do you believe your goals are being accomplished?
- Are you having fun yet still feeling challenged?

Incorporate what you have learned from your battery of questions when planning the client's next workout and overall program progression. Your client will know that his feedback counts, that you are listening, and that your true intention is to use the running dialogue to improve the program.

Setting Professional Boundaries

Different trainers have different opinions about where professional boundaries should be drawn

and duties lie. Your choice will directly affect your ability to maintain a service focus. A survey (Gavin 1998) of personal trainers indicated that age may have some effect on where trainers draw the line. Younger trainers were slightly more likely to become personal friends with clients and a part of clients' social circles. Younger trainers were more comfortable with giving and receiving personal advice. These same trainers were more ready to accept financial advice or approve of working for clients in a role outside of personal training. Older trainers (age 41 plus) were less likely to give advice outside of paid sessions or consultations. Older trainers held the lowest approval rating for selling equipment and were least likely to endorse "personal" conversations with clients. Although all age groups disapproved of romantic involvement with clients, older trainers judged this behavior most severely. In line with this, older trainers were most disapproving of emotional involvement with clients (Gavin 1998).

These findings indicate that as trainers and the industry mature, the professional role delineation will be increasingly defined in black and white terms with respect to what is acceptable. It's amazing to me that even when romantic involvement with clients was queried, many trainers responded with an "okay" or "maybe," which, according to Gavin (1998), is quite a distance from a strong and certain no! An older, more mature trainer seems to be saying no to nonprofessional roles and any behavior that is questionable or could erode his credibility. Older trainers seem more secure and confident that they should not give away their limited time for nothing. They say no to free advice outside of the training session. On the other hand, younger trainers may be able to teach older trainers a thing or two. They are more likely to be open to advice from clients who could help their business grow and are more open to selling equipment. Consider a professional relationship where clients can participate on an advisory board or a trainer can responsibly expand her business by selling exercise equipment or other products. It is possible that some older trainers stay away from these possibilities, for example, because these particular areas have received so much criticism in the past. More experienced trainers, not necessarily older, were more likely to

sanction receiving business or financial advice from clients.

Making the Client–Trainer Relationship Work

A trainer should be able to adapt to varying personalities. As mentioned, a trainer needs the ability to "chameleon" or change colors to match the client's mood. Conversely, a trainer should also be selective with regard to whom she will train. It makes no sense to train clients who will not work with you or who show you little respect. Clients who impose unrealistic demands, fail to attend scheduled sessions, resist following the program you have planned, or are rude or difficult are clients you can afford not to train. Work with clients with whom you can build a trusting and effective relationship. An effective relationship means both parties put forth an honest effort to make the relationship click. Forcing relationships is nonproductive, hurtful, and stressful to all involved. Noncompliant or hostile conduct on the client's part is not acceptable. It is up to the trainer to insist upon, develop, and nurture a relationship that exhibits professional and courteous behavior between trainer and client. This reciprocity is a must for healthy, productive, and long-term associations.

Understanding the Impact of Your Words and Actions

Cavalier or insensitive comments are never appropriate. You may have never thought about it in these terms, but our interaction with clients can present a health risk not only to us but to the client. In fact, our interaction can be so damaging that we counsel our clients right out the door, right out of their desire to pursue health and fitness. To follow are two scenarios to illustrate what I mean.

Case 1: A 50-year-old man with several risk factors for heart disease and other chronic illnesses asks you, "Do I seem over the hill?" You respond with one of the following:

a. "Over the hill? Chances are you have years, no decades, of productivity, fulfillment, laughs, contributions, and assorted adventures ahead of you. Assuming, of course, you stop whining about being over the hill."

b. "It depends." (Without a doubt, this response never helps anyone.)

c. "If you lose 30 pounds, stop smoking, eat less fat and sugar, make a few friends, exercise, and get a life, probably not. But it doesn't matter; being over the hill is no big deal anyway."

d. "Gee, I don't know. You are a mess!"

e. None of the above or some combination thereof.

Case 2: A client says, "I don't have the time or willpower to do all the things I know I should do to get fit and healthier." You say one of the following:

a. "I don't have time for sleeping, eating, relieving myself, and many other activities. But, considering the advantages, I find time. Come on, just do it!"

b. "I have a great book (700 pages, small print) for you." (You lend the person your favorite and most technical wellness book.)

c. "You do have time. It's just not a priority for you, yet. With better information, support, and inspiration, you might decide you're ready. Recall the immortal words of Yogi Berra: 'When you come to a fork in the road—take it!' "

d. "Too bad."

e. None of the above or some combination thereof.

Did you answer both questions correctly? I would base "correctness" on whether your response matched the individual's need at that moment. I have worked with an incredible variety of clients, and a seemingly simple, but profound realization is that people are different and unique. The approaches we use with them must be personal, caring, and individualized. Don't lose the connection to the person that makes the relationship special.

Robert Fulghum (1993), in his book *All I Really Needed to Know I Learned in Kindergarten,* tells a story about a little kid, Norman, the barking pig. Norman wanted to be in his kindergarten class play. But the teacher informed Norman that there were no parts left. Norman insisted and volunteered to be a pig. The teacher told Norman there was no pig in Cinderella. Norman said, "There is one now!" During rehearsal Norman followed Cinderella and barked when scenes particularly moved

him to do so. The teacher pointed out that pigs don't bark. Norman said, "This one does!" Opening night, Norman quietly followed Cinderella. But, when the prince swept her off her feet, Norman leapt to his feet and barked joyously. Norman received a standing ovation.

This story champions the significance of life, spontaneity, tuning into individual personalities, and celebrating the uniqueness of people. Let individuality flow and not only will your client be showered with joy, but you'll be blessed as well. A little bit of the kid in all of us should be encouraged. Ask a child about possibilities and the list is endless: Life is beautiful and has hope, meaning, and purpose. Ask an adult, and the limitations and qualifications are greater than those found in the small print of discount airline fares. Children are enthralled by life's possibilities at every level. Ask them whether they can do something and you get, "How soon do you want it!"

Even if it means bending the rules of tradition or moving beyond boundaries of the norm, adults can and should be encouraged to turn into barking pigs. Not only do our words and counsel have impact, but also what we allow and encourage outside the rules of tradition has great influence. We should nurture a bit of the barking pig in all of our clients!

Recognizing Client Types

With a loving smile, I lump the majority of my clients into the following categories:

- **Special needs client.** These clients may have a special physical condition, may need to be cradled and cared for, or may require extreme patience and empathy with regard to the pain or other physical challenge they are dealing with. The client is not a troubled client but is one who must be given personal care and whose situation may need to be thoroughly researched and managed in conjunction with a licensed health care professional. Working with special needs clients has helped me to grow, mature, and learn, and it can often be humbling. Fulfilling at least part of this person's need, or being part of her health and fitness management team, is extremely rewarding professionally and personally.

- **Dream client.** This client will try anything, plays the role of guinea pig for new training approaches, asks you what you learned the past weekend at a workshop, is enthusiastic and always positive, thanks you over and over, tells you that you changed his life and saved him from imminent death, and tells you that you were the reason he married and had children and because of all of these reasons the family wants to adopt you. Of course, since you anticipate each session with this client with enthusiasm, sometimes you think you should pay this client for attending the training session.

- **Professional client.** This client is appreciative and efficient and wants to get down to business. The professional client is always courteous, politely thanks you, and offers a handshake after every workout. She's been training with you for many years, expects you to start and finish on time, and desires to have little to do with you outside of the shared training environment. I love this client!

- **"Punish me" client.** This client does not listen, never wants to change workouts, loves familiar routines, loves ruts, loves intensity, and expects every minute of the workout to be fully used. If he's not hurting or doesn't "feel it," he wants to know why and what can be done about it. The punish-me client considers throwing up once during a workout a good day and twice a great day. He doesn't take a shower when finished and is in a hurry to combatively engage the world postworkout. This client can wear me out, but I like a challenge.

- **Take-control client.** This client demonstrates a need to exert personal and often abusive control over you. This tendency can leave you feeling less than whole and often intimidated. The relationship dynamic is controlled by the individual, who is driven to dominate every aspect of the trainer–client relationship. Don't take this behavior personally, because this is how take-control clients generally behave; however, you must regain equal footing. It's easy to keep domineering clients off balance if you are prepared, professional, unabashedly honest with your feelings, and articulate. Refer to the "power trap" in the next section.

- **Exceptionally needy or dependent client.** This client is extremely appreciative, respectful, and thankful for what you do. She's

lovable as a teddy bear, flatters you, and worships the ground you walk on. Eventually, she can become a parasite that draws all of your energy from you and truly tries your patience. No substitute trainers will suffice; only you will fulfill her need. Refer to the "dependency trap" in the next section.

- **Troubled client.** This client often exhibits bizarre and irrational behavior, discloses inappropriate, intimate information (I call this TMI—too much information!), and displays abusive or otherwise disruptive behavior. Generally this client is beyond my expertise unless I am working in conjunction with the appropriate professional who is treating the situation. I often assist the individual in finding someone who can professionally and expertly help him.

- **Ex-client (or soon to be).** This client is disrespectful of my policies and me, lacks respect for other clients, or otherwise grinds down my emotional and physical endurance. But, before I lose the client, I must be certain that the departure is not caused by inadequate service or some other business flaw.

Don't run from clients with special challenges and personality. Changing colors to meet individual needs is okay if you are not compromising business and personal ethics at the expense of a one-sided, parasitical relationship. One trainer told me, "I have two difficult clients, two very special clients, I would not trade—most days." Clients can be simultaneously challenging and rewarding to work with. On the other hand, you have to know how to professionally balance client–trainer relationships so they remain productive and don't leave you exhausted and depleted.

Balancing Client Relationships on Your Own Terms

If you find yourself hating what you do, trust your intuition that something is terribly wrong. Many times the problem lies in the relationship you have developed with one or several clients who have fallen wildly out of your control.

Do you have a client who literally makes you sick with nervous tension in anticipation of the impending workout? Or, does anxiety swell up when you need to discuss broken policy or unpaid

invoices with the offending client? Have you become your client's personal concierge, alarm clock, and daily counsel? What about that client who really irritates you and is entirely unreliable? This client always shows up late, expects a full workout, never apologizes, or calls you at the last minute to cancel the scheduled session. You've read your cancellation policy to the offending person and told the individual that you've been pushed to your professional limits and that her behavior is unacceptable and disrespectful of you. The client responds by saying that she will change her ways. She loves working out with you and says that she is really sorry for having hurt and taken advantage of you. You're ecstatic and can't believe the sincere response and your good fortune. Thirty days later, nothing has changed except for your increasing level of stress and frustration.

Is there anything you can do? Can you regain control of relationships that have gained a devastating and negative momentum? Can you respond professionally, treat the client fairly, and resolve the situation so that it becomes a win–win for both trainer and client? James Gavin, PhD, a professor of applied human sciences at Concordia University in Montreal, terms these types of situations as "relation traps." Because life is about relationships, you must know how to manage them! Dr. Gavin portrays three common traps—dependency, power, and sexuality traps—that are played out over and over again in personal training forums all over the world, sometimes with disastrous results.

Dependency Trap

The client's viewpoint—total and utter dependence, "I can't function or live without you"—is initially probably well intentioned on the client's part. This situation can be attractive and seductive for the trainer, from both financial and ego perspectives. Generally, trainers like to help and play the role of "fix-it person." Plus, we like to believe we are needed and, to a certain extent, may foster client dependency. It provides job security and massages the immature ego. (As you mature professionally, this type of obsessive client behavior becomes a noose around your neck that continues to tighten and take your breath away. That's why you must discourage this type of attachment. See the partnering concepts presented in chapters 2 and 5.)

When a client begins to play the helpless role and you take responsibility for the person's own welfare, you may already be snared. If you have become someone's personal valet, psychologist, and physical trainer, you have to question how you inherited those responsibilities, which will quickly become a heavy burden to shoulder. Eventually this load will wear you down and you will come to resent the role, if not the person. Your motivation comes from a genuine desire to help people, and the client greatly admires you—to the point of complete dependence. The trap is set. Dr. Gavin says that you become an easy target for being hooked to the client's feelings of dependency because of your need to be helpful. Although it fits the personal trainer's job description to be helpful, taking responsibility for another person's life does not work and doesn't serve the trainer or client.

Power Trap

The client clearly communicates to you verbally and by her actions that she paid for this session, owns you, and totally dictates workout sessions. She dominates conversation, thinks she can disregard policy, always owes you money, and never pays invoices in full on time. She reschedules at the last minute, and she believes problems that she creates are yours and not hers. She blatantly disrespects you, is condescending, always wants it her way or no way, doesn't listen, is rude to you and other clients, and—whether you like it or not—is the boss! Any of these traits may foretell that you are about to fall into the power trap, especially if you believe the relationship has spiraled beyond your control and you become anxious anytime you engage this client.

Do you feel helpless, stressed, or sick to your stomach when working or communicating with this client? Part of this hopelessness stems from not confronting the offensive behavior. By nature, many trainers like to please, and just like a parent–child relationship, trying to please results from a need to be validated with regard to self-worth. Where do your self-worth and personal esteem come from? Don't rely on your clients to build you up. Look to other sources or you're in for an emotional roller-coaster ride. The trap gets set by our desire to accommodate and satisfy the client. Because you never will satisfy her, and she continues to pay for your services, you are caught!

Clients who need to be dominating or controlling may exhibit such behavior in outrageous or subtle ways. The final issue often centers on control. For the client to maintain absolute control often requires her to tear you down through intentional or subconscious behavior. If the client always has to have it her way, doesn't consider your feelings or perspective, critiques your training style to the point where you think you should consider a new field, "throws" the due payment at you, withholds money due you for training service, politely or aggressively refuses to heed any of your carefully worded suggestions, or otherwise erodes your sense of worth and self-esteem, you are a victim of someone's ongoing power play. Although I wouldn't take it personally, it's time to break free of this situation. Neutralize such an attack with good defense and a proactive agenda. You cannot afford to be sucked dry emotionally and physically to feed another individual's need to demonstrate her superiority and power over you in every situation.

Sexuality Trap

The sexuality trap can be a dangerous two-way street. Is the client or trainer knowingly, or unwittingly, setting the trap? How you or your client dress can show a nonverbal need to be desired or liked. For example, if a female client constantly trains braless in a skimpy T-shirt, no comment may indicate to her that the male trainer is comfortable with or desires this type of dress or is physically attracted to her. She may or may not intend that it be provocative. How do you feel, and is it professionally appropriate? A direct comment that you are not professionally comfortable with her attire or that some of your other clients have told you that it makes them uneasy clearly communicates your stance. Handle this gently so that your behavior does not embarrass the client over what is possibly an innocent omission or lack of awareness.

Don't waffle when communicating. Don't let the client think, for example, that you're okay with the situation; it's only "others" who are concerned or uncomfortable. Let the client know exactly how you feel. The client may otherwise think, "He still desires me." You will encounter

many clients who do not have healthy relationships with spouses, other intimates, or their circle of acquaintances. Some will try to draw you into their own dysfunction. It's a game that is dangerous and can be hurtful. Consequences of playing the game knowingly or unwittingly can be disastrous.

When you are involved in the sexuality trap, the client wants to "turn you on." The client must win sexually and to do this he or she must seduce you in one way or another. You must clearly state you are not interested. I deflect this situation quickly by talking about my wife and kids and how happy and content I am with my personal life. If I need to be more direct, I do not hesitate. Relationship dynamics work on a reciprocal basis. If workout encounters are sexually charged, initiated by trainer or client, clear communication must be quickly established to eliminate any sexually oriented innuendo that originates from physical contact, dress, or spoken words.

How Close Should You Get to Your Client?

Your relationship with the client should be a two-way street that reflects mutual caring, respect, understanding, and fairness. Sexual innuendo is always inappropriate professionally, and I believe a trainer can easily become too involved in a client's personal or social life. I plainly communicate, to most of my clients' relief, that I am not interested in their wealth or contacts or in joining their social circles. I deeply care for and respect my clients' families and selectively will attend graduations, bar or bat mitzvahs, birthday parties, or other significant events occasionally to honor the client and family member. I try to gauge the importance of this attendance and its personal meaning to the client. In a discriminating fashion I move in and out of my clients' personal lives, and only upon invitations that I perceive to be important. In doing so, I not only preserve the professional boundaries I must maintain but guard my private time as well.

Trapped? How to Get Out!

Trainers can experience any one of hundreds of relationship scenarios. All have their own particulars and strange twists. Some traps are subtle, and others are outright alarming. Any can progress to a point where you have lost control of the situation. What do you do? This is how you get out. According to Dr. Gavin, you can follow six principles to maintain a professional line and your sanity.

- **Recognize the communication pattern.** If your gut instinct is telling you something is not right, you don't feel comfortable, or the relationship has become an incredible energy drain, don't think this is an invention of your imagination! You and your client have a problem that needs to be resolved. Gavin encourages you to assess "who's doing what to whom." Consider all verbal and nonverbal communication.

- **Acknowledge how the relationship hooks you.** Obviously you have played a role in this relationship. What's the attraction to you? How are your needs being met, and how have you allowed, encouraged, or enabled this undesirable relationship to proceed? Is your desire to help and nurture your clients being manipulated for all it's worth, or do you desire to be sexually and physically attractive to your clients, sending a misleading and confusing message?

- **Review your role and proper limits.** Revisit your mission and purpose statements. What is your job? What is the client's role? Respect, follow, and reestablish the roles set up in your client agreement or contract. Identify what defines a professional personal trainer.

- **Challenge the behavior, not the person.** It is critical to maintain respectful behavior toward the client professionally and as a person while simultaneously refusing to satisfy this particular need. (Or, is it your need?) Gavin says you can attack the person or attend to the behavior. Behavior must be challenged, even the little issues. Small behavior slips build over time and what was once misbehavior becomes the norm. Ignoring or displaying indifference toward an unacceptable behavior can be interpreted by the person as approval. Silence may be misinterpreted.

- **Reassert rules and roles.** Identify the behavior problem and discuss it in accordance with stated policies or appropriate and professional behavior that is expected of the client and trainer. For example, if someone is always late, identify the lateness and its implication for whatever remaining time is available for

the scheduled session. If you let your clients know that certain behavior is unfair, disruptive, uncomfortable, inconvenient, disrespectful, or not in accordance with your agreement, and if you suggest agreeing on a stated solution, most clients conform quickly and really do wish to please you. Face the challenge and correct the behavior. I guarantee you this: Unacceptable behavior will not go away or correct itself.

■ **End the relationship if the behavior continues.** To maintain control, as well as healthy and professional relationships, a trainer has to be willing to identify and face the problem and possibly lose a client in the process. Otherwise, if you're afraid to lose a client, you will never honestly deal with issues that bother you. Not being able to free yourself from relationship traps will have more negative impact on your professional and personal life than the loss of a client and associated income. Gavin says that once you have clarified interpersonal boundaries and business policy, and the client continues to ignore or violate them, it's appropriate to end the relationship. Trainers should not play roles for which they are not professionally prepared. Some problems are beyond your scope, and even if you think you could handle them, it's not your job. Don't

think you've failed as a professional if you've fallen into a trap. Simply identify the situation, and dictate personal and client behavior change that must occur. If the relationship doesn't turn around quickly, recognize that change is not likely going to occur and that the current situation is unhealthy, and end the relationship professionally. I often recommend other trainers or services that can better meet needs I am not capable of meeting or do not want to meet. I let the client know that the relationship is not working for me and why, and I try not to point blame or make the client feel personally wrong (Gavin 1999).

Working With Difficult Clients

Whenever I encounter conflict, I return to the topic of expectations. Nowhere is this more important than when training clients who are tough to please or move toward a totally dependent relationship. You must redefine, if necessary, what is expected of both the trainer and the client.

Dr. James Gavin offers 15 suggestions that can help you create win–win solutions when conflict arises (Gavin and Gavin 1999; see box on this page).

15 Suggestions for Settling Conflict Successfully

1. **Clarify what the conflict is about.** What is the core issue that relates to you?

2. **Decide whether the issue is worth confronting.** Does the conflict warrant your energy? Can you be part of a solution? Is the timing right for you to become involved?

3. **Describe the other person's action.** Identify the behavior without accusing. An accusatory approach stops at saying, "Your behavior irritates me." Define the actions or behavior that continually irritates you.

4. **Define the conflict as a mutual problem.** Acknowledge how the situation affects both parties and that you desire a win–win resolution.

5. **Define the issue as specifically as possible.** For example, "What's been bothering me is your repeated cancellation with less than 24 hours notice and your refusal to pay for the session even though we have been over my cancellation policy several times."

6. **Factually describe the effect of the conflict.** The conflict may affect time, money, personal energy and vitality, morale, or the client–trainer relationship.

7. **Describe your emotional response to the other's actions.** Clients should know how you feel. Feelings move you past "right" and "wrong." Feelings are your reality and should not be discounted. Tell the offending client, for example, "It upset me when I waited an hour for you to arrive at your scheduled appointment."

Continued ➤

➤ *Continued*

8. **Describe anything that you did, or did not do, that may have contributed to the conflict.** For example, you could tell the client, "I probably should have let you know . . ." or "If had given you immediate feedback . . ." Conflict is usually two-sided.

9. **Show your understanding of the other person's perspective.** Ask the involved person how she sees the conflict. You need to hear and then demonstrate to the person verbally by repeating what you have heard ("mirroring"), so that she knows you have heard her accurately.

10. **Create a mutual definition of the issue.** This requires that both parties acknowledge that the issue presents a conflict. If the client believes that this is your problem and not his, resolution will be impossible.

11. **Generate potential solutions for mutual benefit.** This requires you to maintain an open mind and belief that the solution is something to be discovered rather than imposed. Granted, some situations are black and white from policy perspective (e.g., invoices must be paid on time), but if you can brainstorm a solution together, this cooperative effort can foster the relationship.

12. **Jointly evaluate the potential solutions.** Unless the conflict involves an abuse or policy break that must be enforced, don't expect the first solution to be the final answer.

13. **Detail the mutual solution.** Don't only discuss the solution; put it in writing. All of the details need to be specified and consequences outlined if the solution doesn't solve the problem.

14. **Implement the solution.** Mutually implement the new solution after responsibilities are assigned.

15. **Follow up.** Acknowledge success or failure. Always commend someone for making an effort to change or improve a relationship. Ask whether you're upholding your end of the deal!

Trust your emotions. Take time to understand feelings that do not "feel right." Talk with peers and, in most instances, your client. If the principals (your client and you) are not present and accountable, there is little hope of positive resolution. It is okay to end a relationship. You are not a failure. Differentiate "right and wrong" versus "this is not working for me." Maintain fairness and your integrity, core values, and beliefs, and you know you're on the right track toward resolving conflict, even if it ends in losing a client. Most times you can have it your way, build a solid relationship, and keep the client too! Whatever the outcome, Dr. Gavin recommends that you stay calm and develop perspective as you resolve conflict. Perspective involves appreciating and getting to know where your client is coming from. Balance your ego, which wants to win, with your heart, which wants to protect the relationship, and contrast that with what is healthy for you! In this way, you can turn conflict into opportunity.

Understanding What Drives Your Clients

If you want to understand what motivates your clients, take a personal interest in finding out what makes them tick. How do you do that? You ask them and then listen and act on the information. Because you probably see your clients more regularly than any other fitness or health professional in their life, you have a huge opportunity to get to know them.

Twelve years ago, the concept of understanding your client was novel. This became apparent to me after I received a letter from a personal friend and top trainer based in Chicago, Mark Cibrario. In part, Mark wrote, "*Going Solo* [my first book on personal training] inspired me to come up with this 'Personal Characteristics and Lifestyle Profile.' We are using this profile as a means to get to know and understand our clients a little better. Thus, we are now experiencing a

little less frustration and understand that there are a lot of things outside our control—more than we thought—that greatly impact our clients' attitudes each day." I still have the handwritten letter, because even then, I realized that the issue of client relationship was important stuff. And so did Mark.

Understanding and appreciating your clients at deeper personal and emotional levels go beyond what a good or ordinary trainer does with regard to client relationships. This level of service and care starts to encompass what a "master trainer" can give to a client. It requires time and effort and necessitates that you use some kind of tool to help you understand the person with whom you are working. After all, the more you understand each client's unique personality, the easier it is to offer an individual and personalized training service. This is what clients pay for!

Several interactive and proactive tools are available to help you better understand and meet changing client needs:

- Client feedback surveys (pages 156 and 176)
- Medical history, activity, and nutritional questionnaires (appendix)
- Personal Characteristics and Lifestyle Profile that you can develop and administer yourself (form 7.2, page 167)
- Commercially available Personal Fitness System™ (PFS) Interactive Wellness tool (see this page)

Using the Personal Characteristics and Lifestyle Profile

The Personal Characteristics and Lifestyle Profile is best administered by the personal trainer and is different than a medical history questionnaire or profile. You can easily modify the following sample, form 7.2, to best meet your needs. (Also, refer to the appendix, short- and long-form medical history questionnaires for nutritional habits, activity, and lifestyle questionnaires.)

Using the Personal Fitness System™ (PFS): Interactive Wellness

An excellent tool you can use to gain knowledge and understanding of yourself and your clients is the Personal Fitness System™ (PFS) Interactive Wellness tool. After you complete the 10-minute PFS questionnaire, computer software creates a behavior profile based on the responses. You can use this information in many ways:

- Improve compliance with programs
- Gain commitment for improving fitness and wellness
- Accelerate client achievement
- Give constructive feedback and criticism
- Avoid misunderstanding between client and professional
- Get new clients off to a fast and productive start
- Build a strong professional relationship from the beginning
- Discover what makes your client feel comfortable and at ease during a session
 (PFS can be contacted at 480-951-0822 or e-mail dharper@pfsinsights.com or visit www.pfsinsights.com)

By having a handle on these eight powerful and crucial issues, you will enhance your effectiveness and your client's success. The PFS process, or one that you design by yourself or use from this book, creates another difference between you and the trainer next door. It loudly proclaims your interest in identifying each client's motivation as well as your desire to communicate effectively.

Your client must always remain a part of the process. Her input and sense of personal involvement are important components in directing your program design and developing long-term, committed relationships. This type of interactive communication continues throughout successful personal trainer–client relationships. If you have done a thorough job of gathering information and listening, you should understand the inner workings of your client and know what makes her tick.

Cultivating Listening Skills

You can passively listen or actively listen, and if you really hear what your client is saying, you can act on what you've heard.

F O R M 7.2 Sample Personal Characteristics and Lifestyle Profile

1. What is your occupation? _____

2. Do you consider your position at work to be

 ___ Sedentary?

 ___ Moderately active?

 ___ Active?

3. On the average, how many days per week do you work? _____

4. On the average, how many hours per day do you work? _____

5. How much time off do you take for vacation, per year? _____

6. Are you presently:

 ___ Single?

 ___ Married?

 ___ Divorced?

 ___ Separated?

 ___ Widowed?

7. How many children do you have? _____

 Age(s): _____

 Name(s): _____

8. List some of your hobbies or interests, other than exercise:

 a. _____

 b. _____

 c. _____

 d. _____

 e. _____

9. Which of the following traits most accurately describe your personality?

 ___ Competitive and motivated

 ___ Relaxed and easy going

 ___ Quiet and shy

Continued ➤

From *The Complete Book of Personal Training,* by Douglas S. Brooks, 2004, Champaign, IL: Human Kinetics.

10. How often do you experience "negative" stress from each of the following:

	Always	Usually	Frequently	Rarely	Never
Work:	——	——	——	——	——
Home or family:	——	——	——	——	——
Financial pressure:	——	——	——	——	——
Social pressure:	——	——	——	——	——
Personal health:	——	——	——	——	——

11. How often do you suffer from fatigue and tiredness during the day?

___ Every day

___ Usually

___ Frequently

___ Rarely

___ Never

12. How often do you wake up refreshed and relaxed in the morning?

___ Every day

___ Usually

___ Frequently

___ Rarely

___ Never

13. How often do you sleep soundly at night?

___ Every day

___ Usually

___ Frequently

___ Rarely

___ Never

14. At present, why are you interested in a personal trainer? (Mark all that apply.)

___ Accountability

___ Motivation

___ Education

___ Specific medical concerns or special needs

___ Assistance and direction in reaching personal health and fitness goals

___ Other: _____

From *The Complete Book of Personal Training,* by Douglas S. Brooks, 2004, Champaign, IL: Human Kinetics.

Continued ➤

➤ *Continued*

15. **What type of trainer do you prefer? (Mark all that apply.)**

___ Challenging, hands-on, pushing personal limits

___ Gentle, guiding, nurturing

___ Take control

___ Teacher, educator, facilitator

___ "Drill sergeant"

16. **What are your personal goals and expectations of this program?**

17. **Indicate the major reason why you exercise:**

___ I do not exercise.

___ It makes me feel good.

___ I'm trying to lose weight.

___ It's good for my health (i.e., prevention of illness).

___ My doctor told me to exercise.

___ It makes me look better.

From *The Complete Book of Personal Training,* by Douglas S. Brooks, 2004, Champaign, IL: Human Kinetics.

Passive Listening

Passive listening means that you genuinely pay attention to the speaker yet make no verbal response. Continuous eye contact, smiling, nodding, and leaning attentively forward are effective uses of body language to communicate that you are really listening. However, your follow-up actions and conversation must support that you were actually listening! Keep your mind quiet and still. Don't race into the future. Listen. Really listen.

Active Listening

Literally, your ears still do the work, but you actively interact, returning the focus to the speaker. You might ask for a clarification or rephrase something to communicate to the speaker that you did, indeed, hear him. Some communication specialists call this amplification. One question or clarification leads to another, and an end result is that the speaker really believes he is heard. Investigative reporters and physicians who perform "histories" to arrive at accurate conclusions or diagnoses often are superb at this type of communication.

Action

Here, not only does your mouth take action, but your programming, policy decisions, and other aspects of your business reflect what you have heard. During conversation, before you act, verify what you have heard by using verification and amplification techniques. Try to repeat what you perceive is the intent of the speaker's statement and what he is trying to share with you. For example, "What I hear you saying is . . ." or "If I understand you correctly . . ." are excellent ways to verify what you think you heard. This way, information is not miscommunicated, and you have an opportunity to act appropriately. Your client will verify whether you've heard correctly.

Developing Real-Life Communication Expertise

Day-to-day personal training communication skills are essential not only to help your clients understand and accept business policy, rules, and regulations but also to help you and the client—as a team—to fully develop the client's program.

Good listening and interactive steps that include amplification (getting clear on what you hear) and verification (check it once, check it twice to make sure you've got it right) can help to dissolve client resistance to policy or programming decisions. Why? Because, if you use communication skills like these, clients really believe that you listen, hear them, and consider their opinions and feelings. Yet, because you are fair and a good listener, you can offer your professional judgment and be perfectly honest. In turn, your clients will listen to and respect you!

Let's say a client tells you that he doesn't want to "run and sweat." By asking amplification questions you can get at the root of the problem. By asking the right question, you find that John hates to run and sweat because he was a college track athlete and did repeated all-out track sprints until he vomited. He equates running with this type of effort. Next you clarify by saying, "If I've got this right, you . . ." Now you know what you're dealing with, and it's much easier to convince him of the difference between your running program and a collegiate sprint program! Whenever a client offers an objection, you can always offer a solution if you understand his resistance.

Generally, the resistance you are trying to overcome involves misinformation, personal observation, and past experiences. All three can be formidable foes or your best allies. Objection that stems from these areas can be overcome if you exhibit good listening skills, empathize with the client, and offer a satisfying solution.

Misinformation

A client says, "I don't want to increase the weight I lift because I don't want to get unsightly and bulky muscles." This is an opportunity to explain individual responses to exercise (two people can be on the same program and get entirely different results), sex differences, and genetic influence. Additionally, before you launch into your script, ask why the client feels this way. This allows the client to vent, clarify, and amplify her beliefs. You can respond by empathizing and by letting her understand that you understand her concerns. As you share your approach and interact, and before you take over, ask the client "What do you think?" Usually the response is, "Okay, let's give it a shot!"

Personal Observation (or Too Little Information)

A client tells you that he saw someone lifting with fast repetitions and noted how defined and lean the individual was. Or maybe he even saw a well-respected trainer using uncontrolled rep speed with a client who looked very good. He asks you, "Why aren't we training that way?" Without getting defensive or pointing an accusing finger at the other exerciser or trainer, you should explain how you vary the number of seconds per rep but that keeping control is always the key, independent of the number of seconds it takes to perform a repetition. You can support your decision to train this way because of the increased likelihood of injury that comes with uncontrolled lifting and because faster speeds recruit less muscle for a given resistance or load. Your client who lifts with control definitely receives the greatest benefit. You can also discuss that any type of training, as long as it is different or harder, can produce results. Training results or a "good body" does not always justify the means or training methods used. You can also discuss the myth of spot reduction and other "leaning" or "trimming" exercises that are associated with a high number of repetitions performed quickly.

Provide information and education from a caring and modest, although knowledgeable, stance. On the other hand, if you need to learn something, humble yourself and investigate. If you know you're on track, give your client confidence in your methodology by laying the foundation. Do what is necessary to serve your client's best interest.

Past Experiences

You've heard the following: "I only want to do upper body strength exercises because I've

strength trained my legs before and they just got bigger and bigger. I hated how I looked. Even if I just step on a stair-stepper my legs balloon up." Although you'd like to target the major muscle groups of the body to attain muscular balance, the client strongly objects. If you asked about what kinds of physical changes she disliked and what type of program she was on, you might find she was doing multiple sets of squats, lunges, seated leg presses, and leg extensions and was not happy with how her quads increased in size. You find she was working 6 to 10 reps to failure, which would augment muscle size to a greater degree compared with 20 reps to failure. After stating that you understand her concerns given her past experience, you might suggest that you limit the number of quadriceps exercises and work at a higher rep range. You can explain about different exercises that target different areas of the lower body—not just the quads—and the difference between higher rep and lower rep training loads. Let her know you can, with her consent, carefully select leg exercises that can tone and firm her legs, while quite possibly ending up with the look she wants. You tell her, "I can't guarantee I'll match your expectation, but I'll gamble we can get close and end up with an entirely different result compared with your previous frustrating and disappointing experience." She says, "Okay, but we better be careful and I'm watching closely! And if I don't like it, we'll change, right?" You respond with a warm smile and say, "You bet!" Now, you're onto a new journey, a willing client in tow.

Using Communication Skills in Day-to-Day Personal Training

Personal trainers play a variety of roles when running a business and training clients. Whether you're making business decisions about expansion or hiring new employees; wearing the public relations and advertising, accountant, or salesperson hats; or attempting to match your training style with a variety of clients and present a physical presence that each client is comfortable with—how you communicate will affect what you accomplish. Don't forget to consider cultural influences (e.g., a

thumbs up doesn't mean "way to go" in all cultures) and religious beliefs.

There is much more to training than demonstrating an exercise, going through a line of equipment, or programming a number of reps and sets. If you hope to create the most positive and productive learning and training environment for each of your clients—and cultivate committed clients—use a number of methods to get your message across and make sure the methods used are a perfect fit to each client.

Developing Verbal and Nonverbal Communication Skills

Generally, communication experts break down this complex art of interaction into two basic areas, verbal and nonverbal. (Don't forget to use written communication—such as business policy, newsletters, e-mail—to effectively communicate with your clients, too.) Verbal communication skills include what you say, how you say it, speech patterns, and voice volume. Nonverbal communication skill—what you don't speak but communicate loud and clear—is represented by physical appearance, body language, facial expression, and touch.

Physical Appearance and Dress

You might question, "Really! How I dress and physically look fall under the category of communication skills?" Absolutely! In fact, you first communicate to clients via your outward appearance, and first impressions are often lasting.

Physically, independent of our unique body types, fitness professionals should personify fitness and health. You should follow a standard of professional dress, chosen with the intent of making the client's training environment "emotionally safe," comfortable, and nonintimidating. You should also foster a professional image that stems from a suitable dress code. This is in contrast to dress standards that only reflect your individualism and freedom of choice. A cavalier attitude prevails if you answer the question, "Why do you dress like that?" with, "Because I can." Indifference or naivete toward client feelings is bad business.

Making a fashion or other statement, even though I can, isn't worth it if I risk being insensitive to a particular client or it affects my bottom line. Maybe there isn't a right or wrong, but there are consequences based on your choices, and your client will react favorably or disapprove or will be offended or encouraged. Your first hint that you've made a mistake is a client who leaves your business or doesn't even consider training with you for what you see as no apparent reason. Remain sensitive to this aspect of communication and its impact on client perception. Survey the degree of acceptability from the client's perspective. Regardless of your opinion, take time to ask yourself, "Do my dress and physical appearance best serve my clientele's interests and motivate them?"

Demonstration, Visualization or Painting a Mental Picture, and Hands-On Correction

Some trainers and clients are uncomfortable with touch or hands-on correction. If this is true, remember that the use of demonstrations, mirrors, videotaping, and visualization can create vivid mental pictures and bring about the necessary change in exercise technique. Use a variety of mental pictures that you create with words, demonstrations, or other feedback gained from video playback or well-positioned mirrors. A lively vocabulary that creates descriptions (nontouch) and analogies will provide the breakthrough that can help your client get it right.

Hands-On Correction

Hands-on correction or spotting is very effective anytime but especially when a client is physically blocked from moving forward. However, you must respect your clients' personal boundaries. Personally, I am very comfortable spotting or physically manipulating my clients so they can "see" and "feel" correct exercise position. My years of experience as a college gymnast and as a women's collegiate and club gymnastics coach helped me to grow very accustomed to hands-on spotting from a safety and execution perspective. However, before I physically position or reposition a client or assist a movement, I ask for his or her permission to use hands-on corrective spotting.

If your client refuses permission or you sense the client is uncomfortable even after permission is given, make sure you plainly communicate that hands-on spotting is not necessary for an effective workout and that several other clients prefer that you don't use this method. Put the client at ease with a decision not to be touched or give him another chance to tell you that, "In truth, I'm not totally comfortable with it." Many other tools are available to you that won't cause a client to feel uneasy.

Given permission, I explain what I will be doing, why, and where I will be touching. This instruction isn't an oral dissertation but is simply explained as we move through the session. Don't shock or frighten clients with unannounced hand or bodily contact. (Don't assume that supporting someone's spine with your body during a latissimus pull-down is completely innocuous!) Most clients who are new to personal training don't really think about being touched by a trainer until it happens. For many clients, announced or unannounced, this is no big deal. For another client, the shock, fear, and surprise could be a major personal violation. You might be thinking, "Isn't that overreacting? Making a mountain out of a mole hill?" Your opinion or perspective does not matter here. The issue is to honor and respect your client's space by communicating first, before taking any action or making any assumptions. Err on the side of being ultrasensitive and cautious when it comes to personal boundaries. Leave the decision of physical manipulation to your clients. If permission is granted, both the client and you can relax and enjoy the benefits that hands-on correction adds to a professional training situation.

Positive Verbal Correction

Although you shouldn't patronize your clients, you can correct, encourage, and guide clients with positive language. For example, rather than tell a client, "You're arching your back!" I could suggest that she soften or bend her knees, tighten her abdominal muscles slightly, or roll her hips under. I might follow this with, "Perfect! See how that takes the stress off of your lower back by minimizing the arch? Now you're positioned in neutral spinal posture, not arching your back excessively and not flattening it!"

I try to ensure that my manner of speech, voice volume, and speed of delivery are calm, focused, patient, enthusiastic, and caring without being overbearing or boring. My encouragement, correction, and guidance are selective, versus a nonstop ramble. Not only is constant corrective commentary irritating, it isn't long before the client believes she'll never "get it" or satisfy you. It also won't be long before your good intention causes her to stop listening and maybe start looking for another trainer.

I don't necessarily try to match a client's personality with communication techniques because I don't want to have to "one-up" her in terms of voice volume or "talk down" to or overly baby a less aggressive client. I don't want to compete with my client in any manner. Develop a flexible style—your style—that can be adjusted to the person you're working with but still represents who you are. This will come off as honest and real, rather than forced, contrived, or fake.

Athletic-Ready Stance

You know the stance . . . feet are shoulder-width apart, your body is upright, eyes are intent, knees are slightly flexed, and you're ready to pounce. Of course, my clients know what an athletic-ready stance is because we use it in various sports conditioning and balance drills. I try to adopt this attentive posture during personal training sessions. I develop the sense that I am on edge throughout the workout by using eye contact and being very focused. You'll never see me lounging against a wall or piece of equipment. My eyes don't wonder, my thoughts don't drift, and I never display body language that says I have left the session. My facial expressions tell my clients I am with them! I position myself so that I can talk to and with my clients, not "down" or "at" them. I can effectively communicate a lot of energy, focus, commitment, and professionalism with this stance.

Blending Communication Approaches

Verbal and nonverbal communication blends to form a mix of support, motivation, encouragement, guidance, correction, and education for your clients. As is true for programming, one style of communication does not fit all. A variety of methods must be used that relate to how each client best learns and is motivated. How are you doing? Solicit feedback and ask your clients!

Motivating Your Clients

Besides using superb verbal and nonverbal communication skills, you must sometimes wax philosophic to motivate your clients. Sometimes the philosophy, as applied toward some area of fitness they are struggling with, rings true to them and spurs them on!

Most of my clients, along with the majority of the world's population, do not believe there are enough hours in each day to get everything done. I approach my clients philosophically about this universal need for more time by using what I call the "time account" fable. Basically, it goes like this: Everyone starts the day with the same amount of time banked for the coming day—86,400 seconds. And each person chooses how he or she invests those seconds.

I follow this little story with reasons (excuses) for not exercising and let my clients come up with some, too. After I share my woes, which include travel, fatigue, family, and lack of overall balance in life, reasons for not exercising are followed by reasons for exercising. Funny, all of my clients know they should exercise and why but still find it entertaining to "whine" about. We all have so little leisure time that we should find something to fill our free time that has value, meaning, and reward. No, this does not refer to channel surfing or sacking out on the couch! Then, what is important? Exercise! Exercise should be part of every client's answer.

Getting Exercise Done

To get exercise "done," a client must schedule and balance his or her exercise priorities.

■ **Treat exercise as a priority.** Just as you schedule and partake in personal hygiene, business, and family commitments, so should you prioritize exercise.

■ **Set a planned course of action.**

1. Define your goals.
2. Schedule: Think it and ink it!
3. Accountability: Enlist the help of your partner, your family, or a trainer.

- **Target the right equipment.** The wrong equipment can make exercise less fun and enjoyable and is likely to give a client another reason to quit.

- **Invest minimal time** and capture a big health and fitness return. Smart training results in efficient workouts and maximizes results.

- **Protect your exercise** time as a lioness would her cubs. Create sacred time and set your commitments, including exercise, in stone.

- **Do not strive for perfection.** Emphasize the goal of progress—not perfection!

- **Passion: The unscientific factor.** You must enjoy what you do!

What Works

Results from the IDEA Personal Training Survey (IDEA 1998a) strongly indicate that trainers use positive, supportive, and affirming reinforcement to motivate their clients. This is in contrast to loud, forceful, critical, or extremely evaluative approaches. A majority of trainers used self-comparisons to rate improvement (refer to chapter 11) versus an evaluative approach using norm-based comparisons. Early behaviorists championed the idea that positive feedback has a far more beneficial impact on behavior than criticism. The advice was to focus on the positive without patronizing your client. Accordingly, the results of this survey showed that personal trainers seem to be following this advice. One interesting note: Older trainers may be more discriminating when providing reinforcement (Gavin 1998). In reference to this last survey finding, if the entire workout is full of exclamations like "great," "excellent," "outstanding," "superb," you have to wonder about the genuine impact of this feedback and the sincerity of its delivery and content.

Pointing out what clients are doing correctly and incorrectly, asking how clients feel during sessions, comparing client improvement to prior personal performance, and continual encouragement ("You can do it!") are methods that can motivate clients. Be sure to recognize client improvement but maintain sincerity. It's fair to praise in accordance with the significance of the accomplishment.

What Doesn't Work

Take each point made in the previous section, "What Works," turn it 180 degrees, and you have the list. At the top of my list of methods that don't work is an approach that is domineering, aggressive, and of boot-camp mentality. I'm not comfortable with it and neither are my clients. Develop a style that does not evolve from trying to be like someone else. Don't try to be "like Mike"; instead champion, develop, and know your own style.

A close second is related to trainers who lose contact with the client. For example, they ignore the client's feedback or are more interested in gazing past the client to check their fit bodies in the nearest mirror. The workout becomes something for the trainer to check off of her "to do" list.

New trainers commonly make the mistake of pushing trainees too hard in the early phase of their workouts. Possibly, through a combination of naivete, ignorance, lack of maturity, or misguided but well-intentioned enthusiasm, the trainer fails to respect physical and psychological limits. This again is extremely personal territory. Don't violate your client by failing to be sensitive to this issue. It's always better to do too little than too much. People work out to feel and look better, and they want to enjoy the experience.

Using Motivation Magic

Effectively motivating people to stick with exercise and see them through emotional and physical plateaus does not result from a set of magic tricks. That would be an illusion! Successfully motivating your clients requires you to develop a set of skills and strategies that work with each client and help them attain their health and fitness goals over the long term, even if you don't train them. The foundations you help to set should serve clients for a lifetime, with or without your assistance.

Wants and Needs

Motivation must be individualized, and you cannot individualize without communication. I find out what my clients want and what drives

them through an ongoing information-gathering process (see chapter 10). This allows me to create and focus on a program made up of what my clients want and need.

Setting Realistic Goals

Setting realistic and attainable goals (chapter 12) allows you to stay current with your clients' expectations and desires. Mental, emotional, and physical needs change with any progressive and well-planned program. This ongoing planning and reevaluation stage allows you to attain goals in a purposeful way. It's much like periodization, which aims for "planned results," versus a haphazard approach that entails no forethought, organization, or preparation.

Inspiration

Although you cannot drag a client to inspired heights, external factors within your control can greatly influence a client's sense of hope, excitement, and enthusiasm for the training environment. What you say, how you say it, how often it is said, and your own positive attitude count! Sometimes I believe we are more inspirational than motivational. We can inspire our clients by our example and love of what we do.

Education

Without pontificating or "talking down" to clients, you need to help clients understand why they are exercising and taking care of their personal health. This understanding leads to a higher level of commitment and independence. Clients become solidly rooted in what they are doing. Specific educational information gives exercise purpose and clarifies the long-term picture.

Fun and Play

It's not desirable for a trainer to become her client's buddy, but variety, enjoyment, and professional "friendship" on the training floor will help the client get the most out of each training session. Joking between exercises or reciprocating a playful verbal tease is appropriate with some clients. Every client has a degree of child in him—a bit of a "barking pig"—and it's helpful to let this escape occasionally.

Feedback

Properly doled out recognition for individual achievement, no matter how little or how great, is essential. I prefer to err on the side of giving too much positive reinforcement than too little. Still, I try to discern and be judicious when praising my clients so my intentions remain believable and sincere.

Put It in Writing

Sedentary patients who receive oral exercise advice and a written exercise prescription from their physician will increase physical activity more than patients who receive oral advice alone (Rubin 1998). Using Personal Agreement and Goal Sheets and self-contracts (chapter 3) and goal-setting forms (chapter 12) is a good way to get your clients to commit to getting results, in writing. Once the self-contract is set in writing, outcome becomes objective and can be evaluated, and then the program can be adjusted to meet current client needs. Put in a word, this form of "magic" is called accountability!

Staying Motivated

Having your clients stick with exercise and maintain enthusiasm toward it may be your biggest challenge. Most people who love exercise, who stick with it, have "learned" to do so. Clients should rest assured that this desire to work out is not innate in most people. With the right approach and encouragement, however, a burning passion can evolve, especially if this is combined with life-changing results. Administering the following Exercise Experience Form (form 7.3) can help the client and you stay in touch with client perceptions and whether your clients are struggling with motivational issues.

Helping Your Clients Change

I've believed for many years that it's not up to the trainer, but rather it's up to the client. Ultimately, your clients are responsible for change. Clients who keep exercising are often intrinsically or self-motivated. This is another hard concept to swallow. Personal trainers by

F O R M 7.3 Exercise Experience Form

Complete this form as soon as possible after your exercise session. It will improve your awareness of the exercise experience and help you focus on the process rather than the outcome. Discuss your responses with your trainer during the next session.

How enjoyable was the session? _____

Were you satisfied with how you did? _____

Did you attain your goals? _____

How well did you concentrate during the workout? _____

Did you wish you'd been doing something else? _____

Was this activity important to you? _____

Were you in control of the situation? _____

Did the activity challenge you? _____

Did your skill level match the activity? _____

Reprinted from Staying Motivated 1998.

From *The Complete Book of Personal Training,* by Douglas S. Brooks, 2004, Champaign, IL: Human Kinetics.

nature, myself included, want to solve every client issue. Somehow, we believe we are responsible for bringing our clients to full fruition through our personal strength and will. This is the perfect setup for failure. We must accept our role as a guide for the client's health and fitness journey.

This chapter focused on building intrinsic motivation and personal confidence in the client. To build self-confidence in others, you have to feel good about yourself. Do you feel empowered? Are you growing, maturing, and still learning? Are you in control of client relationships? If so, there's a good chance you are on your way to becoming a "master" trainer who can pass this full development, sophistication, and experience to your client in the form of his or her self-empowerment.

Empowerment steps can be as easy as getting to know your clients, supporting who they are, clarifying the relationship boundaries and purpose, sharing information and education that will help clients believe they can exist independent of you, listening twice as much as you talk, keeping the focus and attention on the client, helping your clients feel smart and good about themselves, firing the judge in you, "showing" clients more than "telling" them,

and, finally, setting a course of action in both words and writing.

Epilogue

I believe personal training is all about creating the best outcome for and serving your client. A large portion of the client–trainer relationship is dependent on perception, intellect, and the mind. We must have impressions and make choices. Keep George Bernard Shaw's quote in mind when developing this ever-changing, dynamic relationship. "Those who cannot change their minds cannot change anything." Note the quote did not state that trainers who cannot change a client's mind are failures!

The Gift

Dr. James Gavin may have put it best: "My gift for you as a personal trainer is to tell you that you are not responsible for fixing your clients. Caring for them is enough—it's their job to change. And the bonus gift is that in presenting yourself this way to your clients, you may find the understanding and self-esteem to make whatever health change is important to your life" (Gavin 1997, p. 38). Now, that's good advice for you and your clients!

CHAPTER 8

Legal and Professional Responsibilities

The words *legal, liability, litigation, lawsuit,* and *attorney* may send chills up and down the spines of trainers as cold sweat simultaneously trickles down their temples. These words may inspire mean-spirited attorney jokes. Or they may have no effect if a trainer is clueless about her legal responsibilities to the client, to herself, and to her business. There is no need, if you take prudent steps, to fear legalities concerning you and your business. But, equally true, there is no excuse for naivete about legal responsibilities.

To run a successful business you must be comfortable with legal concerns. On one hand, don't lose sleep over possible litigation. Instead, take preventive steps and become adequately informed in this area of your business. (Here, again, do your homework!) If you are ever in doubt about a legal issue, although it may sound cliche, contact legal counsel to get clear-cut, legally defensible, and accurate direction.

The information in this chapter is not intended as legal advice. I hope the points discussed will raise your awareness about various business and legal concerns, prompt you to ask the right questions, and strongly encourage you to seek expert legal counsel when appropriate. Sport law interpretation can vary between state, province, and country. When you are developing guidelines and regulations that will be viewed as legally binding and personally protective, always consult attorneys in your state, province, or country for specific solutions to your legal questions.

Understanding the Basics

It is cliché but true; we live in a very litigious world. You can be sued for doing too little (omission) or nothing, for actions well intentioned, or for taking action that is beyond your training (commission).

Scope of Practice

Whether you work as an employee or independent contractor, clients will ask you for advice. You need to know the scope of your discipline, stay within your scope of practice, and back this with adequate knowledge. Ignorance is not an acceptable defense.

Don't play doctor or pretend to have the cure for whatever ails your client. Common sense says you should not misrepresent your expertise or understanding of health and fitness issues. Most countries have laws that mandate severe penalties for those who practice medicine without a license.

It's tempting to offer advice when asked for our opinion, and you will be asked countless times! If you have the expertise and qualifications it's okay to give an opinion, but generally, when asked about treating injuries or taking medications, limit your general recommendations to standard first aid procedures.

Know your limits of expertise and general counsel. I hope that you are wise and mature enough to recommend that a client seek expert counsel from a licensed health care practitioner, or that you seek out expert guidance so you can

properly advise your client when warranted. After receiving professional guidance, and if it is appropriate that you still work with the client, continue to keep comprehensive records and modify the workout to reflect the professional's guidelines and the client's needs.

Know when to pass training situations to others who can more competently serve the client. This ability to stay within the realm of duties, responsibilities, and technical competence for which you are prepared is essential if you want to limit your risk and focus on the client's best interest.

Understanding your levels of competence and what you are trained to do goes hand in hand with establishing a group of allied health care professionals who are trained in disciplines beyond your expertise. Establish a network of counselors, dietitians, doctors, and other licensed professionals who can provide services to your clients beyond what you can safely and expertly offer.

You should use health assessments to determine fitness levels rather than use them to recommend treatment, diagnose, or otherwise ascertain whether the individual is ready to begin an exercise program. Physical fitness assessment or testing is not appropriate for all clients. Fitness assessment is an optional motivational tool that can be used with some of your clients to motivate them, whereas a well-designed health history and medical questionnaire is mandatory and can help you decide whether the client is able to enter into a physical program or whether you should seek additional counsel. This questionnaire is used to help screen the client for placement in a fitness program (see the appendix and chapters 10 and 11 for more information).

You must understand the information you ask about and know how to interpret it and apply it to the client being screened. When significant risk factors or other questions arise regarding the individual's health status, you should refer him to a qualified health care professional for clearance before the exercise program begins.

Standard of Care

The legal concept of "standard of care" really refers to "ordinary care." Ordinary care reflects what a prudent, responsible, and professional trainer would do in a given situation. In other words, your actions must be in accordance with services that are appropriate for the age, condition, and knowledge of the participant, and, in addition, the methodology and programming used must synchronize with current professional standards. In the event of litigation, attorneys representing the plaintiff might ask an expert witness what other fitness professionals of similar training would have done in the same situation. Additionally, other leading authorities could be called to testify about acceptable standards, and credible industry texts might be cited to establish or ascertain whether the action was appropriate and in line with current standards.

Trainers are obligated to use ordinary care when training clients. If you follow an acceptable standard of ordinary care, you will be taking action to avoid injuring a client by using training methods that are reasonable and that a prudent trainer would use.

Any state, province, or country that does not require trainers to be licensed will most likely judge you by two items: The first is a standard of care that is often based on criteria set by leading educational and certifying organizations and accepted by the industry as evidenced by its adoption. The second is expert witness testimony that indicates what a careful, prudent, updated, and professional personal trainer would have done in the same training scenario.

Avoiding Lawsuits

Most lawsuits and claims filed against trainers and fitness facilities occur when negligence is evident and often are related to the following:

- Failure to screen participants
- Failure to adequately instruct or supervise participants during recommended or prescribed activity
- Failure to properly assemble, maintain, or adjust equipment
- Failure to maintain physical plant (facility) integrity
- Failure to comply with industry standards
- Failure to provide appropriate emergency responses to those in need (Herbert 1997)

Keep Accurate and Updated Records

Using waiver or release forms, informed consent forms (or express assumption of risk), and health history questionnaires is expected as part of thorough client screening and is a good attempt to inform clients about potential risks inherent to a physical training program.

If you train away from your regular training site or outdoors, for example, visit the area ahead of time, be sure your insurance carrier covers this training situation, consider using a specialized waiver form that informs the client about any inherent risks, and take along a fully charged cellular phone in case an emergency arises.

Use Common Sense to Prevent Lawsuits

Lawsuits can best be prevented by adequately screening your clients, developing safe programs that meet industry standards and include prudent progression and correct exercise technique, and closely supervising the entire workout. This vigilance ranges from equipment setup and maintenance to spotting and verbal instruction. Remain attentive from the start of the workout to its finish. Proper instruction and watchful supervision are key.

Minimize Your Risk and Exposure to Litigation:

- Adhere to industry standards and guidelines developed and published by respected and authoritative professional organizations.
- Develop and implement initial and ongoing client screening procedures.
- Appropriately prescribe (plan) and supervise activity.

(Note: The word *prescription* traditionally is used to denote a program or medication scheme prescribed by a licensed professional. Personal trainers generally do not prescribe exercise programming unless they have specialized training or credentials.)

- Implement ongoing facility and equipment inspection and maintenance.
- Provide properly certified and trained fitness professionals who will deliver relevant services that are within their scope of practice.

- Provide cardiopulmonary resuscitation (CPR) and first aid through trained and certified personnel.
- Adopt, and update as appropriate, a written emergency response plan that is rehearsed periodically and modified as necessary (Herbert 1997).

Practicing Risk Management

As part of risk management and to avoid litigation, you must identify, limit, reduce, and transfer possible risks to minimize your liability exposure. You have to do the "right things," take prudent steps, and follow industry standards and guidelines. Beyond these principles, the foundation of sound risk management is a reliable insurance program that provides a carrier-paid defense (insurance company covers this expense) in the event of lawsuits and also pays for any damage awards.

If risks can't be eliminated, you can use transfer mechanisms, which can help eliminate or limit personal liability; these include waivers and releases, informed consent or express assumption of risk forms, and, as mentioned, professional liability insurance. Despite what you can do to limit, reduce, or eliminate legal risks, professional liability insurance is mandatory in today's litigious society and remains one of the most important, cost-effective components of an effective risk management program.

Risks Related to Trainer Qualifications

You can never acquire too much knowledge. A formal degree in a fitness-related area and certification help to establish credibility and demonstrate that you have, at the least, basic or minimal competency to perform the duties associated with personal training. Certifications and advanced degrees can further specify and document expertise.

Looking good on paper is one aspect of competence. Following the rules, regulations, guidelines, and expected behaviors set forth by reputable and standard-setting organizations is another. Education, by itself, may prove you have the qualifications but will not

protect you from being sued. You must also act in accordance with your level of qualification and with what is defined as accepted and proper operating protocol at that time. Even when you perform perfectly and in accordance with every industry guideline, you still could be sued! So you must obtain professional liability insurance.

Risks Related to the Conduct of the Training Program

How would a prudent, professional, and informed trainer progress a client's program? If you know the answer to this question, there's a good chance you'll be able to avoid injuring a client and the high likelihood of subsequent litigation.

You must observe these points:

1. Follow a logical progression in your program.

2. Develop short- and long-term goals for the training program that fit nicely into the concept of programming periodization; this allows you to document activities that took place and were in line with accepted industry practices. Consider planning programs on computers to save you time and to help you avoid information storage hassles.

3. Know and follow the standards and procedures advocated by leading authorities and certifying organizations in the personal training profession.

4. Develop and communicate safety procedures and rules to your clients in writing and verbally; provide the information in writing and have them sign appropriate forms (e.g., waiver and consent forms) that will help to limit your risk or liability; make clients aware of inherent risks associated with your training program.

5. Screen the participant so you can understand risks related to her age, current health status, current activity and fitness level, and underlying disease, and use this information to create a safer, more effective training program.

6. Closely supervise the client's workout, training program, and progression; it is estimated that 80 percent of all sport-related lawsuits stem from inadequate supervision.

7. Be prepared for a medical emergency. The trainer should be certified in CPR and first aid procedures and have a written emergency plan in place and posted, including emergency numbers. Failure to act correctly and quickly, failure to give emergency treatment, failure to administer proper treatment, and delays in providing treatment are common allegations associated with lawsuits.

Risks Involving the Training Area and Equipment

Is the training environment (home, gym, club, private studio, outdoor area) in which you train your client safe? Can all risk management strategies you have in place be applied to each setting? For example, does your liability insurance cover off-site or outdoor training? You are required by law to be certain any exercise area is safe. This requires that you inspect the training environment every time you train! It's a good idea to develop a checklist and to record your observations regarding equipment condition, potential problems, condition of the floor surface, dangerous obstructions, or equipment sloppily placed (e.g., dumbbells, stability balls, stretch mats) and note corrective actions you have taken (Cotten 1998b).

Reducing Risks Through Documentation

Starting in chapter 2 and continuing in other business management and policy chapters, I have drilled home the idea of creating a paper trail that objectively documents your intentions and actions. Complete, accurate, and meticulously detailed written records will support your case, save you time and money, and possibly protect you from a lawsuit.

Not only will written documentation save you time and money in the event of litigation, but it will carry more clout with the courts. In the event of a lawsuit, written documentation provides much more reliable and objective evidence to support your position compared with oral testimony that attempts to recount events that happened months or years ago.

Accurate documentation also speaks highly of your professional demeanor and proper protocol, which the courts will view to your advantage. Good record keeping will help you to provide updated and complete services to

your clients, too. You can modify programs in a more timely manner when you have updated notes and records.

Written documentation in the following areas should be considered. Keep copies of overall training plans; daily workouts; equipment inspection checklists; a liability waiver; medical history screening forms (periodically update these); a written warning of risk or informed consent regarding the exercise plan, testing, or other activity; a written emergency plan; and an accident report.

Maintain written documents on file for at least several years; I recommend that you maintain them for about seven years. You're probably thinking, "Paper trail nightmare!" You can manage the volume of paper and any hassle related to this paper trail documentation by using the appropriate software and computer. The real nightmare is litigation brought against you—even in the event you have taken prudent steps that align with industry standards of conduct—if you have not documented the steps taken or cannot easily retrieve the information.

Accident Report Form

Dr. Cotten (1998b) identifies eight types of information that an accident report form should generate. Always file this information in the event of an accident or other injury to one of your clients. You may not need the information until several years later.

1. Identification Information Record the activity or event, date and time, person in charge, person injured, witnesses (names, addresses, phone numbers), and name of the insurance company.

2. Location of Accident Note the area where the person was injured (e.g., weight machines, pool, shower, offsite outdoor location) and location of the witnesses, person in charge, and any other participants.

3. Action of the Injured Party Describe what was going on (i.e., the type of activity, cardiovascular training), who was involved, and specifically what exercise or movement the injured party was performing, and explain the action that led to the injury in such detail that the accident could be reconstructed from the information years later. Stay with facts here, not opinion.

4. Sequences of Events Identify the point in the session during which the accident occurred (e.g., during warm-up, conditioning, or cool-down), and record any instructions that were given.

5. Preventive Measures Taken by the Injured Party State what the injured person could have done to prevent the accident. Dr. Cotten emphasizes that you should not describe what the trainer could have done to prevent the accident. If sued, you will surely be asked about preventive measures by the prosecuting party.

6. Procedures Followed in Rendering Aid Identify who rendered first aid, the nature of the aid, the person who phoned for help, who was called for help and how soon, how soon help arrived, and the nature of the injury.

7. Disposition or Follow-Up This "next day follow-up" involves getting information from a hospital or physician and stating the recommendations set forth regarding the time the injured person should refrain from exercise. Record who made these follow-up entries on the injury report.

8. Person Completing Accident Report Cite the name and position of the person filling out the report. Note whether the person saw the accident and, if not, who supplied the information about the accident so that the report could be filed (Cotten 1998b).

Waivers

Although you may have heard that waivers are "not worth the paper they are written on" and know that waivers may not always hold up in a court of law, in many instances waivers are very effective in limiting liability attributable to personal negligence. Remember, negligence can occur when you are simply careless or make an "honest" mistake.

It is highly recommended that you have every client sign a properly worded liability waiver before beginning an exercise program. Waivers can prevent, or at least limit, the likelihood of successful lawsuits arising from negligence that is not deemed gross, or what attorneys describe as the failure to exercise "slight care."

Create a waiver (form 8.1 or 8.2) that is separate from other documents. If the form is included within a service contract or other agreement, you must be certain that the document or paragraph related to the waiver is clearly

FORM 8.1 Sample Minimal Language Waiver and Release of Liability

In consideration for being allowed to participate in the personal fitness training program, I, on behalf of myself, my spouse, my heirs, and my estate, hereby agree to release (trainer or company name) and employees and agents from liability for injury, death, or loss suffered by me while using the facility or equipment or in any way associated with participating in any personal fitness activities associated with (trainer or company name) resulting from the ordinary negligence of the same.

_____ _____
Signature of Participant Date

Cotten (1998a)

FORM 8.2 Sample Complete Waiver and Release of Liability

In consideration for being allowed to participate in the personal fitness training program and in consideration of my membership and being able to use (company or individual name) facilities and equipment, I hereby waive, release and covenant not to sue (company name or individual), its owners, employees, instructors, or agents from all present and future claims resulting from ordinary negligence on the part of (company name or individual) or others listed for personal injury or death, or from loss, damage, or theft of personal property. This includes all claims arising as a result of using the facilities and equipment of (company name or individual) and engaging in any (company name or individual) activities or any activities incidental thereto. On behalf of myself, my family, estate, heirs, or assigns, I hereby voluntarily waive all claims resulting from ordinary negligence.

Furthermore, I am aware that personal training program activities, as well as health and fitness club activities, can range from vigorous cardiovascular activity (e.g., group aerobics, running, cycling, treadmills, steppers, or racquetball) to the strenuous exertion of strength training (e.g., free weights, weight machines). I understand that these and other physical activities at (company name or individual) involve certain inherent risks, including but not limited to death, serious neck and spinal injuries resulting in complete or partial paralysis, heart attacks, and injury to bones, joints, or muscles. My participation is voluntary with full knowledge of such inherent participatory dangers, and I hereby agree to assume any and all inherent risks of property damage, personal injury, or death.

I understand that this waiver is intended to be as broad and inclusive as permitted by the laws of (specify state, province, or country) and agree that if any portion is held invalid, the remainder of the waiver will continue in full legal force and effect. I further affirm that the venue for any legal proceedings shall be in (specify state, province, or country).

I have read this form and fully understand that by signing this form, I am giving up legal rights and remedies that may be available to me for the ordinary negligence of (company name or individual) or any of the parties listed above.

_____ _____
Signature of Participant Date

Modified from Cotten 1998a

How to Limit Your Liability

A good acronym to memorize if you want to limit your liability is ARRT. The concepts of avoidance, retention, reduction, and transfer can go a long way in reducing your risk, according to Dr. David Stotlar (1996), director of the School of Kinesiology at the University of Northern Colorado.

1. **Avoidance.** Risk outweighs any potential benefit. You must judge whether the activity is too risky or hazardous to justify its use. Examples include exercises that are considered high risk or contraindicated by current industry standards or training environments that present unjustifiable risk to the client (e.g., an open-water ocean swim during conditions of strong riptide or undercurrents).

2. **Retention.** Implementing this concept requires common sense and a sense of doing the right thing. Budget for situations that arise where, for example, you pay for the cost of an emergency room treatment for an injured client. Even if your client resists, saying it was his or her fault, take care of any costs. This act of professionalism, kindness, and concern is much cheaper than litigation at a later date.

3. **Reduction.** Constantly evaluate, update, and compare your instruction and other programming to current industry standards and mandates. When you are vigilant about continually improving and updating program policy to be in accordance with prevailing national standards, you greatly reduce your exposure to liability.

4. **Transfer.** Probably the easiest and most cost-effective manner in which you can reduce or transfer risk is to purchase liability insurance.

separated from the main body of the contract by using large and bold type, for example. Before using the waiver, always have your attorney review and approve the language. See the box, "How to Limit Your Liability," for other useful precautions in addition to waivers.

Minimizing Risk

It is obvious that avoiding litigation, or limiting the likelihood that a lawsuit will be filed against you, has a lot to do with how you manage risk and whether you do the right thing as well as keep your clients' best interests at heart. Effective risk management requires you to carefully examine how you treat your clients and to take a close look at your business policies, safety procedures, emergency medical contingency plans, liability insurance, and other business procedures.

Although this doesn't sound very legal, clients who like you will be less likely to sue you! At some point you have to stop worrying about legal matters. You need to take all of the right steps, but consider this next point. I believe that the genuine liking my clients have for me is one reason why I have never been sued. Any trainer can make a mistake. But it is evident

to my clients that I have their best interests at heart by the business and programming decisions I have implemented to protect them.

If you keep your clients' needs, desires, and personal well-being in the forefront and you have built a strong professional relationship, your chances of being sued are greatly lessened. A healthy relationship based on the interests and well-being of a client will likely cause that client to give you a margin of error, the benefit of doubt, before wanting to proceed with a lawsuit against you.

Understanding Legal Implications

Because some experienced trainers may not have chosen to read chapter 2 (about breaking into personal training), I want to refer you to some sections in which I believe the legal information presented for the start-up trainer breaking into the business warrants review by the more seasoned, veteran trainer. Legal and professional insight is appropriate for both new and seasoned trainers! Refer to chapter 2 for in-depth discussion of the following topics and read the following for a condensed version.

Should You Incorporate?

Two of the most common arguments for incorporating a business include an attempt to shield yourself and your business from personal liability and to gain tax advantages. Let's dispel the myth of incorporating in an attempt to limit all personal liability. Whether you incorporate or not, whether you provide service, for example, that is injurious or grossly incompetent compared with industry standards of care, you can and probably will be sued. If a corporation is sued, the successful litigation brought against the corporation would be termed by attorneys as "piercing the corporate veil."

The veil, obviously, does not protect you from lawsuits or totally limit personal liability. A friend who is a top litigator says he asks one question when a client approaches him with a potential case. He asks, "Does the defendant have any business or personal assets?" If the answer is yes and the court rules in his favor, he says those assets are accessible.

As your income increases or you hire one or more employees, it's appropriate to discuss incorporating with an attorney, a CPA, or a competent financial advisor. I have found input from all three sources to be of incalculable value, because three very different expert perspectives shaped my final decision. If incorporation doesn't seem like a good business decision today, don't shelve the concept forever. Months or years down the road it might be the right decision. Would I incorporate solely from a standpoint of protecting myself from lawsuits? Of course, the answer is no.

What Qualifications Are Required?

Amazingly, the personal training industry is a self-regulated service business. Anyone can claim to be a personal trainer. A college degree in a related health and fitness field is an excellent plus for any trainer and quickly establishes a degree of credibility. Certification also presents evidence of competence.

One of the most important professional markers, for any trainer, is updated certification that is nationally recognized. At the least, this will provide some evidence of competency to the courts, from a legal standpoint. The certification indicates that the trainer who possesses it is involved and updated in health- and fitness-related fields. I would prefer a certified instructor with no degree over a PhD who has not updated the degree she earned 15 years ago.

I hope the previous commentary will answer the next question: "Do I need a certification if I have a health- or fitness-related degree?" The issue, of course, is updated versus outdated information and living on past accomplishments rather than current. The legal implication is obvious.

At a minimum, certification is essential, although not legally required. Professional personal trainers are certified, carry liability insurance, and are trained in CPR and first aid. Furthermore, it is almost impossible to get liability insurance unless you're certified.

Eight Reasons to Get and Stay Certified

1. Consumers (potential clients) know to ask for and hire certified trainers.

2. Current certification tells prospective clients, employers, and a court of law that you are updated and involved in the health and fitness field.

3. Professional credibility and competence will receive an instant boost.

4. Your knowledge base and programming skills will increase. An updated certificate requires you to take courses on a regular basis, called continuing education credits or units, to keep your certification in force.

5. Licensed health care professionals, including physicians, osteopaths, registered dietitians, chiropractors, and physical therapists as well as other health professionals will more likely refer their patients to you.

6. You will be able to more easily obtain personal liability insurance.

7. You may be able to secure business loans more easily by establishing solid credentials, and your organization will more likely be viewed as a legitimate part of the business community.

8. In the event you're sued, a court of law will recognize certification as a professional, prudent, and appropriate credential for someone who calls him- or herself a personal trainer.

Should You Carry Liability Insurance?

Every trainer should carry liability insurance. No matter how good you are or how professional you

might be, someone could get hurt or judge you to be at fault in a given situation because of an action you take, or do not take, that results in injury or loss of any kind. Right or wrong is not the issue here. Your client can sue you. Anyone can sue you! So, the obvious response is to protect yourself from personal liability claims and lessen the resultant financial and emotional stress created by successful or attempted litigation against you.

However, I want my clients to know that I carry liability insurance to protect them! Something can go wrong during training, and I want them to know that their well-being is literally insured. To deny the possibility of ever erring or being involved in a lawsuit is naive. Liability insurance is a strong statement regarding your professionalism, is a "friend" in court when you are documenting prudent steps you have taken to ensure your clients' well-being, and indicates that you have your clients' best interests at heart. Liability is also a "friend" if you are found negligent and ordered to pay a large settlement to a client-plaintiff.

Affordable liability insurance is available through a number of certifying or member organizations. This coverage is often available to professionals who possess the requirements of the organization but aren't necessarily certified by or don't belong to the group.

Is CPR and First Aid Training Necessary?

Possessing a current CPR card and training in first aid is not mandated legally. But the true professional must not be without this training. Also, many certification organizations and liability insurance providers require that you maintain current CPR status as one of the stipulations (continuing education classes are the other key requirement) necessary to renew certification or to successfully obtain insurance coverage. Most likely, I hope, you will never have to lead a rescue effort using CPR, help clear a blocked airway in a choking victim, or perform a first aid treatment on a client. But, legal matters and self-protection aside, whether it was your child or a client who needed these lifesaving skills, could you ever forgive yourself for not acquiring this simple and easily obtainable expertise?

A reasonable and prudent trainer will carry a current CPR card and be trained in first aid. This type of preparation dovetails with legal and industry standards in most communities around the world.

Laying Your Legal and Client-Care Concerns to Rest

Keep your client's best interest at heart, and many questions about the qualities you should strive for, the skills you should attain, and the services you should provide answer themselves. Many of your legal concerns can be laid to rest if you implement prudent preventive and risk management strategies and prioritize your client's well-being at all times.

➤ Author's note: I wish to extend special thanks to Doyice Cotten, EdD; David Herbert, JD; Brian Koeberle, JD; Sara Kooperman, JD; and David Stotlar, EdD for each individual's pioneering work in helping trainers worldwide understand how sport management and sport law apply to our profession as well as helping trainers to become "legally responsible."

Legal References and Suggested Reading

Cotten, D.J. 1998a. "Do Waivers Work?" *IDEA Personal Trainer* (Apr.): 41-7.

Cotten, D.J. 1998b. "Strategies for Managing Risk." *IDEA Personal Trainer* (Mar.): 49-54.

Cotten, D., and J. Wilde. 1997. *Sport Law for Sports Managers.* Dubuque, IA: Kendall/Hunt.

Herbert, David 1997. "Insure Your Success." *Certified News* 3 (April/May): 1-2.

Herbert, D.L. 1989. *The Standards Book for Exercise Programs.* Canton, OH: Professional Reports Corporation.

Koeberle, B. 1990. *Legal Aspects of Personal Training.* Canton, OH: Professional Reports Corporation.

Nygaard, G., and Boone, T.H. 1989. *Law for Physical Educators and Coaches.* Columbus, OH: Publishing Horizons.

Stotlar, D.K. 1996. "Legal Guidelines and Professional Responsibilities." *ACE Personal Trainer Manual.* San Diego, CA: ACE.

Legal Consultation

Doyice J. Cotten, EdD, specializes in liability waivers and is the owner of Sport Risk Consulting, a risk management business. Contact him at 912-764-4848 or e-mail: doyicej@gsaix.cc.gasou.edu.

CHAPTER 9

Control Your Finances—and Control Your Future

Would you like to retire? Can you retire? How comfortable your financial situation will be when you choose to retire will depend on what you do today and the plans you make for the future. How golden will your retirement years be?

When I ask older adults what their biggest concerns are, I repeatedly hear these concerns:

1. Will I be able to maintain my health and physical independence?
2. Will I have enough money for retirement and be able to continue living a comfortable lifestyle?

How "healthy" will your retirement years be? Plan for financial health as you do for your physical health. Understand the steps you must take to cover this important aspect of your future. You must exercise regularly to receive continued health benefits. You must contribute regularly to a retirement plan to build a retirement nest egg. You can talk about exercising but if you don't do it, you receive no benefit. You can talk about retirement plans, but if you don't take action, you'll be in for a shocking surprise in the not too distant future.

Exercise and personal health do not happen alone, and neither does your financial well-being. Many of your clients have expressed to you at some point that one of the reasons they hired you was that they felt overwhelmed and didn't know where to start with their fitness program. If you don't know where to start with your retirement plans, arm yourself with the following information, be prepared to ask some pointed questions, do your investigative work, and take action. If you're already well on your way to a secure financial future, you may pick up a few tips from this chapter to further focus your retirement efforts.

Please note that some sections of this chapter especially apply to personal trainers who reside in the United States, because I refer to specific taxation standards, retirement plans, and law. Of course, it is essential to investigate laws and options that apply to your country, state, or province. The principles discussed here should help you to take advantage of local laws and taxation rules, ask the right questions, and get the right answers so that you can create a solid retirement plan.

Financial Fitness

Only about 5 to 8 percent of personal trainers command yearly income that is greater than US$40,000 (IDEA 1997, 1998a). With the cost of doing business and personal expenditures eating up a lot of the generated personal training revenue, it will take a prudent, intelligent, frugal, and disciplined professional trainer to prepare for a comfortable retirement.

Starting a business requires trainers to be personally involved in the many aspects of running a successful operation. But how closely have you looked at the area of personal financial planning? You need to ask yourself two questions:

1. If you've got cash today, will it be there for you tomorrow?
2. Is your principal growing today so that it can multiply and work for you tomorrow?

Personal Financial Planning

Just as creating a fitness program or building a successful business requires strategic planning that is well thought out, the same is true for personal financial planning.

Personal financial planning involves your current business dealings and fiscal health as well as preparing for future financial needs. From a financial perspective, you might want to ask, "What do I have now, and what do I want to have in the future?" Long-term financial well-being does not come about on its own!

Many personal trainers are self-employed (own their own business or work as an independent contractor) or are employed by a small personal training company. In these employment situations, often little thought is given to retirement plans. On the other hand, larger companies often offer substantial retirement plans that employees participate in (both employees and employer contribute) and value as a significant employee perk.

In the United States, few retirement options were available to sole proprietors and smaller business operations until quite recently. Now, whether you're a partnership, corporation, or independent business owner, you can set up and participate in a retirement plan that has advantages to you and any employees to whom you choose to offer this incentive. If you're employed by a business that does not offer a retirement plan, you should establish your own.

Financial Advisors

The best financial advice I receive comes from my CPA and my investment brokers at Morgan-Stanley. Your tax advisor can offer investment direction and advice that goes beyond obvious tax implications and filing returns. The poorest investment advice I ever received, and for which I paid a substantial fee, came from a paid financial planner. That is not to say that all financial planners are incompetent, but the obvious win–win combination is to obtain counsel from an investment brokerage team, an accounting firm, and a financial planner and his or her associates.

My mistake was relying on one source of information rather than using a team approach. Financial planning decisions should be made only after you have accumulated information from a variety of sources and understand all the investment and planning information presented.

Financial planners, investment brokers, and certified public tax accountants are paid to perform a service for you. Let them work for you. A good brokerage firm and its agents can, at the click of a computer mouse, calculate the cost of your retirement—meaning what you must save—based on what you view as acceptable or desirable. Generally, this type of advice is "free," although the professionals will generate revenue through placing investments for you and managing your accounts. Work with investment brokers who are up front about commissions and other fees. Some are willing to take reduced commissions and limit transactions that generate these types of fees, which ultimately come out of your pocket. Talk to your broker about these issues and make sure the cost of the service fits your goals. If she is up front and not evasive regarding these issues, this is a good indicator that you're working with an honest, straightforward person who has your best financial interests at heart.

Financial planners generally are not tied to any one specific financial instrument, which leaves them free to recommend a smorgasbord of sound financial investments from a variety of sources.

A good investment firm or planner will help you to invest according to your temperament, your desires, and the amount of risk you want to take. How will they know what you want? Like a good trainer, they take a "history," do their homework, and find out as much as they can about you. They will listen and implement, guide and facilitate, but ultimately the financial decisions should be left to you, with all risks and advantages spelled out by the broker. If your current situation isn't a team approach and your planner doesn't seem to have an interest in what you'd like to accomplish with your finances, it's best to move on.

A good financial planner or investment broker will take a history and, at the least, find out what you want to accomplish, how much money you want to have available per month during retirement, and the amount of financial risk you want to incur while attaining your investment goals. Historically, a diversified approach to investment—meaning

investment strategy that might range from low to medium to higher risk—wins over placing your accumulating nest egg into one type of investment.

Tax, Business, and Investment Records

A solid retirement plan starts with good tax and business records. You cannot be too exact with record keeping. There is no margin for sloppiness. Additionally, effective cash management—this includes keeping meticulous records and staying current during the fiscal year rather than waiting until the last minute to categorize a year's worth of expenditures—helps simplify tax preparation. Why? Because you've already gathered, organized, and totaled your receipts and other records of expenditure. At this point, getting your taxes done and filed only requires that you fill out the right forms or supply this information to your tax accountant. This aspect of preparation and record keeping, even if you use a CPA to file your taxes, can save you hundreds of dollars because the person preparing your taxes won't be required to organize and tally your write-offs and other expenditures. Plus, it helps you maintain a hands-on awareness of expenses associated with your business. (See chapter 6, Managing Your Time, for software resources that can help with record keeping, accounting, and tax filing.)

Hired Expertise

I don't try to figure out everything on my own, although ultimately, any financial decision is mine alone. I maintain contact with the financial aspect of my business by overseeing, at the least, every financial detail. Still, it makes sense to consult and use a CPA who loves what she is doing and is a pro. In the long run, this expertise will save me time and money. My personal experience proves this true. I could list the details of tax preparation in this text—what is allowed for write-offs and what isn't—but it could be outdated tomorrow. I choose to hire expertise in the form of a professional who makes it her full-time business to know what is currently in my financial interest. I can't optimize my financial situation without her professional help.

Necessary Tax, Business Deductions, and Business Information Guidelines

At a minimum, you need to organize your tax and business record information to include the following.

Tax Information

- Receipts for business expenses that are dated and organized by the week, month, and year
- Proof of ownership and cost of depreciable property, including any office or workout equipment
- Tax identification (ID) number, which may be a specific business tax ID or social security number
- Written proof of the type of business you are operating (i.e., employee, sole proprietor, corporation, partnership)
- Income and expense ledger organized by the week, month, and year
- Mileage log if you use a vehicle for business
- Entertainment log (meals, hotel, travel)

Deductions

As mentioned in chapter 2, a well-run business can take advantage of many legal tax breaks. This can make the difference between a failed business and one that is financially successful.

Whether you file taxes yourself or have a professional submit them, you must have a method to organize your receipts, canceled checks, invoices, and other expenses. For an easy and relatively inexpensive yet effective setup that can work for you as you grow your business, refer to chapter 6 for software and computer recommendations.

No one wants to overlook legitimate tax deductions. This oversight will cost you money that could have been put directly into your pocket. Self-employed personal trainers can deduct any ordinary and necessary business expenses that are a direct result of operating their businesses. The deductions are subtracted from gross income, which is a tax write-off advantage for you.

Evolve your tax write-off categories with a financial advisor (like your accountant) who understands your business. Opportunities for tax breaks will change as your business develops and tax law changes.

To follow is a partial grouping of potential tax itemization categories:

- Vehicle, usually depreciated
- Associated travel costs such as gas, maintenance, and repair
- Studio or private training facility equipment
- Portable training equipment that you carry to your clients' homes
- Home office or gym space ✓
- Office equipment and services
- Office supplies
- Business phone
- Answering system
- Leasehold improvements
- Professional membership organizations
- Certification or licensure costs
- Continuing education costs
- Professional library and professional magazines
- Music tape or disk or DVD library ✓
- Towels or towel service
- Janitor or cleaning service
- Rest room supplies
- Miscellaneous workout equipment
- Professional uniform and athletic shoes
- Professional services and legal expenses
- Promotional materials
- Advertising (ads, brochures)
- Insurance that includes liability, general, and personal
- Miscellaneous consultant fees
- Client gifts and promotions
- Meals and entertainment
- Client fitness excursions
- Self-employment tax ✓

Basic Business Decisions

Legitimize your business as quickly as possible. Some decisions in personal training are not specific to training or equipment but involve more traditional business considerations, such as naming the company, setting up the billing and accounting procedures, investigating taxes and liability concerns, getting adequate personal and liability insurance, and marketing yourself. Because most businesses fail because of poor organization and a lack of direction, it clearly is to your advantage to establish as comprehensive a business plan as you can. See chapters 2 and 3 for an in-depth discussion of these basics.

Your Business Plan

The bottom line of any successful business is service, service, and more service! If the enterprise is not streamlined, it will interfere with your ability to provide an exceptional product, which is personalized training.

First, set or reevaluate your business direction. Do you want to train full time? How much money do you need or want to make? How many hours or days per week can you work? What services can you provide? As your business expands, do you want to work as a trainer, administrator, or both? Most new businesses start out with you, the sole proprietor, playing the role of business administrator and personal trainer.

Your behind-the-scenes operations, compared with your personal and training skills, are equally important to your overall success. Although the importance of your financial status may not be apparent at first, mismanaged funds, poor accounting, and resulting cash flow problems eventually infect your business and hamper your ability to deliver top-notch service. A good accountant or business advisor can keep you on track. Develop relationships with business professionals early in your career. You still make the important decisions, but expert opinion will give you valuable information to consider before you implement a business policy.

Bookkeeping

Money issues can divide employees and clients unless you are scrupulous with your bookkeeping. To make sure you have your finances in order, use a daily appointment book (i.e., handwritten record or high-tech palm computer) that has ample room in the margins for notes regarding cancellations, late arrivals, questions that you need to follow up on, equipment orders, and payments. No matter what else is occurring, take a few minutes after the workout and

note billing or workout information. At least once a week enter the workouts, billings, and any payments received into the "billing book" (this can be hand written or computerized) by transferring the information from your daily appointment book. Whether the client's billing cycle occurs at the end of the month or the individual pays in advance, this ensures that you have accurate and complete records of all transactions and services rendered.

The advantages of streamlining your business operations and avoiding labor-intensive paperwork make the use of computers and software essential. If you can't integrate computer technology into your business right away, place it as a backburner priority that you'll implement as soon as the opportunity presents itself. Not only does technology save you time—and personal trainers say that time is their number one commodity—but it also gives the impression that your business is professional, organized, and state of the art.

Figure 9.1 shows a simple billing ledger that will get your record keeping off to the right start. If you're running your business without a computer, use the workout billing ledger to quickly and accurately track your clients' payments and to accurately bill for services rendered. The workout billing ledger is a simple yet effective system to keep a running, current tabulation of your clients' accumulated charges and payments, and it is very easy to stay on top of. As soon as you can, purchase a computer and the requisite software to track your business transactions (see chapter 6 for more information). Even after you purchase software, this form can help you track information that can later be entered into your computer system.

Taxes

The word *taxes* should not make you shudder in fear. Of course, if your records are scattered, in shambles, or nonexistent, or you're not reporting all of your income, go ahead and tremble. A scenario like this guarantees financial and emotional stress. On the other hand, a well-run business can take advantage of many tax breaks. This can actually help make the business more viable and financially successful. Obviously, taxes are another area where it pays to be organized.

Whether you file taxes yourself or have a professional submit them, you must have a method to organize your receipts, canceled checks, invoices, and other documents. If you're not set up with a computer and business software, here's an easy, yet effective system that can work for you as you grow your business (also, refer to figure 9.1).

Before I ran my business with the aid of computer technology, I organized and labeled individual envelopes for checking, credit cards, and miscellaneous cash expenses as well as other write-off categories. These were placed inside a hanging file folder. As I accumulated expense receipts, I placed them in the appropriate account envelope. When a bill, account statement, or invoice arrived, I pulled the corresponding account envelope, cross-checked the statement with my receipts, and at this point issued a check for any money due. Then, I placed each receipt into a tax write-off category envelope.

Using computer software like Quicken, Quick Books, or Microsoft Money allows you to avoid this last, cumbersome step. Instead of manually placing receipts in envelopes, you would enter the amount into the computer in its appropriate category as you cross-reference an account statement. The idea is that you handle the data once, not several times, and the software has the capability of printing out just about any kind of cash flow report you want. This feature is handy in helping you file your annual tax returns and can assist you in obtaining loans and figuring estimated quarterly taxes. Again, you save precious time by streamlining your business operations.

Establish your tax write-off categories with a financial advisor (like your accountant) who understands your business. Opportunities for tax breaks will change as your business develops. Refer to "Deductions"—this chapter—for a partial list of potential tax itemization categories.

You can organize receipts (or input them into your computer) on a monthly, bimonthly, quarterly, or yearly basis. My recommendation is to update your accounting monthly. The longer you wait, the more daunting the task.

File every receipt (or input the amount into your computer) in the appropriate category

Workout Billing Ledger

Client name: _____

Month	Workout dates & notes; Product purchase/equipment billing	Charges	Date rec.	Payments received	Balance due	Billing date
	Balance due from previous page				$300.00	
June	15, 17, 19	$150.00			$450.00	
June	23, 25 (L.C.)	$100.00			$550.00	
June	Payment		6/25	$300.00	$250.00	
June	Equipment purchase (HR monitor)	$210.00			$460.00	7/1 Invoice #310
July	3, 5, 7	$150.00			$610.00	
July	10, 12 (L.C. no charge), 14, 15	$150.00			$760.00	
July	Payment (invoice #310)		7/17	$460.00	$300.00	

L.C. —denotes a late cancellation

FIGURE 9.1 Sample workout billing ledger.

➤ Author's Note: This is a simple billing ledger that will get your record keeping off to the right start.

and write information on each receipt reflecting what it was spent on. Even if you use a computer, be sure to make notes on receipts just in case you are audited and questioned on a particular write-off. Written notes will clarify the transaction and will likely satisfy the scrutiny of the audit official. The Internal Revenue Service (IRS) appreciates records that are detailed and exact. Meticulous record keeping makes a huge difference when questions arise with regard to past expenditures or if your business is audited, and it will save you time and money. Taking steps like this will help you take full advantage of available tax write-offs and give you peace of mind.

I used to hand the categorized packets of receipts to my accountant, who examined them for possible write-offs and further itemized them for tax purposes. Today, my accountant receives an in-depth computer printout or cash flow report quarterly. This report categorizes different business expenses and can be printed out in a few seconds. Also, I have up-to-date financial information if I've kept my accounting current (e.g., have input the data). If my financial picture looks different—for example, my earnings are up or down—I may print out cash flow reports monthly so that my financial team can help develop a better tax strategy.

When I started my business I did the sorting and organizing, asked many questions, and contacted numerous experts to gain information and to save money. At that point in my career I had more time than money! Regardless of your situation, without accurate record keeping—which requires you to record information on your business receipts and categorize them into expense areas such as insurance, uniforms, equipment, and travel, to name a few—you will be unable to take advantage of many deductions legally available to you. As a result, you will have to pay substantially higher taxes and that is money taken directly from your profits.

I know that some trainers run their businesses on a cash basis as much as possible and report only a small portion of their income. However, you should report all personal training income for several reasons, not to mention ethical implications. First, many of your clients may be able to write off a portion of the services you provide and likely will file a 1099 tax form. Essentially, this form is a report to the government that discloses money paid to you for a given calendar year. The implications are obvious. Your income must match what is reported to the government. Finally, failure to report income is dishonest, unethical, and illegal.

Here's another scenario that can trap you. A client may approach you with a cash offer for training, and what the client expects to receive in return is a reduced training rate. The implied motivation is obvious. The client is thinking that you will not have to pay taxes on the earnings, so you now have a greater profit margin to work with, which means you can give him a reduced rate. In the client's eyes, this is a win–win situation. Wrong! The client is encouraging you to cheat and engage in unscrupulous business practice. It's up to you to extinguish this idea. Quickly let the client know that you report all of your income and that your rate is firm, thus offering no advantage. A meticulously and professionally run business leaves you with a clear conscience so that you can focus on client care.

How you run the financial end of your business makes a professional statement. "Cash under the table" businesses don't have the seriousness and longevity of a real business. Create a legacy of legitimacy that surrounds your business by letting people know you are a part of the business community and that you play by the rules.

Full disclosure and reporting of your income also can help you establish a strong financial portfolio. At some point, you will want to buy a house or new equipment or expand your business. To get a loan, you will have to convince the lending agency that you are a good risk. By being able to give the lending institute an accurate, documented picture of your income, you stand a much better chance of qualifying for the loan. It's pretty difficult to explain to the loan agency that you're an upstanding member of society and the business community, as well as an all-around great person, but that you really made $30,000 more than your financial statement reflects and you chose not to report the income. Yet, you continue, you are trustworthy. The contradiction is obvious.

If you have stolen money from your business (embezzled might be a more straightforward term) and are caught, an audit will be traumatic, time consuming, and potentially expensive, and your less than honorable as well as

illegal practices will be discovered. If your records are accurate and your returns honest, an audit will require little of your time and even less emotional cost. Paying what you owe up front to the government is less expensive when viewed from a number of perspectives. Don't believe that most trainers underreport their income. This kind of thinking is a rationalization that makes it easier for someone to justify dishonest and illegal choices. Most trainers are ethical and honest and don't break the law.

Here's a final word that might help you get through your tax-related responsibilities. Although new laws are supposed to continue to simplify the filing process, it still seems wise to hire the best licensed accountant (CPA) you can find, as soon as you can afford this invaluable service. Before you think you can't afford an accountant, consider what this service can do for you. My accountant saves me more each year in tax write-offs than I pay for his or her services. As you look into hiring an accountant, ask this professional to justify the expense when compared with cost savings. A good accountant will gladly demonstrate how this service makes financial sense. Once the numbers are revealed, the decision becomes very easy to make.

Hiring an accountant will be one of the best decisions you ever make. Tax and investment management strategies are too extensive and specialized for me to direct and still do what I like best, which is learning new training information and working with my clients. Paying an accountant is effective in terms of both time and cost, yet I can still make the decisions.

Hired Tax Preparation

Because I often see trainers struggle with this question, I want you to know you're on the right track if you think you should pass this burden on. Go with my earlier suggestion and hire an accountant as soon as you can.

Filing your own taxes is a lot more than just owning accounting software that can help you stay on top of your business' profit and loss statements or minimize your costs. I'm not encouraging you to be "hands-off" regarding your financial status. But few trainers have the time to acquire a wide-ranging knowledge of current tax laws. Not hiring an accountant will cost you money if you don't know every tax write-off advantage available to you or if you

could generate more money by using the time to train clients or grow your business.

Accountants can help you organize your approach to record keeping and documenting expenses and can educate you as to what you can and cannot deduct. If you want to minimize filing costs, ask the accountant in advance how you can organize your receipts and record keeping to save the accountant time when preparing your tax return.

Your expertise is personal training, not accounting and tax return preparation. Besides allowing you to focus on your business, hiring an accountant will give you peace of mind knowing that your taxes have been filed correctly and professionally. In the event of a financial audit, having a tax professional on your side from the beginning will make the audit less emotionally trying and ultimately will save you precious personal time as well as money.

Choosing an Accountant

Choosing an accountant is part of building your team. Although it's wise to have a relationship with a banker, an insurance broker, a stock broker or investment manager, an attorney, and an accountant, it not always easy to find an individual who understands your business needs. As is true in any situation that requires you to gain new knowledge and insight, you must be able to speak the language of the financial world and ask the right questions. However, an accountant who is sensitive to your needs and understands you are not the expert will guide you and help you understand the difference between bookkeeper, accountant, and CPA.

Start the search for your financial wizards by asking your clients, other trainers, or acquaintances who they would recommend. When you interview, ask these key questions:

1. What is your background?
2. What is your knowledge of my business?
3. To which professional organizations do you belong?
4. What is your fee structure?
5. Can you and will you provide related business referrals if needed? (Piccone 1997)

When you're ready to enter into an agreement, have the CPA or accountant prepare an

"engagement letter." This letter references the agreement between you and the accountant with regard to services to be rendered, your responsibilities, and the fees and payment terms.

Liability

Because we live in a suit-happy society, trainers, like other health care professionals, should be acutely aware of their legal obligations and responsibilities. Unfortunately, there are no uniform, nationally recognized standards of practice for personal trainers, so questions of negligence, malpractice, liability insurance, the use of medical and testing procedures, informed consent, the authority for exercise prescription, and supervision are increasingly complicated. Because issues like these can end up in court, no one should enter into training without researching this issue and obtaining adequate coverage. Obtaining liability insurance is an important aspect of a complete financial plan.

It is beyond the scope of this book to provide detailed, specific advice on liability insurance, other than to urge the trainer to carry what she and any consultant or professional organization think is adequate coverage. Because I believe it is not sound to blindly rely on one person's advice, be it an insurance representative or attorney, I also urge trainers to spend time understanding their professional responsibilities with regard to the law as well as the potential legal pitfalls regarding health screening, fitness testing, exercise programming, instruction, supervision, facilities, and equipment. How do you become informed in these diverse areas? Ask questions and get opinions. Then, identify an insurance policy that covers your needs.

During your investigation, you may receive seemingly contradictory information. For example, published guidelines or standards that are established for service professionals like personal trainers, and that are often referred and adhered to by our industry, do not always dovetail from organization to organization. Recall that no single source can be a substitute for the numerous expert legal and medical opinions you uncover in your search for the right protection.

After reading or listening to several authoritative sources, you will have a better idea of the standard of care and what questions to ask when you strive to secure adequate coverage. The unique circumstances that pertain to your situation and to the particular laws of the state or country where you live require an individualized approach to the solution.

The possibility of liability lawsuits and the existence of legal risks should be taken seriously by every trainer. The skilled professional who understands and uses proper exercise methods and procedures is far less likely to be embroiled in legal problems than the self-proclaimed expert who tries to make money off the fitness industry without bothering to become qualified first.

The importance of preparing for and anticipating potentially litigious situations cannot be overstated. There are more trainers and more clients now, so logically there will be more lawsuits. In these lawsuits, the trainer will be expected, and in some cases legally challenged, to have a level of expertise appropriate to the health or disease status of the client, as related to the services rendered.

You must accurately assess your personal abilities relative to different sectors of the exercising population. If asked to in a court of law, you must be able to demonstrate and document your capacity to deliver effective and safe exercise services.

Contrary to many trainers' beliefs, the responsibility to deliver competent service applies not only to their work with high-risk patients but also to work with apparently healthy, low-risk clientele. An "apparently healthy adult" may have undiagnosed chronic diseases (e.g., apparently healthy people die daily from heart attacks) or other evolving diseases that have not yet exhibited major symptoms. Despite the lack of symptoms or the apparent well-being of the client, the trainer may still be liable for an accident or injury or even the death of a client. It is not enough, then, to only give a high standard of service to obviously ill or at-risk clients. This standard of care applies to all of your clients, regardless of their perceived health status.

The lack of clear standards means that fitness professionals are operating in a gray area. Professional competence may be easier to justify if it is backed up by formal training in academic subjects and professional fields relating to sports medicine. Certification is certainly a plus because it indicates current involvement in

the profession (if the certification is updated, generally biannually with the required continuing education credits or units). Legal accountability provides yet another argument for education; you can never have enough knowledge.

Continuing education that updates knowledge and skills is essential. Certification in cardiopulmonary resuscitation (CPR) and being qualified to administer first aid also are mandatory.

Although the following should not be construed as comprehensive or legal advice, any trainer should have a working knowledge of and concern for the following areas as they apply to his state or country laws and potential legal situations:

1. **Physical facility and all equipment contained within the training facility.** The legal risks inherent to the operation can be substantially reduced by providing instruction and appropriate warnings and by maintaining the equipment and facility.

2. **Practices of personnel and the documentation thereof (even if it is a sole proprietorship).** Successful suits are far less likely when staff act professionally and follow documented, conservative procedures. The trainer therefore has no choice but to develop and adhere to clear and professionally defensible policies and procedures that are in accordance with the prevailing judgment of experts in the field. When combined with individual training and competency certification, adherence to the guidelines should indicate the trainer's capacity to provide proper care to his clients.

3. **Program documentation and the use of acceptable legal forms.** Using both program documentation and acceptable legal forms can minimize the legal risks associated with exercise programs and services. Informed consent and waiver forms, medical histories and screening, and carefully documented participant records made by the staff during testing or training sessions can assist in the event of litigation.

4. **General and professional liability insurance.** It is essential that trainers have both general and professional liability insurance. General or personal insurance can protect the trainer's investment in the event of theft, fire, and personal health problems or disability.

Professional liability insurance is a must for every trainer. Indirectly, having liability insurance shows that you run a professional business. Despite all reasonable precautions, lawsuits can occur. Proper insurance coverage for your program and any personnel who work for, or with you, is critical because it can reduce financial consequences and personal liability if you are sued.

Liability insurance, depending on your needs, can cost as little as a dollar per day. There is no excuse, especially financial, for not having insurance. If you're entering the profession of personal fitness training, liability insurance is a necessary cost of doing business. It's a write-off anyway and is one of your line items or budgeted costs that you will carry over every year.

Because there is strength in numbers, insurance purchased through a large fitness professional group (certifying agency or member organization) may have the broadest coverage at the lowest rates. This is in contrast to using an insurance broker to seek out separate coverage to insure your business. Many trainers who have gone this route found the quotes were cost prohibitive but that the umbrella coverage provided by larger associations that cater to fitness professionals was very affordable and effective. On the other hand, if your business someday grosses millions of dollars—and yes, a colleague of mine who bills training and rehabilitation services to insurance companies does indeed gross this kind of revenue—you may need additional coverage that costs thousands of dollars per month. Trainers just starting out find the dollar per day number a little more inviting and affordable. Regardless, you should thoroughly review your liability and other insurance needs with an insurance company representative who can explain the policy and why it adequately covers your business's insurance needs, before you purchase the policy. Forethought, planning, prevention, and doing your homework go a long way in avoiding legal and financial pitfalls related to liability issues.

Retiring at a Level of Income You Desire

To retire at your desired income level, you must have principal, which means a good amount of

money in one or more accounts. Then, you can build or multiply principal primarily through (1) earning and saving or (2) earning, saving, and investing. Money that earns significant interest compounds your principal much more quickly, especially when compared to saving dollar-by-dollar and placing your savings in low-interest-bearing accounts. Although I've given the "answer" away, investment that earns interest beyond the smallest amount available from a low-risk, conservative investment or savings plan, and assumes a moderate amount of financial risk, is often the realistic way to build a successful retirement plan. Age (invest for the long-term if retirement years are not around the corner) and long-term market return average are generally on your side if you get started now.

You must determine how much income you want to live on when you retire. Many financial advisors recommend a goal of about 75 percent of preretirement income. Next, have your financial advisor calculate what it will take in terms of savings and investment to finance your retirement in the fashion you'd like to live. Now you know how much money you have to save from that point on, and what type of investments you should consider until retirement, to attain your goal.

The advisor also can help you calculate what inflation will do to your financial nest egg in terms of purchasing power available to you years later. Failure to calculate for inflation sets you up for a rude awakening when retirement rolls around and leaves your golden retirement years smelling more like rotten eggs. Fail to consider inflation and you may find yourself well short of your financial needs as you enter retirement.

Tax-Deferred Savings and Investments

Most financial experts recommend tax-deferred savings or investments compared with taxable savings or investments. If you save money and earn interest, or investments produce income, these gains are generally taxable at year end. If you can defer tax payments until retirement when you take your money out in distributions, this is called tax-deferred saving. Taxable income does not allow you to defer tax payments and, compared with tax-deferred investment, literally stunts the ability of your principal to grow and work for you. Overall, your principal grows much more slowly, which greatly slows the growth of your net worth or retirement account. The bottom line is that tax-deferred saving is smart because your money increases much faster. Tax-deferred retirement plans are available to all types of businesses and business people. Refer to "Understanding Retirement Plans" in this chapter.

Investing for Retirement— Six Key Principles

My investment broker team at Morgan-Stanley has driven six key concepts into my brain:

1. Invest the majority of your cash in tax-deferred retirement plans. If you have more money than you know what to do with, taxable investment accounts are appropriate. However, tax-deferred retirement plans make the most sense from a yearly tax advantage standpoint and in relation to your retirement needs.

2. Maximize your yearly contribution to your retirement plan. It is amazing what time can do to leverage and increase your principal, especially in a tax-deferred retirement plan. I lament the thousands of dollars I have spent on trivial pursuits of leisure and "toys," when I realize what that money would have earned over a 35-year period and if invested, even conservatively, how greatly it would have affected my retirement principal and overall financial status (see "The Rule of 72," on page 198).

Yearly earnings, the type of retirement plan you participate in, and law determine how much you can contribute yearly. But, remember, you must have put aside enough money so that you can maximize your legal contribution each year. This takes planning. Maximizing your tax-deferred retirement plan contribution gives you significant tax advantages, which legally puts more take-home money in your pocket and will help you to quickly build your principal so that it can work for you through your retirement years.

The Rule of 72

To follow are a few simple mathematical examples that illustrate how much impact "numbers" can have on your financial portfolio. The "rule of 72" is a mathematical equation that analysts use to determine, among other things, how quickly money will double in value (Jacobs 1995, p. 30).

Example 1: If you deposit US$10,000 in an account earning 10 percent interest and leave it there, how long will it take to double in value?

Divide 72 by 10 and you get 7.2. Once every 7.2 years that $10,000 will double in value. Earlier I lamented about frivolously spending thousands of dollars that I could have invested into my financial portfolio. Let's say that by the time I was 30 I had, for the sheer joy of it, spent $10,000 that I could have invested. If I had invested that money and retired 35 years later at the age of 65, that $10,000 would have doubled almost five times (35 years later divided by 7.2 equals 4.86) and turned into about $300,000 at a 10 percent return! That is why I bemoan "the lost opportunity!"

Example 2: Using the rule of 72, you can also demonstrate the difference between a $10,000 investment that receives a 10 percent return and the same investment that receives a 5 percent return. Divide 72 by 5 and you find your money will only double every 14.4 years. That same $10,000 would double only 2.4 times over the 35 years. The investment would only be worth about $50,000, compared with $300,000 for the same 10 percent return and same number of years as illustrated in Example 1!

Example 3: Using the rule of 72, you can quickly estimate the impact of inflation on your purchasing power. Let's say inflation runs at 5 percent for an extended period of time. Divide 72 by 5 and you come up with 14.4. Once every 14.4 years your purchasing power would be cut in half as a direct result of inflation. Think about inflation's impact in these terms. Let's say you retire with a million dollars. In 35 years your purchasing power would have been halved at least twice if inflation continued to run at 5 percent. Your million, in theory, first shrunk to $500,000 and 14.4 years later was again slashed to $250,000. This last figure, in terms of purchasing power, indicates what a million dollars will buy you 35 years later—$250,000 worth of goods!

You can see why it will save you time, money, and the likelihood of financial fiasco if you seek out expert, professional, and honest financial counsel.

The biggest roadblock to financial success is procrastination. Although you must have goals, avoid unwise financial choices by being informed, limit debt, steer clear of poor investments, be aware of inflation's impact on your purchasing power, and understand that taxes can take a significant portion of your earning(s). Procrastination is any investor's biggest enemy. Let time work for you, not against you! Take concrete steps toward securing your financial future. It's never too late to start taking care of yourself or saving for your retirement, but the earlier you start, the better.

Jacobs (1995, pg. 33) illustrates the disparity between a trainer who invests $100 per month at 8 percent and a trainer who waits 10 years and then begins investing the same amount per month. After 20 years, the difference between the two accounts (20 years of your money working for you versus only 10) would be more than $40,000. The take-action trainer would have three times more money than the procrastinator!

3. Invest for the long-term. Generally, even if you are 40 years or older, age is on your side. Investment time frames that run from 20 to 45 years make time your ally. Market return averages over 5- and 10-year periods tend to smooth out over time. Don't get involved in the emotional roller-coaster of market ups and downs. Trends and returns on investments must be monitored, but "hunkering" down for the long haul often makes the best fiscal sense.

I invest differently than my parents, who are 70 plus years of age. For example, an older adult's investment accounts may transition into more liquid or readily available investments that are

lower risk, but they also yield lower returns. Someone who is 40 years old can expect to earn income and build principal for another 20 to 25 years. An individualized investment approach says that these different circumstances require diverse approaches. (Do you see how this starts to look like personalized program design?)

"Rolling the dice," playing the market daily, or otherwise gambling your savings on high-risk investments is not sound financial management. Someone will probably make a lot of money, but there is a high probability it won't be you.

4. Diversify your investments. This means that you spread your money among a number of different investments. A diversified investment portfolio provides a measure of protection in the event a portion of the market "tanks" or some other investment performs poorly. A portfolio that is properly balanced will provide consistent returns, minimize financial risk or disaster, and help you to attain your financial goals.

5. Ask questions. Your financial advisement team not only should anticipate your needs and offer you the information you need to make smart and informed decisions but should encourage you to ask questions and should answer those questions in a way that is easy to understand. If you do not ask, you will never know. I constantly ask my advisors to show me examples using "real numbers" related to my current tax and income situation that demonstrate important financial concepts, like increasing principal and how it works for you over time. I ask straightforward questions—no egos allowed since I am hungry to learn—about how a certain investment, strategy, or long-term investment plan will benefit me. If my team cannot sell the investment or concept or explain it in a manner in which I can truly comprehend its advantages, I won't even consider it. Plus, at this point I would also reconsider why I was consulting with them in the first place, and if a superior attitude is also present, it's time to find a new relationship!

If the advisor is condescending, impatient, or indifferent to your questions, it's time to seek other professional guidance. Think about how you instruct and share information with clients. You don't pontificate but instead nurture, encourage, and teach. You take time and share because you care. You can break down complex information to a simple level that the client can use and understand. You should demand no less from individuals you employ for their expertise, especially in the arena of personal finances.

6. Review investment performance. My investment team encourages review because they are accountable to me. I pay them for sound, smart, and effective financial advice. Just like your clients expect results, so should you expect results when you use professional services. I receive monthly reports on how my investment portfolio is performing. At a minimum, investments should be reviewed quarterly. If you believe that individual investments are not doing well or that the overall portfolio is not performing up to expectations and is not meeting your team's goals, discuss this with your counsel. Part of the review process serves to reinforce the commitment to a long-term investment philosophy but also to identify mistakes and to correct them quickly. As a team you have to know when to cut your losses and "get out of town," when to stick with the investment for the long-haul, or when to modify your investment strategy.

Different Types of Investments

Myriad investment opportunities (and nightmares) exist. The following investment opportunities are commonly discussed, and each has a certain degree of risk.

Risk

More risk equals more potential for return but also increases your chances of losing money. If you choose to enter into risky investments, you need to ask, "Can I afford to lose this money?" If you can't, you probably shouldn't entertain the thought.

Mutual Funds

Many investment consultants believe that mutual funds are a sound investment. Although this is generally true, the fund is only as good as its track record and often its "money manager." There are high-, medium-, and low-risk funds, too. "Mutual" comes from the fact that you combine your money with other investors to invest in, for example, the stocks of different companies

that are selected for a particular mutual fund. Your risk is spread among the performance and stocks of a number of companies in the mutual fund portfolio, and this provides, in a sense, an automatic diversity within this single investment. Although you may be receiving investment advice from a financial planner or investment broker, you also get the expertise of the professional money manager who oversees the mutual fund.

After deciding how much of your money you want to allocate to a mutual fund that consists of stocks, bonds, or a combination of the two, you can also request that funds be withdrawn from your paycheck or checking account so that the funds are available when you're required to contribute to the plan.

Mutual funds can be good financial vehicles that allow you to diversify and own stocks or bonds while maintaining a balanced portfolio and minimizing risk, or choosing the amount of financial risk you will incur.

Stocks

Stocks, by their nature, are generally a riskier investment and have the potential to provide a significantly greater return for the money invested. Purchasing stocks also may require you to invest larger amounts of money. Stocks can be bought independently or via mutual funds. High-, medium-, and low-risk stock purchases are available.

Bonds, Savings Bonds, Saving Accounts, and Treasury Bills

Bonds, savings bonds, saving accounts, and treasury bills are the closest thing to risk-free investment you can find. The downside is that the return on these investments is relatively minimal and can cost you tens of thousands of dollars in potential income over long periods of time. Choosing a low-risk 5 percent investment return compared with a moderate-risk 10 percent investment return over 20 years could be the difference between golden retirement years and scraping by. Don't underestimate how money and principal can quickly multiply over the years if properly invested. Ask your financial advisor to illustrate an example that fits your financial situation (refer to the box on page 198).

Understanding Retirement Plans

Here I'm talking about "benefits" and what different plans have to offer you. In some employment situations you will have no choices. Either you're automatically entered into the retirement plan (although laws usually require that most plans offer different types of "fund" or investment choices to match an individual's risk tolerance), or no plan is offered. If the latter is true, you need to initiate a plan for retirement. Action becomes your choice!

Independent of the plan you choose to initiate or are automatically entered into, you should be able to take advantage of tax-deferred saving, the rule of 72, and the magic of compounding principal. Whether you're self-employed or work for someone else, a retirement contribution plan is available that fits your needs and situation, and you must get it working for you as soon as possible.

Key Retirement Plan Benefit

Most retirement accounts grow your money faster because the earnings are tax deferred until retirement. Simply, more money stays in your account and builds your principal according to the rule of 72. Second, when you withdraw the money at retirement it is taxed at your ordinary tax rate, which will probably be lower than the rate you were taxed at during your prime income-earning years.

Allocated Plans

Allocated plans give each participant a separate investment account. Allocated plans that are typical include 401(k), 403(b), 457, SEP, SIMPLE, and SIMPLE 401(k). Some experts believe that these allocated, self-directed plans are the best way to set up a retirement plan for "99 percent of Americans" (Pickering 1999). They generally fall under the category of "employer retirement plans," and employers and employees may or may not be able to use the same qualified plan. Let your advisor explain how and why a given program will or will not work for you.

Following is a small sample of retirement plans that work for small businesses and sole

proprietors. Each plan can offer a variety of investment or fund opportunities from which to choose, and you should consider these within the context of current law.

Individual Retirement Account (IRA)

IRAs fall under the category of individual retirement plans; examples are IRA, Roth IRA, and Education IRA. Whether self-employed or an employee, anyone can set up an IRA. If you are an employee and already participating in a retirement plan, make sure no restrictions exist.

An IRA is a personal retirement account or savings. You can contribute deductible and nondeductible payments. Both have the benefit of being tax deferred. A Roth IRA is similar to an IRA, but contributions are not tax deductible. Earnings can be tax deferred. Education IRAs allow for annual contributions per child until the age of 18. This IRA may be used to pay for qualified higher education expenses. The contributions are not tax deductible but the earnings do accumulate tax deferred. Distributions for qualified higher education purposes are not subject to taxes, although the funds must be used by the time the child reaches age 30 or the account will be taxed and subject to penalty.

Simplified Employee Pension (SEP)* Plan

SEPs are a form of individualized retirement accounts that are especially well-suited for business owners who want to establish retirement benefits without incurring extensive administrative costs and are looking for a low-cost solution to personal retirement needs. Eligible employees must be included in the plan. Annual contributions are not required, which is good if a particular year does not allow you to contribute or contribution would create a financial squeeze. On the other hand, if you don't contribute, you'll lose the multiplying benefit of tax-deferred income and the tax advantage your contribution offers. You, as the employer (remember, you employ yourself, too) may deduct 100 percent of the contribution from taxable business profits. This can dramatically lower your taxable income and save you a significant amount of money, depending on what your profits are taxed at.

*Keogh plans are another form of employer retirement plans that you may have heard about, but they are being phased out and are now referred to as profit sharing or money purchase plans. These plans are excellent for small businesses (small number of employees) because they allow a larger contribution for owners, since generally, their salary would be greater than that of employees.

401(k) Plan

Only a business owner can set up this profit-sharing plan. Typically, this is called a "defined contribution plan." It is similar to a SIMPLE IRA because it consists of a salary-deferred program for eligible employees, and matching contributions can be made by employers. Salary deferral simply means that employees may contribute pretax dollars through a salary reduction agreement. Employer contributions are 100 percent tax deductible.

Changing Tax Law and Retirement Plan Options

Tax laws and retirement plan options can change quickly and seem complicated, and they present you with what seems like an impossible task in terms of keeping up with changes. You must enlist the help of experts who are abreast of this ever-changing gauntlet of information. Make your life easier by seeking updated, accurate, and usable information from reliable experts. You should have a great interest in your financial future, but your passion is probably more closely aligned with personal training. Understanding tax laws and sorting through a myriad of retirement plan options are probably not your area of expertise.

Estate Planning

Estate planning is one of the most important areas of a balanced and sound financial game plan. It's amazing the number of people who never plan this aspect of their financial picture. Not doing so is comparable to forgetting to train one of the major components of fitness (cardiovascular, strength, flexibility). Could you imagine doing that?

I don't believe estate planning and its importance hit home with me until it was revealed to me what impact a poor plan or no plan would have on the future financial well-being of my wife and children in the event I were to prematurely die. In addition, I realized that on the eventual death of both my wife and I and consequent distribution of what is now The Brooks Family Trust, taxes could have had a huge impact—had we not established this trust—on our ability to pass the bulk of our holdings to our sons as well as other family members and entities.

As odd as it may seem, your death and subsequent transfer of your estate can cost a lot of money and result in the bulk of your life holdings not ending up with whom you intended. My first reaction was, "That's absurd! Not fair!" However, this is reality, and it's easy to do something about the fees and taxes assessed on distribution of your estate without putting a burden on your heirs or having the government or other appointed officials decide how the bulk of your estate will be distributed.

Your Estate

Simply, your estate is all of the wealth and "things" you have accumulated during your lifetime. Your home, stocks, bonds, retirement plans, art, insurance policies, real estate, business interests or partnerships, personal effects and other toys, and anything you hold title to make up your estate holdings. The simple goal of estate planning is to reduce the common fees and taxes associated with the distribution of your estate so that the individuals and organizations you specify receive the bulk of your wealth that you accumulated over your lifetime, with the least amount of hassle.

Distribution Through a Will or Trust

Effective distribution depends on creation of an adequate will or trust. The worst way to have your estate distributed is without a valid will. This situation, besides causing confusion and other complications that cost money and can burden family members, means that the court will decide how the estate is to be distributed if no valid will is available. Needless to say, this is not an optimal situation.

Discuss with a qualified professional the differences between wills and various forms of trusts. Generally, when an estate is distributed via a will, a court administers the will in accordance with your wishes, via your written requirements (will). From probate (court) your assets are distributed to the proper family heirs or other designated beneficiaries.

A trust is a separate, taxable entity in which you can place all of your assets. Properly formed trusts can avoid probate as well as the time and cost associated with these court procedures. Furthermore, a "testamentary trust" can help you reduce taxes on estates valued at more than $600,000, and a "living trust" can designate the management (the person or group that oversees the overall estate management after your death) of the estate. This type of setup can help to avoid costly court procedures and expensive settlement costs as well as the potential for upsetting emotional battles between heirs and court-assigned officials. Finally, an "irrevocable life insurance trust" can be established that places the proceeds outside of the confines of your estate, so that these funds will not be calculated as part of your estate for estate tax purposes.

Getting Your Estate in Order

With regard to estate planning, it pays, literally, to be informed and to get your affairs in order. Claiming ignorance or feeling as though you were victimized by bureaucracy does not accomplish your intentions for distributing your estate. Take the steps necessary to manage your assets now, upon your death, and, if appropriate, well after you have passed.

Ready, Set, Retire!

My personal image of myself in retirement is not one of "checking out." You won't hear me encouraging my peers to "take it easy," either. That's advice nobody needs. In fact, I'll probably be busier loving my grandkids (God willing), being much more benevolent, and volunteering for many good causes. I might even lecture and write books just because it's the right thing to do and take on pro-bono personal training "cases." And, I'll turn from cross-training between my children (i.e., chasing and keeping up with their

schedules and lives) and grandkids and return to the way I once trained BK (before kids). Time will be my greatest ally and in ample supply, compared with the present, when I never have enough of this precious commodity.

I see retirement as a majestic time, especially if my health and personal fitness are top notch and my personal financial picture is solid enough to allow me to give back and sustain the lifestyle I desire. I will be proactive in sustaining and improving both my health and personal financial outlook!

I believe that financial independence and security are important commodities that will give me the resources and time to go where I want when I want and to do what I want when I want. (I don't want to work at a job because I have to in order to make ends meet!) This type of financial and time freedom will enable me to give to whomever or whatever organization I want and will allow me to give to, be with, and provide for my family in the fashion I would like to! (I want to spoil my family!)

On my deathbed, I hope to conclude, "Retirement was very good to my family and me!" Glorious retirement years do not happen by

themselves. Preparation, planning, and action are required to secure your future and your family's well-being. Just as I understand the importance of personal health, so have I come to understand the significance and value of preparing for financial health and well-being in anticipation of the golden years.

One final word: Just as is true for a fitness program, it is never too late to begin a retirement plan! The key is to start today! Let time work for you!

Financial Issues: Suggested Reading

If you'd like to read more than the works cited in this chapter, check out the following:

Jacobs, V. 1995. "Financial Fitness." *IDEA Personal Trainer* (Nov./Dec.): 26-35.

Justice, G. 1996. "The Numbers Game." *IDEA Personal Trainer* (July/Aug.): 37-39.

Peters, C. 1999. "A Taxing Issue." *IDEA Health & Fitness Source* (Feb.): 57-61.

Rotan, D. 1996. "Ready to Retire?" *IDEA Personal Trainer* (Jan.): 10-15.

PART II

FOUNDATIONS BEHIND PROGRAM DESIGN THAT WORKS

CHAPTER 10

Gathering Information (Screening)

Jerry was referred to me by a cardiologist. Six months earlier Jerry had undergone a second, successful heart bypass surgery. I quickly realized that Jerry's perception of his health status was very different from his doctor's perception. On his medical history questionnaire he treated his heart disease as though it was no more serious than a mild cold. He told me the doctor said, "You can do anything; everything is perfect with your health." His doctor, however, gave me explicit limitations and guidelines regarding cardiorespiratory exercise type (mode), duration, and intensity. The doctor was very specific about heart rate and blood pressure monitoring and how to safely approach resistance training with Jerry.

I realized Jerry's written responses revealed that he truly believed surgery could correct any health problems he might have. His doctor strongly denounced this and added, "My goal is to get Jerry to the 'wake-up call' before he's run out of second chances." Jerry could not realistically evaluate the seriousness of his heart disease because of fear and his desire to go on with life in his usual, unrestricted manner.

Obviously, if I had relied on Jerry as my only source of information, I may have put my client at risk for serious complication or even death. Also, I would have never developed an effective support network for optimizing Jerry's health. Jerry presented a new challenge to me every time we got together. I learned many of the approaches I used with Jerry from his wife and attending physician. Both had much more experience dealing with his disposition and were glad to share it. Because we all had Jerry's well-being at the top of our lists, my "team" expanded to client, wife, and doctor.

Exercise Theory and Individual Client Need

The best way to build a bridge between your knowledge of exercise science and a program that will meet each client's specific needs is by gathering as much personal information about your clients as you can and as is appropriate. Even when you are designing an exercise program for a healthy, asymptomatic individual, you must uncover and account for many factors that go beyond your client's current health status.

The information gathering process includes the following:

- Medical history and health questionnaire—get information about your client in writing before workouts start.
- Client interview—get information and personal perspective by talking.
- Fitness testing—(Fitness testing should be considered an optional step. Refer to this chapter, as well as chapters 2 and 11 and the appendix, for information about fitness versus diagnostic testing.)

Remove the Liability Burden During the Screening Process

Proper written and verbal (interview) screening—along with the development of key liaisons with appropriate medical professionals—can help relieve you of some of the liability and expertise burden. How do you know whether it is safe or appropriate for a client to begin physical activity? Do not try to make decisions like

this completely on your own. Failing to consult with or refer the client to the proper professional is a mistake that can totally undermine your personal training business. The liability implications are obvious. The risk for a successful lawsuit against you increases when you accept a client for whom you do not have the capacity to provide appropriate services, you pretend to have competence in a particular area, you fail to follow up on areas of concern that have been brought to your attention, or you allow a client to take part in an activity session before a proper screening and medical evaluation have been completed.

Even if you are not sued, in the event of injury or even death, the client or family members may lose confidence in you, question your integrity, and wonder about your ability to deliver competent service. This can certainly affect client referrals and is a very short-sighted way to run your business. Take the pressure off. Ask the right questions, gather information, and take time to conduct the appropriate preexercise groundwork to answer the question, "When is a prospective client ready to exercise?"

If in Doubt, Seek an Expert Opinion

If you have any questions or hesitations concerning the safety of an individual's program, check with your client's physician or qualified health care provider. Establish a relationship with your client's health care provider, particularly when you are working with higher risk clients. In addition, this kind of maturity, as exhibited by knowing when to refer, will help you create opportunities (i.e., working with licensed health care providers) in the health care industry and medical community.

Make Responsible Business Choices

Health management organizations (HMOs) and licensed professionals often prefer to focus on prevention and early detection of disease. For example, you may discover high blood pressure in a client who did not receive regular health checkups and refer the person to a medical doctor. You will have decreased the potential long-term costs to the individual and insurance company and demonstrated to

a physician your ability to be discerning and professional. A process like this can open up many doors of opportunity. And it all begins with a simple screening process that is centered on your client's well-being.

Medical History and Health Questionnaire and Lifestyle Profile

The medical history and health questionnaire (refer to the appendix for long- and short-form questionnaires, as well as activity and eating habits questionnaires; see also the Sample Personal Characteristics and Lifestyle Profile, form 7.2) asks questions about medical issues and concerns and other useful personal information, such as current and past activity habits and lifestyle behaviors. It should be administered and thoroughly reviewed before the client begins any program that requires physical activity, including fitness assessment and testing.

Questionnaires, as well as informed consent and release forms and liability waivers (appendix and chapter 8), can identify clients who may need medical clearance before participating in an exercise program as well as limit your personal liability. Signed forms document that you have acted in a legally responsible manner, in accordance with industry standards and guidelines.

The questionnaire should ask only for information that you understand and can interpret to determine your client's course of action. A short-form medical history and health questionnaire is appropriate for apparently low-risk clients or short-term clients requesting only a consultation or occasional help with the design and progression of their program. The short form also makes sense if you are not comfortable using an involved medical history questionnaire, or if a client resists a longer, more involved form. A properly designed short form certainly is not a compromise for information gathering but simply is sometimes more appropriate to your situation.

The long-form medical and health history in the appendix is designed to be repetitive. I have found that asking relatively similar questions in different ways and in different sections of the form is more likely to elicit the information that

I need. If the first version of the question does not alert me to a consideration, then the second or third approach may. For example, a client may not indicate risk factors for heart disease but may give the information in a different form when answering questions about blood pressure, blood lipids, or the health history of relatives or immediate family. Although some of my clients have observed that the form is repetitive and are curious as to why, the majority see no pattern and often their answers reflect this.

Informed consent and release and waiver forms (see samples in the appendix and chapter 8) explain the exercise tests, procedures, or activities your client will be part of; present possible risks or discomforts that might be expected during an exercise or evaluative program; and make you available to answer your client's questions. Signed consent and waiver forms provide evidence that your client is participating voluntarily, understands the apparent risks associated with participation, and retains the right to deny consent or stop the procedures at any point during the testing, evaluation, or other activity. Forms like these, when properly written and executed, can help protect you from liability and inform your clients as to exactly what they will be experiencing.

Red Flags

When something on the medical and health history questionnaire appears out of the ordinary, I term this a "red flag." Red flags generally need some kind of attention or follow-up that may be beyond your expertise. A few examples of red flags include age of the individual, history of heart disease, orthopedic concerns, high blood pressure, pregnancy (see box on this page), and diabetes.

If your client informs you about any medical concern that you are not confident you have the expertise to safely and effectively work with, refer him or her to a physician or other medical expert for evaluation and clearance before the individual begins an exercise program. This situation is an example of when your advisory board (chapter 3) can be of invaluable assistance if you do not know the best direction to take.

Case in Point: New Client

A red flag also can signify an area where you simply need more information before you can begin to create the best and safest program for your client. For example, let's say a new client appears for an initial consultation holding her new baby. She is only 2 weeks postpartum and anxious to "whip her body back into shape, starting today."

Although you may not be an expert in working with perinatal clients, you are concerned with the possibility of postpartum bleeding that often occurs if new moms start exercising too soon. In addition, you have read that the hormone relaxin, secreted during pregnancy, maintains its effect on joint laxity for about four to six weeks, or longer, after child birth. You explain to her some of your concerns regarding her recent pregnancy and the importance of your screening process.

She is impressed by your professionalism, knowledge, and concern and is eager to introduce you to her obstetrician. She now understands the necessity for you to gather invaluable information about her. She says, "I can't believe this. Other trainers that I have worked with started me on a program as soon as they could schedule me in. I think I'm beginning to understand what a professional personal trainer is really like. I'll fax this medical form back to you as soon as possible and I'll call my ob–gyn tomorrow to introduce you. By the way, my mom has diabetes and my dad struggles with high blood pressure and arthritis." By asking for information and insisting on following through, you will uncover invaluable information (i.e., familial diabetes and high blood pressure) that will further your ability to create a program that is both preventive and safe.

Physician-Directed Diagnostic Testing

When should you proceed with this step? The purpose of a diagnostic health evaluation is to detect the presence of disease. Conducted by a physician or qualified exercise physiologist, it may include a coronary risk factor analysis, physical examination, and laboratory tests. The results indicate whether individuals are classified as apparently healthy, at higher risk, or with disease.

The American College of Sports Medicine (ACSM and AHA 1998) recommends that "all facilities offering exercise equipment or services should conduct cardiovascular screening of all new members and/or prospective users" (p. 1012). An excellent example of a screening device is a self-administered questionnaire such as the revised Physical Activity Readiness Questionnaire (PAR-Q). A physical examination and medical clearance are recommended for new exercisers who meet the following criteria (ACSM 1995):

- Men over 40 years of age
- Women over 50 years of age
- Individuals at higher risk who have one or more coronary risk factors or symptoms of cardiopulmonary or metabolic disease
- Those with known cardiovascular, pulmonary, or metabolic disorders

It may be in the best interests of individuals who fall into one or more of the preceding categories to have a diagnostic stress test administered with medical supervision. These tests are administered with physician supervision and conducted by exercise technicians who are well trained and experienced in monitoring exercise tests and emergencies. If you have questions about beginning an exercise program with any client, contact the client's health care provider or enlist the assistance of your advisory board members who have expertise in this area.

Client Interview

The client interview is an ongoing dialogue between you and the client. Initially, it allows you to gather facts regarding your client's interests, needs, and understanding of fitness in relationship to health. This conversation expands on the information you receive from the written medical history questionnaire. The interview with a busy mother on this page provides a good example.

The interview helps you to find out what the client wants to accomplish. By acknowledging the client's perspective of what direction the program should take, you encourage your client to feel ownership. Because of this, the client will likely take some degree of responsibility for the program content and will be accountable for exercising regularly. This intrinsic motivation will go a long way in making your client compliant. Self-motivation is easy to develop in clients when you incorporate the client's interests into the program. You also need to account for his or her health and fitness needs.

Case in Point: Busy Mom

Jani is a busy mom with two young children. She loves to play tennis and is concerned about her overall health and fitness program. She told me, "Even though I live for improving my tennis skills, I'm concerned about other areas of fitness I may be ignoring, like flexibility and strength. How do I fit it all in?"

The balanced physical programming solution could be a total conditioning program that takes place entirely on court. You create a program that includes 15 minutes of tennis-specific cardiorespiratory conditioning, agility, and skill drills. Eight minutes of tennis-specific flexibility training follows this cardiorespiratory segment. This sport-specific foundation is a perfect preparation for her scheduled match play. After the match, you have her complete 15 minutes of upper body strength work using elastic resistance attached to a courtside net standard. During her competitive season, Jani plays tennis three times per week and enters tournaments on weekends. Because she completed her sport-specific workout three times per week on her own during tennis season, you added two workouts per week with you to concentrate on both functional and traditional strength development for her lower body and trunk. To balance the approach, you also integrate upper body strength exercises and include flexibility training.

Your clients must always remain a part of this process. Their input and sense of personal involvement will help you design safe and effective programs that clients are likely to continue with over time. This type of interactive and perpetual communication continues throughout successful personal trainer–client relationships. If you have done a thorough job of gathering information, you should understand the inner workings of your clients, know what makes them tick, and have the right information to optimize the training program.

➤ An excellent tool you can use to gain better knowledge and understanding of yourself and your clients is the Personal Fitness System™ (PFS) Interactive Wellness tool. After you complete the 10-minute PFS questionnaire, you can use computer software to create a behavior profile based on the responses. (See chapter 7 for more information on this useful high-tech tool, as well as a sample and information on how to administer a low-tech Personal Characteristics and Lifestyle Profile, form 7.2.)

CHAPTER 11

Practical Fitness Testing and Assessment

The sophistication, range, and complexity of a testing program can vary greatly depending on the tester's capabilities. Many successful trainers perform no fitness testing. Fitness testing from a motivational, nondiagnostic viewpoint is not a requirement, although a diagnostic evaluation may be an excellent idea if your screening procedure uncovers areas of risk that need to be further evaluated (see chapter 10). The prudent and wise trainer knows that it is necessary to administer a complete written medical evaluation to determine the readiness of his or her client to engage safely in a fitness program.

I usually encourage motivational, nondiagnostic testing if I see it as a plus for my client, and many of my clients enjoy it, too. But for some of my clients, testing is inappropriate from a psychological or physiological standpoint. A trainer can formulate an effective program, and determine whether a client should begin the program, by relying on information provided by verbal interview and completed medical history forms, in addition to information obtained from the client's health care practitioner.

If you are considering testing and are not a diagnostic expert, you can still include tests that offer valid data about the fitness components you will be measuring, after the client is cleared for an exercise program through proper screening (chapter 10 and appendix). Consider using tests that involve a minimal amount of testing time, are simple to administer and evaluate, clearly reflect changes in physical fitness, and require a minimal amount of money for equipment. Testing can include cardiovascular evaluation, flexibility tests that measure flexibility and evaluate posture, and

muscle strength and endurance tests. Resting, exercise, and recovery blood pressure and heart rate are also useful measurements to record. Measuring body composition by using a skinfold caliper or a cloth tape measure can be appropriate, too.

You must understand your role as a trainer who performs fitness evaluations versus a medical diagnostic evaluation expert. Explain this to your client, medical advisory committee, and any other individuals who need to know the parameters of your expertise and intentions. Put it in writing, too.

For years, health and fitness professionals have tested physical fitness programs before, during, and after extended periods of training to determine changes in physical fitness. Following is an example of how problems occur with regard to the roles most trainers play in assessment: Let's say a stethoscope is used to monitor heart rate or blood pressure during a cardiovascular fitness test. The test's purpose often is misinterpreted because of the introduction of a stethoscope, which the client perceives to be a medical instrument. The trainer should clearly communicate that the test is given only to assess cardiovascular fitness and not for exercise clearance or diagnosis of abnormalities or disease. This is true for any fitness component you choose to test, unless you are expertly qualified.

Any fitness program should require completed medical history forms, medical clearance from a physician if appropriate, and informed consent forms before any participant is considered for physical fitness testing and any type of physical conditioning program.

At best, the world of fitness testing and assessment is confusing. This topic would demand a book in itself to catalog the array of testing methods available and opinions regarding how best to carry out fitness testing and assessment. Yet, extensive nondiagnostic testing and assessment (see chapter 10) are rarely required of any client. This chapter presents a sensible testing and assessment approach that will meet the needs of your clients, will not overwhelm you with complexity or sheer volume of options, and won't consume too much of your time.

Fitness Testing— An Optional Motivational Tool

Ask most trainers whether fitness testing is required, and they will say, with a puzzled look, "Of course it is! Isn't it?"

Nondiagnostic Fitness Testing

Nondiagnostic fitness testing (as opposed to diagnostic fitness assessment in a medically supervised setting) should be considered an optional motivation tool that can be used to excite clients about improving their fitness. When you record measurements over specific time periods, such as every four to six weeks, clients can see personal improvement in a variety of areas. (Refer to chapter 10 for additional discussion of physician-directed diagnostic testing, the purpose of which is to detect the presence of disease.)

Fitness testing is not a diagnostic tool that assesses an individual's diseased or nondiseased status. Nor is it a tool to determine your client's readiness to engage in activity. A properly designed medical history and health questionnaire, verbal client interviews, and discussion with your client's health care professionals should largely determine your client's readiness to participate safely.

Deciding When to Test

Fitness testing is not an absolute necessity. Ask yourself a few questions: Does the test put your client in a high-risk performance situation that is inappropriate for his or her current fitness and health status? For example, can you see the absurdity of maximally testing an individual who is just beginning a strength program to determine starting loads? Additionally, does the test have the potential to embarrass the client? If so, don't use it. If you are working with an extremely overfat, sedentary individual, is it really necessary to administer tests to establish that the person is overfat, has a low level of cardiorespiratory fitness, and has flexibility or postural imbalances? A visual check, proper health screening, and conversation will detail all of this without putting the client at risk for injury or emotional insult.

Administer tests only when they have the potential to encourage the client and don't place the client at risk. It is not very motivating for an obese individual to be told that the jaws of the skinfold caliper will not open wide enough to allow a measurement. Stay sensitive to your client's physical and emotional realities.

Initial and Follow-Up Fitness Assessments

Timing of the initial fitness assessment depends primarily on your client's needs and fitness history. For many of your clients, it is prudent to create a foundation of conditioning before any testing and, of course, to commence physical training after a proper medical history screening has been performed. Following this sequence of steps is especially prudent if you choose to assess your less fit or special needs clients with tests that require physical activity.

After initial testing, retesting coincides nicely with the phases of (1) initial conditioning, (2) improvement, and (3) maintenance described by the American College of Sports Medicine (ACSM 1995). Significant gains in conditioning will likely occur in the first four to six weeks of training in a properly designed program. Testing and assessment, especially during the early stages of an exercise program, can be highly motivational because the rate of improvement will be great.

Retesting six to eight weeks after the initial test makes sense from a standpoint of physiological adaptation. You are also likely to motivate your clients with the probable "before and after" improvements. Testing again at six

months, one year, and once per year thereafter is a reasonable plan to follow, based on documented adaptations to a progressive training program. More frequent assessment remains an option for some or all of the tests. For example, blood pressure and body composition are quick and easy to assess and generally present no risk to the client.

Using Fitness Assessment Results

Before you conduct an array of fitness tests, you need to identify how you will use the results to motivate the client and improve his or her program. Many trainers acknowledge that they don't truly know why they are testing; many have a vague notion along the lines of, "This is a standard battery of tests that everyone uses." Most likely, they have not considered how the results will be used to enhance a client's training program. The tests must be specific and relevant to what the client wants to achieve.

There are two ways—one common and the other not so common—to catalog fitness assessment outcomes. You may find one or the other, or a combination of the two, more appropriate depending on the client.

One method is to compare assessment results to the results (or norms) of other people who have taken the tests. The second is to compare the client's own assessment results to his or her previous results to determine the percentage of improvement from test to test. The approach you use depends on the client's needs or abilities. In addition, information obtained from the medical history questionnaire and client interview, the client's current level of fitness and health, his or her psychological profile, and your understanding of the assessment process will help influence appropriate assessment decisions.

Using Norms

When you use norms, you compare the client's results with typical responses for people in the same age group. By comparing your client's results with age-adjusted norms, you are able to somewhat quantify your client's effort by using a percentile or a descriptive rating scale that ranges, for example, from excellent to very poor. When your client tests at the 90th percen-

tile on a particular evaluation, this means that approximately 89 percent of the people who take this test score lower. On the other hand, if your client tests at the 11th percentile, about 89 percent of the people tested score higher.

If you are comparing testing results to norms, you must follow the exact procedures (protocols) used to establish the norms. For example, if the test calls for a specific cadence and step height, this must be reproduced exactly for the norms to be valid.

I often call norms the "judgment" scale. Norms are a double-edged sword that can motivate or discourage, depending on how the scale rates your client's performance. Moreover, comparison to norms may or may not be relevant to your client's current situation. Any improvement, regardless of absolute starting point, is positive. And even after months of significant improvement, norm ratings may still rate your client in the lowest category. When I have a client who I anticipate will perform very well, I exploit norms and percentiles, knowing the high ranking will "drive" the client. Occasionally a negative or low rating could motivate a client in a positive direction. However, be selective and sensitive when using percentile rankings and norm comparisons.

Using Percent Improvement

The better approach for most clients is to show improvement relative to the client's starting point. This enables you to track improvements in fitness that are specific to the individual client. I have had clients who would find it very disheartening to be compared with a standard of excellence or performance that, at this time in their health and fitness journey, seems impossible to achieve.

Another advantage to using percent improvement is that you can develop your own testing protocols. Remember, using norms requires that you follow established protocol. By modifying existing tests, thereby creating your own assessments, you can more effectively and safely meet the needs of your clients.

Calculating Percent Improvement

Percent improvement is easily calculated by subtracting the most recent test result from the

previous test. This difference is then divided by the previous test result and multiplied by 100. For percentage improvement to have any validity related to previous efforts, the testing protocol must be identical. Follow the procedures in this chapter for creating your own tests, or follow any other testing protocol you choose to use. Table 11.1 uses a client's raw cardiorespiratory testing data, as well as data from a strength test and timed one-mile walk test, to demonstrate how easy it is to calculate personal percentage improvement.

Case Study: Norms or Percent Improvement?

Let's look at how three clients reacted to fitness assessment. The information you choose to emphasize from your testing and assessment, and how you quantify it (norms versus percent improvement), can have very different impacts.

John. John's initial cardiorespiratory assessment put him near a zero percentile ranking, a level rated as "very poor." I did not share this information with John, because it would not have been much of a motivator. John was, as he put it, simply "glad to have finished in one piece and still be alive!" I explained to him that we would refer to this starting point (his heart rate response) as a measure of his current level of fitness. These data (table 11.1) would be used later to objectively establish some of the improvements that he would be certain to achieve over a fairly short time period.

Sue. After Sue had trained with me for two years, she told me that she wanted to have a percentage body fat assessment performed with skinfold calipers. In the past I had discussed an array of possible assessment approaches and had given her several options, which included body composition assessment, but Sue had expressed little interest. She didn't need a body fat analysis to tell her she was extremely overfat! After recording the measurements, I entered the data into a popular generalized equation. Sue's body fat was 48 percent.

It was obvious that it would be very negative to inform her that her percent fat calculation rated at or near a zero percentile ranking in the "very, very poor" category and that she was, technically, still clinically obese. Because she did not ask, I did not offer to disclose. Instead, I said, "Now, we've got your site-specific measurements that we can refer to as you continue to lose fat weight and change your body composition and shape." See table 11.2 (Sue's data).

Epilogue. About six weeks later, at their urging, I retested both John and Sue. John's exercise heart rate dropped 16 percent (from 168 to

TABLE 11.1 Calculate Percent Improvement

Fitness component	(a) Initial or previous test result	(b) Retest #1 or most recent test result	(c) Difference between previous and most recent test result (a − b)	(d) Difference divided by initial or previous test result [(c ÷ a) ✗ 100]
Cardiovascular (heart rate in beats/minute)	168 beats/ minute	142 beats/ minute	26 beats/ minute	26 ÷ 168 = .1547; .1547 × 100 = about 16% improvement
Strength (repetitions completed)	8 repetitions	13 repetitions	5 repetitions	5 ÷ 8 = .625; .625 × 100 = about 63% improvement
Cardiovascular (time for one-mile walk test)	28 minutes	20 minutes	8 minutes	8 ÷ 28 = .286; .286 × 100 = about 29% improvement

TABLE 11.2 How to Practically Use Fat Fold Measurements (Sue's Data)

Client: Sue **Age:** 54 **Scale weight:** 154 **Testing date:** 8/1

Fat fold measurement site	Previous fat fold measurement in millimeters	New measurement in millimeters	New and previous measurement change in millimeters (+ or −)	Percentage of change
Scapula	13.8	13.0	−0.8	5.8
Triceps	21.2	20.0	−1.2	5.7
Chest	NA	NA	NA	NA
Axilla (under the arm)	17.0	15.2	−1.8	10.6
Iliac crest	18.2	13.1	−5.1	28.0
Abdomen	23.2	15.8	−7.4	31.9
Thigh	29.0	26.5	−2.5	8.6
Sum of fat fold measures	122.4	103.6	−18.8	15.4

Note: NA = not applicable.

142) for the same exercise test protocol we had used weeks earlier (refer to table 11.1). Although I knew John only moved to the fifth percentile and was still rated "very poor" when compared with norms, the test "felt easier" and John was ecstatic. John, who is an investment banker, said, "I'd take a 16 percent return on my money anytime!" which reflects his percentage improvement from his initial to most recent test result (table 11.1).

Sue's body fat percentage, upon retesting, dropped from 48 to 44 percent. This is an 8 percent improvement when calculated by using the percent improvement method (4 percent difference divided by original calculation of 48 percent, which equals .083 × 100 or about 8 percent). I had to chuckle when Sue, who manages a large mutual fund, said, "I wish I could get that return on all of my investments." Finally, any trainer would have liked her comment, "Absolutely not possible!", when I told her that her sum of skinfolds, based on initial

measurements she only vaguely remembered and that I had taken two years previous, had gone down from 232 to 122.4 millimeters. This change reflected a 47 percent improvement! (This percentage is calculated by taking 232 − 122.4, which equals 109.6; this difference is divided by the original sum of measurements, which was 232; 109.6 divided by 232 equals .472 and multiplied by 100 equals about 47 percent.) What would you report to Sue after two years of steady improvement if the improvement only moved her toward the 10th percentile and she was still categorically rated "very, very poor"? She certainly would not need to hear this type of information and would definitely be more motivated by personal percentage improvement. Needless to say, you want to manipulate statistics to give your clients a sense of hope.

Also, in terms of my personal worth to both John and Sue, I had attained a new level. After all, I had just helped them achieve significant returns on their investments.

Sally. Sally, on the other hand, is an age-group triathlete champion. She sees testing as simply another competitive event that she will do very well at or probably even "win." Her first two questions were, "What performance standards do I have to attain to beat the highest scores?" and "What percentage of body fat puts me at levels that compare with world-class triathletes?"

It is obvious that because of her competitive nature, fitness, and skill level, her self-esteem will benefit with norm comparison because she is always rated by the "judgment" scale as excellent and she is usually in the 99th percentile based on her results. Fitness testing and assessment are fun for Sally, because it is not a question of her doing well but, instead, an issue of how well she will test.

Weaknesses With Traditional Testing and Assessment Approaches

Personal trainers typically test submaximal cardiorespiratory fitness, muscle strength and endurance, flexibility, and percentage body fat. Examples and descriptions of traditional testing and assessment models can be found in the list of references and suggested reading at the end of this chapter. Many of the current models have both strengths and weaknesses in their abilities to assess improvements in your clients' different areas of fitness. In fact, some tests not only have very little relevance to a client's current situation, but they may even put the individual at risk. To the unsuspecting trainer, the inadequacies may not be easily identified for a specific client's unique needs.

Cardiorespiratory Testing

Have you ever looked closely at the progression of overload for submaximal bicycle ergometer, treadmill, and step tests when measuring cardiorespiratory fitness? Is the steady-rate building phase long enough to ensure a safe test? Is the incremental increase in heart rate or functional capacity ($\dot{V}O_2$) that is required to perform the cardiorespiratory test within a safe limit of effort for your client?

To follow is an example that further illustrates my point. A standard cardiorespiratory test protocol calls for the use of a step height of 12 inches and cadence of 96 beats per minute. A step height of 12 inches may quickly elicit a maximal heart rate response from a less fit client, and the step height might add orthopedic stress to the client's knee because the step is too high in relation to the client's unique anatomic considerations. Is a traditional test setup like this safe and in the best interest of all your clients?

Strength Testing

Although maximal strength tests (called 1-repetition maximum or 1RM testing) are not bad, they are often inappropriately administered because the client is not physically or psychologically ready. Furthermore, most muscular strength and endurance tests fail to measure balanced muscular strength and endurance. If balanced muscular fitness is the goal, all of the major muscle groups in the body should be assessed. Yet, testing of all the paired agonist and antagonist muscle relationships (e.g., quadriceps and hamstrings) is rarely performed. Many of these tests use traditional protocols that usually test only maximal muscular strength or use exercises that are biomechanically unsafe or have little application to your client's daily movement and exercise patterns.

Finally, have you ever wondered what testing grip strength by using a hand dynamometer has to do with your clients' exercise and movement needs? It is questionable whether there is any application in most instances, but many trainers unfailingly include such a test in their protocol.

Flexibility and Postural Assessment

Assessing only "flexibility" is not adequate, as is commonly done, and established approaches must be questioned. For example, trainers must go beyond the simple sit-and-reach test to assess flexibility, and they should consider eliminating it from the protocol. Some experts, including Plowman (1992) and Kendall et al. (1993), question whether the sit-and-reach test can be administered safely to a variety of populations and whether it actually provides any specific or valuable information about flexibility in the low back, hamstrings, and gastrocnemius muscle groups.

On the other hand, functional hamstring flexibility is easily assessed by having your client lie supine. One leg is lifted while the other is kept flat on the ground. Neither knee should be bent. Sufficient hamstring flexibility is exhibited when the raised leg can reach a vertical position (90 degrees of hip flexion) with no outside assistance.

Because flexibility is joint specific, a number of specific flexibility and postural assessment tests are needed to adequately evaluate your client's range of motion.

To be effective, an approach must address all of the body's postural misalignments and areas of insufficient flexibility. A well-rounded approach to this area of testing and assessment comes about when flexibility is viewed from a context of posture and movement, versus testing a muscle group for the sake of testing.

Practical, Contemporary, Personalized Approach to Testing

As mentioned, I would need an entire book to completely discuss the pros and cons of fitness assessment procedures, to describe proper procedures, and to address every possibility. However, my intention is to provide real-life, practical testing options that will complement the testing procedures with which you're already familiar.

I encourage you to question and investigate the appropriateness of traditional fitness assessment "recipes." Too often, a series of evaluations or testing battery is used again and again, regardless of the unique needs of individual clients and limitations of the tests.

Before you choose or develop any tests, ask yourself the questions listed under "Any Assessment Drill." This drill will help you evaluate tests and come to one of two conclusions. Either the tests are appropriate, safe, and useful for motivating your client toward success in a goal-oriented, individualized program—or they need to be modified or discarded.

Any Assessment Drill

1. Why am I administering these tests? What am I measuring, and how will I use these mea-surements to motivate my clients toward their goals and to aid exercise compliance?

2. Are the tests safe in relation to my clients' current level of fitness?

3. Are the tests appropriate to my clients' personal health and fitness needs?

4. Do the tests reflect balanced fitness by measuring and assessing all of the major components of fitness (cardiorespiratory, strength, flexibility and posture, and functional fitness) and key aspects within each component of fitness?

5. Do the tests accurately measure what they are intended to measure, and, if so, is it a useful criterion by which to motivate and measure client improvement? (e.g, if you consider administering a hand dynamometer test to measure static strength and endurance of grip-squeezing muscles of the hand, the issue is not whether this is a "good" or "bad" test but rather its usefulness to the client.)

If you are not sure of the answer to any of these questions, and especially if you doubt whether the procedure has any relevance or suspect it presents potential risk to your client, do not use it!

Creating Your Own Fitness Tests

You can easily create your own testing protocol by borrowing ideas from traditional tests. For example, I often modify step tests by using a two- to four-inch step platform versus 10, 12, or 18 inches, and I often decrease the commonly recommended cadence of 96 beats per minute. If I do this, the norms of the standard test no longer apply (if available), and during the retest I must replicate the procedure I used to gain the initial data. This ensures that the testing will be reliable and valid when I track client improvement over specific time periods and calculate personal percentage improvement. However, the results are relevant to my client's current situation and the previous test. As a result, I believe I have the best world of options and can better fulfill the testing and assessment needs of individual clients. Additional examples follow in the remainder of this chapter.

Determining What to Test

I encourage personal trainers, if appropriate to their client's needs, to attain the skills necessary to administer submaximal cardiorespiratory, muscular strength and endurance, and flexibility and postural assessment tests. In addition, body composition and resting blood pressure measurements are simple skills to learn and safe to administer. An excellent way to attain the skills necessary to accurately administer any assessment test is by attending educational conferences, seminars, or workshops that offer hands-on learning experiences.

Cardiorespiratory Endurance

Your clients may ask you, "How strong is my heart?" They may have heard friends talking about a "submax O$_2$ test" and ask, "What in the world is that?"

You tell the client, "Submax is short for submaximal and tells you that you're working at a level of effort below all-out effort. This usually equates to about 70 to 85 percent of maximal heart rate or a level of effort (referred to as rating of perceived exertion, or RPE) that is 3 to 7 (moderate to hard). Submax tests give you an idea of how strong your heart is and how well it can pump oxygen to your muscles. The more fit your heart is, the more calories you can burn and the more energy you'll have!"

When you compare submax test results, they can help you evaluate whether your client's aerobic training is effective and motivate him or her toward new goals. It is an objective measure that will show whether you're on track with your exercise planning and progression.

Submax tests should be preceded by an easy warm-up of at least three to five minutes and followed with a gradual cool-down of three to five minutes and stretching.

You are not limited to the tests and assessments in this book. You can substitute any cardiorespiratory exercise for the ones discussed in this chapter. Simply apply the principles and philosophy as you see fit, and use the testing setups as your template.

One-Mile Walk–Run Test

The one-mile walk–run test is one of the simplest ways to submaximally test aerobic fitness. This test requires a watch that measures seconds and a measured one-mile walking or running route. (If this distance seems intimidating or is too long for a client, create a course of any length and follow the procedures.)

Before the client walks, walks and runs, or runs the course, have her warm up for three to five minutes. She should cover the route as fast as she can. Record the time it takes. A trained speed walker may finish in eight to nine minutes (a speed of 7.5-6.7 miles per hour), whereas a fast runner may complete the course in six minutes (a speed of 10 miles per hour). If she's out of shape she might take as long as 30 minutes (a speed of 2.0 miles per hour) or longer. No matter! Simply note how long it took the client to complete the mile course.

Take her pulse for 10 seconds immediately after she completes the course. This is called the exercise heart rate (EHR). Measure her heart rate at the radial pulse near her thumb and wrist, or use a heart rate monitor. If manually monitoring pulse, multiply this number by 6 to get her heart rate count for one minute. For example, if you counted 20 beats in 10 seconds, 20 multiplied by 6 equals 120 beats of your client's heart per minute.

One minute after she stops exercising, take her pulse again for another 10-second count. This second pulse measure is called the recovery heart rate (RyHR). Record this information on the Aerobic Test Evaluation Sheet (form 11.1).

When you retest four to six weeks later, your client will be pleased by how much faster she can complete this same course, and she may have progressed from a walk to a run. In addition, her exercise heart rate and recovery heart rate will be lower (meaning the test is easier and she recovers from the effort more quickly). Your client's faster speed, lower exercising heart rate, and quicker recovery heart rate are excellent indicators that your program is working.

FORM **11.1** **Aerobic Test Evaluation Sheet**

(Use this form for the one-mile walk–run and step tests)

Name: _____ Age: _____ Start date: _____

Measurement date:										

Record one-minute exercise heart rate (EHR) and recovery heart rate (RyHR) in each box. Find heart rate by taking a 10-second heart rate count and multiplying the 10-second count by 6.

One-Mile Walk, Walk and Run, or Run

EHR Example: 120										
RyHR Example: 80										

Step Test

EHR Example: 135										
RyHR Example: 85										

From *The Complete Book of Personal Training,* by Douglas S. Brooks, 2004, Champaign, IL: Human Kinetics.

Step Test

Typically you'll see this test performed with a 12-inch step. However, for some clients a 12-inch step is too high. It may cause them to reach a maximal or high heart rate quickly, or the height of the step could stress their knees. You can test using any step height, just be sure to retest using the same height. (The 12-inch height is used most often so you can use the associated norms and percentile rankings to rate your client's performances.) If you like numbers and statistics but don't want to test a client on a predetermined step height and don't want to compare your client to norms or follow standard protocols, just calculate your client's personal percentage improvement when you retest.

To perform the test, have your client step at a steady cadence that you can replicate from test to test. For example, count "up" (right foot), "up" (left foot), "down" (right foot), "down" (left foot) and take about one second for each "up," "up," "down," "down," or a total of four seconds. If you have a metronome, set it for 96 beats per minute (or slower if appropriate) and have your client step with the same "up," "up," "down," "down" rhythm. A prerecorded cadence on a cassette or CD works well, too.

Use a stair step or small, stable platform or a commercially available adjustable step (figure 11.1). The platform should be no higher than 12 inches. Any height less than that also works if it is right for your client. Have your client step up and down on the step or platform for three minutes or some other appropriate duration.

Determine the client's EHR by taking her pulse for 10 seconds immediately after she completes the three-minute stepping duration. Then measure her RyHR one minute after she stops exercising. Record this information on the Aerobic Test Evaluation Sheet (form 11.1, this page).

If you follow this same procedure (protocol) each time you test, you can get a reliable result that can be used to evaluate changes in your client's aerobic fitness. Be sure to use the same step height and stepping duration and otherwise follow the exact procedures for each retest.

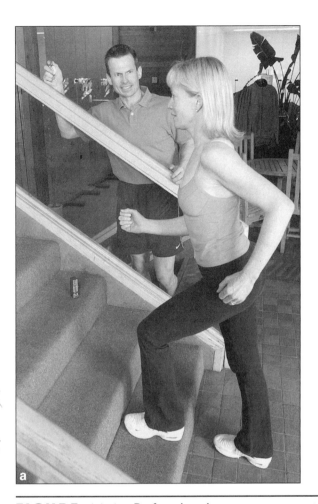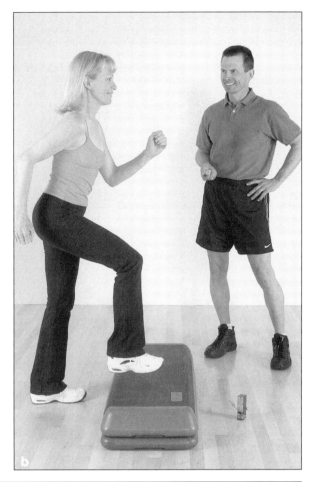

FIGURE 11.1　Performing the step test on a stair step *(a)* or step platform *(b)*.

Muscular Strength and Endurance

Often, muscular strength and endurance testing falls under the heading of strength testing. However, muscular strength and endurance are different. Muscular strength can be characterized as the ability of your muscles to produce high levels of force for short time periods (e.g., 30-90 seconds). Muscular endurance is defined as the muscles' ability to fight off fatigue for longer periods of time. Both types of strength lead to improved athletic performance, effective and safe daily movement, and good posture.

As stated earlier, you are not limited to the following exercises. You can substitute any resistance training exercise for the ones discussed. Apply the testing and assessment principles and philosophy as you see fit, and use the testing setups as your template.

Muscular Endurance Test

It is likely that many of your clients have never asked you how much endurance their muscles have. Don't let this lead you to believe that muscular endurance is not important. The ability to sustain muscle contraction (relatively high levels of muscular force production that can be sustained without quickly fatiguing) over longer time periods can help your client, for example, maintain proper skill execution (skill levels decrease when fatigue sets in) and correct posture.

Push-Up Test

Implying that women should perform modified or bent-leg push-ups and men standard, straight-body pushups is sexist. Whether your client performs a bent-leg or a straight-body push-up depends on upper body strength. If your client can't perform at least 13 straight-body or standard push-ups, then use the modified, bent-leg version (figure 11.2). (Any amount fewer than 13 and you're measuring muscle strength!)

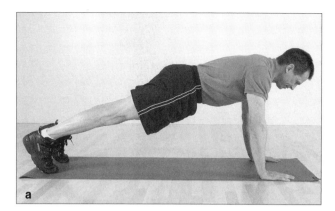
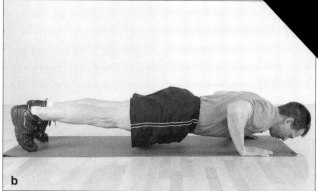
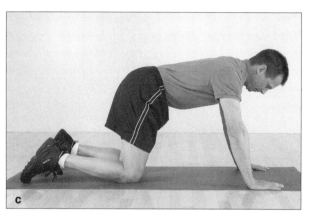
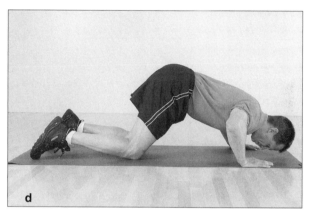

FIGURE 11.2 (*a*) and (*b*) A standard push-up should be performed with the back straight, the hands about shoulder-width apart, and the head neither up nor down. Only the feet and hands touch the floor in the starting position. (*c*) and (*d*) For the modified bent-knee version, the only difference is that the knees touch the floor, bent at a 90° angle with the ankles hip-width apart.

Both your male and female clients can perform either the bent-knee or standard (straight-body) push-up. The goal of the push-up test is to have the client perform the most push-ups he or she can. This test measures the endurance, and to some degree the strength, of your client's chest, shoulder, and arm muscles.

A light aerobic warm-up and gentle stretching of the upper body should precede this test. After you choose the style of push-up, have the client lower his chest toward the floor until it touches a rolled up towel (about three inches thick) and return to a straight-arm position. The push-up should be performed with control, using one-second up and one-second down as a guide. If you have a metronome, set it at 60 beats per minute. If you don't have a metronome, the testing won't be as exact when you try to replicate the test for future comparisons, but you can simply count, for example, "one thousand one" and repeat this count when you

have the client reverse direction and return to the straight-arm position.

Your client should lower his entire body and keep his back from sagging by setting neutral lumbar posture. The client must push up to a straight-arm position (not locked or hyper-extended) on each repetition to have it count toward the test score. Test score is the total number of push-ups completed. When your client can't return to the straight-arm start position or maintain an even rhythm, the test is over. Record the number of push-ups your client did on the Muscular Endurance Testing Sheet (see form 11.2) and consider retesting four to six weeks later.

You may want to calculate personal percentage improvement (discussed earlier in this chapter) after your first retest and thereafter. Or you can simply note how many more push-ups your client is able to do after each retest.

Muscular Endurance Testing Sheet (Push-Ups)

Age: _____ Start date: _____

date										
Number of modified bent-knee push-ups completed										
Number of straight-body or standard push-ups completed										

From *The Complete Book of Personal Training,* by Douglas S. Brooks, 2004, Champaign, IL: Human Kinetics.

Abdominal Curl-Up Test

The old sit-up tests were used to measure an individual's ability to perform a full sit-up. Generally, your feet were held and with reckless abandon you did as many sit-ups as you could in 60 seconds. However, the sit-up is not an accurate measure of abdominal strength and endurance because it requires the use of hip flexor muscles and, additionally, puts unnecessary stress on the spine and associated disks and ligaments.

The abdominal curl-up test has no time limit and teaches good exercise technique. However, if your client has a history of back pain, check with his or her doctor before using this or any other type of test that targets the trunk.

The goal of the curl-up test is to count the maximum number of abdominal "crunches" that the client can complete before reaching muscular failure (i.e., "I can't do another one with good form."). Curl-up test results are a good indicator of abdominal muscle endurance.

A light aerobic warm-up and gentle stretching should precede this test. To set up the test, have your client lie on her back, with her knees bent, arms at her side, and palms facing down. Without lifting either head or shoulders, the client should reach with her fingers toward her feet and press her shoulders away from the ears. Place horizontal pieces of tape at the farthest points the fingers touched. Place two more pieces of tape two and a half inches beyond these marks. (See figure 11.3, which shows the start and end position of the abdominal curl-up test.)

To perform the test, have your client lie on her back with her palms facing down, fingertips resting on the edges of the top pieces of tape, closest to her shoulders. Make sure your client's shoulders are pressed down and away from her ears (figure 11.3a). The client should bend her knees enough to allow her to place her feet a comfortable distance away from her buttocks, and she should keep her feet flat on the floor. Now, your client should focus on drawing her ribs down toward her hips. As a consequence, her head, shoulders, and torso will lift.

Next, her fingertips should slide along the floor until they touch the top edges of the lower tape markings, and then the client should return to the starting position. Your client should continue performing the curl-up (with control, about two seconds up and two seconds down) until she (1) can't do any more, (2) can no longer touch the bottom pieces of tape, or (3) cannot maintain the rhythm she started the test with (two seconds up, two seconds down).

The fingertips of both hands must touch the bottom tape markings on either side of the

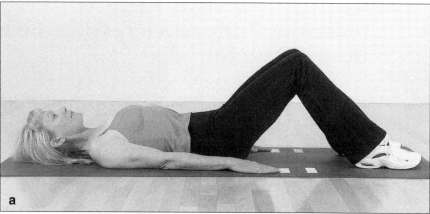

FIGURE 11.3 (*a*) Start position of the abdominal curl-up test; (*b*) end position of the abdominal curl-up test.

client's body to count as a repetition. Touching both pieces of tape also keeps the client from moving only one side of her body. The abdominal curl-up test score is the number of controlled touches your client can make on the bottom tape marks.

Record the total number of repetitions on the abdominal curl-up testing sheet (see form 11.3) so that you can compare your client's performance with future efforts. You may want to calculate personal percentage improvement after her first retest and thereafter. Or, you can simply note how many more curl-ups your client is able to do after each retest.

Muscular Strength Test

Every client wants to know how strong he or she is! In as little as four to six weeks of smart training, your client can see dramatic improvements in strength. So naturally, you'll probably want to measure how well your clients are doing. Strength testing, by its nature, is riskier than endurance tests. Be careful you don't hurt or intimidate any of your clients! Testing strength incorrectly will sabotage the best of intentions (like being able to exercise regularly)!

Perform this type of testing only after your client has trained with heavier resistance, for example, 8 to 12 repetitions performed to fatigue, for at least four to six weeks.

Rest time between any repeat attempts should be about two to five minutes to ensure that muscles are recovered and ready to "fire" again.

During the repetitions, monitor your client's breathing technique and insist that he maintain proper technique. Generally, your client should inhale during the eccentric part of the repetition and exhale during the concentric portion. The key is for him to breathe regularly and to never hold his breath. Sustained breath holding under heavy loads can significantly increase pressure in the chest, raising blood pressure and heart rate to unnecessarily high and potentially dangerous levels.

FORM **11.3** **Muscular Endurance Testing Sheet (Abdominal Curl-Up)**

Name: _____ Age: _____ Start date: _____

Measurement date									
Number of curl-ups completed									

A strength test requires an aerobic warm-up. It's also wise to include a couple of lightweight warm-up sets and gentle stretching before the test. A proper warm-up, along with the help of a spotter, will enable the client to perform this test in the safest manner. It's a good idea that you supervise and spot the test for maximum safety. If your client tests on her own time, recommend that a skilled workout partner assist her. A spotter should always be present because the person being tested may not be able to complete the number of repetitions planned and then safely extricate herself from the exercise.

The client should maintain control through each lifting movement. Use two seconds up and two seconds down. If you have a metronome, set it at 30 beats per minute (which equals two seconds up and two seconds down, if you stay on the rhythm of one beat up, one beat down). If you don't have a metronome, the testing won't be as exact when you try to replicate the test for future comparisons, but you can simply count, for example, "one thousand one, one thousand two" and repeat this count when movement direction is reversed.

After the test, record the amount of weight lifted and the number of reps completed on the Muscular Strength Testing Sheet (form 11.4). Any repetition in which the spotter does any of the work should not be included in the final count and should mark the endpoint of the test.

8 to 12RM Test

What's great about the 8 to 12RM test is that you can use any common exercise and equipment that you're currently using with your clients. Plus you can target all of the major muscle groups, which is not typically done during strength assessment. (An RM is the most amount of weight your client can lift with good form. 1RM is the most amount of weight she can lift once, whereas 10RM is the most amount of weight she can lift 10 times without losing form.)

A light aerobic warm-up and gentle stretching of the upper body should precede this test. Consider using lighter warm-up sets, as well. After warming up, choose any exercise and use enough resistance to cause your client's muscles to fatigue between 8 and 12 reps. (If he can do more than 12 reps, add more resistance.) The exercise should be performed in a controlled manner, for example, two seconds up and two seconds down. If the client cannot finish a rep (be sure he's spotted) or can no longer maintain a smooth rhythm, the test is over. Record the number of reps and weight lifted on the Muscular Strength Testing Sheet (form 11.4, page 227).

If you're using elastic resistance, count the number of times the tubing is wrapped around your client's hand (wrapping more times around makes it harder) or note how far he is standing from its attachment point (the farther he is from the attachment point, the harder it is).

Muscular Strength Testing Sheet (8–12 Repetition Maximum)

Name: _____ Age: _____ Start date: _____

Measurement date					

Exercise	Reps/weight	Reps/weight	Reps/weight	Reps/weight	Reps/weight

Retest about four to six weeks later using the same weight or resistance and procedures. Your client will probably be able to do more repetitions. This indicates an increase in strength. By the way, if your client is getting stronger his muscles are also becoming more fatigue resistant because absolute muscular endurance increases with strength gains. Because muscular endurance is increasing as he gets stronger, he can do more repetitions for any given amount of weight that he could lift previously. At some point, for example after several retests, increase the resistance being used so that the client fatigues between 8 and 12 reps again. Retest using this new resistance. Being able to do more reps and progressively increasing resistance are good indicators that your client's strength training program is producing results.

Posture and Flexibility

For most people, good posture does not occur naturally. It happens when an individual gains an awareness of how his or her posture compares with good posture. A trainer might ask a client, "Is your head forward and chin jutted toward the ceiling? Is your upper back rounded? Do you walk with a hunched-over look?" Poor posture and chronic misalignment of the neck, shoulders, and hips can lead to pain during rest or play and place a lot of mechanical stress on joints, ligaments, and muscles.

Poor posture is changed consciously with strengthening, stretching, and "posture checks" throughout the day. (Are you slouching in your chair?) Good body alignment not only improves performance but also prevents pain, discomfort, and injury.

Flexibility (affected by poor posture) is simply defined as how far and how easily you can move your joints. This is a measure of how tight your muscles are. Unrestricted and easy movement enhances safety and efficiency, and it allows you to participate effectively in daily tasks.

Flexibility and postural assessment information is essential so you can motivate your client toward better body alignment and gather critical information for the physical program. Is the client's skeletal alignment normal? Are postural imbalances present that need to be addressed through proper strengthening and stretching exercises?

Poor posture can place an excessive orthopedic burden on bones, joints, muscles, tendons, and ligaments. Therefore, you should identify any significant postural imperfections that might predispose your client to injuries. Improvements in posture will probably involve several different areas of the body. Correcting only a single misalignment will be unsuccessful. In addition, you must measure and reevaluate exercise-related postural and range-of-motion changes over specific time periods. Otherwise, you're simply talking the talk and acknowledging its importance, but you're not walking the walk!

This section will help you identify posture that is good or needs improvement and identify total body flexibility that is acceptable. This type of assessment will show the client how to create correct alignment and attain a healthy posture.

When you screen a client for posture, ask him or her to wear minimal clothing (like a bathing suit) and no shoes. Do the screening in front of a mirror. Have the individual assume a relaxed, normal posture. The client shouldn't try to correct poor posture during the test.

All posture and flexibility assessment tests should include a three- to five-minute warm-up and gentle stretching before the tests. This will help avoid injury or muscle strain and allow your client to perform each test better.

All of the tests should be performed with control. Your client should never try to, or be encouraged to, force her body to a point of pain or extreme discomfort.

Repeat these tests every four to six weeks to monitor her progress. After the client successfully passes all tests, continue the stretching and strengthening exercises that helped her improve posture and reach new levels of flexibility.

FORM 11.5 Posture Assessment Check Sheet

Head and Upper Back

Good head posture: Head aligned over shoulders Needs some work: Chin jutted forward

❏ Check when you pass

 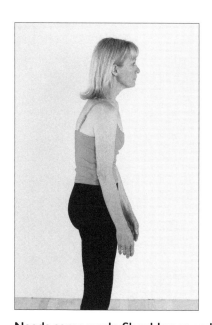

Good upper back posture: Shoulders pulled slightly back Needs some work: Shoulders rounded

❏ Check when you pass

Solution:
A forward head position usually occurs because of weak upper back muscles and tight shoulder and chest muscles and is a compensatory posture resulting from the resultant hunched-over position of the upper back. This misaligned head position can be corrected by reversing this rounded-shoulder and hunched-back posture. Simply stretch the front of your shoulders and chest muscles and strengthen your upper back.

Continued ➤

➤ *Continued*

Low Back and Abdominals

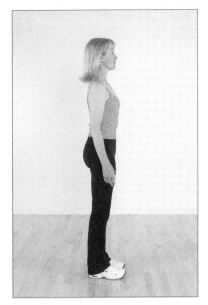 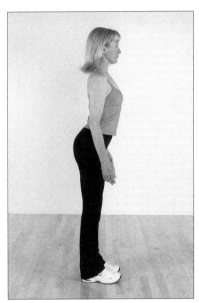 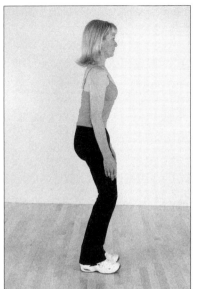

Good low back posture: Head, shoulders, hips, and ankles are aligned. A natural curve is present in the low back and neck area.

❏ Check when you pass

Needs some work: Arched back or flat back.

Good abdominal posture: Stomach does not stick out beyond the chest

❏ Check when you pass

Needs some work: Stomach or abdomen is protruding

Solution:
If your back is excessively arched, stretch your hip flexors (front of the hip). Although tight back muscles may cause your low back to be arched and your abdomen to protrude, this usually is not the case. Because most people sit in cars and office chairs with poor posture (rounded low back and upper back), the lower back muscles are usually overstretched and weak. Consequently, it is usually not necessary to stretch these muscles. Instead, strengthen your abdomen muscles to correct a protruding abdomen and an arched back, and stretch the hip flexors.

F O R M **11.6 Flexibility Check Sheet**

*See chapter 20 for instructions on performing stretches and chapter 19 for strengthening exercises that can help improve your posture.

Shoulders (outward rotation)

Instructions: Raise your hand behind your head and down toward the opposite shoulder blade.

Goal: To touch the top of the opposite shoulder blade

Stretches:

- shoulder press backward overhead or down
- triceps stretch overhead

❐ Check when you pass

Shoulders (inward rotation)

Instructions: Turn your palm facing behind you and place it in the low back. Raise your hand toward the opposite shoulder blade.

Goal: To touch the opposite shoulder blade

Stretches:

- shoulder pull-back: clasp your hands together behind your body and lift your arms.

❐ Check when you pass

Low back

Instructions: Lie on your back and pull both knees toward your chest by grasping the back of your thighs with your hands

Goal: To have the upper thighs touch the chest

Stretches:

- single- or double-knee stretches to the chest
- cat back

❐ Check when you pass

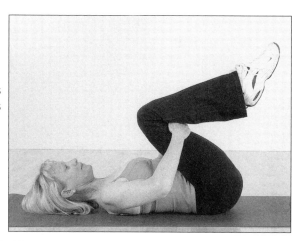

Continued ➤

Front of hips (hip flexors)

Instructions: Lie on your back with one leg straight and hug the other leg to your chest by grasping the back of your thigh with your hands

Goal: To have the upper thigh of the bent leg touch the chest while the back of the lower leg of the straight leg remains in contact with the floor; the knee of the straight leg must not bend

Stretches:

- kneeling or standing hip flexor stretches

❒ Check when you pass

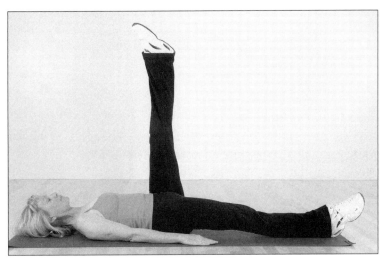

Back of the thighs (hamstrings)

Instructions: Lie on your back with both legs flat on the floor; then lift one leg upward

Goal: To lift one leg to a vertical position without bending either knee

Stretches:

- standing or lying hamstring stretches

❒ Check when you pass

Front of thighs (quadriceps)

Instructions: Lie on your stomach with your knees together; keep one leg straight and pull the heel toward the buttocks by grasping the top of your foot (shoe laces) with the hand that's on the same side of the leg you're stretching

Goal: To draw the heel toward and to easily touch the heel to the buttocks

Stretches:

- standing or lying quadriceps stretches

❒ Check when you pass

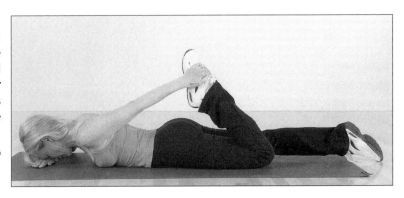

Continued ➤

➤ *Continued*

Calves and ankles

Instructions: Sit on the floor with an upright posture or lean back slightly with your arms supported behind you; position your legs straight out in front of you; draw your toe toward your shin

Goal: To easily move your toes toward your shin so that they are past perpendicular to the floor/ceiling

Stretches:

- standing wall press
- seated calf stretch

☐ Check when you pass

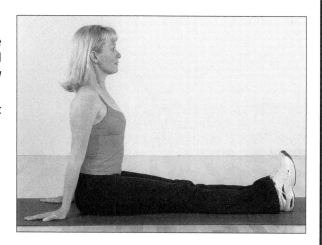

Shins and ankles

Instructions: Sit on the floor with an upright posture or lean back slightly with your arms supported behind you; position your legs straight out in front of you; point your toes away from you toward the floor

Goal: To move your toes from an orientation toward the ceiling (90 degrees) to a position of 45 degrees (bottom of foot is 3–4 inches from floor)

Stretches:

- shin on tibialis stretches

☐ Check when you pass

You need to strengthen your client's back muscles, too. Strong low back muscles contribute to posture and a healthy back. If your client's back is more flat than arched, it's probably a good idea to stretch the back of the upper leg (hamstrings).

If you notice any of the following postural deviations while assessing your client's body posture in the mirror, you may want to discuss these with his or her doctor. Postural abnormalities you should be concerned with include the following:

- Hyperextended knees or knees that "push back"
- Excessively high arches
- A second toe that is longer than the big toe (Morton's foot)

- Uneven shoulders or hips
- Bowed legs (knees are apart when ankles touch)
- Knock-kneed (knees touch when feet are apart)
- A sideways curvature of the spine (scoliosis)
- Ankles that are excessively rolled in (overpronated or everted) or excessively rolled out (oversupinated or inverted)

Finally, if a client has pain or discomfort, or you have questions regarding the right approach to improving spinal posture and back health, contact your circle of experts (your advisory board) and your client's doctor for guidance.

Body Composition

Why should a client be worried about how much of him is fat, bone, and muscle? Having too much body fat has bigger implications than just appearance or its potentially negative impact on athletic performance. Too much fat is associated with an increased risk for heart disease, diabetes, some cancers, and many other health problems.

Although experts still argue about the ideal range of body fat, men should strive for between 12 and 18 percent. Women should shoot for between 16 and 26 percent. Women naturally carry more fat than men and this is related to the role women's bodies play in producing offspring. Competitive athletes generally have body fat measurements—depending on the sport they participate in and genetics—that fall below these percentages.

If you choose to calculate your client's body fat, remember to focus on improvement from the starting point versus concentrating on the actual percentage of fat and then comparing it to norm standards. A long-term goal would be to decrease body fat relative to your client's starting point. Additionally, many "fat experts" argue that it may not be necessary to fall within any specific range to be healthy! However, optimal training results and health are probably more attainable if your client's body fat falls within these ranges set for men and women. Too much fat is bad for any client's health!

Insufficient Body Fat

It is possible for a client to be too thin. This is not the problem of most Americans or the world population that has copied affluent Westerners' health, fitness, and diet patterns, but for many dedicated exercisers the last goal they should set is to lose body fat. Too little fat, especially in women, can lead to permanent bone loss and osteoporosis (bone weakening disease), bone fractures, and irregular or missed menstrual periods.

An Easy Way to Measure Body Fat

One of the easiest and most useful ways to measure fat, and keep track of fat loss, is by using fat calipers or a tape measure. Both methods are simple and inexpensive. Understanding the pros and cons of several methods used to document weight loss will help you understand why calipers and tape measures are the right measurement tools for you to use.

Body Weight

Following your client's daily body weight fluctuations can drive you to the point of insanity! Body weight (also called scale weight) is determined by using a home or gym scale. However, scale weight doesn't tell the whole story and can lead you and your client astray. Scale weight can go up or down a few pounds depending on how much, or how little, your client has had to eat or drink before weighing or whether he or she has recently eliminated. Body weight fluctuations are very common during a woman's normal menstrual cycle. Also, clothes can increase weight in varying amounts.

If your client insists on weighing herself (weighing in isn't all bad), have her do so infrequently. To increase consistency among weigh-ins, she should weigh herself at the same time (in the morning and before breakfast is a good time), use the same scale, and wear the same clothes or none at all.

Occasional weighing (i.e., not obsessive and about once every week or two) may help your client spot an increase in weight. If you think it might be a fickle fluctuation (like water retention during a woman's menstrual cycle), check your client's body fat measurements with fat calipers or a tape measure. If she's gained fat, an immediate reversal is called for. People who keep large amounts of weight off successfully say the secret to their success is to reverse small fat gains immediately.

Percent Body Fat

Percent body fat can be determined by using one of three popular methods: hydrostatic weighing (the "dunk tank"), bioelectrical impedance (very high tech but not necessarily accurate), and skinfold measurements using "fat" calipers.

Hydrostatic Weighing

Hydrostatic weighing is often referred to as "underwater weighing" or the "dunk tank."

Getting dunked involves being suspended in a harness that resembles a lawn chair that is attached to a scale. After being positioned in the chair the person is lowered into a tank of water. Sounds like a mess, doesn't it? There goes at least five dollars worth of hair gel!

Hydrostatic weighing can be fairly accurate, yet it requires a great deal of time, effort, expertise, and expense. This method serves as the "gold standard" to validate body fat percentage predictions using skinfold measurements obtained with a skinfold caliper.

Bioelectrical Impedance

Bioelectrical impedance is often discussed in magazines and on TV. This type of testing is based on the fact that electrical impulses sent through lean tissue (like muscle) have greater conductivity than those sent through fat tissue. Don't assume that this type of testing is quick, simple, and accurate. The results can vary from test to test by as much as 40 percent. Many factors make this test procedure susceptible to being inaccurate. In fact, no recognized industry standard for creating the formulas (which are programmed into the machine) exists for these machines, and accurate results partially depend on the equation. In other words, the information the computer spits out is only as accurate as the information that is fed in.

The bioelectrical impedance test is less accurate than dunking or skinfold measurements (mentioned next). Bioelectrical impedance tends to overestimate body fat percentage if you are very lean and underestimate body fat percentage if you have a lot of fat. In the future, bioelectrical impedance may one day rate as a preferred method for estimating percent body fat.

Skinfold Measurements

Skinfold measurement is the most common fat test you'll run across. Skinfold calipers somewhat resemble a bug's pincers. Fortunately they do not feel the same. When you measure fat, you need to firmly pull the fat away from the muscle, but the sensation is not painful. A gauge on the calipers measures the thickness of the fat. (A skinfold is composed of the two layers of skin you pinched, plus the fat.) Most tests require three to seven different measurements to predict body fat percentage.

Measuring Body Fat by Using Skinfold Measurements

Taking skinfold measurements is easy. Practice increases measurement accuracy and accurate location of the measurement site. The skinfold caliper moves the client beyond the "pinch an inch" and gives you accurate, reproducible results. Almost every fitness professional will advise you to monitor body fat percentage.

Independent of the skinfold caliper you use and the number of sites you measure, follow these simple steps:

1. Firmly pinch the skinfold between your thumb and forefinger (see figure 11.4). Place the jaws of the caliper over the skinfold while continuing to hold the skinfold with the other hand.

2. Repeat each measurement three times and use the average as your measurement. Measure in a cyclical fashion. For example, if measuring three sites, measure sites one, two, and three before returning to site one for a repeat measurement.

3. Take any skinfold measurements before exercise. Because blood travels to the skin to help cool the body during exercise, the skinfold measurement would be thicker immediately following a workout. This would make your client test fatter, which is just what he or she doesn't need! Also, it's hard to firmly squeeze the skinfold when your client's skin is slippery from sweat.

4. Follow these simple procedures, use a quality skinfold caliper, and locate a good generalized fat equation (Heyward 1991; Jackson and Pollock 1985) to predict body fat or simply use personal percentage improvement, and your percent body fat data will be very accurate and of value to your client!

Using Skinfold Measurements Practically

Skinfold measurements may be used to predict a percentage of body fat and to show improvements, or lack of improvement, in the area of body composition. Body composition measurements are generally motivational because they can demonstrate safe and progressive fat loss and reinforce the effectiveness of the training program.

I prefer using the measurements in the manner illustrated in table 11.2. This method

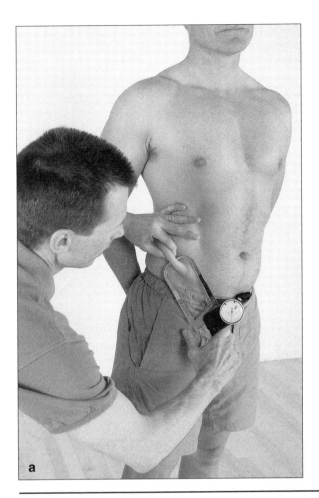

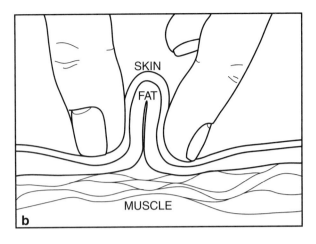

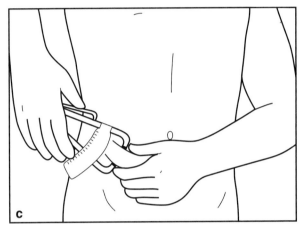

FIGURE 11.4 After locating the right spot *(a)*, grab the skin and pinch *(b)*. Use the calipers to measure the width of the pinched skin *(c)*.

b and c Reprinted from D. Brooks 1999.

demonstrates changes that are specific to the individual client by using the concept of personal percentage improvement.

On the other hand, predicting a percentage of body fat or referring to norms compares the client to others. For people who are lean and fit, or otherwise mentally prepared, this can be an exciting motivator. For overfat individuals, this can be a powerful form of negative feedback and another roadblock to becoming fit.

There are three ways to use fat fold measurements without predicting a percentage of body fat. The sum of the measurements of all fat fold (skinfold) measurement sites can be used to estimate a relative degree of fatness for comparison over time (table 11.2). However, it is not necessary to label this degree of fatness (e.g., a percentile, other ranking, or description such as "poor"). It is simply a number.

Second, body fat distribution that is specific to each site measured (site-specific) can be docu-

mented and changes noted at each retest (table 11.2). From this information, a genetically determined profile of where fat is lost and gained can be observed. This type of information is useful in counseling clients who are frustrated by the pattern of fat loss that is determined by genetics and cannot be altered.

The third way to use fat fold measurements is as a "before and after" percentage of change. Before and after percentage of change can be used with both individual site-specific measures and the sum of measurements. In table 11.2, percentage of change, as previously discussed, is calculated by dividing the change (difference) in millimeters by the previous measurement and multiplying by 100.

Case Study: Body Composition

Let's say that I calculated a client's overall body fat percentage difference from test 1 to test 2 and, in real numbers, it only changed 2.5 percent.

Although this is significant to a scientist, it is difficult to convince many clients that this percentage improvement was worth the effort. Earlier in this chapter, I mentioned Sue's situation and how I chose not to disclose her body fat percentage calculation because she had not inquired about it and because I didn't think she would receive the news with enthusiasm.

However, it was easy and fun for both of us to identify where Sue was losing body fat, based on her genetic profile, and what the site-specific measurements revealed and how this related to how her clothes were fitting (table 11.2).

During previous months, she had lost significant fat in the scapulae and triceps area. Sue was initially frustrated and questioned why she could not selectively "spot reduce" the areas of the body that she viewed as problem regions. I had explained, with patience and consistency, that if she followed her program she would finally lose fat in other areas of the body. She understood and accepted that this was her genetic profile for fat distribution and loss and that its pattern could not be altered.

Sue was quite excited to see her consistent effort pay off with a huge percentage of improvement (28 percent and 31.9 percent, respectively) in two site-specific measurements of the abdominal and hip (iliac crest) regions, which, of course, is where she wanted to lose weight. I pointed out that her relative degree of fatness (sum of fat fold measures) decreased overall by 15.4 percent (table 11.2).

Sue was ecstatic and ready to progress to her next goal of healthy weight loss. I never told her about my 2.5 percent "secret," yet I think this was the right professional choice because today she is maintaining a healthy and fit 17 percent body fat.

Measuring Body Fat by Using Tape or Circumference Measurements

Measuring with a tape (a cloth measuring tape works best) is another excellent and quick way to determine whether your client is losing fat. (It's a good idea to use both the skinfold calipers and tape measurements to most effectively monitor your client's body fat and body composition changes.)

Using the tape parallels asking, "How do your clothes fit?" If your client's pants or bra straps are no longer snug, she knows that she's losing inches (or at least millimeters!) of fat. Clients know that when tape measurements are shrinking and clothes are fitting more loosely, they are dropping fat.

Keep the body part being measured relaxed. There are many possible measurement locations, but the following five are quick to administer:

1. **Chest.** Take the chest measurement at nipple level. Run the tape from behind the client toward the front (figure 11.5).

FIGURE 11.5 Tape measurement for chest.

2. **Upper arm.** Take the upper arm measurement around the largest part of the upper arm (figure 11.6). The arm being measured should hang downward and be relaxed. (Note: Your client can take this measurement by himself if he uses a piece of sticky tape to attach one end of the cloth tape to his arm!)

FIGURE 11.6 Tape measurement for upper arm.

3. Waist. Take the waist measurement at the narrowest point of your client's waist. Run the tape from behind him toward the front (figure 11.7).

FIGURE 11.7 Tape measurement for waist.

4. Hips. Take the hip measurement while your client stands with his feet together. Run the tape from behind the client and around the greatest protrusion of the buttocks (where your client's buttocks stick out the farthest; figure 11.8).

FIGURE 11.8 Tape measurement for hips.

5. Thigh. Take the thigh measurement around the largest part of upper leg, which is usually just below the buttocks or gluteal fold (figure 11.9).

FIGURE 11.9 Tape measurement for thigh.

Photos are shown with a trainer present so that you can easily view how the trainer positions himself during the measurement procedure and placement of the tape. Note the trainer is positioned in front of the client for all measurements or slightly off to one side. It is also evident that you can encourage your clients to self-administer these tests if appropriate.

Record your measurements on the Tape Measurements Record-Keeping Sheet (form 11.7) and consider calculating personal percentage improvement from test to test.

Blood Pressure

High blood pressure, or hypertension, is an often asymptomatic disease that influences the progression of various vascular diseases, including coronary heart disease. Early detection of hypertension and consistent monitoring of blood pressure may help your client avoid symptomatic vascular disease, such as heart attack, stroke, intermittent claudication, or pain in the lower extremities.

Working with your client's physician to help interpret the blood pressure values you obtain

FORM 11.7 Tape Measurements Record-Keeping Sheet

Name: _____ Age: _____ Start date: _____

Measurement date									

Tape measure site locations (measured in inches or millimeters with a cloth tape):

Chest									
Upper arm									
Waist									
Hips									
Thigh									

Reprinted from D. Brooks 1999.

From *The Complete Book of Personal Training,* by Douglas S. Brooks, 2004, Champaign, IL: Human Kinetics.

can be an invaluable service to the client. This holds particularly true if your client does not receive regular medical checkups. In this case, you become a "health information link" to your client's health care experts.

Taking resting blood pressure is easy. Volunteers throughout the world who have no medical training successfully and accurately measure blood pressure. Participate in a local clinic or workshop, or volunteer to be trained and offer your newly learned skill on a volunteer basis.

Successful Testing and Assessment

The key to fitness testing and assessment success is to individualize this evaluative process to each client. Fitness assessment may or may not be a tool that will motivate your clients. In fact, it may not be safe or appropriate.

Use the wealth of information you have collected from the health history questionnaire (found in the appendix) and from your ongoing interview process to detect health risks that require referral to medical professionals. This information will also help you determine whether testing and assessment are appropriate at a particular point for each client.

To establish the safest and most effective assessment process, you must do the following:

1. Stay within your knowledge base.

2. Refer when appropriate.

3. Listen to the client and incorporate all information you have accumulated.

4. Move past standard or traditional testing and assessment limitations.

These steps will help you to create an experience that is safe, fun, productive, useful, successful, and personal for each of your clients!

Fitness Assessment: Suggested Reading

The following reading list, combined with the works cited in this chapter, contains a substantial body of literature for trainers interested in traditional, norm-based approaches to fitness testing and assessment. I continue to use many of these fundamental and sound approaches, and I have noted exceptions in this chapter. Many of the following are superb resources that reinforce traditional testing and assessment methodology:

American Council on Exercise. 1996. *Personal Trainer Manual.* San Diego, CA: ACE.

Brittingham, M. 1999. *The Fitness Analyst.* Information on this excellent testing and assessment software is available through Brittingham Software Design Inc., 908-879-4991, or visit their Web page at www.BSDIFITNESS.com.

Golding, L., C. Meyers, and W. Sinning. 1989. *The Y's Way to Physical Fitness*. Champaign, IL: Human Kinetics.

MacDougal, J.D., H. Wenger, and H. Green. 1991. *Physiological Testing of the High-Performance Athlete*. Champaign, IL: Human Kinetics.

McArdle, W., F. Katch, and V. Katch. 1991. *Exercise Physiology—Energy, Nutrition, and Human Performance*. 3rd ed. Philadelphia: Lea & Febiger.

Nieman, D.C. 1995. *Fitness and Sports Medicine: A Health-Related Approach*. 3rd ed. Palo Alto, CA: Bull.

Wilmore, J., and D. Costill. 1994. *Physiology of Sport and Exercise*. Champaign, IL: Human Kinetics.

CHAPTER 12

Achieving Goal- and People-Oriented Programming

It has been said, "If you keep doing what you have always done, you will get what you have always gotten." A workout program cannot proceed according to a plan if you have no plan, nor can you expect great results without a road map to guide you! You must set a planned course of action, which is what many clients do not do for themselves; whether the client knows it or not, this is often the reason he or she hires a personal trainer.

The questions, "How much exercise is enough?" and "What type of exercise is best for developing and maintaining fitness?" are asked by anyone who's serious about his or her training program. Trainers can, of course, help answer these questions. The next question that usually follows is, "How can you (the trainer) devise a training program that gets me the results I want in an efficient way?" These are good examples of program design questions, and you'll find the answers and new ideas for approaching these issues in other chapters. This chapter focuses on setting a goal-oriented course of action and personalizing your programming.

Importance of Setting Goals

Before digesting the information found in various program design chapters, take some time to focus on the information here. Commit to the idea of having your clients set realistic goals to help you organize their training. By taking this bit of information into account (goals really represent desire and hope!), you'll find that your clients will become more motivated to follow the program because you know what they want to accomplish.

Too often, individuals set goals and either don't incorporate the goals into the exercise planning phase or never revisit them. Setting and reevaluating personal goals keep you and the client accountable; they keep your client's training program, mind, and body fresh; and they keep the results coming in! Finally, the trainer must be willing to reevaluate and change directions when the evidence warrants it (see chapter 14, Track Your Client's Progress).

Evaluating Your Client's Goals

Before you encourage your client to set personal goals, you need to evaluate whether the client is training for health or fitness. This consideration will affect how you design and approach personalized programming.

In July 1993, the American College of Sports Medicine (ACSM) and the Centers for Disease Control (CDC), in cooperation with the President's Council on Physical Fitness and Sports, released a statement announcing that a persuasive body of scientific evidence indicates that regular, moderate-intensity physical activity offers substantial health benefits to the public.

The 1993 recommendations state that every adult should accumulate 30 minutes or more of moderate-intensity physical activity on most days of the week. Additionally, performing a

series of short bouts of exercise of moderate intensity, lasting from about 8 to 10 minutes, with total duration being at least 30 minutes per day, will also provide significant and similar health benefits compared with exercising for 30 minutes all at one time. In other words, the total amount of activity is the key, not whether it is performed continuously. That is good news for someone who finds 30 minutes of continuous activity, of any kind, rather daunting.

The statement further recommends incorporating activity into daily routines, which is time efficient and nonintimidating. Examples of effective activity include walking stairs instead of riding elevators, gardening, raking leaves, shoveling snow, dancing, vigorously cleaning house, and strolling. Planned exercise or recreational activity such as an aerobics class, hiking, biking, tennis, swimming, or strength training may also be used to meet "movement requirements."

It is now clear that lower levels of physical activity may reduce the risk for certain chronic degenerative diseases. For the trainer, this is not an issue of right and wrong, or easy versus moderate or vigorous exercise, but an issue of personal knowledge and appropriateness. It is an issue of encouraging a majority of the population, who need moderate and regular physical activity, to exercise effectively.

Physical fitness is made up of the right balance between amount and intensity of cardiovascular fitness, muscular strength and endurance, flexibility training, and functional fitness activity. Fitness is often defined as the "ability to perform moderate to vigorous levels of physical activity without undue fatigue." That statement probably doesn't mean a whole lot to most fitness enthusiasts. More important, fitness training should encompass the capability and personal desire to maintain this activity level throughout life, and the person should experience a consistent level of enjoyment and fitness benefits while taking part in such activity. The client should like what he or she is doing!

On the other hand, many of your clients will be looking to move beyond moderate physical activity and toward optimizing their health, fitness, and performance training returns. Regardless of which is true, let individual client goals, needs, and personality reflect the correct direction.

Describing and Recording Goals

It's appropriate to get your clients to focus on where they'd like to go—what they'd like to accomplish—regarding their fitness goals. To do so, you need to have your clients put their goals in writing.

You should set goals and keep records because the adaptive response (this occurs when clients work harder than the body is accustomed to and they become more fit) to training is complex and individual. In other words, individual clients will most likely respond differently to exactly the same program. Because of this, update client goals and record progress or lack thereof, so appropriate changes can be made to create continued gains in fitness.

If this concept of developing goals is to be useful, you must have the client do the following:

- Set realistic goals
- Be specific
- Commit goals to paper
- Reevaluate goals regularly

Writing Goals

Have your client develop both short-term, mid-term, and long-term goals. Short-term goals should be attainable in about four to eight weeks and mid-term goals from eight weeks to six months. Attaining success in shorter time periods will keep your client's desire pumped and her commitment to exercise high. Long-term goals can be reached any time after six months and might not be attained for a year or longer.

Identifying Fitness Goals

Your client has probably already shared several fitness and health goals that he would like to achieve. Use the ideas in the "Goal-Setting Checklist" section, described subsequently, to stimulate further thought. Then, add any new goal ideas to the personal goals you and the client have already thought of but maybe he hasn't written down on the Fitness Goal Tracking Form (figures 12.1, 12.2, and form 12.1).

Sample Fitness Goal Tracking Form (Short-term)

Goal type (circle one): (Short term) Mid-term Long-term

Goal: Stop missing workouts for frivolous reasons. Commit!

Date goal set: 6/15

Date you'd like to accomplish your goal: 6/25

Date goal accomplished: Action steps in place 6/20. Yes! I'm on my way!

Plan of attack for accomplishing my goal:

1. Call Mary and commit to exercising with her on Monday, Wednesday, and Friday at 6:30 A.M. Schedule two appointments per week with my personal trainer on Tuesday and Thursday at 8 A.M.

2. Plan recreational activities with my kids and spouse on the weekends and two nights per week. Emphasize fun and active time with my family.

3. Cut out mindless channel surfing on the TV.

Goal reevaluation and change from first writing:

It might be more realistic to expect that it would take at least six months to establish a committed relationship with a training partner and integrate personal training sessions and family recreational activity into your daily schedule.

FIGURE 12.1 Sample fitness goal tracking form (short-term).
Reprinted from D. Brooks 1999

Sample Fitness Goal Tracking Form (Mid-term)

Goal type (circle one): Short term (Mid-term) Long-term

Goal: Finish in top third of San Diego short-course triathlon field

Date goal set: 2/20

Date you'd like to accomplish your goal: 8/16

Date goal accomplished: 8/16

Plan of attack for accomplishing my goal:

As soon as weather permits, move my indoor cycle and run training outside. Enter six short-course triathlons to give me race experience and to use as race pace/sharpening training sessions. Periodize my program to emphasize running, cycling, and swimming, but maintain my strength and flexibility with traditional stretch and strength programs. Join an organized swim program to strengthen my weakest event and get some coaching lessons from the local professional triathlete coach. Use heart rate to monitor potential overuse symptoms as I increase the duration and intensity of my workouts. Keep it FUN!

Goal reevaluation and change from first writing:

If your goal isn't attainable or realistic, create a new goal. Don't set yourself up for failure because you weren't willing to adjust the initial goal-writing effort or because of unrealistic good intentions.

If the goal had been to complete an Ironman triathlon six months from the starting date, a realistic adjustment to the goal would be to compete in short-course triathlons for the current season and lay the foundation of training necessary to complete an Ironman triathlon in the fall of the following year.

FIGURE 12.2 Sample fitness goal tracking form (mid-term).
Reprinted from D. Brooks 1999

F O R M **12.1** **Fitness Goal Tracking Form**

Goal type (circle one): Short term Mid-term Long-term

Goal: _____

Date goal set: _____

Date you'd like to accomplish your goal: _____

Date goal accomplished: _____

Plan of attack for accomplishing my goal:

Goal reevaluation and change from first writing:

Reprinted from D. Brooks 1999

From *The Complete Book of Personal Training,* by Douglas S. Brooks, 2004, Champaign, IL: Human Kinetics.

Using the Goal-Setting Checklist will help ensure that your client's goal list covers all of his health and fitness needs. A sharp personal trainer puts this kind of thought process to work in designing the best program for a client, one that meets his needs and desires.

Goal-Setting Checklist

When your client can write down what she wants to accomplish, it better programs her mind and body to achieve that goal. Start with a few targets (goals). You can't hit a target unless you have at least one! Setting goals helps your client identify and understand what motivates her to work out and why she should continue to work out and be concerned with her personal health.

To push the goal-setting process along, ask your client to respond to the following questions and to incorporate these principles as part of her own goal-setting process:

1. Why are you currently exercising or why do you want to exercise? Remind your client that looking, performing, and feeling better are good long-term goals, but that she shouldn't forget about short-term, specific goals. A good short-term goal might be to strength train three days per week. This is realistic and achievable and will motivate the client until she reaches more ambitious goals.

2. What motivates you to exercise? The client should write a list of her motivations. This kind of introspection will help develop goals that work for her!

3. What activities do you like? Using a variety of activities will help the client avoid boredom and overuse injuries and find activities she enjoys.

4. Do you enjoy exercising? If the client likes what she is doing, she'll be more likely to incorporate fitness as a permanent lifestyle change.

5. Can you commit to regular exercise? Encourage the client to set minimal (when the client is extremely busy) and optimal (when the client's life is under control) training schedules. If the client commits to a schedule, she will be more likely to stay active and get results. Results, in and of themselves, are motivating. Have your client repeat this phrase: "Exercise is a year-round habit, like personal hygiene. It is not a part-time hobby." Remind the client that health and fitness are easier to maintain than to regain!

6. Is the program reasonable? Ask the client, "Is this a schedule you can realistically commit to for a lifetime and still maintain other responsibilities?" Make sure the number of days she works out and the duration of her workouts are in line with what she wants to accomplish. Help the client to be realistic. Although substantial health and fitness benefits can be derived from three workouts per week, it won't allow the client to be competitive on a world-class level.

7. What is the "big picture"? Remind your client that through her commitment to consistent workouts and other positive lifestyle changes, she should remember the ultimate goal of improving her quality of life.

8. What are your specific goals? Encourage your client to be as specific as possible in detailing the goal and how she is going to attain it. Fitness goals can be performance or health related or as simple as lifting more weight, losing fat, and exercising regularly. After goals are set, you can help put the plan into action.

9. How do you schedule and organize your day? Your client must take the steps necessary to "make it happen" (schedule exercise!) and adjust her plans when necessary. People who exercise in the morning are more likely to stick with their program. Regardless, the client must somehow schedule exercise into her day so that it gets done. She should view this commitment as an appointment she would not dare miss and should selfishly protect this sacred time. Written plans are more likely to be accomplished than good intentions, so I admonish my clients, "Don't just think it, ink it!"

10. Do you spend a reasonable effort exercising? My clients are used to hearing, "If you're going to spend the time exercising, why not maximize your fitness return?" Going through mindless motions is different than a sincere and concentrated effort. Developing this attitude will make the time the client spends exercising more productive and enjoyable.

11. Do you avoid missing workouts? I tell a delinquent client to "feel at least a twinge of guilt" when she lets her commitment to workouts slide. However, she should balance this with feeling comfortable about missing a few workouts when injury or sickness require it and to forget the past and get back on track as soon as possible.

12. Do you feel good after a workout? If your client doesn't feel a positive postexercise glow, it is not likely that she will continue. Being a little tired from a "champion" effort will help the client feel good, cast a wry smile, and bask in postexercise accomplishment!

Motivation to achieve a goal happens when the goal is meaningful and fits the individual. Once the client sets personal goals, break long-term goals, like losing 20 pounds or running a marathon 10 minutes faster than the client's previous best, into more manageable goals. These short-term challenges not only are more likely to be realistic but also allow the client to achieve one goal while keeping the next within attainable reach (mid-term). Emphasize the goal of progress, not perfection!

Scheduling Your Client's Workouts

Scheduling is critical to the success of your client's workout program. Scheduling means commitment, and commitment means success. Of course, a trainer writes a client's workout times in an appointment book, but so should a client write his workout in his appointment book and honor it as an important covenant. This commitment should be viewed no differently than the client meeting with his boss or prospective customer. It should not be easily erased, rescheduled, or canceled.

Over the many years that I have trained clients, the number one reason the majority of my clients train with me year after year, according to them, is because our relationship requires them to schedule and commit to an appointment. Sure, they like the fact that I motivate them, change their programs, give them new information, encourage them, and listen to them, but let me risk being repetitive by saying it again. The number one reason their programs are successful is because they engrave this commitment into their appointment books with indelible ink and rarely miss the opportunity to work out, feel better, and receive great results!

I tell my clients that their programs will result in success if they schedule their exercise commitment into their daily appointment book and value it as they would any other responsibility!

When is the best time to work out? Don't let this question throw you. Forget about metabolism, circadian and biological rhythms, and the body's daily ups and downs. Simply encourage your client to etch the time in stone when it best fits his personality (if he hates rising early, forget about scheduling early morning workouts) and other personal commitments. Have the client use the Weekly Workout Schedule Planning Sheet (figure 12.3) to schedule workouts. The client can transfer the schedule to his daily planning book or he can carry the planning sheet with him. Remember, the best time for your client to workout is the time at which he will get it done!

I often distribute the blank Weekly Workout Schedule Planning Sheet (form 12.2) to my clients so they can schedule their weekly exercise commitment, whether they're working out with me or on their own. This makes it easier for me to highlight appointments clients have scheduled with me and to delegate additional fitness responsibility (e.g., workouts on their own, keeping food diaries) to clients. Having clients schedule their own workouts seems to develop a higher level of accountability toward getting exercise done. Commitment that runs high and is generated from within (versus from the trainer only) appears to result from the client taking responsibility for his commitment to personal well-being.

Being Honest With Your Client

Well-known sports medicine expert Dr. Randy Eichner calls self-delusion the "most popular indoor sport" (Eichner 1993). What he's getting at is that most of us overestimate how much we exercise and underestimate how much we eat. Although weight maintenance and weight loss are very complex, for example, part of the reason that some obese people can't lose weight, according to Dr. Eichner, is because of self-delusion. (Even though you or your clients may not be obese, keep reading!) He refers to a sophisticated study reporting that in the failed diet group, subjects ate 1,000 calories more than they recorded in their diaries and burned 250 fewer calories than their exercise records indicated. Interestingly, this same pattern is seen in young, old, fat, or slim people (i.e., all of us!). Four out of five people believe that they eat less and exercise more than they actually do (Eichner 1993).

Regardless of stated and written client goals, results depend on what your client is doing, not what he believes he is doing or what he would like to accomplish! You and your clients need to set goals, reevaluate them, and track progress (chapter 14), and the client must commit to the action steps that make goal attainment possible.

10 Steps to Effective Program Design

"You mean you planned this for me?" exclaimed one of my clients when we began introducing variety into her workout by changing exercises and intensity of effort. Years ago, as a new trainer, I had wrongly assumed that clients understood my professional dedication and the time I invested in planning and periodizing their programs. In that moment I realized that many trainers do little to progress individual training programs. Her emphasis on "for me" magnified the importance of the words *individual, personal, commitment,* and *service,* which are the essence of personal training program design.

Whether or not you are an experienced personal trainer, you probably have questions about program design. It does not take long to realize that a one-size-fits-all program design does not work and that there is always something to be learned, especially in this information-dense era. Every individual has unique needs, interests, and responses to various activities and protocols. Although an understanding of exercise physiology and movement sciences is a prerequisite to creative exercise programming, personal trainers armed with only this information may still be puzzled about the practical solutions to their clients' individual needs.

I understand the challenge of building a bridge between the science and the individual. After training an average of 40 to 50 clients a week for nine years, I learned to blend the usable and practical aspect of theory into the reality of day-to-day personal training. To move from theory to application, plan quality programs using a step-by-step process.

Sample Weekly Workout Schedule Planning Sheet

Week of: _____ 6/10-6/16 _____

Monday	Tuesday	Wednesday	Thursday	Friday	Saturday	Sunday
With whom: Mary	With whom: John, my personal trainer	With whom: Mary	With whom: John, my personal trainer	With whom: Mary	With whom: Family	With whom: Family
Where: Meet at park	Where: Gym	Where: Meet at park	Where: Gym	Where: Meet at park	Where: Hike and soccer	Where: Rest day
A.M.	**A.M.**	**A.M.**	**A.M.**	**A.M.**	**A.M.**	**A.M.**
5:00	5:00	5:00	5:00	5:00	5:00	5:00
(6:00)	6:00	(6:00)	6:00	(6:00)	6:00	6:00
7:00	7:00	7:00	7:00	7:00	7:00	7:00
8:00	8:00	8:00	8:00	8:00	8:00	8:00
9:00	9:00	9:00	9:00	9:00	9:00	9:00
10:00	10:00	10:00	10:00	10:00	(10:00)	10:00
11:00	11:00	11:00	11:00	11:00	11:00	11:00
P.M.	**P.M.**	**P.M.**	**P.M.**	**P.M.**	**P.M.**	**P.M.**
12:00	12:00	12:00	12:00	12:00	12:00	12:00
1:00	1:00	1:00	1:00	1:00	1:00	1:00
2:00	2:00	2:00	2:00	2:00	2:00	2:00
3:00	3:00	3:00	3:00	3:00	3:00	3:00
4:00	4:00	4:00	4:00	4:00	(4:00)	4:00
5:00	5:00	5:00	5:00	5:00	5:00	5:00
6:00	(6:00)	6:00	(6:00)	6:00	6:00	6:00
7:00	7:00	7:00	7:00	7:00	7:00	7:00
8:00	8:00	8:00	8:00	8:00	8:00	8:00
9:00	9:00	9:00	9:00	9:00	9:00	9:00

FIGURE 12.3 Sample weekly workout schedule planning sheet.

FORM 12.2 Weekly Workout Schedule Planning Sheet

Week of: _____

Monday	Tuesday		Thursday	Friday	Saturday	Sunday
With whom:	With whom:	With whom:	With whom:	With whom:	With whom:	With whom:
Where:	Where:	Where:	Where:	Where:	Where:	Where:
A.M.	**A.M.**	**A.M.**	**A.M.**	**A.M.**	**A.M.**	**A.M.**
5:00	5:00	5:00	5:00	5:00	5:00	5:00
6:00	6:00	6:00	6:00	6:00	6:00	6:00
7:00	7:00	7:00	7:00	7:00	7:00	7:00
8:00	8:00	8:00	8:00	8:00	8:00	8:00
9:00	9:00	9:00	9:00	9:00	9:00	9:00
10:00	10:00	10:00	10:00	10:00	10:00	10:00
11:00	11:00	11:00	11:00	11:00	11:00	11:00
P.M.	**P.M.**	**P.M.**	**P.M.**	**P.M.**	**P.M.**	**P.M.**
12:00	12:00	12:00	12:00	12:00	12:00	12:00
1:00	1:00	1:00	1:00	1:00	1:00	1:00
2:00	2:00	2:00	2:00	2:00	2:00	2:00
3:00	3:00	3:00	3:00	3:00	3:00	3:00
4:00	4:00	4:00	4:00	4:00	4:00	4:00
5:00	5:00	5:00	5:00	5:00	5:00	5:00
6:00	6:00	6:00	6:00	6:00	6:00	6:00
7:00	7:00	7:00	7:00	7:00	7:00	7:00
8:00	8:00	8:00	8:00	8:00	8:00	8:00
9:00	9:00	9:00	9:00	9:00	9:00	9:00

Reprinted from D. Brooks 1999

From *The Complete Book of Personal Training,* by Douglas S. Brooks, 2004, Champaign, IL: Human Kinetics.

Many personal trainers and their clients do not understand the necessity and importance of a plan of action. Many clients assume (too often, correctly) that a personal training session involves little forethought and planning.

If you are retelling the same story day in and day out, not only will your clients fail to progress, but you will fail to create a sense of value regarding the long-term services you provide to your clients. Personal training must evolve beyond a flurry of unplanned activity. We need to create programs that change the perception of the consumer, who often believes that the only way to progress, add variety, or create freshness in a training program is to hire another personal trainer, followed by another and another!

By moving through each of these 10 steps with every client, I have a format that ensures each training program is built on a solid foundation of science while being customized to each client's individual needs. That way, clients can maintain motivation and trust in my skills, and I am confident that the program is safe, effective, and sufficiently multidimensional to keep them interested. You can use these same steps to help your clients achieve consistent results and to increase your clientele's perceived value of you.

Step 1: Information Gathering

The information-gathering process involves three steps (chapter 10).

The **medical history questionnaire** (appendix) asks questions that elicit information you need to identify medical concerns, your clients' personal understanding of basic fitness concepts, current and past fitness activities, goals and interests, and eating habits.

The **client interview** is an ongoing dialogue that takes your medical history questionnaire to a more personal level. For the program to be effective, you must consider the goals and preferences of your clients, understand how you can best communicate with them, and encourage feedback at every opportunity. Create a motivational environment where communication comes first and results in program compliance. How you interact with your clients greatly influences how they think about themselves and how they think about you.

Fitness testing is an optional motivational tool that many trainers use to define a starting point and to excite their clients about changes in their fitness over time (chapter 11).

Step 2: Balanced Physical Programming

Once the background and homework have been done (Step 1) and you understand the client's goals, physical programming for the majority of the population includes cardiorespiratory conditioning, muscular strength and endurance conditioning, flexibility training, and functional training. All of these key components of fitness must be addressed correctly to ensure a balanced approach to your client's health and fitness.

Within each component, you likewise balance fitness. For example, within the muscular strength and endurance component, all agonist and antagonist muscle pairs, such as the biceps and triceps, need to be challenged.

Balanced physical programming walks a fine line between listening to what your client is telling you that she wants and incorporating these interests into a program that also contains what she needs from a total wellness perspective. Explain to your client the importance of including all aspects of fitness.

Step 3: Cardiorespiratory Conditioning

Cardiorespiratory conditioning is attained by using activity that involves large-muscle, rhythmic, continuous movement that simultaneously increases heart rate and blood flow back to the heart. This type of conditioning can decrease risk factors associated with heart disease, can increase endurance and personal vitality, and can help with weight maintenance or loss. Use a variety of cardiorespiratory activities (walking, running, biking, swimming) to challenge the heart and lungs and to avoid overuse injury associated with unrelenting and repetitive motions performed day after day.

Step 4: Muscular Strength and Endurance Conditioning

Most of your clients should engage in strength training. Proper strength training can boost metabolism, help decrease fat mass or maintain

ideal weight, decrease the risk for osteoporosis, increase self-esteem, preserve personal physical independence, and increase strength, to name a few benefits.

Effective muscular strength and endurance conditioning depends on a progressive increase in resistance over time that challenges all of the movements to which muscles contribute. For balance, work all of the body's paired agonist and antagonist muscles.

Step 5: Flexibility Training

Flexibility is most simply defined as range of motion (ROM) available to a joint or joints. The concept of functional range of motion (FROM) expands this limited view. Healthy or desired flexibility is a capacity to move freely in every intended direction. The movement should be confined to a joint's FROM or intended movement capabilities. This is different from the joint's normal ROM because normal is not always healthy or adequate for individual movement pattern needs. The development of functional or usable flexibility entails challenging ROM in a manner that closely mimics daily or functional movement. Because flexibility is specific to each joint's musculature, design a program that stretches all areas of the body, especially those that often lack adequate flexibility.

Step 6: Active Rest

Regardless of fitness level, thread the concept of active rest throughout your clients' fitness routines. The active rest concept sequences exercises to help structure a workout that optimizes workout time and accommodates the client's fitness level. Typically, a large amount of time in traditional fitness programs involves recovery from work performed. There are several ways to minimize wasted recovery time or to eliminate it.

1. Use perceived exertion (RPE) and intervals (effort, recovery) to keep your client in motion during cardiorespiratory conditioning.

2. Sequence resistance training exercises so that they alternate from muscle group to muscle group or from upper to lower body to the trunk.

3. If a muscle group is targeted for consecutive multiple sets, use the recovery phase for some other type of physical training.

For clients who are looking for maximum results with minimum time investment, active rest is an excellent way to optimize their time.

Step 7: Cross-Training and Periodization

Now that the programming foundation is set, the fun continues as you change the program with cross-training (variety) and periodization (cycling intensity of effort over specific time periods). When you understand the concept of specific overload and its effect on the body's energy systems and the three major components of fitness (chapter 15), the world of programming choices becomes less confusing. Overload definitions reveal exactly what effect a certain intensity, duration, frequency, and type of activity will have on any component of fitness. This leads to productive and efficient activity that helps your clients attain program goals.

Some clients like change and some do not. Continued communication (the ongoing "interview") and feedback from your clients are essential concerning any program changes. Changing for the sake of variety, or because you (the trainer) need a change, is the wrong reason. Change is best implemented when your client is ready physiologically and psychologically.

Step 8: Special Needs for Healthy and High-Risk Populations

All of your clients have special concerns. You already have the knowledge (or soon will!) to balance fitness among cardiorespiratory, muscular strength and endurance, and flexibility components. You will need to consider issues such as exercise for performance versus fitness versus health; safe weight maintenance and loss; strength plateaus; and higher need situations that include pregnancy, diabetes, arthritis, asthma, and working with the older adult or youth. You may also need to address nutritional concerns and motivational and psychological needs. You will need to determine what style of communication works best with each client. Taking all of these issues into account will help you design a program that best matches each client.

Step 9: Success and Adherence

Encouraging the client's perception that he is successful is one of the most important aspects of program design. Four factors ensure exercise adherence and a successful business.

1. Time—keep most workouts around one hour, two to three times per week.
2. Variety and periodization—use cross-training when appropriate and cycle how hard the client works over specific periods of time.
3. Intrinsic motivation—both you and the client should know why he wants to exercise (ask him!).
4. Lifestyle changes—clients must like what they are doing to incorporate the new behavior into lifelong habits.

Many people do not want to exercise "hard." Most exercise to feel better and have more energy for daily living. As trainers, we need to step away from our own preferences and walk into the lives, and understand the thinking, of our clients. Most of our clients would not plan their exercise programs like we plan our own. Consider this thought seriously and you're on your way to designing effective and safe programs and developing workouts your clients will stick with over the long haul!

Step 10: The Reality Factor

I have worked with clients in a personal training situation for about 20 years and counting. I don't work out 50 to 70 clients per week anymore, but the "reality factor" is as evident today as it was years ago when I was working with clients from early in the morning to late at night. Many clients still do not perform perfect exercise technique. Some have not included all of the ideal components of a balanced fitness program in their daily schedule. Others have never linked their low-level cardiorespiratory segments into a continual effort. Most will never experience proprioceptive neuromuscular facilitation stretching in its true and intense form.

Although the majority of clients are not the perfect models of textbook programming, their individual improvement can be great and their lives can improve. Rather than create a program that your peers would approve of, attempt to optimize your client's involvement in fitness for a lifetime, with whatever techniques it takes.

Stay away from becoming a robotic trainer who uses one program for every client. Fitness programming is not a clear-cut issue. An effective program and business offer a smorgasbord of options that change as your client does.

Case Study: Program Design for "Real People"

Bob was evaluated as clinically obese and had the approval of his primary health care professional to begin an exercise program. His overfat state and my conversations with his doctor indicated that his cardiorespiratory conditioning was low, and there were orthopedic concerns related to his knees, hips, and low back. Yet, Bob was extremely strong and agile at 6 feet 4 inches and more than 350 pounds.

After gathering information on Bob, I believed it was imperative to focus on his goals and psychological makeup. (At a later date, I would let him know fitness testing was an option he could choose.) One of his long-term goals was to run 10K distances. Was it going to be possible? I didn't know.

Since his diagnostic stress test indicated no limitations with regard to exercising heart rate, the immediate concern was orthopedic. Bob was excited to begin his journey toward the 10K goal, so we started to develop baseline fitness by walking, walking inclines, recumbent stationary biking, stair and machine stepping, lateral slide training (careful here!), participating in a balanced strength program, functional balance training, and flexibility training. We did not initially focus on a host of "negative" issues such as diet or weight loss (Bob said he "had been there, done that"). Still, I made no promises.

My concerns as a trainer were the obvious goals of strengthening the joints and joint musculature and improving Bob's cardiorespiratory system. To these I attached a host of health-related issues, such as fat loss, decreased risk of heart disease, decreased blood pressure, improved lipid profile, decreased risk of orthopedic injury, decreased risk for type 2 diabetes, as well as a hope that Bob would become more connected to and accepting of who he was physically.

Bob, on the other hand, simply wanted to run.

Over a period of months we "shuffled" our way to a walk–jog. Bob soon complained of discomfort in the lower leg and foot. We immediately backed off. One day as we exited my studio to take a fast stride, I grabbed a small football. Bob fancied himself as a strong, fleet-footed athlete. My plan was to institute a form of interval conditioning by tossing the football back and forth. Bob would walk–shuffle–run a pass pattern, make the spectacular catch, and recover as I ran my requisite pattern.

The result: Bob's perceived exertion was a 10, his perceived fun was a 10, and he had no resultant orthopedic problems. He accomplished more total work during his time slot, became more fit, and burned more calories. This is certainly not your textbook program (and following the "rules" book would not have been successful with Bob), but it worked because Bob unknowingly sought fun and variety as the first two requirements for enjoying and sticking with fitness activities.

From day to day we used various cardiovascular options. Excellent choices included the recumbent stationary bike, stepping, treadmill, cross-country ski simulator, water fitness, and, of course, tossing the football as our personal favorite. We used recovery phases or steady-state (rate) workloads to discuss his current health questions and further optimize the training session.

Bob never did run a 10K or even a continuous 5K. But in his pursuit of the 10K he discovered something of more value—fun! Bob told me, "Fun and success are direct derivatives from a program that works with my psychological make-up and body, instead of against them." That is what training smart is all about! The pearls of wisdom that I derived from Bob, and continue to use with every one of my clients, include these:

- Listen to your client. It merits repeating: Listen!

- Pay attention to what your client wants, while simultaneously formulating a program that also encompasses his needs.

- Have your client listen closely to what his body is telling him.

- Encourage your client to tell you how he feels.

- Act on your client's personal feelings and perceptions.

- Lead your client to understand why he exercises by asking him to express his emotions and needs and to identify the activities that meet them.

The point, of course, is to flow with your client. My first reaction to Bob's request was that Bob would never run injury-free, which would have slammed the door shut on Bob's motivation. It was more effective to use that motivation and work toward his goal. Much of the success of a personal trainer is born in technical competency. However, you also need people skills, flexibility toward the approaches you use to solve each "client puzzle," and the ability to listen to and interpret your client's needs and desires. This case study is an example of what I refer to as reality in the day to day of personal training!

Fitness Programming That Fails to Deliver Results

Fitness programming that fails to deliver results is often a direct consequence of a poor understanding of applied physiology and biomechanics. We have to understand how the human body works and attain a high level of technical competence, which is expected for any profession.

Programming that fails is frequently a result of program design that is driven by consumer demands, fads, exercise trends based on little scientific substance, or traditional approaches that are less than optimum but have never been questioned. Often, little importance is given to the scientific backing of, for example, a particular strength training movement, proper use of a particular piece of exercise equipment, or a diet plan. Variety for the sake of variety becomes the fashion and the form with a bias toward introducing anything new or trendy. Little attention is given to whether the approach is in the client's best interest.

Choosing this type of programming philosophy will compromise your integrity and hamper

your client's program. Short-lived variety and current "fitness fashion" can lead to client injury, disillusionment, dropout, and, needless to say, a decline in your business. Consumer interests must be satisfied, but they can be done in an entertaining, reputable, and effective way.

Effective programming maintains a close interaction between science, yourself, and the client's needs. And it goes beyond activity for the sake of activity, encompassing broader ranging health and wellness issues. To create programming that delivers, keep these five points in mind:

1. Programming that meets the ongoing and changing needs of your clients is a dynamic process of personal interaction and versatile program choices.

2. Keep the client and her needs at the center of your training focus.

3. Continue to educate yourself and constantly ask why you are using a particular approach and how it benefits the client.

4. Implement programming ideas when you fully understand the concept and can communicate it to your client.

5. Keep and encourage open communication.

Program design is certainly a dynamic and ever-changing process. You must identify goals and know the individual client, and then you can plan the program. Armed with a solid scientific and philosophical basis for your decision making, you are on the road to creating the best exercise programming for your clients.

Promises, Promises, Promises

If you are going to go beyond meeting your clients' needs every day, a good general rule is to underpromise and overdeliver. I have followed this creed all of my professional life. I am direct and honest with my clients in respect to what I think can be accomplished within the constraints of a particular client's time commitment and personal makeup. I always err on the side of conservative estimates about goal accomplishment. If we go further than expected, my client is encouraged rather than discouraged by failure to attain an unrealistic goal.

Programming for Life

No program or exercise guideline should be written in stone. Err on the side of conservatism. Intensity is relative to the individual. You must know your client's physical limits and her perception of what is too much. Do not join the ranks of many trainers who create programs that are too hard for their clients. If your programs are too difficult, you might injure your clients and you surely will defeat them.

Program recommendations should be developed that reflect your clients' needs, goals, and abilities. A "sliding scale" allows you to individualize the amount of time, training frequency, and intensity of effort for each client. This flexible approach enhances the cardiorespiratory, muscular strength and endurance, and flexibility components of the program. For example, a particular client might need you to design a program that provides the proper amount of physical activity to attain maximal benefit at the lowest risk of injury, with minimal time investment, while taking into account the individuality of the client. Now you've created what I call the "sliding success scale," which, because of the individuality factor that is inherent to such an approach, will work well with all of your clients.

One of your goals as a personal trainer is to help your client maintain her newly acquired level of health and fitness throughout her lifetime. Maintaining, for example, fitness level and desired percentage of body fat indicates a client's happiness with her current self and state of health. This is a positive phase that you hope will last a lifetime.

Maintenance is not regression. Maintenance is the health or fitness level that allows the client to be comfortable and satisfied with the changes in her physical self and lifestyle. After any amount of sustained training (several months or more), a slowdown in training benefits is inevitable. Prepare your client in advance of this phenomenon so that she experiences it in a positive manner.

Depending on a client's willingness to commit more time or to exercise harder, a plateau in strength, cardiorespiratory fitness, or flexibility may or may not be permanent. Plateaus are an opportunity to reevaluate goals, set new ones, and find out where your client wants to

go with her exercise programming. A plateau is certainly not a time of doing nothing or a dead end. Instead, it may lead to further gains in fitness through a revised program.

At the very least, a successful program requires a continual effort on your part, and your client's, to sustain this desired level of health and fitness. Accomplish this by motivating your client to exercise regularly and with variety. At some point, maintenance of health and fitness will become the most rewarding and exciting result for your client!

CHAPTER 13

Periodization: A Model for Planned Results

It's hard to embrace a word that's difficult to pronounce and that many trainers do not fully understand. But periodization will give your client's training new life, and it's easy to implement.

A periodized program varies how hard, how much, and how often you train, and the types of activity you train with, over specific time periods. Periodization encourages you to introduce purposeful change and variety into your client's training program. Periodization is probably best and most simply defined as "planned results."

Most fitness articles mention, and most fitness professionals would agree, that periodization should be incorporated into every training program. Although there is quite a bit of information about periodization training for elite athletes, these programs are very technical, are highly specific, focus on "peaking" for athletic performance, and are often confusing because there is no one standard approach. Few formulas exist for trainers that explain how to incorporate a periodized program into their clients' fitness routines without investing hours of planning. Fortunately, when existing models of periodization for athletes are carefully studied, it's possible to identify common characteristics that you can use in mainstream fitness.

By manipulating volume of work (i.e., reps, sets, or duration of effort) and intensity of effort (as measured by resistance, weight lifted, speed, heart rate, or perceived exertion), and by strategically incorporating rest, maintenance, and recovery phases in the overall periodization plan, you can transfer complex concepts of periodization to fitness goals. These include weight management, increased muscle strength, improved cardiovascular fitness, and performance enhancement—improving, for example, your client's best 10K running time.

Periodization has the potential to do the following:

- Promote optimal response to the training stimulus or work effort
- Decrease the potential for overuse injuries
- Keep your clients fresh and progressing toward their ultimate training goals
- Optimize your clients' personal efforts
- Enhance client compliance

Principles of Periodization

Periodization is a method that helps you organize training. A periodized program cycles volume and intensity over specific time periods. Periodization can be viewed from two perspectives. One perspective is to use an activity or sport by itself to develop fitness or enhance health. A second approach uses the activity or sport, along with other nonspecific cross-training activities, to improve fitness or health while simultaneously progressing the client's training.

Considerable scientific research and experience show that the second system—using sport movement and supplementary training that includes a variety of cardiorespiratory, muscular strength and endurance, and flexibility conditioning—is far more effective than training with activity skills or sport alone (Bompa 1999; Fleck and Kraemer 1996; Siff and Verkhoshansky 1993). Regardless of which approach

is used, the underlying science is related to optimal stress or intensity and restoration or recovery. Of these key aspects—intensity and recovery—one is not better than the other. Each must be given equal emphasis and time.

From Athlete to Fitness Client

Periodization attempts to increase training results yet provides for adequate recovery while simultaneously preventing detraining or overtraining. When you use known physiological training principles such as progressive overload, progressive adaptation, and training effect, as well as what is known about maintaining fitness gains, avoiding overuse injuries, peaking for performance, and training for health gains, an identifiable formula for periodization emerges for fitness. When creating a periodized program, develop the following:

- Short-term microcycles, which focus on daily and weekly variation in volume, intensity, loading, and exercise selection
- Mid-term mesocycles, which usually begin with a high-volume phase and end with a high-intensity peaking phase
- Long-term macrocycle, which is generally composed of several mesocycles

Volume refers to repetitions, sets, minutes, distance, and duration. Intensity refers to load, force, weight lifted, and speed or it can be measured by heart rate response or perceived exertion.

For elite athletes, a microcycle typically lasts 5 to 10 days; a mesocycle lasts 1 to 4 months; and a macrocycle lasts 10 to 12 months. Three major phases of training are recognized during a year (macrocycle), and these same phases can be recognized within a several-month time period that I call a mini-macrocycle. For athletes, the phases generally include preparation, competition, and postcompetition.

The most obvious difference between elite athletes and most fitness participants is that the average fitness participant doesn't need to "peak" for performance. For the athlete, maximal performance generally coincides with important competitions (Bompa 1999; Fleck and Kraemer 1996; Siff and Verkhoshansky 1993).

Thus, the change from one phase of training to another will be subtler for fitness training than for the high-level athlete. For the average client, macrocycle phases translate to three phases: preparation or buildup, goal attainment, and recovery. Within the preparation or goal-attainment phases, specific energy and physiological system manipulations may be accomplished to attain goals that include muscle hypertrophy and increased oxygen uptake (improved cardiovascular fitness). For most active people who have achieved a desirable level of fitness, the goals may be to insert a variety of activity, solidify current fitness levels, and establish commitment to regular exercise.

Ongoing evaluation of the needs and goals of each client is a necessity, whether the individual is just starting an exercise program or has attained a good level of fitness. A well-planned periodized program looks at short-term, mid-term, and long-term needs of the client. Such a planning process considers the following:

- Daily workouts
- An agenda that accounts for three to four weeks of training
- An overall annual scheme, or at least a plan for several months

The essence of periodization is training with variety of activity; training with varied, progressive intensities; and training with at least three- to four-week mesocycles of progressive overload—always following a concentrated effort of progressive overload with at least several workouts of active recovery. Active recovery, or active rest, usually is performed at lower intensities of effort and duration than previous exercise levels. Also, you should consider using different activities, at least part of the time, for this recovery and restoration period.

When the client achieves planned results, you then determine the intensity of effort or load for the next phase. Generally, unless the client is entering into a restoration phase or ending a mesocycle of three to four weeks, the sequence of the preceding workouts is repeated at higher intensity levels. This cyclic process and your client's response will determine the contents and organization of the program.

Figure 13.1 illustrates a progressive overload pattern using active rest after each three- to

four-week mesocycle. Longer mesocycles, for example, four to eight weeks, can also be used, but I find the shorter cycles work well with the average participant's attention span and desire for change. The beginning of each new mesocycle should be started at a lower intensity than used in the last week of the previous mesocycle.

Periodization Model for Health and Fitness

For the average client, periodization means that workouts will be varied over set time periods to optimize performance and fitness gains. Follow these steps to plan a progressive, goal-oriented training program that achieves superb results.

Step 1: Set Goals
- Cardiorespiratory
- Muscular strength and endurance
- Flexibility
- Other

Step 2: Determine How to Achieve Goals
- Assess time availability.
- Identify types (mode) of activity.
- Match training to goals.
- Choose activities that your client likes.

Step 3: Identify Training Phases

Training Phases
- Develop 3- to 10-day short-term planning (microcycle).

- Develop at least a three- to four-week training plan (mesocycle).
- Develop a yearly organizational training plan (macrocycle) or at least three to four months of mesocycles.
- Plan a general preparation phase of three to four weeks (one mesocycle), which may repeat several times.

Exercise Plan
- Manipulate frequency, intensity, and duration of each activity for specific results in the body's energy and physiological systems.
- Apply appropriate frequency, intensity, and duration principles to each fitness component in the general preparation and goal phase.
- Control results by proper intensity of effort (load) and adequate recovery (restoration).

Step 4: Plan Volume and Intensity (Overload)
- Vary volume and overload on a cyclic basis.
- Significant change should generally occur every four to eight weeks and small changes are acceptable within a 3- to 10-day microcycle.
- Plan to increase or decrease volume and intensity.
- Use lower intensities and less duration during restoration (active rest).
- Start the new mesocycle after active recovery at a slightly lower intensity than the previous cycle.

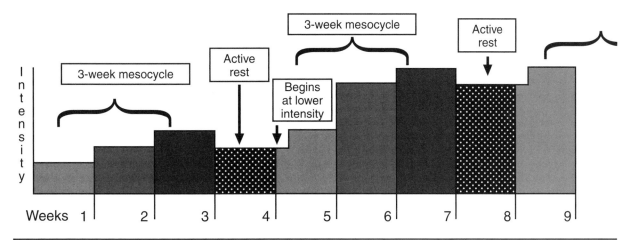

FIGURE 13.1 Applying periodization to fitness.

Reprinted from Gross, Kelly, Martinez Design 1996.

Recovery

- Generally, do not increase progressive overload for more than three to five continuous weeks.

- Follow any sustained, progressive overload of about three weeks with at least several days of active recovery activity at lower intensity. (The effort is less intense compared with the last overload phase in which the client participated.)

- After active recovery, start the new mesocycle at a slightly lower intensity than the previous cycle (see figure 13.1).

- Break up every three- to five-week progressive increase in overload (mesocycle) with active recovery at a lower intensity. The key to optimal results is not a steady, relentless increase in intensity over long periods of time.

Step 5: Regularly Evaluate the Periodization Planning Process

- Monitor results and progress.
- Use fitness assessment (optional).
- Recognize goal achievement.
- Maintain an ongoing dialogue with the client.
- Observe client compliance and enthusiasm toward the program.

Case Study: From Theory to Client Program

Let's apply the preceding principles to the program of a hypothetical client. Jenna is a new exerciser and her goals are weight loss, weight management, and increased energy level. Jenna understands that a long-term plan (macrocycle) will focus on fitness components that will help her realize her training goals.

1. Set goals. An optional first step in creating a periodized program is to assess Jenna's current fitness levels in categories related to her goals of weight loss, weight management, and increased energy. Fitness testing will establish a reference point for comparing fitness improvements over time. This is one way to evaluate the effectiveness of a planning program.

Jenna was interested in having a percent body fat analysis performed with skinfold calipers as well as a submaximal cardiorespiratory assessment.

2. Determine how to achieve goals. Improvements in cardiorespiratory fitness and muscular strength and endurance will help Jenna attain her goals. She understands the contribution of cardiorespiratory fitness to calorie burning and that if she becomes increasingly fit, she will be able to burn more calories and fat. She also will develop greater endurance, which could make her feel more energetic.

Strength training will enhance Jenna's feelings of personal power and control. Because gains in muscle strength increase muscle endurance, she will have more energy and strength at the end of the day. Also, increases in lean muscle mass will reshape her body and increase her resting metabolic rate, which will help her lose body fat and maintain her new, desirable weight.

Part of the solution to attaining goals is to create an environment where your client has a sense of ownership (a feeling that, "This is what I want to do!") and personal responsibility and an understanding of why a specific approach is being used. This feeling of ownership and responsibility can be realized only through communication and education.

After you talk about her goals, it becomes clear that Jenna wants to accomplish her objectives with a multi-activity approach.

3. Identify training phases. It is usually unrealistic to plan an entire year and expect typical clients to stick with the plan to its conclusion. Instead, stay focused on microcycles and mesocycles. This will save valuable time when one of life's events inevitably necessitates a major change in your client's training program or schedule.

Using a 3- to 10-day microcycle (a 7-day cycle works best with average clients because it is easier to track and usually includes two to three workouts), plan a menu of workouts that fits into this time frame. Extend the microcycle to a planned three- to four-week mesocycle, and next consider planning a mini-macrocycle of three to four months (long-term planning).

Because Jenna is new to fitness and her goals are set, her first microcycles will focus on a preparation phase that reflects the goals of increased overall endurance (energy) and weight management. Her program looks like this:

- A series of six or seven microcycles (about two months) emphasizing a basic, but progressive, resistance and cardiorespiratory program. This series of microcycles is equivalent to two mesocycles. (Each mesocycle is about four weeks in length.)

- After the first mesocycle (about four weeks), active rest should be used for about three to five workouts.

- A second mesocycle will emphasize continued, progressive increases in intensity. If Jenna is ready, exercise variety will be introduced within each fitness component.

4. Plan volume and intensity. After the preparation phase is well established (in about eight weeks), the third mesocycle begins and progresses to the goal phase. This cycle emphasizes a hypertrophy phase for strength and continued challenges in duration and intensity of effort for cardiorespiratory conditioning. For example, Jenna may have progressed from a 12- to 20-repetition overload to fatigue to an 8- to 12-repetition overload to fatigue. Because the first two mesocycles built the base of aerobic endurance, the third mesocycle will incorporate intervals, and intensity, duration, and frequency will be manipulated.

The goal of these specific time periods is to provide an overload that is challenging, progressive, and appropriate to Jenna's new fitness gains. Micro- and mesocycles also provide for goal attainment that is reasonable and attainable in short time frames. Short-term accomplishment keeps the participant motivated, compliant, and physically fresh.

After the completion of this third mesocycle, active rest will be used, including a variety of cross-training activities. Jenna will experience different cardiovascular conditioning activities, change strength exercises, or switch to entirely different (nonrelated) activity during this active recovery.

Remember, active recovery is performed at lower intensities of effort (and usually with less quantity or duration) than in previous micro- or mesocycle time periods. Active recovery allows for physical recovery and enhancement of the adaptation process. This "unloading" phase is critical to optimizing results and minimizing injury potential. Effort is 50 percent of the training equation, and recovery is the other half!

5. Evaluate the program. Jenna's goals, results, interest, and enthusiasm cannot be assessed too often. This keeps an open and fresh communication about Jenna's needs and wants and continues to ask, "Where should we, as a team, go from here?"

Implementing Periodized Fitness

The key to successful periodization is the ability to create challenges to the body with new activities and progressive overload (intensity). If your client's body is constantly challenged, it will keep responding, her mind will stay inspired, and her risk of overuse injury will decrease. Just as her body experiences the peak benefits of one mesocycle of planned workouts and starts to adapt to it, she moves into a new four-week cycle that offers an entirely new set of challenges.

Management and organization of a client's program involve your awareness of what drives the client's motivation and personality. Within a 24-hour period, a person's perceptions of his or her fatigue, strength, and motivation may vary, so it is helpful to be aware of influences on your client that will challenge you to adapt planning.

You can track a periodization program in several ways. One low-tech idea is to label a manila folder with each mesocycle and keep the client's workout card in the file. You may have four manila file folders inside one hanging file for each client. You can organize the same system on your computer by creating a file for each mesocycle and placing programs in it. The periodization planning worksheet is a model that you may want to follow as you develop your own record-keeping system (see figure 13.2). Also, consider using the software recommended in chapter 6 or at the end of this chapter to streamline your record keeping and minimize lost time.

A comprehensive, accurate planning process will draw heavily on your practical experience and knowledge of the scientific theory behind training. Periodization, planning, and program organization are not inherently complex. However, planning does require some forethought and time investment. On the other hand, it is well worth that investment, because periodization makes both the trainer and client accountable for results. Because the process involves management, planning, and organization, it is results oriented. Because of this, everybody wins!

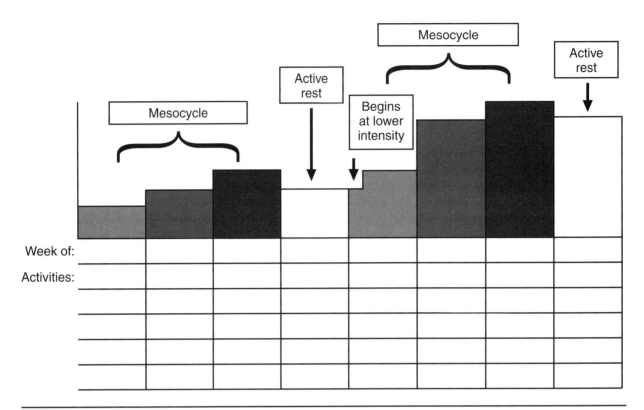

FIGURE 13.2 Periodization planning worksheet.

Reprinted from D. Brooks 1999.

Practical Application of Periodization Principles

For fitness results, client compliance, and variety, periodization works. Let's recap the process. Determine the client's goals, identify the training phases, and include recovery time. Training phases include short microcycles, month-long mesocycles, and annual macrocycles. Manipulate volume and intensity within the cycles, changing one element at a time. Keep careful records to maintain the cycling as well as to enable you to evaluate program results.

See chapter 18 for progressive cardiovascular training and walking–running programs and chapter 19 for two sample periodized strength training programs.

Avoiding Overtraining by Including Rest and Recovery

One planning consideration related to periodization is equal parts of recovery and intensity or stress. A basic principle of training is to stress, or overload, the physiological systems. Positive, although stressful, overloads cause the body to respond with, for example, increases in strength, muscular endurance, or cardiorespiratory capacity.

The basic training principle of using progressive increases in overload or intensity carries a risk of overtraining. Overtraining is a combination of stress that is experienced through work, home, social interactions, and training load. It can lead to staleness, exhaustion, and injury. You must avoid overtraining the client by first placing work and recovery cycles into the plan and then altering the training program when it becomes apparent the client is overtrained or at risk of becoming overtrained.

Susceptibility to overtraining can result from a lethal combination of a zealous, hard-driving trainer and a client who is extremely motivated. When a client attempts to perform his best during every training session and is motivated to extend this effort by a well-meaning trainer, you invite injury or emotional burnout. Nothing will shut down the training process and compliance more quickly than this scenario. It

also can cause a trainer to lose the confidence of the client, possibly losing the client or making him hesitant to refer other individuals.

The underlying causes of overtraining or staleness (mental and physical) are a combination of emotional and physical factors. Hans Selye (1978), in his book, *The Stress of Life*, noted that a breakdown in tolerance of stress can occur as often from a sudden increase in anxiety as from an increase in physical distress. The emotional demands of life, family pressures, a personal desire to excel at every undertaking, and the expectations of significant others can be sources of intolerable emotional stress. In addition to the stress of exercise and training, environmental factors such as heat stress and improper nutrition also may lead to overtraining symptoms.

When planning programs, consider the total stress your clients are under. For example, during tax season an accountant may be more susceptible to overtraining. Designing a training regimen that provides the level of stress needed for optimal physiological improvement without exceeding your client's tolerance is a difficult task. Much like heart disease, which develops insidiously, overtraining exhibits no preliminary symptoms to warn you that your clients are approaching becoming overtrained. By the time you realize that you have pushed clients too hard, the damage is already done.

Identifying Overtraining

Although the symptoms of overtraining may vary greatly from one individual to another, the most common are feelings of heaviness and the inability to perform well and concentrate (see the box below for additional symptoms). Working out is no longer a joy. It has turned into a struggle. If you believe this situation exists, it is time to make some immediate changes in the program. Do not hesitate to ask your clients how they feel and to encourage honest discussion.

Overtraining Warning Signs

Health Signs

- Elevated resting heart rate, blood pressure, or both
- Generalized body aches and pain
- Head colds (especially if chronic), allergic reactions, or both
- Body weight loss with decreased appetite
- Occasional nausea

Life Signs

- Personal problems; increased tension, anger, and irritability
- No interest in activities they usually enjoy
- Sleep disturbances (loss of sleep)

Training Signs

- Loss of motivation to train, or staleness
- Cutting sessions short: "An hour seems too long!"
- Performance decrements
- Unusual muscle soreness and tenderness after training
- Fatigue that lingers during workout and through the day
- Longer time required for recovery immediately after the workout

Idiosyncratic personality variables, as well as mood swings, can be distinguished from overtraining by simply expressing your observations to your client. Also, day-to-day variations in the sensations of fatigue should not be confused with overtraining. It is okay for your client to feel tired or challenged from a workout, and it is not uncommon to feel "heavy" after a day of hard training. These are often short-lived sensations that dissipate before the next training session. Coupled with rest or a light day of training after the hard session and proper nutrition, these symptoms are usually relieved. By keeping track of these general indicators and erring on the side of caution, you can prevent most cases of overtraining.

If you're a veteran trainer reading the overtraining warning signs, I imagine that a smile is spreading across your face! Head colds, general body aches and pains, personal problems, and loss of motivation are often challenges that you deal with every day with certain clients. It might even lead you to the tongue-in-cheek conclusion that your client is in a perpetual state of overtraining! All joking aside, signs of overtraining warrant a sincere and objective investigation.

Physiological Indicators of Overtraining

In an effort to objectively diagnose overtraining, several researchers have used various physiological measurements. Examples include measurements of blood enzymes, resting levels of blood lactate, observation of muscle damage, white blood cell count, alterations in blood plasma, and study of electrocardiograph (ECG) tracings. Despite these various attempts to objectively diagnose overtraining, no single physiological measurement has proved 100 percent causative. In a practical sense, these variables would be of no use to you anyway, because most trainers do not have access to sophisticated testing.

It is not surprising that overtraining has a dramatic effect on the energy demands for a given submaximal exercise bout (Wilmore and Costill 1994). When your client shows symptoms of overtraining, you will find that her heart rate for a given effort is significantly higher and, often, oxygen cost of the activity is

greater. For instance, if your client's heart rate (HR) for a workload of 5 miles per hour on a treadmill is normally 135 beats per minute, this same level of effort might increase to 145 beats per minute if your client was approaching, or already in a state of, being overtrained.

The reasons for the increase in HR are not totally clear. Your client is not losing her aerobic fitness, but her skill, form, and efficiency may be deteriorating. This means she is less efficient mechanically and physiologically, which translates to increased heart rates and energy expenditure for given workloads compared with a trained state where overtraining has not occurred.

The best and most practical way for personal trainers to monitor overtraining is by observing heart response during rest or during activity.

Using resting heart rate as an indicator of overtraining. If your client's resting heart rate (RHR) is 10 percent above normal, it indicates she may be overtrained. (Normal resting heart rate should be determined when the client isn't feeling exhausted, sick, or overtrained.) Although your client may claim she is feeling fine, it's a good idea to pay close attention to nutrition and hydration and switch to more moderate or recovery-type workouts. If resting heart rate is 20 percent above normal, your client should take the day off, drastically cut back on the workout, or change the focus of the workout, for instance, from anaerobic interval emphasis to stretching. In this case, the client will probably tell you "something is off" or that she is not feeling "just right" or "top notch."

Using exercise heart rate as an indicator of overtraining. To use heart rate during activity as an indicator of overtraining, follow three steps:

1. Record your client's HR at a fixed pace and load, on any piece of cardiovascular equipment at the onset of training, or before a new phase in your client's program. This is called the untrained heart rate response (UT).

2. Record your client's HR at the same given pace and load and on the same piece of equipment anytime after significant and progressive training. This is called the trained heart rate response (TR).

3. Record your client's HR at the same fixed pace and overload and on the same piece of

equipment during any period when she demonstrates symptoms of being overtrained. This is called the overtrained heart rate response (OT).

When you compare these HR measurements, you will usually find the UT heart rate to be highest, followed by the OT and finally TR. These results would indicate that TR was most efficient for the given pace and overload on a particular piece of equipment. The OT was higher than the TR because of overtraining but was still lower or more efficient than UT. By using heart rate response to given workloads, you can objectively monitor the direction of training so that it remains beneficial. Such data and observations may provide a warning signal for overtraining. Whenever you record a client's heart rate that is 5 to 10 percent higher than her TR, it's time to evaluate your client's status. She's at risk for overtraining.

Overtraining: Prevention Wins Over Recovery

If you suspect overtraining, encourage your client to take a day off from training, introduce variety (cross-train), or at least cut back in volume and intensity of overload.

As mentioned, if your client's RHR is 20 percent above normal, encourage her to avoid training that day or significantly alter the planned workout. As mentioned, an emphasis on stretch and relaxation may be appropriate.

It appears that the intensity (e.g., speed of running or amount of weight lifted) is potentially more stressful than volume of training (reps, more days, duration of each session). However, excess in either intensity or volume, or simultaneous increases in intensity and volume, may lead to overuse injuries and overtraining.

Prevention is always preferable to attempting to remedy the psychological and physiological state of an overtrained or injured client. An excellent way to minimize the risk of overstressing is to follow cyclic (periodization) training procedures. Periodization fosters results and prevents overtraining because it alternates easy, moderate, and harder periods of training over specific time periods. As a general rule, one or two days of hard training should be followed by an equal number of easy days.

The importance of variety, cross-training, active recovery, and actual days of rest for the mind and body cannot be overemphasized. Simply by using a different activity and a different exercise stress, your clients will likely respond positively to the workout challenges. The optimal adaptive response often occurs when the training you present is mixed with new activities and recovery.

Avoiding Overtraining With Sensible Progression

An easy way to discourage or hurt your client is by piling on too much, too soon. Keep the following points in mind when planning your clients' workouts to avoid falling into this trap:

1. Allow about two weeks to let your client get used to any increase in level of effort before making the workout any harder or longer. This is especially true for those clients just starting to work out.

2. Do not progress to harder workouts if your client reports any extreme soreness or stiffness or lingering fatigue.

3. When increasing amount of weight lifted or duration of cardiovascular efforts, do not increase by more than about 5 percent.

4. Sensible progression cannot occur too slowly. Your client's commitment to exercise should be for a lifetime. Patience is the rule if you want to avoid causing injury and discomfort to your client during exercise.

Recovery From Overtraining

Relief from overtraining usually comes from a significant reduction in training intensity, a change of activity, or complete rest. Many coaches and trainers generally suggest a few days of easy training using the same activity. Many experts, to the contrary, observe that participants recover faster when they rest completely or engage in some other form of very low intensity exercise. If you suspect overtraining, have the client take a day off from training, introduce variety (cross-train), or at least cut back in how long and how hard he works out.

Have the client record in an exercise diary how he feels during and after his workouts ("journaling"). A quick look back at previous workouts will help you monitor heart rate, weight lifted (i.e., performance), and how the client felt. For instance, if his heart rate was 10 beats higher for his usual three-mile run and his legs "felt like lead," this indicates your client could be spiraling into an overtrained state.

Overtraining, once known only in the athlete's arena, is being seen more often with well-intentioned, committed exercisers who ignore the obvious warning signs and symptoms. If a client always feels sluggish, is not eating, is sleeping poorly, feels depressed, feels like she's got the weight of the world on her shoulders (everything is work and a big effort!), is wrung out, is worn out, and experiences negative moods, the solution is simple: Have her take some time off!

Knowing When to Quit

You will rarely hear me utter the word "quit." But, there is a time and place, as any card player would tell you, to "know when to fold them." Should your client become injured or even if you think the possibility exists as a result of overtraining, you should encourage the client to contact her doctor. This professional can help you and the client distinguish between normal postexercise discomfort and pain related to injury. You need to prevent further injury (stop and seek counsel) and get your client back on track with her exercise program as soon as possible after an injury. But first she must heal.

The following "levels of pain" and practical pointers can help you make the right decision with regard to having your client continue exercise or contact her doctor.

Level 1: Pain that is present after your client finished exercising but goes away that same day

Level 2: Pain that starts during exercise but isn't so bad that the client can't keep going or persevere with extreme discomfort

Level 3: Pain that starts during exercise but really limits what the client can do and eventually keeps the client from continuing

Level 4: Pain that continues even when the client is not exercising and the client is constantly "reminded" of the problem with even the slightest physical activity (Kibler 1997).

Although you should not attempt to play doctor (if you have any doubts or concerns, always contact your client's doctor), Levels 1 and 2 usually can be countered with ice application, a reduction in exercise duration and intensity, gentle stretching, and over-the-counter analgesics (e.g., ibuprofen found in Advil and Nuprin). Ibuprofen effectively fights pain and inflammation, whereas products containing acetaminophen, like Tylenol, can reduce or eliminate pain but have no anti-inflammatory action. Often, the key to reducing the effects of injury is to limit swelling. Using ice, elevating the injured body part, and taking anti-inflammatory medicine can be highly effective.

The key is not to exacerbate the situation by being too aggressive with your client's workouts or ignoring obvious pain signals. If the pain and discomfort become great enough, they are often "self-limiting." In other words, if your client has any common sense left and is "listening" to her body, she will take the sensible approach and stop. She may need your encouragement to do so! If your client is experiencing the symptoms associated with pain levels 3 or 4, she should seek medical advice from a qualified health care professional.

Last Words on Overtraining

Don't let exercise become a negative addiction that keeps a client from listening to his or her body. Help your clients to know when to pull back. Familiarize yourself with this chapter. If you think any of your clients are approaching the brink of overtraining, make the right changes in their workout plans. If you suspect the possibility of an injury that may have resulted from the training program (overtraining or other), make sure the client contacts his doctor. Staleness or injury from overtraining can have serious consequences with regard to your clients' physical and mental health.

Software Resources

Two useful software programs can help you measure fitness and assist with program planning and periodization. Programs that I use and find extremely helpful are BSDI's *Fitness Analyst*™—Personal Trainer Edition (Web site: www.BSDIFitness.com) and Summit's, *Personal Trainer Assist*™ (Web site: www.the-summit.co.uk).

Periodization: Suggested Reading

If you'd like to read more than the works cited in this chapter, check out the following:

Bompa, T. 1983. *Theory and Methodology of Training.* Dubuque, IA: Kendall/Hunt.

Metveyev, L. 198 1. *Fundamentals of Sports Training.* Moscow: Progress.

Ozolin, N. 1971. *The Athlete's Training System for Competition.* Moscow: Fizkultura i Sport Publication.

Vorobyev, A. 1978. *A Textbook on Weight Lifting.* Budapest: International Weightlifting Federation.

CHAPTER 14

Track Your Client's Progress

It's too easy for your clients to get bogged down with what they have not accomplished (that's what long-term goals are for; refer to chapter 12). John Wooden, the legendary UCLA basketball coach, said, "Don't let what you cannot do interfere with what you can do." Encourage your clients to focus on the positive, what they can do and have done. Applaud their progress when you compare how far they have come with where they started.

Knowing Where Your Client Has Been, Where She Is, and Where She Wants to Go

If you want to create a program that is goal and results oriented, you need to know where your client has been (chapter 10), where she is (chapter 11), and where she'd like to go (chapter 12). If you use the information in chapters 10 through 12, you can record a starting point from which to compare your client's fitness improvements over time. But, remember this documentation is only a starting point. You need to continually keep track of the client's progress by periodically reassessing her fitness level. Results depend on what the client is achieving—not what you or she thinks she is doing.

Reassessing Your Client's Fitness Level

Ongoing reassessment is essential if you are to objectively measure your client's progress. This regular checkup of the fitness program you have planned for your client holds you accountable for making changes that are needed and for giving your client a pat on the back for a job well done! Tracking and evaluating the client's progress will help her achieve her goals and keep her workouts focused and on target.

Knowing When to Test and Retest

Although it may be appropriate to initially test your client when starting her program, you may also want to create a foundation of conditioning first (see chapter 11). Regardless of when you first administer any type of assessment, retesting six to eight weeks after the initial tests makes sense because you'll likely see great improvements if your client is working out regularly, eating right, and following a progressive, well-planned program. These significant "before and after" improvements will further motivate your client. Testing again at six months, at one year, and at least once a year thereafter is a reasonable plan to follow. If you want to test more frequently, do so.

Tracking Your Client's Progress

The results of your client's tests can be recorded on the various sheets located in chapter 11. Keeping track of your client's results allows you and the client to see how much he has improved between test dates. These tests will also tell you, the trainer, whether your exercise programs and eating plans are working!

Most test results, unfortunately, are filed away to collect dust, never to be revisited. Don't let this happen! Your client's results can illuminate the areas of fitness in which he needs to improve and simultaneously motivate him to keep progressing. Realize that if your client is new to training, during the first three to six

months of training he'll probably see outstanding improvement. After this time period, results will come at a less dramatic pace, but steadily. Explaining this fact about training improvements will keep the client—whether a veteran or a beginning exerciser—from developing unrealistic expectations. Not only is testing a smart approach toward optimizing training results, but it can also be highly motivating if correctly used and if the procedures are individualized to each client.

Using Performance Graphs

Performance graphs are an excellent tool to give you an overall picture of the direction your client's training is headed. Over the first three to four weeks, these graphs generally should show a steady increase in training load, followed by a plateau or dip, followed by another steady increase that lasts about three to four weeks. This increase, followed by a leveling or slight dip, reflects a program that is properly periodized and allows for both hard training and recovery, which ultimately results in optimal training (refer to chapter 13).

The performance graph has both a vertical and a horizontal axis or line. The vertical line represents your client's performance whereas the horizontal axis indicates time. The performance graph could be created by using past and current body fat measurements, strength tests, cardiovascular tests, or amount of weight being lifted for a particular strength exercise. As your client gets more fit, his body weight and heart rate will decrease, resulting in a graph that starts high and ends low, whereas strength tests and amount of weight lifted will start low and end higher.

One of my clients' favorite results to record on the performance graph (figures 14.1 and 14.2) is "personal percent improvement," which you learned how to calculate in chapter 11. These few examples should show you how easy it is to create a bar graph or "performance line" for almost any fitness-related task in which your clients participate.

Note that the horizontal line of the performance graph represents time, and generally it is easiest to record improvement by weeks and months.

Two software programs that I use and find extremely helpful to record and chart client progress—both also incorporate a variety of charts and graphs—are BSDI's *Fitness Analyst*™—Personal Trainer Edition (Web site: www.BSDIFitness.com) and Summit's *Personal Trainer Assist*™ (Web site: www.the-summit.co.uk).

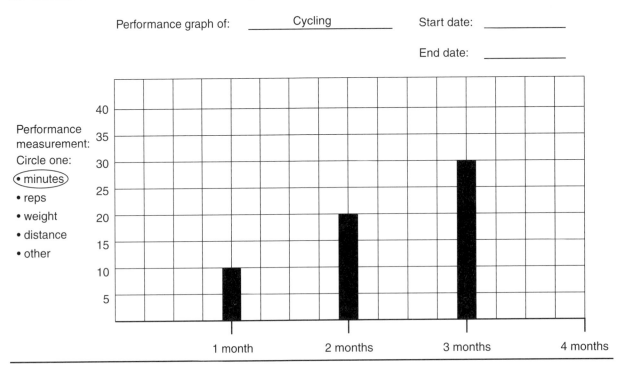

FIGURE 14.1 Sample performance graph.

Reprinted from D. Brooks 1999.

FIGURE 14.2 Blank performance graph.
Reprinted from D. Brooks 1999.

Using the "Week-at-a-Glance" Workout Log

Let's say you want to detail and record your client's workouts, yet you also want to streamline your record-keeping process. A "week-at-a-glance" workout log (figure 14.3 and form 14.1) will keep you and your client in touch and accountable to one another for workout planning (trainer's job with client input) and execution (trainer and client's job). Whether you use computers and software to keep track of workouts or manually track the progress, journaling your client's workout efforts is essential.

It takes you or your client only a few minutes to enter goals, resting pulse (the client should take it each morning), type of workout, distances, and intensity at which the client will train and to provide an overall comment about the client's general postworkout feeling and perceptions. I find it very productive to do this type of planning with my clients.

Calculating Percent Improvement

You can use two approaches to quantify your client's fitness assessment and testing results:

comparing your client's test results to the results of others who have taken the test, and calculating your client's personal percent improvement. Norms are a double-edged sword that can motivate or discourage, depending on how the scale rates your client's performance. By calculating personal percent improvement, you compare your client's assessment results only to her starting point and subsequent tests. In my opinion, any improvement, regardless of starting point, is positive. Refer to chapter 11 for a complete discussion and to learn how to calculate personal percent improvement.

Detraining and the Psychology Behind Maintaining Progress

How do you keep your clients progressing? Track their progress and empower them with knowledge! Nothing is more discouraging to a client than believing she is about to lose all of her hard-won fitness and health gains. You can thwart unnecessary concern or frustration about detraining (losing one's training results) through common sense and facts.

What happens if your client travels for extended periods of time, gets sick, or needs

Sample Week-at-a-Glance Workout Log

Goal	Day	A.M. pulse	Workout description	Cardio* distance/time	Comments
Moderate cardio workout	Mon	60	Easy run, light stretching after the run, abdominal and back strength exercises	50 minutes	Starting to feel tired; needed an easy workout
Full body strength workout	Tue	65	6-8 reps today, per set, target all of the muscle groups	35 minutes	Cut my workout short; body feels heavy
Interval workout	Wed	68	Canceled workout; just not feeling good	N/A	I need a rest!
Light stationary bike and strength workout	Thu	62	45 minutes on bike; some easy speed play; full body strength workout using 12-15 reps to fatigue	45 minutes on bike plus 30 minutes strength time	Rest felt great; body's starting to respond again; training is fun! Glad I changed my workout plans.
Rest	Fri	62	Complete rest/ recovery	N/A	Feeling good, but I want to keep in my planned rest day.
Long run	Sat	59	90-minute run with easy intervals (20-second pickups followed by easy recovery); 20-minute stretch	90 minutes plus stretch time	Stretch felt great, needed that! Back on track, run felt easy and comfortable.
Family time	Sun	61	2-3 hour hike with light pack, moderate pace	about 3 hours	Nice!! Will do 3 hard strength workouts next week.

*Detail your strength workout on the record-keeping sheet found in chapter 19 called Week-at-a-Glance Strength Workout Log.

FIGURE 14.3 Sample week-at-a-glance log.

Reprinted from D. Brooks 1999.

Goal	Day	A.M. pulse	Workout description	Cardio* distance/time	Comments
	Mon				
	Tue				
	Wed				
	Thu				
	Fri				
	Sat				
	Sun				

*Detail your strength workout on the record-keeping sheet found in chapter 19 called Week-at-a-Glance Strength Workout Log

Reprinted from D. Brooks 1999.

From *The Complete Book of Personal Training,* by Douglas S. Brooks, 2004, Champaign, IL: Human Kinetics.

some time off because she's overtrained? If the client takes a few days of planned rest, will her training results quickly go down the drain? Clients constantly ask me, "What is the most efficient way to keep fit?" and "Is there a way to maintain my gains in fitness when I don't have the time to work out the way I'd like to?"

Most of my clients want to know how easily they can lose, or regain, their hard-won training benefits. It is true that you can't store exercise, and detraining starts to occur fairly rapidly once exercise participation stops.

The positive side is that fitness gains may not be lost as quickly as most clients might think, although they would swear to the contrary. Additional good news is that it may take less exercise than a client believes necessary to maintain fitness levels. A philosophy I like to instill in my clients is, "Why lose fitness when it's so easy to keep?"

It has been well established that the effects of physical training are indeed transient and reversible if regular training is not possible. On the other hand, recent studies (reported in Bompa 1999 and Brooks 1997a) have made it clear that a few days of rest, or a reduction in training, will not negatively affect training performance—and may even enhance it. This is especially true for highly trained athletes or very fit clients who train aggressively, and it is probably related to the importance of recovery in optimizing the adaptation response and avoiding overtraining.

Maintaining Cardiovascular Fitness

The heart is not unlike other muscles in the body. If it is not conditioned by large-muscle, rhythmic activity that simultaneously increases heart rate and directs a large volume of blood back to the heart, it becomes deconditioned and less efficient at delivering blood and oxygen. A lack of regular endurance training can significantly compromise the cardiovascular system.

It is interesting that in one study (21 days of complete bed rest reported by Brooks 1997a), untrained subjects experienced a smaller decrease in $\dot{V}O_2$max than trained subjects and regained their initial fitness levels in less time. In fact, it took only 10 days of reconditioning for the

untrained versus 40 days for trained subjects to return to their previous fitness level. This demonstrates that a highly trained athlete (or dedicated fitness enthusiast) has more to lose in terms of fitness and takes significantly longer to regain peak performance and conditioning levels.

This observation has implications for sports conditioning specificity if you have a client who competes to win. She needs a year-round, periodized training program that includes maintenance phases so significant levels of fitness are not lost.

The heart strengthens itself in proportion to the force it must contract against. Because of this, periods of inactivity lead to substantial cardiovascular deconditioning. But, even limited activity (note that the study mentioned in the previous paragraph used complete bed rest) provides considerable conditioning for the heart. Day-to-day activity provides some maintenance of key cardiovascular functions because the heart must contract forcefully enough to circulate the blood against the demands of gravity. There is a significant difference between complete inactivity (bed rest) and cessation of training because of travel or sickness that occurs while your client can still participate in her normal daily routine. Minimal activity—whether formal workout or simply being busy with daily routine—helps the client maintain fitness gains.

Minimum Quantities of Cardiovascular Exercise

To follow are the optimal frequency, duration, and level of exercise intensity required to maintain aerobic improvements attained through training.

Early studies found that cardiovascular fitness was maintained by exercising three times per week. Significant losses in endurance conditioning were observed in subjects when they exercised only once or twice per week. Duration and intensity were held constant.

The key variable that was identified in more recent research, in regard to a maintenance effect on cardiovascular fitness, was the degree of effort, or intensity. In this landmark study (reported by Brooks 1997a), as little as one third reduction in intensity significantly decreased $\dot{V}O_2$max.

Intensity of training is the primary factor in maintaining the trained state. To maintain car-

diovascular fitness generally requires at least three training sessions per week at a training intensity of at least 70 percent of $\dot{V}O_2$max or heart rate reserve (HRR).

Health or Performance?

The results of these studies (reported in Brooks 1997a) should not be interpreted to mean that exercise performed less than three times per week at less than 70 percent of HRR is not valuable. Health gains can be realized with much less exercise and lower intensities. Furthermore, health gains do not necessarily require an increase in $\dot{V}O_2$max. Other variables can contribute to health improvement that are the result of moderate cardiovascular training and include increased cardiovascular endurance (working at a higher percentage of your maximum), weight loss, and decreased risk for heart disease.

Information like this can easily be applied to your client's current fitness status. Everyone has a percentage of $\dot{V}O_2$max that corresponds to a steady rate (easy pace) or lower at which he can easily exercise. A deconditioned person might be able to barely sustain a two- to three-mile-per-hour (20-30 minute-per-mile) walk. A highly conditioned individual might be able to sustain a 10-mile-per-hour (six-minute-per-mile) running pace. Regardless of fitness level, if either of these specific intensities is reduced by about one third or greater, aerobic conditioning will decrease. However, if intensity is kept constant and frequency and duration are reduced by no more than two thirds, any physiological adaptations or health and fitness gains realized will probably be maintained (Brooks 1997a). Put another way, if previous exercise intensity is maintained during a period of less training, regardless of your client's current fitness level, the frequency (how often) and duration (how much) of physical activity required to maintain this specific level of aerobic fitness are less than that required to improve it.

Here's the application perspective that will help to keep your clients motivated. If a client, for example, is vacationing, recreating, or on business travel for about 10 days, and he is normally active or involved in some type of regular training, a decrease in his normal routine will have little impact on overall health and fitness. It is very encouraging for a client to know that most cardiovascular training benefits can be kept by maintaining current level of effort while simultaneously reducing frequency and duration of effort by as much as two thirds.

When Less Is Better

Many athletes and fitness enthusiasts would be better off using less time and more effort. This idea is supported by Dr. Robert Hickson, who completed a series of three studies (referred to previously, Brooks 1997a) that led him (Hickson) to conclude that once you've attained a high level of fitness, maintenance of these newly won gains requires less time.

The argument for less is relevant to both health-oriented clients and athletes with regard to (1) increased performance, (2) the same or possibly less time commitment, (3) a reduced risk of injury from overtraining, and (4) less chance of personal burnout. Your client may be training as often as ever and notice that fitness gains, or performance, are falling off. Of course, as the client's fitness improves, fitness gains are harder to come by. At some point the client may wonder why he should keep working out so much if the effort isn't culminating in results and the drudgery of the effort is taking its toll.

Many top-ranked athletes and their coaches are putting the concept of less into action and drastically cutting back on training time. Guess what? Training results can improve drastically. Some initial gains might be attributed to rest and recovery, which allow for positive training adaptations to take place in response to the hard efforts. But, what kept the gains coming was another "secret" ingredient—intensity of effort!

Your clients can maintain any level of fitness with reduced duration and frequency if intensity is maintained. The key is to first attain an acceptable level of fitness. After doing so, then you and the client can worry about maintaining gains and manipulating the various variables of frequency, intensity, and duration that best fit into your client's schedule.

Journalist Ken McAlpine calls it "training's corollary of compromise: Less is *not* more, but less is often enough! Sometimes you have to give up what you know for what works" (McAlpine 1993, p.163). Remember, until your client actually gets into great shape, you as well as the client won't get far thinking about minimums, and if you focus on intensity before proper increases in duration and frequency, there is a higher risk of injury and noncompliance.

Maintaining Muscular Endurance, Strength, and Power

If your client is following a regular strength and conditioning program of three sessions per week and she misses a workout or so, does her strength greatly decline? Or, if your client temporarily cuts down on the number of strength workouts she participates in weekly, is the result going to be disastrous? Many clients who strength train on a regular basis are afraid that muscular strength and endurance gained through training will be lost after a brief period of time away from their regular training effort. "Not to worry!" say most researchers. Compared with cardiovascular conditioning, which itself isn't hopeless with regard to losing benefits, strength is kept over a much longer period of time after detraining begins.

Although levels of strength, power, and muscular endurance are reduced once your client stops or alters her training, these changes are relatively small during the first few months following the cessation of training.

A few days of recovery or missed workouts will probably have little effect. A week or two of complete inactivity starts to affect these systems (strength or cardiovascular). However, it seems that anaerobic (strength) performance gains are much easier to maintain compared with endurance or cardiovascular training benefits.

Development of muscular strength requires an anaerobic effort, and it has been shown that maintaining strength levels requires fairly little time investment compared with maintaining aerobic or muscular endurance capacity (Brooks 1997a).

When an individual breaks an arm or a leg and the broken limb is placed in a rigid cast to immobilize it, changes immediately start taking place in both the bone and surrounding muscles. It is now clearly understood that skeletal muscles will substantially decrease in size (atrophy) with complete inactivity. Accompanying this decrease in size is a considerable loss in strength and power.

The physiological mechanisms responsible for this decline in muscle strength with immobilization are not clearly understood. One thought is that muscle disuse also reduces the frequency of neurological stimulation and normal pathways for the recruitment of muscle. Part of the strength loss that is associated with detraining may be produced by an inability to activate previously active muscle.

Although total inactivity will lead to very rapid losses in both strength and power, periods of reduced activity may lead to gradual losses that become significant only as the changes accumulate over long periods of time. Just as is true for cardiovascular conditioning, being active with daily tasks and reducing training has much less impact on muscle and bone loss than being confined to a bed or immobilized by a cast.

Noted physiologist Dr. David Costill (Costill 1988; Wilmore and Costill 1994) reported that muscle strength and power gained during training can be kept for up to six weeks of inactivity. In addition, Costill stated that about 50 percent of the strength gained with training can be maintained for up to a year following the end of the training program. Other studies have shown that it takes less effort to regain lost strength than it does to gain it (Nieman 1997). This is welcome news for any training schedule that is interrupted by life's events.

Even more exciting, research appears to confirm that strength gains can be maintained for at least 12 to 16 weeks with minimal stimulation, as related to frequency of training. Intensity rather than exercise duration or frequency is the key stimulus for increasing or maintaining strength. Single-set training seems to be almost as effective as multiple-set training, especially early in training and with previously sedentary adults. Experienced lifters also can benefit from single-set training.

According to Costill (other research supports this idea, reported in Brooks 1997a; Plowman and Smith 1997), working out once every 10 to 14 days can maintain the strength, power, and

muscular endurance that your client gained through more frequent and longer resistance training sessions, if intensity is maintained (Costill 1988).

When you reduce the number of workouts, for example, from three to one or two times per week, strength can be maintained. One researcher explained, "If you want to maintain your strength when you are working out less often, you must make sure that your workout is just as difficult as the workout you conduct when you are training more frequently" (IDEA Today 1989, p. 13).

Evidently, muscle requires a less frequent stimulus to retain its strength, power, and size. This has exciting implications if, for instance, your client is injured or on vacation, and it can be a powerful motivator if your client has attained a level of muscular strength and endurance she would like to maintain but no longer can invest the amount of time that was necessary to achieve this fitness level.

Maintaining Flexibility Gains

Even though flexibility is gained quickly, it is lost rather quickly during inactivity. Keep flexibility training at the forefront of your client's program. It is as important as cardiovascular and strength training for balanced fitness.

Although flexibility can be attained in a relatively short period of time, it is in your client's best interest to maintain functional levels of flexibility. Reduced flexibility may leave your client more susceptible to injury and can affect her actual performance and enjoyment of physical activity. Besides all of this, stretching feels good!

Regaining Fitness

Many studies (reported in Brooks 1997a) support the idea that regaining previous fitness levels requires far less effort than it took to first acquire. This is motivating news, and although I do not dispute this thought from a research perspective, I contend that it is far easier to maintain some semblance of training and general activity. When your client yo-yos between low and high levels of fitness, he risks

lack of compliance to his exercise program and possible injury.

If a client stops exercising for two weeks or longer, he shouldn't pick up where he left off. Be certain the client starts out, for example, at an overall lower intensity. Less resistance, slower speeds, and shorter durations are in order. The odds are that your client will regain his previous levels of fitness fairly quickly if he allows for this progressive adaptation to the "new" stresses he is placing on his body. Temper your client's enthusiasm for starting out too intensely after time off!

Missing an exercise session periodically will not greatly affect current levels of fitness. Regardless of fitness level and component of fitness being trained, intensity of effort is the key to optimizing training effects and achieving results. Reducing training frequency and duration will not drastically affect fitness as long as training intensity is maintained. Minimal activity—whether a formal workout or simply daily routine—helps your client maintain fitness gains. Remember, doing something is far superior to doing nothing. This knowledge should become an integral part of motivating your client to maintain progress.

Taking Your Client's Fitness to the Next Level

Results start with a dream, an idea, and time commitment. The successful path continues with a growing knowledge base and accurate information. Your client's program goes nowhere without a goal-oriented plan of action and an objective evaluative process that tells her (and the trainer) whether the program is working.

Reevaluate Client Goals

Would you like your client's fitness program to push on toward the standards of personal health and fitness you have set together? Revisit your client's goals, both long and short term, and keep track of her efforts. Evaluate client progress by reassessing her fitness level regularly and graphing her progress, for example, on a performance graph. The information that you accumulate is useful to you and your client, but only if you use it! Put the information in this

book to work. Take action and follow through so you will have a complete approach to designing and monitoring your client's fitness program to ensure maximum results.

The evaluation and testing sheets, performance graphs, and workout record-keeping logs that are provided in *The Complete Book of Personal Training* will make it easy for you to keep a written record of your client's program. This objective information, recorded over periods of time when you and your client's memories are sharp and accurate, will give you a true sense of whether your program is achieving progressive results. Compare your client's workout progress to her current goals. Are they in line with one another, or do you need to make a change or reevaluate? Remember, it takes time, consistent effort, and accurate record keeping to stay on track with program design and client goal attainment.

Monitoring your client's training efforts and setting new goals are exciting because they signify the rewards she is reaping from your dedicated and planned efforts. Results don't just happen; they occur because you have planned your client's route and, together, you and your client have carried out the "orders." A successful direction is impossible without first helping your client set goals and then following these with updated goals that reflect your client's current situation.

Adjust Your Client's Workouts

Many programs fail because the client doesn't realize what is realistic with regard to fitness and health gains or losses and doesn't have proper perspective. Other times programs fail not because a client doesn't know what to do but because the person fails to act on the knowledge she already possesses. In yet other cases, frustration can lead to failure. Help your clients take charge and move forward! Use client test results and record-keeping sheets to determine the effectiveness of your programs. Help your clients set and reset realistic and attainable goals. An approach like this will work miracles in helping you to elevate client motivation and desire.

Provide your clients with the right tools and accurate information so that they can continue to move personal fitness to new levels and document progress. The combination of assessment, cardiorespiratory training, strength training, flexibility training, proper nutrition, cross-training, and periodizing programs indicates a program that is moving in the right direction. Covering all aspects of program design will provide your clients with the essentials to move their programs toward optimal results.

CHAPTER 15

Science Behind Accurate Exercise Programs

"You will ask, I have often been asked, what happens to the body in training? I am sorry, I do not know. Perhaps the blood supply to the active muscles becomes better, the capillaries responding more rapidly to the needs of the muscles; perhaps more alkali is deposited in the fibres to neutralize the acid formed by exertion. More glycogen seems to be deposited in them as a store of energy, and certainly, . . . the nervous system which governs them learns in training to work more economically. Perhaps by training the recovery process is quickened. Maybe the actual mechanical strength of the muscle fibre and its surrounding membrane (sarcolemma) is increased by training so that it can stand, without injury, the strains and stresses of violent effort. All these factors may be at work, but at present we can only point to the importance and interest of the problem, and suggest that someone should investigate it properly." (Hill 1927)

Energy Systems at a Glance

Depending on the intensity and duration of an activity, as well as your client's fitness level, the body uses energy from three metabolic, or energy-producing, pathways. Understanding how the body makes energy is useful regardless of the component of fitness you are training—cardiorespiratory, muscular strength and endurance, or flexibility.

The diversity of the three energy systems allows you to accommodate a variety of energy needs based on the type and intensity of the activity (table 15.1).

Immediate energy: The adenosine triphosphate–creatine phosphate (ATP-CP) system (phosphagen system). The immediate energy system allows your client to snatch a toppling child, spike a volleyball, and react immediately to any situation that requires movement.

Short-term energy: The lactic acid system (anaerobic glycolysis). The short-term energy system is largely responsible for creating the energy needed for a client to walk up a 100-yard hill as fast as possible, or pass another participant in a 5K race with a burst of speed.

Long-term energy: The aerobic system. The aerobic system supplies the energy needed to walk or cycle continuously. In fact, any activity where you sustain activity beyond three to five minutes relies primarily on the long-term energy system.

Energy Spectrum

At any given time, all three energy systems are functioning simultaneously. The percentage of contribution from each system, termed the energy spectrum, is determined primarily by the intensity and duration of the activity and the participant's fitness level. The energy needs of the muscles are not satisfied by an all-or-nothing approach. Instead, one system merges smoothly into the other, with all systems functioning simultaneously, regardless of intensity, with considerable overlap.

You can think of the energy systems as three light bulbs that have dimmer switches. Depending on the energy demands placed on

TABLE 15.1 Energy System Characteristics

	Immediate energy or ATP-CP system	Short-term energy or lactic acid or glycolytic system	Long-term energy or oxidative system
	Anaerobic system	**Anaerobic system**	**Aerobic system**
Fuel or substrate	CP Stored ATP	Blood glucose Glycogen	Fatty acids Blood glucose Glycogen
Intensity RPE Percent $\dot{V}O_2$	Very, very hard 9-10 Borg scale[a] >95 percent max	Very hard 7 Borg scale[a] 85-95 percent max	Moderate to somewhat hard 3-4 Borg scale[a] <85 percent max
Time to fatigue	Very short duration (1-10 seconds)	Short duration (60-180 seconds)	Longer duration (>3 minutes)
Limits to ATP production	Limited muscle stores of CP and ATP	Lactic acid accumulation Rapid fatigue	Depletion of muscle glycogen and glucose Insufficient oxygen delivery or utilization

Note: ATP = adenosine triphosphate; CP = creatine phosphate; RPE = rating of perceived exertion.

the muscles of the body, one of the three energy systems will glow more brightly than another. As exercise intensity and energy demands change, another system may shine more or less brightly, as the dimmer switch is turned either up or down. Regardless, there will always be at least a low-level glow, or energy contribution, from all three energy systems.

Energy and Food

Energy for physical activity and for sustaining all cellular function is derived from food—carbohydrate, fat, and protein. Energy that is synthesized from food is chemically released by breaking the food molecule bonds and then stored in a high-energy compound called adenosine triphosphate (ATP). ATP is called "the energy currency" of the cell because it is required for all processes related to cellular function. Without ATP, energy from food could not be harnessed to perform work. ATP is essential and allows the body to form and conserve potential energy. All three energy systems use ATP as their operative foundation and work on

the premise that potential energy is released by splitting molecular bonds and conserved by the formation of new bonds. This process is repeated over and over in the three energy systems.

Immediate Energy: ATP-CP System

ATP, necessary for all energy-requiring processes in cells, is the immediately available form of energy used for muscular contraction and motor movement. Because very small amounts of ATP are stored in the body at any one time, ATP must resynthesize by breaking down and reforming its bonds. Consequently, athletes in activities that depend heavily on ATP stores—like sprinting or Olympic weightlifting—can benefit from training the specific muscles used in the activity so they can store more ATP.

It's easy to see why training the ATP-CP system may not be necessary for many of your clients. It takes a highly motivated, highly skilled client, with specific, short-term, all-out

performance efforts in mind to desire this type of energy system improvement. Needless to say, many of your clients would not find this effort easy or enjoyable.

Short-Term Energy: Lactic Acid or Glycolytic System

Because only a small amount of ATP is available in your body, the body must continually resynthesize ATP or physical effort would be limited quickly. The short-term lactic acid system allows ATP and CP to be resynthesized at a rapid rate.

Anaerobic glycolysis is used when energy from ATP is needed for activities requiring high-intensity effort for periods longer than the phosphagen system (ATP-CP) can provide. For example, walking up a 100-yard hill as fast as possible, lateral or slide training in an athletic position at 60 slides per minute for 90 seconds, or passing a participant in a 5K race with a 60-second burst of speed would require anaerobic glycolysis.

Anaerobic glycolysis ultimately leads to the formation and significant accumulation of lactic acid. This creates a "burning" sensation in the exercising muscles and eventually requires a decrease in intensity or cessation of activity. The most rapidly accumulated and highest lactic acid levels are reached during maximal exercise that can be sustained for 60 to 180 seconds (McArdle, Katch, and Katch 1991; 1996). The short-term energy system supplies energy beyond that which the ATP-CP system is capable of supplying.

It is obvious that all-out effort from several seconds to three minutes relies almost exclusively on the ATP-CP and lactic acid systems. If all-out effort is moderated to a less intense effort, the period of activity that can be sustained will be extended, with both anaerobic and aerobic energy pathways contributing.

Lactic Acid and Aerobic and Anaerobic Energy Production

Lactic acid does not accumulate significantly at all levels of activity. During light to moderate levels of activity, ATP energy production is met by processes that predominantly use oxygen (aerobic processes). The small amount of lactic

acid that is produced under these conditions is easily oxidized (used for energy) in the muscle or liver.

At all times, even at rest or during mild exercise, both aerobic and anaerobic processes are active in the body (i.e., energy spectrum). For example, the red blood cells (RBCs) of the body contain no mitochondria, the "aerobic powerhouses" of cells. Because RBCs cannot produce energy aerobically, lactic acid is continually formed to supply the energy they require. Conversely, even at the highest maximal effort, although anaerobic metabolism predominates, aerobic metabolism simultaneously sustains some type of cellular function. However, in the case of RBCs or low-level activity, lactic acid does not build up because its production rate equals its removal rate. As exercise intensity increases, the role of lactic acid becomes more significant.

Lactic Acid Accumulation Threshold

Lactic acid begins to accumulate and increase quickly at about 50 to 55 percent of a healthy, untrained client's maximal aerobic capacity, $\dot{V}O_2max$, or heart rate reserve (HRR). (Note: All of these terms are similar.) This is comparable to 60 to 65 percent of maximum heart rate. In a conditioned participant, significant lactate accumulation may not occur until 80 to 85 percent of $\dot{V}O_2max$. The increase in lactic acid becomes exponentially pronounced as the activity becomes more intense relative to current fitness level and indicates that the aerobic energy system can no longer meet the additional energy requirements of the exercising muscles at this particular intensity.

At some point, the participant will reach a threshold or a limiting factor in continued performance. This is commonly associated with anaerobic threshold (AT) but more precisely labeled blood lactate threshold (BLT) or onset of blood lactate accumulation (OBLA). As BLT is reached, the demands of exercise can no longer be met by available aerobic sources, and the anaerobic lactic acid system begins to play a predominant role. This is reflected by a blood lactate concentration well above resting values and eventually results in an inability to sustain that level of intensity.

Through training that is sufficiently intense but still appropriate to a client's current fitness level, specific local muscular adaptations account for a lower production rate, increased tolerance, and a quicker removal rate of lactic acid at any exercise intensity. Changes related to these adaptations allow a client to work at increasingly more intense paces and for longer duration. As the client becomes increasingly fit, he can work at increasingly harder paces that he can sustain with aerobic energy production. The bottom line is that the client can accomplish more total work and maximize caloric expenditure.

Long-Term Energy: Aerobic or Oxidative System

The aerobic system is the last of three stages of energy transfer in the body. It is the most complex of the three energy systems, but I will not go into lengthy detail.

The long-term energy system is an oxidative system. With the aid of oxygen, this system breaks down fuels (food) to generate energy. This disassembling of mainly carbohydrates and fats is referred to as cellular respiration. As a side note, protein does not contribute significantly to total energy expenditure. Although protein, or specifically amino acids, can enter into oxidative metabolism and be converted to glucose through gluconeogenesis, proteins are not a "preferred fuel." Protein metabolism accounts for less than 5 to 10 percent of energy needs in a healthy body. Protein generally is ignored when estimating total energy expenditure during rest and exercise (Brooks 1997a; Plowman and Smith 1997; Wilmore and Costill 1994).

This aerobic process (cellular respiration) of ATP production occurs within special cell organelles—the mitochondria. The lactic acid and ATP-CP systems are not very efficient at producing a large amount of ATP. A large percentage of the total potential ATP produced via the lactic acid and ATP-CP systems is never realized from the breakdown of their primary energy substrate, carbohydrate. This inefficiency is a result of an inability of these systems to completely oxidize (break down) fuel or metabolic fragments.

On the other hand, a large amount of ATP is created efficiently by the aerobic system because of its capacity to completely oxidize carbohydrate, fat, and other fuel fragments created by incomplete oxidation of these substrates during anaerobic metabolism.

If the body is oxidizing or disassembling carbohydrate, the complex processes of aerobic glycolysis, the Krebs cycle, and the electron transport chain are involved. The end product of anaerobic and aerobic glycolysis is the same—pyruvic acid. However, in the case of anaerobic glycolysis, and without the presence of adequate oxygen, pyruvic acid is converted to lactic acid. In the presence of sufficient oxygen, pyruvic acid is converted to acetyl coenzyme A (CoA). This conversion in the presence of oxygen allows acetyl CoA to enter the Krebs or citric acid cycle. The Krebs cycle is a very complex series of chemical reactions that permits complete oxidation of acetyl CoA. The remaining carbon of the original carbohydrate combines with oxygen and forms carbon dioxide (CO_2). CO_2 is carried to the lungs by the blood and easily expelled.

During glycolysis, hydrogen is released as the carbohydrate (glucose), is metabolized to pyruvic acid, and enters into the Krebs cycle. This accumulation of hydrogen in the cell must be eliminated or the cell will become too acidic. The Krebs cycle is closely associated with a series of chemical reactions known as the electron transport chain. Hydrogen released during aerobic glycolysis and during the Krebs cycle combines with two coenzymes (nicotinamide adenine dinucleotide and flavin adenine dinucleotide) that carry the hydrogen to the electron transport chain. At the end of this chain of reactions, the hydrogen combines with oxygen to form water. This prevents an acidic cell environment, and water is easily eliminated from the body via sweat and expelled air. The energy yield from complete oxidation of a single molecule of glycogen is 38 or 39 ATP versus only 3 ATP from anaerobic glycolysis.

Fat must be oxidized, because muscle and liver glycogen stores may be able to provide only 1,200 to 2,000 kilocalories of energy. Energy from fat is virtually unlimited in the presence of sufficient oxygen. Triglycerides are the major energy source and are stored in fat cells and skeletal muscle fibers. If a triglyceride is to be

used for energy, it must be broken down to one molecule of glycerol and three molecules of free fatty acids (FFAs) in a process called lipolysis. Once the FFAs are free of the glycerol molecule, they can easily enter the blood and be used by skeletal muscle. FFAs enter muscle cells and are broken down within the mitochondria. This breakdown of the fat within the mitochondria is called beta oxidation. It results in the formation of acetic acid and ultimately acetyl CoA.

At this point, as with carbohydrate oxidation, acetyl CoA that is formed by beta oxidation enters the Krebs cycle. Hydrogen that is generated in the Krebs cycle is transported to the electron transport chain and, as in carbohydrate metabolism, the end products of FFA oxidation are a high yield of ATP, water, and carbon dioxide.

Fat metabolism can generate even more energy than oxidative carbohydrate metabolism, but it requires more oxygen. That is why carbohydrate is generally the preferred fuel of the body during high-intensity exercise. However, with specific training adaptations, the body can become a more efficient fat user, even at higher intensities, thus sparing precious glycogen stores and blood glucose.

Oxidative processes, as related to endurance activities and recovery from anaerobic activity, rely on the body's ability to effectively deliver and use oxygen in the working muscles. Vigorous activity could not extend beyond several minutes and recovery from anaerobic efforts would not be possible if not for the long-term oxidative system. Now that the complex science associated with energy production has been discussed, let's look at how you can use this information to train your clients.

Training Energy Systems

As mentioned, many clients will not choose to train the ATP-CP system to any great degree because this type of training requires intense, short, maximal bursts of activity. Average clients generally do not have a functional use for this type of training, although the ATP system is regularly called on in day-to-day tasks.

When training energy systems, ask, "Is the type of training required to influence this specific energy system compatible with my client's workout and health-related goals?" The answer should dictate the specific type of energy system training you choose to use.

It is clear that the intensity of an activity determines which of the body's three energy systems will predominate. Each system has a purpose that can translate to a client's goals. Understanding how and when the aerobic and anaerobic energy systems contribute will enable you to choose which one to emphasize. Having the ability to train or influence the three energy systems will greatly affect your client's ability to get specific results.

Physiology of Warm-Up and Cool-Down

Have you ever caught yourself paying less than sufficient attention to a client who is warming up or cooling down? Independent of fitness level, the warm-up and cool-down are both meaningful and productive parts of any workout. Warm-up and cool-down are too often left out of client programs or paid too little attention. Yet, stretching, resistance training, and cardiorespiratory activities require both.

Physiologically, the gentler, steady movements used in warm-up and cool-down prepare the client for successful activity and allow for a comfortable return to the preexercise state following the effort. Plus, warm-up and cool-down present excellent times when you can effectively communicate with and motivate your client. These quiet times are perfect for gathering information and can help to ensure success and exercise adherence. While your client is training at a lesser intensity, you can update him on new health and fitness information, talk about exercise technique, and discuss his diet, nutritional program, and any other concerns or interests he might have.

Physiological Benefits of Warm-Up

There are several possible mechanisms by which warm-up could improve performance or personal well-being during exercise, related to resultant increases in blood flow and in muscle and core temperature. A proper warm-up accomplishes more than you might imagine.

1. Permits a gradual increase in metabolic requirements. Warm-up activity enhances cardiorespiratory performance and is less stressful to your client's body and heart. Also, hemoglobin releases oxygen to the working muscles more readily at higher temperatures. This facilitates increased oxygen utilization (extraction) by the muscles, making physical performance more effective and efficient.

2. Prevents the premature onset of blood lactic acid accumulation and premature fatigue. A progressive warm-up prevents your clients from going too quickly from low intensity to high intensity by increasing blood flow through active tissues. For example, the working muscles are active tissue, and as the local vascular bed (capillaries serving the muscles in demand) dilates because of progressive increases in exercise intensity and the resultant increase in blood perfusion to the exercising muscle, the body can provide most of the energy requirements aerobically.

Blood flow increases because higher temperatures in the body's core and its musculature cause vasodilation or a widening of the blood vessel diameter. During warm-up, blood travels from the body's core to the working muscles. More blood availability means more oxygen and nutrients to fuel exercise and muscle contraction, insignificant accumulations of blood lactate, and efficient removal of metabolic by-product production. Metabolic by-product production includes lactic acid (blood lactate), carbon dioxide, and water.

3. Causes a gradual increase in muscle temperature. A proper warm-up can reduce the likelihood of soft-tissue (muscle fascia or muscle) injury and increases the effectiveness of sustained stretching. Muscle tissue and fascia become more stretchable, and this reduces the risk of overstretching or tearing muscle fibers, tendons, and connective tissues. Sufficient warm-up is especially important to your clients who are involved in activities that require greater than normal range of motion (ROM).

Increased muscle temperature can also allow for greater mechanical efficiency because of lowered viscous resistance within muscles. Viscosity (thickness) of the muscle protoplasm decreases, allowing the protein filaments (actin and myosin) that make up the muscle fibers to contract with less resistance. Warmed up muscles move faster and generate force more effectively than "cold" muscles. Warm-up also facilitates joint lubrication, allowing for easier movement.

4. Enhances neural transmission for muscle contraction and motor-unit recruitment. Motor skills improve at higher temperatures because nerve impulses travel faster. Increases in core temperature enhance speed of muscle contraction and force generated, along with muscle relaxation. Sports and activities that require coordination, quick reaction times, and agility benefit greatly from a warm-up.

5. Provides an "early alert" for screening potential musculoskeletal or cardiorespiratory problems. Symptoms or other warning signs may worsen at higher intensities of exercise. A progressive warm-up can alert the client or trainer to a problem before it is more likely to cause injury or death at increased exercise intensities.

It's obvious that warm-up accomplishes changes in the body that may reduce the risk of injury and improve performance. Graduated, low-level aerobic exercise is essential for maximizing safe and efficient movement for most clients. The warm-up should progressively increase heart rate, blood pressure, oxygen consumption, and dilation of the blood vessels, and it should decrease the elasticity (or the tissue's resistance to stretch) of the active muscles and fascial tissue. Warming up increases the temperature of the muscle and connective tissue, likely reducing the risk of soft-tissue injury. Additionally, warm-up activity facilitates flexibility gains when proper stretching methods are used (chapter 20). Warm up also reduces the stress placed on the heart and lessens the likelihood of heart attack in susceptible individuals. Finally, warming up can make the exercise session seem more comfortable and enjoyable for your client.

Psychological Considerations

Sports enthusiasts at all levels often consider some prior activity to prepare them mentally for their event or activity. Some evidence supports the contention that a warm-up specific to the activity itself improves the necessary skill and coordination. Consequently, sports that require accuracy, timing, and precise movements generally benefit from some type of specific warm-up

or "formal" preliminary practice. Many experts believe that prior exercise like this, especially before a strenuous effort, gradually prepares a person to go "all out" with less likelihood of injury.

Warm-Up Theory Into Practice

A **general warm-up** may involve rhythmic and continuous movement, large-muscle group involvement, and calisthenic exercises that are usually unrelated to the specific neuromuscular action of the activity that is to follow. A general warm-up will often precede an activity-specific warm-up.

An **activity-specific warm-up** reflects the specificity principle and provides a skill rehearsal. Swinging an unweighted baseball bat or tennis racket is an example. "Rehearsing" resistance training movements with light resistance is another example of an activity-specific warm-up.

Passive warm-up techniques include massage and heat applications. However, external techniques such as heat packs or sauna are less likely to warm deep muscles. In fact, they may be counterproductive. When surface temperature of the skin is increased, blood vessels near the skin surface dilate and divert large amounts of blood to the skin, away from working muscles.

The warm-up should be progressive and of sufficient intensity and duration to increase muscle and core temperature without causing fatigue or reducing energy stores. These considerations are highly individualized. Adequate warm-up for an Olympic athlete in a variety of events might totally exhaust a deconditioned person. At a minimum, sufficient duration means about three to five minutes, the time necessary for achieving steady rate in a progressive manner.

Warming up the body allows the cardiorespiratory system to adjust blood flow effectively from the abdominal area to active muscles, where the need for oxygen is increasing in response to exercise. This blood shunt is accomplished by vasoconstriction (narrowing of artery diameter) in arteries that supply blood to the viscera (gut) and vasodilation in arteries that deliver blood to the active muscles. If three to five minutes of gradual warm-up is not performed, heart rate can quickly increase in

an attempt to supply adequate oxygen to the muscles, as required by the increased workload. An inappropriately high heart rate can be reached if an intense pace is attempted too soon, especially in less conditioned clients.

- **Intensity:** Elevate resting heart rates of 40 to 75 beats per minute to about 90 to 120 beats per minute before moving on to higher intensity aerobic exercise. On the revised 10-point Borg scale (Borg 1982) for rating of perceived exertion (RPE), a warm-up builds to 3, which indicates a moderate effort.

- **Temperature:** Temperature of muscle tissue rises about 3.6 degrees Fahrenheit during the warm-up, which should produce sweating in about three to five minutes. However, monitoring sweat is an imprecise gauge to determine the effectiveness of a warm-up. Many factors, including individual sweat response, humidity, and the temperature of the exercise environment, influence how quickly sweat appears on the skin.

- **Duration:** The length of the warm-up should be based on the activity your client is participating in, the intensity of the activity, and the client's current level of fitness. A minimum of three to five minutes is recommended for any activity. Older exercisers, beginners, overweight individuals, pregnant women, and cardiac patients may need a more gradual and longer (10- to 15-minute) warm-up for a safe transition to more intense exercise. Activity ideally should begin within several minutes of the end of the warm-up; however, some benefit of warm-up may be retained for up to an hour.

- **Activity:** Move the client through an easy range of motion (ROM) and never beyond a point of gentle tension or strain. Keep your client's movements fluid, rhythmic, and controlled. This type of approach works well for resistance training warm-up, too. Use specific muscles in a way that mimics the anticipated activity and gradually brings about the ROM necessary for the ensuing activity.

An additional component of warm-up is the addition of flexibility exercises after the progressive warm-up. Try to match the flexibility exercises to the demands of the upcoming activity. For example, extreme ROMs are not necessary before a fitness walking program. In this case, a

warm-up without stretching before the activity will be adequate. However, if your client is going to perform a 5K race at her fastest walking or running pace or participate in an aggressive match of singles tennis, a more thorough warm-up and stretching segment before the activity may accommodate the energy demands, ROM, and biomechanical stresses of high-intensity activity. However, recent research suggests that stretching can alter a muscle's ability to create force and may be counterproductive prior to exercise (Fowles, Sale, and MacDougall 2000). An activity specific warm-up seems to be more appropriate in light of recent research, when compared to stretching.

If the training goal is to concentrate on flexibility gains, do so only after an extensive warm-up (15-20 minutes) or after warming up and having the client participate in the chosen activity. Stretching can take place any time after your client is adequately warmed up. Stretching by itself is not an adequate warm-up. Forcing movement when muscles are "cold" is less effective at increasing ROM safely and can cause injury (chapter 20).

Sudden Strenuous Exercise and Cardiovascular Response

Do you have clients who have heart disease or some other limitation related to the heart and vascular system? What about clients involved in occupations and sports requiring sudden bursts of high-intensity activity? Numerous studies (Clark and Sherman 1998) have evaluated the effects of warm-up exercise on cardiovascular response to sudden and strenuous exercise. Remember, strenuous exercise is relative to an individual's fitness level. Walking at three miles per hour may be strenuous for an unfit person.

Research (Clark and Sherman 1998) has proven that sudden intense exercise does not allow the body enough time to divert blood to the muscles, which can result in poor oxygen supply to the heart. Warming up for at least a couple of minutes, and better yet 10 to 15 minutes, significantly enhances the body's ability to deliver oxygen to the heart.

It is apparent, then, that warm-up is especially important for clients who have cardiovascular problems that limit the heart's oxygen supply. Brief, prior exercise most likely provides for more optimal blood pressure and hormonal adjustment at the onset of strenuous exercise. For clients with these circumstances, warm-up has the potential to do the following:

- Reduce the myocardial workload and thus the myocardial oxygen requirement.

- Provide adequate coronary blood flow in sudden, high-intensity exercise that follows such a warm-up.

Your immediate thought might be, "But I don't work with high-risk clientele." However, regardless of how carefully you may screen your clients, there is the possibility that one may have undiagnosed heart disease. There are many reasons for warming up. It's smart to add this to your list!

Physiological Rationale for Cool-Down

The purpose of the cool-down is to slowly decrease heart rate and overall metabolism, which were elevated during your client's workout. An adequate cool-down gives your client a psychological break to savor the great feelings of postexercise accomplishment or what I call "postexercise glow."

What, specifically, can a proper cool-down accomplish?

1. Increase removal of lactic acid and lessen the potential for postexercise muscle soreness. In normal exercise situations, lactic acid itself does not cause or contribute significantly to muscle soreness. Any soreness is probably a result of all-out or unaccustomed effort and soft-tissue damage caused by the activity. In the presence of oxygen during recovery or lessened intensity, lactic acid becomes an energy source (this chapter, "Energy Systems at a Glance"). But high-intensity exercise associated with lactic acid production often does create delayed-onset muscle soreness (DOMS). It is largely believed that DOMS is caused by actual damage to, or disruption of, the body's muscle-cell membranes.

Remember that delayed soreness usually occurs from microtrauma of the tissues, dependent on the type and intensity of exercise. However, there is evidence that lactic acid may irritate tissue much like a piece of meat would deteriorate if suspended in a glass of carbonated beverage. Both situations are very acidic environments and

could contribute to breakdown of tissue (Smith 1993). This finding may be especially relevant to an athlete's training program when she engages in, and repeats, high levels of anaerobic effort over a number of days, weeks, or years.

2. Reduce any tendency toward postexercise fainting and dizziness. The rhythmic "milking" action of muscular contraction and consequent compression of the veins is critical to ensure adequate venous return and reduce the likelihood of fainting or creating unnecessary stress to the heart. If blood is pooled in the lower extremities (venous pooling) from a sudden cessation of exercise, the high hydrostatic forces decrease venous return and blood pressure declines.

At the same time, the heart rate accelerates, which means that the heart muscle needs more blood and oxygen at a time when its supply may be compromised. Having blood in the chambers of the heart does nothing in terms of supplying oxygen to the heart muscle. To nourish the heart muscle, blood must first be ejected from the left ventricle. With each heartbeat, the driving force of the heart pushes a portion of blood out of the heart's left ventricle and into the coronary arteries. An adequate oxygen supply is critical for the myocardium, because unlike skeletal muscle, heart tissue has an extremely limited ability to generate energy anaerobically.

3. May reduce the likelihood of some muscle soreness if stretching is added. By preventing muscle spasms or involuntary contractions of the muscles, a proper cool-down may reduce soreness.

4. Help lower blood levels of adrenaline. Adrenaline that lingers in the bloodstream can stress the heart. The continuation of mild exercise into recovery may minimize any possible negative effects on heart function because of elevated catecholamines epinephrine and norepinephrine. These adrenaline-like hormones affect the body's response to increasing quantity and intensity of exercise, and their levels increase after exercise (Plowman and Smith 1997; McArdle, Katch, and Katch 1991; 1996).

What Happens If Your Client Does Not Cool Down?

After moderate or vigorous exercise, depending on your client's fitness level and body position, the following take place:

- Blood pressure decreases.
- Less blood returns to the heart (venous return).
- Stroke volume decreases.

Because of these physiological adjustments, there is an increased chance that the heart or brain could be deprived of necessary oxygen, resulting in dizziness, fainting, heart attack, or stroke. A "cardiac event" is associated with heart attack symptoms that can include chest pains, angina, or an actual heart attack (myocardial infarction, which is death of heart muscle tissue).

Applying Cool-Down Strategies

An active cool-down of moderate to mild exercise means that clients continue exercising at an intensity lower than they used during the main body of their cardiorespiratory or other conditioning workout. This mild level of activity facilitates blood flow through the vascular network (including the heart) during recovery. With a proper active cool-down, your client's heart will work less (fewer beats per minute) and require less oxygen. Cooling down is more likely to prevent an undiagnosed cardiac event or unnecessary physiological or psychological stress to your client.

Duration: At least five minutes of an activity with gradually lessening intensity is generally advocated before exercise is stopped. This reduces the chances of abrupt physiological alterations, especially those involving the heart.

Activity: Using a low-intensity, rhythmic activity during cool-down allows the body to reverse the blood shunt, or the shift that occurred during activity to help ensure adequate blood flow to the working muscles.

Intensity: A normal reduction of exercise intensity is usually reflected by the return of exercise heart rate—rather quickly—to lower levels and eventually to the individual's resting level. When monitored accurately, heart rate is a very good indicator of your client's recovery status. Your client can be expected to attain a recovery heart rate of approximately 120 beats per minute in about three minutes. After about five minutes, a heart rate of around 100 beats per minute is likely. A "quick" recovery depends

on your client's current fitness level, the intensity of effort for the preceding workout, and the appropriateness and intensity of the cool-down activity.

Using Cool-Down to Increase Exercise Compliance

A cool-down period is an effective time to ask your client to personally acknowledge the tangible and quite significant accomplishments she has just achieved. Ask your client, "How do you feel at this very instant?" Most feel at least better than before the session began, and many feel wonderful. A very few remain unreceptive, combative, and just outright ornery!

Regardless, don't let your clients cheat their bodies and their minds out of a cool-down. Too many times, your client's daily accomplishments can be lost because of a focus on long-term goals or a hectic daily schedule. Before you let your client jump back into a stressful and harried routine, give her the chance to smile and say, "You know, that was a pretty good workout and I feel great!"

Physiology of Cardiorespiratory Training

Most types of cells—including the heart, nerves, and brain—can produce energy only aerobically. That is why a constant supply of oxygen to these cells is necessary. Because of this, the aerobic energy system is the predominant energy system in the body. A healthy cardiorespiratory system that is challenged by appropriate physical activity and not compromised by a poor diet ensures an adequate supply of oxygen for most of the body's functions and oxygen-demanding tissues. Cardiorespiratory training or aerobic conditioning moves the body toward being a more "efficient machine" in relation to its ability to carry out everyday tasks and recreation.

The *cardiorespiratory (C-R) system* (often referred to as the cardiovascular system) is really a transport network in the body. *Cardio* refers to the heart and its pumping force that circulates the blood through an amazing network of blood vessels. *Respiratory* refers to the lungs and the exchange of gases. Oxygen and carbon dioxide are exchanged in the lungs as well as in the cells of the body.

The C-R system consists of the heart, lungs, arteries (carrying oxygen-loaded blood away from the heart throughout the body), capillaries (exchanging gases, nutrients, and by-products between the bloodstream and cells), and veins (carrying oxygen-depleted blood back to the heart). One purpose of the cardiorespiratory system is to deliver oxygen to the various tissues of the body, both at rest and during a broad spectrum of exercise intensities, from low level to high level.

Blood is the vehicle that delivers oxygen and nutrients (like fat and carbohydrate) to the cells in the body where they are needed to produce ATP. Blood also picks up *metabolic by-products* of energy metabolism, including lactic acid, water, and carbon dioxide. In contrast to a *waste product* that has no usefulness and is difficult to dispose of, by-products such as carbon dioxide can easily be carried to the lungs and breathed out of the body, and water can be sweated out of the body or breathed out. *Lactic acid* is carried to the liver, where it is metabolized or oxidized.

Lactic acid is not a waste product. Its production at higher intensity levels allows you or a client to work out at harder levels than can be sustained with aerobic metabolism. During recovery, or when the activity is slowed, sufficient oxygen becomes available again and lactic acid is oxidized and converted to pyruvic acid, which eventually is used as an energy source. In the presence of oxygen, lactate enters the glycolytic pathway, is converted to pyruvic acid, enters the Krebs cycle, and is oxidized for energy. Furthermore, the potential energy in the lactate and pyruvate molecules formed during strenuous activity can be used to resynthesize glucose (gluconeogenesis) in the liver through a process called the Cori cycle (McArdle, Katch, and Katch 1991; 1996). The Cori cycle provides an additional means for lactic acid removal, as well as a source for meeting blood glucose and muscle glycogen needs (this chapter, "Energy Systems at a Glance").

Energy for Cardiorespiratory Conditioning

The body can be thought of as a factory. It processes different raw materials to make its final product, which is energy. Energy is used by

every cell in the body, including skeletal muscle cells, which produce movement. Oxygen, carbohydrate (sugar and starches), fat, and protein are the raw materials available in a virtually unlimited supply.

Adenosine triphosphate (ATP) is the high-energy compound that is formed from the oxidation of fat and carbohydrate. It is used as the energy supply for muscles and other bodily functions. When a muscle contracts and exerts force, the energy used to drive the contraction comes from ATP. However, because the amount of ATP stored in the muscle is small, your body begins to immediately produce more ATP by breaking down carbohydrate and fat. Otherwise, the duration of activity would be severely limited. ATP is ultimately the body's only energy source and is supplied both aerobically and anaerobically.

To understand how a muscle cell produces energy for cardiorespiratory effort, let's tie together the two primary energy systems of the body. *Aerobic* means "with oxygen." Energy is produced aerobically as long as enough oxygen is supplied to the exercising muscles by the C-R system. Even when the C-R system is unable to supply enough oxygen, your skeletal muscles can still produce energy via a process called *anaerobic metabolism*. The muscles produce energy "without oxygen" or, more accurately, without sufficient oxygen. The immediate energy (ATP-CP) and short-term energy (lactic acid) systems contribute to anaerobic metabolism.

In intense exercise of short duration (100-yard dash, traditional resistance training, shot-put), the energy is predominantly derived from the already-present stores of intramuscular ATP and CP. This type of energy production primarily requires use of the immediate and short-term anaerobic energy systems. After several minutes, oxygen consumption becomes important if the activity is to be sustained, and at this point, the predominant energy pathway is the long-term, aerobic energy system.

To fully develop the C-R system, both aerobic and anaerobic energy systems must be trained. Additionally, if reducing body fat is a goal of the exercise program, you should include both types of training. Why? The anaerobic systems use stored ATP-CP and burn glucose, a simple sugar derived from carbohydrates. The aerobic system also uses glucose but, in the process, it uses fat as well. Stored body fat is released into the bloodstream and sent to the muscles, where, in the presence of oxygen and glucose, it is metabolized aerobically to produce energy. Fat can only be metabolized or "burned" aerobically (in the presence of oxygen). The by-products of energy production using the aerobic system are carbon dioxide and water, and they do not lead to premature muscle fatigue.

Aerobic Versus Anaerobic Exercise

Aerobic or anaerobic exercise is not an issue of "good" or "bad," or of one being better than the other. The question is, Which type of exercise is appropriate to your client's needs and exercise goals?

Even though we say that a client is "aerobic" or "anaerobic" when performing exercise, these terms actually, and more accurately, refer to the muscles being used for the activity since the energy for muscle contraction and movement is produced inside the muscle cells. Aerobic exercise means that the muscles your client is using to perform a specific activity are getting enough oxygen to meet the energy needs via aerobic processes. Anaerobic exercise occurs when the exercising muscles no longer get enough oxygen to produce the necessary energy aerobically and must rely on the anaerobic system. The more fit your client is, the more capable her C-R system is of delivering adequate oxygen to sustain aerobic energy production at increasingly higher levels of intensity.

Moving Along the Energy Spectrum

At rest, muscles are aerobic. Note that the "body" is always aerobic because the cells of the heart, brain, and nerves need a constant supply of oxygen to meet their energy demands and sustain cellular life. Rest is an exercise intensity and requires a volume of oxygen (VO_2) to sustain resting energy demands of the body.

As exercise intensity increases from rest to walking to running six-minute miles, the demand for oxygen continues to increase. It becomes more of a challenge for the C-R system to get enough oxygen to the working muscles. And, unless the muscle cells are trained to do

so, they may not be able to extract available oxygen from the blood as exercise intensity increases. Somewhere between about 50 and 85 percent of maximum aerobic capacity (depending on fitness level and specific genetic factors), the delivery and utilization of oxygen to the exercising muscles become inadequate. At this point, muscles shift largely to the anaerobic energy system to support continued contractions. For example, energy derived from anaerobic metabolism is predominant when one is strength training to fatigue in 8 to 12 repetitions or when participating in other strenuous efforts (i.e., interval training) that last from 30 seconds to about two or three minutes.

The intensity at which the muscles no longer get enough oxygen to produce energy predominantly by aerobic metabolism is commonly referred to as *anaerobic threshold*. Crossing the anaerobic threshold usually is accompanied by a significant increase in breathing or respiration, a burning feeling in the muscles (accumulation of lactate from anaerobic energy-system contribution), and a feeling that the client would like to slow down or cannot continue this activity at the current pace indefinitely. She probably will not be able to string together three or four words without gasping.

Even the recovery from traditional anaerobic strength efforts (muscle fatigue in about 30-90 seconds or 8-12 repetitions) could not be accomplished without the long-term aerobic system. I sometimes use this information to motivate clients who only want to strength train. I explain that their anaerobic strength training may be enhanced by more effective and quicker recovery as a result of aerobic conditioning. Many clients find it difficult to understand how aerobic effort enhances anaerobic effort, recovery, and total well-being. This explanation helps answer your clients' questions about the importance of using a balanced approach to achieve fitness.

Although one energy system will predominate over the other, both aerobic and anaerobic energy systems are always working, regardless of intensity or type of activity. The aerobic system produces a great deal of energy and is the dominant energy system at rest, during mild to moderate or even high-intensity activity if the client is highly conditioned, and during recovery from anaerobic efforts. The anaerobic system can produce energy quickly for powerful and immediate muscle contractions and does not require oxygen for the process. However, the trade-off for immediate muscular response is susceptibility to quicker fatigue.

Of course, your client's body does not switch over to the anaerobic system all at once—or in fact totally—but gradually shifts gears to produce energy at a faster rate than can aerobically be supplied. The speed and extent of this shift between aerobic and anaerobic energy production depend on the demand brought about by the relative intensity of exercise. Any activity that can be performed at an "aerobic" pace can also be pushed to an "anaerobic" level of intensity, and vice versa. As a client becomes more fit, surges of increased intensity above what is comfortable (i.e., interval training) might be appropriate for a variety of fitness levels (chapter 18).

Physiological Adjustments to Energy Demand

The body makes several physiological adjustments to meet the increased energy requirements of exercising skeletal muscles during cardiorespiratory effort and during recovery from anaerobic effort. The primary objective of these adjustments is to provide an exercising muscle with oxygenated blood that can be used to produce energy (ATP). Your client's endurance capabilities will be greatly influenced by the magnitude and direction of these changes.

Cardiac Output

Cardiac output (\dot{Q}) is the product of stroke volume (SV) and heart rate (HR), where $\dot{Q} = HR \times SV$. This measure indicates the rate of oxygen delivery to your exercising muscles. As more work is performed (large-muscle, rhythmic, sustained activity), more blood is pumped per minute by the heart. With training, the client is able to deliver the same amount of blood and oxygen needed to accomplish a given workload with fewer heartbeats per minute because of the increased amount of blood the heart can pump each beat (SV).

Heart Rate

Heart rate (HR) is the number of times the heart beats per minute. As your client becomes more fit for a given amount of work (e.g., walking or

running a specific distance at a set pace), HR decreases and an increased stroke volume accomplishes the necessary delivery of oxygen and blood. As exercise intensity increases, HR will increase up to a point. When your client reaches or nears her maximum $\dot{V}O_2$ (the highest level of oxygen delivery and utilization), heart rate begins to level off and is referred to as *maximal heart rate* (MHR).

MHR declines with age, and training cannot affect this aging consequence. But staying fit allows a client to work at a higher percentage of her attainable maximum, thus attenuating the greatest of aging effects—inactivity!

Stroke Volume

Stroke volume (SV) is the other primary determinant of \dot{Q} and is the amount of blood ejected from the heart during each beat. Unlike HR and \dot{Q}, SV does not increase linearly (i.e., in a predictable, upward, or increasing manner) with work rate. SV increases progressively until a work rate equivalent to approximately 50 to 75 percent of $\dot{V}O_2$max is reached. Thereafter, continued increases in work rate cause little or no increase in SV.

Exercise-induced increases in SV are believed to be the result of factors that are both intrinsic and extrinsic to the heart. According to the Frank-Starling law, a greater stretch is placed on the muscle fibers of the heart due to a greater venous return of blood to the heart, resulting in a more forceful contraction of those fibers and consequently a greater SV. Extrinsic factors such as increased nervous (sympathetic) or endocrine (release of adrenal hormones epinephrine and norepinephrine) stimulation to the heart also can contribute to the increased SV that occurs during exercise. These types of influences and the improvements that result in increased SV are a direct result of physical training. See the box on page 290 for more information on $\dot{V}O_2$.

Blood Pressure (BP)

Blood pressure is the amount of force exerted on the arterial wall. Understanding the dynamic nature of blood pressure is useful in comprehending how the body responds to exercise.

Systolic blood pressure (SBP) is the force developed by the heart during left ventricular contraction (ejection of blood from the heart's left ventricle). SBP increases linearly with work

rate increases. In other words, as heart rate and exercise intensity increase, so does SBP.

Diastolic blood pressure (DBP) indicates the pressure in the arterial system during ventricular relaxation and reflects the lowest resistance to blood flow. It changes little from rest to maximal levels of exercise in healthy people.

Pulse pressure is the difference between SBP and DBP. It increases in direct proportion to the intensity of exercise. Pulse pressure is significant because it reflects the driving force for blood flow in the arteries.

The sum of all the forces that oppose blood flow in the systemic circulation is called **total peripheral resistance (TPR).** Numerous factors affect TPR, including blood viscosity (thickness), vessel length, hydrostatic pressure (pressure created in a fluid system or environment such as is present in the body), and vessel diameter.

Vessel diameter is by far the most important of these factors. To emphasize what impact this has, if one vessel has one half the radius of another and if all other factors are equal, the larger vessel would have 16 times (i.e., radius of two taken to the fourth power) less resistance than the smaller vessel. As a result, 16 times more blood would flow through the larger vessel at the same pressure.

Certain organs require more blood flow than others during physical activity. The same is true for skeletal muscle. The active muscles demand a greater flow during activity and generally do not require a large volume of blood during rest. During exercise, resistance in the vessels supplying the muscle and skin is decreased. This implies that blood flow to these parts of the body is enhanced.

Resistance in vessels supplying visceral organs (the liver, gastrointestinal tract, kidneys) is increased during activity. Increased resistance indicates that blood flow to the visceral organs is reduced, thus freeing up oxygen for more immediate and demanding needs of the exercising body.

The ability of the body to get blood to the exercising muscle and increase the flow of blood to the surface of the skin to help dissipate heat is attributable to metabolic conditions that instantaneously affect the diameter of arteries and veins. When the diameter is increased,

Understanding VO_2: Oxygen Delivery and Utilization

Volume of oxygen (VO_2).

VO_2 is the scientific representation of how the body delivers and uses oxygen. You need to understand VO_2 when discussing the terms *cardiorespiratory conditioning, aerobic,* and *anaerobic.*

The ability to deliver and "use" or extract oxygen, termed the arteriovenous oxygen difference, or (a-v̄)O_2 difference, depends partially on the amount of blood pumped per minute by the heart (cardiac output or delivery) and specificity (oxygen extraction). These two aspects, delivery and utilization of oxygen, comprise VO_2.

This combination of delivery (\dot{Q}) of blood and extraction [(a-v̄)O_2 difference] of oxygen from blood is represented by the Fick equation.

Fick Equation

$$VO_2 = \dot{Q} \times (a\text{-}\bar{v})O_2 \text{ difference}$$
or simply,
$$VO_2 = \text{Delivery } (\dot{Q}) \times \text{Extraction } [(a\text{-}\bar{v})O_2 \text{ difference}]$$

$\dot{V}O_2$ is a volume of oxygen consumed by the body on a continuum from death (no oxygen requirements!), rest (low-level oxygen requirements), and submaximal activity (moderate to high oxygen requirements), to all-out maximal effort (very high oxygen requirements either during or after the activity). Fick's equation demonstrates the body's ability to deliver (\dot{Q}) blood that is loaded with oxygen, and then extract [(a-v̄)O_2 difference] the oxygen needed for activity as well as other bodily functions that include cell repair and growth.

Cardiac output or \dot{Q} has already been characterized as the blood delivery component of VO_2. You can liken this to a truck leaving a loading dock (the heart), loaded with marbles (oxygen-laden red blood cells), headed for a delivery point (in the case of activity, the exercising muscles). Generally, the more fit a client is and the more he is accustomed to the specific type of activity, the more likely the "delivery" (oxygen) will be accepted (extracted or utilized) at the delivery point (working muscles).

The ability to extract oxygen efficiently is an example of the complexities of biochemistry and training specificity. When, as a result of proper and progressive cardiorespiratory training, a client increases both anaerobic and aerobic enzymes, capillary density, and mitochondria through training adaptations, he is affecting the body's biochemistry and its ability to effectively deliver and use oxygen. This increases the body's capability to produce energy efficiently and effectively.

Arteriovenous oxygen difference.

The (a-v̄)O_2 difference is the technical characterization for *oxygen extraction.* It is the other critical component of VO_2 and indicates the ability of your client's muscle cells to use oxygen. For example, the oxygen content of blood at rest varies from 20 milliliters of oxygen for every 100 milliliters of arterial blood to 14 milliliters of oxygen for every 100 milliliters of venous blood. The difference between these two values, $20 - 14 = 6$ milliliters, is referred to as the arteriovenous oxygen difference, or (a-v̄)O_2 difference.

The (a-v̄)O_2 difference is the difference between the oxygen content of the arterial blood (oxygenated blood as it leaves the heart) and mixed venous blood (after it has passed skeletal muscle and given some of its original oxygen content). This value reflects the extent to which oxygen is extracted or removed from the blood as it passes through the body. Cardiorespiratory conditioning that uses proper exercise intensity, duration, and frequency results in a progressive increase in the (a-v̄)O_2 difference, not to mention increases in $\dot{V}O_2$max. This adaptation reflects a decreasing venous (blood that is returned to the heart) oxygen content and indicates

Continued ➤

➤ *Continued*

a greater utilization of oxygen by the working muscles. Exercising muscles can reduce the oxygen content of venous blood from one half to one third of resting levels in fit clients. This indicates that your client's muscles are extracting a much higher proportion of the oxygen delivered to them (the muscles) in the arterial blood. As much as 85 percent of the oxygen in arterial blood can be removed during maximal exercise in highly trained individuals. It is apparent that effective delivery and transport of the "oxygen molecule cargo" are not very helpful if the oxygen cannot be accepted (extracted) at the delivery site (working muscles).

Maximum oxygen uptake.

At this point, you may be asking yourself, "So, what is the significance of maximum oxygen uptake or $\dot{V}O_2$max?" When a client participates in exercise that is above the intensity of exercise to which he is accustomed, heart rate, respiration, and oxygen intake increase. However, a point occurs beyond which oxygen intake cannot increase, even though more work is being performed. At this point, your client has reached a level that is commonly referred to as maximal oxygen uptake (similar terms include maximal oxygen consumption, maximal aerobic power, or $\dot{V}O_2$max). It is generally assumed that this represents your client's capacity for the *aerobic resynthesis* (production) of ATP.

$\dot{V}O_2$max is considered by many experts to be the single best indicator of cardiorespiratory fitness, because it involves the optimal ability of three major systems—pulmonary (lungs), cardiovascular (heart and blood vessels), and muscular (skeletal muscles)—of the body to take in, transport, and use oxygen. A higher maximal oxygen uptake results in a greater physical working capacity.

However, the ability to deliver and use a large volume of oxygen (i.e., $\dot{V}O_2$) at sustained levels of intensity above rest determines a client's work capacity or how efficient and effective his body can be during activity. In other words, although $\dot{V}O_2$max is important, the percentage of your client's $\dot{V}O_2$max that can be used and sustained is also important. For example, if you compared two clients, client A might have a higher $\dot{V}O_2$max than client B. But let's say that client B can sustain a higher percentage of her lower max compared with client A. Because of client B's capacity to sustain a higher percentage of her lower $\dot{V}O_2$max, client B will outperform client A, even though client A has the higher $\dot{V}O_2$max. It is obvious that $\dot{V}O_2$max is not the lone indicator of a client's ability to perform cardiorespiratory effort.

At any level below $\dot{V}O_2$max, a fit person is able to more efficiently deliver and use that particular volume of oxygen required by the body's systems for that specific activity and intensity. This translates into a more effective and efficient client in terms of physical work capacity. In addition, the client may have developed what I call a "fitness margin." Having a fitness margin means a client has energy left over for daily activities, including time with family, recreation, and hobbies as well as a higher tolerance for dealing with life's accumulated stress.

this is termed **vasodilation.** TPR tends to decrease during progressive, dynamic exercise, because vasodilation is occurring in the muscles and skin. This seems to override the **vasoconstriction** (narrowing of the internal diameter of the blood vessel) that occurs in the organs. The net result is less total resistance to blood flow.

In addition, stimulation of nerves to the venous vessels causes them to "stiffen." Such **venoconstriction** permits large quantities of blood to move from peripheral veins (toward the extremities) into the central circulation.

Vasoconstriction, vasodilation, and venoconstriction all work to allow more blood (and oxygen) to be available for the exercising muscle and the cooling process in the body, thus optimizing the immediate exercise situation.

Any increase in maximum cardiac output directly affects your client's capacity to circulate oxygen. An increase in maximum cardiac output clearly results in a proportionate increase in the potential for aerobic metabolism. Proper C-R training conditions the entire cardiorespiratory system and maximizes the availability of oxygen to the body's systems.

Energy Production and Physiological Adaptations to Exercise

Let's take a look at a practical chronology of how the body makes energy and how it makes physiological adjustments to exercise (overload). This understanding will go a long way in bridging theory and practical application when you are designing programs.

In a healthy person, resting energy needs are predominantly and easily met by the aerobic energy system. When the activity demands placed on the body increase, the body immediately needs greater amounts of energy to sustain this new level of work. However, the rate of aerobic energy production is sluggish when one is moving from low levels of activity to higher levels that demand more oxygen. Oxygen must be breathed in, transferred from the lungs to the blood, carried to the heart, and then pumped to the muscles where it is needed.

Because of the mechanics involved in getting oxygen to the working muscles, a delay exists in the delivery of oxygen from the heart and vascular system. This is termed oxygen deficit; it is associated with the beginning phases of exercise and occurs to some extent even during low-intensity exercise.

Oxygen deficit occurs because oxygen consumption requires several minutes to reach the required oxygen intake for a given, submaximal exercise intensity. Even though the oxygen requirement for the given activity is constant from the very start of the exercise, this initial period of exercise has an oxygen consumption that is below the needed level.

You can ease the transition by including a slower, progressive warm-up in the workout rather than a quick jump to training pace. This gives the body time to shunt blood flow to the exercising muscles. However, you can't completely eliminate oxygen deficit because the immediate energy for muscular work comes from the anaerobic breakdown of ATP in the muscle. Although oxygen deficit will occur to some degree when a person moves from rest to higher levels of cardiorespiratory effort, effects such as breathlessness can be diminished with a proper warm-up.

After the initial minutes of exercise, oxygen consumption increases rapidly until a plateau in oxygen consumption is reached (usually between the third and fourth minute). After the exerciser has reached this plateau, if intensity remains constant, oxygen consumption is relatively stable. This plateau is considered the steady state or steady rate (see figure 15.1).

Steady rate reflects a balance between the energy required by the working muscles and the rate of ATP production by the aerobic energy system. If exercise is started at a slow pace, a steady rate is reached in about the third or fourth minute. Steady-rate activity can be described as a level of cardiorespiratory effort that is relatively easy to maintain; the pace should be easy to sustain for five minutes or longer.

Under steady-rate metabolic conditions, lactate accumulation is minimal because there is an abundance of available oxygen. The energy demands of steady-rate activity are met predominantly by aerobic metabolism of carbohydrates and fat. Steady rate occurs during aerobic glycolysis and submaximal levels of exercise.

A **maximum steady-rate** or -state (MSR or MSS) level equates with anaerobic threshold and blood lactate threshold and varies from one individual to the next. Genetic influences aside, differences depend primarily on a client's ability to deliver and use oxygen according to current cardiorespiratory fitness level. For a sedentary client, going from rest to slow walking at about a 20-minute-per-mile pace may push the need for energy (ATP) by the muscle into anaerobic metabolism. MSR exists at very low-intensity levels of activity. Contrast this to a highly conditioned client, who can maintain energy balance aerobically at very intense levels of exercise. For example, in a highly conditioned and genetically blessed marathon runner, steady-rate aerobic metabolism can be maintained at a pace well under a six-minute mile, for 26 miles! Maximum steady-rate exercise represents a high exercise intensity that your client cannot maintain for prolonged periods of time. For more information on steady rate and cardiorespiratory training, see chapter 18.

Recovery Oxygen Consumption

In **recovery** from exercise, the oxygen consumed in excess of the resting value of oxygen consumption has been termed oxygen debt or recovery oxygen consumption (refer to figure

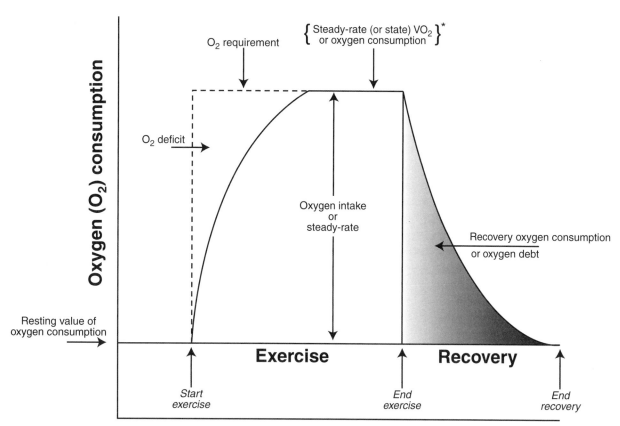

FIGURE 15.1 Oxygen deficit and oxygen debt.

Reprinted from D. Brooks 1998.

15.1). **Recovery oxygen debt** is calculated as the total oxygen consumed in recovery minus the total oxygen that theoretically would be consumed at rest during the recovery period. To understand this concept in manageable terms, I'll use a discussion by scientist A.V. Hill, as reported in McArdle, Katch, and Katch (1991).

In 1922, Hill and others discussed energy metabolism during exercise and recovery in financial-accounting terms. The body's carbohydrate stores were likened to energy "credits." If these stored credits were expended during exercise, then a "debt" was incurred. The greater the energy deficit, or use of available stored energy credits, the larger the energy debt. The accumulation of lactic acid during the anaerobic component of exercise represented utilization of the stored energy credit, glycogen. Although scientists now know that recovery oxygen uptake is a more complex issue, this was thought to represent the metabolic cost of repaying this debt—thus the term *oxygen debt*.

There is no doubt that the elevated aerobic metabolism in recovery is necessary. When a client is breathing harder after activity, more oxygen is being taken in to help restore the body's capability to produce energy (i.e., replenish glycogen stores and synthesis of ATP). In recovery from strenuous exercise, recovery oxygen consumption (oxygen debt) replenishes the high-energy phosphates (ATP-CP, or anaerobic energy) depleted by exercise. In recovery from strenuous to moderate exercise, recovery oxygen also is used to resynthesize a portion of lactic acid to glycogen. The main source for reestablished preexercise glycogen levels, however, is carbohydrate in the diet, not resynthesized lactic acid. Therefore, clients must consume adequate carbohydrate to reestablish glycogen stores in the muscle and liver.

Oxygen debt includes oxygen deficit (figure 15.1). Furthermore, it reflects the energy costs of both (1) anaerobic metabolism during exercise and (2) the respiratory, circulatory, hormonal, tissue repair, ionic (redistribution of calcium,

potassium, and sodium within the muscle and other body parts), and thermal adjustments that occur in recovery (McArdle, Katch, and Katch 1991; 1996). During recovery, all of these processes require oxygen in amounts well above resting rates to return the body to normal.

After any kind of exercise, the body does not return immediately to a resting level of oxygen consumption. One function of a cool-down is to safely and with the least amount of physiological stress return the body to a resting $\dot{V}O_2$ level. During submaximal (easy to moderate) efforts, the return to resting level after exercise is hardly noticeable. During strenuous activity, the return to preactivity metabolic rate (resting oxygen consumption or $\dot{V}O_2$) is perceptible in terms of, for example, breathing rate, possibly sweat rate, and increased time necessary to return to preexercise levels.

Implications of Oxygen Debt for Exercise and Recovery

Procedures for speeding recovery from exercise generally can be labeled as either active or passive. In **active recovery,** which is often called "cooling-down" or "tapering-off," submaximal exercise is performed in the belief that this continued movement in some way prevents muscle cramps and stiffness and facilitates the recovery process. With **passive recovery,** the person usually lies down or is totally inactive, with the hope that complete inactivity may reduce overall energy requirements and thus free oxygen for the recovery process.

Argument for passive recovery. When a person is recovering from steady-rate exercise, the recovery is more rapid with passive procedures because no appreciable lactic acid accumulates with steady-rate aerobic exercise. Regardless, additional exercise can begin again quite quickly without the hindering effects of fatigue.

It may be argued that both lying down (passive) or low-level activity will facilitate recovery fairly quickly. Even though research indicates that the passive method is optimum, the passive approach may be more appropriate if, for example, you are working with a client who has a history of heart disease, if a heart attack or symptoms indicating a potential for one have occurred, or if you are trying to optimize a specific training response. Practically speaking, low-level activity will not hinder your client's recovery in most instances.

Argument for active recovery. When exercise intensity for the average individual exceeds about 55 to 60 percent of $\dot{V}O_2$max (about 70-75 percent of maximum heart rate), a steady rate of aerobic metabolism is usually no longer maintained. Lactic acid formation can exceed its rate of removal, and lactic acid accumulates. Soon the exerciser becomes exhausted. (Highly trained endurance athletes can maintain 85 percent or greater of their $\dot{V}O_2$max at a steady rate and very fit clients can work at higher percentages of their maximum capacities—i.e., 75-85 percent—without accumulating significant amounts of lactic acid.)

Lactic acid removal is accelerated by active recovery. Large-muscle, rhythmic activity that is at about steady rate or lower is clearly more effective in facilitating lactate removal compared with passive recovery (Plowman and Smith 1997; McArdle, Katch, and Katch 1991; 1996). It is unclear why active recovery benefits lactic acid removal, although it may be the result of increased blood flow both through "lactate-using" organs like the liver and heart and through the muscles, which can also use lactate. However, if the exercise participated in during active recovery is too intense, and is at or above the lactate or steady-rate threshold, it can prolong recovery by increasing lactic acid formation.

Practical application. This information about lactic acid production and MSR should have a great impact on how you train clients for sports such as long-distance running, basketball, soccer, or tennis. During practice or competition, if a client is pushed to a high level of anaerobic metabolism, she may not fully recover during the brief rest periods inherent to a particular activity or sport. This may affect performance or ability to compete at a competitive level or can increase the risk for injury. The solution lies in sport-specific training that trains the client at and above MSR and replicates energy production and recovery that occur in the activity.

Clients whose primary goals are health and fitness, when left to their own choice, will often naturally select or fall into an optimal recovery exercise intensity (McArdle, Katch, and Katch 1991; 1996). Recovery intensity should occur

below lactate-accumulation threshold or at a level of exercise intensity that the client can easily maintain without breathlessness. The client should be able to speak three or four words at a time without gasping and should report that muscles do not ache or burn (from lactic acid accumulation). Appropriate recovery exercise or cool-down helps return the body's systems to normal or resting levels.

Applying Overload to Cardiorespiratory Fitness

When you are designing exercise programs, you must apply the appropriate amount of overload to improve the cardiorespiratory system.

Complete overload for cardiorespiratory training could be defined as a rhythmic, continuous, large-muscle activity that promotes a simultaneous increase in heart rate and return of blood (venous return) to the heart. If continued improvements are to be realized, the overload must be progressive in nature.

Many factors may increase heart rate without increasing blood return to the heart, such as the influence of drugs, excitement, heat, or traditional resistance training. Yet sustaining a large volume of venous return is essential for a significant training effect to occur in cardiorespiratory fitness.

To further shape the cardiorespiratory overload definition, frequency, intensity, and duration must be considered. Once you have identified the right kind of activity that satisfies the overload definition, it is generally recommended that your client exercise and challenge this component of fitness three to five times per week.

ACSM (1995) intensity guidelines for healthy adults are set at 50 to 85 percent of $\dot{V}O_2$max or heart rate reserve (HRR). This compares with 60 to 90 percent of maximum heart rate (MHR). The recommended duration is 20 to 60 minutes.

The minimum threshold for increasing $\dot{V}O_2$max is 50 percent of $\dot{V}O_2$max or HRR. This compares to about 60 percent of MHR. However, an increase in $\dot{V}O_2$max is not essential for substantial and beneficial effects on your client's health or improvements in cardiorespiratory endurance. Additionally, research suggests that frequency and duration greatly influence $\dot{V}O_2$max and that total volume of work (frequency, intensity, and duration) has more impact with regard to cardiorespiratory adaptations compared with focusing on intensity or duration individually (Plowman and Smith 1997).

The ability to work at a higher percentage of $\dot{V}O_2$max (not necessarily increasing maximum $\dot{V}O_2$) and improve your client's health is enhanced by moderate and consistent C-R training. This includes both continuous training (aerobic) and interval training (largely anaerobic) to optimize cardiorespiratory fitness (chapter 18).

Physiological Outcome of Correct Cardiorespiratory Exercise Overload

The correct exercise overload may have the following effects in creating a more efficient cardiorespiratory system that is able to better deliver and extract oxygen.

The following points are well documented:

1. **Capillary density** increases with endurance-type training. This increased capillarization allows for better distribution of nutrients and oxygen to the working muscle and enhances metabolic by-product (lactic acid, carbon dioxide, water) removal.

2. The size and number of **mitochondria,** which are characterized as aerobic "powerhouses" in the cell, increase with endurance training. This adaptation allows a higher level of aerobic metabolism to be maintained because aerobic metabolism occurs in the mitochondria.

3. **Aerobic enzymes** (protein substances in the cell that facilitate energy production) increase with endurance training and enhance the ability to use oxygen more efficiently. This adaptation facilitates the aerobic energy-production process.

4. **High-intensity interval conditioning** has a positive training effect on shifting the metabolic profile of fast-twitch, type IIa muscle fibers toward a fiber with greater endurance.

5. **Blood delivery (cardiac output or \dot{Q})** is improved by a stronger heart that has a greater pumping or volume capacity per heartbeat.

6. **Oxygen extraction,** or (a-\bar{v})O_2 difference, is improved by regular and specific training.

Such physiological and biochemical changes in the muscle cells of the body enhance the cell's capacity to generate ATP aerobically while working at increasingly higher levels of exercise intensity.

Choosing the Training Method

When cardiorespiratory fitness levels improve, goals change, or client interests vary, you can use any large-muscle, rhythmic activity to challenge the client. No one cardiorespiratory activity is better than another.

The appropriate approach to exercise training in general is to analyze an activity in terms of its specific energy requirements and then train specifically to improve those systems. An improved capacity for energy transfer (oxygen delivery and utilization) usually translates into improved exercise performance and health.

Optimizing cardiorespiratory conditioning requires training of both aerobic and anaerobic pathways. Interval conditioning can increase your client's ability to delay the need for anaerobic glycolysis by increasing an individual's anaerobic threshold or maximum steady rate (MSR). Adaptations to intermittent cardiorespiratory work efforts (interval training) that are above what your client normally works at (steady rate) increase your client's ability to work at increasingly intense workloads that would not have been possible in a less trained state.

How you choose to train depends on whether the activity fits your client and he is motivated to pursue it. In terms of intensity or level of effort, it helps to ask, "Right intensity for what?" Consider such issues as your client's current fitness level and personal goals. Ask whether he is training for performance, improved fitness, maximal caloric expenditure, "fat burning," or other health-related issues.

Excellent cardiorespiratory activities include, but are not limited to, walking, swimming, water fitness, jogging, running, cross-country skiing, skate skiing, in-line skating, lateral movement training (slide), indoor cycle training, outdoor cycling, mountain biking, and step training.

As with all programming decisions, take a realistic look at your client's time availability and psychological profile. Work within his parameters, emphasizing individual makeup and drive, and identify activities he truly enjoys.

Cardiorespiratory training does not have to be boring or repetitive. By choosing regimens that enhance both the aerobic and anaerobic energy systems, you can keep C-R conditioning motivating. You need to know how the energy systems interact to set the appropriate intensity levels and to match training with client goals. See chapters 17 and 18 for help in gauging the right exercise intensity and additional programming ideas for cardiorespiratory training.

Physiology of Resistance Training and Muscular Fitness

Adequate muscular strength and endurance are extremely beneficial for all of your clients. Every client needs to maintain muscular fitness and muscle mass.

Resistance training is the process of overloading the muscular system (Fleck and Kraemer 1997). The term **resistance training** is used to cover all types of strength or weight training, including these:

- Free weights (dynamic constant resistance)
- Variable resistance (dynamic variable resistance)
- Elastic resistance (another form of dynamic variable resistance)
- Concentric, eccentric, and isometric force production (commonly lumped together as different types of "muscle contractions" but more accurately labeled as types of force production)
- Isokinetic training

Resistance training not only develops muscular strength and endurance but also can improve the muscles' ability to recover from the physical stresses of daily life. Moreover, some of the deterioration of physical fitness associated with aging may be lessened with regular exercise training, especially resistance training (Evans and Rosenberg 1991; Wilmore and Costill 1994).

Health Benefits Associated With Resistance Training

- Fat loss, weight control, weight maintenance
- Increased metabolism
- Increased calorie burning during resistance training
- Increased calorie burning after exercise
- Reductions in resting blood pressure for clients with high blood pressure or borderline high blood pressure
- Decreased risk for type 2 diabetes (previously referred to as adult-onset diabetes or non-insulin-dependent diabetes mellitus)
- Positive changes in blood lipid profiles
- Decreased risk for osteoporosis
- Increased bone mineral content
- Improved structural and functional integrity of tendons and ligaments
- Personal physical independence
- Protection from joint and muscle injury
- Enhanced physical activity experiences
- Improved posture
- Improved physical image
- Improved self-esteem

Clients can see significant results from proper resistance or strength training because many people have followed ineffective strength programs or have never participated in a program. As a personal trainer, you are in the position to design effective strength training programs once you understand skeletal muscle structure and function. Then you can bridge this theory into day-to-day applications (chapter 19) to help clients achieve their goals.

Structure of Skeletal Muscle

Muscle is composed mainly of water and protein. The physical structure of muscle looks like this: Millions of muscle fibers are individually wrapped by a connective tissue, or fascia, called endomysium. These fibers are then grouped—like a bundle of straws—and surrounded by a second layer of tissue called the perimysium. These groups together form the muscle, which is itself covered in a fibrous, fascial layer of connective tissue called the epimysium, which then tapers to form the dense and strong tendons attaching the muscle to the bone. See figure

15.2 for an illustration of skeletal muscle structure and anatomy.

Gross Muscular Contraction and Movement

Tendons attach muscles to bones at points called origins and insertions. Origins are where the tendon attaches to the more stable part of the body (usually closest to the midline). Insertions, where the muscle attaches to the more moveable skeletal structure, are usually distal. The tendinous attachment of the muscle that is least stable (generally the insertion) will be drawn toward the origin.

For example, the biceps muscle crosses the shoulder and the elbow joints. Of the two attachment areas, the shoulder (origin) generally is accepted to be more stable in conventional elbow flexion movements. The insertion (below the elbow) of the biceps moves toward the origin when the muscle contracts, because the muscle contracts toward its middle. Note that the effect of origin and insertion can sometimes be reversed by stabilizing various body parts.

Finally, the force of muscular contraction is transmitted directly from muscle's connective

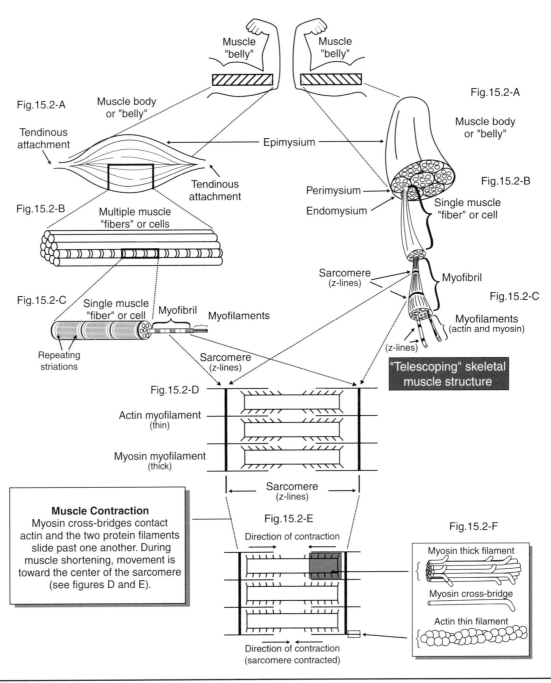

FIGURE 15.2 Skeletal muscle structure and anatomy.

Reprinted from D. Brooks 1998.

tissue harness (endomysium, perimysium, and epimysium culminating in tendons), via tendons, to these skeletal attachment points referred to as origin and insertion.

Inside the Fascia

Beneath the endomysium that wraps individual muscle fibers is the **sarcolemma.** The sarcolemma is a thin, stretchable membrane (like plastic wrap) that houses the muscle fiber's contractile proteins (actin and myosin), enzymes, fat, glycogen, nuclei, and specialized cellular organelles. **Sarcoplasm,** contained within the sarcolemma, bathes these cellular contents. Located within sarcoplasm is the **sarcoplasmic reticulum.** This serves as a delivery network, via interconnecting tubular channels, to help facilitate muscular contraction. The sarcoplasmic reticulum also provides the muscle fiber with additional structural integrity.

Supplying Blood to the Muscle

Muscles need oxygen from circulating blood. To accommodate these needs, the blood vessels constrict and dilate, moderating the delivery of blood to the muscles. During large-muscle, continuous activity, this vasoconstriction and vasodilation occur rhythmically. Combined with a "milking action" caused by active muscle, this rhythmic pulse helps the heart facilitate efficient blood delivery throughout the body. But during strenuous activity, where muscle contracts to about 60 percent of its capacity (about 15 reps or less to failure), blood flow to involved muscle may entirely stop.

Another factor affecting blood flow is the Valsalva maneuver, which occurs when an exerciser holds his breath momentarily while beginning a strenuous effort. This alters the pressures within the body, which in turn causes the heart to work harder to supply oxygen to the muscles—increasing both heart rate and blood pressure.

Breath holding may present a health risk to a client with, for example, undiagnosed heart disease or high blood pressure by putting more of a load on the heart through increased heart rate and additional demand for oxygen in the cardiac muscle.

Although momentary breath holding is generally a normal occurrence during the beginning of each strength exercise repetition, the key is to make sure your client does not sustain it through the entire repetition. This scenario lends additional importance to properly screening your clients and receiving medical clearance or guidance if questions arise concerning the potential for undiagnosed disease (chapter 10).

Microstructure of Skeletal Muscle

On a microscopic level, muscle fibers are composed of several levels of subcellular organization. Each muscle fiber is made up of smaller units called myofibrils, or simply fibrils. These, in turn, are made up of even smaller units called myofilaments, or filaments. And these myofilaments are made up of even smaller repeating units named sarcomeres—the smallest functional contractile unit of muscle fiber. Sarcomeres contain the proteins actin and myosin; the thin actin filaments and thick myosin filaments are key players in the mechanical process of muscular contraction (figure 15.2c-f).

Skeletal Muscle Structure and Anatomy

To envision the telescoping nature of the muscle, start by "seeing" a single muscle fiber as a straw (figure 15.2 b and c). Within this straw, and lying parallel, are numerous smaller straws, or myofibrils (figure 15.2c). If we look at the end of the straw, or at a cross-sectional view, the ends of the myofibrils are peppered with small black dots. (This looks like an arrangement of small black dots made by a pencil point.) Within the smaller myofibril straws, as compared with a single muscle fiber, are thinner straws (small black dots) that are the myofilaments (figure 15.2c). Now you can see how these subcellular units are put together much like three telescoping sleeves (the straws). From a group of muscle fibers, one single fiber may be "telescoped" out, followed by a myofibril and then a myofilament. They slide neatly into one another and are parallel (figure 15.2a-c).

Sliding Filament Theory: How Muscles Contract

Actin and myosin proteins overlap in such a way that they connect as the muscle contracts. As long as the stimulus for contraction is strong enough, the actin and myosin filaments slide past one another, contacting and then releasing contact over and over. Although the filaments do not change length, the sliding filament theory suggests that this contact between the myofilaments causes muscles to shorten or lengthen as they slide past each other (figure 15.2d-f).

Myosin has hockey stick-shaped structures (cross-bridges) with the curved ends extending toward the thinner actin filaments (which are shaped rather like strings of fish eggs). As they slide past each other, the "hook" end of the myosin contacts the string of actin and causes the actin to move or slide over the myosin filament. This action, a contact and release movement performed over and over—likened to a person climbing a rope hand over hand—allows the muscle to lengthen or shorten during dynamic force production (figure 15.2d-f).

Although the actual process is quite complex, note that the rearrangement of actin and myosin moves toward the middle of the

sarcomere (figure 15.2d and e). Consequently, the least stable end of a muscle's attachment (usually the insertion) is going to be more movable and will move toward the more stabilized attachment (usually the origin). Because a muscle contracts toward its center, as evidenced by the mechanical action of actin and myosin in the sarcomere, tension will be created on both tendinous attachments. If one is more mobile than the other, it will move toward the other attachment point. If both are fixed or stabilized, such as during isometric force production, considerable force may be produced, but little to no movement will occur at the joint. This concept will help you understand how movement occurs in the human body, and it gives you the ability to evaluate and design effective and safe strength exercises (chapter 19).

Motor Unit Nerve Supply to the Muscle

Although all muscle fibers share a basic structure, skeletal muscle fibers can be further classified by their contractile and metabolic characteristics. The major muscle fiber classifications are slow twitch (ST) and fast twitch (FT).

Slow-twitch fibers (type I) contract relatively slowly and generate energy predominantly through aerobic metabolism. Fast-twitch fibers are further divided into FT type IIa and FT type IIb (a third FT category also has been identified, but here we focus on type IIa and IIb fibers). FT type IIb fibers generate energy mostly through anaerobic pathways, whereas FT type IIa fibers show a combination of FT and ST fiber traits. FT type IIa can contribute to aerobic or anaerobic training, depending on the type of training being executed. For example, traditional interval training would have very different effects on FT IIa muscle fibers than traditional strength training.

Muscle fibers contract at the command of a **motor nerve.** A **motor unit** is defined as a motor nerve and all of the specific muscle fibers it innervates or activates. More specifically, motor units contract, all or none, at the command of a motor nerve. As the sarcomere is the smallest functional unit of muscle contraction, so the motor unit is the smallest functional unit of neuromuscular control.

One single motor nerve usually serves many individual muscle fibers. This is possible because of the structure of the nerve; the nerve unit ends in an axon with many branches reaching to the muscle fibers. The number of muscle fibers innervated by a specific nerve generally is related to the type of movement the muscle must perform. The more precise and specific the motor function, the fewer muscle fibers served by the motor nerve. Therefore, delicate work like that performed by the eye muscles may require a nerve to serve fewer than 10 muscle fibers, whereas less complicated movements requiring gross motor control may involve a few thousand fibers stimulated by one nerve.

The way in which motor units activate fibers is crucial to skilled or powerful movement. To understand how the muscle varies force, remember that each muscle has many motor nerves available to activate its many muscle fibers. The type and intensity of activity will determine which motor units are activated.

Characteristics of Motor Units

As mentioned previously, motor units respond to nerve stimulus in an all-or-nothing manner. When the nervous system says move, all the fibers of a motor unit move simultaneously. However, that doesn't mean the entire muscle responds; because a single muscle may have hundreds of motor units, the nervous system may call up many or only a few. Moreover, the frequency at which the motor units fire is variable, meaning it can be increased or decreased to assist in controlling force production. This force regulation is called force gradation, and it allows us to control our movements. By blending recruitment of motor units and the rate of their firing, optimal patterns of neural discharge permit a wide variety of graded (weak to strong) contractions (McArdle, Katch, and Katch 1991; 1996).

Motor units consist of fibers of one specific type (either FT or ST) or subdivision of a particular fiber type (i.e., FT IIa or IIb) that have the same metabolic profile (McArdle, Katch, and Katch 1991; 1996). Remember, each muscle of the body contains many motor units. If the proper and varied overload is not used with your clients, their training programs may not be stimulating the desired motor units and optimizing the overall training result. Table 15.2 summarizes the characteristics of motor units.

Motor units are classified into one of three categories depending on the following:

1. Their speed of contraction
2. The amount of force they generate
3. Whether they resist fatigue or, conversely, fatigue relatively quickly

Fast-Twitch Fibers

FT muscle fibers or motor units, especially type IIb, generate energy very quickly for swift, forceful contractions (like a 40-yard sprint or a 1RM lift). These fibers are involved in high-intensity, short-duration work bouts that depend almost entirely on anaerobic metabolism for energy. These units reach greater peak tension than slow-twitch muscle units and develop that tension nearly twice as fast. FT fibers also fatigue more quickly; a short set of 2 to 10 reps to muscle fatigue would require significant contribution from both type IIa and IIb fibers.

Slow-Twitch Fibers

ST, or type I, fibers or motor units are ideal for the performance of low-intensity, long-duration (endurance) activities. Activities like this include long-distance running, swimming, walking, and long sets of low-intensity resistance training exercise (about 20 repetitions or more).

ST fibers generate energy through aerobic energy transfer. Their high concentration of mitochondria, high levels of myoglobin, and proportionately larger capacity for blood flow give ST fibers a greater aptitude for aerobic metabolism. Although they fire and contract more slowly than FT fibers, ST fibers are much more fatigue resistant.

Characteristics of ST fibers include high aerobic enzyme activity, high capillary density (for better oxygen delivery and by-product removal), high intramuscular triglyceride (fat) stores, and a high resistance to muscular fatigue.

Hereditary Influences and Fiber Type Distribution

The percentage of either FT or ST fibers that you have in your body is determined largely by genetics. Research indicates that what a person is born with, in terms of percentage of FT versus ST fibers, probably remains fairly constant throughout life. Because genes definitely affect performance and adaptation to training loads, it's easy to see the significance of not being able to choose your parents! How well a client performs compared with others is largely determined by individual genetic makeup. But all of your clients can realize dramatic improvements in muscular strength and endurance gains relative to their starting point.

Fiber Type Conversion

Research indicates that it is probably not likely that FT fibers will change to ST fibers, or vice versa, in normal training conditions. However, it is interesting to note that an extensive review of research showed that extreme and prolonged training may change skeletal muscle fiber type. This does not mean, however, that fibers actually physically change to another type. Instead, it means that chronic stimulation may transform the basic properties of muscle fibers. High-intensity interval training, for example, might contribute to this type of response in FT IIa fibers. This is possible because the fibers' metabolic characteristics and the threshold at which the motor neuron fires determine the appropriate level of intensity (and type of activity) that will engage the motor unit.

Practical Considerations

A more practical fact is that particular metabolic characteristics of all fiber types can be

T A B L E 15.2 Characteristics of Motor Units

Type I: slow twitch	Slow contraction speed	Low force (tension) production	Highly resistant to fatigue
Type IIa: fast twitch	Fast contraction speed	Characteristics (i.e., of fatigue and amount of force production) can be influenced by the type of training	Fatigue resistant
Type IIb: fast twitch	Fast contraction speed	High force production	Susceptible to quick fatigue

Reprinted from D. Brooks 1998.

modified by specific training. High-intensity, anaerobic strength training is necessary to stimulate optimal FT fiber adaptation. This includes, for example, increases in muscle size and anaerobic enzymes. On the other hand, the highly adaptable FT IIa fiber, with prolonged high-intensity cardiorespiratory training, can become almost as fatigue resistant as the slow-twitch units (McArdle, Katch, and Katch 1991; 1996).

But high-repetition schemes (greater than about 20 reps) or endurance activities will not significantly call these FT IIa motor units into play. Because of this, your client will never realize optimal muscular development unless you choose a correct and specific overload that causes these units to adapt to a load placed on the body that requires their activation.

Order of Fiber-Type Recruitment or "Firing Pattern"

Motor units are recruited in a particular order that best allows them to control muscle movement. This recruitment order is affected by the type of activity, the force required, the movement pattern, and the position of the body; of these four, force or intensity "rules." In other words, intensity or the amount of resistance used will have the greatest impact on the development of muscular fitness.

This is called a "ramplike recruitment effect." In muscular activity requiring contractions of increasing force, ST motor units are recruited for lighter effort. When effort moves to higher intensities rather quickly, FT units are required (see figure 15.3). This ensures that slow-fatiguing ST fibers are engaged first, leaving quickly fatigued FT fibers available for strenuous effort. The theoretical and simplified order of recruitment would be ST followed by FT IIa and finally followed by FT IIb motor units. The key factors determining whether FT or ST motor units are recruited are the total amount of force and speed of contraction necessary to perform the movement pattern or muscular contraction.

The average client has a ratio of 50 percent FT to about 50 percent ST motor units, which means that performing low-intensity work will challenge half the muscle mass in an individual's body. This has implications for both cardiorespiratory fitness and muscular strength and endurance. Steady-rate training exclusively will not develop a cardiorespiratory training effect in the highly adaptable FT IIa fibers, and strength training repetitions of 20 reps or higher will not significantly call into play FT motor units, which are highly conducive to strength gains and hypertrophy, based on their contractile and metabolic characteristics.

Regarding strength training, I want to make this point again. In the average body, 50 percent of the muscle mass that is especially well suited for gains in strength and hypertrophy will not be developed to a large extent if not challenged with sufficient intensity. To significantly recruit FT fibers, resistance exercise must be sufficiently intense (Grimby and Hannerz 1977, as reported in Fleck and Kraemer 1997). This is not new information!

Practical Application

As a trainer, you do not necessarily have to add weight to affect motor-unit recruitment and create a new overload. Although adding weight is often a first step, simply changing the exercise movement or the participant's position will provide overload (change) without increasing absolute weight being lifted.

For multifunctional muscles, order of motor-unit recruitment can also change from one movement to another. For example, motor-unit recruitment order in the quadriceps is different for performance of a seated leg extension on a machine compared with knee extension performed during a squat movement (Fleck and Kraemer 1997). Variation in motor-unit recruitment order is most likely one of the factors responsible for additional strength gains even though the same muscle groups may be involved in a similar exercise variation or different exercises.

Variation in recruitment order provides some evidence that to completely develop a particular muscle (activate more motor units), it must be exercised with several different movements or types of equipment, even though the same joint actions and muscle groups are used. In addition, exercise must be of sufficient intensity to stimulate recruitment of FT IIa and IIb motor units.

Speed of Movement

If a large amount of force is necessary either to move a heavy weight slowly or to move a light weight quickly, predominantly FT motor

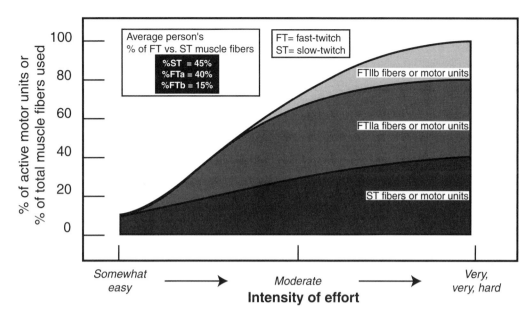

FIGURE 15.3 Ramp-like recruitment (order of muscle fiber or motor unit recruitment patterns). Reprinted from D. Brooks 1998.

units are recruited. More total force is exerted when a heavy weight is moved slowly and controlled through a range of movement. This is true even though the same amount of work is accomplished whether you move a weight slowly or quickly (e.g., when one is performing a biceps curl, the hand is successfully brought toward the shoulder regardless of movement speed).

Although there are some sport-specific performance issues related to speed of movement and specificity, most of your clients would probably gain the most benefit from their resistance training program by moving an appropriate overload through an appropriate range of movement in a controlled and steady manner.

Such information helps you understand the specific requirements along the continuum for training and competition versus health and fitness improvements. Scientific information backs the idea that training done at a slow pace

and with light force will emphasize the use of mostly ST fibers, inducing little training effect on FT IIa or FT IIb fibers. Long, slow training bouts—or, for that matter, long, fast training bouts—that use high-repetition schemes do not generally prepare muscle for the demands of competition or higher muscular forces and do not optimize stimulation and training effect of your client's muscle mass.

Even functional strength training, which usually emphasizes "usable" muscular endurance, balance, and maintenance of correct body alignment, should incorporate some high-intensity strength training or functional strength drills that focus on the development of power (product of force and speed). This type of training can prepare the body for high force requirements provided by everyday challenges, such as reacting to a loss of balance on a slippery surface, not to mention sport-specific preparation.

*30-90 sec.
fatigue*

Developing Muscular Strength and Muscular Endurance

Both muscular strength and muscular endurance contribute to the health and well-being of your clients. **Muscular strength** refers to the muscle's ability to exert force at a given speed of movement. There is a wide continuum of muscular strength, ranging from repeated contractions to a 1RM effort (the greatest amount of weight that can be lifted once, with good form). **Muscular endurance** refers to the ability of your client to persist in physical activity or resist premature muscular fatigue.

With chronic exercise, a number of adaptations occur in the neuromuscular system. Of course, the extent of these adaptations will depend on the type of training program followed. If training emphasizes cardiorespiratory endurance, such as jogging, walking, or swimming, then little or no gain in strength will occur. Likewise, a program of stretching to increase flexibility, combined with light calisthenics, will produce substantial gains in flexibility, small to moderate gains in muscular endurance and strength, and no gain in cardiorespiratory fitness.

The bottom line is that if you want to optimize adaptation and results in any component of fitness, focus on and train that area of fitness with separate and specific overload.

Developing Strength and Hypertrophy

Muscular fitness is developed by placing a demand, or overload, on the muscles in a manner in which the muscle is not accustomed. If overload is applied in a progressive and sensible manner, the neuromuscular system will adapt positively to this demand. As a result, your client becomes stronger, undergoes changes in physical appearance, and is better able to sustain muscular activity that requires muscle endurance or strength.

Muscular Strength Overload Definition

The general guideline for improvement calls for exercise that uses a progressive increase in resistance over time, causes the targeted muscles to fatigue in about 30 to 90 seconds, and results in challenges for all major movements (joint actions) to which the muscles contribute.

As your client gets stronger, she will need to increase the resistance she works against to continue increasing her strength and endurance. Also, gradual increases in intensity will reduce the likelihood of injury. Appropriate intensity (attaining muscular fatigue in about 30-90 seconds) is necessary to optimize training results. All major movements of the body must be challenged to ensure balanced strength between opposing muscle groups of the body.

Factors Influencing Strength

Numerous authors cite several factors that influence strength or the amount of force that can be exerted during a muscle contraction. Neural inhibition, number of contracting muscle fibers, contractile state of fibers, and mechanical advantage or disadvantage of the lever system influence force generation. Furthermore, a stretched muscle is capable of exerting more force, whereas a muscle that is overstretched will produce less force, because the contractile proteins actin and myosin are not favorably aligned. Several factors, including sex, muscle size, and muscle fiber type, influence muscular strength and endurance gains as well as muscle hypertrophy.

How Muscles Become Stronger

There are many myths and misconceptions in the area of resistance training. Just how exactly does your client become stronger? For many years it was assumed that strength gains were a direct result of increases in muscle size. But, recent research suggests that there is more involved in understanding the basic mechanisms of strength gains than a simple relationship to the size of the muscle. This may be because of adaptations in the way the muscle works or rather in the way motor units recruit and fire. This is particularly true for understanding strength gains that occur in the absence of hypertrophy, such that occur when youth strength train, as well as for understanding superhuman physical accomplishments (like the headline, "Boy Lifts Car Off Chest of Trapped Father").

This is not to imply that muscle size does not affect the ultimate strength potential of muscle. However, these examples indicate that mechanisms responsible for gains in strength are very complex, are multifaceted, and are not well understood by scientists at this time.

Neural Influences on Muscular Strength

The neurons that control muscles have the ability to cause muscle contraction and prevent you from exerting more force than the body can handle; you can manipulate these excitatory and inhibitory impulses to increase strength gains. Through a progressive strength training program, connective tissues can be strengthened, allowing more force to be exerted before a neuro-reflex causes the muscle to relax. It is possible that proper resistance training can gradually overcome or counteract inhibitory impulses that can limit strength gains. This would enable muscle to reach greater levels of strength and force production, which would typically occur following participation in a strength training program.

Note also that whether an individual motor unit will fire or remain relaxed depends on the sum of all the impulses acting on it. That means that if there are more excitatory impulses commanding the motor unit to fire than inhibitory influences commanding it to relax, the unit will be activated and will contribute to muscle contraction.

Research clearly indicates that neural adaptations could be the key factor in increasing strength through strength training (McDonagh and Davies 1984; Wilmore and Costill 1994). In fact, researcher Michael Pollock believes that as much as 75 to 80 percent of the increases in strength attributable to a resistance training program may be related to neural adaptations, whereas only about 25 percent of strength increases may be related to muscle hypertrophy (ACSM 1990, 1995).

Early Training and Strength Adaptations

Generally, adaptations to resistance training during the first four to six weeks of a training program occur on the neural level, whereas physical (hypertrophy) changes to the muscle itself predominate after an introductory phase. However, neural adaptations still occur after this point; highly trained athletes rely largely on neural adaptations to increase strength. And finally, these neural influences together with hormonal influences help scientists explain sudden bursts of extreme strength not precipitated by a training program (e.g., "Boy Lifts Car Off Chest of Trapped Father").

It seems likely that significant gains in strength are the result of an increased ability to recruit additional motor units, sustain them in a contracted state (frequency of firing), and synchronize their firing to facilitate contraction and maximization of force production.

It is documented that nervous system adaptations and a learning curve that exists for new activities at least partially account for your client's ability to lift more absolute weight and produce more muscular force within the early weeks of training. Because most studies typically involve training programs that last 8 to 20 weeks, much of the documented improvement in muscle strength is related to this combination of neural and physical adaptations.

Neural adaptations to resistance training include both an increase in the number of motor units that can be fired at any give time and an increase in the frequency of motor unit firing. Increasing the number of motor units that are fired may be caused by an increase in neural drive to the muscle or a removal of neural inhibition. Improved coordination among agonist muscles (muscles that work together to produce a specific movement) and deactivation of antagonist muscles (muscles that produce force and movement in the opposite direction) may also contribute to the ability to generate greater muscular force following resistance training.

Muscle Hypertrophy

Although it is not known specifically how training stimulates increased protein synthesis, there are two current hypotheses to explain how muscles hypertrophy.

The first says that cells can "read" a signal prompted by tension developed in the muscle during resistance exercise. This hypothesis is supported by the fact that little or no hypertrophy occurs during resistance training when intensity is low.

The second hypothesis involves the theory of breakdown and repair. According to this theory, during each training session part of the muscle is broken down, and the repair process gradually builds up muscle to a higher level. The breakdown and repair hypothesis is supported by studies that have identified skeletal muscle damage following heavy resistance exercise through key markers in the blood.

However, muscle damage associated with a strenuous effort should not imply a cause-and-effect relationship between gains in strength and hypertrophy. The process of hypertrophy is directly related to the synthesis (putting together) of cellular material. This is particularly true of actin and myosin protein filaments that constitute the functional contractile elements (sarcomeres) of muscle. The word *synthesis* implies that strength training is a positive, building (anabolic) process, as opposed to a negative or catabolic (breaking down) process.

In my opinion, physiological evidence indicates that some breakdown of muscle will occur as an inevitable consequence of aggressive training (proper intensity to maximize strength and hypertrophy gains). However, I don't believe that muscle repairs and grows stronger as a result of muscle damage. The key stimulus for protein synthesis and neural adaptation is proper overload. Muscle damage does not, of itself, stimulate muscle to grow or the nervous system to adapt. However, muscle damage is often a common result of hard training.

As an example, you can overstretch a muscle and create soreness, which is more accurately identified as muscle damage, or microtrauma. However, damaging muscle in any training scenario is not the proper and specific overload stimulus to cause positive growth or nervous system adaptations. Additionally, because of microtrauma and related scarring in muscle tissue that is associated with excessive muscle damage, and the resultant lesser blood supply to the scarred area because of accumulated trauma, the fibers are more susceptible to recurrent injury.

Sex Differences Related to Resistance Training

Until puberty, boys and girls share similar strength levels; afterwards, increasing levels of the hormone testosterone give boys, on average, an edge in developing muscle size and strength. Testosterone levels are on a continuum between men and women, with some females normally possessing high levels of this hormone (McArdle, Katch, and Katch 1991; 1996).

However, size of muscle is not the entire story. The issue, in terms of muscular force

generation, is not as simple as it seems. For instance, how do you explain similar strength improvements in men and women, even though muscular hypertrophy is typically less in women? In terms of sex differences, the main difference in response to resistance training between men and women seems to be only the degree of muscle hypertrophy (McArdle, Katch, and Katch 1991; 1996). And a larger and stronger muscle is not necessarily more successful in sport or everyday tasks.

In absolute measures of strength, men are approximately 35 percent stronger than women in total body strength. Studies indicate that college women tend to have about half the arm and shoulder strength, and about 30 percent less leg strength, than college men (Sharkey 1990). The relationship between testosterone and strength could be incidental (i.e., high levels of testosterone equate to high levels of strength and the ability to gain significant size), or strength differences could be attributable to other factors. Testosterone may make one more aggressive, and aggressive individuals train harder. Additionally, regarding the strength discrepancies between men and women and between the upper and lower body, more of the lean body mass of women is found in the lower body, whereas more of the lean mass of men is found in the upper body. Another likely possibility is related to body fat.

Women generally have more sex-specific body fat than men. When strength per pound of lean body weight (body weight minus fat weight) is considered, women have slightly stronger legs, whereas arm strength is still some 30 percent below men's values. Wilmore and Costill (1994, p. 447) suggested that because women use their legs as men do, they are similar in strength. It may be that the typical woman's role in our society does not encourage her to challenge upper body strength. This may be the factor that is preventing women as a group from gaining in this category.

Generally, bigger muscles mean stronger muscles. The force a single muscle fiber generates is related to cross-sectional area of the fiber. Men, in many instances, are stronger in an absolute measure (they can lift more weight or exert more force) simply because they have more muscle tissue, not stronger muscle tissue. Numerous physiology texts emphasize that

there is no physiological difference between muscle fibers in a male and a female; both have FT and ST fibers, and both have similar distribution of fiber types and contractile properties. The strength of a given cross-sectional area of a muscle fiber is the same for men and women. Sex may influence the quantity of muscle but not the quality of it.

This information should answer the question, "Should women be trained differently than men?" The answer is an emphatic no! It's true that women and men are different, and women have special concerns related to aging, exercise technique (e.g., wider hips, narrower shoulders, tendency toward excessive mobility at specific joints), menstrual function, pregnancy, and psychological and social factors, but generally, women are able to use the same training programs as men. These facts simply indicate that other variables, which go well beyond the size of muscle, influence different strength levels between men and women as well as among people of the same sex.

Can You Really Control Results?

The degree of strength that can be gained by skeletal muscle hypertrophy and neural adaptations depends on a number of factors, which include these:

- The characteristics of the training program
- The potential for muscle to increase in size

Progressive and intense resistance training stimulates an increase in the cross-sectional area of both slow-twitch (type I) and fast-twitch (type II) muscle fibers. Generally, a greater degree of hypertrophy occurs in type II fibers. But, hypertrophy occurs in type I fibers as well.

The greater degree of hypertrophy found in type II fibers is probably the result of an increased involvement of these fibers in resistance training because of their metabolic and physical characteristics, which are conducive to gains in size and anaerobic metabolism. Likewise, the greatest amount of atrophy resulting from inactivity occurs in type II fibers.

No human studies have conclusively indicated that resistance training increases the number (hyperplasia) of type II fibers relative to type I, so your client's potential to increase muscle size and muscle strength may be genetically predetermined by the number of type II fibers she possesses, by hormonal and other genetic factors, and by the resistance training program that you design.

Research shows that the ability to exert more muscular force after resistance training is not solely dependent on an increase in fiber size. Adaptations in the connective tissue harness and the nervous system contribute to total force production capability in muscles. In fact, many scientists argue that changes in connective tissue and the nervous system may have a greater effect on overall strength than muscle hypertrophy.

Muscle Soreness

After workouts, your clients may experience one of three types of muscle soreness. The first may be "soreness" that is felt while exercising (feeling the "burn" during high-intensity resistance training or cardiorespiratory conditioning) or immediately after intense exercise during the cool-down. This is usually a transient type of soreness related to lactic acid buildup during anaerobic effort. The majority of lactic acid is usually cleared from the body in about 30 to 60 minutes.

Physiologists (McArdle, Katch, and Katch 1991, 1996; Wilmore and Costill 1994) indicate that lactate buildup is not related to postexercise soreness and discomfort that occur 24 to 48 hours after cessation of "normal" training (in contrast to repeated high-intensity anaerobic training efforts over extended time periods). Remember, lactic acid is not a waste product but simply a by-product of anaerobic effort. When sufficient oxygen becomes available, lactate is metabolized and can be used as energy. Any immediate soreness after exercise could indicate microtrauma to connective tissue or the muscle, and soreness that does not dissipate would not be caused by lactic acid.

The second and third types of soreness may occur for an extended period of time following cessation of workouts. Your client may experience soreness and stiffness in the muscles and joints several hours after the workout, and then a **delayed-onset muscle soreness (DOMS)**

may set in and last several days. DOMS can occur when a person resumes activity after a layoff, participates in an unfamiliar activity (even if conditioned), or increases intensity, frequency or duration. DOMS indicates that the body is adapting to demands of exercise to which it is unaccustomed.

The exact cause of DOMS is unknown. Eccentric contractions, and to some extent isometric contractions, generally cause the greatest amount of postexercise soreness (McArdle, Katch, and Katch 1991; 1996). This close relationship of DOMS to the eccentric, or "negative," phase of muscular contraction may occur because of the mechanics between actin and myosin protein filaments. During an eccentric effort, muscle is trying to shorten or overcome external resistance. However, the outside force is greater than the force-producing capacity of muscles involved in the effort. This lengthens the muscle and associated connective tissue while the muscle develops tension.

The preceding scenario leads to extremely high intramuscular forces and lends physiological credence to the most respected theories about muscle soreness and stiffness. These theories have the majority of experimental evidence supporting the presence of microscopic tears in muscle fiber, tears in the muscle–tendon interface, and damage to the myofascial connective tissue surrounding muscle fibers and the muscle.

New trainees should avoid activity that involves concentrated eccentric muscular effort. Activity that is unfamiliar to the seasoned client should be approached sensibly by using gradual progressions. Finally, if intensity, duration, or frequency is being increased, it should be done in a conservative and progressive manner. Refer to chapter 13 for a discussion on overtraining.

Implications for Resistance Training

It is clear that resistance training is an integral part of a well-rounded training program. The ACSM recommends moderate- to high-intensity resistance training, sufficient to develop and maintain muscle mass, as part of any adult fitness program. The ACSM suggests as a minimum one set of 8 to 12 repetitions of 8 to 10 exercises that challenge the major muscle groups, at least two days per week. For older adults, ACSM recommends 12 to 15 repetitions (ACSM 1990, 1995).

ACSM bases the minimal standards for resistance training on at least two factors. The first is the time that it takes to complete a comprehensive, well-rounded program. Programs lasting more than 60 minutes per session are associated with higher dropout rates. Second, although greater frequencies of training and additional sets or combinations of sets and repetitions elicit greater strength gains, the magnitude of the difference is usually small.

According to a review of research (ACSM 1990, 1995), strength training two days per week, in accordance with these guidelines, confers 80 percent of the strength gains seen when one trains three days per week. When coupled with significant results, this lower frequency may encourage compliance.

Smart Resistance Training

Effective resistance training results in wide-ranging health benefits and noticeable physical improvements for your clients. Although an increase in muscle size is not necessarily a prerequisite for improving strength or power, muscular hypertrophy typically is a result. Hypertrophy seems to occur significantly after six weeks. Effective strength training is directly related to a program that uses an appropriate overload or intensity. Both fast-twitch and slow-twitch muscle fibers need to be trained, and to accomplish this, both moderate- and high-intensity resistance training are desirable. Nonetheless, one set for beginners and two sets for average clients, done twice per week, is more than adequate to realize or maintain significant strength gains. Eight to 10 exercises performed in a range of 8 to 20 repetitions, to fatigue, generally fits within strength improvement protocols.

Physiology of Flexibility Training

Too often clients rush off to their busy scheduled day following a workout. Yet taking the time for flexibility training can give them a great opportunity to reflect on both short- and long-term accomplishments. Besides the physical benefits,

stretching creates an opportunity to increase a client's sense of self-esteem by acknowledging what has just been accomplished during the workout. Stretching can be a very enjoyable, relaxing part of a client's workout.

Benefits of Stretching

Stretching has many benefits for your clients. It can improve posture, increase ROM, improve functional flexibility, increase nutrition to the joints, prevent injuries, reduce muscle soreness, increase personal enjoyment, enhance relaxation, and reduce stress.

Better posture. Improved posture may help your client avoid chronic injuries attributable to poor postural alignment and muscular imbalances. Flexibility training can help realign skeletal structure that has adapted to incorrect posture and poor exercise technique. Clients will find it easier to maintain proper posture throughout the day, and improved muscular balance will make the efforts of daily activities less strenuous and more efficient.

Scientific evidence is available that indicates the risk of incurring low back pain and experiencing stress to the lumbar spine can be avoided with increased pelvic mobility (Plowman 1992), though more recent research (McGill 2002, p. 216) states that spine flexibility has little predictive value as related to low back problems. Sufficient flexibility and strength in the hamstrings (knee joint); gluteus minimus, medius, and maximus; hip flexors; and low back musculature are merited, but the approach should be based on a person's injury history and exercise goal (McGill 2002).

Increased ROM available at joints. Increased ROM can provide greater mechanical efficiency and result in safer and more effective movement. A mobile joint moves more easily through a range of motion and requires less energy.

Development of functional or "usable" flexibility. ROM should be challenged in a manner that closely mimics daily movement.

Injury prevention. Although it hasn't been proven absolutely, most experts agree that greater ROM (but not too much!) makes tissues less resistant to stretch. This means clients are less likely to incur injury; because their tissues can move through a greater range, the tissues

are less prone to soft tissue damage. However, adequate strength and stability must also be present simultaneously (McGill 2002).

Increased blood supply, nutrients, and joint synovial fluid. Holding and releasing stretches, along with an adequate warm-up, elevate the temperature of tissues and increase circulation and the delivery of nutrients through the blood. In addition, regular stretching decreases the thickness of synovial fluid, making it easier for nutrients to travel to cartilage. This in turn may lead to greater freedom of movement in the joint and less degenerative joint disease.

Reduced muscular soreness. Research indicates that slow, static stretching, performed after exercise, reduces or prevents delayed muscular soreness and enhances recovery from exercise (deVries 1961a and b). Although the physiological reason for this effect is unclear, it may be attributable in part to the increase in muscle temperature and circulation and the enhanced blood supply and nutrient delivery from the alternating tension and release experienced in the muscles during stretching. Additionally, stretching can limit postexercise muscle spasms that could contribute to muscle soreness.

Personal enjoyment, relaxation, and reduced stress. Performed in the proper environment and with correct technique, stretching encourages muscular as well as mental relaxation. Overall stress levels may be reduced as a result of personal enjoyment and because of the physical release of tension induced by stretching.

These stretching-related benefits indicate why all of your clients should stretch. Additionally, once you understand the neurophysiology and physical properties of the tissues you are stretching, you can better formulate a specific, safe, and effective approach to stretching for all of your clients.

Anatomy of Flexibility

Flexibility is most easily introduced by defining it as the **range of motion (ROM)** available to a joint or joints. Healthy, or desired, flexibility should be viewed as a capacity to move freely in every intended direction. The movement should be confined to the joint's **functional range of motion (FROM)** or intended movement capabilities. This is different from the joint's normal

ROM, because normal is not always healthy, or adequate, for individual clients.

Each joint in the body has a specific optimal FROM. The knee joint, for example, is intended to move like a hinge (unlike the shoulder, which moves in circular motions as well). The optimal FROM for the knee—full extension to full flexion—encompasses about 135 degrees. However, this "natural" range, at any joint, generally decreases with age, injuries, and decreasing activity levels. Many of your clients will have decreased FROM because of inactivity or because they have not adequately addressed this aspect of fitness in their workouts.

Connective tissues of the joint include cartilage, ligaments, tendons, and muscle fascia or fascial sheath. Cartilage is often present between bony surfaces and provides a degree of protection for bony surfaces by providing "padding" and shock absorption. The fibers in cartilage are somewhat stretchable or "forgiving" in terms of their tissue properties. This characteristic enhances shock-absorbing capability. Ligaments connect bone to bone and offer stability and integrity to joint structures in areas of the body such as the spine, knee, and shoulder. Tendons connect muscles to bone and transfer the force of muscle contraction to the skeletal system. This results in efficient bodily movement. Discussed earlier, muscle fascia "wraps" the entire muscle.

Physical Properties of Connective Tissues

The physical properties of connective tissues determine flexibility at the joint. For example, ligaments and tendons are rich in the protein collagen. The fibers of these tissues are arranged in parallel and are closely "packed" together. This creates a high tensile strength and a tissue that is designed to be nonstretchable or highly resistant to stretch.

Flexibility is **joint specific,** which means that flexibility in one joint does not influence flexibility in another joint. Johns and Wright (1962) identified specific limitations to degrees of motion about a joint. Flexibility in a joint is limited by several factors, including joint shape and the elasticity (a measure of a tissue's resistance to stretch) of tendons, ligaments, muscle fascia, and the skin. Joint shape cannot be

changed, except in the case of injury, but soft tissues can be altered. Whether the change is "good" or "bad" in terms of ROM increases depends on the tissue being stretched. Permanent elongation of muscle fascia is positive and can increase ROM around a joint without causing injury, whereas overstretching a ligament or tendon can result in injury.

Flexibility is influenced by other factors as well:

- Genetic inheritance
- Tension (partial contraction) in the muscle
- Neuromuscular influence (from sensory organs such as the muscle spindle and Golgi tendon organ)

What Is Stretched During Flexibility Training

What exactly are you trying to stretch in a flexibility training program? Studies have shown that muscle fascia offers little resistance to stretch (i.e., its low elasticity means it is very stretchable). Muscle itself, if relaxed and free of the limits of the muscle fascia, can be stretched to 150 percent of its length (McArdle, Katch, and Katch 1991; 1996). Soft tissue components of a muscle begin to break down if the muscle is stretched beyond 160 percent of its normal length (Taylor et al. 1990). More is not better! Consequently, it appears that muscle fascia is the most significant factor that you can improve to gain flexibility.

Muscle fascia's physical properties are not unlike that of candy taffy. When muscle fascia is warm, it is stretchable. When it is cold, it is much less pliable. Because of these physical characteristics, a participant should warm the body first and hold sustained stretches so that the muscle fascia can "cool" in a new and lengthened position. This is an excellent visualization to help clients better understand the goals of their stretching programs.

Vocabulary of Flexibility

For the sake of clarity, let's define several terms. **Distensibility** is a term used to describe "stretchability," as opposed to inextensibility or lack of stretchability. Muscle fascia is very distensible, or stretchable; ligaments are not.

Elasticity is often confused with distensibility. Elasticity, as mentioned, is a measure of a tissue's resistance to stretch. Ligaments and tendons have a high resistance to stretch and are characterized as having a high degree of elasticity. Muscle fascia, on the other hand, has a low degree of elasticity, is distensible, and is easily stretched. Your ability to differentiate the terms *elasticity* and *stretchability* is most important when reading and interpreting scientific literature. For the sake of clarity, a tissue that has a high elasticity has a high resistance to stretch.

After the stretching force is removed during an **elastic** stretch, the tissue being stretched is able to recover or return to its original length. A **plastic** stretch is nonrecoverable and results in permanent elongation of the soft tissue being stretched. **Elastic tissue** consists largely of muscle fibers, fascia, ligaments, or cartilage. Muscle fibers, cartilage, and ligaments will recover quickly from the force of a stretch or impact that does not exceed their elastic limit, whereas the plastic or permanent "deformation" of the connective tissue framework (muscle fascia) might remain with proper and regular stretching. Whether this return to prestretched length is desirable or not depends on what tissue is being stretched.

A tissue's **elastic limit** refers to the smallest amount of stress (stretching force) necessary to produce permanent or nonrecoverable lengthening of a soft tissue. Once a tissue's elastic limit is exceeded, a return to its original length is not immediately possible, even after the stretching force is removed, and injury can occur during this process of exceeding elastic limit.

Beyond the elastic limit, internal damage occurs in various soft tissue protein arrangements. For example, exceeding the elastic limit of ligaments damages their collagenous fibers. This is referred to as a **sprain**. Damage to muscle fibers or cells caused by exceeding their elastic limit is referred to as a muscle **strain.** Sprains and strains range from first degree or minor damage to the extreme of tissue rupture or a complete tearing of the tissue.

Exceeding the elastic limit of muscle fascia is entirely different from exceeding the elastic limits of ligaments, tendons, or muscles. Five factors influence the "stretching outcome" and determine whether elongation of tissue is recoverable (elastic stretch) or nonrecoverable (permanent or plastic stretch):

1. Type of force
2. Mechanics of the stretch and exercise position
3. Duration of the stretch
4. Intensity of the stretch
5. Temperature of the muscle during the stretch

Whether a stretch is productive and increases ROM without increasing the risk for injury depends on the tissue being stretched, as influenced by proper or improper stretching procedure.

Physiology Behind Stretch

Proprioception is a term used to describe the normal, ongoing awareness of the position, balance, and movement of one's body or any of its parts (Blakiston's Medical Dictionary 1980). **Sensory organs** relay proprioceptive information via the central nervous system, giving an individual a sense of body or limb position in space. This is also referred to as **kinesthetic awareness.** Sensory organs, for example, allow you to know your elbow is bent even if you can't see your arm.

Two sensory organs, the muscle spindle and the Golgi tendon organ, factor into your flexibility training program. The **muscle spindles** are located between the muscle fibers. They are sensitive to the resting length of the muscle, changes in the length of the muscle, and the speed at which lengthening occurs. Muscle spindles help the body maintain tone and posture, and they present a defense mechanism, through the stretch reflex, that can help prevent muscle injury.

If the muscles are stretched too fast, the spindles initiate the **stretch reflex** (also known as myotatic stretch reflex). This causes the muscle group to reflexively shorten and protect itself from being overstretched. If an attempt is made to elongate muscle fascia while the muscle itself is shortening, the risk of injury to muscle fiber is obvious. The force produced by the stretch reflex is proportional to the force or speed of the stretch. Conversely, if the stretch is performed slowly and in a controlled manner, the stretch reflex may be avoided or will be of low intensity.

The **Golgi tendon organs (GTOs),** located in the muscle tendon, are sensitive to force

production and monitor tension in the muscle. When their thresholds are exceeded, a reflexive response causes the affected muscle to relax. This is referred to as an inverse myotatic reflex or **inverse stretch reflex.** The force necessary to stimulate the GTOs is much greater than the force needed to activate a muscle spindle and resultant stretch reflex. During training, if you can cause the GTOs to fire, the signal they receive to relax overrides the muscle spindles' signal to contract, which relaxes the affected muscle group. Ultimately, stretching a relaxed muscle leads to more effective flexibility training.

Reciprocal innervation is a reflex inhibition that involves agonist and antagonistic muscles. When a muscle group contracts, its opposing or antagonistic muscle group reflexively relaxes. Reciprocal innervation can be used in conjunction with stretching procedures, including proprioceptive neuromuscular facilitation and active stretching, to promote muscle relaxation and optimal stretching conditions to increase ROM.

For example, if the goal is to stretch the hamstrings group from a supine position, tightening the quadriceps would cause the hamstrings muscles to relax because of reciprocal innervation. In general motor movement, reciprocal innervation allows for coordinated motor movement. During stretching, it is a reflex mechanism that can be used to relax muscle. Potentially, this will allow for more effective stretching.

Static Flexibility Compared With Dynamic Flexibility

Forces responsible for stretch can be broadly categorized as either **active** or passive. An active stretch occurs when an agonist muscle moves a body part through a range of motion, and the force provided by the active contraction of musculature stretches the opposing (antagonist) muscles. For example, if the elbow is flexed, the contracting biceps actively stretches the opposing or triceps musculature.

Passive stretches occur when outside forces assist in the stretching process. Passive forces that can contribute to muscular and fascial elongation include gravity, momentum or motion, passive force applied by a trainer to another individual, or force provided by some part of one's own body (pulling your leg forward into a hamstrings stretch from a supine position).

Two basic categories identify how flexibility is gained. **Static flexibility** generally refers to a combination of active and passive movements that lengthen the muscles and fascia in a controlled manner. Once lengthened, the position is sustained for at least several seconds.

Dynamic flexibility involves the use of momentum to gain an advantage in "overstretching" an area of the body. This is traditionally referred to as ballistic stretching. Although there is sufficient reasoning to justify this type of stretching for elite athletes, the risk versus effectiveness should be carefully examined.

A professional tennis player needs sufficient dynamic flexibility in the shoulder to slam a tennis serve 120 miles per hour. Likewise, a recreational exerciser and mother needs sufficient dynamic flexibility in various joints of the body to play softball on the weekends and care for her children. Normal ROM attained through static stretching may be sufficient to meet the dynamic needs of the mom, whereas dynamic flexibility training may be required to meet the demands imposed on the professional tennis player.

Hardy and Jones (1986) suggested that the use of dynamic flexibility is probably important in explosive speed events. This might include world-class gymnastics, a 100-meter track sprint, aerobic competitions, dance, or diving. Hardy and Jones' study did not confirm that dynamic flexibility and the associated ballistic movements are the best method to improve flexibility. Rather, they simply recognized that ballistic movements are included in these sports.

Hartley O'Brien (1980) defined active flexibility as the "maximum, unassisted range of movement." Thus, active flexibility can be improved by increasing the strength of the agonist or decreasing resistance to movement in the antagonist. Proprioceptive neuromuscular facilitation (PNF) stretching can achieve this goal, which is why PNF stretching is very popular with athletes whose events require dynamic flexibility. PNF stretching is an advanced form of flexibility training that takes advantage of sensory organ response to facilitate flexibility gains.

However, aggressive attempts to increase dynamic flexibility should be carefully examined when you are working with the general

population. The risk of injury may greatly increase, whereas the gains for most clients will be about the same when using sustained static stretching.

In fact, many experts suggest that abrupt stretching may lead to injury. That is why most fitness experts generally recommend static stretching programs that gradually increase ROM and hold stretching positions with static force (no bouncing) applied during the stretch. The types of stretching can further be categorized as to their relative risk (see box on this page).

An excellent approach to stretching is to use a combination of active, controlled passive, and static stretching techniques. With this approach, an active contraction is initiated with agonist muscles. This begins the stretch process and defines a client's active range of motion (AROM). Once the AROM is determined, you have a better idea of a client's elastic limit and associated constraints to safe movement. This step may be followed by application of an outside or passive force that is used to enhance movement through a greater ROM. And finally, a static and sustained stretch is held.

It should now be obvious—there is no one best way to stretch (Plowman and Smith 1997, p. 507). Using a variety of stretching methods improves flexibility. You must carefully consider the client's goal, his current fitness level, individual limitations to ROM, the type of activity the client is regularly active in, and risk versus effectiveness.

Types of Stretching and Associated Risk

Five types of stretching techniques are available:

1. Static stretching
Low force, controlled tension, low risk
Static stretching is defined as a controlled stretch, held at the point of mild tension for about 10 to 60 seconds. This lengthens the muscle.

2. Dynamic or ballistic stretching
High force, high tension, high risk
Dynamic or ballistic stretching uses bouncing, jerking, or abrupt movements to gain momentum into the posture to facilitate overstretching.

3. Active stretching
Low force, low tension, low risk
This involves voluntary, unassisted movement that requires strength and muscular contraction of the agonist muscle (prime mover). For example, in a supine position, the hip flexors can contract actively to draw the leg forward and the hip into flexion. The agonist is unassisted by external (passive) forces. The purpose of the stretch is to actively stretch the hamstrings group by using only the muscular effort and strength provided by the agonist hip flexors.

4. Passive stretching
Higher potential force, higher potential tension, higher potential risk
Passive stretching occurs when movements are accomplished through the use of an outside (external) force, such as gravity, momentum, force provided by a partner, or force provided by pulling on one's own body part.

5. PNF stretching
High force, high tension, high risk
PNF stretching works by first putting the targeted muscle on stretch and then generating a maximal force in the muscle being stretched. This procedure can activate a sensory organ called the Golgi tendon organ, which causes the affected muscle to relax. A relaxed muscle will more easily allow the muscle fascia to be elongated, thus creating a stretching environment where excellent gains in flexibility can be realized. PNF stretching also can involve a variation of these methods.

Flexibility Adaptations

Flexibility adaptations occur both immediately and over longer periods of time. That is because proper stretching involves sensory organs and connective tissue adaptations that may result in both elastic and plastic (permanent) changes. Short-term improvements can occur in as little as a week (Plowman and Smith, p. 506).

Acute adaptations that can occur during stretching include the stretch reflex (muscle spindles), inverse stretch reflex (GTOs), and reciprocal innervation. A muscle spindle's effect (shortening of or tension in muscle) can be neutralized during a stretch if the stretch is maintained or if the GTOs are activated. Over time, with repeated stretching, the threshold or point at which the muscle spindle is activated can be increased, making it less likely to "fire" and create tension in the muscle fibers.

Long-term adaptations or chronic changes relate more to plastic elongation of muscle fascia. Constant application of appropriate force leads to progressive "creep" or change in length of fascia. This is a time-dependent mechanism that occurs as the muscle spindles' discharge is decreased. Permanent deformation of the muscle fascia occurs when the muscle and fascia are held in a lengthened position for sustained time periods.

For permanent or long-term elongation, fascia responds best to low-force, long-duration holds and is most easily stretched when the muscles and body are warmed up. It has been well established that increases in intramuscular temperature through a proper warm-up decrease viscosity, or a tissue's resistance to stretch (Sapega et al. 1981).

A multitude of circumstances can add to or detract from the success of a flexibility training program. These include but are not limited to age, exercise, inactivity, intramuscular temperature, body type, and sex. According to Kravitz and Kosich (1993), there does not appear to be a body build that consistently has "good flexibility."

Several authors report that females tend to be more flexible, in general, than males (Alter 1988; Holland 1968, reported by Kravitz and Kosich 1993). Although conclusive evidence is lacking, a female's tendency to be more flexible than most males in the pelvic region may be related to the female's role in childbearing.

Beyond these issues, it seems that a regular commitment to exercise is the most influential variable that can affect flexibility.

Age and Inactivity

Adults lose significant amounts of flexibility as they age. In many cases, this loss of mobility is more related to inactivity than any "inevitable" aging process. Exercise contributes significantly to joint stability and flexibility maintenance (Spirduso 1995). Spirduso reported that stretching and progressive resistance training exercise produced the same percentage of improvement in ROM in elderly subjects aged 63 to 88 years as it did in younger subjects aged 15 to 19 years.

The greatest potential for increases in flexibility probably occurs between the ages of 7 and 12. Significant changes occur in connective tissue during the mid-20s that begin to affect the ease at which a client can maintain or gain ROM. Alter (1988) reported that aging increases both the diameter of collagen fibers and the number of intermolecular cross-links. This age-related change in connective tissues makes soft tissue more resistant to stretch or plastic deformation.

Because hydration of the musculature decreases as one ages, the delivery of nutrients and joint lubrication also decrease. This makes musculature and soft tissue more susceptible to injury. However, the natural decrease in flexibility that occurs with aging is relatively small compared with the influences of an inactive lifestyle. Functional ROM and movement options at all of the joints of the body can be readily preserved with a regular program of stretching and movement-related activities that target the whole body.

Stretching Summary

Stretching muscle fascia and protecting other connective tissue from injury are critical to an effective stretching program. When a client's goal is health and fitness, functional movement is the goal. There are five different types of stretching, and all must be evaluated for risk. Most clients will benefit from a combination of stretching methods and a complete understanding, on the trainer's part, of the physiology and anatomy of stretch.

Physiology: Suggested Reading

If you'd like to read more than the works cited in this chapter, check out the following:

Alter, M.J. 1990. *Sport Stretch*. Champaign, IL: Human Kinetics.

Corbin, C.V., and L. Noble. 1980. "Flexibility: A Major Component of Physical Fitness." *Journal of Physical Education and Recreation* 51 (6): 23-24; 57-60.

Etnyre, B.R., and E.J. Lee. 1987. "Comments on Proprioceptive Neuromuscular Facilitation Stretching Techniques." *Research Quarterly for Exercise and Sport* 58: 184-8.

Hutton, R.S. 1992. "Neuromuscular Basis of Stretching Exercises." Pp. 29-38 in *Strength and Power in Sport,* ed. P.V. Komi. Cambridge, MA: Blackwell Scientific.

McAtee, R. 1993. *Facilitated Stretching*. Champaign, IL: Human Kinetics.

Moore, M., and R. Hutton. 1989. "Electromyographic Investigation of Muscle Stretching Techniques." *Medicine and Science in Sports and Exercise* 12 (5): 322-9.

Murphy, R.D. 1991. "A Critical Look at Static Stretching: Are We Doing Our Patients Harm?" *Chiropractic Sports Medicine* 5 (3): 67-70.

Osternig, L.R. 1990. "Differential Responses to Proprioceptive Neuromuscular Facilitation (PNF) Stretch Techniques." *Medicine and Science in Sports and Exercise* 22 (1): 106-11.

Plowman, S. 1992. "Physical Activity, Physical Fitness and Low Back Pain." *Exercise and Sport Sciences Reviews* 20: 221-42.

Siff, M.C. 1990. *The Science of Flexibility and Stretching*. Johannesburg, South Africa: School of Mechanical Engineering, University of Witwatersrand.

Siff, M.C. 1993. *Super Training: A Textbook on the Biomechanics and Physiology of Strength Conditioning for Sport*. Johannesburg, South Africa: School of Mechanical Engineering, University of the Witwatersrand.

Sullivan, M.G., J.J. Dejulia, and T.W. Worrell. 1992. "Effect of Pelvic Position and Stretching Method on Hamstring Muscle Flexibility." *Medicine and Science in Sports and Exercise* 24 (12): 1383-9.

Voss D., M. Ionta, and B. Myers. 1985. *Proprioceptive Neuromuscular Facilitation: Patterns and Techniques*. 3rd ed. Philadelphia: Harper & Row.

Wallin, D., B. Ekblom, R. Grahn, and T. Nordenberg. 1985. "Improvement of Muscle Flexibility: A Comparison Between Two Techniques." *American Journal of Sports Medicine* 13: 263-8.

Right Workout Environment, Right Workout Equipment

Rarely should the place where your client works out and the equipment available determine training results. Probably the most important factor is how much effort your client puts into a well-designed workout progression.

Although training location and equipment availability don't make or break a program, they can have a big impact, especially if you choose poorly for a client's home gym or your own facility. If you train out of or lease space that already has equipment, carefully evaluate what the facility has to offer.

It is encouraging to know that many simple solutions exist when you are confronted with limited equipment options (see "Working With Minimal Equipment" later this chapter). On the other hand, working in a well-equipped gym and pleasing environment does not guarantee a successful training outcome. Your decisions about how you design a client's program, where you work him out, and what equipment you use should be made only after you do your homework.

Working Out at a Commercial Training Facility

Working out in a public gym has received both rave reviews and harsh criticism. Here are the questions to ask when trying to match a client to the right training environment:

1. Is the gym right for the client?
2. Does the social environment motivate or distract?
3. Are the excitement and noise a call to action or a bombardment to the senses?
4. Does being around other exercisers (many of whom are buffed or scantily clad) encourage or intimidate?

Being associated with a health club or fitness studio provides you a place to work out and, most likely, gives you a diversity of equipment options that can help you create a balanced, varied, and interesting program for your clients. Gym workouts can also complement activities you do with clients in their homes or outside the club.

Caveat! If your client's impression of the public gym is that of a crowded and far-away "fitness factory," he might be one of the increasing number of people who are opting to bypass the crowds and stay fit by setting up a gym at home or training at a private or semiprivate personal training facility. If your client believes that the initiation fee and monthly dues are only buying him a chance to visit a gym that is more like an experience in Jurassic Park—too loud, with too many sweating, competitive people waiting in line to push and pull against resistance or run nowhere on a treadmill—then he's ready for a home gym. At the least, you need to offer a more private training option. In a more private setting, there's also a good chance you'll make better use of your time with the client, and this may enhance the training session value in the eyes of the paying client.

Working Out at Home

If the goose bumps and anxiety are just starting to fade after reading the previous section,

you're probably thinking (as is your client) that working out in the privacy of a home or private studio is indeed a great idea, if for no better reasons than saving time and personal sanity! Usually there is no prime time in a home gym, unless, of course, your client's private home life invades!

But just because your client exercises at home doesn't mean he won't still belong to a health club or exercise at a personal training studio. A study by the Fitness Products Council showed that 63 percent of exercisers who belonged to a health club also exercised with equipment in their homes. In the same study, 43 percent of Americans surveyed said they didn't exercise regularly because of time constraints (Florez 1997).

It's ideal if the opportunity to work out is available at every turn in your client's daily schedule. It makes sense for your client to be committed to exercise and for exercise to be easy, accessible, and convenient. A home gym provides for these possibilities.

Creating a Home Gym

Creating a home gym, if approached correctly, is easy and satisfying. Joining a health club requires you to check out the facility, equipment options, and staff, but it's fairly easy to make an informed decision as to whether the club or personal training facility is right for you and your client. Likewise, you need to do some earnest homework and consider some important questions before you establish your client's "fitness palace."

Locating the Right Exercise Space

It is essential to place your client's home gym in a comfortable and inviting area. You can create a superb gym anywhere, whether in a small studio apartment, a townhouse, a condominium, a home office, or an estate. But, if the gym is cramped, dim, drab, dingy, or stuffy, this isn't a place you or your client will want to spend time. If it's bright, organized, uncluttered, fresh, and attractive, it's a lot easier to get excited about exercising.

Natural light works best to motivate exercise spirit, and windows and skylights can provide a visual distraction. Walls and mirrors can take you only so far. (Some days, your client just doesn't want to look at himself or that picture of some "hard body" on the wall.) If the space you've chosen is dark or your client works out in the evening, provide enough artificial lighting so that the client doesn't think he's at a candle-lit dinner or mired in a dungeon. Create an option for fresh air ventilation if at all possible. At a minimum, air circulation should be provided by a heating and cooling system or portable fans. You, as well as your client, will appreciate the right lighting and refreshing air, in all seasons. Build a gym environment that proves irresistible!

Hardwood floors are an ideal surface on which to place equipment. They are stable and easy to clean. Their downside is that they scratch easily and are noisier. (Noise is especially relevant to consider if your client has family members or neighbors who don't appreciate early, or late night, exercise enthusiasm!) To protect wood floors and ease the noise concern, rubber mats (some interlock into a number of configurations) are available and specially designed to fit beneath exercise equipment or cover an entire area. If you use carpeting or a rug, a short-pile indoor-outdoor cut is the best. Both should be of commercial (heavy-duty) quality and have little or no padding underneath. Equipment can leave an almost permanent imprint on thickly padded surfaces and can create a less stable exercising surface. When your client exercises on the floor, use an exercise mat to protect the carpeting from sweat and to help cushion your client's body. Choose carpet color combinations that will not show dirt, machinery oil, or foot traffic patterns.

Mirrors not only help you and your client check exercise form and posture, but if placed correctly, they can turn a small area into a seemingly larger space. Mirrors can help create a feeling of openness and a sense of spaciousness when it does not physically exist. A single five foot by six to eight foot mirror placed horizontally on a wall, and about 18 inches from the floor, can totally change the atmosphere of any exercise area.

Finally, it's nice to consider the positive aspects of watching TV, listening to music, and using a cordless phone while exercising. For many people the obvious attraction is distraction and the ability to accomplish two or three

tasks simultaneously in a time slot designated for exercise. For example, your client might tell you that he got his exercise in, called a couple of friends, and kept an ear tuned to his favorite TV show. To the purist exerciser or trainer, this may seem like a cop-out and a less than desirable training atmosphere. But if time is at a premium or if these activities help your client pass the time, get the results he wants, and have fun, they are worth a try. I encourage my clients to do anything that helps them "get it done!"

Home Equipment Purchases

Here's a primer on how to select home gym equipment for clients. Before you look at the "Home Gym Preassessment Questionnaire" (see the box below) and the "Checklist for Home Equipment Purchases" on page 320, plant the following thought firmly in your brain!

Regardless of the size of your client's home gym space, whether you have an entire room or a small corner of a room, try to minimize the necessity of taking down and setting up equipment.

Many programs and good intentions fall short because of a failure to commit space for permanent setup of equipment. The necessity to set up and take down equipment gives your client another excuse for not exercising. You don't need a lot of space to establish a workout space. With smart shopping, you can buy equipment that fits into small spaces, is versatile with regard to exercise options (it offers more than one type of exercise), and won't compromise the effectiveness and safety of the workout. Sales pitches often hype the benefit of storing equipment, but the equipment often doesn't get used when it's under a client's bed or in a closet! Ask your clients the questions found in the box on this page to determine if a home gym is right for them.

Checklist for Home Equipment Purchases

This checklist (form 16.1) will encourage you to think about information you should consider before buying home fitness equipment. Put a check next to each question to which your answer is yes. If you check off the majority of questions in the list, you're on your way to making an informed and useful choice.

Home Gym Preassessment Questionnaire

What fitness activities do you like?

What fitness activities do you enjoy and believe you would continue for a lifetime?

What types of fitness equipment have you used and enjoyed in the past?

What, if any, physical limitations do you have (problems such as a bad back, knees, shoulders, or wrists or arthritis)?

How do you think equipment choices would complement, or possibly exacerbate, any physical condition you identified previously?

Your short- and long-term goals should be considered in relation to what you are considering purchasing. How will the equipment purchased help you accomplish your goals?

Will your equipment selections allow you to create balanced workout options that target the major components of fitness, including cardiovascular conditioning, muscular strength and endurance, and flexibility training?

Does your home gym equipment offer you the option of cross-training and variety?

Will anyone else in your household use the equipment? If so, will the equipment selection meet their goals and allow them to exercise safely? Will children be using the equipment?

Are you willing to dedicate space in your home? If so, have you thought about electrical prerequisites (most home version cardio machines use standard wall outlets), weight requirements, lighting needs, and floor surface to be used?

FORM 16.1 Checklist for Home Equipment Purchases

❏ Will you look to a "specialty fitness retailer" or other qualified fitness professional to assist you in your research and selection of home fitness or facility equipment? Specialty fitness retailers usually have qualified sales personnel compared with mass merchandising sporting goods chains. Additionally, many specialty retailers carry commercial grade equipment—like the equipment clubs use, which is expected to get heavy use—as well as high-quality home versions of similar trustworthy, time-tested equipment.

❏ Do you understand the high-tech talk? If not, ask what it means, what it costs you, and how it will help your client's program. If you're more confused after you ask the question, it's time to move on. Consider attending major equipment trade shows to gain knowledge and insight about equipment evolution.

❏ Will you consider each piece of equipment that you purchase with regard to cost, space efficiency, portability, variety, and diversity, and the importance of these five qualities to each workout space you design? (A bench that declines, lies flat, and inclines is a good example of a piece of equipment with these five qualities.)

❏ Have you tried out each piece of equipment to ascertain whether you like it and whether it would be appropriate for your client? When you shop, wear your workout shoes and comfortable clothes. Spend at least 5 to 10 minutes on every piece of equipment you're considering, and make your own adjustments after the salesperson shows you how. Many specialty retail stores will encourage you to test ride equipment and have models set up for this purpose. Or, you can visit local gyms and experience a variety of equipment. Many gyms offer free one-week trials you can take advantage of, or you can purchase day or short-term memberships so you can try out different equipment.

❏ Have you talked to other personal trainers and clients who have used this equipment? (Ask the person selling the equipment to give you a list of customers who have bought that particular piece of equipment.)

❏ Will your client really use the equipment you purchase or is it going to become a high-priced dust collector?

❏ Are you committed to buying quality equipment that will last you or your client a lifetime? This is in comparison to buying "junk" that will have to be replaced, will frustrate exercise efforts, and may be unsafe!

❏ Is this a piece of equipment that will stand the test time, or is a trend that will fall out of fashion in time? (Good examples of timeless equipment that never lose their appeal are motorized treadmills and dumbbells.)

❏ Does an equipment purchase come with personal instruction (specialty store retailers usually have a very knowledgeable sales staff), a videotaped workout and instruction, or other written instructional material? (Some retailers will be happy to arrange a free orientation with a professional who can show you the ins and outs of new equipment.)

❏ What is the warranty for parts and labor? Although the manufacturer's warranty is usually 90 days, ask retailers whether they'll back the equipment for a year. To get a sale, they probably will. Besides, if you're buying a quality piece of equipment, this one-year insurance is probably overkill and the store won't really be at any additional risk. But why not ask for it?

❏ Can warranty work, part replacement, repairs, and service be performed locally, or do you have to ship the equipment? Local specialty retailers generally take care of you since they'd like your repeat business or references. And they usually have a full-service repair, delivery, and maintenance department.

❏ Can you trade the equipment in and upgrade to a higher quality piece?

❏ Has the store you're considering purchasing from been in business for a number of years? (Ask the store manager whether you could contact any customers who have purchased equipment you're interested in and who might be available to talk with you about their purchase.)

❏ Is the equipment made by a major manufacturer? With regard to quality and equipment that will serve you for the long haul, you usually can't go wrong buying brand names.

Continued ➤

➤ *Continued*

❑ Is the equipment quiet when in use?

❑ Is the cushioning made of dense and supportive yet forgiving material? Is the external upholstery covering of high quality? Compare commercial equipment like you see in gyms with some "cheesy" home exercise equipment and you'll see, and feel, the difference. Go for the high-grade equipment. You'll pay more and be glad you did!

❑ Do cables and pulleys move smoothly and quietly?

❑ What are the safety features?

❑ Is the cost of delivery and installation included in the purchase price? If not, bargain for it!

❑ Is any assembly required after delivery? If it is necessary, is it included in the purchase price? If it isn't, ask for it. If a lot of assembly is necessary, you have the potential for numerous nuts and bolts to work themselves loose over time. Look for pieces that have welded frames and joints and minimal assembly requirements.

❑ What is the return policy? The manufacturer or retail store should offer, at a minimum, an unconditional, 30-day return policy. If for some reason you buy equipment you haven't tried, find out the details of returning the product. Do you have to pay return shipping, and is any of your original purchase price nonrefundable? Can you trust the company you're buying from? A "free" 30-day trial can cost you some significant money, not to mention the hassle of repacking the "junk" and sending it back!

❑ If a salesperson hurries or tries to push you into a quick decision without answering your questions and encouraging you to try the equipment, will you promptly and politely walk out the door?

Aerobic Training Equipment

The simplest, and least expensive, cardiovascular equipment is a good pair of walking, running, or cross-training shoes! Regardless of how your client strengthens his heart, he'll probably need at least a couple pairs of good "treads" to complement the cardio activities he participates in. Different activities often require different shoes and, quite honestly, shoes need time to air out before the next workout. So, it's a good idea to either personally guide your client in shoe selection or encourage him to visit a high-end specialty shoe store where sales staff can help him select the correct type of shoes for his workouts.

Some examples of the more popular cardiovascular equipment you have to choose from are treadmills, steppers, elliptical trainers, ski machines, lateral trainers (side-to-side sliding movement), manual resistance stationary cycles, electronic stationary cycles (i.e., programmable and usually an upright sitting position), recumbent bikes, and rowing machines. The interest seen in stationary cycling or spin-training warrants that you try this breed of high-performance spin training bikes. This class of stationary bike is more fully adjustable to your body's dimensions,

but try before you buy! Stationary bikes have come a long way.

There are many safety features, different types of electronics, and optional upgrade choices available in this category. Your choice should be based on what your clients love to do, balanced fitness programming, and variety that is worth its price.

Which cardio equipment is best? Contrary to what you hear, no one cardiovascular machine or activity is better than another when calorie expenditure, fat burning, and physical conditioning benefits are compared. How long, how hard, and how often your client exercises can easily be adjusted on all cardiovascular training equipment, so that effort can be comparable between any cardiovascular conditioning activity.

Remember the truism, "Know thyself." Help your clients find several activities they really enjoy and purchase a couple pieces of equipment so they can cross-train indoors when necessary. Probably the most solid choice you can make is to purchase a fully automated treadmill. (If your clients despise walking or running on treadmills, forget this recommendation!) Complement this choice with a manual resistance bike, stepper, and elliptical

or rowing machine. Cross-training between different types of aerobic exercise will keep your clients from getting bored and provide new physiological stimulation. You can even create an exciting sports conditioning circuit. This type of approach will keep you and your clients enthusiastic about exercise and keep them from hitting exercise plateaus and falling into an exercise "rut." Remember, you can exercise with your clients outdoors, too!

Strength Training Equipment

Don't believe it when you hear that "weight machines" or multistation gyms are the safest. You have to ask, "Safest, compared with what?" It is true you can't drop a weight on the floor, or your client's toe, when using these units. But what good is this safety feature if you wreck a client's shoulder because an exercise motion is incorrectly designed and you have no way to correct or adjust the design flaw? A client can easily injure a limb or two by incorrectly entering and exiting a machine! On the other hand, like most pieces of exercise equipment, machines aren't necessarily bad, if they're designed correctly and used properly.

Unfounded biases and hearsay sometimes blind you to the big picture and can lead you astray, get you or your clients hurt, prevent you from getting the results you want for your clients, and keep you lost in the "hardware" jungle! Read on so you can get the whole story.

A wide variety of strength exercise equipment is available for you to train the entire body effectively. There is overlap from category to category. Strength exercise equipment includes the following:

- Free weights
- Multistation weight machine
- Pulley or cable systems
- Elastic resistance cable or tubing
- Training without equipment

Choose strength equipment that offers you the option to increase resistance as your clients get stronger. Free weights, multistation weight machines, pulley or cable systems, and elastic resistance cables and tubing are good examples of equipment that can provide progressive overload. This type of equipment allows you to increase weight once your client can perform more repetitions than his recommended range. This keeps your client progressing and the results coming.

Free Weights

Barbells and dumbbells generally have free weights or weight plates attached to them (figure 16.1). Barbells are long, straight bars that allow you to attach weight plates onto each end of the bar. When barbells are loaded, your client needs two hands to lift them, unless she's unusually strong. Dumbbells are short bars with weight plates on both ends. Usually your client lifts one with each hand or uses a single dumbbell in each hand, depending on the exercise. The plates can be attached securely with retaining collars or more permanent fixtures that eliminate the possibility of the free weight falling off during exercise.

FIGURE 16.1 Dumbbells, barbells, and free weights allow weight to be increased progressively as your client's strength increases.

Free weights are efficient because they don't take up much room, they are inexpensive and versatile compared with machines, and you can do numerous exercises that are biomechanically correct. You don't need $100,000 worth of equipment to get a great strength workout, yet you can replicate what you can do with $100,000 worth of strength training machines!

Free weights work with your body, not against it, if you've been instructed correctly with regard to technique and you're using the right exercises. Free weights also require balance and stabilization, which is relevant because your client's everyday activities and the sports she participates in also require balance, stabilization, and coordination.

Free-weight workouts don't take much time if you avoid adjustable dumbbells that require you to slide weight plates on and then secure them with safety collars so they don't slide onto your client's face! Instead, opt for "fixed" dumbbells. These are not adjustable and are bombproof with minimal maintenance. They don't come apart on you or your client! You grab the pair you need, your client does the exercise, and you're both ready to move on to the next one.

One system I have seen on the market that is very efficient with regard to cost and space is a selectorized dumbbell system. This setup gives you a whole set of dumbbells and its unique design doesn't require much space, which can be beneficial whether you're in a studio or home gym environment. It's nice to have this versatility without having to take up the space of an entire wall, which is required of a dumbbell rack that houses 10 to 15 pairs of dumbbells. Selectorized dumbbell systems are available up to 120 pounds, and you can change from 5 pounds to 120 pounds in seconds.

When using free weights, follow these guidelines:

- Keep your client's level of concentration and focus high.

- Have your client lift weight that he can control.

- If the weight the client is using is hard to balance or control because it's too heavy or he's reached a point of fatigue, lower the weight and start again with less weight, or end the exercise.

- Make sure you or the client remove the weight carefully from the rack and replace it with precision and control. (Many injuries during strength training come from carelessly picking up or returning weight to storage racks or the floor.)

- Help your client learn how to move into and out of an exercise safely.

Multistation Weight Machines

Many multistation strength "gyms" require your client to push, pull, or curl in a predetermined range (figure 16.2). (Some companies are now making commercial quality equipment that allows the user to define the range of motion. This design concept is trickling down to home gym design and allows greater biomechanical adjustability.) You have probably used a machine that doesn't feel right or creates discomfort in a joint. Likely, with such a machine you're performing an ineffective or unsafe exercise with no option to modify it. Before you buy, try out the

FIGURE 16.2 Multi-station weight machine.

machine and each exercise it offers. The range of motion should feel natural and comfortable, and at no point during a movement should you feel joint discomfort or pain. Additionally, many multistation gyms do not have a diverse choice of exercise options. Can you target all the major muscle groups? Don't trust that all manufacturers know what they're doing and have placed the client's interest first with regard to exercise design and selection. Often, they don't!

If you choose to purchase a higher end home gym, you'll find it has multiple weight stacks, it has a removable bench that lies flat and inclines at several different angles, and it can train most, if not all, of the major muscle groups. Plus, your client can train without needing a spotting partner because the weight can't fall on him and the machine "footprint" can take up as little as four by eight feet of space. (Make sure your client's ceiling height accommodates the machine.) Multiple weight stacks require fewer adjustments and cable connections as you move from exercise to exercise, and more than one person can work out at a time. The guide rods and cables will operate smoothly and quietly.

Adding a full range of dumbbells to your workout arsenal will add all the strength exercise options you'll ever need, and you can use the bench that comes with the multistation gym.

Weight machines usually come with a stack of weights, although there are other effective options (i.e., Bowflex and the composite resistance rods provide comparable resistance and are easy to move because you don't have to cart around stacks of steel). When using stacked plates or selectorized plates, you select the amount of weight you want by inserting a T-shaped pin through a small hole drilled in each weight plate.

As we have discussed, one problem with machines is that they're usually designed as "one size fits all." Some machines use a cam design to alter the amount of weight you work against at different points through the range of motion. This represents a "strength curve" and what is called variable resistance. Do you think your client's strength curve is the same as the man or woman next door who has arms the size of your legs? Do you believe for a minute his or her hips, arms, and upper torso are of similar width or length to every person in the gym and

that a female client's strength is the same as the hulk wanting to take over the machine she's on? "One size fits all" doesn't deliver a whole lot to anyone!

Realize that weight machines won't size up perfectly to everyone. If it feels wrong, don't use the machine. You can adjust endlessly and it will never be right!

Do strength machines work? Of course. They get similar results when compared with tubing and free weights, with appropriate load being the determining factor. Results are not dependent on what type of equipment is being used or whether it's variable resistance. What counts is whether your client is working to fatigue, generally between 6 and 20 reps.

Are multistation gyms safer than other equipment? Maybe and maybe not! You often hear that they're ideal for beginners because they're so safe—meaning, the weight can't fall on someone. Yet, I can already hear fingers crunching, hair ripping (stuck in pulley or cable systems), and joints aching because people have been led to believe machines are perfectly safe. Train your clients to be careful when they're around a weight stack. And though weight may never fall on them, if they fatigue more quickly than planned or the machine is adjusted improperly, they can surely have a limb detached from its joint. For example, a pullover exercise can turn into an injury nightmare scenario. If the client isn't spotted or positioned correctly, doesn't return to the starting position correctly, or did not take her "Gumby the stretch person" pills that day, she could be crawling over to a phone and dialing 911.

Machines tend to isolate muscles. They don't require balance and stabilization like that which is used for everyday activity and sports movement. So think about a balanced approach, here. If your client always trains on machines, add some upper body dumbbell exercises, squats, and lunges to his routine.

Finally, machines generally are not portable (ever try to fit one in your client's suitcase or your car?) and they are pricey. Learn how to work out with minimal equipment, like free weights, dumbbells, and tubing, and still optimize your client's training result. This is especially true if you travel to client homes or your client is on the road a lot. Your client who travels excessively often doesn't know what

exercising equipment or environment will be available to him, and the ability to work out with minimal equipment can keep him from missing successive workouts.

Elastic Resistance

I know what you're thinking. "Aagh, come on— tubing? Let's get real and move to the machines and weight!" Okay, I know I'm talking about sophisticated "rubber bands," but do they ever work well. You can purchase elastic resistance in different thicknesses that allow you to vary resistance up or down, and they come in the form of "tubes" or thin, long sheets. Rotating or nylon handles attached to tubing can make them easier to use for some exercises. Tubing can travel with you or a client, it takes up little space, and it's inexpensive and effective! And tubing is like free weights or cable systems in that you can work with your client's body because the range of motion is not predetermined and using tubing requires some balance and stabilizing force as the elastic resistance stretches. You can easily hook elastic resistance bands in a door jam (with a door attachment strap) or wrap them around a stair banister or piece of exercise equipment (figure 16.3). Once they are attached, you have a variety of versatile exercise options. In fact, you can replicate all of the exercises you could do with a $100,000 lineup of weight machines!

FIGURE 16.3 Elastic tubing.

In other words, you have hundreds of exercises to choose from. If your client works against a heavy enough resistance as provided by appropriate tube thickness, multiple strands of tubing, or a shortened tube (which increases load), he'll get the same results he would receive from weight machines or dumbbells. Muscles only know fatigue and correct mechanics. They cannot differentiate the type of equipment being used. Simply, strength results are determined by working at sufficient exercise load or intensity.

Calisthenics and Lifting Body Weight

The biggest drawback to a client using his body weight for strength exercises is that usually the exercise is too hard or too easy. And if the amount of effort is just right, it's not long before it becomes too easy. Take push-ups or chin-ups as examples. Some clients can't do any, others can manage a few, and a small number can crank out reps indefinitely. If the exercise is too hard or too easy, your client is not using her time wisely.

Using calisthenics and body weight is not an issue of good or bad. These methods simply have limitations. To determine effectiveness, ask this question: "Can I fatigue the muscles I'm targeting in 6 to 20 reps?" If you can't, you're not optimizing strength results or your client's time!

Working With Minimal Equipment

Many trainers feel helpless if they are presented with limited equipment options, especially if they are accustomed to a multitude of equipment choices. However, the effectiveness, or lack of effectiveness, of exercise is generally not determined by the amount, cost, or type of training equipment. The basis of program design, regardless of equipment options, is in the physiology of the energy, cardiorespiratory, and muscular systems and the methods used to manipulate them. Equipment options should not limit the specific joint action and body parts you can target during strength training, nor should they limit the effectiveness of your client's cardiorespiratory workouts.

Armed with the following approach, you will no longer be limited by lack of equipment or numbly "go through a line of equipment." This chapter gives you an approach that puts the control and direction of the workout back into your hands.

Your clients will be more excited about the changes they feel and see in their bodies than about any equipment you bring to them! Focus on effective training versus variety of equipment. You'll increase your value as a trainer in their eyes and overcome seemingly limited situations with practical and effective solutions.

Trainers who work in clients' homes generally have limited equipment choices. Yet clients may already have equipment that just needs to be dusted off. If you're bringing the equipment, search for equipment that can serve more than one function. For example, use a step platform for cardio conditioning and as a weight bench. Consider activities or training methods that do not require equipment. Outdoor training, cross-training, walking, running, and the use of "real" stairs are practical examples. And, remember that manual resistance (trainer-resisted) and client body weight resistance are valid and effective methods to overload major muscle groups for strength training. With all these options, workouts are certainly not limited.

Selecting Essential Equipment

I said it earlier and I'll say it again! When you are purchasing equipment for an exercise environment, consider five qualities: diversity, variety, portability, space efficiency, and cost.

An example that has all five qualities is a bench that inclines, declines, and lies flat. Another example is elastic resistance, which can be used to challenge many different body movements and can provide progressive overload. Both types of equipment can be easily transported, take up minimum space, and are reasonably priced.

When you are training a client in the home or at a small personal training facility, diversity, variety, portability, space efficiency, and cost are especially important. At the beginning of a program, your client is probably not sure of his commitment to you and training in general. He wants an effective workout but may not initially want to invest a significant sum of money in equipment if you're working him out at home. You can alleviate these concerns by explaining that superb workouts are possible with little equipment and that you possess all of the equipment needed to get his program started. After weeks of training, your client will probably be interested in creating or expanding his home gym. Although not an absolute necessity, expanding equipment options at home is usually a natural response to a positive relationship with you.

Besides the time-tested cardio machines and strength training equipment already discussed, several pieces of exercise apparatus are incredibly productive in contributing to a well-rounded, interesting, versatile, and effective training program. In fact, many of these options are some of the best-kept secrets in the fitness industry!

Following are equipment choices that are some combination of cost-effectiveness, portability, and versatility. Some of the options are perfect to use even in an atmosphere where there is a wide assortment of equipment, such as a commercial club. None of these choices compromise the workout. Even in situations where you have every equipment option you might want to return to these choices, as I do, because they provide fun and variety.

Dumbbells

Selectorized dumbbell system. The selectorized dumbbell system (figure 16.4) allows you to strength train safely and effectively with unlimited exercise variety, minimal space requirements, and minimal dollar investment.

- An alternative is several pairs of fixed dumbbells (weight plates secured in a "bombproof" manner) that are appropriate to your client's current strength level.

- Changeable (nonfixed) dumbbells are another acceptable choice, but be aware of safety issues. Secure the quick-release locking collars before every exercise, and never hold the weights over your client's face.

- PlateMates® provide the perfect way to add increments of 1-1/4, 2-1/2, 3-3/4, and 5 pounds to your existing dumbbells or multigym weight stack (figure 16.5). Being able to attach microloads helps you avoid the dangerous alternative of large jumps in weight. Attach the magnetic PlateMate® to a selectorized

FIGURE 16.4 Selectorized dumbbells.

FIGURE 16.5 Magnetic attachments adhere directly to weights, allowing you to add small increases to your load.

dumbbell, fixed-weight dumbbell, or weight stack. They are available in 1-1/4- and 2-1/2-pound sizes (combine them to get the 3-3/4- and 5-pound increases). And don't worry; they are very secure!

Multigym and Pulley or Cable Systems

The Bowflex® strength training machine is a good example of a nontraditional pulley or cable system (figure 16.6). Bowflex allows you to strength train safely and effectively in your home with unlimited exercise variety, minimal space requirements, and reasonable dollar investment. This pulley or cable system uses composite rods for progressive resistance and is a great choice for a multigym station if you don't like the idea of weight stacks and restricted movement patterns. Test the Bowflex and other multistation units before you buy (they're not for everyone!).

Elastic Resistance

Elastic resistance devices such as tubing or bands provide variable resistance with many different strengths of tubing. Attached handles and bars can make it easy to perform a variety of exercises. Door attachments and wall-mounted units increase elastic resistance versatility.

Stability Ball

This round, air-filled ball is used extensively by physical therapists to strengthen and stretch the body. It is especially well suited for strengthening the abdominal and back areas. It provides a cushion of air to work from and support your client's body, and you can change how hard the client works by how you position your client's body on the ball. The stability ball provides major muscle group overload and flexibility training. It also can be used as an exercise bench.

Trainer-Assisted Manual Resistance

Trainer-assisted resistance is very effective and allows you to add overload and assist with range of motion or correct technique. Partner resistance should only be used if the partner is trusted and knowledgeable.

FIGURE 16.6 The Bowflex system is one nontraditional multistation option.

Your Client's Body Weight As Resistance

A variety of exercises, such as a push-up, dip, or heel raise, use this technique. Limitations of using this type of resistance were mentioned in the discussion of calisthenics and body weight exercise.

Adjustable Step Platform

An adjustable step platform can be used for cardio and strength training in combination with weights or tubing. It doubles as a flat, incline, or decline strength bench.

Adjustable Exercise Bench

This piece of equipment replaces the need for two benches because it is adjustable from flat to vertical. You can use it to perform many

strength-training exercises from supported-standing or seated positions.

Manual Rowing Machine (Nonflywheel)

A manual rowing machine can be used for cardio or strength training by changing resistance. Quick fatigue (30-90 seconds) and more resistance will result in strength gains, whereas high-repetition overload (three minutes or longer) provides cardiovascular training results. By facing forward in the seat and pushing the hands away from the chest, your client can work the triceps, front of the shoulder, and chest. By facing backward and pulling, your client targets the biceps, back of the shoulders, and upper back.

Equipment Essentials: The Final Word

Don't believe all the stories about a particular piece of equipment's overstated magnificence, effectiveness, and "magical qualities." You've got to use the right equipment (defined by your client's goal), the client has to like using it, the equipment needs to be used correctly, and, finally, you will have to modify that which is poorly designed or choose not to use it!

How you use equipment—regardless of its cost—is of utmost importance. A close second with regard to importance is quality of equipment, because good technique can be short-circuited by poor equipment.

From a physiological standpoint, how the body adapts to overload (good stress) to which it is not accustomed (results in a training effect) does not change. And neither does the body differentiate from one piece of equipment to the next. As pointed out earlier, the body only understands effective training and correct overload, regardless of equipment choice.

You need to ask, "Can the equipment I'm using deliver?" In other words, principles of overload and how you get results do not change. If the equipment allows you to exercise a client harder than his body is used to, and he enjoys doing so on a regular basis, you'll get results and client compliance. On the other hand, high-priced equipment won't do the work for your client or plan a smart program for the trainer. Plus, when pricey equipment is compared with less expensive equipment, better results are certainly never guaranteed. You need to distinguish between useless equipment and high-grade (not necessarily top-dollar) equipment. Obviously, by following the right training guidelines and using correct exercise technique, you optimize your client's training result.

The key is to select equipment that can meet the overload and biomechanical standards described in this book as well as accomplish your client's goals. Neither you nor your client needs to have an unlimited budget to purchase equipment. On the other hand, if all the extra gadgets and comforts of top-of-the-line models motivate your client to exercise and budget is not of concern, then they're worth the price.

PART III

PROGRAM DESIGN: APPLICATION THAT BRIDGES THEORY TO PRACTICE

CHAPTER 17

Gauging Exercise Intensity

To most effectively measure and monitor your clients' cardiorespiratory effort, you'll need to blend scientific measurement with subjective judgment when determining appropriate exercise intensity.

What's the value in measuring exercise intensity? Knowing the appropriate "training sensitive zone" allows you to guide clients' efforts to a level that improves their conditioning while keeping heart rate in a safe range. It also enables you to demonstrate fitness improvements in your clients, such as seen by a decrease in resting heart rate or a decrease in heart rate response for a submaximal workload or effort (refer to chapter 11). Yet there is still considerable confusion about appropriate training intensities, especially in the areas of "fat burning" and exercise for health versus fitness or elite performance.

There are numerous methods for monitoring exercise intensity. Most trainers will use one or more of five methods:

Percentage of maximal heart rate (MHR). MHR is determined by counting heartbeats and using a formula based on age-related norms to estimate a preferred intensity level.

Heart rate maximum reserve (HRR). HRR, or the Karvonen formula, is used to estimate an intensity level or training range. Many professionals prefer HRR over MHR.

Rating of perceived exertion (RPE). RPE uses the client's perception of effort. I prefer to gauge RPE with a 1 through 10 numerical rating scale and verbal exertion cues.

Talk test. The talk test is used to identify a level of breathlessness and is often used in combination with RPE.

Preferred exertion (PE). With PE, the exerciser chooses a preferred exertion level, often in combination with RPE.

The first two of the preceding methods are used to estimate a target heart rate (THR) or training heart rate range (THRR). A THRR is calculated when two THRs are determined. Which is the right method for your client? How important is an exacting intensity level for achieving results and keeping your client safe?

How Accurately Does Heart Rate Reflect Oxygen Consumption?

Training-sensitive zone has its physiological basis in the laboratory. Heart rate (HR) is the number of heartbeats within a specified time frame. As a general rule, maximal aerobic capacity ($\dot{V}O_2$max)—defined as the maximum capacity to generate adenosine triphosphate (ATP) aerobically—improves if exercise is intense enough to increase heart rate to about 70 percent of MHR. This is equivalent to about 50 to 55 percent of $\dot{V}O_2$max or HRR (McArdle, Katch, and Katch 1991, 1996; Wilmore and Costill 1994). This level of effort appears to be the minimal stimulus required for training improvements in maximal aerobic capacity, though frequency and duration have impact as well (Plowman and Smith 1997). However, this level of effort is not necessary to reach health-related goals. For relatively deconditioned clients, the training threshold may be closer to 60 percent of MHR, which corresponds to about 40 to 45 percent of $\dot{V}O_2$max (McArdle, Katch, and Katch 1991; 1996; Wilmore and Costill 1994). The lower limits for a training-sensitive threshold related to improved aerobic capacity (but not necessarily improved $\dot{V}O_2$max) depend on the client's current fitness capacity and state of training.

The point is that seemingly minimal efforts by your clients should be encouraged. Work efforts that take a client beyond what she is accustomed to can contribute significantly to positive conditioning effects and health gains.

HRR and $\dot{V}O_2$

For nearly all levels of submaximal exercise, the percentage of MHR does not equal the same percentage of $\dot{V}O_2$max or aerobic capacity. On the other hand, the Karvonen formula, explained later in this chapter, is used to predict HRR and correlates directly to $\dot{V}O_2$max.

Let's look at the conditions that influence heart rate increases or decreases:

1. Rhythmic, continuous, large-muscle activity that simultaneously increases heart rate and venous return (proper and complete overload definition for cardiorespiratory fitness) increases heart rate, workload, and oxygen consumption.

2. When large amounts of muscle mass are engaged (i.e., large-muscle, rhythmic movement), metabolism requirements increase heart rate, workload, and oxygen consumption.

3. Arm movement overhead elicits a **pressor response** (heart rate increases without a matching increase in oxygen consumption) with or without light handheld weights, and although heart rate increases, a matching increase in oxygen consumption does not occur. In this case, monitoring exercise heart rate alone does not provide an accurate picture of oxygen consumption, work rate, or caloric expenditure.

4. Strong resistive efforts that increase resistance to blood flow increase heart rate. This includes traditional resistance training and may or may not be combined with a **Valsalva maneuver** (a momentary or sustained holding of the breath upon strenuous effort). However, a matching increase in oxygen consumption does not occur, which means that the increased heart rate in this situation also provides an inaccurate picture of oxygen consumption and work effort.

5. Dehydration, temperature, emotions, and drugs and medication can increase or decrease heart rate, but like the pressor response, this heart rate count does not provide an accurate picture of exercise effort and oxygen use.

Accuracy of Predicting THRR

Let's compare each of the variables that can affect HR against the capabilities of a predicted THRR to accurately reflect exercise intensity as measured by actual oxygen consumption.

THRR can be a useful indicator—if measured accurately—of oxygen consumption, calorie burning, and metabolism in continuous, dynamic activity that involves a large amount of muscle mass and simultaneously increases HR and blood flow (venous return) to the heart (in other words, "cardiovascular" or aerobic activity). It is oxygen consumption that stimulates cardiorespiratory system training adaptations (your client becomes more fit and heart healthy), not only a fast or increased heart rate. Many factors can increase heart rate that have no effect on cardiorespiratory training adaptations (see previous section on conditions that affect heart rate).

You can see why heart rate measurement and associated THRRs can accurately reflect work performed by the average client with no special concerns if she is engaged in rhythmic,

Short List of Abbreviations

THR	Training or target heart rate
THRR	Training or target heart rate range (includes an upper and lower limit THR)
EHR	Exercise or exercising heart rate
MHR	Maximum or maximal heart rate
HRR	Heart rate reserve or heart rate maximum reserve
RPE	Rating of perceived exertion
PE	Preferred exertion

continuous, large-muscle activity. But, although heart rate may be a good indicator of training intensity in generally healthy adults, heart rate may not be a good indicator of intensity for other people or for some kinds of activity.

When Heart Rate Monitoring May Not Be the Best Choice

Training heart rate may not be the best choice to monitor exercise intensity for the following:

1. People taking medication that can slow HR. If HR is used, the exercising HR must be determined while the client is medicated (taking any prescribed medication) and under medical supervision, so the heart rate is more likely to reflect the actual effort of the exercising client.

2. Clients who are unable to accurately monitor HR. You must check the accuracy of your client's pulse counts or of the heart rate monitor he is using.

3. Clients, such as those in cardiac rehabilitation, who require very accurate heart rate monitoring. Prediction equations (such as 220 minus age) that are used to estimate maximal heart rate, and from which training or target heart rates are estimated, have a large amount of error inherent to them, often plus or minus 10 to 12 beats per minute.

4. Clients who participate in activities where standard equations and prediction methods may not apply, such as swimming or activities that may invoke a pressor response (e.g., hands overhead or resistance training).

Swimming usually elicits a lower maximal heart rate response—10 to 13 beats per minute lower compared with running or cycling (McArdle, Katch, and Katch 1991, 1996; Wilmore and Costill 1994). The combined effects of a prone body position, which may allow the heart to distribute blood more uniformly and do not require it to pump against gravity, and submersion in water probably account for swimming's slightly lower exercise heart rate. Being submersed in water may facilitate blood return to the heart, and rapid heat dissipation in cool water may require less work from the heart if hydration is maintained.

On the other hand, excessively warm water temperatures will increase HR. Furthermore, swimming involves more arm work and uses less muscle mass than, for example, running and cycling. Use of less muscle mass also would elicit a lower maximal heart rate response compared with running and cycling. Because of these reasons, it may be impossible for your client to reach land-based THRR or MHR while swimming.

When figuring THR for swimming, subtract about 13 beats from either an actual land-based MHR or a predicted MHR. (An upper and lower limit THR must be calculated to create a THRR.) Then, mix in a dose of common sense and use perception of effort to zero in on the right training effort.

In contrast to swimming, **aerobic dance** or other group exercise classes can elicit a higher maximal heart rate response for given exercise efforts when compared with running and cycling. This probably results from the use of overhead arm movements and the upright posture associated with some group exercise classes.

When arms are moved overhead, with or without light handheld weights, a pressor response may be elicited, resulting in a heart rate increase without a linear or matching increase in oxygen consumption. The occurrence of a pressor response results in an inaccurate reflection of cardiorespiratory work effort because oxygen consumption increase does not parallel the elevated HR response.

Pressor response also occurs during traditional resistance training exercise. Resistance training (i.e., 8-12 reps to fatigue) has erroneously been identified on several occasions as effective cardiorespiratory activity because HR can remain elevated during this type of training. Cause (a type of exercise) and effect (increased heart rate) certainly do not hold true here. If we only looked at the increased heart rate, we could erroneously assume that the activity provided cardiorespiratory conditioning. However, when oxygen consumption is measured during this type of resistance training, it is found that HR is an inaccurate measurement of exercise intensity, as measured by the metabolic requirements of increased oxygen consumption. In other words, HR increases without a parallel increase in oxygen consumption.

Mounting evidence shows that, because of the previously mentioned limitations, RPE may be the better choice to gauge exercise intensity, in terms of effectiveness and safety (Ebbeling, Ward, and Rippe 1991). To use RPE most effectively, the relationship between heart rate (cardiac response) and RPE (physiological response) has to be accurately established (refer to the case study later in this chapter). In my opinion, using both RPE and heart rate may be the most useful approach.

Has Heart Rate Monitoring Been Overemphasized?

Many experts believe that THR has been overemphasized for average exercise participants and can, in many instances, lead to inappropriate exercise intensities. This includes exercising too hard as well as exercising with too little effort. The resultant effects can be injury, lawsuits, lack of results for time invested, and an alarmingly high number of clients who quit exercising.

Monitoring exercise heart rate precisely and accurately is probably of greatest importance to competitive athletes and cardiac patients, for example. High-intensity interval training for highly conditioned athletes is very structured. Both the effort and recovery of the interval are closely monitored in the belief that this will produce optimal training result and accomplish specific "energy system training." After a thorough diagnostic evaluation, cardiac patients are assigned a precise THRR or RPE. The THRR for the cardiac patient is critical to observe and closely follow. Close adherence and regular diagnostic checkups by the attending physician increase the likelihood that the patient can continue to exercise without risk of angina and heart arrhythmia, or even death.

Preferred Exertion

For a healthy adult, many experts are recommending a combination of RPE and **preferred exertion (PE)**. A research team (Dishman, Farquhar, and Cureton 1994) has suggested using a PE protocol where the client's preference for exercise intensity dictates effort. The authors recommend that this preferred effort fall between some minimal range of not too hard or easy. In other words, encourage your

clients to exercise according to how they feel rather than to a strict exercise heart rate, which may not reflect a preferred level of effort.

Exercise Compliance

Because a wide range of exercise intensities confer health benefits, what is most important is that the client perceive the effort as manageable and enjoyable. It seems this approach might be safer and might better promote long-term exercise compliance, compared with traditional approaches that focus on precise physiological criteria, such as heart rate, to dictate effort.

Exercise dropout rates are as high as 45 percent, and it is reported that 8 to 22 percent of American adults are not exercising with sufficient intensity and regularity to satisfy conventional training guidelines for improvement in fitness (Dishman, Farquhar, and Cureton 1994). Traditional criteria that set exercise intensity often conflict with a client's effort preference. Dishman (1994) stated, "If inactive people select, or are prescribed, an intensity that is perceived as very effortful relative to their physiological responses, they may be less attracted to continued participation" (p. 1090). Additionally, PE works on both sides of the effort dilemma because some clients may prefer to exceed the conventional or prescribed exercise plan.

Teach your clients how to "tune in" to their bodies. Use a combination of heart rate monitoring, perception of effort, and preferred exertion to produce the safest, most effective, and time-efficient results.

Methods for Determining Target Heart Rate and Training Heart Rate Range

To work in the so-called training-sensitive zone, MHR is usually determined (predicted or actual) so that your client can work at some preferred or targeted percentage of MHR. A percentage of MHR is referred to as THR. To determine THRR, an upper limit THR and a lower limit THR must be chosen.

Determining Actual or Predicted Maximal Heart Rate

An actual MHR is more useful and accurate than one you predict. Actual MHR for a specific activity can easily be determined after two to four minutes of all-out effort if peak heart rate is accurately monitored. However, this involves considerable motivation and is not advisable for clients who do not have medical clearance or are at any kind of health risk. A maximal aerobic capacity test or "max stress test" performed in a properly supervised clinical setting is another excellent way to determine actual MHR. However, as with any maximal test, there is some risk of injury or even death. Additionally, many clients do not wish to incur the discomfort or cost or do not have easy access to this type of testing.

Predicting an Age-Adjusted Maximal Heart Rate

Most trainers and consumers use a simple formula to predict an age-adjusted maximal heart rate. However, this method for determining age-adjusted maximal heart rate has limitations because clients of a particular age do not all possess the same MHR. This is certainly not reason enough to never use predicted MHR, but you do need to recognize the limitations of prediction.

The most common of these age-based prediction formulas is 220 − age = MHR. Generally, it is cited that an age-predicted MHR prediction equation gives a standard error of deviation that is plus or minus 10 to 12 beats per minute.

However, in one study about 95 percent of men and women aged 40 had an MHR between 160 and 200 beats per minute (McArdle, Katch, and Katch 1991; 1996). Because of this large variance (plus or minus 20 beats per minute, because 220 − 40 = 180) in measured MHRs, you must account for individual responses to assigned training heart rate ranges. Some will be too easy and some too hard, based on the predicted training range. Necessary adjustments must be made with regard to individual effort so that the THRR best fits your client's current fitness level, health needs, and preferred level of exertion. This information lends additional support for using predicted THRRs and RPE simultaneously to determine client exercise intensity.

Gauging Exercise Intensity Using Heart Rate

Overall, heart rate is a relatively accurate means of monitoring and determining exercise intensity. When heart rates are accurately monitored, you can assure your clients of predictable and efficient results. Furthermore, you can motivate clients with the fact that low-level intensity and low to moderate training heart rates can provide them significant and measurable health and fitness results.

Upper and lower limit THRs for clients on medication should be determined in a clinical setting, under medical supervision. The client should be medicated when THR or THRR is determined.

An appropriate THRR that accommodates most levels of fitness, for asymptomatic individuals, is from about 40 to 85 percent of $\dot{V}O_2$max or HRR (ACSM 1995). A given percentage of HRR corresponds directly to the same percentage of $\dot{V}O_2$max, whereas 40 to 85 percent of $\dot{V}O_2$max or HRR corresponds to about 50 to 90 percent of MHR (table 17.1). This wide training range—40 to 85 percent—could be called the "training sensitive zone" for improvements in health and fitness for a majority of the inactive and active population. There is no need to label a certain zone as fat-burning or another as aerobic. Instead, match the zone or range to your clients' goals and current levels of fitness. Train a variety of ranges to completely train the cardiorespiratory system.

Using Percentage of Maximal Heart Rate

If you can, use an actual MHR for your client. If that's not possible, use a simple age-based prediction formula like 220 − age.

THRR results from the MHR being multiplied by an upper limit THR percentage and a lower limit THR percentage. Generally, a THRR is desired because this provides some flexibility as to the degree of effort within which the client will work.

TABLE 17.1

Relation Between Percent Maximum Heart Rate, HRR, and Percent Maximum $\dot{V}O_2$

For any given percentage of MHR, the corresponding percentage of max $\dot{V}O_2$ is at least 5-10 percent less. Note that the corresponding HRR, as predicted by the Karvonen formula, matches perfectly with max $\dot{V}O_2$ or aerobic capacity. Thus, Karvonen predictions more closely reflect actual percentage of max $\dot{V}O_2$.

Percent maximum HR	Percent HR maximum reserve (HRR)	Percent maximum $\dot{V}O_2$ or aerobic capacity
50	28	28
60	42	42
70	56	56
80	70	70
90	83	83
100	100	100

Adapted from McArdle et al. 1991.

Case Study: Calculating Recovery and Exercise THRRs As a Percentage of MHR

Your 47-year-old female client, Roxanne, is a competitive long-distance runner. Her interval training regimen benefits from a high level of accuracy in heart rate monitoring. You decide that Roxanne needs a specific recovery THRR to fall into between effort intervals of 85 and 95 percent of MHR (about 80-85 percent of $\dot{V}O_2$max or HRR).

Target heart rate (THR) = [(220 – age) or actual MHR] × desired percent of MHR

Roxanne's maximal heart rate, as determined by a maximal stress test, is 187. Note that her predicted MHR (220 – 47) is only 173. Therefore, you use her actual MHR (187) to determine her training and recovery THRRs. It is obvious that THRR can be used for determining both proper cardiorespiratory effort and recovery.

First, determine Roxanne's recovery THRR.

THR (lower intensity limit) equals:

MHR × .80
187 (MHR) × .80 = 149.6

THR (higher intensity limit) equals:

MHR × .85
187 (MHR) × .85 = 158.95

Roxanne's THRR for recovery after high-intensity intervals is between 149 and 159 beats per minute. Her 10-second HR count is about 25 to 26 beats per minute and is determined by dividing 149.6 and 158.95 by 6.

Then, you would need to determine an exercise THRR. Calculate a THR at 85 percent, 90 percent, and 95 percent of Roxanne's MHR to determine her range of target heart rates.

Adapting the Training Range

Your best bet will be to use a combination of perception of effort and HR. Your client's feelings and feedback, along with consultation with your client's attending health care professional, will most accurately guide adjustments in level of effort.

Using Heart Rate Maximum Reserve Method (Karvonen's Formula)

The Karvonen formula is used to predict maximum HRR. HRR accommodates various fitness level differences and more accurately predicts training heart rate range because individual resting heart rate (RHR) is entered into the formula. HRR is the method I prefer to use to calculate training ranges for my clients.

HRR is based on a simple concept. As your client becomes more fit, her heart becomes stronger and more efficient. Consequently, for any given submaximal workload, HR will be lower. This includes RHR. Using RHR helps avoid lumping clients into statistical averages, which can be less effective and even dangerous when calculating THRRs.

Furthermore, an actual MHR should be used in the HRR equation, as previously mentioned. According to exercise physiologist Tom LaFontaine, maximum HR for 100 men aged 30 may vary from 166 to 214 beats per minute. Based on the age equation, 220 – 30 = 190, all of these individuals would have THRs predicted from an estimated MHR of 190. The error is plus or minus 24. The use of actual MHR and RHR in predicting THRR in the Karvonen equation has profound implications in terms of achieving accuracy and personalizing training to the client's current fitness level.

Karvonen's formula is probably the most widely used method of calculating THR for cardiorespiratory conditioning. With this formula, the percentage of HRR that a participant should be working at, or within, corresponds directly with $\dot{V}O_2$max. For example, an individual working at 80 to 85 percent of his HRR would be exercising at an intensity of about 80 to 85 percent of his $\dot{V}O_2$max (see table 17.1 for a representation of this relationship). Forms 17.1 and 17.2 demonstrate how to calculate THR by using the Karvonen method.

Counting Heartbeats With Manual Palpation

One of the easiest and most practical ways to measure HR is by palpation technique, immediately after exercise is stopped. (Manual

F O R M 17.1 Worksheet 1: Sample Calculation of THR Using the Karvonen Method

Maury is a 48-year-old man with a resting heart rate (RHR) of 79 who wishes to train at 80 percent of heart rate reserve (HRR). Here's how you calculate his THR using the Karvonen method.

(1) Find Maury's estimated maximal heart rate (EMHR) using 220 – age, because his true maximal heart rate (TMHR) is not available.

EMHR = 220 – age

EMHR = 220 – 48 = 172

(2) Find Maury's heart rate reserve (HRR).

HRR = EMHR – RHR

HRR = 172 – 79 = 93

(3) Calculate Maury's target heart rate (THR).

THR = HRR × training intensity percentage + RHR

THR = 93 × .8 + 79

 = HRR × percent training intensity + RHR

 = 74.4 + 79

 = 153.4 beats per minute

THR = 153 to 154 beats per minute (which is 80 percent of HRR plus RHR).

Reprinted from D. Brooks 1999.

F O R M **17.2 Worksheet 2: Worksheet for Calculating THR Using the Karvonen Method**

The following worksheet allows you to calculate target heart rate (THR) by using either a true maximal heart rate (TMHR) as determined by a short, all-out effort (discussed previously) or an estimated maximal heart rate (EMHR) as determined by the formula 220 – age. You will recall from previous discussion that when determining maximal heart rate (MHR), it is preferable to use a true rather than estimated or calculated MHR. Both resting heart rate and MHR numbers are necessary to calculate THR, using the Karvonen method.

(1) Determine resting heart rate (RHR), TMHR, or estimated maximal heart rate (EMHR).

RHR: _____

TMHR or EMHR:_____

(2) Calculate heart rate reserve (HRR) by using the following formula:

(HRR) = (TMHR or EMHR) – RHR

HRR = _____ (TMHR or EMHR) – (RHR)

(3) Calculate THR by using the following formula:

THR = HRR × training intensity percentage + RHR

THR = ____ (HRR) × _____ (training intensity percentage) + _____ (RHR)

THR = _____

Or simply: THR = [MHR (predicted or actual) – RHR] × training intensity percentage + RHR ✗ 80

Reprinted from D. Brooks 1999.

From *The Complete Book of Personal Training,* by Douglas S. Brooks, 2004, Champaign, IL: Human Kinetics.

palpation during certain types of exercise, e.g., running or walking, is more difficult although not impossible.) Palpation involves a manual touch to feel the pulse created by the heart's pumping action.

Pulse usually is measured at the carotid artery in the neck or the radial artery in the wrist (figure 17.1). Practice taking your own pulse at these sites. To take your client's pulse at the neck, touch your index and middle fingers to the front of her neck, near the jaw and alongside the trachea (or windpipe or Adam's apple). To take the radial pulse, use the same two fingers to find the pulse at the thumb side of the wrist. For either method, do not use your thumb; doing so can cause you to feel your own pulse instead, producing an inaccurate count. Generally, it is recommended that pulse be taken at the radial site to avoid a reflexive response to touch that can occur at the carotid site, which results in inaccurate pulse counts. Please note that, with some clients, you might have difficulty locating the pulse manually. In those cases, use a stethoscope or heart rate monitor.

Counting Pulse Accurately

Accurate pulse count assessment is essential when monitoring exercise intensity. Inaccuracies may arise from starting the counts incorrectly, not starting and ending on the correct time frame, improper hand placement, and miscounting the pulse during the timed pulse-monitoring period.

Using Time Intervals

The longer the time interval used to measure pulse, the more accurate the reading. When monitoring beats per minute during a 60-second count, missing the starting beat, a middle beat, and the ending beat is not critical. This results in an error of three. However, during a 10-second count, three missed beats would give you a projected count 18 beats too low!

Whether you use a 10-second count multiplied by 6, 15 seconds multiplied by 4, 30 seconds multiplied by 2, or a full 60-second count, standardize and be consistent with your approach for determining beats per minute that reflects a one-minute count.

FIGURE 17.1 Pulse being taken at the wrist site.

Counting Resting and Activity Heart Rate

Resting heart rate is probably best recorded when using a 60-second count, although using a 30-second count is acceptable. During activity, a 10-second HR count may be ideal.

In a healthy client, exercise heart rate begins to slow quickly, usually after only 15 seconds, once exercise is stopped. Pollock and Wilmore (1990) recommend a 10-second count, assuming that it takes about two to four seconds to properly position finger placement. Counting the beat for 10 seconds will allow you to determine the heart rate before the crucial 15-second window expires. This will avoid error as a result of heartbeat deceleration if longer counts are used.

Counting Technique

Locate the pulse and repeatedly count "one, one, one . . ." to establish heart rate rhythm. Begin when you (or your client) have established a sense for the heartbeat pattern or rhythm. This will ensure a more accurate postexercise

and actual exercise HR count. However, the pulse should be located and the HR rhythm established within seconds after exercise is completed or slowed for a count.

What are you counting? Imagine six vertical lines representing heartbeats. If you count each beat (starting with "one") at the top of each line, your count will be six. If you count cardiac cycles in between beats, your count will be five. This representation of heartbeats as lines can help you understand why your count should start on "one" during normal exercise situations (Pollock and Wilmore 1990) versus zero.

Counting Heartbeats Using Heart Rate Monitors

Wireless heart rate monitors are computerized, electronic digital readout devices that are worn on the wrist like a watch or are mounted on exercise equipment. The heart rate monitor constantly displays your client's heart rate, giving updated exercise intensity information every

few seconds. This is an attractive alternative given the potential inaccuracies of monitoring HR by palpation.

The most important feature of a heart rate monitor is its method of pulse detection. Inexpensive—and often the least accurate—models operate by a principle called "photo-reflectance." Sensors placed on the earlobe or fingertip use a photocell and light source to detect pulse. These types of devices are sensitive to body movement and often give inaccurate readings if heart rate moves above 110 beats per minute.

More accurate heart rate monitors transmit the electrical activity of the heart through an electrode harness that is positioned on the chest to a watchlike receiver mounted on exercise equipment or the wrist. Because there are no wires connecting the transmitter to the receiver, wireless telemetry models do not interfere with upper body or arm movement.

Heart rate monitors make it easier to monitor HR during exercise and recovery. They reduce the need to stop or slow activity to get an accurate HR and replace the inaccuracy often associated with manual heart rate monitoring. Excellent research (Leger and Thivierge 1988) indicates that several companies have reliable heart rate measurement devices. Even so, it is a good idea, in consideration of occasional erroneous readings that may result from depleted batteries or product malfunctions, to use RPE in conjunction with this and any type of heart rate monitoring.

Rating Exertion: A Method That Uses Perception of Exertion

An easy and practical way to monitor the intensity of cardiorespiratory effort is using an individual's sense or perception of effort. Getting in tune with this "sense" allows clients to "check in" with how they are feeling at any given moment. Because a manual heart rate count is often difficult to perform accurately and can be distracting, perceived effort may be more effective and safer for many personal training situations (Ebbeling, Ward, and Rippe 1991; Dishman 1994). Furthermore, when subjective judgement is used in conjunction with HR monitoring, it provides a double check on the accuracy and effectiveness of training heart rate range. This is especially important if THRR is predicted by using an estimated maximal heart rate.

Perception of effort can be taught by associating HR response with a particular numerical rating and its assigned descriptive terms on a scale of 1 to 10. For example, a moderate level of effort is rated 2 to 3 numerically and "somewhat easy" to "moderate" descriptively (see table 17.2). When your clients get very skilled at this rating game—and it is a fun game to challenge your clients with—they will be able to consistently estimate exercising heart rates within about plus or minus five beats per

TABLE 17.2 10-Point Exertion Scale

Cardiorespiratory conditioning	Numerical rating: 0-10	Instructor exertion cues
	0	
	0.5	Very, very easy
	1	Very easy
Recovery or warm-up effort	2	Somewhat easy
Recovery or warm-up effort	3	Moderate
Aerobic effort	4	Somewhat hard
Aerobic effort	5	Hard
	6	
Anaerobic effort	7	Very hard
Anaerobic effort	8	
Anaerobic effort	9	
Anaerobic effort	10	Very, very hard

minute. A wireless heart rate monitor is an excellent tool to teach this association between HR and a client's sense of exercise effort.

Rating exercise based on a perception of effort is especially appropriate for your clients who do not have typical heart rate responses to progressive aerobic exercise. This includes clients who are on beta-blockers (and other medications), some cardiac and diabetic clients, pregnant clients, and any others who may not have a predictable heart rate response to cardiorespiratory activity. In fact, using perceived exertion monitoring methods with these types of clients is often the preferred way to monitor exercise intensity. Make this decision after consultation with your client's qualified health care provider.

The following points will help you improve the accuracy of this method:

1. Teach accurate manual heart rate measurement. Establish a relationship between physiological response (heart rate) and subjective feelings, or perceived level of effort. Heart rate is a direct measure of physiological response to aerobic or anaerobic cardiorespiratory effort. This is in contrast to a predicted measure. Poor heart rate measurement technique results in error. A wireless heart rate monitor is a good tool to help establish your client's HR relationship with a 10-point numerical rating (table 17.2) and associated "feeling" of effort, especially if you or your client is struggling with accurate and consistent manual heart rate measurement.

2. To help establish the relationship between HR response and the numerical and descriptive scales (table 17.2), relate a particular activity, such as walking leisurely, stair stepping vigorously, interval conditioning, or steady-rate swimming, to this numerical rating and descriptive terms. For example, steady-rate swimming and leisure walking would be assigned numerical values at the lower end of intensity for most clients, whereas high-intensity interval conditioning, regardless of the activity chosen, would be at the higher end.

3. Periodically monitor HR and update the association of your client's HR response to the ratings found in the exertion scale. I have found that it is easy to become overly confident in your client's ability to consistently and accurately estimate perceived effort. "Check in" often to be aware of training adaptations that take place, such as a decreased HR for a given submaximal load. To reestablish an accurate association of exercise intensity (HR) with a perception of effort, return to heart rate. Of course, HR is an objective measure of exercise intensity and oxygen consumption only if it is recorded accurately.

When your client becomes better conditioned, her perception of exertion at a given level of effort will remain about the same even as you increase overload. Equally true is that as fitness level increases, the intensity of activity that your client engages in must increase if continued improvements are desired. If intensity is simply maintained, she will enter a phase of cardiorespiratory maintenance, which may or may not be appropriate to her current fitness level and goals. You will have to determine direction based on each client's individual training situation.

Ultimately, once taught by you, all of your clients can take responsibility for working at a level of cardiorespiratory aerobic or anaerobic exercise intensity that they perceive as reasonable, fun, and something they will likely continue!

Case Study: Playing the Game—Associating HR With Exertion Perception

Kendall loves to walk. A main emphasis of her cardiorespiratory workout is combining recreational strolls (warm-up), fitness walking (steady-rate), and race walking (at or slightly above steady rate or what could be termed interval conditioning). By using wireless telemetry to monitor heart rate (you can also use accurate manual palpation monitoring techniques), we established the association between Kendall's heart rate and perception of effort.

Stroll. HR response to a two- to three-mile-per-hour stroll was 105 to 115 beats per minute. Using table 17.2, the 10-point exertion scale, Kendall describes this level of effort as "very, very easy" to "very easy" or about 0.5 to 1 on the exertion scale.

Fitness walking is about three to five miles per hour. Although sustainable for indefinite time periods, five miles per hour (12-minute-

mile pace) elicits about 145 beats per minute and is a level of effort that is "somewhat hard," according to Kendall. The numerical rating on the exertion scale for this level of effort is 4.

Race walking. Kendall's technique allows her to complete a 10K race averaging a "race pace" that is between 10- and 11-minute miles (6 miles per hour to about 5.5 miles per hour) at a heart rate between 150 and 165 beats per minute. Kendall rates this effort as "somewhat hard" to "hard." The numerical rating is 4 to 5.

Interval training. A brief burst of "speed play" to pass another competitor in a race is rated at 7 or 8 and is associated with a "very hard" effort. Her HR reaches 165 to 170 beats per minute. Some of our interval conditioning drills push her to 10 on the exertion scale, or "very, very hard," and her HR may reach 180 beats per minute.

The game. Initially, to learn the association between HR and exertion perception, we played a game. I continually asked Kendall to guess her resting, exercising, and recovery heart rates. For example, before either one of us looked at her wireless heart rate monitor during exercise, she first estimated her exercising heart rate and gave me a number (10-point exertion scale, 1-10) and descriptive term (from the exertion scale) to describe her level of effort. When we first started the game, Kendall thought her stroll elicited about a 130 heart rate. She associated it with a numerical effort of 1 and as "really easy." She was surprised to find her actual HR was only around 100 beats per minute, even though her description of the effort was accurate.

Eventually, by playing the game, Kendall could accurately guess her level of effort at any intensity within plus or minus five beats per minute. It was interesting for me to observe that Kendall's choice of descriptive terms and numerical ratings (effort perception) always provided the most accurate estimate of how she was feeling and of her immediate exercise intensity. You should use this association drill, regardless of the client or her goals, if you are to accurately and effectively use a client's subjective judgment when rating exercise effort. The point is that Kendall can accurately assess how hard she is working with descriptive terms, based on how exercise feels, independent of heart rate response.

10-Point Exertion Scale

Table 17.2 provides an excellent frame of reference from which to teach clients how to associate perception of effort with actual heart rate. The numerical values of this 10-point exertion scale range from 0 to 10, with 10 representing maximal or "very, very hard" exertion. The cardiorespiratory conditioning column contains recommended exertion levels for recovery or warm-up (2-3), aerobic steady-rate training (4-6), and anaerobic intervals (7-10). The client's association with the numerical rating is found by looking horizontally across the scale. The Instructor Exertion Cues (Brooks et al. 1995) provide language that might be more practical to use by the trainer, as opposed to other language found in the literature.

The training-sensitive zone based on a heart rate reserve (HRR) of 40 to 85 percent (equivalent to about 50-90 percent of MHR) corresponds to a rating of 3 to 7 on the exertion scale. A rating of 3 to 7 classifies the exercise intensity as "moderate" to "very hard." Note that a rating of 1 or 2 ("very easy" to "somewhat easy") may be sufficient to increase fitness levels in some populations and may be well below 40 percent of $\dot{V}O_2$max or HRR.

Generally, a rating of 3 to 7 for most personal training clients is safe and effective. Anaerobic intervals may use ratings as high as 7 to 10 ("very hard" to "very, very hard").

Talk Test

The talk test is an excellent approach for monitoring exercise intensity with clients who have a low level of conditioning or are just starting a conditioning program. (It is also effective for use with highly trained athletes, as are subjective ratings.) For general health gains, a person should be "comfortably uncomfortable" in terms of intensity. He should be able to breathe easily throughout the duration of the activity. Generally, the client should be able to string together several words without gasping and remain conversational. Use the talk test to ascertain whether a reasonable level of effort is being maintained—neither too hard nor too easy!

Unless the client is practicing anaerobic interval conditioning, it is appropriate for most clients to slow down when the following occur:

1. There is a noticeable increase in respiration. Breathing occurs in gasps, and it is difficult to string together two or three words of conversation. Extreme breathlessness is a sign of exceeding anaerobic or steady-rate threshold and may or may not be desirable.

2. Muscles start to "burn" and participants find the activity very uncomfortable. The client fatigues prematurely ("I can't go any longer") and wants to stop the workout.

Breathlessness and burning muscles indicate that your client is feeling the onset of blood lactate accumulation. She has reached her **anaerobic or steady-rate threshold** (more accurately called the respiratory threshold or blood lactate threshold). The respiratory threshold occurs as the exercise becomes more intense and the muscle cells can no longer meet the additional energy demands aerobically. Working at intensities the client is unaccustomed to is neither "good" nor "bad" but simply a matter of appropriateness.

Final Words on Gauging Exercise Intensity

There are numerous ways to determine whether your client is working at the right level of effort, and a good trainer will use most of them. These include various methods of heart rate monitoring and rating of perceived exertion. Correct exercise intensity must be used if clients are to gain the level of conditioning they desire while remaining safe and comfortable.

What's the Perfect Effort?

Although the talk test and subjective exertion ratings can stand alone as valid ways to ensure your client is working at the right level of effort, heart rate gives an internal look at what is going on with the body. In theory, heart rate doesn't lie because it is an actual response of your client's body. Heart rate response can tell

your client what kind of shape she's in, how much she's improved, and whether she is training too hard. Heart rate is precise in its ability to tell you how your client's body is responding to training. It is an objective number versus a subjective rating.

I believe that combining the talk test, subjective ratings, and heart rate measurement is the most precise way of gauging your client's level of effort. For example, if your client's training zone is slightly off and she's working at a heart rate that is too hard, using a subjective rating of how she feels or the talk test is going to tell you to have her back off. And if the training is too easy, you know you can push her a little harder.

The Golden Rule

For a moment, let's forget science, heart rate, and calculations. The golden rule with regard to gauging your client's level of effort is this: If it doesn't feel right to her, or doesn't match her goal, change her level of effort.

Your client's preference for an exercise intensity and what you and she believe should dictate effort will indicate the right programming direction. A perfect effort that a client will stick with falls between some minimal range of not too hard and not too easy, and one that will be in accordance with her training goals (obviously, anaerobic intervals are going to feel hard!).

In other words, clients should exercise according to how they feel, rather than to a strict exercise heart rate, which may not reflect a level of effort that is conducive to training result and helping them stick to an exercise program. Your client should perceive her workouts as manageable and enjoyable, because such a wide range of exercise intensities confer health benefits. Approaching exercise with this attitude is safer and will promote long-term exercise compliance. Part of a trainer's job is helping clients stick to their exercise program, helping them love and enjoy what they are doing, as well as furthering results.

Cardiorespiratory Conditioning Programming

Although exercise that challenges the cardiorespiratory system may seem like the simple part of an exercise program—anyone can walk, run, or bike, right?—you know that's not necessarily the case. A more sophisticated approach—one that uses cross-training and periodization—allows your clients to avoid boredom during aerobic exercise while improving their results. Creating new programming is a good mental challenge for you, too.

Training Aerobically

Before you decide how long, how hard, and how often a client should participate in cardiorespiratory activities, you must make sure you're applying the correct overload to strengthen your client's heart.

The correct and most comprehensive definition of overload is that it is a simultaneous increase in heart rate and return of blood (venous return) to the heart caused by a rhythmic, continuous, large-muscle activity. If continued improvements are to be realized, the overload must be progressive in nature. (That's a complex way of saying your client needs to keep working harder to keep seeing progress!)

Many factors can increase heart rate without increasing blood return to the heart. Certain drugs, excitement, stress, a hot environment, dehydration, or traditional resistance training are examples. Yet sustaining a large volume of blood return to the heart (venous return) is essential to bring about a significant training effect. Lifting moderate to heavy weights (i.e., 1-12 reps to fatigue) will increase your client's heart rate but will not significantly increase

oxygen intake—a situation known as the pressor response. This does not result in a large volume of blood returning to the heart, because the heart has to pump harder to overcome the resistance to blood flow caused by moderate to heavy exercise. If you're measuring heart rate in a situation like this, you will have a false impression that your client is doing effective cardio training, based on the increased heart rate. Heart rate alone does not provide enough information for you to determine whether your client is doing the right kind of activity to train the cardiovascular system (refer to chapters 15 and 17).

Activities that have the potential to simultaneously increase heart rate and return large volumes of blood back to the heart typically involve the large muscles of the hips, thighs, and buttocks. Examples include walking, hiking, jogging, running, cycling, in-line skating, swimming, cross-country skiing, and stair stepping.

Steady Rate

Your client needs to know what steady-rate pace means and feels like if she wants to train smart. **Steady-rate** exercise is a level of cardiovascular effort that is easy to maintain. You might describe this level of intensity to your client as "cruising" or characterize it by saying, "You could keep this up all day long!" Another good indicator of steady rate is whether your client can sustain the pace for about two to three minutes or longer. If the client falls off her exercise bike after 12 seconds, she's not working her muscles aerobically and she's not at a steady rate of exercise (see chapter 17).

Why should your client understand how she feels during a steady-rate effort? Because there will be instances, such as during interval training, that she will be encouraged to work beyond this comfort zone. Conversely, when she's recovering from vigorous exercise, the client might be asked to work at or below this steady-rate level. Knowing what "hard" or "easy" exercise feels like will help optimize any client's training results. Both are equally important.

Effective Aerobic Activity

To maximize benefits and results, cardiorespiratory exercise must increase heart rate and cause large amounts of blood to be pumped from, and back to, the heart. This is what conditions your client's heart and provides all of those training benefits. Flexing fingers repeatedly, lifting heavy weights, or working hard at rhythmically pumping a channel changer are not effective aerobic exercises because they don't significantly increase heart rate, oxygen consumption, and the amount of blood being pumped.

How Often, How Long, and How Hard

To further refine your approach to cardiorespiratory training, you have to make choices about the frequency (how often), duration (how long), and intensity (how hard) at which your client will train.

How Often

If your client wants to see serious improvements in her fitness and has developed a good training base, you need to challenge this aerobic component of fitness a minimum of three and up to six times per week.

If your client is just starting a program or is out of shape, don't let these recommendations mislead you or discourage the client. Instead, have her perform cardio training two to three times per week and wait at least a day between sessions. You'll see significant fitness improvement and health benefits. Your long-term goal is to build your client up to exercising on most days of the week.

How Long

How long your client should work out depends on her current level of fitness. Again, if she's just starting a program or is out of shape, don't

follow textbook recommendations. Instead, start with 5 to 10 minutes once or twice per day. Your client will see significant fitness improvement and health benefits. Your long-term goal is to build your client's exercise duration to 30 minutes of cardiorespiratory activity on most days of the week.

Conditioning Stages for Frequency and Duration

Choose stage 1, 2, 3, or 4 depending on your client's current aerobic conditioning level. Aerobic or steady-rate training lays the groundwork for more advanced cardiorespiratory exercise, like interval training.

Stage 1: Conditioning Base If your client is just starting out, hasn't exercised in a long time, or is out of shape, allow her at least four to six weeks to progress to a solid base of aerobic conditioning. You cannot progress too slowly.

Start with 5 to 15 minutes of aerobic activity like walking or biking. The activity can be performed continuously or broken up, for example, into smaller 10-minute segments. On her own, your client could walk her dog for 10 minutes in the morning, take a 10-minute stroll at lunch, and walk around her neighborhood in the evening. This type of "informal" activity counts toward your client's health and fitness goals! After a couple of weeks, shoot for 20 to 30 minutes per session with you, the trainer. Remember, you can break any longer duration into more manageable shorter bouts of about 10 minutes each and gradually work the client to nonstop and longer time goals.

Stage 2: Moving Beyond Base Level Fitness If your client is working out regularly, this stage can easily last up to six months. (Inconsistent training means she'll stay in this stage longer.) Gradually increase your client's exercise duration. This means about 5 to 10 percent increases every two to three weeks until your client is comfortable completing 30 minutes of activity. Once again, it isn't necessary for your client to engage in 30 minutes of activity in one continuous effort to get excellent health and fitness results. Toward the end of this stage you might be able to work the client up to an hour of total activity, a couple of times per week, to add variety and challenge to her workouts. Generally, exercising beyond an hour leads to diminished fitness returns (your client's results

don't equal the effort and time she puts in) and an increased risk for injury.

Stage 3: Maintenance Reaching a point where a client can maintain her fitness level is certainly not regression! It's simply an acknowledgment on your client's behalf of a personal commitment to continue her program in a fun, varied, and effective manner.

Many of your clients already have a high level of aerobic fitness. Here's a reality check for you and your client: It's hard to improve fitness forever. One of your clients can probably remember when she first started a program and how ecstatic she was when her personal results began to cascade in immediately. Then, after training regularly and progressively for three to six months, or maybe it was a year and a half, those results slow to a trickle. It is at this point, and for the rest of your clients' lives, that they should begin to maintain this fitness base by cross-training, add anaerobic conditioning intervals, and vary how often, how long, and hard they work out. Both the trainer and the client must keep the workouts fun! This approach and commonsense rationale will help any client improve fitness and minimize the chance of client burnout.

Maintaining a certain fitness level does not mean "sentencing" your client to a life commitment of the same old boring routine. In fact, maintaining fitness is far from this dreary scenario. Reaching a point of maintenance simply acknowledges your client's acceptance of a desired state of personal health.

After any amount of sustained training (three to six months or longer), a slowdown in training benefits is inevitable. Prepare your client in advance for this unavoidable physiological reality so that he can experience it in a positive light. The ultimate goal of any client should be to maintain his current program and level of fitness, for life!

Stage 4: Optional High-Intensity Training Clients can move from maintenance periods to improving fitness by using interval and cross-training. All programs should be periodized (chapter 13).

How Hard

Aerobic intensity guidelines for healthy adults are generally set at 50 to 85 percent of $\dot{V}O_2$max or heart rate reserve (HRR). Training intensities are determined by taking a percentage of $\dot{V}O_2$max or HRR; this is a target heart rate (THR). When you figure a low- and high-end percentage, this creates a target heart rate range (THRR) that your client trains within. It's easier to figure out a heart rate training range by calculating your client's HRR than by determining $\dot{V}O_2$max, and HRR compares directly to $\dot{V}O_2$max, anyway. These calculations are discussed in depth in chapter 17. If you don't like to use heart rate, use the 10-point exertion scale, or both. For more about the exertion scale, see table 17.2, page 342.

If your client is deconditioned or just starting a program, once again, adjust the following recommendations. They are not written in stone. Moderate- to low-level and consistent cardiovascular training—well below the recommendations set forth—can result in substantial and beneficial effects to your client's health and can greatly improve cardiovascular endurance.

Conditioning Stages for Intensity

Choose stage 1, 2, 3, or 4 depending on your client's current aerobic conditioning base. These aerobic conditioning intensities should be complemented by anaerobic interval conditioning to reach top levels of fitness, when appropriate to your client's situation.

Stage 1: Conditioning Base

Have your client work at a heart rate training zone between 40 and 60 percent of his heart rate reserve (HRR). This corresponds to a subjective judgment of effort that falls between 2 to 3 ("somewhat easy" to "moderate") or 3 to 4 ("moderate" to "somewhat hard"). Your client should be able to speak short sentences without gasping while exercising at this level of effort.

Stage 2: Moving Beyond Base-Level Fitness

Target a heart rate training zone between 60 and 75 percent of your client's HRR. This corresponds to a perceived rating of effort that is 3 to 5 ("moderate" to "hard"). If you want higher levels of fitness, raise your client's training zone to 70 to 85 percent of HRR. This corresponds to a rating of 4 to 6 ("somewhat hard" to "very hard"). Remember, your client is still engaging in aerobic training. Even with these increasing exercise intensities, your client should still be

able to speak short sentences during the activity without gasping.

Stage 3: Maintenance

Encourage your client to maintain his level of effort and consistency but introduce variety. Work at both the high and low ends of the heart rate training zones and introduce some easy or "cruiser" workouts using the lower intensities in the base-level stage.

Stage 4: Optional High-Intensity Training

Your client can move from maintenance periods to improving fitness by using interval training (85 percent and greater of HRR) and cross-training.

Case Study—VO_2 and Cardiorespiratory Fitness

The correct activity, frequency, duration, and intensity have the biggest impact on your clients' accomplishment of their specific fitness goals. Let's look at the following scenario to explain the relationship of VO_2 to heart rate, stroke volume, and oxygen extraction.

Mary and Susan, who are the same size, are jogging at about a nine-minute mile. This is a submaximal exercise pace for both women. Because they weigh the same, it is reasonable to assume they will use approximately the same amount of oxygen when exercising at this pace. Why does Mary, who is less trained aerobically, have so much trouble keeping up with Susan, who is aerobically more fit?

The answer involves VO_2 and the ways oxygen is delivered and used. VO_2 is related directly to cardiac output (\dot{Q}). Because cardiac output equals heart rate times stroke volume ($\dot{Q} = HR \times SV$), the person with the larger stroke volume will need fewer beats of the heart to pump the same amount of blood. That's Susan, the more highly trained person. Furthermore, Susan will be better able to use oxygen, as would be evident by her greater arteriovenous oxygen difference, or $(a-\bar{v})O_2$ difference, at the site of oxygen delivery to the exercising muscles.

Mary, the lesser trained person, will have a much higher heart rate at any given workload compared with Susan. Mary might become "winded" or tired or have labored breathing if she tries to maintain an even pace with Susan. Why? Simply, Mary is less efficient at oxygen delivery and extraction than Susan. Both Susan and Mary will deliver about the same amount of oxygen to satisfy the oxygen demands of the given submaximal activity, but Susan (more fit) will deliver the oxygen in a more efficient manner. That is why Susan's perceived effort is much less than Mary's, even though they are accomplishing the same amount of absolute work (i.e., they cover the same distance) and burning about the same number of calories (because their weights are similar, they require similar amounts of oxygen and calories expended for a given distance).

Additionally, Susan and Mary have different anaerobic or steady-rate thresholds. Here is where Susan's fitness advantage is really highlighted. If exercise intensity is increased above the nine-minute-per-mile pace, which for this example is submaximal for both women, eventually Mary would not be able to tolerate and sustain as high an intensity as Susan. Because of Susan's better conditioning, her anaerobic threshold occurs later than Mary's, allowing her to work harder and longer at higher levels of effort that are very manageable. Susan has a higher $\dot{V}O_2$max and can work at a higher percentage of her $\dot{V}O_2$max.

The bottom line is that Susan can work harder over given time periods and harder and longer in general compared with Mary. And she can sustain these higher intensity and longer duration efforts predominantly with the long-term or aerobic energy pathway. In a given time period, Susan can optimize fitness gains and calorie burning by working at an optimal yet manageable level of intensity in relation to her better level of conditioning.

Smart Progression

In regard to progressing to a higher intensity level, longer duration, or more frequent sessions, it is generally a good rule to change only one of these elements at a time. Your client runs a higher risk of overuse injury if you simultaneously increase more than one of these elements. A conservative yet effective guideline is to increase intensity or duration by no more than about 5 percent. The client should adapt to this increase over a period of a week or two,

and then you can consider changing one of the other components or further progressing the one the client has adapted to.

The training program outlined next is a progressive training program for cardiovascular conditioning (table 18.1). It can be used for any aerobic activity your client chooses.

Running or Walking 5K, 10K, and Beyond

Programming for walking, running, biking, swimming, or other endurance activities can use the cardiorespiratory training principles that follow.

Case Study: 5K, 10K, and Beyond

Let's say that one of your clients is interested in running a 5K (3.1 miles) and another a 10K (6.2 miles). How fast should your client run? How often? How far? Should the client race? Is running for duration better than set mileage?

TABLE **18.1** Progressive Cardiovascular Training Program

Conditioning Base

Week	How often (times per week)	How long (minutes)	How hard (%HRR)	How hard (RPE)	RPE descriptive rating
1	2-3	5-15	40-50	2-4	Somewhat easy to somewhat hard
2	2-3	5-15	40-50	2-4	Somewhat easy to somewhat hard
3	2-3	10-17	40-50	2-4	Somewhat easy to somewhat hard
4	2-3	10-17	50-60	2-4	Somewhat easy to somewhat hard
5	3	15-20	50-60	2-4	Somewhat easy to somewhat hard
6	3-4	15-20	50-60	2-4	Somewhat easy to somewhat hard

Moving Beyond Base-Level Fitness

7-9	3-4	20-25	60-65	3-4	Moderate to somewhat hard
10-13	3-4	21-25	65-70	4-5	Somewhat hard to hard
14-16	3-4	26-30	65-70	4-5	Somewhat hard to hard
17-19	3-5	26-30	70-75	4-5	Somewhat hard to hard
20-23	3-5	31-35	70-75	4-5	Somewhat hard to hard
24-27	3-6	31-35	70-75	4-5	Somewhat hard to hard

Maintenance

After 4-6 months	3-6	30-60	70-85	4-6	Somewhat hard to very hard

High-Intensity Interval (optional)

After 4-6 months of steady training	1-2	See interval training this chapter	85-100	6-10	Very hard to very very hard

Base Program Approach

Goal: Run two to three miles and possibly enter a 5K

Basic Training

1. Run or walk easy, aerobically (below steady rate), and for duration versus preset mileage.

2. Begin with 10 to 15 minutes of running or walking.

3. To complete a 5K run or jog would realistically require about 20 to 35 minutes (30-45 minutes walking), depending on the fitness level of the client. To prepare a base for attaining this duration or distance, a frequency of three to five walk–runs of 10 to 15 minutes per week is a good starting point.

4. A "competitive" 5K might require 15 to 25 miles of running per week and at least one long run of five to eight miles. (Note the transition here from counting minutes or duration to tracking miles or distance.)

Building the Base Program

1. Don't increase duration by greater than 10 percent (5 percent increases are even safer).

2. Allow two to three weeks to stabilize training effects before increasing speed or duration. Rarely should both be increased simultaneously in average runners.

3. Keep performance comparisons relative to the individual client's starting point.

Advanced "Base" Training

Introduce interval training, technique drills that focus on leg turnover, posture, and arm carriage and turnover.

Running or Walking a 10K Distance

Goal: To run or walk 6.2 miles

Running or walking 6.2 miles is a major milestone and goal accomplishment for many clients. Once the distance is completed or easy to attain, the next question your client will ask is, "What do I need to do to run it faster?" Here's a simple, yet effective progression.

Setting Goals for the First-Time 10K Racer

"10K-ready" base training requirements:

1. Complete the 10K distance two times weekly or about 12 total miles per week for two weeks before the race date or attempt at 6.2 miles.

2. Progress to this weekly distance or mile total in about 12 weeks, after base training has been completed.

3. Training should be done at a perceived level of effort that falls between 3 to 4, which equates with a moderate to somewhat hard or challenging effort.

4. Encourage your client to complete the entire 10K distance in training. At minimum, 3.5 to 4 miles should be run continuously in at least one session, each week, during the weeks leading up to the 10K attempt.

Progressing the 10K Program

1. **Conditioning foundation.** Build to a minimum run of two miles. You can start the client with a walk–jog of three to four minutes and slowly build up this starting duration. It is not necessary that the client ever progress to running (refer to the 5K program).

2. **Encourage the client to build to running (or walking) four to five times per week.** This will result in an accumulation of 8 to 10 miles per week, at a minimum.

3. **A 12-week program and progression.** After base fitness is established, 12 weeks provides enough time to increase the client's fitness level, taper or recover from the progressive training, cross-train, and ensure balanced fitness by adding stretching and strength training.

Assigning Duration in Minutes

The concept of exercising for minutes, versus a distance guideline, allows you to adjust easily to how your client feels. Also, the duration in minutes base is universal and can be assigned to any cardiovascular activity.

If you use the duration concept for running or walking, you might want to determine a reference base by having your client run an "easy" mile. (For some of your clients there is no such thing as an easy mile, or it might not be possible for them to complete this distance. Remain sensitive and provide alternatives!) Time the moderate effort and this will give you an idea of how much distance or mileage is covered if you assign running workouts in minutes. I often use minutes, not miles, to set the "distance" guidelines for cardiorespiratory workouts.

Serious Training

The concept of serious, planned, and balanced training is defined by the acronym SERIOUS.

S = Speed. Contrary to what you might think, speed here means "easy" speed or relaxed running. Teach your client to run, walk, or bike, for example, with economy of movement and with ease of movement, even when working hard. An ability to run relaxed is a trademark of all top runners. This type of speed training matches with low-intensity effort and uses overdistance training. During overdistance training, which are long runs done at easy paces, the client practices five- to eight-second "pickups" or increases in speed to practice flawless running technique. For advanced runners, the set of pickups is initiated every 15 to 20 minutes, and this technique is employed in every stage of training. Intensity is set at about 70 to 75 percent of maximal heart rate, which is an easy or moderate effort.

E = Endurance. Endurance training increases $\dot{V}O_2$max or the percentage of maximum a client can work at by increasing the ability of working muscles to deliver and use oxygen more efficiently. Training intensity is set at 70 to 75 percent of maximal heart rate. Refer to chapters 15 and 17.

R = Race or pace. This phase of training focuses on sharpening or "peaking" racing skills. Practice mimics actual races, so intensity of training is set at 90 to 100 percent of maximal heart rate and workouts use paced trials, intervals, or bursts.

I = Intervals. Workout effort is followed by a recovery segment, and these intervals are performed on flat terrain. Interval training improves anaerobic threshold, and training takes place at about 80 to 90 percent of maximal heart rate. Interval training is a critical aspect of training if improved performance is to occur. See more on interval training later in this chapter.

O = Overdistance. Overdistance (OD) training is similar to endurance training. Intensity of effort is set at 60 to 70 percent of maximal heart rate instead of 70 to 75 percent as is used in endurance training. This type of training is performed for longer periods of time compared with endurance training. Overdistance training can be two to three times the distance that is required for endurance training. For example, 60 to 90 minutes is a good ballpark for OD training that is being used to prepare for a 10K distance.

U = Up or vertical interval. This is interval training on hilly terrain. The intensity is the same as that used on flat terrain, so 80 to 90 percent of maximal heart rate is the target.

S = Strength (and flexibility). Generally, strength training is a small but important part of a serious or recreational runner's program. About 20 percent of the training that occurs in the base stage should be strength. As a runner progresses to peak or racing stages, time spent strength training may shrink to 10 percent of the total training time. Strength gains can easily be maintained by using two 25-minute sessions per week. Use 8 to 10 exercises to target all the muscles, and emphasize the upper back and trunk, because these are key postural muscles that when fatigued can greatly affect running economy. Depending on the stage of training, 8 to 25 repetitions to fatigue will be performed. Flexibility training should be performed after sufficient warm-up (see chapters 15 and 20; Sleamaker and Browning 1996).

Training for a Fast 10K

Each training phase has a very focused purpose in creating physiological, neuromuscular, and psychological changes in the competitive client.

Inside Five Stages of Training

Base

Base training builds the client's aerobic base. It should last from 4 to 20 weeks, and about 75 percent of the entire training sessions should occur at 60 to 70 percent maximal heart rate. This type of training increases the body's ability to use oxygen ($\dot{V}O_2$), making the body more efficient at oxygen transport, extraction, energy use, and production.

Intensity

Training the body to work at higher intensities increases the body's ability to sustain higher intensity (faster) efforts for longer periods of time. Training like this usually lasts from 4

to 16 weeks. Fifty percent of the training will consist of overdistance work, done at 60 to 70 percent of maximal heart rate. The other 50 percent of training time will be used to train speed, intervals, and race-pace efforts. A well-conditioned runner will work at 80 to 90 percent of maximal heart rate.

Peaking

Peaking is commonly referred to as "sharpening" and "tapering." Total volume of work is decreased. The goal in this training phase is to transition hard training efforts into optimal performance. This phase lasts from 4 to 8 weeks, and 50 percent of the training session is spent training speed, intervals, and race pace at an effort that is 90 to 100 percent of maximal heart rate. The other half of the training session is dedicated to overdistance training and is done at 60 to 70 percent of maximal heart rate.

Racing Stage

This phase can last from 8 to 16 weeks. Fifty percent of the session is spent on speed, intervals, and race-pace training, at 90 to 100 percent of maximal heart rate. The other half of the training time is focused on overdistance training, done at an intensity of 60 to 70 percent of maximal heart rate. Overdistance training helps maintain the high-level aerobic base and provides for a built-in active recovery.

Restoration Stage

Peak racing form and high-intensity training can only be maintained for about two to four months. The restoration or recovery phase should include active recovery, should emphasize variety and fun, and should involve reduced training volume and intensity. Consider using different activities to give your client a mental break as well.

This case study progression can serve as a solid template from which to progress cardiorespiratory training programs to higher levels.

Interval Training and Fat Burning

Interval training does not have to push a client's anaerobic limits, although it can. For many, interval training conjures up the terms *intense, hard,* and *painful* and the image of pro-

fessional athletes collapsing in an exhausted heap on the ground. Stay with me! Interval training can be done more moderately, while simultaneously reaping its rewards. Define what interval training is and isn't, and broaden its scope of application.

Who Should Interval Train

Is interval training for everyone? Many competent and well-informed trainers will answer that it is not, but I don't agree with this traditional answer. Interval training can work for almost everyone. This holds especially true if you're looking to improve a client's endurance, increase fat loss and calorie burning, and improve personal performance. Interval training can help your clients reach higher levels of fitness, regardless of their current level of training or fitness.

Defining an Interval

What do an athlete in a competitive tennis match, a person running to the gate to catch an airplane, a cross-country skier moving over rolling terrain, athletes engaged in bursts of intense activity in team sports, and a grandmother climbing a hill during her afternoon walk have in common? All are using an **effort interval,** working a little harder than steady rate. This acceleration in level of effort is then followed by a moderate **recovery interval** or time period, where activity returns to an easily sustainable level of effort. The beauty of an interval conditioning program is that the physiological requirements demanded of the body are very similar to movement experiences of everyday life.

What's in a Name?

I propose that the term *interval conditioning* serve as an umbrella term over spontaneous intervals, fitness intervals, and traditional performance interval training (figure 18.1).

Make Interval Training Work for All Your Clients

Interval training is great for many reasons, and one of them is that it's adaptable to any client's needs. The following options can help you tailor your program to best suit the client.

FIGURE 18.1 Interval conditioning.

Spontaneous intervals. For less conditioned participants, it may make more sense to begin interval conditioning with **spontaneous intervals** or "speed play." In this type of training, you simply ask your client to increase cardiorespiratory effort intensity for various amounts of time and follow this with adequate recovery. Intensity is ultimately controlled by the client, although you are encouraging effort that is more challenging than an easy effort. For example, you might encourage a client who is running or walking outdoors to speed up until he reaches a stop sign that is several hundred yards away. Spontaneous intervals can be used with highly conditioned athletes, too.

Fitness intervals. You can encourage fitness-minded clients to perform intervals by using a more structured interval model called "fitness intervals." When performing fitness intervals, the client periodically increases intensity throughout a workout and recovers or "catches his breath" before initiating another high-intensity bout. Fitness intervals can vary in terms of duration of the effort interval and recovery from the effort. I will follow with specific recommendations. However, intensity is usually controlled by the client. Again, the client is encouraged to work at a level of effort that is harder than normal. This is in contrast to performance interval training, where specific guidelines are given for both duration and intensity of effort and recovery intervals.

Performance interval training. Competitive athletes have used this type of training for many years. In **performance interval training,** intervals often involve periods of maximal or near-maximal effort followed by short periods of rest. Efforts may range as high as 85 to 110 percent of $\dot{V}O_2$max. Such a method of training leads to significant performance benefits, in great measure attributable to a lower production rate of lactic acid, increased tolerance to its buildup, and increased removal of lactic acid, with resultant increases in $\dot{V}O_2$max. Only well-trained athletes should participate in performance intervals. Because of the high-intensity nature of this type of training, an untrained client is at an increased risk for injury, not to mention quick fatigue, if performance intervals are attempted.

Key Point 1: Interval training is different than interval conditioning. The concept of interval conditioning serves a broader spectrum of fitness levels and needs while simultaneously preserving the classic, high-intensity approach to intervals, referred to as performance interval training.

Key Point 2: Using spontaneous or fitness intervals in many of your clients' programs can be an excellent idea. The client controls intensity. Using these models, the trainer is simply encouraging a client to work a little harder than he is accustomed.

Interval Conditioning Program Design

By targeting specific client goals, needs, and current fitness levels, you can use classic interval training principles with less fit individuals, higher risk or special needs clients, fitness enthusiasts, clients looking for health benefits, or performance athletes.

Interval Conditioning in Different Training Scenarios

When you work with **special populations**—including the physically challenged, cardiac rehabilitation patients, perinatal clients, youth, seniors, and people with diabetes, asthma, or other medical conditions—interval conditioning may be the best choice of conditioning to optimize aerobic benefits and minimize risks. However, the program needs to be carefully planned with each client's physician.

In many cases, heat buildup is a major concern of the exercising client with special needs. This may be true for the client who is pregnant, one with multiple sclerosis, or anyone who has a sensitivity, whether temporary or permanent, to core temperature buildup. In any of these instances, interval conditioning at the right intensity may keep the core temperature from rising as dramatically as in continuous aerobic training. (The goal may not be to increase intensity but to simply use intermittent or interval activity and keep the level of effort consistent.)

Often, when you are working with people who have special needs, the principle to be borrowed from interval training is the use of intermittent cardiorespiratory effort. The principles of intermittent training can be applied successfully to many training situations.

Interval Conditioning With Any Cardiorespiratory Activity

Whether you're working in the water or engaging in any land-based cardiorespiratory activity, the concepts of interval conditioning are universal. Intensity, duration, recovery, and frequency rule the training outcome. A trainer can use a variety of pure cardio activities or design creative circuit workouts. Optimal interval conditioning results require that a cardiorespiratory recovery interval be performed after the effort interval. Effort intervals and recovery intervals both consist of cardiorespiratory activity. This characterization defines true interval conditioning.

Interval Training Versus Circuit Training

Interval training is not necessarily circuit training. Some **circuit training** formats substitute another fitness component such as strength training for the recovery interval. This is not considered interval training. A circuit is generally characterized by physical activity at a variety of work stations. Your client may move from one station to another or perform the circuit at one versatile station. Traditional circuits often contain workstations that are composed of entirely cardiorespiratory activity, entirely muscular strength and endurance activity, or a combination of both types of physical training.

In a circuit that has at least one station for cardiorespiratory activity, interval conditioning can be an option at that cardio station. On the other hand, the cardio station also can be used for steady-rate training rather than interval conditioning. Interval conditioning may be part of a circuit training workout or may be used at a particular cardiorespiratory circuit station, but it is not circuit training itself. When an athlete is performing a true interval, the cardiorespiratory effort interval should be followed by a less intense cardiorespiratory recovery interval.

How Hard Your Client Should Work

The intensity that should be encouraged for fitness and health intervals, as related to interval conditioning, is a level where the client works a little harder than that to which he is accustomed. This will, most likely, allow him to train at or above steady-rate or anaerobic threshold and will allow him to accomplish more work and total caloric expenditure in a given amount of time while simultaneously increasing fitness.

Applying Interval Conditioning to a Wide Range of Clients

Figure 18.2 illustrates how interval conditioning might look when applied to performance training (highly conditioned client) and fitness training (less fit client).

The concept of interval conditioning can be applied to a wide range of clients and can enhance a workout regardless of current fitness level or training goal. Here's how.

The less fit client uses an extended warm-up and steady-rate preparation period and recovers from his effort intervals below his steady-rate threshold. Note the difference between the steady-rate thresholds (80 percent versus 40 percent of $\dot{V}O_2$max) of the conditioned and less fit clients (figure 18.2). After reaching peak intensity, the highly conditioned client returns quickly to steady rate and uses a shorter recovery time period. Intensity of effort (vertical axis) is paired with duration (horizontal axis) of effort and recovery. Both clients will improve fitness and optimize training relative to their current fitness levels because they are working harder than that to which they are accustomed.

Benefits of Interval Training

Why would a client want to participate in interval training and work harder than normal? Interval training can help to fully develop the

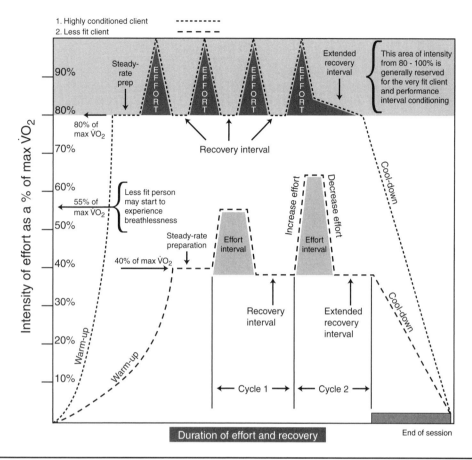

FIGURE 18.2 Interval training for the highly conditioned and less fit client.

Reprinted from D. Brooks 1998.

cardiovascular system and maximize total caloric expenditure. It's fun, too, and helps add variety to a client's cardiovascular training program. But remind your clients that they don't have to train like pro athletes to get significant training benefits!

1. Increased Cardiorespiratory Fitness (Aerobic Endurance)

Interval conditioning can increase a client's ability to exercise longer at the limits of aerobic metabolism. This is greater than what can be accomplished with continuous training or aerobic training only. Because of this, interval training can help to improve fitness levels and total caloric expenditure.

2. Increased Anaerobic Threshold

Proper and appropriate interval conditioning can raise a client's anaerobic threshold whether he's deconditioned or very fit. This level of effort that the client can sustain is referred to as **maximum steady rate (MSR)**. Increasing your client's anaerobic threshold, or MSR, is

directly dependent on high-intensity (working harder than that to which he is accustomed) anaerobic interval conditioning that is relative to his current fitness level.

3. Increased Work Effort in Manageable Doses

This resultant change in anaerobic threshold allows the client to work at increasingly intense paces, and for longer durations, at a perceived level of effort that is easily tolerable.

4. More Total Work Accomplished: More Total Calories and Fat Used per Session

For a given time period, more total exercise effort is accumulated during an interval workout. If your client has limited time to exercise, this allows him to burn more total calories and fat and become more fit in a given exercise time period. Interval conditioning can make more effective use of time, whether the client is deconditioned or highly fit. Do not train to the exclusion of steady-rate training; simply add interval conditioning to the overall program.

5. Maximum Use of Time

Because the client realizes more total work (intensity) and caloric expenditure within given time frames, this results in more effective use of your client's finite time.

6. Increased Exercise Compliance

Exercise compliance will increase because of the following factors:

- Fun and enjoyment
- Exercise variety
- New and challenging physiological overload
- Decreased overuse injury potential
- Client concentration and focus
- Client being mentally engaged, causing an impression that workout time passes quickly
- Client perceptions of confidence and feelings of accomplishment

Interval Training Programming Ins and Outs

Optimizing cardiovascular conditioning requires the client to work harder than an "easy" pace. Interval training involves relatively short durations of harder intensity, compared with a comfortable level of effort (steady rate), followed by easier intensity that is at or below steady rate.

As previously mentioned, your clients need to know what steady-rate pace feels like if they're going to interval train. You see how important this simple concept is with regard to using interval conditioning.

MSR is the highest exercise intensity you can maintain for prolonged periods of time (greater than about three minutes). Exercise performed below or at MSR relies predominantly on the aerobic energy system.

Your clients need to understand how they feel during a steady-rate effort because there will be instances, such as during interval training efforts, in which they will be encouraged to work beyond this comfort zone. Conversely, when they're recovering from vigorous interval exercise efforts, they will work at or below this level. Knowing what "hard" or "easy" exercise feels like will help optimize your clients' interval training results. Both types of exercise are equally important.

Interval training or conditioning is, simply, working at a harder level of cardiovascular effort than that to which your client is accustomed. Interval training is performed by using intermittent work effort that is at or above your client's steady-rate level of effort, with the effort being followed by cardio activity that is steady rate or lower.

Interval conditioning involves both aerobic and anaerobic processes; the energy needs of the body's musculature are not switched on or off. Any time exercise intensity or duration changes, there will be an appropriate shift to either more or less involvement of a particular energy system, depending on the nature of the change. For example, as your client's cardiovascular effort approaches a duration of about three minutes, the aerobic system supplies the largest percentage of the required energy to the working muscles. During high-intensity cardio activity up to about two to three minutes—your client couldn't sustain the level of effort longer than this—anaerobic energy sources are the significant contributing factor.

For a healthy, untrained person, lactic acid begins to accumulate (the result of working above MSR and not being able to produce the required energy aerobically) and rises quickly at about 50 to 55 percent of maximal aerobic capacity, $\dot{V}O_2max$, or heart rate reserve (HRR)—all of these terms are similar. If your client is highly conditioned, this accumulation of lactic acid may not occur until 80 to 85 percent of HRR (refer to chapter 15).

At some point, your client will reach a threshold, or a limiting factor, that does not allow him to continue performance at that particular level of intensity. This point of lactic acid accumulation is his anaerobic threshold. Remember that steady rate is a balance between energy demands by the muscle and aerobic metabolism. During steady-rate activity (submaximal), any lactic acid production and accumulation are minimal.

How Interval Training and Steady Rate Relate to Your Clients

Maximum steady-rate levels and anaerobic threshold vary from one individual to the next, depending primarily on a person's ability to deliver and use oxygen. This, of course, is dependent on individual genetics and conditioning level. For a sedentary client, going

from rest to slow walking, let's say about three miles per hour or a 20-minute-per-mile pace, may push the client's needs for energy (adenosine triphosphate) into and require significant contribution from anaerobic metabolism. In this case, maximum steady rate exists relatively, at very low intensity levels of activity. Contrast this to a highly conditioned person, where the energy balance can be maintained aerobically at very intense levels of exercise. For example, in a highly conditioned and genetically blessed marathon runner, steady-rate aerobic metabolism can be maintained at a pace near five minutes per mile, for 26 miles!

Getting Results Using Intervals

To become more fit using intervals requires your client to work at and above steady rate and recover at or below steady rate. It's that simple. Your client must work harder than he is accustomed, and just about every client can do that.

Working at the Right Level of Effort

Heart rate is a relatively accurate means of monitoring exercise intensity. An appropriate range of training that accommodates most levels of fitness is from 40 to 85 percent of $\dot{V}O_2$max or HRR. To calculate the appropriate THR for interval conditioning, it is desirable to calculate HRR according to Karvonen's formula (see chapter 17, for a complete discussion on HRR, THR, and perceived exertion ratings).

An easy and practical way to monitor effort and recovery intervals is by using a client's perception of effort. Using a manual heart rate count to monitor exercise intensity during interval conditioning is often difficult and distracting, and it's inappropriate for high-risk populations. Because there is a high correlation between the participant's heart rate response to exercise and perceived exertion, this subjective evaluation of effort is a means for the participant to "check in" with how he is feeling at any given moment. Perception of effort is often used in conjunction with the "talk test." Once the relationship has been established between exercise heart rate and this subjective rating of effort, perceived exertion can be used in place of, or better yet, in combination with heart rate monitoring.

The **training sensitive zone** based on an HRR of 40 to 85 percent (equivalent to about 50-90 percent of maximal heart rate) corresponds to a subjective rating of 3 to 7 on the 10-point exertion scale (table 18.2). A rating of 3 to 7 classifies the exercise intensity as "moderate" to "very hard." Generally, a perceived exertion of 3 to 7 for most personal training clients is safe and effective. Anaerobic intervals may use ratings as high as 7 to 10 ("very hard," to "very, very hard").

As a client's fitness level increases, the intensity of activity in which she engages continuously should increase, if continued improvements are expected. In this case, after training adaptations occur, to elicit a similar effort rating will require an increase in aerobic exercise intensity. If intensity is simply maintained, as opposed to being progressively increased over time, a phase of maintenance will be entered.

Even though your client will have a similar subjective rating of effort, the actual intensity of exercise needed to elicit this same effort rating will increase as her fitness progresses.

10-Point Exertion Scale

The cardiorespiratory conditioning column in table 18.2 shows recommended exertion levels for recovery (2-3), aerobic interval training (4-6), and anaerobic intervals (7-10). These ratings, and their association with the numerical rating of the 10-point exertion scale, are found by looking horizontally across the scale. The last column, trainer exertion cues, presents language that may be more practical for the trainer to use.

Interval Conditioning Terminology

Interval conditioning uses repeated cardiovascular **effort intervals** (i.e., work intervals) that are performed above intensities at which your client is used to working, such as that which occurs during steady-rate effort or continuous training. To sustain and repeat these higher intensities, the effort intervals are followed by cardiovascular **recovery intervals**—"rest" periods that use low-level, active recovery and

TABLE 18.2 10-Point Exertion Scale

Cardiorespiratory conditioning	Numerical rating: 0-10	Trainer exertion cues
	0	
	0.5	Very, very easy
	1	Very easy
Recovery or warm-up effort	2	Somewhat easy
Recovery or warm-up effort	3	Moderate
Aerobic effort	4	Somewhat hard
Aerobic effort	5	Hard
	6	
Anaerobic effort	7	Very Hard
Anaerobic effort	8	
Anaerobic effort	9	
Anaerobic effort	10	Very, very hard

are performed at steady-rate or lower intensity. An effort interval followed by a recovery interval is termed a **cycle.** One or more cycles can be referred to as a repetition or repeats (repeat intervals).

Aerobic interval conditioning. "Aerobic" interval conditioning involves training just below, at, or slightly above anaerobic or MSR threshold. Although some anaerobic metabolism occurs to supply the energy need in this type of effort, especially if above MSR, the effort is predominantly aerobic.

Anaerobic interval conditioning. On the other hand, "anaerobic" interval conditioning involves training significantly above anaerobic or MSR threshold and recovering at or below anaerobic or MSR threshold. This type of training requires a predominance of anaerobic energy metabolism.

Interval Training Models

Interval training design is partly art and partly science. You'll learn a lot through experience, trial and error, observing what works, and keeping records. But you can't find a better starting point, or enhance your current interval training program more, than by using the interval conditioning concepts of speed play, fitness interval, and performance interval training and their associated models. Here's the layout for these interval training recipes.

Speed Play Model

If your client is in good shape, or is not in such great shape, or has never tried interval training, you may want to begin with speed play. It's easy to experiment with speed play and adjust the training to individual levels of fitness. In this type of training, your client increases cardiovascular effort for various amounts of time and follows this with adequate recovery. For example, if your client is running, cycling, or walking outdoors you might have her speed up a little until she reaches a stop sign that is several hundred yards away. This 30-seconds or so of effort is followed by three times more rest, or 90 seconds of easy recovery. You can "play" as many times as you like and your client chooses the intensity. Speed play works whether your client is highly fit or deconditioned because the trainer can keep the training intensity relative to the client's current fitness level.

Health and Fitness Interval Training Model

Health and fitness intervals have a broad and clear application to most clients. This type of interval is more structured than speed play intervals and can be performed by using an aerobic or an anaerobic model. The goal is to work from "somewhat hard" to "very hard" on the 10-point rating scale.

Aerobic Fitness Model

During **aerobic fitness intervals,** a 1:1 effort-to-recovery ratio is used, which means

there is an equal amount of effort to recovery in each interval cycle. With this ratio, a one-minute effort interval will be followed by a one-minute recovery interval. Generally, it is best to perform aerobic effort intervals for a duration of 2-3 minutes or less, and don't exceed 5 minutes. If effort intervals exceed 5 minutes you've transitioned to steady-rate training. Table 18.3 details the aerobic fitness model.

Because your client determines the level of exertion, and because the effort should remain moderate (steady rate), it is not necessary to have a high level of fitness to participate in aerobic intervals. However, the anaerobic fitness interval model that follows does assume a moderate to high level of fitness.

Anaerobic Fitness Model

During **anaerobic fitness intervals,** a 1:3 effort-to-recovery ratio is used. With this ratio, a one-minute effort interval will be followed by a three-minute recovery interval. Generally, it is best to perform anaerobic effort intervals for a duration of 90 seconds or less. If effort intervals are performed at proper intensity, a 90-second or less duration ensures that the anaerobic system will receive a conditioning challenge. Table 18.4 details the anaerobic fitness model. During recovery, your client should reach a level that feels "easy" before you initiate another interval.

In either model, intensity ultimately is determined by the client, but he is encouraged to push his level of effort so that it corresponds to the recommended perceived exertion rating or heart rate. Each client's perception will be different, but the end goal is to work the interval at a level of effort that is higher than what the client would normally do and corresponds to the descriptive ratings (i.e., "moderate" or "somewhat hard" to "hard").

Performance Interval Training Model

One of your clients might be a competitive tri-athlete, race-walker, or runner who desires to increase her speed. Or, you might have a client

TABLE **18.3** Aerobic Fitness Model

Ratio	1:1 effort to recovery (work-to-rest ratio)
Duration	3 to 5 minutes for effort interval 3 to 5 minutes for recovery interval Minutes of effort and recovery may vary from 3 to 5 minutes as long as the 1:1 ratio of effort to recovery is observed for each cycle.
Intensity	Participant controlled Effort intervals: 4 to 6 on 10-point exertion scale Recovery intervals: 2 to 3 on 10-point exertion scale
Frequency	Number of cycles accomplished is dependent on time availability and client's fitness level and goals.

TABLE **18.4** Anaerobic Fitness Model

Ratio	1:3 effort to recovery
Duration	30 to 90 seconds of effort interval 1.5 to 4.5 minutes for recovery interval Duration of effort and recovery can vary within the preceding parameters as long as the 1:3 ratio of effort to recovery is observed for each cycle.
Intensity	Participant controlled Effort intervals: 7 to 10 on 10-point exertion scale Recovery intervals: 2 to 3 on 10-point exertion scale
Frequency	Number of cycles accomplished is dependent on time availability and client's fitness level and goals.

Reprinted from D. Brooks 1999.

who is superbly conditioned but a little bored, is looking for a challenge and more results, and wants to take her cardiovascular fitness to the next level. Performance intervals are an excellent training technique to enhance cardiovascular fitness and performance.

The most structured of the interval formulas, these particular performance interval models serve as examples of classic, high-intensity performance interval training. Before progressing to these models, make sure your client is highly conditioned, properly motivated, and ready to train in the structured and physically intense environment of performance interval training.

The three performance interval models that follow assume a high level of fitness (tables 18.5-18.7). Intensity, duration, and frequency are fixed according to specific performance goals. Use perception of effort and heart rate to monitor effort and recovery

intervals; monitor heart rate with a wireless heart rate monitor. Notice that there are two anaerobic performance interval models. The second continues to challenge the client as her cardiovascular fitness level progresses. Model 2 not only increases exercise intensity, but it simultaneously decreases recovery time, which makes the interval very challenging.

Recovery After Interval Conditioning Efforts

Anaerobic interval conditioning is performed at the expense of lactic acid buildup in the exercising muscles and blood. The length of time it takes to recover from anaerobic intervals is determined by the ratios of effort and recovery durations and training goal (sometimes recovery is deliberately shortened to increase overall intensity of a set of intervals).

TABLE 18.5 Aerobic Performance Model

Ratio	1:1 effort and recovery
Duration	3 to 5 minutes of effort interval 3 to 5 minutes of recovery interval Duration of effort and recovery can vary within the preceding parameters as long as the 1:1 ratio of effort to recovery is observed for each cycle.
Intensity	Effort intervals: 80 to 85 percent of HRR (4-6 on 10-point exertion scale) Recovery intervals: 2 to 3 on 10-point exertion scale
Frequency	Number of cycles accomplished is dependent on time availability and client's fitness level and goals.

TABLE 18.6 Anaerobic Performance Model 1

Ratio	1:3 effort and recovery
Duration	30 to 90 seconds of effort interval 1.5 to 4.5 minutes of recovery interval Duration of effort and recovery can vary within the preceding parameters as long as the 1:3 ratio of effort to recovery is observed for each cycle.
Intensity	Effort intervals: 85 to 90 percent of HRR (5-8 on 10-point exertion scale) Recovery intervals: 2 to 3 on 10-point exertion scale
Frequency	Number of cycles accomplished is dependent on time availability and client's fitness level and goals.

Reprinted from D. Brooks 1999.

TABLE 18.7 Anaerobic Performance Model 2

Ratio	1:2 effort and recovery
Duration	30 to 90 seconds of effort interval 1 to 3 minutes of recovery interval Duration of effort and recovery can vary within the preceding parameters as long as the 1:2 ratio of effort to recovery is observed for each cycle.
Intensity	Effort intervals: Greater than 90 percent of HRR (8-10 on 10-point exertion scale) Recovery intervals: 2 to 3 on 10-point exertion scale
Frequency	Number of cycles accomplished is dependent on time availability and client's fitness level and goals.

Reprinted from D. Brooks 1999.

Recovery of proper duration and intensity after anaerobic effort intervals is crucial. It is during recovery that many of the specific training adaptations occur. In other words, the numerous benefits and training results you earn from interval training come during recovery. Don't cut it short. It is as important as the effort!

In addition, active recovery helps speed recovery. During **active recovery,** submaximal exercise (usually steady rate or lower) is performed in the belief that this continued movement prevents muscle cramps and stiffness and facilitates the recovery process.

Lactic acid removal is accelerated by active recovery exercise, which clearly is more effective in facilitating lactic acid removal compared with passive recovery (i.e., lying down). Easy aerobic exercise may facilitate the removal of lactic acid because of increased blood flow. Increased availability of blood flow and oxygen to the muscle, at moderate levels of exercise, allows the lactic acid to be used within the muscle (see chapter 15).

Using Interval Training to Maximize Fat and Calorie Burning

There is a lot of confusion surrounding the ideas of "fat burning" versus "carbohydrate burning." Should your client slow down, go longer, or work harder to burn fat? Let's clear up a few myths about fat.

Many people have been misled to believe that it is necessary to exercise for at least 20 minutes and work at a low exercise intensity to use fat. First, let's dispel the 20-minute myth.

Even when you're flat on your back, the calories you burn come from both fat and carbohydrate. You are very "aerobic" at rest and using fat. It is not necessary to exercise a minimum of 20 minutes to begin using fat for energy. (Your client shouldn't be discouraged if he can't last for 20 minutes. Something is better than nothing, and as the client gets stronger he can eventually extend the duration.)

Do you burn more fat when you go slow? The answer is yes and no but mostly no. It is true that as you exercise harder you burn a little less fat per calorie and, conversely, going slower burns a little more fat per calorie. This seems to support the idea that as exercise becomes harder, less total fat is burned. But this information actually supports the fact that only less fat is burned per single calorie. Here's the rest of the story. Cranking up the pace burns more total calories and more fat calories. Why? Because at the end of the harder workout you breathe more oxygen, and each liter of oxygen taken in burns five calories, which means you'll burn more calories and fat for a given duration of exercise if you exercise harder. Table 18.8 shows what this relationship looks like.

The data convincingly show that for a given time period (30 minutes in this example), the harder pace of exercise burns more total fat and calories compared with a lesser intensity that burns more fat per single calorie (Stanforth and Buono 1989).

Best Level of Effort for Burning Fat and Losing Weight

The discussion of burning fat and losing weight comes down to four key points:

TABLE 18.8 Using Fat

Exercise intensity	Less intense: 30 minutes of exercise at 50 percent of heart rate reserve	More intense: 30 minutes of exercise at 75 percent of heart rate reserve
Result	More fat burned, about 50 percent from fat per single calorie	Less fat burned, about 40 percent from fat per single calorie
Total calories used	225	315
Total fat calories used	113	126

Reprinted from D. Brooks 1999.

1. Don't slow down or change how hard you are exercising if you can keep up the pace for however long you want to exercise. Exercising as hard as you comfortably can will optimize total calories and fat used. This type of continuous aerobic training also can be alternated with low-level aerobic training. Both help you burn fat.

2. If the exercise is too hard or limits how long you'd like to exercise or your goal number of intervals, then it makes sense to slow down and go longer.

3. Working aerobically and anaerobically is necessary to optimize your ability to burn fat. Aerobic training has a different physiological impact than anaerobic training with regard to optimizing fat and calorie burning. That's why you need to do both.

4. Most experts believe that the key to losing weight is the total number of calories you expend during exercise. Whether you're burning fat or carbohydrate does not seem to be important, so your clients don't even have to concern themselves with whether they're burning fat.

Why Interval Training Maximizes Calories Burned

Many traditional workouts are designed to accommodate about 30 to 45 minutes of continuous cardiovascular training. If your client's goal is to lose weight, she'd be better off working at 80 percent of her $\dot{V}O_2$max or HRR. However, even though 80 percent of HRR would maximize calorie and fat utilization compared with a lesser level of intensity, it is a much more difficult workout than a lower percentage of HRR. A more realistic exertion level would be about 70 percent of HRR, if the client is fairly fit. This intensity level is more likely to be maintained over 30 to 45 minutes, and this level of effort still uses plenty of calories.

But if the client has difficulty maintaining high, or even moderate, levels of continuous cardiovascular effort, interval conditioning allows her to accumulate more total exercise, performed at higher intensities, and in tolerable doses of duration. For many clients it is much easier to endure relatively short durations of higher intensity work. And these higher intensities eventually will allow your clients to work at higher levels of effort in relative comfort. Previously, this same effort would have quickly exhausted some of them.

If your client is deconditioned, he should probably exercise at a level of intensity he can maintain to optimize fat and calorie burning. Build the client's base of conditioning with moderate levels of effort that last three or more minutes and then worry about optimizing how hard he works as he becomes more fit. As fitness improves, encourage him to work out at manageable effort intervals of slightly higher intensity than that to which he is accustomed, in addition to his regular aerobic training.

Guidelines for Performing Intervals Safely and Effectively

1. As with any type of fitness activity, precede the intervals with a warm-up of at least 5 to 10 minutes and follow with a cool-down of at least 5 minutes. After the cool-down, your client should feel like his heart rate and breathing are back to preexercise levels.

2. If the client feels ready for the next interval, then do it. If he needs more time to recover, allow him to take it. Remember, common sense always rules. Keep interval training fun, challenging, and aligned with your client's workout goals.

3. Beginning or deconditioned clients should not participate in interval conditioning that pushes to a level of effort that rates 7 to 10 ("very hard" to "very, very hard").

4. Carefully monitor your client's exertion level. Exhaustion is not the goal. Interval training should be enjoyable and, although challenging, should not create lingering exhaustion or a negative experience.

5. Let the client control how hard the interval is pushed, even though you can encourage the client to exert beyond his comfort zone.

6. Interval training workouts that repeat about 10 to 12 anaerobic efforts should be used only once or twice per week. Monitor your clients' workouts and make sure they are recovering adequately to avoid overtraining.

Top Aerobic Exercise

No one cardiovascular activity is better than another! Manipulating how hard (intensity), how often (duration), and how long (frequency) your client participates in a particular aerobic activity determines its effectiveness or lack thereof. And of course, your client has to like what he is doing. These are the key ingredients that determine the effectiveness of any cardiovascular activity.

Choose the type of aerobic activity that is right for your client by helping him to identify an exercise that he can see himself sticking to, and enjoying, for the rest of his life. If you can help your client discover an aerobic activity he is likely to do on a regular basis, then you've found a "top" cardiovascular activity. Often, the best aerobic exercise will be not one but several activities that are fun, feel good to your client's body, and keeps his mind refreshed and his results progressing.

When cardiovascular fitness levels improve, goals change, or your client's interests vary, you can use any large-muscle, rhythmic activity to keep his program on track. The final selection depends on whether the cardiovascular activity "fits" the client and he's motivated to pursue and stay with it. Excellent cardiovascular activities include, but are not limited to, walking, swimming, water fitness, jogging, running, cross-country skiing, in-line skating, lateral movement training (slide), cycling, mountain biking, and step training.

As with all programming choices, don't take lightly your client's individual makeup and what drives him. Find activity that he loves, looks forward to, is passionate about, and truly enjoys. As a team, if you choose the right activities, neither of you will want to miss a workout. As a trainer, you know you're on the right track when your client guards his exercise time with vigor!

Cardiovascular training does not have to be boring or repetitive or lead to overuse injuries. You can keep clients mentally and physically fresh by using several cardiovascular activities and periodizing the programs. By choosing workouts that enhance both aerobic and anaerobic energy systems, you can keep cardiorespiratory conditioning interesting and results oriented, regardless of your client's goals or current fitness level!

Cardiorespiratory Conditioning: Suggested Reading

If you'd like to read more than the works cited in this chapter, check out the following:

Anderson, O. 1989. "Understanding the 10K." *Running Research News (RRN)* 5(6): 1-6.

Barstow, T. 1994. "Characterization of VO$_2$ Kinetics During Heavy Exercise." *Medicine and Science in Sports and Exercise* 26 (11): 1327-34.

Borg, G. 1982. "Psychological Bases of Perceived Exertion." *Medicine and Science in Sports and Exercise* 14: 377-87.

Bouchard, C., F. Dionne, J.A. Simoneau, and M. Boulay. 1992. "Genetics of Aerobic and Anaerobic Performances." *Exercise and Sport Science Reviews* 20: 27-58.

Brooks, D. 1994. "Your Client's First 10K and Beyond." *IDEA Personal Trainer Magazine* (Sept.): 13-18.

Brooks, D. 1995b. "Timing Fitness (Periodization)." *IDEA Personal Trainer Magazine* (June): 20-26.

Brooks, D. 1997. *Program Design for Personal Trainers—Bridging Theory Into Application.* Mammoth Lakes, CA: Moves International.

Brooks, D. 1998. "Winter Sports Conditioning." *IDEA Personal Trainer* (June): 26-36.

Brooks, D. 1999. *Your Personal Trainer.* Champaign, IL: Human Kinetics.

Brooks, D, C. Copeland Brooks, Peter Francis, Lorna Francis, Eric Sternlicht and Kathy Stevens. 1995b.

Reebok Interval Program Manual. Stoughton, MA: Reebok International.

Brooks, G.A. 1986. "The Lactate Shuttle During Exercise and Recovery." *Medicine and Science in Sports and Exercise* 18 (3): 360-8.

Daniels, J. 1992. "Making the Most of Your Available Training Time." *Running Research News* 8 (5): 1-4.

Ebbeling, C.B., A. Ward, and J.M. Rippe. 1991. *Comparison Between Palpated Heart Rates and Heart Rates Observed Using the Polar Favor Heart Rate Monitor During an Aerobics Exercise Class.* Worcester, MA: Exercise Physiology and Nutrition Laboratory, University of Massachusetts Medical School.

Gaesser, G. 1994. "Influence of Endurance Training and Catecholamines on Exercise VO_2 Response." *Medicine and Science in Sports and Exercise* 26 (11): 1341-46.

Gregory, L.W. 1979. "The Development of Aerobic Capacity: A Comparison of Continuous and Interval Training." *Research Quarterly* 50: 199-206.

Haskell, W.L. 1994. "Health Consequences of Physical Activity: Understanding and Challenges Regarding Dose-Response." *Medicine and Science in Sports and Exercise* 26: 649-60.

Janssen, P. 1987. *Training Lactate Pulse-Rate.* 5th ed. Polar Electro Oy: Oy Liitto Oulu, Finland

Kaminsky, L., and W. Mitchell. 1993. "Effect of Interval-Type Exercise on Excess Postexercise Oxygen Consumption (EPOC) in Obese and Normal-Weight Women." *Medicine, Exercise, Nutrition, and Health* 2: 106-11.

LaForge, R., and D. Kosich. (1994). "Interval Exercise." *IDEA Personal Trainer Magazine* (Nov./Dec.): 18-24.

Lamb, D. 1984. *Physiology of Exercise: Responses and Adaptations.* New York: Macmillan.

Myers, J., D. Walsh, N. Buchanan, P. McAuley, E. Bowes, and V. Froelicher. 1994. "Increase in Blood Lactate During Ramp Exercise: Comparison of Continuous and Threshold Models." *Medicine and Science in Sports and Exercise* 26 (11): 1413-19.

Plisk, S.S. 1991. "Anaerobic Metabolic Conditioning: A Brief Review of Theory, Strategy and Practical Application." *Journal of Applied Sport Science Research* 5 (1): 22-34.

Poole, D. 1994. "Role of Exercising Muscle in Slow Component of VO_2." *Medicine and Science in Sports and Exercise* 26 (11): 1335-40.

Poole, D., T. Barstow, G. Gaesser, W. Willis, and B. Whipp. 1994. "VO2 Slow Component: Physiological and Functional Significance." *Medicine and Science in Sports and Exercise* 26 (11): 1354-58.

Rontoyannis, G.P. 1988. "Lactate Elimination From the Blood During Active Recovery." *Journal of Sports Medicine and Physical Fitness* 28: 115-23.

Shephard, R., and P.-O. Astrand, eds. 1992. *Endurance in Sport.* Boston: Blackwell Scientific.

Sleamaker, R., and R. Browning. 1996. *Serious Training for Endurance Athletes.* 2d ed. Champaign, IL: Human Kinetics.

Tremblay, A., J.A. Simoneau, and C. Bouchard 1994. "Impact of Exercise Intensity on Body Fatness and Skeletal Muscle Metabolism." *Metabolism* 43 (7, July): 814-18.

Wells, C., and R. Pate. 1988. "Training for Performance of Prolonged Exercise." Chapter 8 in *Prolonged Exercise,* Vol. 1, ed. D. Lamb and R. Murray. Indianapolis, IN: Benchmark Press.

Whipp, B. 1994. "The Slow Component of O_2 Uptake Kinetics During Heavy Exercise." *Medicine and Science in Sports and Exercise* 26 (11): 1319-26.

Willis, W. and M. Jackman. 1994. "Mitochondrial Function During Heavy Exercise." *Medicine and Science in Sports and Exercise* 26 (11): 1347-354.

Wilmore, J.H., and D.L. Costill. 1988. *Training for Sport and Activity.* Dubuque, IA: Brown.

Resistance Training Programming: A Balanced Approach

After reading this chapter, you won't ever be confused by terms like *muscle tone, body shaping,* or *lifting to get cut.* You'll know whether using special equipment can build "long, lean muscles" and the differences between muscle endurance and strength. Plus, you'll know how to design efficient strength-training programs, or you can follow the ones presented, to help your clients attain their strength training goals.

What Resistance Training Is and Isn't

What's the difference between resistance training, strength training, weightlifting, weight training, lifting weights, and pumping iron? No wonder everyone's confused. There really is no difference. Choose your favorite term and stick with it (if you want to impress your clients and friends or confuse them too, use all of them).

Any work against resistance—for example, lifting a dumbbell or handheld weight a number of times or pulling on rubber tubing—is commonly referred to as resistance training. The term *resistance training* is an umbrella term used to cover all types of strength or weight training.

Resistance training includes free weights (like dumbbells, barbells, handheld weights, and free-plates), elastic resistance, weight machines, and even your client's own body weight (e.g., when she does a push-up).

I refer to resistance training and strength training most of the time, but regardless, I know you won't be confused again by this array of terminology that refers to resistance training!

Putting Strength Training Myths to Rest

Misconceptions about strength training are abundant. Everyone has some idea of what they think happens when weights are lifted. But are these impressions accurate? In the next few sections I'll answer some common strength training questions that clients ask. These are the straight answers, in client-friendly language, that you can pass along to your clients when you encounter one of these long-lived myths.

Will I Get Big, Bulky Muscles If I Strength Train?

Maybe and maybe not! Around puberty (about the age of 12-14), boys and girls are at similar strength levels. Males gain a strength advantage when they enter puberty because their bodies start to crank up the production of the predominantly male-dominant hormone testosterone. Men have testosterone levels that are 10 to 30 times higher than women, which makes it easier for them to build more muscle. Although some women possess high levels of this hormone, most don't, which is part of the reason that you see fewer women who build big muscles.

But sex is only one component that determines the size of muscles. Illegal drugs and genetics are two other factors. Many of the oversized men and women on the "pump-you-up" shows are taking drugs that allow them to develop physiques that truly make you wonder whether they come from another planet. This is not natural, safe, ethical, or normal!

The type and amount of muscle your client has, along with body type (i.e., thin, round, strong, or stout), are determined by her mom and dad. So, stress to your clients that they should have carefully chosen their parents! In other words, your client's genetics greatly influence the results she'll see from any type of strength training program. For example, if she has a small, wiry body she'll see some great strength improvements, but she'll probably never be bulging with muscles.

Is It Easier for Some People to Build Muscle and Get Stronger?

Yes. Some people are genetically blessed with regard to developing strength and muscle. Two people of the same sex and similar body types could participate in the exact same program and end up with completely different results. Sometimes it doesn't seem quite fair when two clients invest the same effort and time and one seems to get better results. But that is what I refer to as the "reality factor." Scientists call it "individual response." No two people will respond exactly the same to a given program.

Here's a positive way of looking at individual response. Tell your clients, "Don't compare yourself to others. Look at where you started and how far you've come in terms of your fitness. You can improve compared to your starting point, so keep your focus on personal improvements."

Because the outer bounds of personal fitness are genetically determined (you have no influence even though you'd like to look like Rambo), there is a lot of truth to the statement, "Champion athletes are born." Fortunately, your clients' health and personal fitness have nothing to do with being "body perfect."

Do Some Machines or Weight Equipment Develop Long, Lean Muscles?

No! The claim that some equipment will allow users to develop long, lean muscles is so far from the truth that it's hard to figure where it came from. Genetics, how much resistance you work against, and how often you train are the biggest contributors to how your muscles will develop.

How Long Before I Feel Stronger and See Changes?

Men and women of all ages (even 70, 80, and 90 years young) can increase their strength by more than 50 percent just two months after beginning a strength training program. If you keep training you can double or even triple your strength.

Many people who start lifting feel immediate changes in terms of balance, coordination, and strength. Technically speaking, initial strength improvements in the first four to six weeks of your strength program happen because you get more skillful. This means you learn how to lift better. During these first few weeks, changes also occur in your nervous system that help you use muscle that was "sleeping" before you started pumping weight. This is a wake-up call for the muscle that was previously inactive before you started a strength program.

Physical changes in the muscle start after about six weeks. This is called hypertrophy, which means an increased size in muscle. Most people believe big muscles are strong muscles. And to a certain degree that is true. But, remember that you can get strong without seeing your muscles change. And huge muscles don't necessarily translate well to everyday tasks that involve coordination and balance. Don't measure muscle strength by size alone! You have to ask, "Is this usable strength?"

What Happens to My Muscles When I Get Stronger?

As already mentioned, most (almost 80 percent) of the strength gains you'll get come from your

nerves being able to rally dormant muscle fibers to contract and move the body. The other 20 percent or so comes from your muscles getting bigger (hypertrophy). The role that your nerves play explains why some people keep getting stronger without getting bigger muscles.

What about bulking up? Quite honestly, most people have difficulty putting large amounts of muscle on their body. Certain body types are more likely to develop muscle than others. For example, if you're thin (everyone has been calling you "String-bean" for years), there's a good chance you won't develop big muscles even though you'll get stronger and more "defined" and will improve your running performance. If you've been nicknamed "Refrigerator" for more years than you'd like to remember, you're a good candidate for the sport of bodybuilding, but don't forget cardiovascular training and developing a strong, healthy heart.

In addition, nothing positive will happen to your muscles if you don't use enough weight or resistance in the form of tubes, body weight, machines, or dumbbells. Muscle size and strength will increase little if you use light weights and high repetitions. More on this later. On the other hand, if you don't weight train, your muscles will shrink. This is called atrophy. You've heard it before: Use it or lose it!

How Do I Get Muscle Definition?

Choosing your parents well may be the most important step in getting "defined" or "cut!" Genetics, which you inherited at birth, determines your body type. However, the two steps you can take to influence muscle definition are to lose fat and strength train.

Do My Muscles Turn to Fat If I Stop Strength Training?

No, no, no, no! Under a microscope, fat looks like Honeycomb cereal and muscle like a bundle of straws. The point: They are different from one another.

This misconception that muscle can turn to fat may have started because many highly trained athletes become fat after their sport careers end. Logical deduction says, "He used to have big muscles and no fat; now he quit training and the muscle turned to mush." Here's

the real picture. The athlete quit training, the muscles shrank, and the retired pro continued to take in the same number of calories he did during competitive years. The result is that muscles are history, extra calories are stored as fat, and the former athlete keeps gaining weight.

Does Strength Training Spot-Reduce Problem Areas of My Body?

Spot reduction is not possible. So, strength training, or for that matter any exercise, has nothing to do with spot reducing or being able to selectively lose fat from a specific area of the body by repeatedly moving it. You lose fat when you burn off more calories than you take in. This can be accomplished by exercising (cardiovascular and strength training) and moderate calorie reduction. Even though you may chew on your TV remote or vigorously chomp on gum, this does not reduce flapping jowls or double chins. Spot reducing sounds too good to be true because it's not true!

Should I Get in Shape Before I Start Lifting Weights?

No! This issue is one of the biggest misconceptions of all and deters many people who should be lifting weights. People who are extremely overfat often begin a strength training program before aerobic exercise. Why? Increased strength may help protect joints from injury and improve aerobic activity that requires lower body strength. Lifting weights is nonimpact, and increased muscle gained from lifting can help burn more calories, lose weight, and increase metabolism. Besides, it keeps you motivated because it's a lot more fun and interesting than only doing endless miles on a treadmill.

Do I Have to Spend Hours Strength Training to Get Results?

It's not a requirement that you sentence yourself to four to six hours in the gym laboring over weights, divorce your spouse, and forget about your kids to receive benefits from strength training. Here's the minimal commitment:

Strength train two times per week for about 20 minutes per workout. Now, I've just retired your last reason for not strength training—that you don't have enough time! If you're not pumping, it's time to start!

Should a Woman's Strength Program Differ From a Man's?

Yes and no! Although women are different from men, many books written for women infer that women need to train differently. Women have different and special concerns related to such things as biomechanics and hormonal influences, but they should still follow a training program that is similar to a man's. It was not long ago that certain types of push-ups were characterized as "girl" push-ups and the standard form as a "man's" push-ups, and that women were not thought capable of running a marathon distance without harming their bodies.

No physiologist has ever discovered a female or male muscle fiber, and correct technique does not change between the sexes! Every individual will have special biomechanical concerns and differences. There is simply a right way to perform exercises, regardless of sex. When women are placed on the same strength programs men are using, they make the same, if not greater, gains in muscle strength and endurance. Men and women are different. But, with regard to muscle, the quality of a woman's muscle fiber compares with a man's, although she may have less (quantity) muscle fiber and testosterone. These influences aside, men and women should not train differently. Personal and sports-oriented goals should dictate how the individual should train, independent of sex.

Planning Your Client's Strength Program

There are literally hundreds of strength programs you could follow. Are any of these programs really that different from one another? Are they safe and effective, and do they produce results in an efficient manner? The answer to these last two questions is, more often than not, no and probably not!

Different strength programs are lumped under the term *systems*. A system is any combination of reps, number of sets, and resistance your client works against (e.g., super set, compound, and pyramid are different system names). Often the system's driving force is some kind of hype that sells useless products or services, and it usually doesn't stick around for long. Remember, anyone can name a system and popularize an idiotic approach to strength training that will eventually disgust a fitness professional and quite possibly hurt and frustrate a client. (As you may sense, I believe strongly about this particular discussion.) Some of the dumbest programs carry names like the "100-rep system" and "pump until you puke." These types of systems have nothing to do with sensible training that your client can stick with and get results.

Don't blindly adopt a program or system simply because it was used by a successful athlete who happened to weight train. Do not jump on the bandwagon because "everyone is doing it." Make sure the training system you choose meets your client's needs and current situation.

To follow is what I believe you need to know about your client's strength training program and the questions that need to be answered. Once this foundation of knowledge is laid, you can accomplish your client's strength training goals safely and in the least amount of time.

Amount of Weight (or Resistance)

Everyone asks, "How much weight should my client lift?" It's the wrong question, but the right idea! It is not how much weight your client lifts that is the key but the number of repetitions she performs. Just the number of reps? Well yes, kind of! You should have your client work within a specific framework or number of reps and work muscle until it's fatigued.

If your client is just starting a strength program, don't test his ability to lift the most amount of weight he can for a given lift. This is called a 1-repetition maximum or 1RM test. If the client is just starting, don't put him in a high-risk, maximal-performance situation. Err on the side of using too little weight rather than too much to determine starting points. For example, if your client is doing more reps than you've set for his repetition parameters, it easy to reduce the number of reps by increasing resistance.

The starting load is determined by an appropriate resistance that fatigues the muscle within the stated repetition goal range.

Number of Repetitions

"Rep" is gym slang for "repetition." Your client completes a strength exercise rep when she returns to the start position. For health and fitness, the majority of personal training clients should be doing 6 to 20 reps to fatigue.

If your client is new to strength training, she might be asking, "What's fatigue?" (Worse, and scarier yet, some people refer to this as muscle "failure.") Muscular fatigue, failure, or exhaustion means that somewhere between 6 and 20 reps your client reaches a point where she can't do another repetition with good form. It doesn't mean motivating or "psyching" your client to squeeze out that last rep because you've heard it's the last one that really counts!

Should every client work to fatigue? I know this is a somewhat threatening word, but the answer is yes . . . everyone. If your client is just starting or is out of shape, the number of reps to fatigue that he should complete should fall between 15 and 20, but it's better initially to shoot for 20. This number will give your client's muscles, tendons, and ligaments a chance to get in shape and prevent him from doing too much too soon. Once he's been training four to six weeks at 15 to 20 reps, you may want to aim for 12 to 15 reps to see continued and significant changes in strength and muscle size. To maximize your client's strength and muscle size gains, drop down to 6 to 12 reps after proper progression. This means you'll have to increase the weight your client is lifting if you want him to fall within this lower number of reps. After your client has trained consistently for about six months, you can probably begin to periodize his program to use the entire rep range of 6 to 20. Strength benefits occur at the low, middle, and high end of this repetition range. Don't make the mistake of progressing your client to the low end of the range and having him do all of his strength training there!

Muscular strength and endurance conditioning is anaerobic work that should last only about 30 to 90 seconds. The targeted muscles should fatigue or fail within this time frame. (Two minutes is the outside parameter.) Generally, 6 to 20 repetitions (about four to seven seconds per rep) performed in a controlled manner will fit into this time parameter and produce significant strength gains. Table 19.1 summarizes information about reps and intensity.

Let's go back to the question of how much weight. It's the wrong question! Pick enough resistance to fatigue your client's muscles in one of these three repetition frameworks. Regardless of whether the goal is 15 to 20, 12 to 15, or 6 to 12 reps, you'll find that clients of different strengths will have to work with different amounts of weight or resistance to optimize their personal training results. Consider, for example, two clients performing an arm (biceps) curl side by side. Although both clients fatigue at 15 reps, one is using a 25-pound weight and the other is using an 8-pound weight. Nevertheless, both are working at the effort that is productive for them and will see significant gains in strength.

So you see, it's not how much weight is being lifted in an absolute sense; rather, the key is choosing the right amount of resistance so that your client fatigues between 6 and 20 reps. As your client gets stronger, the number of reps doesn't change (or the rep ranges), but the amount of resistance must increase if the client is going to "fail" within the desired number of repetitions.

Number of Sets

A set is a number of reps (e.g., 6-20). Every group of reps (e.g., 6-10, 8-12, 12-15, or 15-20) to fatigue is a set. Don't go for conventional wisdom, which says your client has to do two or three sets, unless she's been strength training for a while, is looking for more results, and is willing to invest more time.

Initial studies indicated that there was little difference between training with one, two, and three sets if you're untrained (Brooks 1997a). Any additional increase in muscle gain or strength is minimal for each set performed after the first. Untrained participants will see 80 percent of the gains they'll ever get by doing one set of exercise to fatigue, for each exercise they perform. Would they get more results if they did more sets? Yes, but it's a case of diminishing returns. Newer research (Rhea et al. 2002) seems to prove that multiple-set

TABLE 19.1 What You Need to Know About Reps and Intensity

Number of reps	What you get!	How hard (intensity)?	When?
15-20	Muscle endurance, strength, tone, and health benefits	Enough resistance to cause muscle fatigue at 15-20 reps	First 4-6 weeks, or longer, of training whether the client is just starting or out of shape, regardless of age
12-15	Muscle endurance, strength, size, and health benefits	Enough resistance to cause muscle fatigue at 12-15 reps	After at least 4-6 weeks of training at 15-20 reps, if you want continued progress in the client's strength program
6-12	Muscle strength and size (hypertrophy) and health benefits	Enough resistance to cause muscle fatigue at 6-12 reps	After at least 4-6 weeks of training at 12-15 reps to fatigue to maximize strength and muscle size response

training is superior to single-set training in recreationally trained subjects, but one-set training remains an excellent choice to create significant strength gains efficiently in previously untrained adults. In other words, maximal or optimal strength increases (multi-set training) may not be required to meet training goals.

Eventually (after about 3-6 months), your client might have to commit more time if she wants to take the next step in strength fitness. But initially, one set of exercise will get her strong, give her excellent results, and minimize the time she has to spend lifting.

Frequency of Strength Workouts

Your average client needs to strength train a minimum of two times per week with at least a day of rest between strength workouts. That's really all he needs if he's just starting a strength program! Again, research confirms that training two times per week (with one set to fatigue, per exercise) will give a deconditioned person about 80 percent of the gains he would see when compared with training three times per week (ACSM 1995; Brooks 1997a). However, after about three to six months of progressive strength training, your client will probably have to work out about three to four times per week to continue to *optimize* strength gains. On the other hand, it's easy to maintain strength gains with only a couple of workouts per week, if intensity of the workout is maintained regularly.

Time Between Strength Workouts

A day between strength workouts still makes sense when you're targeting all of the major muscles. If you use split routines, give a muscle group at least a day of recovery before targeting that muscle group again. Adequate recovery is essential to avoid hurting your client and to let her body recover from the workout. Although your client may enjoy the challenge, her body is asking for a chance to grow stronger. If you pound the client's body into submission, she will never gain an optimal training effect from her dedicated and hard work.

Number of Exercises

At a minimum, choose 8 to 10 exercises that "hit" all of the major muscle groups. This leads to equal development in all of the opposing muscles. If your client only does arm curls (biceps) and chest presses, this imbalanced approach will negatively affect her posture. Choose more exercises if you wish, but using only about 10 exercises gets the job done and doesn't take much time.

Workout Length

If you follow my recommendation of 6 to 20 reps performed to fatigue, one to two sets of exercise for each major muscle group in the body (which can be accomplished if you wisely choose 8-10 exercises), and your client lifts twice a week, only a 20- to 30-minute time investment for

each strength workout is required. This is something any client can fit in and doesn't necessarily require more training sessions.

Advanced strength training programs are presented later in this chapter. However, I've presented the "minimalist" approach here because I want you to know that your clients don't have to do a lot to get fantastic strength results. That's good news for runners, triathletes, or busy moms and dads who would like to strength train but don't think they have time. If your clients have heard that strength training takes too much time and is hard to do, they've been getting the wrong information!

Exercise Order

Generally, it is best to perform exercise for large muscle groups first, followed by smaller ones. For example, work your clients' hips and buttocks before you work smaller muscles like the front and back of the thighs, calves, and shins. Go for the chest and back before you fatigue your client's shoulders and arms. This makes sense because if the small muscles can't contribute to a movement, they become the weak link in an exercise using large muscle groups or multijoint movements. If you fatigue your client's quads (front of the upper thighs) before he performs a squat or lunge, it's likely his buttock muscles won't get a great challenge because the quads will tire and give out well before the buttock muscles do. Also, there is a safety issue when one performs complex exercises with prefatigued muscles. I usually wouldn't have my client try a heavy squat lift after hammering the quadriceps by using an isolation exercise.

On the other hand, after your client has trained for several months, she may need to train differently even if your approach is counter to the logic presented previously. Always training the same way will limit results and can lead to injury and burnout. I use what I call the **prioritization** or **priority system.** In other words, I train first what I am emphasizing that day. For example, if I prioritize isolation exercises of small muscle groups, I might avoid complex or compound movements that use those same muscles.

When you have your client engage in a total body workout (working all the muscle groups of the body by choosing 8-10 key exercises), it doesn't matter what muscle group you start with. Most of my clients use a total body workout when they strength train because they don't have the time to perform split routines, where different body parts are emphasized over four or five days. During a total body workout, you could, for example, begin with your client's lower body, followed by upper body exercise and then abs or back. In fact, hip-hopping around to different body parts is a great idea because it keeps your client working out while the body part she just targeted gets a chance to recover. This is called "active rest" and lets your client effectively use recovery time between sets.

Rest Between Sets

If you want to finish your client's strength workout in 20 to 30 minutes, you can minimize rest down-time, as mentioned, by changing from upper body to lower body and then to ab and back work. The order in which you do this is not critical—the point is simply switching from one body part to another unrelated part. Generally, 30 seconds to two minutes is recommended for recovery from an exercise your client just completed to fatigue if your goal is to allow a full recovery before you target that particular area of the body again. If you hop-scotch all over the body as you target muscles, you save time. Most of your clients have a finite amount of time set aside for exercise, so this method lets you maximize the amount of time actually spent working out.

Everything You Need to Know About Reps, Sets, and Rest Between Sets

Table 19.2 details the bulk of what you need to know about reps, sets, and rest between sets as well as the strength result your client can expect. Use it to clarify your training direction and planning. Note that an intensity of 12 reps or greater equates to less than 70 percent of a 1RM. Although this load is reasonable to create strength gains, it is not so intense that it would put a deconditioned exerciser at an increased risk for injury. Research indicates that a 10RM lift roughly equates to 75 percent of a client's maximum lifting capacity for any given lift. A 6RM to 10RM intensity seems necessary to optimize muscular strength and hypertrophy

TABLE 19.2 Strength Chart

Resistance	Result	Percent 1RM	Number of reps	Number of sets	Rest between sets
Light	Muscular endurance	<70	15-20 12-15	1-3	20-60 seconds
Moderate	Hypertrophy (increased muscle size) and strength	70-85	8-12 6-10	1-6	60-120 seconds
Heavy	Maximum strength and power	85-100	1-6	1-6+	2-5 minutes

Note. Generally, assume a heavier load as soon as the client is able to complete the required number of reps listed in the strength chart.

gains, but your client must progress to these higher percentages of a 1RM in a progressive manner. Consider that many of your clients will not write a goal that will realistically optimize strength gains. Optimizing strength gains requires hard work and a significantly greater time investment. Be attentive to the goals, interests, and desire of the client when progressing the training program.

Increasing Weight

When your client can easily complete more than her assigned repetitions, it's time to up the ante! Add enough load so that your client can drop back into the rep framework she's working in, but don't add so much she can't complete the minimum number of reps (i.e., 6, 8, 12, or 15). Depending on how you progress or periodize a client's program, it may be appropriate to move the client into an entirely different rep framework. The move can be in any direction, depending on programming intention. Progressively increasing how hard your client works will keep her mind stimulated, her body guessing, and the results coming!

Lifting Technique

The focus of early workouts is not to create muscle failure, although this can occur and is a significant goal, but rather to focus on correct exercise technique. The emphasis on good form gives your client's muscles a chance to adapt progressively to the demands he's placing on them and lets him learn how to perform exercises correctly before he lifts heavier weights.

Lifting With Control and Full Range of Motion

With regard to lifting speed, never say "fast." Instead, preach "control!" Your client is lifting in control if she can stop the exercise "on a dime." I tell my clients that if they leave skid-marks or roll into the intersection, they're lifting too fast. Another good guide is to spend three to four seconds lifting a weight in a steady controlled motion, followed by three to four seconds lowering the weight, with the same degree of smoothness. I encourage about a seven-second repetition, but control is the issue, not the particular count you use. For example, whether you lift in a concentric or eccentric manner with a 2-2, 2-4, 4-2, 3-4, 4-3, 5-2, or 2-5 up–down count, these counting configurations are simply another programming element of variation. I'm not keen on keeping an exact account of seconds per repetition, but if I ask a client to stop the movement at any point during a given strength exercise and she can, this tells me she's lifting at the correct speed, which is controlled.

Your client will get the best results, with the least risk, by controlling a weight slowly through the fullest range of motion she can attain with comfort. Controlled and full range of motion lifting will help your client avoid injuring her joints and muscles and maintain flexibility.

Science and the Speed of Movement

For the average person, gains in strength are best accomplished by moving the weight slowly

(about 4-7 seconds per repetition) through a full range of motion and accomplishing fast-twitch (FT) recruitment by using an appropriately intense overload. Following are seven reasons to control speed of movement (Westcott 1991):

1. Consistent application of force
2. More total muscle tension produced
3. More total muscle force produced
4. More muscle fiber activation, both slow-twitch (ST) and FT
5. Greater muscle power potential through high-intensity force development using controlled speed of movement and appropriately intense overload
6. Less tissue trauma
7. Greater momentum, which increases injury potential and reduces training effect on target muscle groups

Exceptions to these items, or moving a load more quickly, may be appropriate in sport-specific applications and when your client understands the risks.

Breathing Correctly

First and foremost, your client should breathe regularly during strength training. If you want to take it a step further, try to have your client coordinate breathing out when he begins a strength exercise. For example, let's say the client is executing a supine chest press using dumbbells. As your client begins to push his arms away from his chest, it is natural for him to hold his breath for a moment. But, the held breath shouldn't be sustained. Your client should let his breath escape just after or as he begins the press. Generally, your client should breathe in as he returns the weight toward his body. You know your client is not

breathing when he feels the pressure behind his eyeballs start to build and both of you start to wonder at what moment they will explode from his head! If in doubt, simply instruct your client to breathe, breathe, breathe!

Your client shouldn't believe he only gets one breath out and one in. Common sense tells you that it's okay for your client to take small sipping breaths more often if he's lifting with control, which can result in a repetition that takes four to seven seconds to complete.

If your client holds his breath during the entire lift, this can cause blood pressure to rise higher than it should and put unnecessary stress on his heart and vascular system. Breathing correctly can help your client avoid nausea, dizziness, and fainting. At a minimum, have your client remember to breathe regularly throughout each repetition.

Continuum of Training Programs

There is a wide continuum of training programs that range from what I call the "far left" of cardiorespiratory training to the "far right" of maximal muscular strength and power. There is a huge gap in terms of similarity between cardio fitness and muscular endurance (figure 19.1).

Cardiorespiratory fitness gains result in a physiological adaptation that is very different from those adaptations seen in the muscular strength and endurance component. The overload and activities that are required to stimulate change in these components of fitness are very distinct (see chapters 15 and 18). Optimal cardiorespiratory conditioning and muscular strength and endurance conditioning cannot be developed simultaneously.

FIGURE 19.1 Training program continuum.
Reprinted from D. Brooks 1999.

High-Repetition Overloads

Muscle endurance is defined as the ability to sustain repeated contractions without undue fatigue over a longer time period (e.g., about 12-25 reps or higher). As your client becomes stronger, muscular endurance increases, which allows her to perform more reps at a given resistance. As reps increase beyond 25, the movement starts to resemble the overload definition for cardiorespiratory conditioning (continuous, rhythmic movement).

However, do not interpret this statement to imply that significant cardiorespiratory conditioning takes place with high-repetition resistance training schemes. Actually, the load generally does not engage enough muscle mass to generate significant cardiorespiratory training effect, and the light resistance does not promote significant strength gains.

To increase strength, an intensity or load that your client's musculature is unaccustomed to must be presented regularly and progressively. Proper intensity is necessary to stimulate the "cellular machinery" that is responsible for muscle growth and hormonal surges that are anabolic (building) in nature or to stimulate motor learning for synchronous and additional motor unit recruitment. For the beginning to conditioned exerciser, that means 6 to 20 repetitions to muscular fatigue. This repetition parameter works for anybody because it does not define an absolute weight. Instead, the amount of weight lifted reflects the individual's current strength level and requires a resistance that causes the client to fatigue within a specific time or repetition framework.

High-repetition schemes are usually highly ineffective in promoting any kind of health and fitness gains. They do not produce significant gains in muscular strength and endurance over an extended period of time and have little to no effect on cardiorespiratory conditioning, especially when small muscle masses are involved in the exercise (e.g., biceps curl or seated leg extension). Repetitions that are redundantly high are not harmless. They can lead to overuse injuries, not to mention lack of results, frustration, and high exercise dropout rates.

Changing Intensity for Strength Gains

Many trainers think they are obligated to raise the resistance when faced with the challenge of increasing intensity. You can introduce intensity changes in a number of ways without necessarily increasing resistance.

1. **Vary the number of reps** either up or down. Increasing or decreasing the number of reps will stimulate adaptation. Any kind of variety will help break plateaus and rouse the body to adapt. Both higher rep schemes (12-20) as well as lower rep sets (6-12) contribute to muscle hypertrophy. Rest or lighter loads are often warranted because many clients do not allow for the recovery process. Train your client in a manner that he does not regularly train!

2. **Increase the number of sets** for the targeted muscle group.

3. **Sequence** so there is very little recovery between sets targeting the same muscle group. This will cause a different motor-unit recruitment pattern to occur and thus new stimulation.

4. **Use high-intensity training** techniques and systems. Training examples include trisetting, pyramiding, compound training (erroneously called super setting), super setting, breakdown (breaking down the weight being lifted, not the muscle that you want to build), super slow (10-15 seconds per repetition), and forced reps or assisted training. Note my comment on page 379 relative to super slow training. Should super slow training be considered a high-intensity training technique, as is common, in light of recent research (Hunter, Seelhorst, and Snyder 2003)?

5. **Periodize** training using some or all of these techniques. A periodized program cycles volume (sets and reps) and intensity (load or resistance) over specific time periods. This type of organization maximizes adaptation and progression specific to program goals and intensities.

The box on page 377 provides a summary of these points for quick reference.

Varying Your Client's Routine and Moving Past Strength Training Plateaus

Plateaus and overtraining often result from the indefinite use of one training approach. The following ideas can help minimize the possibilities that your client's training will plateau.

1. Initially, change the exercise sequence or change the exercise while leaving the relative intensity or reps, sets, and load the same.

2. Manipulate frequency, intensity (load), and volume (reps and sets) both up and down within the 6- to 20-repetition framework if no sport-specific application is needed. Both higher rep and lower rep schemes contribute to muscle hypertrophy and additional results.

3. Increase the number of sets for the targeted muscle group.

4. Sequence the exercises so there is very little recovery between sets targeting the same muscle group. This will allow for a different motor-unit recruitment pattern—and thus new stimulation.

High-Intensity Training Edge

If your client has been training at an advanced level, high-intensity training may be the edge she needs to move off strength plateaus. Or, at some point in an advanced training program, one of your clients may look for more results within a limited time schedule. In either case, consider using time-proven high-intensity strength training. This type of training emphasizes quality over quantity. On the other hand, high-volume work (working out more times per week and longer each workout) is not realistic in most personal schedules that require a balance between family, work, religion, health and fitness pursuits, and recreation. Although high-volume work is somewhat effective with elite bodybuilders and other professional athletes (remember, they do this for a living in many instances), it can lead to overuse injury and burnout. This is another instance where high-intensity training works. Even when the time and motivation are present to perform high-volume workouts, many experts still argue that quality reigns over quantity when applied to training results. Many competitive lifters are experimenting with decreasing volume of overload and increasing intensity of effort.

Without a doubt, high-intensity strength training is fierce and concentrated, and it requires focus! However, for those clients who are prepared and motivated to move their stalled strength training program to the next level, information in this and previous sections may present exactly what they need to jump-start their strength gains.

When a client complains about lack of results, she has experienced a training plateau. Plateaus occur when a client's rate gain or improvement, as related to her training, slows down. This can result from the indefinite use of one training approach or simply because the client has been a dedicated strength trainer for a long time and her body needs new stimulation.

High-intensity strength training provides a way to train harder without increasing the client's workout times. In other words, she can increase intensity without doing more (i.e., longer workouts) but she will have to work harder to get the results. High-intensity training requires greater muscular effort and places more intense physical demands on muscles. These techniques push your client to a greater degree of fatigue.

How High-Intensity Training Works

In theory, this type of training recruits muscle fibers (motor units) that are not normally challenged because the workout protocol doesn't allow the motor units that were initially fatigued a chance to recover and be used again in the exercise the client is performing. Manipulating the amount of resistance, eliminating recovery on reaching momentary muscle

fatigue, performing more reps while fatigued, and controlling speed of movement are commonly used methods to move strength training into the high-intensity realm. When using high-intensity strength training techniques, your client should expect results because she will get them! She will have also earned them!

Who Should Use High-Intensity Strength Training?

If you have a client who is highly motivated and has a strong strength base, you might want to consider one of the high-intensity strength training techniques that are discussed. Make sure your client's goals are in line with what these approaches offer. They require a good strength conditioning base and high degree of physical effort and are associated with physical discomfort (your client is really pushing it here!).

High-intensity training requires more recovery and adaptation time for muscle tissue, so make sure you mix hard workouts with easy ones or days off (50 percent of the building equation is rest!). Don't use these approaches more than once or twice per week, and keep these tough workouts to no longer than 30 minutes and about 10 exercises. Have the client perform one to two sets per exercise, and realize some of the following techniques require a minimum of two sets (i.e., compound training).

After a high-intensity strength training workout, allow at least one day of recovery before training the targeted muscle groups again. Even after a day's rest, it's a good idea to follow this type of workout with a moderate or light intensity strength workout.

High-Intensity Training Techniques

Following are several of the most highly used and effective high-intensity training techniques, many of which require a workout partner or trainer to assist. It's essential to have a spotter for safety reasons when using high-intensity strength training techniques. Make sure your client is interested in trying these techniques, and is physically and mentally capable, before you begin.

Breakdown Training
Breakdown training usually begins with a normal set of training (i.e., 10-12 reps after a warm-up). When the person reaches momentary muscle failure, each repetition is performed with less weight than the one preceding it. Take off enough weight (usually about 5-15 percent) so that your client can do two to four additional repetitions (more repetitions are okay if she can maintain good form).

Pyramid Training
Pyramid training is a variation of breakdown training, or vice-versa. Each exercise is performed with slightly less or more weight than the one preceding it. This gives you an option of an "up" pyramid (weight increases) or a "down" pyramid (weight decreases). Let's say your client's goal is to start with a weight she can lift 10 to 12 times (10RM-12RM). After the client fatigues at 10RM to 12RM, reduce load by about 5 to 15 percent (down pyramid) and encourage the client to "force" out more reps. Each time your client reaches a point where she cannot complete anymore reps, strip off additional weight, force more reps, and continue in this manner. If you reversed the process, you'd create an up pyramid, which is extremely difficult training. In this situation, increasing the weight by as little as 5 percent is often sufficient and you find that it is not too long before the client cannot perform even one repetition.

Assisted Training or "Forced Reps"
The trainer assists the client in completing a number of reps she could not have completed on her own. Begin the client with a set of repetitions to fatigue (i.e., 10RM-12RM). When she reaches fatigue, still maintaining good technique, help her complete an additional number of reps that she could not have completed on her own. Typically, the trainer lifts 5 to 15 percent of the weight load to assist the client in completing two to four more reps (more is okay if the client can complete the reps with good form).

Negative Training
Negative training allows for about 30 percent more force production than occurs during concentric contraction. Typically, negative training is accomplished by (1) adding manual resistance on the lowering phase of any lift, (2) adjusting the weight lifted and lowered when using a selectorized plate machine—lighter weight when lifting and heavier when lowering,

or (3) assisting your client through a concentric phase with an amount of weight she could not lift on her own and then allowing her to lower the weight during the eccentric phase without assistance.

Negative training is often used with a highly trained individual who is experiencing a plateau. Although caution should be used with any of these techniques, delayed-onset muscle soreness is highly associated with negative training. Therefore, eccentric training should not be emphasized with deconditioned clients.

Super Slow Training: Effective or Hype?

Super slow training or slow training is often described as tedious, torturous, excruciating, and productive! But is this last point substantiated by science? Slow training takes the emphasis away from the number of reps and weight being lifted and focuses on increasing the time of each repetition. Slower movement speed reduces any contribution from momentum in completing the range of motion. In theory, this would result in more tension on the muscle and total force development (meaning more muscle is used or activated).

Super slow training is often referred to as 10-second training, although several options exist with regard to number of seconds that can be assigned to each lifting phase. A popular version involves a 10-second concentric lifting phase, followed by a five-second eccentric, lowering phase for each repetition. You can also reverse the emphasis by lifting the load concentrically in five seconds and following this with a 10-second eccentric phase. Generally, failure is attained in about four to six reps.

Super slow training repetitions can last from 15 to 60 seconds, or longer, as reported in various literature. As the duration of the repetition is increased, the amount of weight that can be lifted decreases and each point of the range of motion receives less than an optimal strength stimulus. For example, if the weight is light enough to perform a 60-second rep, although the effort will be perceived as very difficult, the resistance is not heavy enough to stimulate significant strength gains. Recent research (Hunter, Seelhorst, and Snyder 2003; Keeler et al. 2001) suggests that not only is the metabolic or cardiovascular adaptation to super slow training (15-second repetition) not as effective

when compared to traditional strength and cardiovascular training programs, but it is unlikely to produce significant hypertrophy because the load used to complete a 15-second repetition is less than 30 percent of 1RM. Discomfort is not always an indicator of physiological effectiveness. Compare an effort like this to painting a ceiling. Painting a ceiling is very uncomfortable on the upper body muscles involved if the arms are extended overhead for a period of time, but no professional would ever consider it effective and progressive strength training. Remember, the key stimulus for strength overload is intensity, working harder for shorter durations.

Super Set and Compound Training

Super set training or "super setting" usually refers to working opposing muscle groups (paired agonist and antagonist muscles) in succession (e.g., biceps and triceps or chest and back). This combination is a common approach to training but allows for the muscle group to at least partially recover while the opposing muscle group is working.

Compound training is another type of super setting. It consists of working the same muscle group back to back—two sets of consecutive exercises target the same muscle group but not necessarily with the same exercise. For example, two sets of dumbbell presses performed consecutively, or a seated machine chest press followed by a cable chest press, are variations of compound training. This type of super setting involves performing a set to fatigue, immediately followed by (or after a short rest) additional sets and exercises that target the same muscle group. Super setting seems to work especially well in producing muscular hypertrophy when using a rep scheme of 6 to 10 repetitions to fatigue.

Quality Over Quantity

High-intensity strength training gives you a potential win–win situation. Use high-intensity training to maximize your client's training result within a limited time schedule or to move off of strength training plateaus, but don't go overboard. Just as with volume training, science tells us that more intensity is not always better, even if your client has the time and desire! For optimal muscular development, variety and quality of training are the name of

the game. Use periodization, which can encompass some or all of these high-intensity training techniques, as you vary your client's program on a regular basis.

To reiterate, it seems that the best stimulus for increased strength gains is to make the muscle work harder, not longer.

Functional Training

The number of reps, number of sets, and load are probably least defined when training your client for gains in functional strength. **Functional strength** development should be related to how your client normally engages in activity during a typical day. Although any given day's activity can require a maximal exertion, probably the most important usable strength is muscular endurance that is developed in key postural muscles. Postural muscles maintain correct spinal alignment most hours of the day. However, functional training can also involve other major muscle groups. Additionally, significant gains in both muscular strength and endurance help prevent injuries.

Functional training can use both open-chain and closed-chain exercises. It could be argued that any exercise that improves function is functional. However, functional training usually involves an integrated, coordinated response of the body and more often is associated with closed chain exercise, balance, and stabilization training. **Open chain exercise** (OCE) can be defined as isolated movement. An example of OCE is a seated leg extension. **Closed chain exercise** (CCE) can be defined as an integrated and coordinated response by the body to perform a movement safely and correctly. CCE is demonstrated by performing a squat, lunge, or balancing movement on one leg.

CCE activity closely parallels the way your client moves when performing daily tasks, such as picking up a child or righting himself after a loss of balance. Functional training requires an integration of balance and intrinsic muscular stability while exerting muscular force. An excellent tool to train stability and balance that carries over functionally is a large, round, air-filled stability ball or other tools that include the Bosu Balance Trainer, balance boards, and foam rollers (Brooks and Brooks 2002).

Changing a Strength Program

The first question to ask when you are considering a change in a resistance training program is, "Why?" Is it you, the trainer, who needs a change? Or is it the client?

A program that has leveled off in terms of resistance that can be lifted (intensity) or number of reps and sets that can be completed may or may not be a problem. If the client is pleased with his body image and strength, such a program can be termed "maintenance." Maintenance can be a positive state of training, meaning you are keeping your client's fitness at an optimal level.

Valid reasons for changing a resistance training program include client boredom; lack of motivation; lack of results; desire for change in muscle strength, hypertrophy, or muscle endurance; or a need to change the training environment (such as type of equipment being used or location). Planned variety encourages optimal training. It helps alleviate injury and unproductive training.

Before any changes are made to overload, your client should have a base of muscular strength and endurance. Establish this **strength foundation** by training your clients for at least four to six weeks and possibly as long as six months to a year.

Cross-Training

If your client simply needs variety, try cross-training without initially changing the intensity. An easy first step is to change the sequence of exercises that the client is already doing to create variety and a new overload. It is theorized that this change will alter the fatigue pattern of the involved motor units, causing them to adapt to the new stimulus (Fleck and Kraemer 1997).

The next step is to replace all the exercises, or those you think necessary, in the foundation routine with new ones. Look at the joint actions and muscle groups being used and choose the replacement exercise accordingly. Replace each exercise with one that targets the same muscle groups to preserve balance.

For example, a bench press can be replaced by push-ups, dumbbell presses, incline and decline presses, or dumbbell or elastic resistance chest flys (uses horizontal adduction only) because all of these use elbow extension and horizontal adduction at the shoulder. Machine pullover movements can be replaced by movements that replicate shoulder extension, such as dumbbell or elastic resistance pullovers, one-arm or two-arm "low" rows, or straight-arm pullbacks with dumbbells or elastic resistance.

Any changes in movement patterns (new exercises or slight body position changes), even if you are targeting the same muscle group and using similar joint actions, will require a different motor-unit recruitment pattern (Fleck and Kraemer 1997). This recruitment of muscle fibers in a different order can act as a stimulus (overload) to create further strength gains. Cross-training within the muscular strength and endurance component can positively affect compliance, motivation, and interest as well as stimulate the body toward additional strength gains. For optimal muscular development, selective variety is the name of the game.

Making the Most of the Training System

It is imperative to determine the goal of the individual or program before you ever start training. Understanding how training reps, sets, and intensity affect training outcome will help you sort out the seemingly contradictory statements regarding resistance training. Most systems, regardless of their format, have been proved to be effective (Fleck and Kraemer 1997 cite 27 such programs). Any stimulus presented to the body and to which a client is not accustomed will cause her body to adapt to the new overload. This produces a training effect.

Fortunately, to some degree, regardless of how we train ourselves or others, we often still get results. Whether the method meets your client's needs and safety concerns is another story. Do not join the ranks of trainers who create programs that are too hard (or too easy) or mechanically unsafe for their clients. Even if you do not injure clients, you surely will discourage them.

It is likely that no two people will respond in the same manner to a given training program.

Keep accurate lifting records (reps, sets, resistance, order of exercise, and periodization planning program) so that you can determine the combinations that best stimulate your client's mind and body. Your records, client feedback, appropriate testing, and body fat and circumference measurements will help determine the program's effectiveness. Designing resistance training programs demands constant evaluation, manipulation, and change.

Strength Training Programming You Can Follow

Even if you have all of the knowledge in the world, it takes time to develop good programming. To follow are two periodized sample programs that last 12 and 16 weeks. I encourage you to modify the framework of these two programs to best match your clients' workout needs.

12-Week Entry-Level Strength Periodization Plan

You can manipulate many key strength training variables. They include cadence or lifting speed, rest after each set, changes in exercise choice, lifting form, intensity, exercise order, and exercise sequence, to name a few. Use planned breaks between each four- to six-week segment or mesocycle (periodization, chapter 13).

In this 12-week plan, only the number of repetition and set goals and exercises will change. Because this plan is an entry level program, I have chosen to use one-set training during the first four weeks. This could be maintained for the entire 12 weeks or you can follow my progression. Keep in mind, as you view this very conservative progression, that the following programming goals were considered when this program was designed:

1. Limit the workout to between 20 and 30 minutes.

2. Maximize results with minimal training time.

3. Keep the client injury free.

4. Emphasize other aspects (i.e., cardiovascular and flexibility training) of this entry-level client's program at your discretion.

Additionally, simple exercises and equipment are used to target all of the major muscle groups so that the routine can be done with minimal equipment. You can insert any exercises you desire and use any equipment you choose. Use tables 19.3 through 19.14 to help establish a training program.

16-Week Periodized Program to Develop Maximum Strength

By developing strength, your client can shape his body, change how he looks, and increase muscle size. As you lay the foundation with this 16-week program that progresses to maximal strength development, the early phases serve as a base of muscular strength and endurance.

TABLE 19.3 Block One (First Week)

Body part	Exercise[a]	Number of reps	Number of sets[b]
Chest	Chest press	18-20	1
Back	Low back extension	18-20	1
Abs	Ab curl-up	18-20	1
Biceps	Incline hammer or neutral grip	18-20	1
Triceps	One-arm triceps press	18-20	1
Shoulders	Lateral raise seated	18-20	1
Hips	Supine hip lift with legs on bench (hip extension)	18-20	1
Legs	Manually resisted hamstrings curl	18-20 (each leg)	1
Stabilizer[b]	Pendulum single-leg balance	Repeat three times each side	5-10 seconds each time
Stabilizer[b]	Face-down plank	Repeat three times	5-10 seconds each time

[a]Whenever an exercise option is substituted for another exercise that targets the same body part, follow identical reps and set recommendations. [b]Stabilizer exercises require the client to hold the position for the specified number of seconds.

TABLE 19.4 Block One (Second Week)

Body part	Exercise[a]	Number of reps	Number of sets[b]
Chest	Chest press	18-20	1
Back	Low back extension	18-20	1
Abs	Ab curl-up	18-20	1
Biceps	Incline hammer	18-20	1
Triceps	One-arm triceps press	18-20	1
Shoulders	Lateral raise seated	18-20	1
Hips	Hip lift with legs on bench	18-20	1
Legs	Manually resisted hamstrings curl	18-20 (each leg)	1
Stabilizer[b]	Pendulum single-leg balance	Repeat three times each side	5-10 seconds each time
Stabilizer[b]	Face-down plank	Repeat three times	5-10 seconds each time

[a]Whenever an exercise option is substituted for another exercise that targets the same body part, follow identical reps and set recommendations. [b]Stabilizer exercises require the client to hold the position for the specified number of seconds.

TABLE 19.5 Block One (Third Week)

Body part	Exercise[a]	Number of reps	Number of sets[b]
Chest	Chest press	15-18	1
Back	Low back extension	15-18	1
Abs	Ab curl-up	15-18	1
Biceps	Incline hammer	15-18	1
Triceps	One-arm triceps press	15-18	1
Shoulders	Lateral raise seated	15-18	1
Hips	Hip lift with legs on bench	15-18	1
Legs	Manually resisted hamstrings curl	15-18 (each leg)	1
Stabilizer[b]	Pendulum single-leg balance	Repeat four times each side	5-10 seconds each time
Stabilizer[b]	Face-down plank	Repeat four times	5-10 seconds each time

[a]Whenever an exercise option is substituted for another exercise that targets the same body part, follow identical reps and set recommendations. [b]Stabilizer exercises require the client to hold the position for the specified number of seconds.

TABLE 19.6 Block One (Fourth Week)

Body part	Exercise[a]	Number of reps	Number of sets[b]
Chest	Chest press	15	1
Back	Low back extension	15	1
Abs	Ab curl-up	15	1
Biceps	Incline hammer	15	1
Triceps	One-arm triceps press	15	1
Shoulders	Lateral raise seated	15	1
Hips	Hip lift with legs on bench	15	1
Legs	Manually resisted hamstrings curl	15 (each leg)	1
Stabilizer[b]	Pendulum single-leg balance	Repeat four times each side	10-15 seconds each time
Stabilizer[b]	Face-down plank	Repeat four times	10-15 seconds each time

[a]Whenever an exercise option is substituted for another exercise that targets the same body part, follow identical reps and set recommendations. [b]Stabilizer exercises require the client to hold the position for the specified number of seconds.

TABLE 19.7 Block Two (First Week)

Body part	Exercise[a]	Number of reps	Number of sets[b]
Chest	Push-up	15	1-2
Back	One-arm row with dumbbells	15 (each arm)	1-2
Abs	Combo ab curl	15	1-2
Biceps	Standing biceps curl	15	1-2
Triceps	One-arm triceps press	15 (each arm)	1-2
Shoulders	Overhead press	15	1-2
Hips	Squat holding dumbbells	15	1-2
Legs	Side lift with ankle weights	15 (each leg)	1-2
Stabilizer[b]	Isometric inner thigh squeeze	Repeat three times	5-10 seconds each time
Stabilizer[b]	Face-up plank	Repeat three times	5-10 seconds each time

[a]Whenever an exercise option is substituted for another exercise that targets the same body part, follow identical reps and set recommendations. [b]Stabilizer exercises require the client to hold the position for the specified number of seconds.

TABLE 19.8 Block Two (Second Week)

Body part	Exercise[a]	Number of reps	Number of sets[b]
Chest	Push-up	12-15	1-2
Back	One-arm row with dumbbells	12-15 (each arm)	1-2
Abs	Combo ab curl	12-15	1-2
Biceps	Standing biceps curl	12-15	1-2
Triceps	One-arm triceps press	12-15 (each arm)	1-2
Shoulders	Overhead press	12-15	1-2
Hips	Squat holding dumbbells	12-15	1-2
Legs	Side lift with ankle weights	12-15 (each leg)	1-2
Stabilizer[b]	Isometric inner thigh squeeze	Repeat three times	5-10 seconds each time
Stabilizer[b]	Face-up plank	Repeat three times	5-10 seconds each time

[a]Whenever an exercise option is substituted for another exercise that targets the same body part, follow identical reps and set recommendations. [b]Stabilizer exercises require the client to hold the position for the specified number of seconds.

TABLE 19.9 Block Two (Third Week)

Body part	Exercise[a]	Number of reps	Number of sets[b]
Chest	Push-up	12	1-2
Back	One-arm row with dumbbells	12 (each arm)	1-2
Abs	Combo ab curl	12	1-2
Biceps	Standing biceps curl	12	1-2
Triceps	One-arm triceps press	12 (each arm)	1-2
Shoulders	Overhead press	12	1-2
Hips	Squat holding dumbbells	12	1-2
Legs	Side lift with ankle weights	12 (each leg)	1-2
Stabilizer[b]	Isometric inner thigh squeeze	Repeat four times	5-10 seconds each time
Stabilizer[b]	Face-up plank	Repeat four times	5-10 seconds each time

[a]Whenever an exercise option is substituted for another exercise that targets the same body part, follow identical reps and set recommendations. [b]Stabilizer exercises require the client to hold the position for the specified number of seconds.

TABLE 19.10 Block Two (Fourth Week)

Body part	Exercise[a]	Number of reps	Number of sets[b]
Chest	Push-up	12	1-2
Back	One-arm row with dumbbells	12 (each arm)	1-2
Abs	Combo ab curl	12	1-2
Biceps	Standing biceps curl	12	1-2
Triceps	One-arm triceps press	12 (each arm)	1-2
Shoulders	Overhead press	12	1-2
Hips	Squat holding dumbbells	12	1-2
Legs	Side lift with ankle weights	12 (each leg)	1-2
Stabilizer[b]	Isometric inner thigh squeeze	Repeat four times	10-15 seconds each time
Stabilizer[b]	Face-up plank	Repeat four times	10-15 seconds each time

[a]Whenever an exercise option is substituted for another exercise that targets the same body part, follow identical reps and set recommendations. [b]Stabilizer exercises require the client to hold the position for the specified number of seconds.

TABLE 19.11

Block Three (First Week)

Body part	Exercise[a]	Number of reps	Number of sets[b]
Chest	Chest fly on bench or floor	10-12	1-2
Back	High elbow row	10-12 (each arm)	1-2
Abs	Assisted curl-up	10-12	1-2
Biceps	Preacher curl (flexed shoulder position)	10-12	1-2
Triceps	Triceps dip on chair	10-12	1-2
Shoulders	Rear deltoid raise	10-12	1-2
Hips	Lunge	10-12	1-2
Legs	Heel raise	10-12 (each leg)	1-2
Stabilizer[b]	Push-up position with leg lift	Repeat three times	5-10 seconds each time
Stabilizer[b]	One-leg press	Repeat three times each leg	5-10 seconds each time

[a]Whenever an exercise option is substituted for another exercise that targets the same body part, follow identical reps and set recommendations. [b]Stabilizer exercises require the client to hold the position for the specified number of seconds.

TABLE 19.12

Block Three (Second Week)

Body part	Exercise[a]	Number of reps	Number of sets[b]
Chest	Chest fly on bench or floor	10-12	1-2
Back	High elbow row	10-12 (each arm)	1-2
Abs	Assisted curl-up	10-12	1-2
Biceps	Preacher curl	10-12	1-2
Triceps	Triceps dip on chair	10-12	1-2
Shoulders	Rear deltoid raise	10-12	1-2
Hips	Lunge	10-12	1-2
Legs	Heel raise	10-12 (each leg)	1-2
Stabilizer[b]	Push-up position with leg lift	Repeat three times	5-10 seconds each time
Stabilizer[b]	One-leg press	Repeat three times each leg	5-10 seconds each time

[a]Whenever an exercise option is substituted for another exercise that targets the same body part, follow identical reps and set recommendations. [b]Stabilizer exercises require the client to hold the position for the specified number of seconds.

TABLE 19.13

Block Three (Third Week)

Body part	Exercise[a]	Number of reps	Number of sets[b]
Chest	Chest fly on bench or floor	8-10	1-2
Back	High elbow row	8-10 (each arm)	1-2
Abs	Assisted curl-up	8-10	1-2
Biceps	Preacher curl	8-10	1-2
Triceps	Triceps dip on chair	8-10	1-2
Shoulders	Rear deltoid raise	8-10	1-2
Hips	Lunge	8-10	1-2
Legs	Heel raise	8-10 (each leg)	1-2
Stabilizer[b]	Push-up position with leg lift	Repeat four times	5-10 seconds each time
Stabilizer[b]	One-leg press	Repeat four times each leg	5-10 seconds each time

[a]Whenever an exercise option is substituted for another exercise that targets the same body part, follow identical reps and set recommendations. [b]Stabilizer exercises require the client to hold the position for the specified number of seconds.

TABLE 19.14 Block Three (Fourth Week)

Body part	Exercise[a]	Number of reps	Number of sets[b]
Chest	Chest fly on bench or floor	8-10	1-2
Back	High elbow row	8-10 (each arm)	1-2
Abs	Assisted curl-up	8-10	1-2
Biceps	Preacher curl	8-10	1-2
Triceps	Triceps dip on chair	8-10	1-2
Shoulders	Rear deltoid raise	8-10	1-2
Hips	Lunge	8-10	1-2
Legs	Heel raise	8-10 (each leg)	1-2
Stabilizer[b]	Push-up position with leg lift	Repeat four times	10-15 seconds each time
Stabilizer[b]	One-leg press	Repeat four times each leg	10-15 seconds each time

[a]Whenever an exercise option is substituted for another exercise that targets the same body part, follow identical reps and set recommendations. [b]Stabilizer exercises require the client to hold the position for the specified number of seconds.

This periodized program first develops muscular endurance (shaping, toning, body shaping—call it what you want!) and then progresses your client toward optimal strength development and size gains (muscle hypertrophy). Not only will the client have fun and be challenged, but he'll see great results and his mind and body will feel fresh! So get your client started and let him experience the results of this periodized strength program.

Overview of the Plan
Each phase in this 16-week program is four weeks long. Before you jump into this training program, work with your client to develop his goals and evaluate his current level of fitness.

If your client's goal is to shape and tone his muscles versus developing maximal size and strength, you will maintain his strength fitness by following the guidelines in the first two phases. If he's looking to significantly increase muscle size and strength, have him take on phases III and IV. Phases I and II prepare your client for the high-intensity training he'll experience in phases III and IV as well as for the high-intensity training techniques (i.e., compound and breakdown training) discussed earlier in this chapter.

If you've already laid your client's strength training foundation by training at least four weeks, doing 8 to 10 exercises per workout, performing 15 to 20 reps to fatigue, and lifting two to three times per week, you can start the

client at phase II, or week five of this periodized strength program. Note that as the program progresses, the training becomes harder and takes more time.

Customizing the 16-Week Periodized Workout Schedule
Although this is a review from previous sections, the following points can help you customize individual client workout schedules:

Exercise order. Choose at least 10 to 12 exercises that target all of the major muscle groups. Take a look at the strength exercises in the following section that challenge all of the major muscles of the body.

Number of workouts per week. Place one day of recovery between each strength workout day. You can still train the cardiorespiratory component or stretch on these "off" strength days.

Number of sets and reps. Although the number of sets and reps should be closely followed, they are not written in stone. The progression from week to week builds in flexibility, so feel free to modify (i.e., do less) if your client isn't on "top of her game."

Weight used. The amount of resistance you use is determined by the repetition goal, as related to the training goal (i.e., endurance, hypertrophy, power). Select a resistance that allows your client to complete the goal number of reps or end within a given range of reps with good form.

Movement speed. A 2:4 ratio involves two seconds of lifting and four seconds of lowering. I encourage a four- to seven-second repetition, although I often vary the length of the concentric or eccentric phases as part of my approach to periodizing strength programs.

Recovery time between sets. Use active recovery to make the most of your client's time. If she doesn't feel fully recovered after the allotted recovery duration and full recovery between sets is the goal, allow more time.

Recovery time between four-week phases. Periodization theory indicates that after progressing a program for four to six weeks, a period of restoration should follow this sustained training effort. Encourage your client to do something different for two to three workouts before taking on the next phase of the periodized program.

Phase I: Muscular Endurance

Phase I of the periodized strength program lasts four weeks (table 19.15). The first two weeks consist of light to moderate workouts. This allows for a progressive adaptation to strength loads so that muscles, tendons, and ligaments can become stronger, with less chance of being injured. After two weeks, the workouts consist of light, moderate, and heavy resistance training (higher repetition numbers reflect light loads, whereas lower numbers are heavier resistance). Generally, as your client becomes stronger, she can perform more exercises and sets of repetitions or exercises, train more frequently, and take shorter rest periods between sets. All of these training variables are manipulated in each four-week phase of this 16-week program. These changes accommodate your client's new gains in fitness and provide new challenge (overload). Your client

TABLE 19.15 Phase I: Muscle Endurance

Length of phase: 4 weeks

Goals: Develop general muscle strength and endurance fitness base; prepare for increasingly harder workouts

	Workout	Number of sets	Number of reps	Recovery time between sets (minutes)
Week 1	Workout 1	1	20	2
	Workout 2	1	20	2
	Workout	**Number of sets**	**Number of reps**	**Recovery time between sets (minutes)**
Week 2	Workout 1	1-2	20	1
	Workout 2	2	20	2
	Workout 3 (optional)	1-2	20	1
	Workout	**Number of sets**	**Number of reps**	**Recovery time between sets (minutes)**
Week 3	Workout 1	2	15	2
	Workout 2	1-2	15	2
	Workout 3	2	15	2
	Workout	**Number of sets**	**Number of reps**	**Recovery time between sets (minutes)**
Week 4	Workout 1	2	15	1
	Workout 2	3	15	2
	Workout 3	2	15	1

Reprinted from D. Brooks 1999.

will continue to get stronger and build muscle, and she'll gain these results safely.

Phase II: Muscular Strength and Hypertrophy (Level 1)

Phase II of the periodized strength program lasts four weeks (table 19.16). With further increases in volume (reps, sets) and intensity (resistance), this phase is designed to result in an even greater stimulus for increased muscle size and strength gains. More emphasis is placed on distinct light, moderate, and heavy training sessions. Recovery time and number of reps decrease as this phase progresses, making your client's training harder and providing a greater stimulus for increased muscle size and strength gains.

Phase III: Muscular Strength and Hypertrophy (Level 2)

Phase III of the periodized strength program lasts four weeks and is designed to present

a new training stimulus that will continue to further your client's strength and muscle size gains (table 19.17). During this phase, the biggest emphasis will be on lowering the number of repetitions. Heavier resistance will provide yet another new stimulus to promote strength gains. Because your client will be using heavier resistance that may require more recovery from each set of exercise than is allotted in the chart, allow more time for your client to fully recover. A full recovery allows him to lift safely with heavier weights. During the last week of this phase (week 12), overall work is reduced slightly. This gives your client additional recovery time (don't forget restoration time between phases, too) before you jump into the last strength phase. Don't let the client feel guilty about easing up. Phase IV (beginning week 13) will give your client plenty of opportunity to work very hard, as repetitions continue to decrease.

TABLE 19.16 Phase II: Muscular Strength (Level 1)

Length of phase: 4 weeks
Goals: Increase muscular strength and size (hypertrophy)

	Workout	Number of sets	Number of reps	Recovery time between sets (minutes)
Week 5	Workout 1	3	20	1
	Workout 2	3-4	15	2
	Workout 3	3	15	1
	Workout	**Number of sets**	**Number of reps**	**Recovery time between sets (minutes)**
Week 6	Workout 1	3-4	20	1
	Workout 2	3-4	15	2
	Workout 3	3	12	2
	Workout	**Number of sets**	**Number of reps**	**Recovery time between sets (minutes)**
Week 7	Workout 1	4	20	1
	Workout 2	2-4	15	2
	Workout 3	4	12	2
	Workout	**Number of sets**	**Number of reps**	**Recovery time between sets (minutes)**
Week 8	Workout 1	3	12	1-2
	Workout 2	2	15	1
	Workout 3	3-4	12	1-2

Reprinted from D. Brooks 1999.

TABLE 19.17 Phase III: Muscular Strength (Level 2)

Length of phase: 4 weeks
Goals: Significantly increase muscular strength and size (hypertrophy)

	Workout	Number of sets	Number of reps	Recovery time between sets (minutes)
Week 9	Workout 1	3	12	1
	Workout 2	2	10	1-2
	Workout 3	3	12	1
Week 10	Workout 1	3	10	1-2
	Workout 2	3-4	12	1
	Workout 3	3	10	1-2
Week 11	Workout 1	3-4	10	1
	Workout 2	3	8	1-2
	Workout 3	3	10	1
Week 12	Workout 1	3-4	10	1
	Workout 2	3	10	1
	Workout 3	2	10	1

Reprinted from Brooks (1999).

Phase IV: Optimizing Hypertrophy and Strength

The last phase of the periodized strength program lasts four weeks and is designed to put the finishing touches on your client's 16-week concentration on improving her personal strength (table 19.18). In this phase, the number of reps is decreased even further. Longer rest periods are used because this phase requires hard effort, which in turn requires longer recoveries between exercises to maintain a consistent level of exertion (meaning your client needs to be able to complete the assigned number of reps) from exercise to exercise.

Strength Training Workout Sheet

You can create and record your client's periodized strength workouts on the reproducible form found on page 390.

15 Top Strength Exercises (and How to Do Them)

Not only do these top strength exercises provide a strength workout that targets all of the major muscle groups in the body, but only minimal equipment is needed, and by following these descriptions you can ensure that your client performs the exercises correctly.

The exercises are sequenced so that you can follow the full body routine as listed. Because the same body part is never exercised consecutively, your client actively recovers while doing the next exercise. More advanced routines sequence exercises differently, but this provides a solid, total body workout that incorporates the concept of active recovery.

FORM 19.1 Week-at-a-Glance Strength Workout Log

#	Exercises	Weekly sets/reps	Set	Day 1				Day 2				Day 3			
				1	2	3	4	1	2	3	4	1	2	3	4
1			Wt.												
			Reps												
2			Wt.												
			Reps												
3			Wt.												
			Reps												
4			Wt.												
			Reps												
5			Wt.												
			Reps												
6			Wt.												
			Reps												
7			Wt.												
			Reps												
8			Wt.												
			Reps												
9			Wt.												
			Reps												
10			Wt.												
			Reps												

Phase _____ Week _____

Date _____

Comments _____

Reprinted, by permission, from D. Brooks 1999, *Your personal trainer* (Champaign, IL: Human Kinetics), 206.

From *The Complete Book of Personal Training*, by Douglas S. Brooks, 2004, Champaign, IL: Human Kinetics.

TABLE 19.18 Phase IV: Optimizing Hypertrophy and S

Length of phase: 4 weeks
Goals: Maximize muscle strength and hypertrophy increases

	Workout	Number of sets	Number of reps	Recovery time between sets (minutes)
Week 13	Workout 1	3	8	2
	Workout 2	2	10	1
	Workout 3	3-4	8	2
Week 14	Workout	Number of sets	Number of reps	Recovery time between sets (minutes)
	Workout 1	3	8	2
	Workout 2	2	6	2-3
	Workout 3	3	8	2
Week 15	Workout	Number of sets	Number of reps	Recovery time between sets (minutes)
	Workout 1	3	6	2-3
	Workout 2	3	6	2-3
	Workout 3	3	6	2-3
Week 16	Workout	Number of sets	Number of reps	Recovery time between sets (minutes)
	Workout 1	3-4	6	2-3
	Workout 2	3	6	2-3
	Workout 3	3-4	6	2-3

Reprinted from Brooks 1999.

Strength Exercise 1: Supine Dumbbell Press

Body Parts Targeted

Chest, front of the shoulders, back of the arms

104

Muscles Strengthened

Pectoralis major, anterior deltoids, triceps

Goals

To increase strength in the chest and avoid shoulder stress

Setup and Alignment

Instruct the client: Sit upright at one end of a bench, a dumbbell in each hand, with the dumbbells resting on end and in contact with the upper thigh. From this sitting position roll back to a supine position and simultaneously cradle the weights (I call this the "safe position") to the sides of your chest. (In the safe position, hands, wrists, and elbows will be close to your sides.) Keep your feet on the floor or bring them onto the end of the bench. Head, shoulder blades, and buttocks should be in firm contact with the bench. Maintain the natural arches in your neck and low back. Pull your shoulder blades toward one another (called scapular retraction); keep this retracted position throughout your set of repetitions.

Continued ➤

➤ *Continued*

Performing the Exercise

From the safe position, press the load directly above your shoulders. Rotate your shoulders so that the thumbs face one another and your elbows have moved away from your sides. Lower the weight as though your hands are moving around a fat barrel. Keep your wrists straight and don't let the dumbbells tilt up or down.

Now, press the weight up and visualize that the hands are arcing around a wide barrel. Maintain this position and technique until the last rep. When the weight is lowered, simultaneously bend your elbows and lower the arms until the upper arms (line from elbow to shoulder) are parallel to the ground. Don't let the shoulders rotate forward or back. When pushing the weight up, contract your chest and pull the arms up and back together, while straightening the elbow. Keep the shoulder blades pulled together and the elbows slightly bent (at top of movement) as each repetition is finished. Return to starting position following the barrel arc. On the last repetition, move your elbows forward by rotating at the shoulder (the arms are straight) and cradle the weight back to safe position.

Variations

From a seated or standing position, attach elastic resistance behind you at shoulder height. Although body position has changed, technique does not. When the upper arms are taken back, they should be in line with the sides of the body, not behind it.

Comments

A bench that is too high can force you into an extreme arched-back position if you place your feet on the ground. Make sure you can keep the normal curve in you back during the lift. If you need to, place your feet on the bench itself, although this may make you less stable. You can bring the floor to you by placing a step bench or other prop on either side of the weight bench. Some commercial equipment provides foot pegs for placement of the feet.

Safety Considerations

Don't lower your upper arms any deeper than parallel to the floor, and keep your elbows from moving in or out (you'll know because the weights will follow!). Avoid rounding your upper back by keeping your shoulder blades pulled together. Keep a natural arch in your low back. A flat-back position puts unnecessary stress on your low back. Keep the setup and alignment throughout the movement.

Strength Exercise 2: Kneeling High-Elbow, One-Arm Row

Body Parts Targeted

Sides of the upper back, back of the shoulder, front of upper arm

Muscles Strengthened

Latissimus dorsi, posterior deltoid, biceps

Goals

To strengthen the upper back and back of the shoulder, create muscle balance between the chest and upper back, improve posture

Setup and Alignment

Instruct the client: Place one knee on a bench with the same side hip aligned directly over it (this keeps you from sitting back on your heels and stressing the knee). The knee of the other leg should be at about the same height and slightly bent. Take the hand on the side of knee that's on the bench and place it just off the edge of the bench (this puts less pressure on the wrist), rather than flat on the bench. The upper body should be parallel to the floor. Lower your body, flexing at the knee and hip, to pick up the weight and return to this start position. Hold the dumbbell without tilting it and keep wrist straight. Rotate your shoulder so that your elbow is pointing away from side. Arms hang straight down and your elbow is slightly bent. Pull shoulder blades toward one another (scapular retraction) and keep this retraction throughout the exercise.

Performing the Exercise

Bend the elbow and pull the arm up until the upper arm is parallel to the floor or higher and the bend at the elbow forms a right angle. Pause for a moment and keep the scapulae retracted and elbow pointed away from your side as you return to the starting position. Repeat on the other side.

Variations

1. The low row with dumbbells emphasizes the latissimus muscle. The starting position is the same except that the dumbbell hangs straight down and the elbow is close to the side. The arm "scrapes" by the ribs until the upper arm is parallel to the ground or higher.

2. The high-elbow row can be performed from a standing or seated position by using tubing that is securely attached at shoulder height, in front of you. Both arms can be exercised together.

Continued ➤

➤ *Continued*

Comments

The high-elbow row puts more emphasis on the back of the shoulder, whereas the low row targets the latissimus muscle.

Safety Considerations

Don't use momentum. Control the movement and keep your chest square to the floor (the tendency is to "open" the chest toward the ceiling). Maintain normal curves in your neck and low back. Avoid arching the neck by keeping your head level. Don't rotate your shoulder forward or back (this will change the intended effect of the exercise). Keep the setup and alignment throughout the movement.

Strength Exercise 3: Standing Squat

Body Parts Targeted

Buttocks, front and back of the thighs

Muscles Strengthened

Gluteus maximus, quadriceps, hamstrings

Goals

To strengthen the buttocks and thighs, improve balance, and increase spinal and upper body stabilizing strength

Setup and Alignment

Instruct the client: Stand upright with your weight over both feet. Your feet should be slightly wider than hip width. The feet can either point forward or turn out slightly. Hold a dumbbell in each hand (or use tubing) and let your arms hang naturally, straight down and slightly forward of your hips. In the starting position your hips and knees should be slightly bent, trunk is positioned with a slight forward lean, your head is neutral (chin level with the ground and eyes looking forward) and low back maintains its normal curve, your shoulder blades are pulled toward one another, and your weight is centered over your ankles (don't be forward on your toes or back on the heels).

Performing the Exercise

Bend your knees and slowly move (push back as though you're sitting in a chair) your hips back. Maintain the natural curve in your low back and the slight forward lean of your upper body. Don't round your low back; lean from the hip. Keep your chest lifted (versus rounded) by squeezing your shoulder blades toward one another. The knees should not travel beyond the toes and should stay aligned between the first and fifth toes. The knees should always follow the direction the toes are pointing. A return to the upright starting position requires control and uses the same muscle groups you used when lowering.

Variations

1. Dumbbells may be held at the shoulders or one dumbbell can be held in front of the body with the arms straight and elbows slightly bent. Technique remains the same.

Continued ➤

2. Tubing can be used by grasping its handles and placing the cord securely under your feet. Technique stays the same, but it is recommended that you position and unload (release) the tubing at shoulder height in the lowered position. This will reduce the tension on the tubing.

Comments

When you lower, your squatting muscles are used eccentrically (they produce force while lengthening), and when you return to the upright position these same muscles are used concentrically (they produce force while shortening).

Don't consider placing blocks or weight plates under your heels. This drives your knees forward and places unnecessary stress on the knees. Keep your heels in contact with the floor at all times. Lower until your thighs are about parallel (or slightly higher) to the floor or until the point is reached where you cannot maintain the natural arch in your low back. If your back rounds and the hips roll under, go no lower because this is very stressful to the low back.

Safety Considerations

Keep your back neutral (slightly arched) and your heels on the ground. Align your knees in the direction your feet are pointed, and keep the knees aligned over your feet. Generally, squat no deeper than 90 degrees, or keep your upper thighs parallel to the floor. Keep the setup and alignment throughout the movement.

Strength Exercise 4: Seated Press Overhead

Body Parts Targeted

Front of the shoulders, back of the upper arms, upper neck

Muscles Strengthened

Anterior deltoid, triceps, upper trapezius

Goals

To strengthen the front of the shoulders and chest (to a limited extent)

Setup and Alignment

Instruct the client: Set your incline bench at 20 to 30 degrees of incline (measured from a straight-up position, this is a "slight" incline). Sit with a dumbbell in each hand. The dumbbells rest on end and are in contact with your upper thighs. In this position of inclined support, place your head (head may be slightly forward and supported by a rolled up towel), shoulder blades, and buttocks firmly against the bench and maintain the natural curves of the neck and low back. Raise the dumbbells to shoulder height and split the difference between having your elbows extremely "flared" or open (out to the side) and your elbows close to your sides, or pointing front.

Continued ➤

➤ *Continued*

Performing the Exercise

Initiate the press overhead from this starting position. Keep the weights from tilting and parallel to the floor. Press the weight up as though you're pressing around a fat barrel. Finish the press by bringing the hands or thumbs toward each other. It is not necessary that the dumbbells touch. Lower with control to the starting position and repeat.

Variations

From a seated position on a bench or inclined step, wrap tubing from under the bench seat or step platform top so that it is secure and you have an end in each hand. Sit upright and press slightly up and forward.

Comments

The angle of the bench, about 20 to 30 degrees from vertical (a slight incline), dictates the amount of involvement of the pectoralis major muscle (chest). As the incline is lowered toward horizontal, the "pec" major will become increasingly involved.

Safety Considerations

Do not set the bench directly vertical (straight up). It is rare that you reach directly overhead (normally you reach up and slightly in front of the body to perform everyday tasks and sport movements). Pressing directly overhead, or overhead behind the neck, can put unnecessary stress on the shoulder joint, is often uncomfortable, and makes it difficult to press with good form. Additionally, these higher risk variations do not work the front of the shoulder more effectively. Keep the setup and alignment throughout the movement.

Strength Exercise 5: Sidelying Lateral Abdominal Curl

Body Parts Targeted

Abdominals, low back

Muscles Strengthened

Abdominals: Obliques, rectus abdominis (assists in the lateral curl)
Back muscles: Quadratus lumborum, erector spinae (assists in the lateral curl)

Goals

To strengthen the lateral (outside) fibers of the obliques and to create balanced strength between the rectus abdominis and the obliques, as well as create stabilizing abdominal strength; strengthen the low back

Setup and Alignment

Instruct the client: Lie on the Bosu Balance Trainer on your side. Place your hands behind your head, with the side of your head resting on the arm that is in contact with the Bosu.

Continued ➤

➤ *Continued*

(Note that the lower arm is positioned for comfort and the elbow is pointing forward, whereas the top elbow is "open" and away from the head.) Move your top leg slightly forward and press the foot of the top leg firmly against the floor for stability. The bottom leg is straight or slightly bent. Your shoulders are aligned with your hips (don't flex at the waist or hips).

Performing the Exercise

From this side-lying position, concentrate on drawing the bottom of your rib cage toward the top of the hip. Without letting your hips move forward or backward, lift only as high as the muscles will take you. Return with control to the starting position.

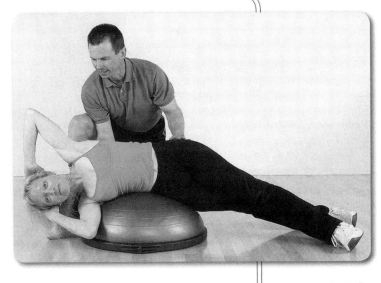

Variations

Initially you can assist this movement with your lower arm. After your strength increases, lift the lower arm just off the floor and then pull your rib cage toward the top of your hip.

Comments

The lateral fibers of the obliques play a significant part in upright postures, so this may be the most important ab exercise you do! This movement is very small and precise. Don't be tempted to use poor or unsafe technique to create excessive motion. These trunk muscles are used more as functional stabilizers (they keep your pelvis and back properly positioned), so remember to let the muscles on the front and back of your trunk move you, and nothing else! Don't let your top hip roll forward or back. This takes the emphasis away from the obliques and back muscles. Keep your top elbow and hip oriented to the ceiling.

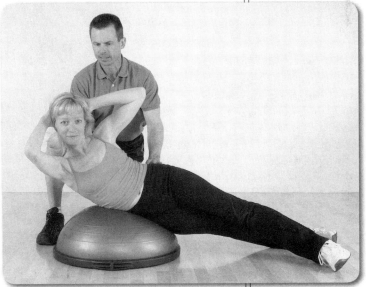

Safety Considerations

Don't tilt your head toward the ceiling. Your ears should stay level with your shoulders and "go along for the ride" as your trunk muscles pull your rib cage toward the hip and raise the upper body slightly off the surface. Keep the setup and alignment throughout the movement.

Strength Exercise 6: Sidelying Rotator Cuff Series (three key exercises from one position)

The rotator cuff is composed of four muscles: supraspinatus, infraspinatus, teres minor, and subscapularis (SITS)

Body Parts Targeted

Shoulder joint

Muscles Strengthened

1. Side-lying abduction: supraspinatus
2. Side-lying external rotation: infraspinatus, teres minor
3. Side-lying internal rotation: subscapularis

Goals

To develop shoulder joint strength and structural integrity

Setup and Alignment

1. Instruct the client: Lie on your side on a comfortable surface and place a rolled-up towel under your head for support. With the weight in hand, rest your top arm on the side of the body. Place your lower arm in a comfortable position. Maintain a slight bend in the knees and hips and keep the natural curve in your low back. (See 1a.)

2. After setting up as in position 1, move the top hand so that the arm is bent 90 degrees (right angle from your body) and the elbow is pressed into the body. The elbow stays "glued" to this spot throughout the exercise. (See 2a.)

3. From setup position 1 or 2, move the weight from the top hand to the bottom hand. Return the top hand to a resting position on the side of the body. Lower the bottom hand so that the elbow is bent at 90 degrees (a right angle from the body) and the hand is just above the floor. Support this position with a towel if uncomfortable. Your bottom elbow stays close to your body and in contact with the floor throughout the exercise. (See 3a.)

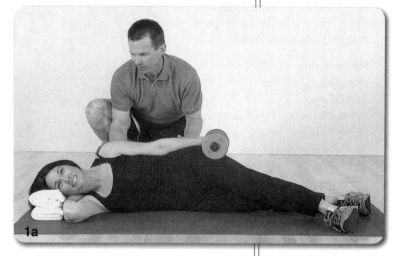

1a

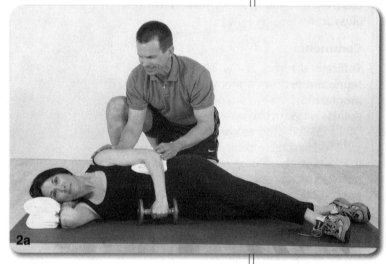

2a

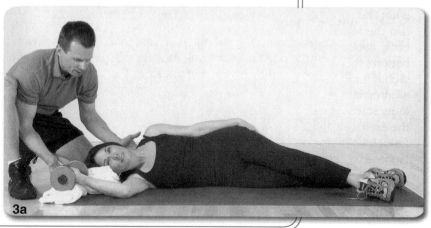

3a

Continued ➤

➤ *Continued*

Performing the Exercises

1. From setup 1, keep the wrist and top arm straight. Lift the arm about 45 to 60 degrees directly toward the ceiling and away from your side. Don't let your body roll forward or back. Keep the top arm aligned over the side of your body throughout the exercise. Return the weight with control. (See 1b.)

2. From setup 2, keep the top arm bent at 90 degrees and the elbow in contact with your side. Keep your wrist straight and lower the weight as far as you can without the elbow lifting from your side. Rotate the arm up and toward the ceiling without your elbow lifting from the side. Don't let your body roll forward or back. Return the weight with control. (See 2b.)

3. From setup 3, keep the bottom arm bent at 90 degrees and close to your body. Your hand is just off the floor in the start position. Rotate your lower arm inward and toward your body without your elbow sliding away from your body. (See 3b.)

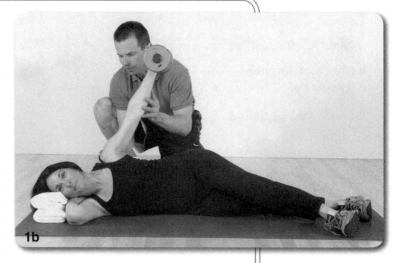

1b

Comments *10 7*

Sufficient rotator cuff muscle strength is the foundation for any upper body strength program or sporting activity that requires the use of the arms, chest, and upper back.

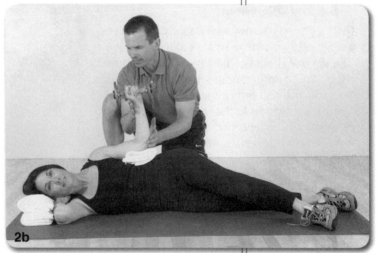

2b

Safety Considerations

1. Support your head so that it is not tilted to either side and maintain the natural curve in your low back. Avoid lying directly on your bottom shoulder by "cheating" it slightly forward during setup and alignment.

2. Support your head so that it is not tilted to either side and maintain the natural curve in your low back. Avoid lying directly on your bottom shoulder by "cheating" it slightly forward during setup and alignment. Keep the upper elbow in its starting position throughout the exercise and pressed into your side. Don't rotate your top arm any higher than 90 degrees (top hand oriented to ceiling). (See 2a and b.)

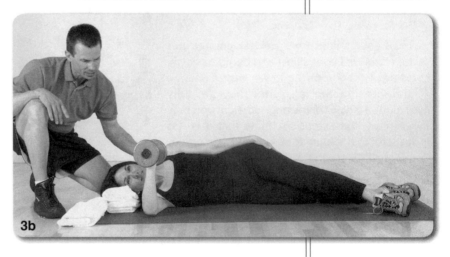

3b

3. Support your head so that it is not tilted to either side and maintain the natural curve in your low back. Avoid lying directly on your bottom shoulder by "cheating" it slightly forward during setup and alignment. Keep the lower elbow in its starting position throughout the exercise. Keep the setup and alignment throughout each movement. (See 3a and b.)

Strength Exercise 7: Seated Leg Extension

Body Parts Targeted

Front of thigh

Muscles Strengthened

Quadriceps group (rectus femoris, vastus medialis, vastus intermedius, vastus lateralis)

Goals

To increase muscular strength in the thigh without compromising the health of the knee joint, maintain or improve knee joint stability and kneecap tracking (correct alignment)

Setup and Alignment

Instruct the client: Adjust the seat so the knees are aligned with the machine's axis of rotation. The leg pad should contact the shin just above the ankle. Sit upright or slightly back, with your buttocks pressed firmly against the back pad. Glue your buttocks to this spot throughout the duration of this exercise! Maintain a natural curve in your low back and neck (chin level with the ground). Squeeze your shoulder blades toward one another (scapular retraction) and position the legs with a maximum bend of 90 degrees. Position your knees in line with your hips and keep your kneecaps oriented to the ceiling (don't let them turn in or out by rotating your hip).

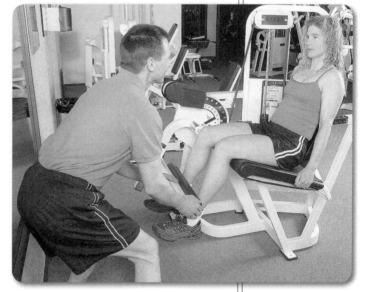

Performing the Exercise

Relax your ankles (toes neither pointed nor pulled toward your shins) and begin to slowly extend (straighten) the lower legs. Continue straightening the legs until they are fully extended (if your hamstrings are tight you may not reach full extension). Note that it is less stressful to the knee to stop about 10 degrees shy of a fully straight leg (Brooks 2001). Avoid rotating your hips in or out (this will cause your kneecaps to rotate inward or outward). Return slowly to starting position.

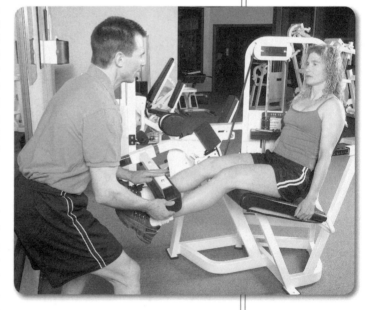

Variations

From a seated position on a bench or inclined step, attach a circular piece of tubing around both ankles. Sit upright and perform the exercise as described previously.

Comments

This is a great exercise to isolate the quadriceps. Unlike compound exercises, such as squats, that require advanced skill, strength, and balance, the seated leg extension allows controlled loading (the exercise is less dynamic and requires less skill). Because one leg

Continued ➤

➤ *Continued*

is often stronger than the other, work the quads one leg at a time, too. This will promote muscle balance.

Safety Considerations

Because this exercise can place considerable stress on the knee joint, follow the preceding instructions and modifications. Because the knee is a "hinge joint," avoid lateral stresses (stresses to the sides of the knee) by keeping the kneecaps oriented to the ceiling. This joint motion (knee extension) is also used in the squat (you can strengthen your quads without this exercise), so if you experience knee discomfort or pain you may want to omit this exercise. Avoid leg extension machines that require you to straighten your knee from a starting position that is greater than 90 degrees (right angle) of knee flexion, in relation to the upper leg. Keep the setup and alignment throughout the movement.

Strength Exercise 8: Prone Spinal Extension

Body Parts Targeted

Low back

Muscles Strengthened

Erector spinae

Goals

To strengthen the low back muscles and increase the structural integrity of the spine

Setup and Alignment

Instruct the client: Position yourself face down (prone) on a comfortable surface with your legs straight and hip-width apart. Rest your forehead on your hands, pointing your elbows to the sides. Pull your shoulder blades together (scapular retraction).

Performing the Exercise

Keeping your hips and feet on the floor and your head on your hands, smoothly lift your upper body off the floor. Keep your shoulder blades pulled together and pulling down toward your buttocks. Lift as high as you can in comfort and without adding momentum. Return slowly to the start position.

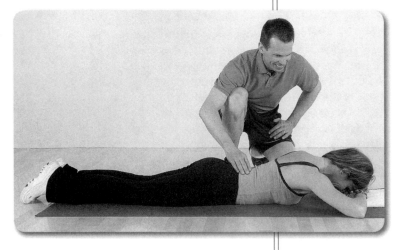

Variations

Perform the same exercise and add rotation. Lift the upper body off the floor slightly before you rotate. A stability ball or Bosu Balance Trainer is an excellent equipment choice for this exercise.

Comments

Improper spinal alignment can result from weak back muscles and poor posture. This exercise can help counter the effects of sitting with a rounded back, which can lead to weak and overstretched back muscles.

Continued ➤

➤ *Continued*

Safety Considerations

Keep the hips pressing firmly into the floor and your feet in contact with the floor at all times. Avoid excessive hyperextension of the low back by lifting the upper body off the floor with control. Maintain proper head and neck alignment by keeping your head in contact with your hands. Keep the setup and alignment throughout the movement.

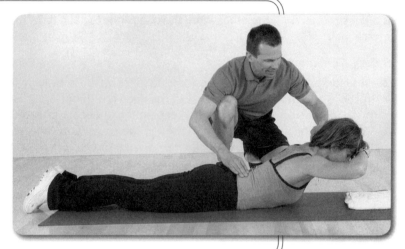

Strength Exercise 9: Prone Leg Curl

Body Parts Targeted

Back of the upper leg

Muscles Strengthened

Hamstrings

Goals

To isolate and strengthen the hamstrings, balance quadriceps strength, stabilize the knee, and help prevent knee injury

Setup and Alignment

Instruct the client: Lie prone (face down) on a leg curl machine with your kneecaps just off the edge of the bench. Line both knees up with the rotational axis of the machine. Adjust the roller pads so they contact the back of the leg just above the heel. Keep your kneecaps facing the floor and your knees in line with your buttock muscles. (This prevents you from positioning your knees too close together or too far apart, which can add lateral stress to this hinge joint.) Grip the handles lightly, but secure and press your body firmly against the pad. Your head should be face down. (If it is more comfortable to move your head to one side, make sure you switch sides at least once during the set.) Begin with the knees slightly bent (this prevents your knees from being hyperextended with

weight load on them) and your ankles relaxed. Stay with this setup until the exercise ends. (Failure to maintain this starting position results in the buttocks "flying" upward, low back arching, and ineffective isolation of the hamstrings.)

Continued ➤

Performing the Exercise

Begin the exercise with the knees slightly bent and a light contraction in the abdominal muscles (this prevents the low back from arching). Relax your ankles (neither point your toes nor pull your toes toward your shins). Draw your heels toward your buttocks by contracting the hamstrings and lifting the lower legs up slowly. The heels may or may not touch your buttocks. Contract the hamstrings fully and return to the starting, slightly bent-knee position.

Variations

Lie face down on a comfortable surface with elastic resistance (flat bands work best versus tubing, which has a tendency to roll up your leg) placed around your ankles. Assume the same setup position as previously. Keep one foot in contact with the ground and draw the other foot toward your buttocks. Return with control and repeat. After completing the desired number of reps, switch to the other leg.

Comments

As with the quadriceps (seated leg extension), it's best to work the hamstrings unilaterally (one at a time) and bilaterally (both legs at the same time) to promote muscle balance. If you always use both legs, it is easy to use one leg more than the other. The tubing variation is a good example of a unilateral leg curl.

Safety Considerations

Maintain a natural arch in your low back. You don't want to round or excessively arch it. Lift with control and the right amount of weight! This will keep your buttocks from "flying" and your low back from arching. Start and finish the leg curl with your knees slightly bent. Keep the setup and alignment throughout the movement.

Strength Exercise 10: Reverse Abdominal Curl

Body Parts Targeted

Emphasis in the lower region of the abdominals (rectus abdominis)

Muscles Strengthened

Rectus abdominis, external obliques

Goals

To control excessive back arch by strengthening the lower region of the rectus abdominis (strong abs can help create good spinal alignment and pelvic stabilization)

Continued ➤

➤ *Continued*

Setup and Alignment

Instruct the client: Lie supine (on your back) on a comfortable surface and start with your knees bent (heels pulled toward your buttocks) and over your hips and a slight curve in your low back. Place your hands alongside you to help provide some balance (don't help by pushing with your arms) and squeeze your shoulder blades together. Do not draw the knees into your chest as you contract your abdominals. (Doing so will cause the hip flexors to initiate the movement with momentum, causing the lower abdominal region to do very little work.)

Performing the Exercise

This small movement is isolated when you contract the abdominals and pull the top of the hips up toward the rib cage. Contract the abdominals enough to flatten the low back and press it firmly into the floor. Continue to pull the pelvis up toward the rib cage, without momentum, until the abs are fully contracted (as far as you can go). Lower with control to the start position (be sure to release to the natural arch in your low back) and repeat.

Variations

To increase the intensity of the exercise, perform the reverse curl with your head at the high end of an inclined bench or step. Or, simultaneously perform a basic curl ("crunch") with this reverse ab curl.

Comments

Technically speaking, there is not an "upper" and "lower" abdominal muscle, but the type of ab work you choose can emphasize the upper or lower regions of this one, long muscle called the rectus abdominis. Additionally, some experts state that from a functional perspective it is not important to differentiate (McGill 2002). The goal of abdominal work should be to strengthen both the upper and lower regions to help you attain or maintain good spinal alignment, not spot reduction.

Safety Considerations

Keep your knees over your hips and avoid swinging your legs. Perform this small range of motion with absolute control. After each reverse ab curl, return your spine to neutral (its natural arch that you started with). Keep the setup and alignment throughout the movement.

Strength Exercise 11: Standing Lateral Raise

Body Parts Targeted

Shoulder

Muscles Strengthened

Middle deltoid

Goals

To strengthen the shoulder with middle deltoid emphasis, promote muscular balance in the shoulder (going beyond challenging the front of the shoulder, which is typically overworked in pressing-type and everyday life movements).

Setup and Alignment

Instruct the client: From a standing position with your knees and hips slightly bent, weights in hand, place your feet about shoulder-width apart. Your elbows should point back and your weights should not tilt up or down. Let your arms hang naturally to your sides, with hands slightly forward of your hips and elbows slightly bent, and lean forward slightly. (This slight lean forward places the middle deltoid directly over the floor, thus allowing gravity and the load to oppose the movement.) Maintain the natural curves in your neck (chin is neither lifted nor dropped) and low back, and pull your shoulder blades toward one another (scapular retraction).

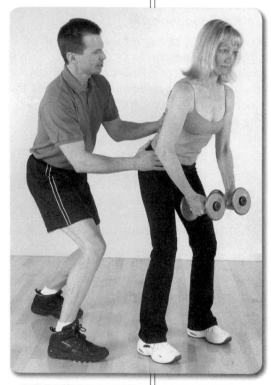

Performing the Exercise

Maintain a slight elbow bend and move ("push") the elbows out to the sides of your body with control. Keep your wrists straight (don't let your hand bend down or up) and raise your arms until they are about parallel to the floor (90 degrees of abduction). Don't let your shoulders rotate in or out (your elbows will point to the ceiling or floor if you do). Lower and repeat.

Variations

1. Using the same setup, perform the exercise unilaterally (only one hand is lifting weight). This allows the opposite hand to support the body by placing it on your thigh.

2. From a standing position, place tubing securely under your feet and grasp each end (or the handles). Perform the exercise as described previously.

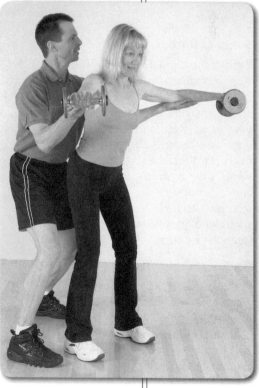

Comments

Generally, this exercise is performed in an upright position, which more effectively targets the front of the shoulder (anterior deltoid). Because the front of the shoulder gets a lot of attention in chest work or any type of pressing motion, leaning slightly from the hip will bring more balanced strength

Continued ➤

➤ *Continued*

to the shoulder region by targeting the middle deltoid. This slight technique variation (the lean forward) places the middle deltoid in perfect alignment against the force of gravity and the resistance being placed against it.

Safety Considerations

Lean forward, or hinge from the hip slightly. Do not round your low back. Raise your upper arms (defined as the line that runs from your elbow to shoulder) no higher than parallel to the floor. Going no higher can help you avoid a painful shoulder situation called shoulder impingement. Keep your thumbs from rotating toward the ceiling or floor (avoids any rotation at wrist or shoulder). Keep the setup and alignment throughout the movement.

Strength Exercise 12: Prone (Facedown) Reverse Hip Lift

Body Parts Targeted

Low back

Muscles Strengthened

Erector spinae

Goals

To strengthen the low back muscles and increase the structural integrity of the spine

Setup and Alignment

Instruct the client: Lie facedown on a step or platform that is four to eight inches off the floor. The edge of the step should be at or slightly above your waist. Rest your knees on the floor and bend them so that your heels are directly above your knees. Wrap your arms around the sides and top edge of the platform and rest your chin on it. Squeeze your shoulder blades toward one another (scapular retraction).

Performing the Exercise

Keep your waist and chin in contact with the platform and tilt your pelvis forward. (Pad the platform to avoid discomfort when the front of your hips rotate forward.) This action will cause your low back to arch. Lift your knees off the floor as far as you can, with control. Use your low back, not

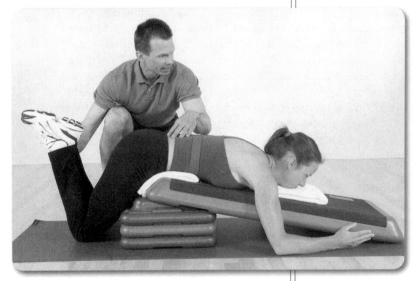

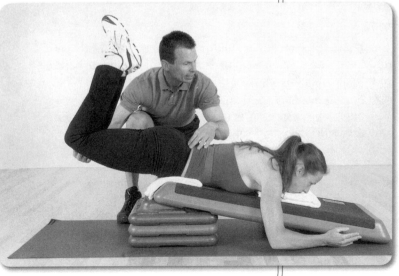

Continued ➤

➤ *Continued*

your glutes. (A common error is to lift the legs from the hip rather than using the low back.)

Variations

Lie facedown on a padded bench that is about 12 inches or more off the floor. This will make the exercise more difficult by increasing available range of motion. Perform the exercise as described previously.

Comments

Typically muscles are worked from their "insertion" attachment point toward a more stable "origin" attachment point. This exercise reverses the normal pull of the low back muscles and trains them in a way different than that to which they are accustomed (e.g., prone spinal extension). One exercise is not better than the other, but this is a sound approach that helps accomplish effective exercise variation. If you have difficulty performing this exercise, position yourself on your hands and knees and practice rounding and arching your back. The arching movement is the "feel" you want to copy for this exercise.

Safety Considerations

Use no momentum. Control your movements. Do not simultaneously lift your head and arch your low back. Keep the setup and alignment throughout the movement.

Strength Exercise 13: Standing Unilateral Heel Raise

Body Parts Targeted

Back of the lower leg

Muscles Strengthened

Gastrocnemius, soleus

Goals

To strengthen the lower leg to help prevent injury and improve the functional abilities of these muscles to assist with running, walking, jumping, pushing off, balance, and ankle stability

Setup and Alignment

Instruct the client: Stand next to a platform or step that is about eight inches off the ground. Place the foot closest to the platform on it, for balance only. Your other foot is close to the platform and pointed forward. Keep your head, shoulders, and hips level and all of your weight over your outside foot (straight leg). Pull your shoulder blades toward one another (scapular retraction) and keep the natural curves in your neck (chin neither tilts up or down) and low back.

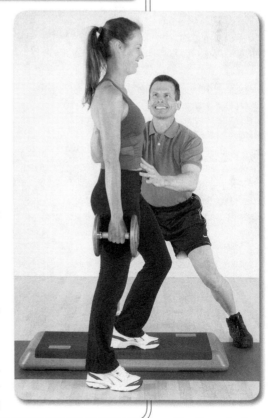

Performing the Exercise

Keep all of your weight on your straight leg and press your forefoot of the weight-bearing leg into the floor, lifting your heel. All of your body weight should move "up." Hips should not

Continued ➤

move forward or back, and you should keep your weight evenly distributed across all five toes. After finishing your set, repeat on the other side.

Variations

Hold dumbbells in either hand and perform the same exercise. The dumbbells provide progressive overload so you can continue to get stronger.

Comments

Balance the unilateral heel raise with an exercise that targets the front of the lower leg. For example, from a seated position, the trainer can manually resist the client's foot as he pulls his toe toward the shin. Weights, tubing, and commercially available devices can be used to challenge the anterior compartment muscles of the lower leg (shin), too.

Safety Considerations

Keep your toes pointed forward during the heel raise. Turning your toes in or out can stress the ankle and has no advantage with regard to working the lower leg muscles more effectively or differently. Maintain the setup and alignment throughout the movement.

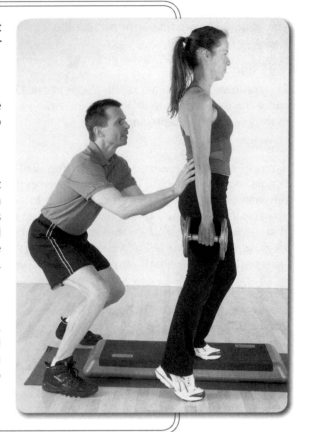

Strength Exercise 14: Supine Unilateral Triceps Press

Body Parts Targeted

Back of the upper arm

Muscles Strengthened

Triceps

Goal

To strengthen the back of the upper arm, in isolation

Setup and Alignment

Instruct the client: Lie supine (on your back) on a bench. Keep your feet on the floor or bring them onto the end of the bench or other foot support device. Regardless, maintain the normal curves in your low back and neck. Your head, shoulder blades, and

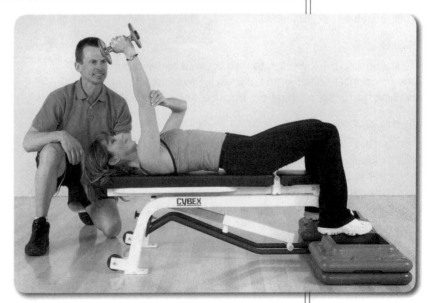

buttocks should be in firm contact with the bench. Pull your shoulder blades toward

Continued ➤

one another (called scapular retraction). With weight in one hand, position this arm with the elbow oriented toward the ceiling and keep it there during the entire set. It should not move forward, back, in, or out. Orient your little finger toward the ceiling. Support the raised arm, just above the elbow, with the other hand.

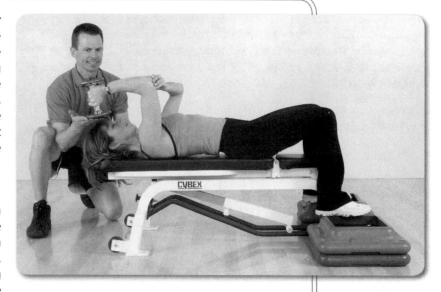

Performing the Exercise

Perform the exercise with one arm (weight in hand) and support the elbow and shoulder position with the other, as described previously. Bend the elbow of the working arm by lowering the hand to the side of the head and toward the bench. Press the weight upward (little finger "leading") until the arm is fully straightened. Keep your wrists straight and don't let the weight tilt up or down. Return with control, and after completing the set, repeat on the other side.

Comments

It's easier to perform this exercise by using one weight, compared with performing a bilateral (both arms simultaneously) movement.

Safety Considerations

Don't let your elbow flare out by keeping your elbow oriented to the ceiling. Lower the weight carefully toward the side of the head and bench. Keep the setup and alignment throughout the movement.

Strength Exercise 15: Standing Biceps Curl

Body Parts Targeted

Front of the upper arm (elbow flexors)

Muscles Strengthened

Biceps group (biceps brachii, brachioradialis, brachialis)

Goals

To strengthen the front of the upper arm, in isolation

Setup and Alignment

Instruct the client: Stand in an upright position with your feet about shoulder-width apart and knees and hips slightly bent (keep your head and shoulders over your hips, not forward of them!). Let your arms hang naturally to your sides, and maintain a "carrying position." Palms face forward (supinated), the upper arms are close to your sides (lightly touching), and the lower arms (from your elbows to your hands) angle away from the

Continued ➤

➤ Continued

body and are wider than the hips. This places your shoulder in a comfortable position and maintains the "true" hinge-joint action of the elbows. Pull your shoulder blades toward one another (scapular retraction). Keep the same shoulder and wrist position (straight and palms forward) throughout the exercise.

Performing the Exercise

Begin with the elbows slightly bent and wrists straight. Contract the elbow flexors and bring your hands toward your shoulders. Do not lean back and push the hips forward. Instead, maintain tension in your abs, and keep your head, shoulders, and hips over your feet. (This will keep the work focused in the arms and not put your low back at risk.) Return and repeat.

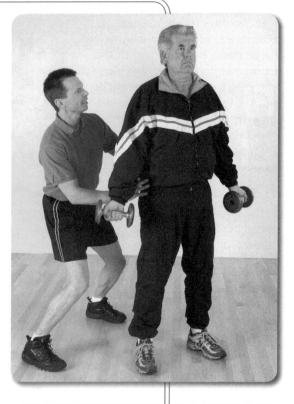

Variations

Using dumbbells or tubing allows you to use two other grips (thumbs facing forward: hammer or neutral grip; palms facing back: overgrip) to emphasize the degree of muscular involvement by various elbow flexors (i.e., biceps brachii, brachioradialis, brachialis). Follow the same technique described previously for either of these hand-position variations.

Comments

All three of the elbow flexors (muscles of the elbow joint) work, regardless of hand position. These hand-position variations—under, over, and neutral—simply allow you to activate each of these muscles to a lesser, or greater, degree.

Safety Considerations

Stay upright and don't bend at your waist. Keep the setup and alignment throughout the movement.

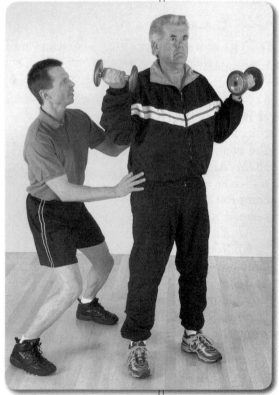

Flexibility Training: Effective Program Design

Flexibility training is probably one of the most overlooked, poorly executed, poorly understood, and undervalued components of physical fitness and health. This chapter discusses proper stretching approaches and provides a number of stretching variations to help your clients effectively accomplish their stretching goals.

Achieving and maintaining flexibility are important factors in reaching optimal physical potential. Flexibility is most simply defined as range of motion (ROM) available to a joint or joints. However, the joint's normal ROM is not always healthy, or adequate, for individual movement pattern needs.

Functional flexibility (Siff and Verkhoshansky 1993) or **functional range of motion (FROM)** is a concept that is gaining momentum. According to Siff, this philosophy changes the goal of stretching from simply increasing ROM to improving the flexibility necessary for a specific activity, sport, or daily chore—without compromising joint stability. This also could be termed "usable" flexibility.

Aren't most clients looking to gain usable flexibility with minimal risk, discomfort, and time commitment? Extreme ranges of motion and contorted stretch postures are high risk for the majority of the population. Static stretching, active stretching, passive stretching, proprioceptive neuromuscular facilitation (PNF) stretching, and active isolated stretching (AIS) will all yield favorable results when performed correctly (more on these later). Stretching can be a very enjoyable, relaxing part of a client's workout. Every client needs to maintain functional movement capability.

Physiological and Biomechanical Basics

A multitude of circumstances can add to or detract from the success of a flexibility training program. It has been well established that increases in intramuscular temperature, through warm-up, decrease viscosity or a tissue's resistance to stretch (Sapega et al. 1981). According to Kravitz and Kosich (1993), there does not appear to be a body build that consistently demonstrates good flexibility.

Several authors report that females tend to be more flexible, in general, than males (Alter 1996; Holland 1968, reported by Kravitz and Kosich 1993). Although conclusive evidence is lacking with regard to sex differences, a female may have a tendency toward greater flexibility in the pelvic region than most males, possibly related to the female's role in childbearing. Beyond these issues, it seems that a regular commitment to stretching exercise is the most influential variable that can affect flexibility gains or losses.

The degree of movement is specific to each joint. Being flexible in one joint does not influence flexibility in another joint. Gains in flexibility are limited largely by four factors:

- The elastic limits of the ligaments and tendons crossing the joint
- The elasticity of the muscle fibers themselves and muscle fascia that encases single muscle fibers, groups of muscle fibers, and the entire muscle

- The bone and joint structure
- The skin

The greatest improvement in flexibility seems to be related to the ability of a stretching program to target the muscle's fascial sheath (which seems to be the most modifiable factor with regard to ROM). When the fascia is warm, it is stretchable. When it is cold, it is less pliable. Ligaments and tendons have a high resistance to stretch, whereas muscle fascia has a low resistance to stretch.

The type of force, mechanics of the stretch and exercise position, duration of the stretch, intensity of the stretch, and temperature of the muscle during the stretch determine whether elongation of tissue is permanent or temporary and whether the stretch is helpful or harmful. If the muscles are stretched too fast, muscle spindles initiate a stretch reflex, which causes the affected muscle group to reflexively shorten and protects it from being overstretched. The resultant increase in muscular tension inhibits the stretching process. If the stretch is performed slowly and with control, the stretch reflex may be avoided or may be of low intensity (see chapter 15 for details on the neurophysiology of muscles and stretching).

Types and Relative Risks of Stretching

Five types of stretching techniques are available:

Static stretching. Static stretching is defined as a controlled stretch, held at the point of mild tension. This places the muscle in a lengthened position, and the stretch is generally sustained for about 10 to 60 seconds.

Dynamic or ballistic stretching. Dynamic or ballistic stretching uses bouncing, jerking, or abrupt movements to gain momentum to facilitate overstretching. Dynamic stretching is a controlled form of ballistic stretching and can be used with some athletic populations. Although ballistic movement often is required in sport, this type of stretching is generally not recommended for average participants.

Active stretching. Active stretching is voluntary, unassisted movement that requires strength

and muscular contraction of the agonist muscle or prime mover (see figure 20.1). For example, in a supine position, the hip flexors can contract actively to draw the leg forward, resulting in hip flexion. The agonist is unassisted by external (passive) forces. The purpose of the stretch is to actively stretch the hip extensors (gluteus maximus and hamstrings) by using only muscular effort and strength provided by the agonist hip flexors.

Passive stretching. Passive stretching occurs when movements are accomplished through the use of an outside (external) force such as that provided by a partner, gravity, or momentum or that provided by pulling on your own body part with another limb (see figure 20.2).

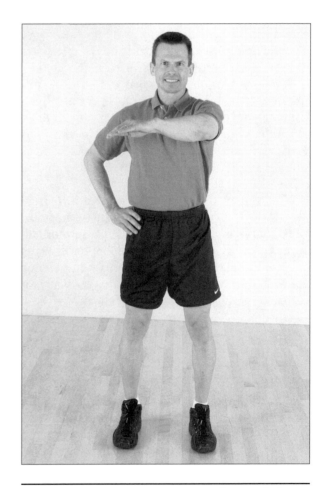

FIGURE 20.1 From a standing or sitting position, hold your arm out in front of you and parallel to the ground. Draw your arm across the body as far as you can without momentum and with no outside assistance.

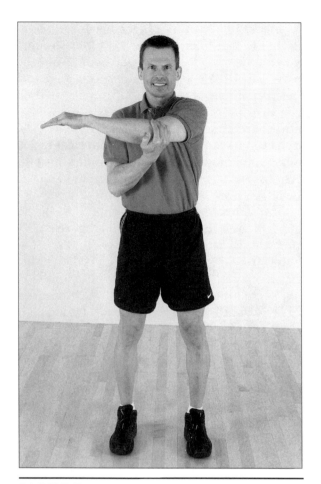

FIGURE 20.2 Assisted or passive stretching uses outside force to assist in the stretch. This time, use the hand opposite of the arm being stretched to gently, and in a controlled manner, pull the arm a little further across the body.

Proprioceptive neuromuscular facilitation (PNF). PNF stretching works by first putting the targeted muscle on a stretch that is fairly intense. The intensity of the stretch is at, or approaches, the elastic limit of the muscle fascia. Then, a maximal force is generated in the muscle that is on stretch. This procedure can activate a sensory organ called the Golgi tendon organ (GTO), which causes the muscle to relax. A muscle that is relaxed or free of tension will more easily allow the muscle fascia to be stretched.

The types of stretching can further be categorized as to their relative risk based on muscular force and tension. These categories are shown in table 20.1.

Which Stretching Methods Work Best?

When deciding what technique or combination of techniques to use, look to science first and then balance this factual information with each client's individual makeup.

Scientists generally think that the major changeable limiting factor affecting flexibility is muscle fascia (Johns and Wright 1962). Almost half of the resistance to ROM is related to muscle fascia. This factor can be modified without negatively affecting joint stability and increasing the risk for injury.

Static stretching, in its various forms, gains the most support in terms of safety and effectiveness. The amount of tissue lengthening that

TABLE 20.1 Relative Risk of Types of Stretching

	Force	Tension	Risk
Active	Low	Low	Low
Controlled passive	Low	Low	Low
Passive	Higher potential	Higher potential	Higher potential
Controlled static	Low	Low	Low
Ballistic	High	High	High
Proprioceptive neuromuscular facilitation (high skill required)	High	High	High

remains after the stretching force is removed is greatest when low-force, long-duration, static stretches are used. This includes active-static stretching, passive-static stretching, PNF followed by an active or a passive stretch into a static hold, or some combination thereof. Static stretching offers a low incidence of injury potential. If your client's goal is to attain functional flexibility, this can easily and effectively be attained with static stretching.

Active stretching, although in theory sound and currently promoted to some extent, can be tedious and demanding for the average client. Many clients lack the requisite agonist strength and mental concentration to bring the limb through an effective and increased ROM. Many clients prefer **passive stretching,** because they seem to be able to "relax" into the stretch, or a combination of active and passive stretching.

Ballistic stretching involves the use of momentum to gain an advantage in overstretching an area of the body. Ballistic stretching tends to encourage recoverable fascial tissue elongation (no change in available ROM) and nonrecoverable muscle or ligament elongation or, in other words, injury. Arguments against ballistic stretching, based on negative short-term and long-term adaptations, include these:

- Ballistic stretching increases muscle soreness.

- Ballistic stretching does not promote tissue adaptation. Tissue adaptation is time dependent, and ballistic stretching does not allow for a lengthened position of the fascia to be sustained.

- Ballistic stretching initiates the stretch reflex and increases muscular tension.

- Ballistic stretching decreases neurological adaptations, especially the muscle spindle and its time-dependent threshold. If the goal is to reset the muscle spindle to a higher level, thus making it easier to attain flexibility gains, ballistic stretching will not facilitate this adaptation.

Although there is sufficient reasoning to justify ballistic stretching to prepare elite athletes for participation, the risk versus effectiveness should be carefully examined. For example,

a professional tennis player needs sufficient dynamic flexibility in the shoulder to slam a tennis serve 120 miles per hour. However, a recreational exerciser may need only sufficient dynamic flexibility to play softball on the weekends. Normal ROM attained through static stretching may be sufficient to meet the dynamic needs of the recreational exerciser, whereas dynamic flexibility training may be required to meet the demands imposed on the body of a professional tennis player.

Many professionals associate ballistic stretching with dynamic stretching. Are they the same? The answer is both yes and no. Ballistic stretching, which mostly has fallen out of favor, especially for general populations, is only one technique of many that could be grouped under the heading of dynamic stretching.

Dynamic stretching can be performed actively, passively, or as a combination of both. Regardless, momentum is used to gain an edge for increasing ROM. Whether dynamic stretching can be done safely depends on the speed and range of motion at which the stretch is being executed and the individual performing the maneuver. Murphy (1991) suggested that for this type of stretching, the ROM should be normal, and it should take about four to five seconds to attain the full, intended ROM at any given joint. In other words, the dynamic ROM should be controlled.

This type of dynamic stretching can be used to prepare an athlete for an aggressive event or for sport-specific preparation. Professional gymnasts, divers, and dancers use dynamic stretching extensively. There is no specific scientific literature that conclusively suggests dynamic stretching is more effective than other methods in producing flexibility gains, and, certainly, there is a higher risk for injury compared with static stretching. I simply want to acknowledge that this type of stretching occurs during many sporting activities, and because of this, choosing to use dynamic stretching to prepare a client for this type of activity might be justified.

Although it is often said that PNF stretching in its various forms yields far greater results than standard static stretching, experts in the field, including Etnyre and Lee (1987), Hutton (1992), and Shrier and Gossal (2000) disagree with this popular notion. Hutton's research

review indicates only that PNF stretching is as effective as other forms of stretching, whereas Shrier and Gossal conclude more research is needed before definitive conclusions can be made. When you read that one method is the best, you need to ask, "For whom and for what?" If attaining functional flexibility is the goal, PNF stretching and its associated risks might be inappropriate. Functional flexibility can be attained easily and effectively with static stretching.

Many of the gains in any fitness component are often related to a client's effort, focus, concentration, and consistency in the effort, as well as the appropriateness of the approach to the individual, rather than any one best way.

PNF Stretching

PNF is an aggressive stretching technique designed to facilitate an increased ROM at the joints. Three questions are often asked regarding PNF stretching:

1. Does PNF stretching belong in a training program?
2. If so, where and when?
3. Is PNF more effective than static stretching?

PNF Stretching Procedures

Although there are numerous protocols, PNF stretching typically involves some variation on these three methods:

1. Contract-relax (CR) followed by passive stretch
2. Contract-relax followed by agonist contraction (CRAC)
3. Contract-relax followed by agonist contraction, followed by a passive stretch (CRAC-P)

The fact that agonist contraction occurs in the second and third methods tells you that these methods use active stretching. All three PNF techniques attempt to invoke neurological responses to facilitate the stretching process.

In the first method, **CR, passive stretch,** the target muscle is put on stretch. For the average client, the degree or intensity of stretch is to the point of mild tension. The amount of intensity or stretch that is applied approximates or

approaches a client's muscle fascial elastic limit. Next, the client will be asked to produce a maximal contraction in the muscle being stretched. During this process, the client should increase the magnitude of the contraction over time, as opposed to an all-out, immediate, 100 percent effort. A muscle on full stretch that is required to produce a maximal contraction is very vulnerable to injury. Rather than "turning on" the contraction as "all or none," which is analogous to turning a light switch on and off, think of this step as something more like slowly intensifying the contraction to a point of maximum. This analogy can be likened to using a dimmer switch to intensify the light of a bulb to maximum brightness or intensity.

For example, to stretch the hamstrings muscle group, your client lies in a supine position and the hamstrings are put on stretch. Next, the client isometrically contracts her hamstrings for 3 to 10 seconds against an "immovable" force. Generally, use your body and have your client attempt to aggressively, yet in a controlled manner, push you away or draw her heel toward her buttocks. I prefer to use about eight seconds to gradually peak the contraction to maximal. The intensity must be "turned on" slowly to lessen the likelihood of injury. This maximum contraction is then followed by a passive (outside force) force application. The client relaxes, and you move her leg forward to flex the hip and stretch the hamstrings and hip extensors.

The **CRAC** technique is similar, but after the maximal contraction an active stretch technique is applied. If we use the preceding example, the hamstrings are stretched and brought to a maximal contraction in about eight seconds. Next, the quadriceps group contracts actively to extend the knee, thus straightening the leg, and the hip flexors actively flex the hip (draw the leg forward toward the client's head), creating an active stretch on the hamstrings. The stretch force is applied actively by contracting the agonist muscles of the quadriceps and hip flexors. No outside (passive) force is applied.

In the **CRAC-P,** all of the steps used for CRAC remain the same. The only difference between the two is the addition of an outside passive force to complete the stretch. The passive stretch is increased to a point of maintainable intensity ("comfortably uncomfortable") and is generally held for 10 to 60 seconds.

PNF Research

In Robert Hutton's (1992) excellent review of the neuromuscular basis of stretching, he noted that a great deal of attention has been placed on PNF stretching techniques on the assumption that they are the most effective methods for increasing ROM. However, his report and many other research studies (Shrier and Gossal 2000) have shown no clear-cut advantages between ROM achieved by PNF techniques and that achieved by static stretching procedures. Part of this disparity is associated with study design. Historically, the results have been rather mixed, but the CRAC-P procedure often has been shown to produce the greatest absolute gains in ROM over other PNF procedures, static stretch, or ballistic stretch, although the results emphasized are sometimes not statistically significant.

Hutton reported it is generally assumed that a maximum contraction prior to stretch, as is done in the PNF procedure, promotes muscle relaxation through mechanisms previously discussed. Contrary to general assumptions, recent findings suggest that, overall, PNF procedures produce greater electromyographic activity in muscle (Shrier and Gossal 2000). Thus, current PNF procedures seem to produce more tension in the muscle, not less. Hutton concluded that constraints within the muscle component in determining ROM have long been underestimated and the role of connective tissue as the major resistance to stretch is possibly overestimated.

The exact mechanisms for flexibility gains are not known. Certain procedures are associated with gains, although the exact science is not understood. In light of soft-tissue characteristics (muscle fascia, its taffylike characteristics, and the effect of temperature increases on fascial tissue) and the body of stretch research that exists, the previously described techniques can be used with a reasonable sense of security in their safety and efficacy. Research (Hutton 1992; Moore and Hutton 1989; Osternig 1990; Shrier and Gossal 2000) may soon influence a change in how PNF stretching is administered or at least provide a better understanding of how PNF stretching works.

Although PNF stretching remains open to controversy, few scientists would argue against the superb results that the combinations of active-static, passive-static, or active-passive-static stretching give the majority of your clients.

When to Use PNF Stretching

I recommend using PNF techniques with participants who are fairly fit and who have good body awareness, physical control, and a base level of strength. (Of course, this recommendation may not be applicable in a medically supervised setting.) Additionally, your client should have a desire to experience this more physically and mentally involved and intense type of training. Pose the following questions when considering its use:

- What are the stretching goals and needs of my client? Are the goals related to sport performance, extreme range of motion, or simply functional flexibility?
- What is my client's conditioning level?
- What is the client's sense of body awareness (proprioceptive) and skill level in performing bodily movements?
- What is my client's motivation level?
- Are my skill and knowledge adequate to administer this technique in a timely, safe, and effective manner?

PNF stretches can be used with a variety of clients, including deconditioned participants, patients in rehabilitation under trained and expert care, and competitive athletes. However, most clients can attain their flexibility goals with static stretching. It may not be necessary to stimulate the GTO with a maximal contraction (i.e., via PNF procedures) or a highly intense and sustained static stretch. The exception to this statement might be a specific rehabilitation situation. In this case, a trained professional, such as a licensed physical therapist, will have the necessary expertise to work with this patient's needs.

Safely teaching PNF stretches requires a clear understanding of neurophysiology, an accurate sense of the limits of a client's body, and constant verbal and nonverbal communication during the stretch. Remember, clients can achieve very acceptable flexibility gains with static stretches, which generally are more comfortable and less likely to cause injury.

Correct PNF teaching technique is best learned from an experienced practitioner of this art. One way to gain this experience is to work with a physical therapist or sports medicine doctor in your professional network. She can help you determine when PNF is appropriate for a client and show you how to perform the stretches properly. Come prepared with a good fundamental knowledge of physiology so you can speak the same language. Hands-on PNF teaching methods also can be learned at workshops, where practicing with other attendees is encouraged. Most presenters are receptive to specific application questions following the presentation.

Active-Isolated Stretching

Although often marketed as a superior stretching technique (relatively little peer-reviewed research exists to support this contention), active-isolated stretching (AIS) essentially is a combination or hybrid of several types of stretching previously mentioned. AIS uses an active stretch, followed by passive assistance to further the stretch, which is then followed by a relatively short and sustained (i.e., static) hold of several seconds. The results associated with AIS are likely related to the total time the muscle spends on stretch or under a stretch tension, as opposed to a superior form of stretching.

How Active-Isolated Stretching Works

AIS is based on principles of neurophysiology, as discussed in chapter 15. AIS uses the reflex mechanism called reciprocal innervation (an inhibitory reflex) to facilitate stretching gains. When one muscle of a paired agonist and antagonist muscle group (e.g., biceps and triceps) contracts, the other automatically relaxes, which allows for coordinated movement. Active-isolated stretching attempts to isolate one joint motion or action at a time, which is a good goal for any type of stretching, because you want to know what you are stretching. In compound stretches, where multiple muscle groups are simultaneously stretched, you don't really know what the weak link is during the stretch.

To stretch a muscle using AIS, the client "isolates" the muscle targeted for the stretch by contracting the opposing muscle and moving through a full range of motion at the joint. This allows the other muscle to relax, and a relaxed muscle is easier to stretch. Once this active range of motion is set, proponents of AIS stretching apply what they call an "active-assistance component." In other words, an outside or passive force, such as the trainer assisting the stretch to gently increase the range of motion, is added to finish the approach. Generally, the client repeats the movement in this manner, with passive assistance at the end of the active range of motion, 10 to 12 times. The assisted or passive stretch facilitated by the trainer lasts or is held only about two seconds. It is recommended that tight areas be targeted with two or three sets.

All of the benefits touted for static or PNF stretching can be attributed to AIS stretching as well; stretching is stretching. AIS is simply a different approach that uses traditional stretching methods (active and passive) and applies intensity (mild tension that is tolerable to the client), repetitions (10-12 shorter reps performed consecutively), and passive holds (about two seconds versus less reps held longer) in a slightly different manner.

Does AIS work? Yes. Is it magical in its ability to produce stretching results? No. AIS works better for some people than others. I do use AIS. Would I use AIS to the exclusion of other stretching methods? I'll let you answer this for yourself!

How to Develop Flexibility

Using a variety of stretching methods best improves flexibility. The goal of each client, the client's fitness level, individual limitations to ROM, the type of activity the client regularly participates in, and risk versus effectiveness must carefully be considered.

A **flexibility warm-up** and **cool-down** can be defined as stretching that takes place before or after an activity to improve performance, reduce the risk of injury, or enhance recovery. The goal is not to increase ROM but to prepare your client's body for upcoming activity or to facilitate recovery from activity. Flexibility training is not, of itself, a warm-up or cool-down.

Any type of stretching should be performed only after an adequate cardiovascular warm-up.

Flexibility training is defined as a planned, deliberate, progressive, and regular program of stretching that causes permanent (plastic) elongation of soft tissues without causing, or contributing to, injury. Flexibility training's focus is to aggressively pursue increases in ROM available at the joint or joints being stretched.

An excellent approach is to use a combination of active, controlled passive, and static stretching technique or a short, repetitive set suggestive of AIS. With these approaches, an active contraction is initiated with agonist muscles. This begins the stretch process and defines an individual's **active range of motion (AROM)**. Once the AROM is determined, the trainer has a better idea of a participant's elastic limit and associated constraints to safe movement. This step may or may not be followed by an application of an outside or passive force that is used to enhance movement through a greater ROM. And finally, a static and sustained stretch is held. Duration of the held stretch can vary.

Following are guidelines for safe and effective flexibility improvement with most clients:

■ Stretch all of the major muscle groups of the body for balance and bodily symmetry, because flexibility is specific to each joint and greatly influences posture. Concentrate on the areas of the body that generally lack adequate flexibility. These include the chest, anterior shoulder, hip flexors, hamstrings, and gastrocnemius and soleus muscle groups of the lower leg (refer to chapter 11).

■ Perform static stretching after a thorough warm-up of at least three to five minutes. A proper warm-up increases body and muscle temperature, increases the likelihood that good gains in range of motion will be attained, and decreases the risk of injury (Shrier and Gossal 2000).

■ Sustain stretches for about 10 to 60 seconds. (The noted exception would be if you choose to use AIS.) Hold each stretch at the point of mild tension or tightness. This is the load or exercise intensity. Stretch to the point where movement or ROM is limited at the joint or to the point where the stretch is felt. Stretching to an intensity that could be described as "comfortably uncomfortable" is okay if the stretch can be sustained. Do not stretch to the point of pain.

■ The recommended frequency for stretching is a minimum of three times per week, although stretching may be performed daily.

■ Perform one to four sets of a stretch per muscle group each time you stretch. (AIS uses more sets and repetitions, with shortened reps or sustained holds.)

■ Stretches should be performed after the muscle is relaxed and warm, in a slow and controlled manner. Progress gradually to greater ranges of motion. When "coming out" of a stretch, release slowly.

■ Use subtle postural variations for given positions to stretch muscles in a variety of ways. The muscles of the body generally have various fiber direction alignments and orientations. When you vary stretches, these structural arrangements within a given muscle will more likely be challenged. This may lead to overall greater flexibility improvement.

■ Focus on proper stretching position and biomechanics that do not put your client at risk because of extreme or contorted postures. Sullivan et al. (1992) reported that the effect of pelvic position (anterior versus posterior tilt) was more important than the stretching method used for gains in flexibility. Position your clients in biomechanically correct postures to facilitate stretching gains and limit the risk for injury.

■ Design programming and assessment that measure improvement in flexibility. Regularly assess and evaluate weaknesses and improvement in flexibility or areas of postural concern. Refer to chapter 11 for a complete discussion of posture assessment and flexibility testing.

■ Have your client participate in a regular stretching program. Possibly the most important factors in stretching, after identifying and using correct stretching methods, are consistency and patience.

These guidelines are, of course, not black and white. Research (Shrier and Gossal 2000; Taylor et al. 1990) suggests that one to four sets of 15 to 30 seconds per stretch might result in optimal flexibility gains. However, these guidelines can encompass a wide range of personal goals, types of stretching, and time commitments while still ensuring excellent flexibility gains.

Best Approach

Without a doubt, using a combination of stretching techniques will be most effective with your clients. You can challenge your clients to become "involved" in the stretch even if you are not using a PNF or an AIS technique. A good way to do so is to ask your client to contract the muscles opposite those being stretched. This invokes the nervous system reflex referred to earlier as **reciprocal innervation.** Reciprocal innervation relaxes the muscles that are paired opposite to those you are stretching. This also provides a good lead into an active stretch and will trigger this relaxation reflex. During stretching, this reflex mechanism can be used to create a relaxed muscle that is being targeted for flexibility gains. Invoking reciprocal innervation will allow for more effective stretching to take place, because it is generally easier to stretch a relaxed muscle and associated fascia.

Additionally, by using a combination of active and passive stretching techniques, you'll stay involved with your clients through hands-on correction and verbal coaching.

Optimal Time to Stretch

When is the best time to fit stretching into your client's program? The answer, of course, is when your client most enjoys and accepts it. Some clients don't like to take time for stretching that lasts more than a minute. If this is your client's personality, "sneak" stretches in during the workout as active recovery. Other clients will look forward to the quiet time-out, relaxation, and stress reduction that an extended series of stretches provides. Work with your client's preferences so that you can maintain and improve on this component of fitness.

The optimal time to stretch depends on the goal of the client, the degree of warm-up that has taken place, and the type of activity, as well as personal preference (Young and Behm 2002). A well-rounded approach to maintaining or increasing FROM will use a variety of stretching techniques.

Graduated, low-level, rhythmic warm-up movement is essential prior to stretching. The warm-up activity should move through an easy range of motion, never going beyond a point perceived as excessive strain. The movements should be kept fluid, rhythmic, and controlled. Duration of a warm-up depends on the activity being participated in and the client. However, for general activity, a minimum of three to five minutes is recommended to increase your client's core temperature sufficiently to reduce viscosity or resistance to stretch in the muscle. High-intensity activity or activity that requires extreme ROM may require 5 to 15 minutes of warm-up as well as an extended stretching period after the warm-up, though more current research questions this wisdom for strength and power activities that are geared to high-level performance (Young and Behm 2002). More research is needed before optimal warm-up protocols can be identified.

Safe and effective stretching can occur after an adequate warm-up, regardless of where it is placed during the workout. But stretching does not replace an adequate warm-up.

If stretches are performed during the warm-up preceding cardiorespiratory activity, the stretches should not last more than about 10 seconds and should be interspersed throughout the warm-up (Kravitz and Kosich 1993). In this case, the goal of the warm-up is to redistribute blood to the working muscles (McArdle, Katch, and Katch 1996). Holds longer than 10 seconds may inhibit an effective blood shift or shunt to working muscles.

To increase ROM, it may be best to perform stretching after cardiorespiratory training or other activity, because the soft tissues will be very warm as a result of an elevated core body temperature and more likely to respond to flexibility training.

Strength Training Is Not Stretching

Although it is generally a good idea to perform resistance training exercise through an active and full ROM, this type of training does not replace flexibility training. Remember, active stretching that occurs during resistance training can be limited by the strength of the agonist and lack of flexibility in the antagonist, which resists the agonist's movement.

Sport Preparation and Stretching

If your client is going out for a leisurely or steady-rate run, it may not be necessary—and in fact, may cause harm—to stretch prior to the run. If your client starts at a slow pace and gradually increases the pace, there is little risk for injury. No extreme ranges of motion or ballistic movement must be prepared for in this case.

Try to match the flexibility exercises to the demands of the upcoming activity. As mentioned, extreme ranges of motion are not necessary before a fitness walking or running program to which the client is already accustomed. However, if she is going to perform a 5K race at her fastest walking or running pace or participate in an aggressive match of singles tennis, a more thorough warm-up and stretching segment may better prepare the client for the energy demands, ROM, and biomechanical stresses of high-intensity activity.

Competitive sports are a different situation, too. A cross-country team might engage in a 10- or 15-minute run to warm the soft tissues of their bodies. If the team is going to train with intervals, which can demand all-out efforts and extreme ROM relative to steady-rate training, stretching is a prudent choice before interval conditioning but only after adequate warm-up. After initially stretching, the team may go for an additional jog of two to three miles, intersperse speed play (speed up and slow down) during the jog, perform the interval workout, cool down with a jog, and engage in stretching or flexibility training again postworkout. This approach is time intensive yet very effective and appropriate. More recent research indicates that a dynamic warm-up may better facilitate performance than static stretching (Young and Behm 2002).

When Not to Stretch

In some situations, it may not be best for your clients to stretch:

- Within the first 24 to 72 hours of muscular or tendinous trauma
- Following muscle strains and ligament sprains

- When joints or muscles are infected or inflamed
- With an area of recent fracture
- When discomfort is felt
- When sharp pains are felt in the joint or muscle
- If severe osteoporosis is present or suspected

Consult with the appropriate medical professional if you have questions or concerns. Rest and ice may be the simple solution in many of the instances cited. However, expert and accurate professional opinion is necessary before proceeding.

Stretching: Putting It All Together

Combining active, passive, and static stretching, with or without stimulating the GTO response (see chapter 15 and PNF this chapter), may best improve flexibility. Furthermore, when results are coupled with manageable and enjoyable effort and efficient use of time, the outcome is often the highest degree of compliance, which is possibly the most important factor in getting results. Review the science and your client's individual needs and physical status before deciding which types of stretching to use. A combination of these approaches will give your clients the right options to attain the best results.

Stretching Right: 15 Classic Flexibility Exercises

I use a combination of active, controlled passive (read this as gentle), and static stretching with my clients. These types of stretching allow me to use a variety of "branded" types of stretching, including PNF and AIS, by simply modifying the following approach to be in accordance with either PNF or AIS stretching procedures. Remember, the following stretches use a combination of active, controlled passive, and static holds.

Step 1: To use this method, an active contraction is initiated with agonist muscles. For example, stand or sit. Hold your arm out in front of you and parallel to the ground. Draw your arm across the body as far as you can without momentum and with no outside assistance. This invokes the nervous system reflex called reciprocal innervation and causes the antagonist muscles on the opposite side to relax. This begins the stretch process and defines your client's AROM. Once AROM is determined or "set," you have a better idea of a safe range of movement for that particular joint and muscle group.

Step 2: Step 1 is followed by application of an outside or passive force that is used to enhance movement through a greater range of motion. For example, have the client use the hand opposite of the arm being stretched to gently, and in a controlled manner, pull the arm a little further across the body. A trainer can facilitate this passive stretch by assisting the ROM with a hands-on spot. This outside force should be applied gradually, gently, and carefully. The tension felt in the back of the shoulder should be tolerable and sustainable.

Step 3: Finally, a static and sustained stretch is held for about 20 to 30 seconds while you or the client maintains the passive, external assistance of your or her hand on the arm being stretched.

Following are 15 stretches and numerous variations that target the muscles your client uses when, for example, he walks, hikes, jogs or runs, cycles, or participates in strength training or cross-training. These stretches will meet your client's flexibility needs by targeting every major body area, especially tight areas like the back of the thighs and lower legs, front and outer part of the hip, chest, and front of the shoulder. All 15 stretches will provide your client a full-body stretch routine that lengthens and relaxes the muscles that are working the hardest during his workouts and throughout his day.

You can have the client perform this series of stretches all at once during a workout or insert stretching throughout the workout as an active recovery. It's not necessary to perform every stretch during each of your client's workouts or to lump all 15 or any other stretches into a continuous time frame. Do what works! If your client likes interspersing stretches throughout the workout, then do it. If your client likes the feel of a continuous stretch segment, so be it. But, whatever you do, don't leave stretching out of your client's program!

Encourage your clients to hold the stretches for about 20 to 30 seconds unless you're using AIS or other stretching approaches that have a different protocol. Be certain that any nontraditional approach is supported by scientific evidence that justifies its use. Your client should feel a gentle stretch in the muscle. Avoid stretching the client's musculature and joints to a point of pain. The client should be positioned comfortably and encouraged to ease into each stretch and to breathe naturally. If you can't get the stretch to feel comfortable for your client's unique body type, even after modifying body position, don't use it. Try a variation or use another stretch that targets that same body part.

Stretch 1: Arm Pull-Back

Body Parts Targeted

Front of the shoulders, chest

Muscles Stretched

Anterior deltoid, pectoralis major

Execution of Stretch

Instruct the client: Stand with feet shoulder-width apart, knees bent slightly, and toes pointing straight ahead. Let arms hang relaxed to either side of your body. Expand the chest and pull shoulders back by squeezing shoulder blades toward each other. Slightly

Continued ➤

➤ *Continued*

bend elbows as you clasp your hands behind your back. Slowly straighten your arms as you lift your hands upward with control. Raise your hands until you feel mild tension in the shoulder and chest region. Lower your arms and then bend your elbows and release your hands from one another, with control.

Tips

Don't bend over at the waist; it puts unnecessary stress on your back and doesn't make the stretch more effective. Keep your shoulders pulled back and avoid rounding the shoulders by pinching your shoulder blades together.

Variations

1. Assume a seated position, but don't round your low back.

2. Perform this exercise while lying face down.

3. In either a seated, standing, or prone (lying face down) position, grasp a towel in each hand and lift your arms backward and up.

4. From a standing position, turn your body slightly to your right and place your right hand behind you in contact with a wall or rest it on an object that supports the hand at about shoulder height. Keeping the hand supported or maintaining contact with the wall, slowly turn your upper body left, or away from the right hand. Repeat on the opposite side.

Health and Performance Purpose

This exercise improves flexibility and relieves tightness in the shoulder and chest regions that results from poor daily posture and repetitive sports movements. Sitting at your desk, driving, continually reaching forward, playing tennis and golf, swimming, walking, and running are examples of activity that can lead to rounded shoulders and hunched-over posture. "Opening up the chest" by squeezing the shoulder blades together and pulling the arms back can prevent or reduce neck pain and improve sport performance that is limited by restricted shoulder movement and poor head alignment. Rounded shoulders and a caved-in chest can cause the neck to jut out, which can lead to chronic misalignment and pain.

Stretch 2: Overhead Triceps and Shoulder Stretch

Body Parts Targeted

Back of the shoulders and upper arms, sides of the upper body

Muscles Stretched

Posterior deltoid and triceps, latissimus dorsi

Execution of Stretch

Instruct the client: Stand with feet shoulder-width apart and knees slightly bent. Lift one arm overhead. Bend this elbow, reaching down with the hand toward the opposite shoulder blade. Walk your fingertips down your back as far as you can. Hold this position. Reach up with the opposite arm and grasp your flexed elbow. Gently assist the stretch by pulling on the elbow.

Continued ➤

➤ *Continued*

Technique and Stretch Tips

Pull your shoulder blades slightly toward one another during the stretch and keep your elbow pointed toward the ceiling.

Variations

If you're unable to stretch comfortably as described, use a towel so that you can link your hands. Place the towel in the hand that is reaching overhead, as described. Rather than reach up and in front of your body with your other hand, reach behind your back with that hand until you can grasp the towel that is dangling down from the upper hand. Pull gently on the towel to assist the stretch.

Health and Performance Purpose

This stretch can help improve flexibility and relieve tightness in the shoulder and back regions that results from poor daily posture and repetitive sport movements.

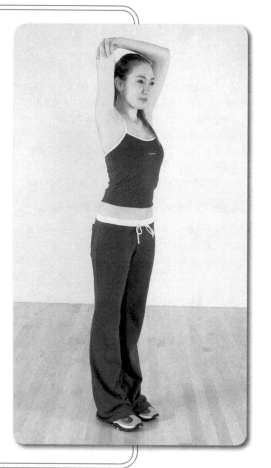

Stretch 3: "Arm-Across" Shoulder Stretch

Body Parts Targeted

Back of the shoulders and upper arms, upper back and sides of the body

Muscles Stretched

Posterior deltoid and triceps, latissimus dorsi

Execution of Stretch

Instruct the client: Stand with your feet a comfortable distance apart, knees slightly bent, and toes pointing forward. Raise the left arm in front of you to shoulder height. Reach across your body with this arm, and use your right hand, coming from below the raised left arm, to grasp just above the left elbow with the opposite hand. As you assist the left arm across the body with your right hand, keep the arm you're stretching parallel to the ground. Repeat on the other side.

Technique and Stretch Tips

Pull the arm slowly across the body until you feel a gentle stretch in the back of the shoulder and upper arm and upper back muscles. Do not rotate your upper body or knees. Instead, keep your shoulders, hips, and knees facing frontward as you pull the arm across. Do not round your low back during the stretch.

Continued ➤

➤ *Continued*

Variations

1. Assume the same starting position and move the arm being stretched forward and up.

2. Assume the same starting position and reach forward with both arms, just below shoulder height. Grasp your left wrist with your right hand. Without rotating your body, pull your left arm out and across toward the right side of your body. You'll feel the stretch through the back of your shoulder and upper arm as well as along the entire left side of the upper body and middle of your back. Repeat on the other side.

Health and Performance Purpose

This stretch can help improve flexibility and relieve tightness in the shoulder, neck, and back regions that results from poor daily posture and repetitive sport movements.

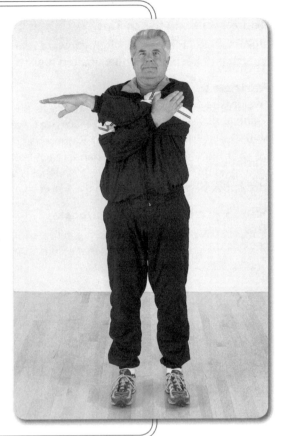

Stretch 4: Arm Press-Down

Body Parts Targeted

Back of the shoulders and upper arms, sides of the body

Muscles Stretched

Posterior deltoid and triceps, latissimus dorsi

Execution of Stretch

Instruct the client: Locate a stable house fixture or piece of equipment that is about hip height. (Examples include stationary bikes, other exercise equipment, and secure stair banisters.) Move your feet about an arm's length from the fixture and stand with your feet at hip width or slightly wider. Your knees should be slightly bent and your toes pointing forward or slightly turned out. Reach forward and place both hands on the

Continued ➤

➤ *Continued*

fixture. Move your hips back and allow your elbows to straighten as you settle into the stretch.

Technique and Stretch Tips

Relax into this stretch by allowing your arms to straighten. You won't get the feeling of a "weightless hang" unless you allow your weight to move back and your arms to straighten. Think about pressing your underarms into the ground and do not round your low back during the stretch. Keep a little tension in your abdominal muscles.

Variation

Use different height fixtures or place your hands higher or lower.

Health and Performance Purpose

This stretch can help improve flexibility and relieve tightness in the shoulder and back regions that results from poor daily posture and repetitive sport movements.

Stretch 5: Arm Press-Down and Inner Thigh Stretch

Body Parts Targeted

Back of the shoulder and upper arm, sides of the body, inner thighs

Muscles Stretched

Posterior deltoid and triceps, latissimus dorsi, adductor (inner thigh) muscles

Execution of Stretch

Instruct the client: The first part of this stretch is the same as stretch 4. Locate a stable house fixture or piece of equipment that is about hip height. (Examples include stationary bikes, other exercise equipment, and secure stair banisters.) Move your feet about an arm's length from the fixture and stand with your feet at hip width or slightly wider. Your knees are slightly bent and your toes are pointing forward or slightly turned out. Reach forward and place both hands on the fixture. Move your hips back and allow your elbows to straighten as you settle into the stretch.

To stretch the inner thighs, slowly shift your hips from this starting, centered position, toward and over your right foot. The right knee may bend slightly and you'll feel the stretch in your left inner thigh (keep this leg straight). Move back through center position, pause for a moment, and then move your hips over the other foot.

Technique and Stretch Tips

You won't get the feeling of a weightless hang unless you allow your weight to move back and your arms to straighten. Think about pressing your underarms into the ground and

Continued ➤

➤ *Continued*

do not round your low back during the stretch. As you move side to side to stretch the inner thighs, keep the movement controlled and minimize any bending of the knees.

Variation

Keep it simple on this one. The best height to stretch the inner thighs is about hip height, so there are no variations for this exercise.

Health and Performance Purpose

This dynamic stretch can help improve flexibility and relieve tightness in the shoulder and back regions that results from poor daily posture and repetitive sports movements. This stretch also allows you to stretch the inner thighs without doing a higher risk, side-to-side, deep-lunge movement.

Stretch 6: Outer Hip Push-Away

Body Parts Targeted

Sides of the hips (outer hip)

Muscles Stretched

Gluteus medius and minimus (hip abductor muscles), tensor fascia latae

Execution of Stretch

Instruct the client: Locate a stable house fixture or piece of equipment that is about hip height. (Examples include stationary bikes, spotting racks, and secure stair banisters.) Stand next to the fixture with your feet at hip width or narrower. Your knees are straight, but not locked, and toes are pointing forward. Reach to the side with your inside hand (closest to the fixture) and grasp the fixture. Take your outside hand and place it on the fixture, to the outside of the other hand. Bend your inside knee slightly and push your opposite hip directly out to the side, away from the fixture. The weight of your body is on the outside leg. Repeat this on the other side.

Technique and Stretch Tips

Keep your feet close to the fixture and about hip-width apart. Form a C-curve with the side of the body that is closest to the fixture. Keep the knee of the hip being stretched fairly straight and the weight of the body on this outside leg.

Variations

1. After getting into the push-away position as described previously, to intensify the stretch, open (turn) your hip that is being stretched away from the center of your body.

2. After getting into the push-away position, to intensify the stretch, take your inside leg (nearest the fixture) and cross it in front of the leg (hip) being stretched. Bear most of your weight on the hip being stretched. Contact the tip of the toe of the non-weight-bearing leg (the inside leg you crossed in front) on the floor for balance.

Continued ➤

3. Combine variations 1 and 2.

4. This stretch can easily be performed from a standing position without the use of a stabilizing fixture. Simply stand with your feet close together, bend one knee slightly, and shift your hips to one side, extending one hip out past the ankle until you feel a gentle stretch in the outer hip (hip abductor muscles). Repeat on the other side.

Health and Performance Purpose

This stretch can improve flexibility and relieve tightness in the sides of the hip and outer thigh that results from poor daily posture and repetitive sports movements that require limited range of motion (like walking, running, and cycling). This stretch also can help reduce the likelihood of an overuse injury. The hip push-away stretches the iliotibial band of fascia of the tensor fascia latae muscle. A tight iliotibial band can lead to overuse injuries at the hip and outer (lateral) knee. If you've had hip replacement surgery, get a doctor's approval before using this stretch.

115

Stretch 7: Quadriceps and Hip Flexor Stretch

Body Parts Targeted

Front of the thigh and hip

Muscles Stretched

Quadriceps and hip flexors (rectus femoris, iliacus, psoas)

Execution of Stretch

Instruct the client: Stand close to a bench, chair, wall, or other solid object. Assist your balance with one hand. Bend one knee and lift your heel toward the buttocks. Reach back with your same side hand and grasp the top of your foot. Keeping the inner thighs close together, slowly pull your heel toward your buttocks until you feel a gentle stretch in the front of your thigh (quadriceps muscle). To stretch your hip flexors, draw your leg back (extend the hip) by tightening the buttocks muscle. Then tighten your abdominals and attempt to roll your hips under you. This technique creates more stretch in the front of the hip (hip flexors). Repeat with your other leg.

Technique and Stretch Tips

Contract your abdominal muscles to avoid arching your low back during the first part of this stretch. Keep your kneecap pointing straight down and oriented to the floor during the stretch. Be sure that your knees are close to one another. If you allow the knee of the leg being stretched to move outward, this puts stress on the medial (inside) ligaments of the knee. Always use the same-side hand to pull the heel toward the buttocks. This avoids lateral (side-to-side) stress to the knee. The knee is a hinge joint and can be injured more easily when lateral forces are applied. An effective quad and hip flexor stretch does not mean that the heel must contact your buttocks. The goal is to stretch muscle tissue, not touch your buttocks with your heel!

Continued ➤

➤ *Continued*

Variations

1. Try this stretch lying on your side or face down. The technique does not change, but this is a more stable position.

2. Emphasize grasping the top of the foot and pulling the bottom of the foot toward the buttocks. This will give you a good stretch in the front of the lower leg (shin).

Health and Performance Purpose

This stretch can improve flexibility and relieve tightness in the front of the thigh and hip that results from poor daily posture and repetitive sport movements that require limited range of motion (such as walking, running, and cycling).

Stretch 8: Standing Hip Flexor Stretch

Body Parts Targeted

Front of the thigh and hip

Muscles Stretched

Hip flexors and, to some degree, quadriceps

Execution of Stretch

Instruct the client: Stand to the side of a chair, wall, or other solid object and assist your balance with one hand. Position your feet so that one foot is in front of the other, or astride. The feet should be placed hip-width apart. Keep your head, shoulders, and hips aligned over one another, and keep your chest lifted by slightly pulling your shoulder blades together. Move your hips forward and bend your front leg without changing your foot position; roll your hips under you without flattening your low back by slightly tightening your abdominals until you feel mild tension in the front of your back leg. Repeat with your other leg.

Technique and Stretch Tips

Maintain an upright posture. Do not bend over from the waist, and it isn't necessary to keep your back leg straight. Once you've assumed an astride stance, one foot in front of the other, keep your feet about hip-width apart. This will help you remain balanced. Bend your front knee as you move your hips forward into the stretch. Avoid arching your back by keeping your abdominal muscles contracted. Tightening your abs will also help stretch the front of the hip.

Variation

Stand upright and perform the stretch described previously without balance assistance.

Health and Performance Purpose

This stretch can improve flexibility and relieve tightness in the front of the thigh and hip that results from poor daily posture and repetitive sports movements. The hip flexors also tend to be very tight because of prolonged and frequent sitting, which is a workplace reality for many people. Tight hip flexors can cause the pelvis to shift forward, creating a chronic arch (swayback) in the low back. This can lead to low back pain and discomfort.

Stretch 9: Standing Hamstrings Stretch

Body Parts Targeted

Back of the thigh

Muscles Stretched

Hamstrings

Execution of Stretch

Instruct the client: Stand on a level surface and extend one leg in front of you. Keep the bottom of the foot in contact with the ground. With your hands resting lightly on the front of your thighs, bend your back knee and lean forward slightly until you feel a stretch in the back of the thigh (hamstrings muscle). Be sure to "hinge" from your hip joint rather than bending (rounding) at your waist or spine. As you lean forward with the upper body, feel as if you are sitting back into an invisible chair. Repeat with your other leg.

Technique and Stretch Tips

When you lean from your hip, place your hands above the knee that is extended in front of you or place one hand on the other thigh. This will prevent you from putting unnecessary pressure on the knee. Do not round at the waist as you lean forward. Hinge from the hip. Once you've assumed an astride stance, one foot in front of the other, keep your feet about hip-width apart. This will help your balance.

Variations

1. Perform the stretch described previously with your front leg placed on an elevated surface. For example, use a table, step, park bench, or chair that is not higher than a foot or two. Point the toe of this elevated leg.

2. To stretch the calf, perform the stretch as described, but instead of keeping the foot in front flat (pointed), pull the toe toward you by using the muscles in the front of your shin. Then, lean slowly forward with the torso. You'll feel the difference. Be sure to stretch the other calf, too.

Health and Performance Purpose

This stretch can help improve flexibility and relieve tightness in the back of the thigh that results from poor daily posture and repetitive sports movements. The hamstrings can become tight if you sit a lot, especially with a rounded low back. Not only is this poor posture stressful to your spinal disks and ligaments, but it can also lead to a chronically flexed or rounded low back posture. This flat-back posture, combined with tight hip flexors and extensors, can lead to limited pelvic movement. This in turn can result in low back pain and discomfort.

Stretch 10: Standing Gluteal Stretch

Body Parts Targeted

Buttocks and outer hip

Muscles Stretched

Gluteus maximus (primarily)

Execution of Stretch

Instruct the client: The setup of this stretch is similar to stretches 4 and 5. Locate a stable house fixture or piece of equipment that is about hip height. (Examples include stationary bikes, other equipment, and secure stair banisters.) Move your feet about an arm's length from the fixture and stand with your feet at hip width or slightly wider. Reach forward and place both hands on the fixture.

Now, move one foot slightly forward and toward the center of your body, toes pointing forward. Lift the other leg off the ground by bending your knee and rotating your thigh outward. Place the ankle of the rotated and lifted leg just above the knee of the support leg. (This forms the figure 4.) Move your hips back and bend the knee of the leg you're standing on. Allow your elbows to straighten as you settle into the stretch. Repeat on the other leg.

Technique and Stretch Tips

Relax into this stretch by allowing your arms to straighten. You won't get the feeling of a "weightless hang" unless you allow your weight to move back and your arms to straighten. Think about pressing your underarms into the ground and do not round your low back during the stretch. Bend the knee of the support leg only as deep as is comfortable.

Variations

1. Increase the stretch by rotating your thigh open more, without assistance (active stretch).

2. Increase the stretch by rotating your thigh open more with the assistance of your same-side hand (passive stretch).

3. Increase the stretch by bending the knee of the support leg deeper. (The thigh should go no deeper than about parallel to the floor.)

Health and Performance Purpose

This stretch can improve flexibility and relieve tightness in the outer hip and buttock regions that results from poor daily posture and repetitive sport movements like those in running, cycling, and walking. These muscles can become tight if you don't stretch them regularly, which can lead to overuse injuries.

Stretch 11: Standing Calf Stretch

Body Parts Targeted

Back of the lower leg (calves)

Muscles Stretched

Gastrocnemius and soleus

Execution of Stretch

Instruct the client: Stand approximately one arm length away from a chair (or wall or tree). Move one foot in close to the chair while extending the other leg behind you. Keep your feet about hip-width apart. With the leg closest to the chair bent and your back leg straight, place your hands on the chair. Keep the back heel on the ground with the knee straight and move your hips forward. The toes of both feet remain pointed forward. Slowly lean forward from the ankle, keeping your back straight, until you feel a stretch in the calf muscles. Repeat with your other leg.

Technique and Stretch Tips

"Lean" forward from your ankles and not your waist, as you shift your hips forward. This is called a straight-body lean. The ears, shoulders, hips, and support leg ankle are aligned. Keep the back heel on the ground and the back leg straight. Keep your feet shoulder-distance apart to assist balance.

Variations

1. Try the same stretch without balance assistance. Stand upright, step forward, and place your hands on the thigh of your front leg.

2. Perform the stretch but bend the back leg to target the stretch in the soleus muscle.

3. See stretch 9, second variation.

Health and Performance Purpose

This stretch can improve flexibility and relieve tightness in the lower leg. The calves can become tight as a result of wearing high heels, walking, running, cycling, and standing for long periods of time. These postural muscles become tight if you don't stretch them regularly, and this can lead to overuse injuries.

Stretch 12: Tibialis Anterior Stretch

Body Parts Targeted

Front of the lower leg (anterior compartment muscles including tibialis anterior). Note: Although this commonly is referred to as a "shin stretch," you cannot stretch the "shin." However, this stretch does effectively target the muscles located on the front of the lower leg.

Muscles Stretched

Tibialis anterior (primary) or anterior compartment group

Execution of Stretch

Instruct the client: Stand to the side of a chair, wall, or other solid object and assist your balance with one hand. One foot is in front of the other or astride. Keep your head, shoulders, and hips aligned and keep your chest lifted by slightly pulling your shoulder blades together. Now, place all of your weight on the forward leg. Point the toe of your back leg and place your toe or shoelaces in contact with the ground. Gently press the top of the foot (shoelaces) and ankle into the ground as your front leg bends. Move your hips forward without changing your foot position until you feel mild tension in the front of your shin. Repeat with the other leg.

Technique and Stretch Tips

Maintain an upright posture. Do not bend over from the waist. Once you've assumed an astride stance, keep your feet about hip-width apart to help your balance. Avoid arching your back by keeping your abdominal muscles contracted. Imagine you are pressing the back leg ankle and top of the foot into the ground and simultaneously pulling them forward. (The back foot does not actually travel forward, but envision this to help you effectively stretch.) Repeat with the other leg.

Variations

1. Stand upright with an astride stance and perform the stretch without balance assistance.

2. Crossovers. Stand upright and cross the right foot over the left foot. Place the right foot so it's just outside the left ankle, and the shoelaces of the right shoe are facing toward the ground (the bottom of the right foot should not be in contact with the ground). Gently press the left shin area into the back of the lower leg (calf) until mild tension is felt in the right shin area. Hold and repeat on the other side.

Health and Performance Purpose

This stretch improves flexibility and relieves tightness in the front of the lower leg that results from repetitive movements. These muscles are required to lift the toe, especially during walking, so that the foot clears the ground and you don't stumble. The muscles in the shin area can become tight if you don't stretch them regularly and can contribute to overuse injuries (e.g., "shin splints") and poor performance.

Stretch 13: Back Curl Stretch

Body Parts Targeted

Low back (lumbar region)

Muscles Stretched

Erector spinae and quadratus lumborum

Execution of Stretch

Instruct the client: Kneel on all fours with your hands directly below your shoulders and knees positioned below your hips. Keep your neck straight (neither lifted nor dropped). Gently pull your shoulder blades toward one another. Your low back is neither flat nor extremely arched (neutral position). Now, tighten your abdominals and roll your hips under you. Hold this rounded low back position for a moment and return to your starting, or neutral, position.

Technique and Stretch Tips

Don't round your upper back. Keep your shoulder blades pulled together during the entire stretch. The only movement occurs between your ribs and the top of your hips.

Variations

1. Lie on your back with your head and feet in contact with the ground and your knees bent. Pull one knee toward the chest, hold the stretch, and lower your leg. Repeat with the other leg.

2. Lie on your back with your head and feet in contact with the ground and your knees bent. Pull both knees toward the chest. Pause and hold the stretch. Lower one leg, then the other. (Lowering both legs simultaneously can strain the low back.)

3. Combine this stretch with stretch 14. This combination creates an excellent pelvic mobility exercise and strengthens the abs and back.

Health and Performance Purpose

This stretch can improve flexibility and relieve tightness in the low back that can result from continual contraction or shortening of these postural muscles. This stretch also can help relax your back muscles and is a great abdominal strengthener. If your back is excessively arched, strong abdominals can control the degree of arch.

Rarely, in today's workplace where hours are spent at a desk or computer, is the low back area tight. Instead, these muscles are usually overstretched! More often than not, the low back muscles need to be strengthened rather than stretched. To avoid overstretching these muscles and hurting your spine, maintain a slight, natural curve in your low back when you sit, stand, and move. Don't let your low back round for extended periods of time.

Stretch 14: Back Arch (or Extension) Stretch

Body Parts Targeted

Abdominals (front of trunk between the ribs and top of the hip)

Muscles Stretched

Abdominals (rectus abdominis and obliques)

Execution of Stretch

Instruct the client: Kneel on all fours with your hands directly below your shoulders and knees positioned below your hips. Keep your neck straight (neither lifted nor dropped). Gently pull your shoulder blades toward one another. Your low back is neither flat nor extremely arched (neutral position). Now, tighten your low back muscles and arch your low back (push your belly button toward the floor). Hold this arched low back position and return to your starting, or neutral, position.

Technique and Stretch Tips

Don't round your upper back. Keep your shoulder blades pulled together during the entire stretch. The only movement occurs between your ribs and the top of your hips.

Variation

Combine this stretch with stretch 13. This combination creates an excellent pelvic mobility exercise as well as ab and back strengthener.

Health and Performance Purpose

Probably more important than stretching your abdominals (although it feels good and maintains range of motion), this stretch is the first step in strengthening the low back muscles. As mentioned in stretch 13, the low back muscles more often need to be strengthened rather than stretched. Low back pain or discomfort can result from weak and overstretched spinal muscles, so this exercise is a good way to increase low back muscle endurance. To avoid hurting your spine, maintain a slight, natural curve in your low back when you sit, stand, and move. Don't let your low back fall into an excessively arched position, simply because of poor posture awareness.

Stretch 15: Lateral Head Tilt

Body Parts Targeted

Sides and back of neck

Muscles Stretched

Neck extensors and lateral flexors

Execution of Stretch

Instruct the client: Stand with your feet hip-width apart and knees slightly bent. Let your arms hang relaxed by your sides. Slowly move your right ear toward your right shoulder. Simultaneously press your left hand toward the floor and your left shoulder away from your left ear. Do this slowly, and with control, until you feel mild tension in the left side of your neck, shoulder, and upper back. Hold this position, release the arm that is pressing down, return your head to its starting position, and then repeat the stretch on the other side.

Technique and Stretch Tips

Tilt your head directly to the side, not forward or back. Use control when pressing your shoulder down to intensify the stretch. If you're already getting an adequate stretch after you tilt the neck, omit the shoulder and hand press.

Variations

1. Perform the stretch as described but vary your head position slightly forward, rather than tilting it directly to the side.

2. Head rotations. Rotate your head side to side by looking over one shoulder, then the other. Keep your chin level or parallel to the floor and your hips and shoulders facing forward.

Health and Performance Purpose

This stretch can improve flexibility and relieve tightness and tension in the sides and back of the neck. Tension in this area of the body results from poor daily posture while seated at a desk or driving, for example, and during repetitive sports movements (such as swimming, biking, or in-line skating). If you're head is positioned properly, your neck should be absent of tension, meaning it is neither forward, back, nor tilted to the side. Take stretch breaks regularly when you're on the job or working out, and check your neck posture regularly. (Use a mirror to help you get a feel for this neutral, tension-free position.)

Stretching on the Stability Ball

The following stability ball stretches and variations are especially helpful in complementing traditional stretch postures. This unique stretching tool can help you target areas of your client's body that are often difficult to stretch effectively, including the trunk, hamstrings, quadriceps, and hip flexor musculature.

Stretch 1: Anterior Trunk Stretch—Supine Position

Muscles Stretched

Rectus abdominis, internal and external obliques, hip flexor group (level III), pectoralis major, anterior deltoid, biceps

Joint Actions

Lumbar spinal extension, cervical spinal extension (levels II and III)

Stabilizing Muscle Groups

Abdominals, hips, legs

Base Position

Supine incline

Execution of Stretch (Level I)

Instruct the client: Recline on the ball in a semirecumbent (supine incline) position. The ball will press comfortably into your middle and low back. Rest your feet flat on the floor, about shoulder-distance apart. Flex knees approximately 90 degrees. Place one hand behind your head to support the neck. The other hand may be placed on the floor to assist in balance or may open to the side.

Relax back into the ball, letting your spine extend as you drape over the ball. Hold this passive stretch at the range of motion that is comfortable.

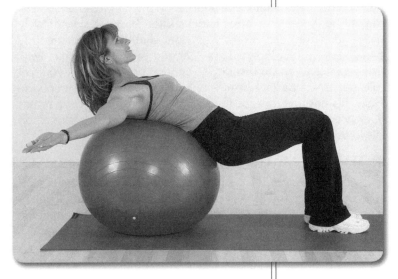

Technique and Cueing Tips

Maintain neutral posture of the cervical spine. If your heels are unable to touch the floor or your knees are excessively flexed, walk your feet forward a little until the feet are flat and the knee angle is closer to 90 degrees.

If the neck becomes fatigued from holding neutral cervical posture, roll slightly forward on the ball, lowering the hips, so that the body is more upright.

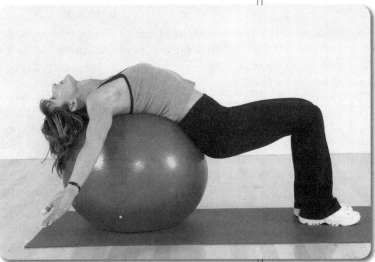

Level II Variation

Begin in the supine incline position described. Place your hands on the floor for balance. Roll forward on the ball, lowering the hips, until you can easily rest the back of the head on the ball. Slowly roll back on the ball, extending the hips slightly more than the level I position (see photo on this page). Your hips will maintain a comfortable degree of flexion. Relax, letting the body drape over the ball with the spine extended. Hold this passive stretch. Hands may remain on the floor for balance or may open to the sides. The back of the head remains on the ball



Continued ➤

Continued ➤

➤ *Continued*

to support the neck in its extended position. The range of motion of this passive stretch may be adjusted by rolling the ball forward or back slightly. Return to starting position by rolling forward on the ball and support the head while returning to neutral position.

This exercise requires more flexibility, balance, and stabilization than the level I variation. For additional balance and stabilization challenge, place the legs in a narrower stance.

Level III Variation

Begin in the supine incline position described previously. Place your hands on the floor for balance. Roll forward on the ball, lowering the hips, until you can easily rest the back of the head on the ball. Slowly roll back on the ball until your hips are fully extended. Relax and let the body drape over the ball with the spine and hips extended. Hold this passive stretch. Hands may open to the sides or reach overhead with the shoulders in a flexed position, palms facing in. The back of the head remains on the ball to support the neck in its extended position. Note that the back and neck are totally supported by the ball, even though this variation requires a greater range of motion.

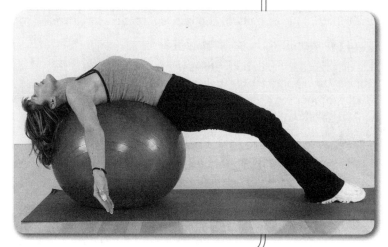

This exercise requires more flexibility, balance, and stabilization than the level II variation. For additional balance and stabilization challenge, place the legs in a narrower stance.

Stretch 2: Rotary Trunk Stretch—Supine on Floor

Primary Muscles Stretched

Lumbar spinal rotators, external and internal obliques; hamstrings, gluteus maximus (level II); latissimus dorsi, posterior deltoid, triceps (long-head), intercostals (level III); general mobility for the trunk and hip

Joint Actions

Trunk rotation; shoulder flexion (level III)

Stabilizing Muscle Groups

Scapular muscles, arms, abdominals, legs

Base Position

Supine with elevated legs

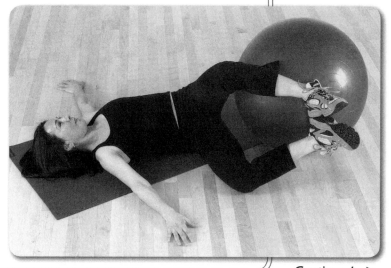

Execution of Stretch (Level I)

Instruct the client: Lie on your back on the floor with your legs and feet resting on the ball. Flex your knees, externally rotate at the hip, and place the soles of your feet close together in a butterfly

Continued ➤

➤ *Continued*

position. Grip the ball lightly between the backs of your thighs and your heels. Place your hands on the floor, palms down, at your sides or slightly below your shoulders.

Slowly roll the ball to one side until the bottom leg touches or is close to the floor. Stop the rotation when the desired amount of stretch is reached. Hold, breathe, and relax into this passive stretch.

Technique and Cueing Tips

Neutral posture of the cervical spine can be maintained, or the head may be turned to the side with the legs if cervical rotation is desired. Attempt to keep both shoulders on or close to the floor. If one shoulder lifts excessively, decrease the rotation in the lower body until this alignment can be maintained. More external hip rotation may decrease the rotary range of motion, and less hip rotation can increase rotary range of motion.

Level II Variation—Scissor Position

Lie on your back with both knees bent and your feet flat on the floor. Rest the ball on the front of your thighs, supporting it with the hands on the sides of the ball. Take one leg and bring it around the ball until the back of that thigh is resting against the ball. You are now gripping the ball in a "scissor" position. The ball is resting against the front of one thigh and the back of the other. Adjust the ball until it feels secure in this scissor position. Then, place your hands on the floor as in the level I variation. Slowly roll to one side until the ball touches or is close to the floor. Stop the rotation when the desired amount of stretch is reached. Hold and relax into this passive stretch.

This stretch requires more flexibility, balance, and stabilization than the level I variation.

Level III Variation—Counterrotated Position

Lie on your back with both knees bent and your feet flat on the floor. Holding the ball in your hands, position the ball so that it is lifted above your chest and head. Slowly lower the legs to one side and simultaneously lower the arms (and ball) to the opposite side. Focus on reaching up and away from the body with the arms and, at the same time, gently press the legs close to the floor. Relax, hold, and breathe with this combination active-passive stretch.

This stretch requires more flexibility, balance, and stabilization than the level I and II variations.

Stretch 3: Hamstrings Stretch—Seated Position

Primary Muscles Stretched

Hamstrings group, gluteus maximus

Joint Actions

Hip flexion, knee extension, anterior pelvic tilt

Stabilizing Muscle Groups

Neck, scapular muscles, arms, abdominals, lumbar spinal extensors, hips, legs

Base Position

Seated

Execution of Stretch (Level I)

Instruct the client: Sit upright on top of the ball with neutral spinal posture. Place your feet flat on the floor, about shoulder-width apart, with minimal weight supported by the feet. Rest your hands lightly on one knee. Place your other leg out in front of you with the knee extended straight but not locked (hyperextended).

Slowly perform an anterior tilt of the pelvis until you feel a gentle stretch in the hamstrings of the extended leg. Breathe and hold this active stretch at a range of motion that is comfortable for you.

Technique and Cueing Tips

As you perform the anterior tilt, visualize rolling the ball back with your "sit bones" (ischial tuberosities). Maintain neutral postural alignment of your cervical spine. Your scapulae should be slightly retracted throughout this stretch. Keep the toes of the extended leg pointing down toward the floor. Pulling the toes toward the shin will cause the gastrocnemius muscle to stretch and may inhibit the hamstrings stretch. (For additional flexibility challenge, add the gastrocnemius stretch.)

Level II Variation

Begin in the seated position with one leg extended as described in level I. Place your hands on your upper thigh. After you perform the anterior pelvic tilt, slowly flex forward at your hips until you feel the desired amount of stretch in the hamstrings. Make sure you hinge at the hips rather than flexing at the spine. Maintain neutral or slightly extended lumbar spinal posture. Hold this combination active-passive stretch at a range of motion that is comfortable.

This stretch requires more flexibility, balance, and stabilization than the level I variation. For additional balance and stabilization challenge, place your legs in a narrower stance.

Stretch 4: Quadriceps and Hip Flexors Stretch—Supine Position

Primary Muscles Stretched

Quadriceps (rectus femoris), hip flexors

Joint Actions

Hip extension, lumbar spinal extension; knee flexion (level II)

Stabilizing Muscle Groups

Scapular muscles, lumbar spinal extensors, obliques, hips, legs

Base Position

Supine with cervical support

Execution of Stretch (Level I)

Instruct the client: Recline on the ball in a semirecumbent (supine incline) position. Take small steps forward, keeping your hips lifted, until the ball is centered under the cervical spine. Your head, neck, shoulders, and upper back are supported on the ball, with the hips, middle back, and low back unsupported. Rest your hands on the floor or on your thighs for more balance challenge.

Lift your hips (by contracting the hamstrings and gluteal muscles) until they are fully extended and your thighs are parallel to the floor. Then extend the spine slightly until you feel a stretch in the front of the hips and thighs. Breathe and hold this active stretch at a range of motion that is comfortable.

Technique and Cueing Tips

Keep your knees flexed approximately 90 degrees. The width of the feet may vary. A narrower stance is more challenging than a shoulder-width or wider stance. Regardless of foot placement, the knees must always stay aligned over the heels. Maintain neutral or slightly extended posture of the lumbar spine.

Level II Variation

Begin in the supine with cervical support position described in level I. Release the hip extension slightly and slide one foot back a few inches toward the ball. Slide the foot only as far as allows you to keep the heel on the floor. This movement will increase the amount of knee flexion on the moving leg. Now extend the hips and lumbar spine as described in level I. You will feel an increased amount of stretch in the quadriceps (especially the rectus femoris) muscles with this variation. For more balance challenge, place your hands on your hips. For less challenge, place your hands on the floor at your sides.

This stretch requires more flexibility, balance, and stabilization than the level I variation.

Stretch 5: Quadriceps and Hip Flexors Stretch— Seated Astride Position

Primary Muscles Stretched

Quadriceps (rectus femoris), hip flexors

Joint Actions

Hip extension; posterior pelvic tilt, knee extension (optional action that pulls the hip into further extension)

Stabilizing Muscle Groups

Neck, scapular muscles, arms, abdominals, lumbar spinal extensors, hips, legs

Base Position

Seated

Execution of Stretch (Level I)

Instruct the client: Sit upright on top of the ball with neutral spinal posture. Place your feet flat on the floor, about shoulder-width apart, with minimal weight supported by the feet.

Place your hands on the ball for balance on either side of one thigh. Then, slowly swing the other leg around to the back of the ball. Support your weight on the front thigh. Extend your back leg as far as is comfortable. Perform a posterior pelvic tilt until you feel a stretch in the front of the hip and thigh. Breathe and hold this combination active-passive stretch at a range of motion that is comfortable.

Technique and Cueing Tips

Maintain neutral posture of the lumbar and cervical spine. Lift up tall through the spine, keeping the shoulders aligned over the hips. The toes of your back leg remain tucked under for balance. To vary the intensity of this stretch, flex or extend (harder) the back knee. Your front knee stays aligned over the heel.

Variation: Seated Lunge Position

Begin in the seated base position described previously in the "astride" lunge setup. Take a small step out diagonally with the front leg. Place both hands on that leg. Rotate your torso toward that leg and extend the opposite leg out behind you with the toes pointed behind you. The top of the foot (and your shoelaces) is pressing and oriented toward the floor. Extend the hip of the back leg as fully as possible. Perform a posterior pelvic tilt by contracting the abdominal muscles. Adjust the intensity of the stretch by flexing (making easier) or extending the back knee. Relax and hold this combination active-passive stretch at a range of motion that is comfortable.

Flexibility: Suggested Reading

If you'd like to read more than the works cited in this chapter, check out these resources:

Alter, M.J. 1990. *Sport Stretch*. Champaign, IL: Human Kinetics.

Anderson, P. 1999. "Active-Isolated Stretching." *IDEA Personal Trainer* (July-Aug.): 31-40.

Brooks, D., and C. Copeland. 1997. *Total Stretch on the Ball: Flexibility Training Using a Stability Ball*. Mammoth Lakes, CA: Moves International.

Corbin, C.V., and L. Noble. 1980. "Flexibility: A Major Component of Physical Fitness." *Journal of Physical Education and Recreation* 51 (6): 23-24, 57-60.

DeVries, H.A. 1961. Electromyographic observations of the effects of static stretching upon muscular distress. *Research Quarterly for Exercise and Sport* 32: 468-79.

Hardy, L., and D. Jones. 1986. "Dynamic Flexibility and Proprioceptive Neuromuscular Facilitation." *Research Quarterly* 57: 105-53.

Hartley O'Brien, S.J. 1980. "Six Mobilization Exercises for Active Range of Hip Flexion." *Research Quarterly* 51 (4): 625-35.

Holland, G.J. 1968. "The Physiology of Flexibility: A Review of the Literature." *Kinesiology Review I*: 49-62.

Kravitz, L., and D. Kosich. 1993. "Flexibility: A Comprehensive Research Review and Program Design Guide." *IDEA Today* (June): 42-9.

McAtee, R. 1993. *Facilitated Stretching*. Champaign, IL: Human Kinetics.

Plowman, S. 1992. "Physical Activity, Physical Fitness and Low Back Pain." *Exercise and Sport Sciences Reviews* 20: 221-42.

Safran, M.R., A.V. Seaber, and W.E. Garrett. 1988. "The Role of Warm-Up in Muscular Injury Prevention." *American Journal of Sports Medicine* 16 (2): 123-29.

Sapega, A.A., T.C. Quedenfeld, R.A. Moyer, and R.A. Butler. 1981. "Biophysical Factors in Range of Motion Exercise." *The Physician and Sportsmedicine* 9 (12): 57-64.

Siff, M.C. 1990. *The Science of Flexibility and Stretching*. Johannesburg, South Africa: School of Mechanical Engineering, University of Witwatersrand.

Smith, B. 1993. *Advanced Fitness Teacher's Manual*. Loughborough, UK: Ludoe.

Spirduso, W. 1995. *Physical Dimensions of Aging*. Champaign, IL: Human Kinetics.

Voss D., M. Ionta, and B. Myers. 1985. *Proprioceptive Neuromuscular Facilitation: Patterns and Techniques*. 3rd ed. Philadelphia: Harper & Row.

Wallin, D., B. Ekblom, R. Grahn, and T. Nordenberg. 1985. "Improvement of Muscle Flexibility: A Comparison Between Two Techniques." *American Journal of Sports Medicine* 13: 263-68.

Fueling Your Clients: Before, During, and After Workouts

Resting Metabolic Rate

Are your clients not getting the performance results or the physical changes they want—like fat loss and muscle gain? Do your clients feel a little "flat" or burned out? If some are saying yes, and you're incorporating all the right workout elements in your clients' programs, they may not be fueling their bodies correctly.

Eating for Exercise

Eating for exercise is not a whole lot different than eating for personal health and well-being. To be sure, there are a few tricks to fueling your client before, during, and after exercise, but the foundational part of his diet (which should be low fat) should not change, whether the client's goal is to feel better, lose weight, or improve health or performance.

Too many athletes and recreational exercisers take their nutritional regimens to unhealthy and unsafe extremes. There is a smart approach to timing the ingestion and quantity (ratio of carbohydrates, fats, and protein) of nutrients based on science and what is known to work with the body's nutritional needs.

If your client is not seeing the training results he wants, fueling the body incorrectly might be the culprit. Food works! It is not the enemy.

Computing Your Client's Daily Calorie Requirements

Do you guess at or even disregard the number of calories your client is eating every day?

Although your client should not be obsessive with calorie counting, it helps to establish a level of calorie intake that covers base calorie or daily intake requirements. Following are two easy ways to determine your client's calorie needs.

Estimating Daily Calorie Requirement Using RMR

The following four steps can help you estimate your client's daily calorie requirement.

1. Determine your client's resting metabolic rate (RMR) by multiplying body weight by 10.

Current body weight × 10 = RMR

RMR is the number of calories it takes to keep the body humming along all day long. RMR can use as many as 75 percent of the calories your client burns in a day to simply maintain bodily functions like producing new skin cells, breathing, making new red blood cells, and keeping the heart pumping! If your client weighs 155 pounds, this is how it works:

155 × 10 = 1,550 = RMR

115

2. Estimate how many calories your client needs for formal (scheduled and planned) exercise each day.

Estimate physical activity energy expenditure by using the following calorie assignments. For an activity that you would consider easy or low level, assign 3 to 5 calories per minute. Give a moderate level activity 6 to 10 calories per minute. If your client is working hard, she gets 11 to 15 calories per minute. If your client has reached a level that could be categorized as "super intensity," this effort rates 16 to 20

/min

calories per minute. (A world-class marathoner or Nordic skier can reach energy expenditures approaching 20 calories per minute! That's Olympic intensity!)

Take the calories per minute assigned for a particular activity (based on the subjective number previously suggested) and multiply it by the number of minutes your client spent exercising. (Rest between strength sets doesn't count. Count only those minutes that are spent active and that are above resting or recovery levels.) Most people overestimate the amount and intensity of activity in which they participate and underreport the amount of food they eat. Estimating how many calories are needed for formal activity can help your clients come up with a very rough estimate of the total calories they expend for a given activity.

Let's say one of your clients participated in a normal, 30-minute strength training session. Thirty minutes × six calories per minute, or 180 total calories, is a good guesstimate. If the client also ran a 10-minute mile (six miles per hour) for 30 minutes, a moderate pace, the client nets about 10 calories per minute, or approximately 300 calories expended. Total formal activity calories for the day: 480.

Formula for Estimating Activity Energy Expenditure:

Calories per minute (for each given activity) × number of minutes spent exercising for each activity = formal exercise energy expenditure.

Many factors influence overall energy requirements of your client's body. Resting metabolic rate and physical activity account for the majority of total energy expenditure during a given day. Activity level, age, sex, size, weight, and body composition influence the remaining daily energy expenditure. To calculate exact daily caloric expenditure is beyond the capabilities of most science labs, let alone most personal trainers!

It is possible to estimate RMR and formal exercise energy requirements to give you a framework from which to formulate how many calories your client should consume daily. If the numbers don't work (your client gains fat weight and she's trying to lose fat), you need to adjust her activity level or food intake, because it becomes apparent the estimates were not accurate. You may need to fine-tune the gross estimate to serve your client's exercising needs and accomplish her health and fitness goals. Table 21.1 gives an approximate rate of calories burned for activities of varying intensity.

3. Next, determine how many calories your client uses for daily activity that is separate from scheduled or "formal" exercise:

- If your client is sedentary, add 20 to 40 percent of the calculated RMR (found in step 1).
- If your client is moderately active, add 40 to 60 percent of the RMR.
- If your client is very active, add 60 to 80 percent of the RMR.

Let's say your client is on the high end of being moderately active:

60 percent × 1,550 RMR = your client's daily activity calories

0.6 × 1,550 RMR = 930 daily activity calories

4. Add the answers from steps 1, 2, and 3 to compute a day's total calorie requirement:

1,550 RMR calories + 480 formal exercise calories + 930 daily activity calories = 2,960 calorie requirement per day

Steps 1, 3, and 4 are from Clark (1997, p. 261).

The following worksheet (form 21.1) can be used to estimate your client's daily calorie requirement.

TABLE 21.1 Physical Activity Energy Expenditure

Level of intensity	Examples	Calories per minute
Low or easy	Weight training	6-10
Moderate	Jumping rope Jogging	11-15
High or difficult	Sprinting Fast rowing	16-20

Reprinted from Brooks (1999).

F O R M **21.1 Worksheet for Estimating Your Client's Daily Calorie Requirement**

1. Determine your client's RMR:

 _____ (current body weight) × 10 = _____ (RMR)

2. Estimate how many calories your client expends participating in formal, scheduled, or planned exercise each day:

 Calories per minute (for each given activity) × number of minutes spent exercising for each activity = formal exercise energy expenditure

 _____ (calories per minute) × _____ (number of minutes exercising) = _____ (formal exercise energy expenditure)

 _____ (calories per minute) × _____ (number of minutes exercising) = _____ (formal exercise energy expenditure)

 _____ (calories per minute) × _____ (number of minutes exercising) = _____ (formal exercise energy expenditure)

 To find total calories used for formal exercise, use this formula to calculate each formal exercise your client participates in (e.g., cardiovascular, strength training).

3. Determine how many calories your client uses for daily activity that is separate from scheduled or formal exercise:
 - If your client is sedentary, add 20 to 40 percent of the client's RMR (found in step 1).
 - If your client is active, add 40 to 60 percent of the client's RMR.
 - If your client is very active, add 60 to 80 percent of the client's RMR.

 _____ (percentage) × _____ (RMR) = _____ (daily activity calories)

4. Add the answers from steps 1, 2, and 3 to compute this day's total calorie requirements:

 _____ (RMR) + _____ (formal exercise calories) + _____ (daily activity calories) = _____
 (calorie requirement for the day) (1/7) 118

Estimate Your Client's Daily Caloric Range by Using Lean Body Mass

To use this technique you must know your client's body fat percentage, which will allow you to calculate his lean body weight (LBW).

1. Multiply your client's body weight by his body fat percentage to get body fat weight.

Body weight × body fat percentage = body fat weight.

Let's say your client weighs 155 pounds and his body fat percentage is 20.

155 × 0.20 = 31 pounds of body fat

2. Next, determine your client's lean body weight (LBW).

Body weight – body fat weight = LBW

155 pounds – 31 pounds = 124 pounds of lean body weight (LBW)

3. Once you have calculated LBW, multiply by 16 to get the lower number in your client's daily caloric range.

124 × 16 = 1,984 calories

4. Compute the upper number of the daily caloric range by adding 500 calories.

1,984 calories + 500 = 2,484 calories

Daily caloric range: 1,984-2,484 calories

Note that the preceding calculation, when compared with the first technique (about 2,960 daily calories required), is about 500 to 1,000

calories different, depending on whether you choose to use the high or low end of the range. This difference stands even though both techniques for estimating daily calorie requirements used a person weighing 155 pounds. The first technique takes into account more variables (exercise, daily activity level) and may be a more accurate predictor of total daily caloric needs for very active people. Form 21.2 can be used to help estimate your client's daily caloric range.

Now that you've computed your client's daily calorie requirements by using one of two methods, heed this good advice: Use common sense in adhering to these estimates! Consider these predictions for what they are—educated guesses and general guides that can help you "ballpark" your client's daily calorie needs. You may need to fine-tune this number as your client's activities change or you find he's not getting the results he wants.

The number of calories your client should be eating daily is not the whole story. (I'll talk about the correct percentage of carbohydrate, fat, and protein later to help you create a balanced diet for your client.) But, you also should help your client to understand how to determine correct food portion size and read food labels. This will greatly affect the quantity and quality of food that he ingests.

Identifying Correct Food Portion Size

Not everyone can eat their cereal out of a "trough" like the legendary Ironman triathlete Dave Scott and still maintain performance and weight. (Dave probably expended about 5,000-6,000 calories per day in training.) I often use a food scale with my clients to drive home the issue of portion control. It is not a shock to me that a majority of my clients vastly underestimate the amount of food they eat. For example, many of my clients thought an acceptable serving from the fish, poultry, or meat group was anything set in front of them. Not so—a 16-ounce steak is over five times the recommended three-ounce serving! I have asked clients to pour three to four ounces of cereal in a bowl, and to their amazement the scale reveals six to eight ounces.

By using the food scale, your clients can quickly learn to judge serving sizes accurately. Seeing what an ounce of cereal or three ounces of lean meat actually looks like is a very powerful teaching tool. This approach has helped many of my clients who have struggled not so much with poor food choices but with simply

F O R M **21.2** **Worksheet for Estimating Your Client's Daily Caloric Range by Using Lean Body Mass**

1. Calculate body fat weight by using your client's known body fat percentage.

 _____ (body weight [pounds]) × _____ (body fat percentage) = _____ (body fat weight [pounds])

2. Determine your client's LBW.

 _____ (body weight) − _____ (body fat weight) = _____ (LBW)

3. Multiply LBW by 16 to determine the lower number in your client's daily caloric range.

 _____ (LBW) × 16 = _____ (lower number in daily caloric range)

4. Compute the upper number of the daily caloric range by adding 500 calories.

 _____ (lower number in caloric range) + 500 calories = _____ (upper number caloric range)

5. Your client's daily calorie range is _____ (result from step 3, lower number in daily caloric range) to _____ (result from step 4, upper number in daily caloric range).

Reprinted from D. Brooks 1999.

From *The Complete Book of Personal Training*, by Douglas S. Brooks, 2004, Champaign, IL: Human Kinetics.

consuming too much food. My clients jokingly refer to this syndrome as, "Too much of a good thing." Once your client gets the picture, she can stop using the scale, or at least weigh food less often, because she has a visual frame of reference.

Realize that if your client borders on undereating, too small portions can jeopardize her health, performance, and weight management goals. Eating too few calories can lead to fatigue, poor performance and, in extreme cases, eating disorders. If you think this situation applies to a client, contact a registered (licensed) dietitian and discuss your client's situation without sharing his or her identity.

Helping Your Clients Learn How to Read Food Labels

Although the food labels we see on foods produced in the United States and internationally are not as useful and easy to understand as they could be, they still can help your clients assess the food they are buying (figure 21.1). Labels can help your clients become more aware of fat intake, quickly see food portion or serving size, and identify what kinds of nutrients are present in the serving. Following is a description of the elements of the labels.

Serving Size

Serving size (see 1 on the Nutrition Facts food label, figure 21.1) helps clients estimate total caloric intake and keep track of the number of servings of a particular food group. As mentioned earlier, a food scale is an effective teaching tool to learn serving size. Actually seeing a serving size on a scale will help your client understand, for example, what a one-ounce serving looks like. This will help the client accurately estimate appropriate portion or serving sizes.

Percent Daily Value

The percent daily value column (see 2, figure 21.1) tells your client how much of the day's worth of fat, cholesterol, sodium, carbohydrates, dietary fiber, and sugars the food provides. If a food contains 20 percent or more of the daily value, whether fat or carbohydrate, it could be considered "high" in that nutrient. "Low" is probably no more than 5 percent.

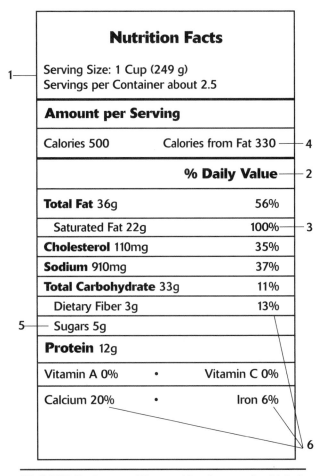

FIGURE 21.1　The nutrition facts on food labels inform consumers of recommended serving sizes and daily values and the amount of fats, sugars, calories, and vitamins and minerals in commercial products.

Saturated Fat

Because saturated fat (see 3, figure 21.1) probably causes the most damage to your client's health, this particular percentage of the daily value must be monitored. (Trans fat or hydrogenated oil, which is just as damaging, will be listed on food labels by January 2006. If hydrogenated oil is the first item listed in the food product's ingredients, that food is loaded with trans fat.)

Calories From Fat

Calories from fat (4, figure 21.1) help your clients quickly see how much fat is in each serving of this particular food. In this example, 330 calories of each 500-calorie serving is from fat. If you divide 330 by 550, you can calculate that 60 percent of each serving is fat! Many experts recommend a daily fat intake of no more than

20 percent of total daily calories. This does not mean that your client shouldn't eat this food, because it's only part of the total daily calories, but it must be balanced with overall daily intake.

Sugar

The FDA has not set a daily value for sugar (5, figure 21.1) because health experts have not yet set a limit on how much should be eaten daily. Furthermore, this number is not very accurate because it does not contain all types of sugars. Your clients should limit intake of simple sugars whenever possible.

Percent Daily Values of Healthier Nutrients

The percent daily values (6, figure 21.1) are based on a daily intake of 2,000 calories. This is very interesting because it allows your client to compare the percentage daily value for healthier nutrients (vitamins A and C, minerals calcium and iron, and dietary fiber) against fat, sodium, and cholesterol.

The typical diet is high in sodium, cholesterol, saturated fat, and total calories. It is well documented that this type of diet greatly increases the risk of heart disease, stroke, diabetes, and some cancers. Moreover, a high fat intake will certainly not complement athletic performance. An aggressive recommendation (for optimal health) is to limit fat intake to about 40 to 50 grams of fat per day. I have found that many of my clients find it easier to concentrate solely on fat gram intake versus the myriad of other diet variables, when their focus is weight loss and personal health. Athletes who train hard need to prioritize carbohydrate intake, too. Daily sodium intake should be kept below 2,000 mg.

Without a doubt, the information on food labels can be used to help your client improve food selection and overall health.

Helping Your Clients Know What Diet to Follow

Not all diets are bad. Do your clients understand what a low-fat diet is? Low fat doesn't mean an extremist approach of no fat. Nor does it characterize a diet where clients can eat unlimited quantities as long as they cut the fat. A low-fat diet is a balanced diet with a variety of healthful food choices, including veggies, fruit, and other low-fat choices.

The low-fat premise is simple. Cut down the fat in the diet and replace it with healthier food choices. Clients who follow a low-fat approach can more easily cut calories, lose weight, decrease their risk for a host of illnesses (like heart disease and diabetes), improve performance, and feel better.

When I advise my clients regarding proper and basic nutrition, I let them know that low-fat eating is the basis of a healthy diet. Overwhelmingly, the bulk of scientific literature supports this view. Refer to chapter 22 for more information.

The Right Ratio of Carbohydrate, Fat, and Protein

Teach your clients about the composition of their training diet. Most sport nutritionists (that's qualified and licensed registered dietitians or RDs, not self-proclaimed "experts") recommend a daily training diet of about 60 to 65 percent carbohydrate, 20 to 25 percent fat, and 15 percent protein intake. (Your client will take in more fat than she thinks because it's hidden in many foods, so have her shoot for the lower number—it's good for her heart.)

If your client is training hard, she should probably bump her carbohydrate intake up to 70 percent before an event (especially if it's an endurance event) or as her training dictates (e.g., if she doesn't fully recover between workouts and can't shake fatigue). To easily up your client's carbohydrate intake, limit fat intake and increase consumption of starches, grains, and fruits (don't overload on simple sugars, whether they come from fruit, juices, or candy). Adequate carbohydrate intake will determine your client's performance and how she feels.

The best way—without sorting through a host of baffling, esoteric, and contradictory opinions—to determine the amount of carbohydrate, fat, and protein a client should place in her diet is to (1) determine ideal daily caloric intake, which is based on total energy expenditure (RMR, formal activity calories, and normal daily activity calories), using one of two

methods described earlier in this chapter, and (2) calculate carbohydrate (multiply by 60-65 percent), fat (multiply by 20-25 percent), and protein (multiply by 15 percent) needs. (See table 21.2 for an example.) Get your clients focused on ingesting enough carbohydrates, without going "carbohydrate crazy" or believing fat is the enemy. If your client loads her diet with starches, grains, cereals, pasta, and fruits, she can concentrate more easily on limiting the fat in her diet.

Have your client use the label-reading skills discussed earlier in this chapter to help him gauge the amount (grams) of each nutrient he is putting into his body daily. Initially, the client can track, calculate, and record this nutritional information by writing it down. Soon, your client will become an expert at estimating values and will develop an intuition for selecting the right balance of foods each day. Let your client know that he will not be tied to recording eating behavior forever, although if he likes the exactness and accountability of recording nutritional intake, the client should keep doing it. Even if you believe your client has the process down perfectly and is seeing the results he wants, it's still a good idea to have him periodically jot down calorie intake and calculate the percentages of carbohydrate, fat, and protein, just to make sure he's on track.

Protein Sources

Your client's protein requirements can be met by eating two to three servings of protein-rich foods per day. This is about four to six ounces of protein-rich food. If your client questions what three ounces of protein looks like, have her use a food scale to measure her next serving of tuna or poultry. Once she gets this frame of reference, she'll be on the road to success. Many Americans eat a 16-ounce steak or half of a chicken and view this as a "serving"—and move unknowingly well beyond their daily protein (not to mention calorie) requirements. On the other hand, if your client always chews on bagels, bread, plain pasta, vegetables, salads, and fruit, it's easy for her to take in too little protein.

Excellent protein-rich foods (which contain amino acids) include lean beef, fish (tuna, salmon, and swordfish are excellent), chicken, turkey, peanut butter, tofu, canned beans, and low-fat dairy products. Other sources include green, leafy vegetables and egg whites. Encourage your clients to read food labels to determine the grams of protein each serving of a particular food provides.

Calculate Carbohydrate and Protein Intake

If you want your client to focus on carbohydrate intake (but not to the exclusion of fat and protein), an easy method to calculate carbohydrate intake is based on body weight only (table 21.3). Researcher Liz Applegate, PhD, determined that three to five grams of carbohydrate per pound of body weight accurately reflects individual carbohydrate needs. Additionally, research supports taking in about 0.6 to 0.9 gram of protein per pound of body weight.

TABLE 21.2 Worksheet for Determining Carbohydrate, Fat, and Protein Ratios

Determine your client's daily caloric requirement using one of two methods described earlier in this chapter.

Using technique 1 for determining daily caloric requirement (described earlier in this chapter), the sample 155-pound person required almost 3,000 calories for that given day to support her exercise, activity, and basal metabolic requirements.

	Total daily calorie intake	Desired percent of each nutrient	Number of calories from daily intake	Number of calories in one gram of the nutrient	Number of grams of nutrient
Carbohydrate	3,000	65	3,000 × .65 = 1,950	4	1,950 ÷ 4 = 487.5
Fat	3,000	20	3,000 × .20 = 600	9	600 ÷ 9 = 67
Protein	3,000	15	3,000 × .15 = 450	4	450 ÷ 4 = 112.5

Reprinted from D. Brooks 1999.

TABLE 21.3 How to Calculate Carbohydrate and Protein Needs per Pound
of Body Weight

	Body weight (pounds)	Grams per pound of body weight	Body weight × grams of nutrient per pound	Grams required per pound of body weight
Carbohydrate	155	3-5	155 × 3 = 465 155 × 5 = 775	465-775
Protein	155	0.6-0.9	155 × 0.6 = 93 155 × 0.9 = 139.5	93-139.5

Reprinted from Brooks (1999).

The upper end of the range of carbohydrate requirements (five grams per pound of body weight) reflects the carbohydrate needs of very active athletes. The lower end of the range (three grams per pound of body weight) is appropriate for an active person looking for the recommended carbohydrate intake of about 60 to 65 percent of total calories consumed.

The protein recommendations (0.6-0.9 gram per pound of body weight) provide for a range of individual protein needs. These amounts are not minimal but provide a margin of safety as well. However, the following clients may require more protein:

- Athletes who exercise intensely (endurance athletes, or those using intervals and strength training)
- Clients who consume too few carbohydrate calories (protein can be converted to sugar and used for energy instead of building muscles and repairing the body)
- Untrained individuals starting an exercise program
- Growing teenagers (they need protein for proper growth and activity)

However, excessive amounts of protein do not enhance muscle size or the health of any of these clients.

Even though heavier body weight requires greater absolute amounts (grams) of carbohydrate, fat, and protein, the percentages of each nutrient taken within this overall higher daily calorie intake do not change.

Generally, carbohydrate should form the foundation of every meal or snack your client eats. Carbohydrates ultimately fuel your client's muscles. Without adequate intake, your client's training suffers, she feels stale, and fatigue overtakes her. Insufficient carbohydrate intake fuels overtraining and that "burned out" feeling.

On the other hand, fat and protein provide nutrients that enhance training and your client's health. Don't encourage clients to obsess on carbohydrate or fat intake to the exclusion of other nutrients. Your client must get enough carbohydrate, fat, and protein in her diet to fuel optimal health and training response and for a well-balanced diet.

Building Muscle Safely and Sensibly

When asked what the best way is to put on muscle, most consumers would respond, "Eat lots of protein!" or, "Drink shakes for extra calories!" Wrong! Calories, regardless of whether they are in the form of carbohydrate, fat, or protein, do not automatically turn into muscle. A high-protein diet does not necessarily result in more muscle because excess protein is not stored as muscle; any calories in excess of your client's daily caloric requirements will be stored as fat.

Although your client needs extra calories if she's training hard, those calories should come predominantly from carbohydrate food sources. Carbohydrates are necessary to fuel muscles so they can perform intense strength training exercise and recover from hard effort. The stimulus for your client's muscles to grow larger comes from overloading them with correct and intense strength exercise, not from overloading your client's body (including her kidneys) with too much protein.

How Your Client Should Eat Before, During, and After Workouts

When and what your client eats can dramatically affect her performance, her next workout, and how she feels overall. As discussed, appropriate carbohydrate, fat, and protein intakes are important before and after intense, anaerobic training (like sprints and strength training), but what your client eats before, during, and after exercise also affects endurance performance.

Realize that one athlete's perfect food may not work for a different client. Although certain types of foods may or may not work for your client's preworkout, workout, or postworkout food consumption, certain categories of food are best eaten at specific times within her overall training schedule. The timing and type of nutrient to ingest are well defined by science. Within each nutrient category, your client will have to decide what works best for her preexercise or precompetition meal. For example, in the category of carbohydrate, does a plain bagel or piece of toast, a banana, or cereal sit better in your client's stomach?

What Your Client Should Eat Before Her Workout, and When

The type of activity and how her body tolerates food intake before activity can influence what and when your client eats. However, science should also guide the decision.

Preexercise food intake can cause abdominal discomfort and bring on the threat of diarrhea. Nevertheless, the client needs food before a workout or competition regimen. Following are some guidelines to help you decide what your client should eat before a workout or competition.

■ The client should consume a low-fat, high-carbohydrate diet daily. This will maintain adequate glycogen stores (stored carbohydrate) in the muscles and liver.

■ The client should avoid foods high in fat and protein before working out or competing.

■ If your client is exercising less than an hour, common carbohydrate choices include bagels, plain or toasted bread, crackers, plain pasta, and bananas. Try different foods and find one or several that don't upset your client's stomach.

■ If your client is exercising longer than 60 minutes, try foods like bananas, oatmeal, and apples because they have a low glycemic index. (Although apples have a low glycemic index, the fructose may upset your client's stomach. Other low glycemic index foods are listed in the box on page 452.) Foods that are rated with a low glycemic index will help fuel your client's performance for longer periods of time.

■ Experiment before your client eats simple sugars (sodas, candies, and some sports drinks), or any foods with a high glycemic index, less than 15 to 120 minutes before a hard workout. Some athletes and recreational exercisers experience a huge decrease in blood sugar after such a "fix," leaving them feeling exhausted, light-headed, and off their game. On the other hand, many athletes (and research confirms this) experience an improvement in performance. To play it safe, have your client consume her sweet snack about 5 to 10 minutes before she exercises. This time span is probably too short to allow insulin to be secreted from the pancreas into the bloodstream and lower blood sugar. When your client starts exercising, her body stops secreting insulin and she should be fine. To escape the need for a quick fix, have your client try eating more food two to four hours before her next workout or competition.

Preexercise nutrition can help your client maintain even levels (not too high or too low) of blood sugar and prevent early fatigue. The right foods, taken at the right time, can calm her stomach by neutralizing stomach acids and keep her from feeling starved. Carbohydrate eaten well in advance of your client's workout can fuel her performance as exercise intensity dictates, as a result of glycogen being stored in the muscle or liver. Foods (especially carbohydrates with a low glycemic index rating) eaten about an hour before your client's workout are digested enough to be used as fuel, and they will continued to be metabolized throughout the exercise session, but they do little to replenish glycogen stores. To replenish glycogen stores, instruct your client to load up after exercise (see "What Your Client Should Eat After Her Workout, and When") and three to four hours before exercise and to maintain her daily, high-carbohydrate diet.

Glycemic Index of Some Popular Foods

A glycemic index rating for a food is determined by its ability to contribute glucose (sugar) to the bloodstream. For example, eat honey and your bloodstream will quickly become loaded with sugar. Quick entry of a sugar into the bloodstream is desirable if you're already exercising or recovering from exercise. Low or moderate glycemic index foods before exercise are preferable when performing exercise longer than an hour because they provide a food source for sustained energy needs. It will be used as you exercise rather than being dumped into your bloodstream immediately. High glycemic index foods stimulate insulin production, which can cause sugar to be stored as glycogen, but can also cause your blood sugar to drop lower than your pre-meal level.

You cannot rate a food as high or low glycemic based solely on its classification as a simple or complex carbohydrate. You might think that an apple (low glycemic index and simple carbohydrate) would have a similar index as watermelon (high glycemic index and simple carbohydrate). Use the table below to decide which foods are appropriate for your needs.

Food*	GI	Food	GI
High		Popcorn	55
Glucose	100	Corn	55
Potato, baked	85	Sweet potato	54
Corn flakes	84	Pound cake, Sara Lee	54
Rice cakes	82	Banana, overripe	52
Potato, microwaved	82	Peas, green	48
Jelly beans	80	Bulgar	48
Vanilla wafers, Nabisco	77	Baked beans	48
Cheerios	74	Rice, white parboiled	47
Cream of Wheat, instant	74	Lentil soup	44
Graham crackers	74	Orange	43
Honey	73	All-Bran cereal	42
Watermelon	72	Spaghetti (no sauce)	41
Bagel, Lender's white	72	Pumpernickel bread	41
Bread, white	70	Apple juice, unsweetened	41
Bread, whole wheat	69 (65-75)		
Shredded wheat	69	**Low**	
Soft drink, Fanta	68	Apple	36
Mars Bar	68	Pear	36
Grape-Nuts	67	PowerBar	30-35
Stoned wheat thins	67	Chocolate milk	34
Cream of Wheat, regular	66	Fruit yogurt, low-fat	33
Couscous	65	Chick-peas	33
Table sugar (sucrose)	65	PR Bar	33
Raisins	64	Lima beans, frozen	32
Oatmeal	61 (42-75)	Split peas, yellow	32
Ice cream	61 (36-80)	Milk, skim	32
		Apricots, dried	31
Moderate		Green beans	30
Muffin, bran	60	Lentils	29
Bran Chex	58	Kidney beans	27
Orange juice	57	Milk, whole	27
Potato, boiled	56	Barley	25
Rice, white long grain	56	Grapefruit	25
Rice, brown	55	Fructose	23

*Amount based on 50 grams of carbohydrate per serving

Foods with a high glycemic response have a value above 60; foods with a moderate glycemic response have a value between 40 to 60; and foods with a low glycemic response have a value less than 40.

Data from food companies and K. Foster-Powell and J. Brand Miller, 1995, "International tables of glycemic index," American Journal of Clinical Nutrition 62: 871S-893S.

Reprinted, with permission, from Nancy Clark, 1997. Nancy Clark's Sport Nutrition Guidebook, 2nd ed. (Champaign, IL: Human Kinetics).

What Your Client Should Eat During Her Workout

Most people who exercise longer than 30 minutes can tolerate small amounts of plain food in their stomachs. Moderate- to even high-intensity endurance activity still allows for food to digest and for your client to exercise more effectively. However, if your client is putting in an all-out effort, she may get the opportunity to revisit what she ate!

If a client's endurance exercise lasts longer than 60 minutes, her nutritional challenge is to preserve a balance in fluid and carbohydrate reservoirs. Your client's fluid intake must match her sweat loss (your client loses water through breathing and sweating), and ingesting enough carbohydrate helps maintain stamina by providing energy and sustaining blood sugar levels. Every hour of endurance exercise requires about 100 to 300 calories of carbohydrates (or more exactly, 0.5 gram of carbohydrates per pound of body weight).

A person weighing 155 pounds would require 77.5 grams (155 × 0.5) of carbohydrate every hour. Physiologically, the body is indifferent to whether the carbohydrate is ingested as a liquid or solid food. Runners, probably because of impact and jarring, seem to prefer liquids; people who participate in activities that have little impact use either solid or liquid food, depending on how well the type of food sits with them. For example, it's easy to carry and eat solid food when cycling, and there is little jarring to wreak havoc on your intestinal system. Twelve, four-ounce "gulps" of a sport drink that provides 25 calories per four-ounce serving would give your client an hourly carbohydrate intake of 300 calories. Some combination of sport drinks, sport bars, bananas, Fig Newtons (my personal favorite), and so on, along with plain water, can provide the necessary nutrients. Try out various options. Your client will find a favorite combination that she swears by!

Your client cannot be competitive at longer durations, although she can probably slog through the effort, without feeding while she exercises. Not only will your client perform better if she eats during extended workouts, she'll feel great and more likely enjoy the experience.

What Your Client Should Eat After Her Workout, and When

What your client should eat after a workout depends on whether your client is a recreational exerciser who trains regularly or is on a demanding, hard-core training program. If your client works out three to five times per week at moderate to hard levels of effort, and optimal performance is not one of her training goals, glycogen stores can be replenished with a regular diet that is high in carbohydrate (60-65 percent of daily calorie intake). If your client works out twice a day, or she's competing two to three times per week in a competitive basketball or volleyball league and working out in the gym, pay close attention to recovery diet.

Athletes often fail to follow a proper recovery diet because they are unaware of its importance to their next day training or performance, they are not hungry or are too tired after the event or workout, or they don't have the time. Have the seriously competitive client make the time for this aspect of her training program. It requires little forethought and is easy to do.

If your client is training hard and often, she should be concerned with fluid replacement immediately after exercising as a means to help her body prepare for the next workout. Immediately on cessation of exercise, your client should begin to replace fluid losses with juices, foods high in water (the kind that run down your face when eaten), sport drinks, and water. Nondiet soft drinks are okay for supplying carbohydrates but provide virtually zero vitamins and minerals.

Your client's first round of carbohydrate "feeding" should begin within 15 minutes after she stops exercising. If she waits longer than that, her glycogen stores will not be replenished as quickly. Your client needs about 300 calories within 2 hours of finishing her exercise and should begin taking them in within 15 minutes of stopping. Carbohydrate-rich foods and beverages are the right food choice for recovery. Follow this initial feeding with about 300 additional carbohydrate calories every two hours thereafter, for six to eight hours. In total, this involves three to four 300-calorie carbohydrate feedings over six to eight hours. A 12-ounce can of soda and a banana are all that it takes to provide your client's first 300 calories! After

hard and sustained exercise, your client's body will crave these calories!

It's also a good idea to mix a little protein with your client's carbohydrate recovery foods. Protein, like carbohydrate, stimulates the production of insulin (a hormone), which helps "herd" blood glucose into the muscles to enhance glycogen replacement. Lean meat and low-fat milk are good examples. But don't have the client go overboard. More is not better. Also, the client needs to maintain her protein needs for muscle growth and cellular repair and production by keeping protein intake at 15 percent of her daily calorie intake.

After exercise, your client's nutritional priorities are carbohydrate and fluid replenishment.

Sport Drinks and Water Intake

Your client probably can't drink enough water before and after exercise, as long as she can tolerate it and has a chance to eliminate before she exercises. At a minimum, your client should drink three to four ounces (a good-sized gulp) of water every 10 to 15 minutes during exercise. If your client is exercising hard, she may require eight ounces of water every 15 to 20 minutes. To determine if your client is taking in enough fluid to match her sweat losses, have the client weigh herself before and after each workout. Her after-workout weight should match her preexercise weight. If your client is drinking enough water, her urine will be pale yellow or almost clear throughout the day, and there will be lots of it. Different environmental conditions and exercise intensities will require more or less fluid intake.

Sport drinks are designed to raise your client's fluid and glycogen levels to preexercise levels. Some drinks also contain electrolytes (minerals) such as potassium and sodium because these minerals are lost in sweat. Usually, a sport drink isn't a consideration unless your client exercises for at least an hour. In this case, your client's primary need is for water, not sugar or minerals. Additionally, a sport energy drink will replace most of the calories a client uses in a half-hour workout. To competitive athletes this is not important, but if one of your client's goals is to lose weight, stick with an energy drink called water!

When you consider the use of a commercial sport drink in your client's workout, follow the guidelines for food intake before, during, and after workouts. Remember, these are primarily carbohydrate (that's sugar) solutions that are weak (4-8 percent solutions that provide about 40-80 calories per eight ounces and work well when taken during exercise) or very concentrated (sweet and best taken as a recovery drink after exercise). There is nothing magical about them, although they can be effective and convenient. You can dilute soft drinks or juices to this same, weak solution of about 40 to 80 calories per eight ounces. A proper and balanced diet, along with using the guidelines for ingesting solid or liquid food before, during, and after exercise, can provide all of your client's nutrient needs regardless of whether you recommend a commercial sport drink.

Training without proper fluid intake does not "toughen" your client. This habit simply makes her better at training when she's dehydrated and nowhere near her top performance capabilities.

Monitoring and Guiding Your Client's Eating Habits

Although your clients should be conscious about what they eat, tracking what they put into their mouths doesn't have to be as complex as cellular physiology. In fact, using the few simple calculations that you learned in this chapter requires little time and can help your client learn to eat smart and be accountable. And your client won't be tied to the math work forever.

Monitor and guide your client's nutrition program by helping her calculate daily calorie intake for at least several weeks. Use the daily calorie requirement to figure her daily carbohydrate needs as 60 to 65 percent, fat as 20 to 25 percent, and protein as 15 percent of her daily calorie requirement. Use a food scale to help your client learn how identify correct food portion sizes, and help your client learn to read food labels so she can keep track of how many grams of carbohydrate, fat, and protein she is taking in each day.

Even after your client has learned to accurately estimate daily calorie requirements and take in the right amount of carbohydrate, fat, and protein, recalculate periodically to keep her honest, adjusting to changes in her program, and on target!

Guiding Clients Toward Healthy Eating Habits

If your client uses words like *strict* or *religion* to describe his dietary approach, encourage him to replace these words with *consistent* or maybe *disciplined*. Better yet, remind him of the "80/20 rule." In other words, a client should follow his eating and exercise plan 80 percent of the time, and he shouldn't worry if he slips 20 percent of the time.

The 80/20 rule replaces the 90/10 principle I used to follow. That is, 90 percent of the time I used to make the "right" and healthy choices, and 10 percent of the time I wouldn't. In reality, I was trying to be perfect. Over the years I have realized that my personal training clients, and I, need to bend the 90/10 principle to take an approach to healthier eating that is going to work in real life. With the addition of two sons, my personal 90/10 principle changed to 80/20 and has even eroded to 70/30 on occasion. Funny how a family can affect your eating habits. However, your clients can still eat healthfully, and perform at high levels, by eating "right" most of the time.

Don't let your clients set themselves up for failure by trying to be perfect all of the time. Approaching personal health, exercise, nutrition, eating habits, and food choices with an all-or-none attitude is the perfect setup for personal failure. Perfection is not normal. Many distractions in the form of travel, job, and family may come up daily. Your clients need a flexible, nonobsessive approach to nutrition (and for that matter, exercise) that encourages consistency, not perfection.

Clients constantly ask questions. Does the latest nutritional aid work? What about that new weight-loss system advertised on television? What's the food pyramid? How can I count fat grams? How much should I eat? These questions are often fueled by inaccurate and sensationalized reporting by the media. For instance, recent headlines have suggested that pasta makes you fat and that a low-fat diet may be harmful to your health. Of course, my clients want my opinion on the latest controversy. There really is no controversy, only confusion, contradiction, improper interpretation of the facts, and inaccurate media messages.

A personal trainer is not a substitute for a registered dietitian or other licensed or degreed nutrition expert. However, you will be asked many nutritional questions by your clients and you should be able to give them accurate, general nutritional guidelines.

Although your main concern may be healthy eating habits, your clients may be coming to you for an answer to the million-dollar question, "What's the best way to lose weight and keep it off?" Of course, the answer is a sensible and realistic approach that incorporates exercise and a low-fat approach to eating. That message alone may be an ongoing challenge to communicate, but you have an even more important message to send. Your client needs to realize that losing weight in the pursuit of perfection will end in failure. It's easy for your clients to be displeased with any success as they realize "there's always another pound to lose." The "perfect body" does not exist, although a personal body image that your client can be comfortable with surely does. Perfection is only an illusion that the mind grasps for in futility—and never reaches. Set your clients up for success, and don't play the weight-loss

yo-yo game! Communicating this message is as much a part of each client's overall health picture as interpreting blood cholesterol levels, recognizing risk factors for heart disease, and working out.

Playing the Weight Loss Game

Your clients know that poor eating habits can lead to poor health. High cholesterol, high amounts of low-density lipoproteins (LDLs, the "bad" cholesterol), heart disease, diabetes, poor self-image, and low energy are a few of the potential outcomes for your clients who are not getting enough exercise and are consuming too many calories, cholesterol, and fat because of poor food selections. Yet, we are fatter than ever as a society, and one out of three American adults is overweight (Andersen 1999, p. 41).

Our culture promotes a sedentary way of life with little physical activity, indulgent eating, and the hope for a quick fix for our weight problems—one that takes little thought or time. Does that last point sound too good to be true? Of course it is, and the billions of dollars that are spent each year for weight-loss schemes and nutritional supplements reflect this futile approach. Michael Jacobson (1995) suggests that the cure for our obesity problem lies in making healthful living easier—by creating a network of bike paths and jogging trails, designing cities and neighborhoods for walking and biking, building schools that encourage and develop a lifelong love of physical activity, disclosing calories on restaurant menus, and providing activities that are fun and doable, so that kids and adults will turn off the television and get out of the easy chair and "into the streets."

I believe what Dr. Jacobson is talking about is a societal behavior and attitude change. It is time to ask our clients for a personal investment and commitment of time and attention with regard to healthy eating habits. It is appropriate that you lead by example and, in turn, ask your clients to influence their family and friends by strong example.

At the forefront of that quick-fix mentality is the word *diet*. To me, a diet is usually associated with severe calorie restriction, deprivation, or some other extreme, unscientific approach,

such as the *Why Women Need Chocolate* diet, the *Zone Favorable High-Fat* diet, the *Carbohydrate Addict's* diet, the *Fit for Life* diet, the *Eat Smart, Think Smart* diet, the *Eat 'till You Puke and Still Lose Weight* diet, and dozens more. According to Kelly Brownell, director of the Center for Eating and Weight Disorders at Yale University, all of these diets have equally compelling testimonials from pseudo-experts who think, or want you to believe, that they have something new.

But, as mentioned in chapter 21, not all diets are bad. A low-fat (not no-fat!) diet works from both a health and weight-loss perspective. You've heard it before—by reducing the fat in the diet and replacing it with healthier choices, your clients can easily cut calories. From a weight loss perspective, it doesn't matter what you eat as long as total calories are reduced (your client's arteries are another matter). However, because fat has more than twice the calories per gram as carbohydrate or protein, your client can eat the same or larger amount of food with food selections that limit fat intake and still take in fewer calories. Therefore, it makes sense to limit fat intake to benefit both your heart and your weight.

Teaching Clients to Eat Healthfully

When you answer client questions by offering sensible eating guidelines, include ideas for low-fat eating in every suggestion. That is the basis of a healthy diet.

Empower Your Clients

Confidence, support, and a realistic approach are the key ingredients to healthy eating habits and weight control. Many of the empowerment tools discussed in this and chapter 21, such as label reading and the food pyramid, will strengthen your client's ability to eat healthfully and lose weight. Additionally, stress the theme of moderation. Reinforce that clients should not be obsessed with weight control, which is ultimately counterproductive. Keep the focus on health. Help your clients learn to know and like themselves better and be easier on themselves. Encourage them to be more compassionate and patient with their progress and effort.

Phase in Behavior Change

Your clients don't have to immediately—or for that matter ever—go from fat to thin. Their health can be greatly affected with small changes. Total cholesterol, LDL cholesterol, and triglycerides significantly decrease—and high-density lipoprotein (HDL) cholesterol significantly increases—every time your client drops five pounds. In one study, 60 percent of people with high blood pressure were able to discontinue their blood pressure medication after losing 10 pounds. And overweight diabetics who lost at least 15 pounds over a year lowered their blood sugar levels by 15 percent, without medication. Those who lost 30 pounds reduced their blood sugar by more than 40 percent even though they remained overweight (Jacobson 1995).

Transition to Healthy Food Choices

Moving to healthier eating is very rewarding. However, remind your clients that tastes are learned. Although some experts would argue that it's easier to make a complete change to a more wholesome diet—vegetables, grains, fruits, and legumes diet—I believe a moderate approach will work well with most of your clients. For example, replace high-fat dairy products with low-fat options before proceeding to nonfat sources. Another progression might be to eat meat less often and purchase cuts that are lowest in fat rather than completely eliminating meat from the diet.

Increase Formal Exercise or Activity Habits

The best kept secret for weight loss is regular activity of any kind. Your clients are lucky to have you to guide them while they identify activities they can enjoy for a lifetime. Also, research indicates that people who exercise regularly usually start eating more healthfully.

Encourage Healthful Eating Habits

Your clients should drink plenty of fluids and eat lots of fruits, vegetables, legumes, and grains—instead of fat-free cakes and cookies loaded with "fake fat" and sugar. Reduce the intake of refined carbohydrates—that includes white flour, white sugar, and white rice—by choosing whole-grain products and natural sweeteners such as fruits, juices, and syrup. Reduce red meat and fatty or fried poultry and fish. Limit hydrogenated oils or trans fat (be sure to read labels). They raise blood cholesterol as much as saturated fat ("Trans: The Phantom Fat" 1996). Gradually reduce both butter and margarine in the diet. Switch to nonfat or low-fat versions of prepared foods and dairy products.

Teach Accurate Calorie Estimation

Although your clients should not be obsessed with an inflexible approach to calorie counting, they need to have some sense of portion control and total daily caloric intake (chapter 21). Both the food pyramid and reading labels (chapter 21) can help your client get a feel for his daily caloric intake without going overboard on a rigid calorie-counting regimen. Also, your clients will quickly learn that not all single servings are the same. For example, an eight-ounce serving of nonfat milk carries with it about 90 calories, whereas an eight-ounce serving of whole milk contains about 150 calories.

Encourage Clients to Consume Calories Evenly Throughout the Day

When the typical diet is analyzed, most of the daily caloric intake is consumed at night. Today's social patterns encourage a light or skipped breakfast, quick lunch, and late dinner, with overconsumption at this evening meal. Calories may be best consumed throughout the day to optimize alertness, energy, and the caloric needs required for basic metabolic maintenance and daily physical activity. Continually eating or grazing throughout the day may not be the best idea, but three to five solid meals and low-fat nutritional snacks, such as fruit, might be a better approach.

Helping Your Clients Lose Weight

Although healthy eating is the first step toward a realistic weight-control program, your clients can use some additional advice in their weight-loss game plans.

Do Not Reduce Daily Caloric Intakes by More Than About 20 Percent

Severe calorie restriction cannot be maintained. Severe restriction ultimately leads to failure in a majority of cases, commonly referred to as yo-yo dieting and weight cycling. Small reductions, made consistently over an extended period of time, are tolerable and can lead to safe and permanent weight loss. On the other hand, don't discourage obese clients from attempting to lose weight because of concerns about the hazards of weight cycling. The National Institutes of Health (1994) report that obese individuals should not allow concerns about the hazards of weight cycling to deter them from efforts to control their body weight (p. 1). This is strong support for continued attempts at weight loss, even if the weight is regained. Even small amounts of weight loss can positively affect health.

Teach Correct Food Portion Size by Using a Food Scale

I often use a food scale with my clients to drive home the issue of portion control. It is not a shock to me that a majority of my clients vastly underestimate the amount of food they eat. (For some of your clients who border on undereating, too small portions can also jeopardize their health and weight management goals.) By using the food scale, your clients can quickly learn to accurately judge serving sizes. This approach has helped many of my clients who have struggled not so much with poor food choices but with simply consuming too much food.

Reverse Small Weight Gains Immediately

Any of your clients who struggle with losing weight often find that the difficult aspect is not initially losing weight but rather keeping it off. The key to keeping weight off is to immediately reverse gains of three to give pounds, according to a study of 160 men and women who successfully kept off an average of 63 pounds for three years (Fletcher 1994). This information presents an argument for your client weighing herself on a nonobsessive although regular basis, every two weeks or so.

Offer Suggestions for Changes in Daily Habits

Here's a list of suggestions you can give clients. They are not only sensible but will help clients develop a low-fat approach to eating:

■ Read food labels consistently and carefully. Make sure the serving size listed on the label is in line with the food pyramid recommendations.

■ Order all toppings and salad dressings on the side. This allows you to control the amount you use. Ask for light, low-fat, or nonfat options. If low-fat options are not available, mix dressings and toppings with vinegar or lemon juice to lower the calorie concentration.

■ Reduce the use of cooking oils and oil-based salad dressings. Using Dijon mustard and nonfat plain yogurt is a great substitute for an oil-based salad dressing.

■ Limit your intake of baked goods that are high in fat. Cookie, pie, and doughnut calories are often at least 50 percent fat.

■ Replace mayonnaise or butter on your sandwiches with mustard. Eat bread plain.

■ Instead of using margarine, butter, or regular sour cream on your baked potato, use nonfat yogurt or nonfat sour cream.

■ Instead of frying food, bake, boil, or poach.

■ Saute food in a low-fat broth or small amount of olive oil. Avoid using solid fats.

■ Use low or nonfat yogurt and cottage cheese and either skim (nonfat) or 1 percent fat milk.

■ Purchase lean cuts of meat and trim any visible fat.

■ Buy chicken and turkey without the skin or remove the skin before eating.

■ Buy ground beef only if it is labeled as 96 percent fat-free. Don't be fooled by labels for "extra-lean ground beef."

■ For dessert, try sorbet, sherbet, nonfat or low-fat frozen yogurt, and fresh fruit.

■ Add water or seltzer to dilute juices and cut calories. Recognize that juices are a food and can add significant calories to your total daily intake.

■ When eating out, order vegetarian, seafood, or poultry dishes instead of beef or pork. Order side dishes that are filling yet low in fat, such as rice. Don't forget that alcoholic beverages count about the same as fat calories. When visiting the movie theater, request air-popped popcorn.

Personal Reality Check— Let's Get Honest!

Randy Eichner calls self-delusion the "most popular indoor sport" (Eichner 1993). What he's getting at is that most of us overestimate how much we exercise and underestimate how much we eat. Although weight maintenance and weight loss are very complex, part of the reason that some obese people can't lose weight, according to Dr. Eichner, is because of self-delusion. He refers to a sophisticated study in the *New England Journal of Medicine* (Lichtman et al. 1992) that reports in the failed diet group, subjects ate 1,000 calories more than they recorded in their diaries and burned 250 fewer calories than their exercise records indicated. Interestingly, this same pattern is seen in young, old, fat, or slim people. Four out of five people believe that they eat less and exercise more than they actually do (Eichner 1993). Regardless of your client's goal, results depend on what she does, not what she believes she is doing.

Using the Food Pyramid

Did you know there is more than one food pyramid model to choose from? The two that I am going to discuss can help you teach your clients to moderate their eating and choose better foods. Both are similar and are practical to implement in your client's busy life.

The United States Department of Agriculture (USDA) replaced its "Basic 4" chart first introduced in the 1950s and named its revamped nutritional educational tool the food pyramid (figure 22.1). It has been received with mixed reviews by nutrition experts but certainly is a helpful improvement compared with earlier models. One weakness of the USDA pyramid is that it does not distinguish among foods within groups. For example, extremely healthful legumes are in the same high-protein category as bacon.

Another approach that builds on the "power of the pyramid" is the Center for Science in the Public Interest (CSPI) healthy eating pyramid. CSPI, the publisher of *Nutrition Action Healthletter*, uses a three-dimensional design that allows for more detail than other pyramids. It classifies foods into groups and tells you what foods within the group are best eaten "anytime," "sometimes," or "seldom." For example, a potato and fruit fit into the "anytime" category, whereas French fries and avocado are placed in the "sometimes" category. This is a strong message that suggests how food is prepared (French fries) can greatly determine how healthy it may be for your client. Although foods may technically be lumped in the same healthy food groups, some (like the avocado) may not actually be that good for you. The CSPI pyramid emphasizes plant-based protein sources, for example, nuts and legumes, over animal-based products. This is exemplified by positioning beans in a higher priority group with vegetables and fruits.

Both the USDA and CSPI models specify number of servings in each food group and offer examples of serving sizes.

The food pyramid focuses on portion sizes. This shows a shift away from concerns of undernourishment and a growing awareness that the real risk is dietary excess, especially concerning too much simple sugar and fat.

When you are using the pyramids, the practical solution is to focus on the pyramids' similarities rather than their differences. The pyramids tell you to eat more whole grain products, fruits, and vegetables and avoid fats and excessive sweets. Both also emphasize portion control and dietary variety.

The best place to start, for healthy eating, is at the base of the food pyramid. The first group is the bread, cereal, rice, and pasta group, of which 6 to 11 servings are recommended per day. Examples of one serving include one slice of bread, one ounce of breakfast cereal, four crackers, or one-half cup of cooked pasta, rice, or cereal.

Next are the vegetable group (three to five servings a day) and fruit group (two to four servings). Serving size examples include one-half cup of raw or cooked broccoli or other vegetables; one cup of leafy raw vegetables; three quarters of a cup of vegetable juice; one piece of medium-sized fruit such as an apple, banana, or orange; one-half cup of chopped, cooked, or canned fruit; one cup of strawberries or grapes; six ounces of fruit juice; and one-quarter cup of dried fruit.

Next are the milk, yogurt, and cheese group (two to three servings a day) and the meat,

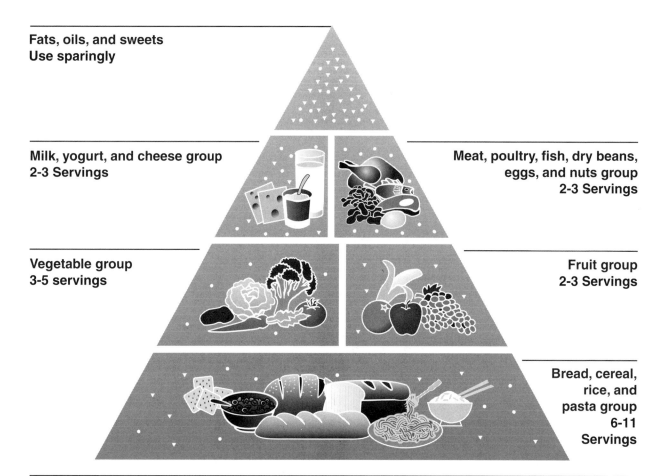

Fats, oils, and sweets
Use sparingly

Milk, yogurt, and cheese group
2-3 Servings

Meat, poultry, fish, dry beans,
eggs, and nuts group
2-3 Servings

Vegetable group
3-5 servings

Fruit group
2-3 Servings

Bread, cereal,
rice, and
pasta group
6-11
Servings

FIGURE 22.1 The USDA Food Pyramid.

poultry, fish, beans, eggs, and nuts food group (two to three servings a day). Choose nonfat or low-fat servings. Serving sizes include one cup or eight ounces of milk, one cup of yogurt, one cup of cottage cheese, one and one-half to two ounces of cheese, three ounces of fish, meat, or poultry, two tablespoons of nuts, one egg, and one-half cup of beans.

Last, the USDA Food Pyramid tells you to use fats, oils, and sweets sparingly. There are no recommended number of daily servings for these categories.

Sharing the Big Picture of Health and Well-Being

Some of your clients may set themselves up for failure by trying to be perfect all of the time.

Many times they may approach health-related issues, such as food choices, with an all-or-none attitude. For example, they may think they have to follow the food pyramid, low-fat, and eating portion recommendations 100 percent of the time—to perfection—or they may as well toss in the towel.

Whether applied to exercise or eating habits, this attitude is the perfect setup for personal failure. Let your clients know that perfection is not normal. Life's little speed bumps and distractions will present themselves regularly. Encourage a flexible approach that encourages consistency, not perfection.

Have your clients follow an eating and exercise plan 80 percent of the time, and tell them not to worry if they slip 20 percent of the time. Everyone needs some operating room to enjoy eating and to be successful!

PART IV

WORKING SAFELY AND EFFECTIVELY WITH SPECIAL POPULATIONS

Working With Special Populations: A Primer

All trainers will have the opportunity to work with a higher risk client. This opportunity will help you discover a new clientele with whom you can have a positive effect and reap rich personal rewards. Two of the biggest obstacles for trainers to overcome with regard to working with special populations center on answering the following questions:

1. Can I work with clients who have special health challenges?
2. How can I develop working relationships with licensed and other health care professionals?

At first glance, if higher need or higher risk clientele intimidate you, please read this introduction and following chapters before you decide whether you will choose to work with this type of person. If you're still not confident about working with special needs groups after reading about various approaches to these specialty markets, realize there is a huge market segment available to you that represents about 80 percent of what is defined as a largely sedentary population that may not have special concerns. An inactive, deconditioned population simply needs a basic, consistently performed exercise program, which most qualified trainers can provide.

Special needs populations and high-risk conditions that trainers might encounter include physically challenged individuals, those with AIDS or HIV, inactive and deconditioned individuals, youth and aging populations, women requiring perinatal care and sports conditioning, or clients with cardiac disease, back problems, obesity, neurological and chronic degenerative diseases, diabetes, or asthma. When you encounter a special needs client, you will have to answer the question, "Do I have the abilities and desire to work with this person?" The keys to working with a high-risk clientele are as follows:

1. Work within the scope of your training.
2. Receive guidance or an exercise prescription from a qualified professional such as a physician, osteopathic doctor, physical therapist, chiropractor, or registered dietitian, if the situation calls for it.

What's within your scope of practice? If you completely understand the necessary precautions or modifications recommended for a client by his health care provider, and you believe you can adhere to them, there is a good likelihood that the client is within your scope of practice or training abilities. Here's the bottom line. Can you set up a training program that is specific, progressive, and performance oriented? If you don't understand a training principle, are unfamiliar with the condition, or are not confident about the training regimen, then it is a prudent idea to refer the client elsewhere or seek additional information and guidance.

Refer to chapters 1 and 5 for additional insight into working with special needs clientele. In addition, I recommend these excellent resources for good information about working with special populations.

American College of Sports Medicine. 1995. *ACSM Guidelines for Exercise Testing and Prescription*. 5th ed. Philadelphia: Williams & Wilkins.

American College of Sports Medicine. 1997. *Exercise Management for Persons With Chronic Diseases and Disabilities*, ed. L. Durstine. Champaign, IL: Human Kinetics.

American College of Sports Medicine. 1998. *ACSM Resource Manual for Guidelines for Exercise Testing and Prescription*. 3rd ed. Baltimore: Williams & Wilkins

Howley, E., and B. Franks. 1997. *Health and Fitness Instructors Handbook*. 3rd. ed. Champaign, IL: Human Kinetics.

McArdle, W., F. Katch, and V. Katch. 1996. *Exercise Physiology Energy, Nutrition and Human Performance*. 3rd ed. Philadelphia: Lea & Febiger.

Managing Cholesterol, HDL, LDL, High Blood Pressure, and Heart Disease

You have a client who is 51 years of age, claims to love exercise, and has a personality that is irresistible. You learn that her mom is obese, is diagnosed with type 2 diabetes, and has high blood pressure. Her father died from a heart attack. When you meet her, it is obvious that she is overfat and deconditioned. Yet she doesn't see her current health as a risk. With her glowing and infectious personality, she says, "So basically, even though my family is unhealthy and hates to exercise, I love it. I'm in perfect health except for a knee that always bothers me and my back goes out occasionally."

Through further dialogue and a written health history, you confirm that she is 34 percent fat, has a blood pressure of 140/90, and has a low level of cardiovascular conditioning. As you wrap up your introductory meeting, she enthusiastically exclaims, "And I love aerobic dance. Not that low-impact fluff. You know, more like that bam-bam stuff you see on television. When can we start?"

Your client's background is a typical history of many clients, both men and women, with whom I have worked over the years. She is positive and her enthusiasm is unbridled. But, as is true for many clients, her personal assessment of her current health and fitness status is completely inaccurate. This is apparent because she believes she has no particular health concerns or "red flags," and, obviously, she possesses a lengthy list of health risk factors!

Prevention Plan for Overall Health

You can use information gained from the screening process (chapters 10, 11, and appendix) to help your clients plan for overall health. Personal trainers have the opportunity to look beyond activity to broader health issues. Physical activity is not your only approach to encouraging a healthy and balanced lifestyle for your clientele. Do you help your clients implement lifestyle behavior changes related to stress, a family history of coronary heart disease, obesity, lack of regular exercise, smoking, high blood pressure, or high cholesterol?

I think the significance of health risks is lost on the general public because of an attitude of denial—the feeling that "I don't really want to know" or "It can't happen to me." That rationale, unfortunately, won't hold true for everyone. Thus, the personal trainer must encourage the client to manage her risk factors with a proactive approach—meaning, do something about it!

The Carter Center (1988) estimates that two out of three deaths in the United States are linked to only six health hazards: tobacco, alcohol, high blood pressure, obesity, high cholesterol, and gaps in medical care for pregnant women and newborn babies. Epidemiological studies would also suggest a seventh, inactivity! All of these risks are largely controllable. By being aware of the health risks that confront

them, at least your clients can make informed decisions about their lifestyles.

Once you understand health risk factors, you can explain to a client what blood cholesterol numbers mean. You can explain how physical activity fits into a program to prevent coronary heart disease (CHD). You can become the bridge between your client and the medical and preventive health community, where practitioners may not have the time, or may not use simple language, to make risk factors easily understood and controlled. By using this type of approach, you are working with clients for their optimal benefit. You are positioning your business for success by helping clients see results that go beyond cosmetic, and you're establishing a link with physicians and health promotion specialists. This raises your perceived value to both clients and health practitioners.

Atherosclerotic Disease

When cholesterol and plaque are deposited in the arteries of the body, they can result in various vascular diseases called **atherosclerotic disease.** Vascular or blood vessel disease can be one of, or a combination of, CHD, stroke, or **peripheral vascular disease (PVD).** Vascular disease is most often caused by atherosclerotic plaque accumulations in the arteries of the brain, legs, and heart.

Coronary artery disease (CAD) is caused by plaque accumulation in the heart's coronary arteries. Examples of CAD-influenced CHD disease include myocardial infarctions (heart attacks), angina (chest pains), and sudden cardiac death. **Strokes** are caused by blood vessel disease in the small arteries of the brain. Strokes can result in severe brain damage, disability, and death. PVD is manifested by cramplike leg pain (claudication) and can lead to gangrene and amputation of the affected extremity. CHD, stroke, and PVD are usually manifestations of atherosclerotic disease, which is caused by cholesterol deposits in the arteries of the heart, brain, or legs. All artery disease can fall under the umbrella term *atherosclerotic disease.*

Coronary Heart Disease

CHD is an imbalance between oxygen available to the heart tissue and the heart's demand for oxygen. Coronary artery circulation is often compromised by a combination of atherosclerosis and arteriosclerosis.

Atherosclerosis affects the diameter of the artery because of changes in the intima (inner most lining) and media (inner layer) of the artery. Accumulation of fats (lipids), blood products, fibrous tissue, and calcium is associated with these changes, which cause a narrowing of the arteries. A decrease in diameter compromises blood delivery by the coronary arteries to the heart.

Arteriosclerosis can cause a thickening of the artery walls and calcium buildup in the artery walls, resulting in a loss of arterial elasticity. This "hardening" of arteries may contribute significantly to decreased blood flow to the heart muscle and increased blood pressure, which place increased mechanical stress on the compromised vascular system.

An enlightening although little-known fact regarding coronary circulation is that blood returning to the heart is totally dependent on the arteries that "feed" the heart, if oxygen and nutrients are to be used by the heart muscle. Many people assume that once blood is returned to the heart, oxygenated, and delivered to the left ventricle (one of four heart chambers), the heart's oxygen and energy needs are ensured. You would think that the blood rushing through the chambers of the heart would nourish the heart. This is not the case.

Blood is carried to the heart muscle tissue through two coronary arteries that branch off the aorta. The blood must be ejected from the left ventricle into the aorta, and it is not until this point that oxygenated blood has an opportunity to enter the coronary circulation or arteries that nourish the heart muscle. These arteries divide into smaller and smaller branches, like all blood vessels, eventually culminating in capillaries. After the blood has passed through the capillaries and the heart tissue has extracted the needed oxygen, it returns by way of venules and veins, which become larger and larger until they, like all other veins in the body, empty into the right atrium of the heart.

In most organs or tissues of the body, there are backup or collateral blood supply routes. In other words, there are often two arteries that "feed" blood to a similar area. These arteries are connected by many cross-channels or collateral

vessels. If one artery is completely blocked at a particular point or largely occluded, the collateral circulation can compensate and deliver the needed blood to sustain tissue function. Unfortunately, this situation does not exist in the wall of the heart to a great degree. The coronary arteries are referred to as "end arteries." Each branch follows its own course with very few connections with other nearby branches. The amount of cross-connections depends on the individual, and activity patterns may influence this to some degree.

If the arteries are inelastic, narrowed, partially blocked, or totally blocked, blood flow will be compromised or entirely blocked. If the nature of the activity, whether rest or vigorous activity, creates a demand for oxygen to the heart muscle that is not met because of compromised coronary circulation, angina (pain associated with ischemia or lack of oxygen to the heart muscle) or a heart attack can occur.

The heart is only as strong as its weakest link, which is usually the vulnerable coronary arteries that branch off from the aorta; blockage in them can compromise coronary circulation. Even though the heart may be full of blood, the blood may never reach and oxygenate the heart muscle if the heart's delivery route, the coronary arteries, is blocked.

Another little-known fact about CHD sheds light on its insidious and extremely dangerous nature. The heart's coronary circulation branches off the aorta and splits into three main delivery routes. These delivery routes further divide to cover the surface area of the heart and bring necessary nutrition and oxygen to the heart muscle. Significant (up to 80-85 percent) occlusion or blockage of the main coronary arteries may bring no symptoms or warning signs. In fact, total occlusion may be present in one or more of the branching, smaller arteries with no symptoms or warning signs presenting.

Understanding CHD Risk

Even though a person has marked and progressive coronary heart disease, it may go undiagnosed and remain asymptomatic. Then a situation such as emotional stress or physical activity (another form of stress) occurs where the oxygen demands of the heart are not met.

Your client may get a warning sign such as chest pains or rapid breathing, but often the first symptom of heart disease is death. There is no second chance.

Only 18 percent of adults are free of commonly identified, major risk factors, according to the Centers for Disease Control (reported by the University of California at Berkeley 1994). Heart attacks account for 500,000 deaths per year, and 20 percent of those deaths occur in people under the age of 65 (American Heart Association 2003; U.C. Berkeley 1994). This is one of the reasons why people need to have a keen awareness of risk factors and take preventive steps to correct modifiable risk factors related to CHD. You can lead this charge with your clients.

Risk factor analysis begins with identifying six factors that increase an individual's risk for CAD and CHD. CAD is caused by plaque accumulation in the heart's coronary arteries. CHD refers to heart attack, angina, and sudden cardiac death. CHD is caused by CAD. Does your health and medical history ask questions about these risks so that you can act on the responses as is appropriate? The six risk factors are these:

- Smoking
- High blood pressure
- High blood cholesterol
- Obesity
- Diabetes
- Inactivity

Having a risk factor does not guarantee a certain outcome. However, when risk factors accumulate for a person, the statistical probability of developing some form of CAD increases exponentially. The combined impact of several risk factors is greater than adding them together. For example, two risk factors result in 3.3 times the risk, and three risk factors result in 10 times the risk.

CAD claims the lives of more than 500,000 women each year, which is approximately twice the number killed by all types of cancer combined (American Heart Association 2003). The risk factors for CAD vary in their impact and are dependent to some degree on whether women have gone through menopause.

Premenopausal (before the cessation of menstruation) women are less likely to suffer from a heart attack. However, if they have diabetes or a predisposition to high cholesterol, hypertension, or a family history of CHD or if they smoke cigarettes, there is an increased risk of heart disease for perimenopausal women (those in the phase of declining menstrual function before menopause). Furthermore, once estrogen production begins to slow, women begin to catch up to and exhibit the same risk for heart disease as men. A 60-year-old postmenopausal woman (i.e., one whose menstrual function has stopped) has the same risk for heart attack as a 50-year-old man.

CHD Risk Factors That Cannot Be Changed

When speaking with clients, cite unchangeable factors but emphasize the risks that can be controlled and changed. By citing these risk factors coupled with the information about the exponential effect of coronary risk factors, you can influence your clients and motivate them toward positive behavior change. The following risk factors are out of your client's control:

Heredity. A parent or sibling who has had a heart attack before the age of 55 if a man or 65 if a woman.

Increasing age. Eighty percent of fatal heart attacks and 55 percent of all heart attacks occur after the age of 65.

Sex. Before age 55, men have a much higher incidence of CAD than women. At about age 60, women begin to develop a similar level of risk.

Race. Because they have a higher risk for hypertension and diabetes, African Americans have an increased risk for CAD.

CHD Risk Factors That Can Be Changed

To follow are key points that you can relay to your clients when educating them about risk factors. In 1992, Dr. JoAnn Manson and her colleagues from Harvard analyzed about 200 studies on CAD to evaluate the role of known preventive measures on the incidence of CAD (Manson et al. 1992). Their results were published in the *New England Journal of Medicine*

and reported in the *Berkeley Wellness Letter* (U.C. Berkeley 1994) and are summarized next.

Smoking. The best advice to smokers: quit! This is the single most effective step that can be taken to reduce the risk of CAD-related death. Most medical professionals would rather deal with an increase in weight than with the effects of smoking. Between 20 and 40 percent of all deaths attributed to CAD are directly related to smoking.

The exciting news about smoking is that the risk for CAD starts to decrease almost immediately after a person quits smoking. It is estimated that within 5 to 10 years, the risk for heart attack declines in the person who has stopped smoking to a level that is similar to someone who has never smoked.

Cholesterol. There is a 2 to 3 percent decline in the risk of heart attack for every 1 percent reduction in blood cholesterol. A "desirable" level of cholesterol is below 200 milligrams per deciliter. The best approach to improving blood lipid and cholesterol levels is to lower cholesterol through diet and raise the protective, high-density lipoprotein (HDL) through regular exercise.

High blood pressure (hypertension). High blood pressure is a risk factor for heart attack and stroke. A borderline high blood pressure reading is 130 systolic over 90 diastolic. For each one-point decrease in diastolic blood pressure, there is a 2 to 3 percent decrease in the risk of heart attack. The easiest way to lower blood pressure is through lifestyle changes. By limiting sodium (salt), losing weight, and decreasing alcohol consumption, people can significantly reduce blood pressure. After conservative measures have failed, medication may be required in conjunction with lifestyle modifications.

Inactivity. Numerous epidemiological studies demonstrate that exercise protects against CAD. A sedentary lifestyle carries with it the same risks as, for example, smoking or high cholesterol. A regular exercise program can reduce the risk of heart attack by 35 to 55 percent. Furthermore, research supports the fact that even low-intensity activities, such as gardening or strolling on a regular and consistent basis, can decrease the risk for heart disease and

increase HDL levels. (This contradicts previous research, which indicated that *only* vigorous activity would decrease risk and increase HDL levels. On the other hand, more rigorous training will further lower risk, when compared to moderate training intensity.)

Following is powerful information that you can use to effectively motivate your clients. Activity, at any level, can achieve the following:

- Increase the efficiency of the heart
- Make the heart stronger
- Reduce blood pressure
- Help control stress levels
- Reduce the likelihood of blood clot formation
- Help the client maintain or lose weight
- Increase the HDL cholesterol carrier

Obesity. About one in three Americans is seriously overweight or obese. This doubles the risk of CAD at any age. Being obese also increases the risk for diabetes, hypertension, and high blood pressure.

Diabetes. Diabetes increases the risk for CAD, high blood pressure, and other health-related risks. Type 2 diabetes (formerly called non-insulin-dependent diabetes mellitus, or NIDDM, and often referred to as adult-onset diabetes) afflicts about 16 million Americans and is often preventable. Weight control, regular aerobic exercise, good nutrition, stress reduction, and other forms of exercise can improve insulin sensitivity and sugar utilization and help control diabetes.

Understanding Cholesterol Levels

Many clients believe that "high" fat (triglyceride) or cholesterol levels equate with certainty of a heart attack. Although you should focus on cholesterol, this focus need not be obsessive, and you must look at the whole picture. Nonetheless, you and your clients should monitor total cholesterol (TC). This measurement includes both HDL and low-density lipoprotein (LDL) cholesterol in the blood, as well as very low density lipoproteins (VLDL). VLDLs are commonly called triglycerides or fat.

It is generally desirable to have a TC reading of below 200 milligrams per deciliter. Borderline is between 200 and 239, and high is 240 or greater (National Cholesterol Education Program 1993). The National Cholesterol Education Program (NCEP) recommends testing for HDL along with TC. A high HDL reading may balance any potential negative effects of a high TC reading.

When TC is divided by HDL, this gives a number called the **TC/HDL ratio.** An ideal value is less than 3.5, although a range of 3.5 to 4.5 is commonly cited as acceptable. The importance of the TC/HDL ratio lies in its ability to reflect how the body is managing individual cholesterol amounts. For example, a low cholesterol level does not make one immune to heart disease. A 180 TC reading, coupled with an HDL of 30, results in a ratio of 6. This level indicates an increased risk for heart disease even though the cholesterol reading, if interpreted by itself, would indicate otherwise.

A client with a TC or cholesterol reading of 240 and an HDL value of 70 would have a TC/HDL ratio of less than 3.5. This indicates a low risk for heart disease, as related to this one risk factor. Look at the whole picture within each risk factor, as well as across the board for every contributing risk factor, rather than taking into account only one isolated factor. Table 23.1 provides information and an equation related to cholesterol.

Structure and Function of Lipoproteins

Cholesterol, fats, and fatlike substances are not soluble in water. They must be packaged as lipoproteins to be transported in the watery medium of blood. Lipoproteins have two functions:

1. They transport cholesterol and blood lipids. Cholesterol is a derivative of fat and is not considered a lipid.
2. They regulate cholesterol and blood lipid levels.

Nearly all of the cholesterol in the blood is carried by HDL and LDL. About three fourths of all blood cholesterol is carried by LDL. It is apparent why a low LDL is preferred in the body. LDL is the prime carrier of cholesterol and

TABLE 23.1 Terminology and Total Cholesterol (TC) Equation

Total cholesterol (TC)	Reflection of three lipoprotein transport vehicles
High-density lipoprotein (HDL)	"Good guy"
	Available to scavenge
	Can reverse transport of cholesterol
	Transports mostly cholesterol
Low-density lipoprotein (LDL)	"Bad guy"
	Deposits cholesterol in arterial wall
	Transports three-fourths of total blood cholesterol
Very low density lipoprotein (VLDL)	Same as triglycerides
	Carries mostly fat
	Carries both saturated and unsaturated fat

TC = HDL + LDL + VLDL

has a tendency to deposit it in arteries, contributing to CAD. VLDLs and chylomicrons carry primarily triglycerides or fat (Byrne 1991).

Low-Density Lipoprotein (LDL)

High levels of LDL are associated with increased risk for CAD, CHD, stroke, and peripheral vascular disease (PVD), thus its characterization as "bad" cholesterol. Byrne (1991) reported that if LDL concentration increases above 100 milligrams per deciliter, some of its cholesterol is deposited in the arterial walls as plaque.

Diet greatly affects the rate of both LDL production and removal. An intake of dietary saturated fat and cholesterol increases the liver's production of VLDLs to transport the lipids in the fat, and, ultimately, some of the VLDLs (triglycerides) are converted into LDLs (Byrne 1991). To compound the problem, saturated fat and cholesterol decrease the ability of the liver to pull LDL out of the bloodstream by literally absorbing the cholesterol-loaded lipoprotein and "digesting" it. This situation further elevates LDL levels (Byrne 1991).

High-Density Lipoprotein (HDL)

HDLs are appropriately referred to as "good" cholesterol. Their importance in decreasing the risk for CAD is highly documented. HDL protects the arterial walls from atherosclerosis by removing some cholesterol from the arterial wall and possibly by inhibiting the entry of cholesterol, to some degree, into arterial wall

tissues (Byrne 1991). Byrne also reported that HDL promotes the production of prostacycline, a substance that inhibits clotting along the inner walls of arteries. The reduced tendency toward clotting because of elevated HDL levels has implications for decreased occurrence of stroke, heart attack, and PVD, which are often caused by blood particles or debris breaking away from diseased arteries where blood coagulation (clotting) has taken place.

High levels of HDL are associated with a lower rate of CHD. As little as a 10 milligram per deciliter increase in HDL can decrease the risk of heart disease by almost half (Byrne 1991). Most HDL is generated by the liver and small intestine.

Although diet has little effect on increased HDL production, exercise and weight reduction seem to be the most effective approaches for increasing HDLs. An increase in HDL may take several months and could be preceded by an initial decrease. As for most health gains, patience, consistency, and moderation rule.

Intake of alcohol has been touted, quite popularly, as a means for increasing the "good cholesterol." Byrne (1991) reported that moderate intake of alcohol can raise HDL by about five milligrams per deciliter. An increase of HDL from 30 to 35 equals a 16.7 percent increase. An increase from 60 to 65 equals an increase of 8.3 percent. As noted previously, an increase in HDL by as little as 10 milligrams per deciliter may halve one's risk for heart disease. Statistically, these numbers deserve consideration,

but you also need to look at the total health picture before recommending this approach to your clients.

First, "moderate" is described as three beers, or two glasses of wine, or two ounces of 100-proof whiskey. The cholesterol increase occurs in a type called HDL-3. Its role in prevention of CHD is not clearly proven. Because the protective benefit is not 100 percent proven, many professionals find it difficult to recommend alcohol intake as a general preventive measure to the public. On the other hand, the negative health consequences of excessive alcohol intake are well documented.

HDL is the key in making the body's reverse cholesterol transport system operate. The outcome of this process is a healing and reversal of the atherosclerotic process. Once HDL picks up cholesterol (free cholesterol or nonesterified) from the other tissues, blood, and arterial walls, it is converted to a cholesterol ester, which prevents it from reentering the arterial wall (Byrne 1991). The cholesterol eventually ends up at the liver, where it is removed or absorbed.

Even though a high HDL level of 60 milligrams per deciliter or greater seems to be protective, the deposit of cholesterol is caused by LDL. Many experts contend that the primary focus of a cholesterol management program is to maintain ideal or lower levels of LDLs. High HDL levels do not exclude the possibility of cholesterol deposition by LDLs. It is apparent that all factors of the blood cholesterol and lipid profile must be managed.

Very Low Density Lipoprotein (and Chylomicrons)

Fat or triglycerides are carried by two lipoproteins. Chylomicrons transport absorbed dietary fat from the intestines to the liver, whereas VLDLs carry triglycerides manufactured in the liver to the rest of the body (Byrne 1991).

Chylomicrons have no impact on CHD and atherosclerosis. Their biggest presence is observed up to several hours after a meal. Because blood is drawn (i.e., for testing purposes) after at least a 12-hour fast for an individual blood panel, nearly all of the triglycerides present in the blood will be contained in VLDLs. Generally, triglycerides refer only to VLDL triglycerides (Byrne 1991).

VLDL contains little cholesterol but large amounts of triglycerides or fat. A large intake of simple sugars, a high-fat diet, excessive consumption of alcohol, and being overweight can contribute to high VLDL levels.

Triglycerides are regulated by hormonal influence and eventually release their fat to the cells of the body. In doing so, these large lipoproteins shrink into smaller LDLs. This physiological link between a high VLDL level and the resultant transformation to LDLs is good reason to keep triglyceride levels down. Triglycerides do not accumulate in the bloodstream like cholesterol because they can be used for energy with resultant end products of carbon dioxide and water. But, if the VLDL is degraded to the "bad guy" LDL, there are more receptor sites to which cholesterol can attach. In combination with the fact that high VLDL levels are associated with depressed HDLs, it seems prudent to keep triglyceride levels below 200 and preferably below 150 milligrams per deciliter. Table 23.2 provides ideal levels and commonly cited ranges of cholesterol and blood-borne fats.

Lowering Cholesterol

After receiving this information, your clients are going to want to know how to lower their cholesterol. That is natural, and you are in the perfect position to facilitate this interest. Here is what your clients have to do.

To lower cholesterol, they need to lose weight, exercise regularly, eat less saturated fat, cut back on cholesterol in foods, eat less trans fat (partially hydrogenated oil), and eat more fruits, vegetables, and other foods high in fiber.

Losing as little as 5 to 10 pounds can make a difference. Losing weight can raise HDL levels and lower LDLs, triglycerides, and blood pressure and help prevent diabetes. Exercise that raises one's heart rate, done as little as three times per week for a total of 30 to 90 minutes per week, can raise HDLs, lower LDLs and triglycerides, decrease blood pressure, help maintain weight, and help prevent diabetes.

A diet low in saturated fat and cholesterol will lower LDL, triglycerides, and cholesterol. Diets rich in **soluble fiber** may lower LDL

TABLE 23.2 Cholesterol and Blood-Borne Fats: Ideal Levels and Commonly Cited Ranges, in Milligrams per Deciliter

	Ideal	Range
Total cholesterol (TC)	<160	140-240
High-density lipoprotein	>60	35-75
Low-density lipoprotein	<100	100-130
Triglycerides	<150	150-250
Very low density lipoprotein (triglycerides divided by 5)	<30	30-50
TC/HDL ratio	<3.5	3.5-4.5

(blood cholesterol) and help control blood sugar levels of people who have diabetes. Soluble fiber is found in oat bran, barley, kidney beans, fruits, and vegetables. Diets rich in **insoluble fiber,** mainly the indigestible cellulose commonly found in the skins of fruits and vegetables and in the coverings of whole grains, such as wheat bran and some cereals, encourage good intestinal function and elimination. A diet low in saturated fat and cholesterol and high in fiber and vegetables also may reduce the risk of cancer, and the high amounts of folic acid (good sources are cereals, lentils, beans, spinach, romaine lettuce, wheat germ, peas, orange juice, and broccoli) present in this type of diet may further lessen your risk for heart disease. Eating less hydrogenated or trans fats will decrease LDL levels ("Trans: The Phantom Fat" 1996).

You can help your clients identify these foods, or refer clients to a registered dietitian.

Increasing HDL Cholesterol

HDL levels of 60 or more are considered desirable. A reading of 35 to 39 is intermediate and below 35 is low. HDLs are described as the cholesterol carrier that scours the blood for debris that could lead to CHD, attaches to it, and transports it out of the arteries. An HDL below 35 is a heart attack risk even if cholesterol is below 200. This is evident from a TC/HDL ratio that equals 5.7, found when using a value of 200 for cholesterol that is divided by an HDL of 35. A low HDL reading indicates that even small amounts of cholesterol in the bloodstream are not being handled effectively by the body. To raise HDL, individuals must do the following:

- Lose weight
- Exercise regularly
- Quit smoking

The impact on CHD of moderate to regular activity and a healthy lifestyle cannot be overstated.

Lowering Triglycerides (VLDLs), the Fat in Your Blood

Your clients can lower triglycerides by losing weight, exercising—even at a moderate intensity—decreasing saturated fat intake, and cutting back on cholesterol-laden foods. An exception to these rules follows.

Your clients may already be eating a low-fat, high-carbohydrate diet. If they still have high triglycerides and low HDLs, consider adding a tablespoon of olive, canola or 100 percent vegetable oil to their diet. A tablespoon of oil has 120 calories and may be used in food preparation. Or, add a quarter cup of nuts to the diet. This strategy may raise HDL and lower triglycerides. However, weight gain still needs to be avoided, and a dietary increase in fat is what most clients do not need.

Blood Pressure

NCEP does not recognize blood pressure as a risk until it is greater than 140 systolic and 90 diastolic. However, if your client's blood pressure is not below 120 systolic and 80 diastolic, an increased risk for CHD and heart attack is present.

The following preventive steps may keep blood pressure from rising or may even lower

it. Losing weight and exercising are the first steps. Eating more fruits and vegetables increases potassium intake, which is helpful. Sodium intake should be reduced to at least 2,400 milligrams per day, preferably less.

Alcohol consumption should be limited to moderate or occasional use. Research indicates that people who limit themselves to one (women) or two (men) drinks per day have a lower risk of CHD than people who do not drink. However, even a drink per day may increase the risk for breast cancer in women, and more than two drinks per day may increase the risk of high blood pressure in women and men. Alcohol abuse should also be considered when weighing the option to drink or not to drink.

CHD Therapies

Given that in most cases the controllable risk factors can be improved—sometimes dramatically—with a healthy diet and exercise, why don't people *just do it?* Perhaps the answer lies both in human nature and the capabilities of modern medicine.

When faced with the uncertainty of how to minimize their risk for CAD, many clients make drugs their first choice. Often this decision is made because of fear and lack of information and professional direction on how to control these risks.

The NCEP suggests drug prescription for high LDL levels only after an exhaustive attempt to use exercise and diet has failed. However, many people fail to follow this more conservative recommendation and opt for the quick fix. I believe drugs should be reserved for special circumstances where honest attempts at diet and exercise have failed. Even if drugs are required, they should not be used to the exclusion of healthy lifestyle choices related to proper food selection and moderate and regular exercise.

In a study that was once thought to be highly provocative, physician Dean Ornish showed that people with CHD were motivated to make profound changes in their lifestyle and were able to reverse arterial blockage (Ornish et al. 1990).

The control group was asked to quit smoking, exercise more, and reduce dietary fat intake to 30 percent of calories. The experimental group ate a vegetarian diet with almost no cholesterol and 7 percent fat. They also participated in stress reduction by practicing meditation, stretches, and deep relaxation. Smoking was prohibited and they exercised at least three hours per week.

The results were dramatic. In one year, the participants in the stricter regimen improved their hearts and arteries, whereas CHD worsened in 50 percent of the control subjects. On an average, coronary blockage decreased 10 percent in the experimental or stricter group but increased slightly in the control group. Also, the experimental group lost an average of 24 pounds, whereas the control group gained an average of two pounds. What contributed most to these results? Was it diet, exercise, weight loss, stress reduction, group support, or a synergistic total? Diet and exercise surely played a big role, in addition to the experimental groups' commitment and dedication to significant changes in their lifestyles.

Will the preceding approach work for your clients? Skepticism remains toward this approach because compliance is the key to success. Can this type of lifestyle intervention be effective for a population that resists cutting fat to a recommended 30 percent level? Ornish et al. (1990) argued that it is easier to motivate people to make big lifestyle changes than small ones. Individuals who make small changes still feel deprived, and they usually experience no reductions in cholesterol or angina symptoms. On the other hand, many experts believe that less extreme changes will lead to a decreased risk for CHD. Any change is better than no change. Sometimes your clients can be set up for failure if a strict, all-or-none approach is advocated as the only remedy. However, an extreme approach seems to work well with individuals who are faced with a choice of life or death.

Many physicians and nurse cardiac specialists prefer primary intervention programming similar to Ornish's but outline less drastic measures. **Primary intervention** is characterized by a conservative, less invasive, approach to lifestyle and behavior change. This is in contrast to more radical treatments like drugs and surgery. Effective primary intervention can involve less drastic lifestyle and behavior changes than those used in Ornish's program, which he believed were necessary to reverse

CAD. However, if your client wants significant results or is facing life-threatening CHD, the Ornish approach might be a perfect fit. With your support, motivation, and knowledge, your clients can succeed. For the majority of apparently nondiseased participants, preventing CAD involves consistency, adherence, and moderation in their approach to diet and exercise.

Prevention Bridge

By understanding the risk factors associated with cardiovascular and other artery disease, you have the potential to improve each client's health status far beyond fitness improvement only. For example, you can take time during a session to explain the terminology and issues surrounding fats, cholesterol, and blood pressure, whereas a client's physician often does not have this time available. Exercise and diet significantly affect risk factors. While helping to improve your client's overall health, you are strengthening links to the medical profession.

Special Section: Interpreting Blood Panel Reports

Recently, my 73-year-old mother added a P.S. about her blood panel in a letter to me.

> P.S. I had my checkup. My cholesterol is down from 257 to 247 (I know this is still too high). HDL was 76, now 78; LDL was 139, is now 135; triglycerides were 211 and now 172. What do you think? Bye for now, Mom

How would you advise and encourage my Mom? A set of specific questions need to be answered:

- Is Mom on the right track?
- Is her cholesterol too high in relation to HDL?
- Should she increase her HDL?
- How can she decrease her triglycerides?

You'll be able to figure out the answers by reading the following information and reviewing previous sections in this chapter. At the end of this section, you'll have a chance to compare your analysis with mine.

How the Report Looks

A typical blood profile, blood work-up, or lipid panel consists of a total cholesterol (TC) reading that reflects how cholesterol and fat are carried in the blood. Lipoproteins include HDL, LDL, VLDL, and chylomicrons. They allow cholesterol and other blood lipids, which are fat soluble, to exist in the watery medium of blood. Lipoproteins transport and regulate blood lipids (Byrne 1991).

In figure 23.1, VLDL, LDL, and TC/HDL ratio are calculated by using the given values for TC, HDL, and triglycerides (VLDL) as determined by a blood analysis.

Note the difference in risk for CHD between the two measurement dates because of the increase in HDL. HDLs have increased to a protective level and LDLs have decreased to 123 milligrams per deciliter, which is below the ideal level of 130 milligrams per deciliter. Although the ratio for TC/HDL exhibited in the first test date is considered normal or an average risk for CHD in the United States, your clients can hardly afford being lumped into "normal." Statistically, normal is neither safe nor protective in this instance. The second test date reveals that TC/HDL ratio has changed to 3.23, which reflects an ideal level.

How the Lab Reports Triglycerides

Triglycerides are simply fat. Very low density lipoproteins (VLDLs) are the same as triglycerides but are an expression of triglycerides divided by 5. Many labs give triglyceride information in the form of VLDLs. To convert this to a standard that is more understandable or familiar to most consumers, VLDLs are multiplied by 5. For example, a 30 milligram per deciliter VLDL reading is converted to triglycerides by multiplying by 5. The resultant 150 milligram per deciliter triglyceride reading is the same, in terms of blood fat levels, as a 30 milligram per deciliter VLDL reading.

Converting Blood Values to International Units

The following conversion factors are used to convert blood cholesterol and lipid values reported in milligrams per deciliter to interna-

Client: JoAnn Date: 6/15

Lab analysis report:

TC = 210; HDL = 42; triglyceride = 110
VLDL = 110 (triglycerides) divided by 5 = 22
LDL = 210 (TC) − [42 (HDL) + 22 (VLDL)]; LDL = 146 (ideal ratio <130)
TC/HDL = 210/42 = 5 (ideal ratio is < 3.5)

Client: JoAnn Date: 9/15

Lab analysis report:

TC = 210; HDL = 65; triglyceride = 110
VLDL = 110 divided by 5 = 22
LDL = 210 − (65 + 22); LDL = 123 (ideal < 130)
TC/HDL = 210/65 = 3.23 (ideal ratio is < 3.5)

Note: TC = total cholesterol; HDL = high-density lipoprotein; VLDL = very low density lipoprotein; LDL = low-density lipoprotein.

FIGURE 23.1 Sample lab analysis.

tional lipid units, which are expressed in millimoles per liter. Converting blood measurements into units of measurement that are familiar will help you accurately interpret research and individual lab reports.

Cholesterol (representation includes values for TC, or HDL, or LDL levels multiplied by the conversion factor)

- When reported in milligrams per deciliter ×.02586 = cholesterol in millimoles per liter

Triglycerides or VLDL (representation includes reported triglycerides or VLDL level times the conversion factor)

- When reported in milligrams per deciliter × .01129 = triglycerides in millimoles per liter

Conversely, if you need to convert measurements in millimoles per liter to milligrams per deciliter, multiply the cholesterol level given in millimoles per liter by 38.67. Multiply the triglyceride level given in millimoles per liter by 88.57 (Byrne 1991).

Interpreting the Numbers

To help your clients interpret cholesterol and blood fat information, share with your client the information in tables 23.1 and 23.2. Most blood reports from labs show a value for TC, and this reflects cholesterol and fat contained in LDL, HDL, and VLDL. However, only HDL and VLDL (remember, triglycerides equal VLDL value times 5) are measured directly. LDL is usually calculated by using the following formula (Byrne 1991), as opposed to actually being measured.

To calculate LDL, use this formula and the blood values derived from the laboratory for TC, HDL, and triglycerides (VLDLs). See figure 23.1.

LDL formula:

$$LDL = TC \text{ (total cholesterol)} - [HDL + VLDL \text{ (triglycerides divided by 5)}].$$
$$LDL = TC - (HDL + VLDL)$$

Evaluating Mom's Report

How did you do? Here's my analysis:

Mom is certainly on the right track. Although some of her improvements are small, even maintenance should be applauded because it's better than regression of any sort. She has decreased her total cholesterol, raised her HDL two points, decreased her LDL, and significantly lowered her triglycerides. Her HDL

increase from 76 to 78 remains in the ideal range, which is a protective factor.

In fact, even though her cholesterol reading of 247 is well above 200 and the ideal of 160 milligrams per deciliter or less, Mom's TC/HDL ratio is only 3.17 (247 divided by 78). Her TC to HDL ratio falls in the ideal range. This information reveals that her body, because of her excellent HDL levels, is handling the higher amounts of cholesterol in her blood effectively. Even though her total cholesterol reading is high, she is at no apparent increased risk for heart disease. She needs to continue working on dropping her cholesterol, LDL, and triglycerides.

Mom can decrease her triglycerides by continuing to decrease her saturated and trans fat (hydrogenated oils) intake as well as any excessive simple sugar (refined) or alcohol consumption. Because some triglycerides (VLDLs) are converted to LDLs (the "bad guy" cholesterol), controlling triglycerides will help decrease LDL. Overall, Mom should receive a thumbs-up for her results and efforts!

Training the Cardiac Patient

Coronary heart disease (CHD) is lethal. Its onset can be insidious (often its first symptom is death), and CHD is one of the leading killers of both men and women. Although there is no certain cure, consistent evidence suggests that atherosclerotic plaque formations can be reversed to some degree with intensive risk factor modification (see chapter 23). An aggressive approach would include helping your client improve her overall risk factor profile by lowering body fat, blood pressure, and blood cholesterol and increasing overall levels of everyday activity. A regular and systematic approach to exercise may be the most powerful nonpharmacological method to favorably alter cardiac risk factors. Intensive risk factor modification can decrease the mortality rate associated with CHD and lessen a patient's likelihood of a second heart attack.

Role of Personal Trainers

Personal trainers are usually presented with two levels of training for patients with CHD (La Forge 2000).

Level 1 training involves a medically referred patient who has, for example, just undergone bypass surgery or experienced a heart attack. These types of cases are usually taken by advanced-practice personal trainers or exercise physiologists who have formalized training and advanced degrees in exercise science and who are experienced in taking direct physician referrals for primary cardiac rehabilitation.

Level 2 training is commonly referred to as post–cardiac rehabilitation or "maintenance phase" exercise therapy. Overseeing programs at this level is generally within the qualifications and scope of practice of qualified, experienced personal trainers. This chapter focuses on level 2 status.

Trainer Qualifications

Trainers who want to work with anyone who has a chronic condition must meet any national and state or province standards of professional competency. Your program must meet the current guidelines that exist for working with such conditions. Advanced training in the area of "clinical exercise specialist" is strongly recommended for trainers who want to work with CHD patients and attending physicians. You need a working knowledge in the following areas:

1. Pathophysiology of coronary disease (see chapter 23)
2. Exercise and its impact on CHD risk factors (see chapter 23)
3. Basic exercise response to the various classes of cardiac drugs
4. Clinical exercise testing results and their applications
5. Cardiac exercise contraindications
6. Exercise prescription methodology for CHD patients
7. Emergency procedures and basic life support (La Forge 2000)

Can you speak the language? Can you work with a high-need client? These are two questions that come to mind regarding clients who have special needs. Refer to chapter 1 and the introduction to part IV for insight that helps you answer these two questions.

Key Training Objectives

A trainer has two primary objectives when training a client with CHD. First, provide individualized, safe, and effective exercise that is in line with limits established by referring physicians or associated health care providers.

Second, provide risk factor modification education in conjunction with physician recommendations. I can't overemphasize the importance of the trainer playing a positive role in encouraging the CHD patient to engage in an active lifestyle and helping the client make sensible nutrition choices. Prevention and regression of CHD are possible!

Training a Cardiac Patient

ACSM (1995) cites the following points as critical for progressing a CHD patient to a less medically supervised environment:

1. The patient's functional exercise capacity is greater than or equal to eight metabolic equivalents (METs) or twice the level of the patient's occupational demand.

2. The patient has an appropriate hemodynamic response to exercise (e.g., normal increases in heart rate and blood pressure).

3. There is an appropriate electrocardiogram (ECG) response to exercise (i.e., no ischemic changes or serious arrhythmia).

4. Cardiac symptoms are stable (i.e., stable and controlled baseline heart rate and blood pressure).

5. There is adequate management of, and success in modifying, CHD risk factors.

6. The patient has demonstrated adequate knowledge of the CHD process, related symptoms, and medications.

Comprehensive cardiac rehabilitation programs usually address all of these issues before the patient is released to a less controlled and less medically supervised setting. If you're not sure the patient is ready for exercise and follow-up behavior modification training with you, check with the patient's cardiologist.

Generally, unless your expertise dictates otherwise, you should look to train patients who have "stable CHD," in other words, either referred patients who have no symptoms or those who have stable or controllable symptoms. Ask the referring physician whether your new client has stable CHD, and, if not, determine what precautions must be taken or refer the patient to someone with more expertise. The box on this page provides a useful pretraining checklist.

Pretraining Checklist

Yes	No	
❑	❑	Have you obtained written informed consent from both the client and physician?
❑	❑	Has your client been classified as medically stable by the physician?
❑	❑	Are you familiar with the client's past medical history and present health status (including nutrition)?
❑	❑	Are you familiar with other coexisting medical conditions and symptoms the client may have?
❑	❑	Do you have a list of the client's medications and know how they may affect the exercise prescription and response to training?
❑	❑	Are you currently trained and certified in CPR?
❑	❑	Do you have an emergency response plan in place?

Exercise Guidelines

For referred patients who have stable CHD, the following exercise guidelines reflect the current recommendations set forth by ACSM (1995), ACSM (1997), and the American Association of Cardiovascular and Pulmonary Rehabilitation (AACVPR 1999).

Note that nearly all of the types of exercise and intensity levels that trainers use with apparently healthy and asymptomatic clients can potentially be used in programs designed for CHD patients with stable coronary disease.

Cardiorespiratory Endurance Activities

Exercise intensity. Exercise intensity for the cardiac patient ranges from 40 to 85 percent of maximal oxygen consumption ($\dot{V}O_2$max) or heart rate reserve (HRR).

How to monitor intensity. Three common methods are suggested to accurately monitor level of effort and ensure safety of the CHD patient:

1. Use a heart rate (HR) range provided by the attending physician that was obtained while the CHD patient was in a medically supervised setting and, if appropriate, while the patient was medicated.

2. Use the Karvonen formula, with physician direction, to calculate training range because this calculation correlates directly to $\dot{V}O_2$max (see chapter 17).

3. Use a rating of perceived exertion, or RPE, (see chapter 17).

Exercise frequency. The cardiac patient should exercise three to five times per week.

Exercise duration. Cardiorespiratory sessions can last 20 to 40 minutes per session for someone who previously had a heart attack and 20 to 60 minutes per session after bypass surgery or angioplasty. An adequate warm-up and cool-down of 5 to 10 minutes is critical to limit avoidable cardiac incidents related to abnormal heart response or function (see chapter 15, sections on warm-up and cool-down).

Exercise modes. A variety of activities that are appropriate include walking, jogging, hiking, cycling, rowing, aerobic circuit training, and water-based exercise.

Resistance Training

Properly supervised, high-intensity (not just aerobic circuit training) strength training appears to be a valuable, safe part of a comprehensive cardiac rehab program in select and properly screened cardiac patients. The apparent value is an earlier acquisition of muscle strength and endurance, which may allow patients to return more quickly and confidently to their usual activities because they feel less fatigued. Strength training also can improve or help to modify cardiac risk factors by improving body composition and maximal treadmill exercise time (Rubin 1999).

Traditionally, post–cardiac rehabilitation protocols for resistance training have called for loads that are about 40 percent of maximum lifting capacity (Drought 1995). More recently (AACVPR 1999), guidelines for rehab programs have called for a weight load that can be lifted comfortably 10 to 12 times. Note that this is not a recommendation for 10 to 12

repetitions to failure or exhaustion. Thus, this corresponds to approximately 60 to 65 percent of maximum or 1RM resistance. This seems to be a more realistic recommendation for producing strength compared with previous recommendations that called for 40 percent. Some research (Faigenbaum et al. 1990; Ghilarducci, Holly, and Amsterdam 1989) reveals that up to 80 percent of maximum may be safe for selected cardiac patients. Before choosing load, be sure to discuss the patient's unique requirements with the attending physician.

When to begin resistance exercise. Indications that the client is ready to begin resistance training include (ACSM 1995) the following:

1. Six weeks have passed since uncomplicated myocardial infarction (heart attack) or bypass surgery.

2. Two weeks have passed since angioplasty, without occurrence of myocardial infarction.

3. The patient has completed four to six weeks of supervised aerobics or phase II cardiac rehab.

4. Resting diastolic blood pressure is less than 105 millimeters of mercury (mmHg).

5. The patient exhibits a peak exercise capacity of greater than 5 METs.

6. The patient is not compromised by congestive heart failure, unstable symptoms, or arrhythmia.

Mode or type of resistance training equipment or programming. Modalities can include free weights, machines, elastic resistance, wall pulleys, dynamic forms of yoga, and circuit resistance training.

General guidelines for resistance training. Following are sensible and effective resistance training guidelines (AACVPR 1999):

1. Exercise large muscle groups before smaller muscle groups.

2. Increase loads by 5 to 10 pounds when 12 to 15 repetitions can be performed. (Note: Smaller or microload increases are certainly acceptable. Err on the side of progressing in a conservative manner. Increasing by no more than 5 to 10 percent of the resistance being lifted is an excellent rule.)

3. Train strength with slow, controlled movements and exercise through a full range of motion.

4. Exhale during the exertion phase of the lift.

5. Avoid sustained gripping with the hands (use a relaxed, loose grip while still maintaining control), which can evoke excessive blood pressure and heart rate responses.

6. Minimize rest periods when appropriate to maximize muscular endurance.

7. Avoid straining and breath holding or forcing reps (don't struggle with the load).

8. Do not exercise to muscle failure, which is the inability to do another repetition.

9. Stop exercise if warning symptoms appear that include dizziness, shortness of breath, irregular heartbeats, or arrhythmia or chest discomfort.

10. Do not perform resistance exercises with patients who have documented congestive heart failure, uncontrolled arrhythmia, severe valvular disease, uncontrollable high blood pressure, or unstable symptoms such as chest pain.

Medications and Coronary Heart Disease

When pharmacological agents are prescribed properly, they enable cardiac patients to exercise safely and effectively and limit the likelihood that exercise-related cardiovascular symptoms will occur. Many heart patients are prescribed drugs that change exercise heart rate and blood pressure response and can even limit exercise capacity. Generally, you should be knowledgeable about the following cardiovascular drug classes and their effect on basic cardiovascular responses. These drug categories include beta-blockers, alpha-blockers, nitrates, digitalis, calcium channel blockers, diuretics, vasodilators, angiotensin-converting enzyme inhibitors, and antiarrhythmic agents. Work with a physician to understand their effects and how their use affects the workout protocol.

Safety Considerations

Be aware of abnormal symptoms. Chest discomfort, lightheadedness, dizziness, or a general feeling of lassitude indicates a need to discontinue exercise. If concerns remain, immediately consult a physician. Avoid exceeding exercise thresholds that bring on these symptoms, and realize that these manifestations can occur hours after the exercise session or the following day.

Avoid exercising after a meal. CHD patients should not exercise for at least 90 minutes, and preferably two or more hours, after full meals.

Avoid sudden onset or session of exercise. CHD patients should not start exercise without an adequate warm-up, and progression to higher levels of intensity should be graduated. Choose cardiorespiratory exercise that provides gradual increases in workload. Require sufficient warm-up and cool-down periods.

Regulate water-based exercise. Water temperature should range from 80 to 92 degrees Fahrenheit. Cold water can increase blood pressure, and water that is too hot will decrease blood pressure and increase heart rate response. Improper temperature also leads to low compliance rates.

Avoid exercise in polluted environments. Exercising in polluted environments is a hazard to health. The cardiac patient has additional concerns if ozone or particulate matter is particularly high because this can impair or compromise cardiac and pulmonary function. When the pollution standards index (PSI) is greater than 100, exercise outdoors should be avoided.

Avoid exercise when viral infections are present. CHD patients should not exercise when they have viral infections, because the heart muscle and the membrane surrounding the heart (pericardium) can be adversely effected (La Forge 2000).

Post–Cardiac Rehabilitation

Post–cardiac rehabilitation or maintenance phase exercise therapy must be combined with disease management for a complete approach to helping heart disease survivors maximize recovery efforts; such a multiphase program

of medical care can help restore the cardiac rehab patient to a full and productive life. Exercise training has become a widely accepted therapeutic modality for CHD patients and has become a central focus in many cardiac rehabilitation and follow-up maintenance programs.

Unless you are a trained specialist in rehabilitation of cardiac patients, it is more than likely that your first encounter with this type of client will be when the patient has been categorized as "late out patient," is in a community rehabilitation exercise program (sometimes referred to as phase III), or is ready to enter phase IV of rehabilitation. A phase IV program is generally a maintenance program and often follows general principles of exercise prescription that are used with apparently healthy people. Regardless, a maintenance program for a cardiac patient usually infers that the patient is entering into a less medically supervised training environment and has stable or controlled CHD.

By the Way, What's a MET?

A MET is the term used to describe a multiple of the resting rate of oxygen consumption ($\dot{V}O_2$ at rest). One MET equals volume of oxygen at rest ($\dot{V}O_2$ at rest), which is approximately 3.5 milliliters per kilogram of body weight per minute. A 2 MET activity indicates an individual is consuming oxygen at twice the resting rate, whereas a 10 MET activity is 10 times the resting rate (10×3.5 milliliters per kilogram of body weight per minute).

Why METs? It's conventional in clinical or hospital settings to express $\dot{V}O_2$ in MET equivalents. This has become the common language of institutions to express oxygen consumption in this unit of measurement.

What do I do with METs? Normally, a given MET level correlates to a given workload on a treadmill, cycle ergometer, or other activity. Various nomograms and charts will indicate the workload equivalent to elicit this appropriate MET or oxygen consumption response. In other words, you have to identify activities that require energy expenditure that falls in that MET range. Sound confusing? It is!

For the typical personal trainer and heart patient, I believe (and ACSM presents the same position) that it is better to work with actual heart rate (HR) training ranges in combination with perceived exertion (RPE). It's simple. If the specialist prescribes a MET level for a patient, ask the doctor what HR and RPE correspond with this MET intensity.

Furthermore, ACSM cautions that the use of METS for activity prescription should be conducted carefully, especially outside of a clinical setting. I believe that clients should know appropriate HR and corresponding RPE for the activity and should check their HR response regularly or use a wireless heart rate monitor for constant feedback. ACSM states that this is especially true for patients with heart disease. Heart rate is a much better indicator than estimated MET level of the appropriate exercise intensity relative to the myocardial (heart) oxygen supply and demand status.

MET equivalents have many advantages in a clinical or research setting, but HR and RPE are more practical and efficient at the maintenance phase level for both the trainer and the cardiac patient.

Case Study: Post–Cardiac Rehabilitation Is More Than Just Exercise

The following scenario describes a patient who has been moved into the phase IV, maintenance, or outpatient category of cardiac rehabilitation.

After having coronary bypass surgery, Carl entered a community-based exercise program after 12 weeks of rehabilitation in a closely supervised hospital setting. At this stage of rehabilitation Carl had clinically stable angina, medically controlled dysrhythmias during exercise, a knowledge of warning symptoms, and the ability to self-regulate his exercise. In other words, Carl was following an exercise prescription of appropriate frequency, intensity, and duration that did not put him at risk for further cardiac complications or death. Coupled with patient education and other intervention methods, such as diet awareness or smoking cessation, this is the right path for Carl. Participation in a safe and effective exercise program

combined with behavior modification, and continuing both for a lifetime, become the common goals of client, trainer, and physician.

Carl is now ready to move to a less supervised or an unsupervised program. This is where the personal trainer can complement the medical community and the cardiac patient. The trainer can encourage regular physical activity within the parameters established by the medical community, play a big factor in patient adherence to a lifelong program, and encourage regular medical follow-up and diagnostic exercise testing by medical personnel. The trainer also can influence positive behavior change in other areas of the client's life as related to risk factors and an ongoing healthy lifestyle.

Getting Started With Carl

Carl wants to work with you, or a physician has referred Carl to you for continuation of rehabilitation into the maintenance phase. What kind of aerobic program would you use? Would you implement a resistance training program? What do you do with METs, and what concerns do you have about Carl's medications?

The answer is to take the pressure off of yourself. It's not incumbent or appropriate for the trainer to diagnose and prescribe. If diagnosis and prescription have not already been provided by a health care professional, you probably should not be working with this client. If an individual contacts you to train, insist that you are given access to his specialist and obtain the needed information. If a doctor refers a patient to you, the information usually will be provided automatically.

Because Carl is ready to enter into a maintenance phase, it is likely he has a functional capacity (VO_2) of greater than 5 METs. Because he has already gone through an intensive and closely monitored rehabilitation, general exercise prescription methods are usually applicable. According to the ACSM, the patient's exercise prescription should gradually be increased to a duration of 45 minutes or more, at 40 to 85 percent of functional, not maximal, capacity. For example, if symptoms are exhibited at a heart rate of 160, a training range would be established by taking 40 to 85 percent of 160 beats per minute, or a similar MET equivalent could be used. Carl would likely be encouraged to partake in three to four sessions per week.

Intensity is based on Carl's current status and any pathological abnormalities that may exist. Thus, you see the obvious need for an ongoing dialogue with Carl's specialist to update any exercise protocols. In addition, besides exercise instruction, a primary goal of the trainer is to promote exercise adherence through client motivation and education.

Should You Use Resistance Training With Carl?

Resistance training is beneficial for a majority of CHD patients who have been adequately evaluated. As Carl becomes stronger through resistance training, he can perform more strenuous activity at a lower percentage of maximal voluntary contraction. This gives him a safety buffer for potential stress overload on his heart.

Primary concerns range from exaggerated blood pressure response, the possibility of ventricular arrhythmias, and adverse effects on the left ventricle attributable to pressure overloads, often brought on by a Valsalva maneuver (sustained breath holding) and lifting weights that are too heavy.

Because aerobic circuit protocols have proven to be very effective when used with CHD patients, it makes sense to start Carl on such a program using weight machines (La Forge 2000). It's usually easier to learn how to use and adjust the machinery, and machines require less balance and skill, are time efficient, and develop both muscular endurance and aerobic capacity if the program is properly designed.

Current research acknowledges that increasingly aggressive strength training, or high-intensity strength training, can take place with select cardiac patients in a properly supervised setting. This type of training appears to be a valuable and safe part of a comprehensive cardiac rehab program (Beniamini et al. 1999). If you decide to set up an aerobic circuit resistance training program, see the guidelines on the next page.

What About Medications?

Carl is medicated with a beta-blocker. The first step is to identify characteristics of the prescribed drugs and educate yourself about their effects. Beta-blockers generally mediate

cardiac stimulation (slow the heart rate) and relax the vascular (blood vessels) and bronchial smooth muscle. Generally, beta-blockers lower resting and exercise heart rate and blood pressure. Armed with this information as obtained from a *Physician's Desk Reference* for medications or other sources, next ask the physician the following series of questions. Is it important when Carl takes the medication in relation to when he exercises? Are there any side effects you should be aware of so you can continue to motivate Carl toward exercise and medication compliance? And finally, what is Carl's training heart rate range (THRR) prescription and associated RPE? The THRR and RPE are based on Carl's individualized graded exercise test, conducted while Carl was on medication. Obviously, a beta-blocker will affect Carl's heart rate response to any given workload from rest to vigorous activity. It's essential to have a specific THRR prescription and associated RPE, as opposed to calculating heart rate training zones based on nonmedicated exercise or estimated maximal heart rates.

The Serious Part Is Over— Make It Fun!

With proper medical supervision and careful progression of the postcardiac program, Carl's recovery should be aggressive, energetic, full of optimism, fun, and successful. However, you can only go forward with confidence if specific parameters have been carefully created by his specialists and if Carl consistently exercises and takes his medication. In this case study, you are aware of Carl's danger zone because you asked for a THRR prescription. A danger zone is an exercise response and intensity level that could cause symptoms such as angina or could put Carl at risk for other complications or death. Training should stay well below any such zone.

Don't Forget That Exercise Alone Isn't Enough

Specific and prescribed exercise isn't enough. A personal trainer can heighten Carl's awareness and motivation to modify other factors that contribute to heart disease. Prevention is the key. A sedentary lifestyle is only one of many coronary risk factors (see chapter 23).

Your perceived value and worth as a trainer are increased by encouraging and guiding Carl toward consistent and increased physical activity and by helping him reduce saturated fat and cholesterol in his diet, attain a lower body fat percentage, stop smoking, control high blood pressure, lower stress, and treat diabetes concerns.

With ongoing communication, follow-up medical evaluations, and motivational and diet awareness interventions, Carl is on the road toward resuming his busy, productive, and energetic life.

Aerobic Circuit Resistance Training (CRT) Guidelines

1. Select approximately 10 to 12 exercises for the circuit. Be sure to include large-muscle group exercise such as leg presses.

2. Set weight resistance at each station at 40 to 60 percent of the patient's maximum achievable load.

3. Your client should be able to perform 12 to 15 repetitions in a controlled fashion (no faster than two seconds lifting and two seconds lowering)—slower is okay.

4. Ensure proper breathing techniques, body position, and range of movement.

5. Generally, the circuit should last 30 to 45 minutes and workloads should be geared to the patient's functional capacity.

6. Ensure that adequate warm-up and cool-down exercises are performed and that the resistive loads are progressed in a conservative, graduated fashion.

7. Have the client rest 15 to 30 seconds between each exercise or enough to ensure adequate recovery yet still challenge the patient's muscular endurance.

Continued ➤

➤ *Continued*

8. Sessions can consist of two to three circuits, depending on the time it takes the client to complete the aerobic circuit. Aerobic CRT can be done two to three times per week.

9. Training intensity is relative to the individual prescription, goal oriented, and monitored individually. Eliminate peer competition or comparison with performance norms.

10. Maintain training logs to record workloads, reps, and sets (and heart rate and blood pressure if indicated by prescription), and be prepared to deliver copies of these records to the attending physician. Maintain records for all programming aspects of the CHD patient even if not required to by the physician.

Determining Starting Load

Warning. Do not test 1-repetition maximum (1RM) or, in other words, the client's ability to lift maximally to determine a starting weight.

The solution. Guess on the side of lifting too light until your client can perform 12 to 15 repetitions in a controlled manner.

Cardiac Clients: Suggested Reading

For more information than the works cited in the chapter provide, check into these resources:

American Association of Cardiovascular and Pulmonary Rehabilitation. 1999. *Guidelines for Cardiac Rehabilitation Programs.* 3rd ed. Champaign IL: Human Kinetics.

Fardy, P., and F. Yanowitz. 1995. *Cardiac Rehabilitation, Adult Fitness and Exercise Testing.* 3rd ed. Philadelphia: Williams & Wilkins.

Gordon, N., and L. Gibbons 1990. *The Cooper Clinic Cardiac Rehabilitation Program.* New York: Simon & Schuster.

Diabetes Mellitus: Types 1 and 2

Individuals who have diabetes mellitus (commonly referred to as diabetes) have trouble removing sugar from their blood. Blood glucose or sugar is produced when food is digested. Normally, during and after a meal, the pancreas produces the hormone insulin, which enables blood glucose to pass into cells where it is stored or metabolized to produce energy.

Although there is not a cure for diabetes, this disease can be controlled. Blood glucose levels can be lowered and normalized with diet, weight loss, physical activity, insulin administration, and medication.

As was true for cardiac rehabilitation patients (chapter 24), it was not too long ago that exercise therapy for those with diabetes was discouraged or, at least, seriously questioned as to its value and safety. Without a doubt, physical exercise, diet, and weight loss play important roles in the successful management of diabetes (as well as heart disease) and seem to play crucial roles in preventing type 2 diabetes (American Council on Exercise [ACE] 1999; Albright et al. 2000; American Diabetes Association [ADA] 2003; Helmrick et al. 1991; Manson et al. 1991). Exercise can cause some complications with the diabetic and is not always the diabetic's solution to control blood sugar levels. Thus, you need a complete understanding of the disease and its progression, as well as a close working relationship with your client and his health care provider.

Given the benefits and risks of exercise for diabetics, the role of exercise in treating diabetes is backed solidly by research. In many individuals, diabetes of all types can be preceded or exacerbated by inactivity. Many experts believe that exercise is a cornerstone in diabetes management and confers many health benefits (Colberg and Swain 2000).

Effects of Diabetes Mellitus

A person with diabetes (if uncontrolled) not only has an elevated blood glucose (sugar) level or hyperglycemia but usually exhibits less than optimal glucose, fat, and protein metabolism. Diabetes mellitus is characterized as a metabolic disorder, and personal trainers need to understand the effects of uncontrolled blood glucose levels on long-term health.

Understanding Diabetes and Its Impact on Personal Health

The prevalence of diabetes is increasing worldwide. In the United States alone, approximately 16 million individuals have some type of diabetes and about 800,000 more develop the disease every year. Of the entire diabetic population, about 95 percent are categorized as type 1 or 2 diabetics. A vast majority of diabetics (90-95 percent) have type 2 diabetes, and more than 1 million individuals have type 1 (ACE 1999; ADA 2003). Astoundingly, close to one third of those afflicted with the disease are undiagnosed (Colberg and Swain 2000), which means untreated physical complications are mounting silently in the individual that could cause long-term or irreversible damage or contribute to

premature death. Unfortunately, undiagnosed diabetes is allowed to progress, and irreparable damage goes unchecked. Heart disease, stroke, kidney failure, amputation, and blindness are a few of the serious consequences.

Why should you be concerned with your client's blood sugar levels? The end result of untreated diabetes is often severe, to say the least, and life threatening at the worst. Compared with adults who do not have diabetes, those with this disease are three times more likely to suffer from a heart attack or stroke. Add risk factors like smoking, high cholesterol, inactivity, and high blood pressure, and the risk of dying (mortality) or getting sick (morbidity) increases exponentially (see chapter 23).

Classifying and Defining the Cause (Etiology) of Diabetes Mellitus

Diabetes can be classified into four categories (type 1, type 2, gestational diabetes, and secondary diabetes). This chapter focuses on types 1 and 2, which account for 95 percent of the diabetic population. Both types have distinct causes and require different management strategies and understanding.

Generally, the pancreas of individuals who have diabetes either cannot produce insulin or cannot produce enough of it (generally type 1), or insulin is manufactured but the target cells—or the insulin receptors on cells—don't respond because they have become resistant or desensitized to the instructions the hormone is giving them. In other words, the hormone loses its effectiveness. This failure of the cells to respond to the messenger hormone insulin is referred to as insulin resistance and is often the culprit in type 2 diabetes. Insulin resistance syndrome is exacerbated by excess body fat (ADA 2003; Colberg and Swain 2000). The bottom line result, in either case, is that the body has trouble clearing glucose from the blood and herding it into the cells of the body. Without intervention, the effects on the body are catastrophic and life threatening.

Type 1 Diabetes

Type 1 diabetes, formerly referred to as juvenile-onset and insulin-dependent diabetes mellitus (IDDM), occurs in about 5 to 10 percent of the diabetic population and requires insulin administration by injection or pump. Quite often, type 1 diabetes presents in individuals who are less than 30 years of age. Risk factors that lead to or cause type 1 diabetes include genetic, autoimmune, and environmental factors. The principal cause of hyperglycemia in type 1 diabetes is an inadequate release of insulin or no release. (Insulin is a regulatory hormone that is released via beta-cells in the pancreas and regulates glucose, fat, and protein metabolism.)

In most individuals with type 1 diabetes, an environmentally triggered autoimmune response selectively destroys pancreatic beta-cells, rendering the body unable to manufacture insulin, and this destruction results in high blood glucose or hyperglycemia (Colberg and Swain 2000). Insulin action or effect is directly related to the degree of glucose control. In other words, is insulin effective in removing blood sugar? Insulin's effectiveness is directly related to the degree of glucose control (ACE 1999). If glucose levels are normal, insulin will yield a normal response.

The key to management strategies is to, as closely as possible, achieve and maintain near normal levels of blood glucose through the use of insulin, self-glucose monitoring, planned exercise, and a carefully laid out diet. The therapeutic objective is easy to identify (i.e., control blood sugar) but often difficult to achieve because of the many factors that influence blood sugar levels. However, normalized blood glucose levels are critical to attain because the likelihood of long-term complications is greatly increased with type 1 diabetes and fluctuating blood sugar levels.

Type 2 Diabetes

Type 2 diabetes, formerly known as adult-onset and non-insulin-dependent diabetes mellitus (NIDDM), affects 90 to 95 percent of the diabetic population and usually occurs in people over the age of 30 (ACE 1999; ADA 2003). Type 2 diabetes typically develops gradually and manifests itself in adulthood. Many people diagnosed with type 2 diabetes are overweight at its onset.

Risk factors for type 2 diabetes include inactivity, obesity, increasing age, ethnicity (Native, African, Hispanic, Asian, and Pacific Island

Americans have a greater susceptibility to type 2 diabetes), and family history of diabetes. Clinically reported problems associated with type 2 diabetes include recent vision problems, slow healing wounds, more infections than usual, leg cramps or a "pins and needles" sensation in the toes and fingers, insatiable thirst or frequent urination, unexplained weight loss, or general fatigue and impotence.

Individuals who have type 2 diabetes are generally insulin resistant, which means the pancreas produces sufficient insulin, but the insulin action is poor at the receptor sites. The receptor sites (i.e., at the muscle) may be too few or may resist the action of the available insulin. This is termed *insulin resistance* and is the primary cause of hyperglycemia or high blood glucose in type 2 diabetes.

Although insulin resistance is common in peripheral tissues like the muscle and liver in type 2 diabetes, lifestyle changes that focus on diet and physical activity can improve insulin action. Being obese and overweight greatly increase the likelihood of insulin resistance; thus, the activity and diet programs should promote weight loss when the situation calls for it.

Many doctors first encourage nonmedical or noninvasive means—such as diet, exercise, and self-testing of blood glucose—and in some cases oral hypoglycemic agents (drugs that are not insulin but act like insulin) or insulin to treat diabetes. However, more than 40 percent of those people with type 2 diabetes progress to insulin injections because they continue a sedentary lifestyle, make poor food choices, and remain obese (ADA 2003).

Some researchers think that obesity makes insulin receptors on cells insensitive to insulin or reduces the number of insulin receptor sites. But, many overweight people are not insulin-resistant and many normal weight people are. Although the reason for insulin resistance in some people is far from clear, it occurs more frequently in some families (i.e., influenced by genetics, ethnicity, or lifestyle choices) and in people who are overweight or inactive.

Regardless of the cause, the pancreas interprets the problem (hyperglycemia) as a lack of insulin production so the pancreas produces more. Increased insulin production may temporarily bring blood glucose levels back down

to normal, but this takes a toll on health. High insulin levels have a negative impact on cholesterol forms (the "good," high-density lipoprotein decreases and the "bad," low-density lipoprotein increases), triglycerides or fat increase in the blood, and blood pressure increases. This whole cluster of abnormal consequences results in a much higher risk of heart disease. Finally, the pancreas can lose the battle to supply enough insulin; if that happens, blood glucose shoots wildly out of control and the person has diabetes. The longer this process goes undiagnosed, the greater likelihood of irreversible damage.

Both types of diabetes, if uncontrolled, can result in debilitating health problems and premature death. Self-monitoring of blood glucose should be adopted along with exercise and diet choices that reflect lifelong, healthy lifestyle changes.

Pathophysiology of Diabetes

Patho literally translates to disease. In the case of the pathophysiology of diabetes, something has gone wrong with the body's ability to regulate blood glucose levels, and the health consequence can be extreme. Approximately 60 to 70 percent of people who are afflicted with diabetes develop mild to severe complications that affect organs and tissues throughout the body, largely because the disease is allowed to progress uncontested (ACE 1999). These complications include the following:

- Retinopathy (damage to the small blood vessels in the eye's retina, which can lead to blindness)
- Glaucoma (an eye disease that can progress to optic disk or nerve damage and gradual loss of vision if left untreated)
- Peripheral neuropathy (damage to nerves and circulation in the extremities, which can lead to infection and amputation)
- Autonomic neuropathy (damage to the autonomic nervous system, which can lead to, for example, a muted sweat and cooling response)
- Nephropathy (kidney disease)

Long-Term Complications of Uncontrolled Diabetes

Diabetes can simply be defined as uncontrolled blood glucose levels. Seemingly innocuous and often insidious in its onset and associated symptoms, diabetes can have lethal health effects.

Diabetes leads to a variety of metabolic and physiological problems. Macrovascular disease affects large blood vessels, whereas microvascular disease generally is associated with small blood vessels and neural complications. Macrovascular (i.e., cardiovascular system and cerebral and peripheral vasculature), microvascular (retina, kidneys, and peripheral nerves), and neural complications can present themselves if blood sugar levels remain unchecked. Macrovascular disease is common in people with diabetes, as is microvascular disease, and is especially prevalent in long-standing diabetes that is untreated. Yet, the onset of these problems is less likely to occur in physically active type 1 and type 2 diabetics (ACE 1999; ACSM 1997; ADA 2003). However, you must know whether macro- or microvascular disease or other complications are present to be able to safely and effectively design exercise programs for diabetics.

Heart Disease and Circulatory Problems

Uncontrolled blood sugar accelerates the progression of coronary artery and heart disease in people with glucose intolerance and hyperglycemia. Additionally, diabetes contributes to atherogenic processes in other large vessels, including those in the lower extremities (peripheral vasculature) and in the brain (cerebral vasculature). This can lead to heart attack, stroke, claudication (pain in the extremities), and amputations.

Retinopathy (Eye Disease)

Physical activity does not seem to worsen this eye disease in diabetics, but clients with retinopathy should not engage in activity that causes dramatic increases in blood pressure.

Neuropathy

Neuropathy is a nerve disease, and complications of diabetes include autonomic neuropathy and peripheral neuropathy. Neuropathy can lead to altered heart rate and blood pressure responses that do not equate with actual exercise intensity as related to heart rate response, or it can result in a muted sweat response or inability to regulate temperature in the body. Peripheral neuropathy especially affects the lower leg and feet. A loss of feeling or sensation in the extremities can lead to overstretching or infection attributable to faulty foot hygiene.

Nephropathy (Kidney Disease)

Although research is inconclusive as to whether exercise-induced blood pressure changes exacerbate the progression of this microvascular kidney disease, it is prudent to avoid activities that cause systolic blood pressure to rise to 180 to 200 millimeters of mercury (mmHg) (ACE 1999; ACSM 1997).

Although complications are common in diabetics (ACE 1999; ACSM 1997; ADA 2003), such complications do not preclude physical activity. Instead, appropriate precautions should be taken by the diabetes management team, which includes the physician, client, client's family, and personal trainer.

As is true of any management effort, it is best to avoid these end-stage consequences of uncontrolled blood glucose levels by diagnosing and treating diabetes in early stages. Finally, do not assume all diabetics have progressive vascular or nerve damage because of undiagnosed or untreated diabetes. Each client should be independently considered and an appropriate exercise program developed based on existing capabilities and limitations.

Therapeutic Interventions for Diabetes Mellitus

The core elements of diabetes therapy include exercise, diet, insulin, blood glucose regulation (i.e., the interactions among diet, insulin, and exercise), and behavioral strategies related to healthy lifestyle changes and choices. The obvious goal of a diabetes intervention approach is to normalize blood glucose levels, and the less obvious goal is to prevent or delay vascular and nerve disease complications associated with diabetes. The trainer needs to be an assertive part of the diabetes treatment team.

Medical Questionnaire Addendum for the Diabetic Client

☐ Is my client's diabetes controlled?

☐ How often has my client been into your office over the past two years and for what reasons (i.e., diabetes complications, preventive, and regular checkups)?

☐ Does my client have any other existing health conditions (i.e., heart disease, high blood pressure, elevated lipids, smoking, obesity) that need to be considered and monitored?

☐ Is my client taking any medications related to diabetes management or otherwise that might influence blood glucose control or his or her ability to engage in regular exercise safely? If so, what medication is being taken, how does it influence my client's response to exercise, and for how long has he or she taken medication?

☐ Does my client have any evidence of macro- or microvascular diseases such as heart or cerebral vascular disease or retinopathy, neuropathy, or nephropathy?

☐ How long has the client had or been treated for diabetes?

☐ Do any outstanding precautions or recommendations exist that I should be aware of before introducing my client to a regular program of physical activity?

☐ May I contact your office for guidance if any concerns or acute events occur as related to diabetes management while working with my client?

Diabetic clients must receive a physician's clearance to begin an exercise program. This questionnaire will help you determine whether any vascular or neural degenerative conditions exist, better understand the client's situation, and establish a positive relationship with the client's physician.

Preexercise Screening, Assessment, and Follow-Up

Besides gathering history about your client and gaining physician approval, monitor client status with follow-up evaluations because diabetes is potentially a progressive disease. The management team must know that the approaches they have chosen are effective. Answer the questions found in the box on this page.

Getting Started

Along with a medical history form, physician approval, and informed consent, it is common to record the resting heart rate and blood pressure of your client. About 60 to 65 percent of people with diabetes have hypertension or high blood pressure. The diabetic client should also bring his glucose meter on any days where physical activity is required, whether it's fitness assessment or a workout. A resting heart rate of greater than 120 beats per minute or a resting blood pressure exceeding 180/105 mmHg is

a contraindication to exercise (Gordon 1993c). Additionally, talk with the doctor and note other contraindications as previously established by ACSM guidelines (Albright et al. 2000; ACSM 1995, 1997).

Fitness Assessment

Fitness assessment of body composition, cardiorespiratory fitness, and musculoskeletal fitness is recommended to help chart client progress and to set goals. Of course, many testing protocols will need to be adapted for the individual client, and testing procedures should be approved by the physician.

Exertion Guidelines

Rating of perceived exertion (RPE) should be incorporated in any diabetic's program to identify exercise intensity, because disease progression, complications, and medication can limit your ability to accurately assess exercise intensity by heart rate monitoring (chapter 17). Discuss this with the physician.

Common Activity Guidelines for Type 1 and Type 2 Diabetes

1. Generally, monitor blood glucose before, during, and after exercise, and take the recommended action if blood glucose is too high or low.

2. Know whether macro- or microvascular complications exist because their presence will influence the physician's exercise prescription and your exercise plan.

3. Instruct the client to always wear a medical ID bracelet or necklace.

4. If insulin injection is required for blood glucose level management, generally the injections are made at a nonactive muscle site on the days of physical activity, although the ADA (2003) states there is no "best place" to inject insulin. (Discuss this with the physician; more likely than not, the client will be very familiar with proper protocol from years of successful diabetes management.)

5. Instruct the client to report and be completely forthcoming about any uncomfortable perceptions or problems he has before, during, or well after exercise cessation.

6. Stress tests are a necessity for clients with heart disease and diabetes and are highly advisable for type 1 diabetics who have had the disease for more than 15 years and are older than 30 and type 2 diabetics older than 35 (ACSM 1995, 1997).

Type 2 diabetes: Participate in low-level activity daily (Albright et al. 2000; ACSM 1995, 1997) or every other day (ACE 1999).

Type 1 diabetes: Participate in physical activity according to tolerance at least three times per week (ACE 1999), or participate 20 to 30 minutes daily (ACSM 1995, 1997).

Source: Guidelines supported by ACE (1999), ACSM (1995, 1997), Albright et al. (2000), ADA (2003).

Note that these guidelines are very conservative and can be greatly modified to include more or less activity, depending on the individual.

Working With Type 1 Diabetes During Exercise

Even though daily aerobic exercise is recommended for type 1 diabetics (Albright et al. 2000; ACSM 1995), improving glucose control for type 1 diabetes is often best achieved in combination with aggressive insulin therapy and self-blood glucose monitoring. Type 1 diabetics are best served by getting exact exercise parameters from their diabetes management team, although the guidelines in table 25.1 establish useful parameters. (The guidelines in table 25.1 are supported by ADA 2003; ACE 1999; and ACSM 1995, 1997)

The type 1 diabetic can improve cardiovascular conditioning and accrue other health-related benefits by exercising three to five days per week. Daily exercise is often unrealistic for type 1 diabetics and can increase the risk for other complications. Type 1 diabetics who have no complications can exercise at 55 to 75 percent of functional capacity or at an RPE of 3 to 5, using a 10-point exertion scale (chapter 17). Sessions should last about 20 to 30 minutes to optimize fitness and health-related returns. Using a predictable and consistent pace is highly recommended.

Resistance training in type 1 diabetes is recommended in most cases. Strength training can increase aerobic capacity and, along with increased muscle mass, can improve insulin sensitivity and thus improve glucose control. The guidelines in table 25.2 are supported by ACE (1999); ACSM (1995, 1997); ADA (2003); and Soukup and Kovaleski (1993). Type 1 diabetics who have no complications can participate in a moderate resistance training program that parallels an entry-level program that nondiabetics would use (see table 25.2). Increases in intensity should be evaluated in comparison to tolerance level of each client. Finalize any plan of action with the attending physician or appropriately trained health expert.

Working With Type 2 Diabetes During Exercise

The focus of a type 2 diabetic's program is to make lifestyle changes, lose weight, and burn

TABLE 25.1 Physical Program Guidelines for Cardiovascular Conditioning in Diabetes

Variable	Nondiabetic	Type 1	Type 2
Frequency	3-6 days/week	3-7 days/week	3-7 days/week
Intensity[a]	55-90 percent HR max RPE[b] 3-7	55-75 percent HR max RPE 3-5	40-70 percent HR max RPE 2-5
Duration	20-30 minutes per session	20-30 minutes per session	20-60 minutes per session
Type[c]		Dynamic movement	Bicycling, walking, hiking, house and yard work, mall walking, water-based fitness

Note: HR = heart rate; RPE = rating of perceived exertion.

[a]HR monitoring may not be accurate for those persons with autonomic neuropathy; [b]RPE using a 1-10 exertion scale (see chapter 17); [c]some people may require nonimpact or non-weight-bearing exercise because of peripheral vascular disease or because of micro- or macrovascular complications.

Source: Range of guidelines supported by ACE 1999; ACSM 1995, 1997; ADA 2003.

TABLE 25.2 Physical Program Guidelines for Resistance Training in Diabetes[a]

Variable	Type 1	Type 2
Frequency	2-3 days per week	2 days per week
Intensity[b]	40-60 percent of 1RM	Lower level intensity at about 40-60 percent of 1RM
Repetitions	8-12 per exercise	15-20 per exercise
Sets	2-3 sets per exercise	1-2 sets per exercise
Number of exercises	8-12 muscle groups	8-12 muscle groups

[a]Persons with microvascular disease should refrain from participating in strenuous resistance training exercise; [b]complications may limit resistance training activity or intensity

Source: Range of guidelines supported by ACE 1999; ACSM 1995, 1997; ADA 2003.

calories by using moderate effort. This program resembles something akin to an overall health and weight management program. If there are no complications, you often can proceed with the same program you would use for a deconditioned or obese exerciser.

The type 2 diabetic must do the following:

1. Lose weight and make better nutrition and food choices

2. Decrease blood pressure and eliminate cardiovascular disease risk factors

3. Increase activity that includes cardiorespiratory, resistance training, and stretching exercises

Many type 2 diagnoses for diabetes are probably more related to lifestyle choices than genetic or other causes. As mentioned, inactivity and decreased sensitivity of the body's tissues (i.e., exercising muscles) to the insulin that is produced by the pancreas can result in hyperglycemia and the diagnosis of type 2 diabetes.

Because many people with type 2 diabetes are deconditioned and obese, cardiovascular activity that lasts 20 to 60 minutes at an intensity of 40 to 70 percent of functional capacity is appropriate. Low-intensity activity is adequate to improve insulin action and blood glucose control, and more moderate exercise lessens the likelihood of musculoskeletal or foot injury in deconditioned diabetics. Exercising frequently, five to seven days per week, maximizes calorie expenditure that is necessary to lose weight (see table 25.1). Continuous steady-rate activity is probably best over the long haul.

Type 2 diabetics also can benefit from resistance training exercise that is of light to moderate intensity (see table 25.2). This type

of training increases muscle mass, increases insulin action, or decreases insulin resistance. Both cardiovascular and metabolic benefits are gained by resistance training. It is a good idea for your client, especially if he is grossly deconditioned, to build a cardiorespiratory base before initiating a resistance training program, although this recommendation does not always hold true. Check with the attending physician. Increases in intensity should be evaluated in comparison to each client's tolerance level. No rules are written in stone and, depending on the program design, these suggestions may or may not be appropriate for your client.

Exercise Program Progression

Not all diabetics fall into general guidelines. Many type 2 diabetes programs for both cardiorespiratory and resistance training closely resemble those of apparently healthy and moderately to highly conditioned adults. Don't prejudge diabetics and assign them to inappropriate (either too hard or too easy) programs. Gather the information you need to set up the safest, most effective program for the diabetic patient.

Often, program progression—which involves frequency, intensity, and duration of effort—is greatly affected by whether your client's diabetes was diagnosed, treated, and controlled at an early stage. Early treatment and management of diabetes can greatly limit the progression of the disease, thus minimizing the necessity for many exercise precautions and constraints. The guidelines and recommendations listed previously are not the final word and vary greatly from case to case.

Exercise program progression is determined largely by age, functional capacity, diabetes-related complications and other medical concerns, personal preferences and tolerance to exercise, and goals. Generally, as is true for most programs, initial changes in the program should focus on duration increases rather than intensity. The blood glucose response to increases in duration will be easier to control, and the likelihood the client will stick with the program is greater.

If your type 1 client is without complications, he will probably follow a program similar to that of an apparently healthy person. The beginning phases of programming for type 2 diabetes requires low intensity and short duration because the client is often out of shape and overweight. In contrast, the type 1 diabetic may not require the same initial modifications because he likely has managed the condition for some time. The program must be progressed to accommodate the physical and mental abilities and clinical status of each client.

Clients with well-controlled diabetes can compete in running races and other athletic events. The key to success in more vigorous and sustained workouts depends greatly on self-monitoring of blood glucose and being sensitive to adjustments that might include changes in insulin doses, medication, exercise, or diet. For many diabetics, athletic competition is not a goal, but improving functional aspects of living and quality of life is a goal.

Benefits and Risks of Exercise for Clients With Diabetes

The benefits of exercise are clear and many:

- Can help manage and control blood sugar levels, especially in type 2 diabetes
- Can help maintain ideal weight
- Can improve quality of life
- Can help avoid development of diabetes
- Can help avoid long-term complications resulting from disease progression

There are also risks of exercise for people with diabetes. The health risks associated with exercise for diabetics increase greatly in relation to the time during which the disease progresses unchecked. Generally, the more irreversible damage that occurred related to macro- and microvascular disease will increase risks related to exercise and create more limitations. However, the question that needs to be answered is, "Can any diabetic afford not to exercise?" Often the answer is an emphatic no, with not exercising being far more risky in terms of overall health impact (ADA 2003; White and Sherman 1999).

Hypoglycemia

The most common problem facing diabetics before, during, or after exercise, is low blood sugar, or hypoglycemia. Hypoglycemia is defined as blood sugar below 80 milligrams per deciliter (ACE 1999).

Symptoms associated with hypoglycemia or an insulin reaction include trembling, shakiness, nervousness, rapid heart rate, shallow breathing, palpitations, increased sweating, pale and clammy skin, excessive hunger, reduced mental ability, exhaustion, light-headedness, or fainting.

After a client exhibits any of these symptoms, he should ingest a fast-acting carbohydrate or sugar snack such as orange juice or a nondiet soda, candy bar, or hard candies (i.e., six pieces). Check the client's blood glucose after about five minutes to determine whether blood glucose has normalized to close to 100 milligrams per deciliter. Continue this simple sugar feeding until blood glucose has risen, and end the exercise session.

It is not always possible to prevent hypoglycemia, and more often it occurs in clients who use insulin or a type 2 diabetic who is using oral hypoglycemic agents or insulin-like drugs. You can minimize the occurrence by discussing the following procedures with the client and physician:

1. Determine the proper site and timing of an insulin injection or intake of medication.

2. Analyze the timing of pre- and postexercise food intake, as well as food intake during exercise.

3. Decide the best time of day for the client to exercise, remaining sensitive to whether the client can comply with this ideal time.

4. Insist on monitoring blood glucose before, during, and after exercise, or as directed by the attending health care expert.

Hyperglycemia

High blood glucose levels occur in diabetics who are not on the proper dosage of insulin because of, for example, a change in food intake or activity level. Not being properly insulinized also can be caused by not using enough insulin, which often occurs because of a change in routine. Also, exercise will worsen hyperglycemia when preexercise levels of blood glucose are elevated. If your client's blood glucose is above 250 milligrams per deciliter, this indicates poor blood glucose control and requires postponement of the exercise until blood glucose decreases below 250 milligrams per deciliter. Usually, a dose of insulin will be required to gain control of blood glucose levels. Overall, moderate exercise intensity seems to facilitate normal blood glucose levels, whereas higher intensity seems to play a role in elevating blood glucose to a hyperglycemic level because of the interaction of regulatory hormones.

Hyperglycemia creates a situation where, without adequate insulin, muscle cells cannot use glucose during exercise. This outcome emphasizes the importance of blood glucose monitoring, especially before exercise (White and Sherman 1999).

Symptoms associated with hyperglycemia include flushed skin, cherry-colored lips, fruity breath, increased thirst, gastrointestinal stress, nausea, abdominal pain, and disorientation.

Final Tally: Risk Versus Effectiveness of Exercise in Diabetes

Uncontrolled blood glucose can result in premature death, coronary heart disease (CHD), kidney failure, blindness, amputations, and a life that is far from optimum. A diabetic who continues to choose an inactive lifestyle, eat poorly, remain grossly overweight, or ignore an uncontrolled blood glucose diagnosis will likely suffer devastating health consequences.

If an active lifestyle is chosen, along with a team management approach toward normalizing blood glucose (this may include insulin injections or pump, diet, and exercise), the severity of the disease can be greatly minimized. The need for medication may decrease and insulin use may decrease or be discontinued in type 2 diabetes. In addition, other CHD risk factors such as high blood pressure and lipid profiles can be improved.

Although exercise is considered a cornerstone in type 2 management by the medical community, glycemic control in individuals with type 1 can be very challenging because of the complexities of regulating blood sugar

with the added, often unpredictable influence of exercise (Colberg and Swain 2000). In addition, clients with type 1 diabetes may not experience improved glycemic control with regular exercise unless diet and insulin dosage are modified (Colberg and Swain 2000).

Although exercise in diabetes has its associated risks, complications, and challenges, the benefits of a well-managed diabetes prevention or treatment program that includes proper exercise and diet and a sensible approach to weight loss seem to far outweigh any potential risks for both type 1 and type 2 diabetes. The American Diabetes Association states that "all patients with diabetes should have the opportunity to benefit from the many valuable effects of exercise" (reported on p. 63, White and Sherman 1999). Exercise and diabetes control can be a winning combination.

Diabetes: Suggested Reading

Look into these works (and those cited in this chapter) for more information.

American Diabetes Association. 1996. *Diabetes: 1996 Vital Statistics*. Alexandria, VA: Author.

Center for Science in the Public's Interest. 1996. "How to Avoid Diabetes." *CSPI Nutrition Action Healthletter* (Sept.): 3-5.

McArdle, W., F. Katch, and V. Katch. 1996. *Exercise Physiology Energy, Nutrition and Human Performance*. 3rd ed. Philadelphia: Lea & Febiger.

Resources

American Diabetes Association: (800) DIABETES, 703-549-1500, or www.diabetes.org.

Centers for Disease Control and Prevention: 770-488-5015 or www.cdc.gov/diabetes/.

National Diabetes Clearinghouse: 301-654-3327 or www.niddk.hih.gov.

Asthma and Your Client

An estimated 14 million Americans are affected by asthma (Bryant et al. 1998). As many as 5 percent of all Americans will experience the symptoms of asthma, which include wheezing, shortness of breath, coughing, a tightness or burning sensation in the chest, abdominal pain, headaches, and fatigue (ACSM 1998). Exercise-induced asthma (EIA) is one of the most common conditions among active children, adolescents, and young adults. It occurs in almost 90 percent of people who have chronic asthma (Lacroix 1999), but vigorous exercise can trigger the same symptoms in people who don't have chronic asthma. Random testing of children who showed no signs of asthma showed a 7 percent prevalence of EIA, implying that some adults and children avoid play or activity, remain undiagnosed, and do not receive the health and fitness benefits an active lifestyle provides (Lacroix 1999). With the presence of asthma so rampant, it is likely that a personal trainer will have an opportunity to work with an asthmatic client.

What Is Asthma?

The word *asthma* is derived from the Greek word that means "to pant," which is an appropriate description of someone who is having an asthmatic attack and laboring to increase air flow. The literal translation of asthma perfectly fits the attempt of the individual to get air in and out of the airways as a result of airway linings that have "tightened" because of inflammation or because of specific trigger factors. Ironically, the individual who experiences an attack is having difficulty getting enough air out of the lungs, not necessarily into them.

Treatment of Asthma

Asthma can be reversed with medication, or a person may "outgrow" the disease at any age (i.e., spontaneous reversal). On the other hand, although the disease is not characterized as progressive—even without treatment—many individuals are affected their entire lives (Lacroix 1999).

Generally, the primary method for controlling asthma involves drug administration, whether inhaled or oral. Specific drugs can either increase an asthmatic's resistance to symptoms on a long-term basis (prophylactic drugs) or can be used to treat the sudden onset (rescue drugs) of an asthmatic attack that occurred in response to an asthma trigger, like exercise or allergens.

Although drugs are useful and often required to help control asthma, clients who have asthma should be encouraged to avoid or eliminate any factors that contribute to asthmatic symptoms. Steps that may help to avoid precipitating events include these:

1. Use a peak flow meter to measure airflow. This inexpensive and easy to use device measures how easily the asthmatic can expel air from the lungs. A huge decrease (i.e., about 10 percent) over baseline measurements indicates an increased level of resistance to airflow in the lungs. If this decrease occurs, the cause needs to be investigated and evaluated. For example, could your client have a respiratory infection?

2. Maintain medication compliance by regularly taking prophylactic drugs to treat asthma for the long term and rescue medicines to treat acute asthmatic symptoms or to avoid them. Stress to your client the importance of adhering

to the recommended dosage because excessive medicine increases the likelihood of, or exacerbates, known side effects.

3. Keep well hydrated. Consuming plenty of water after taking medicine will clear the medicine from the back of the throat, and adequate hydration also can prevent mucus plugging (i.e., mucus blockage) of the small bronchiole tubes (i.e., airways). Mucus plugs can lead to infections that include bronchitis. Your client should remain hydrated before, during, and after exercise, as well as throughout the day.

4. Become aware of any foods that seem to trigger asthma-related symptoms. Diet choices that are asthma triggers can increase the likelihood and severity of asthmatic attack.

Asthma should not be left untreated. Although the disease may not be progressive, treatment can limit or reverse existing symptoms and ensure a more enjoyable quality of life that can include a full slate of unrestricted activity. Asthma should not be left "to treat itself," and it should not be ignored. Aggressive and effective therapies are available today that were not known as recently as a few years ago.

Chronic Asthma

Chronic asthma is typified by an increased reactiveness of the tracheobronchial tree to a wide variety of stimuli that include pollens, cigarette smoke, air pollutants, cold or dry air, viral infections, and physical exertion. Figure 26.1 shows the anatomy of the respiratory system.

When various triggers are present, they can cause smooth muscle contraction in the affected airways, mucous membrane swelling, bronchial wall edema, and excess mucus production, which all contribute to airway narrowing. When the cells lining the airway tubes become inflamed and produce a clear mucus that further clogs the airways, it is difficult for air to pass through the bronchiole tubes to and from the alveolar sacs where the exchange of gases takes place. This reduces oxygen availability. Because of this sequence of events, asthma has been characterized as an air-trapping disease, making exhalation more severely affected than inhalation. Symptoms or clinical manifestations include coughing, wheezing, dyspnea (shortness of breath), and chest tightness.

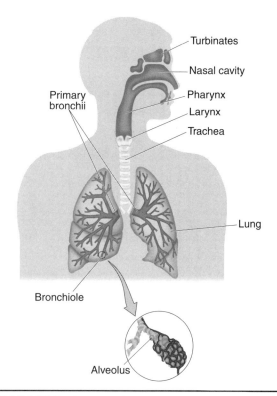

FIGURE 26.1 The anatomy of the respiratory system.
Reprinted from J.H. Wilmore and D. Costill 1994.

Symptoms reverse with treatment. The consequences of airway inflammation and resultant narrowing are believed to be the key to understanding and developing an effective treatment approach. The persistence or reversal of asthma is probably closely related to airway inflammation. Therefore, management of asthma focuses on reducing inflammation by controlling the environment (i.e., triggers or stimuli that induce asthma symptoms) and by using disease-modifying agents (i.e., medications that manage the disease long term, as well as those that treat acute asthma-induced symptoms). These steps go beyond an approach called symptomatic therapy, where treatment is only focused on symptoms of the disease, not prevention.

Specialists have raised the concern that undertreated asthma could lead to pulmonary fibrosis from chronic and repeated inflammation of the bronchial tissues because of a treatment approach that uses symptomatic therapy alone (Lacroix 1999). Simply put, although the disease is not clinically rated as progressive, untreated asthma can worsen because of repeated asthmatic attacks and the associated physical trauma.

Chronic Obstructive Pulmonary Disease

Asthma falls into an inclusive breathing disorder category called chronic obstructive pulmonary disease (COPD), in which asthma, bronchitis, and emphysema are grouped. All are characterized by airflow obstruction that may be accompanied by airway sensitivity (i.e., inflammation, mucus production).

Major risk factors for COPD include age, sex, cigarette smoking, reduced lung function, occupational exposure to dusts and fumes, air pollution, respiratory tract infections (i.e., colds), episodic asthma (control this!), and deficiency or lack of alpha-antitrypsin (an enzyme that normally protects the lungs from inflammatory damage). Of course, many of these contributing factors can be controlled or eliminated by wise management. See the box on this page for more information on obstructive breathing disorders.

Obstructive Breathing Disorders

Obstructive lung diseases result in the individual having difficulty expelling air from the lungs. Major symptoms include breathlessness, wheezing, and coughing. Episodic or intermittent asthma, which includes EIA, is grouped under the COPD umbrella

Episodic or Intermittent Asthma (Includes EIA)

EIA temporarily increases airway resistance via constriction of the bronchiole tubes. EIA is a reversible and controllable condition. Bronchial asthma occurs because of constriction of smooth muscle in the bronchial tree. Its symptoms are reversible and it can be medicated.

Symptoms.

Symptoms can include sudden, short-lived wheezing on exhalation and breathlessness.

Triggers.

Common triggers are pollutants, allergies, cold or dry air, medication, colds, and exercise (EIA) or other physical exertion.

Lung dysfunction.

Pathophysiology includes bronchospasm and inflammation of the bronchial tube lining.

Response to therapy.

Proper treatment can result in complete reversal, especially if the individual avoids triggers and not only treats symptoms with medication but, when appropriate, uses long-term preventive therapies, which may include medication.

Chronic Asthmatic Bronchitis (COPD)

Chronic asthmatic bronchitis is a form of episodic asthma but it is a chronic condition, as the name implies. It occurs because of a thickening and inflammation of the mucous membrane in the bronchial tubes. Exercise doesn't improve the condition but may improve daily living capability. A partial reversal may be possible with medical therapy.

Chronic Bronchitis (COPD)

Chronic bronchitis occurs because of an inflammation of the bronchial tubes, excess mucus secretions, and bronchospasm. Exercise doesn't improve the condition but may improve daily living capability. A partial reversal may be possible with medical therapy.

Emphysema (COPD)

Emphysema occurs when air sac walls (i.e., alveoli; see figure 26.1) lose their elasticity and ability to expel air from the lungs as well as lose their ability to exchange gas between the lungs and bloodstream. Emphysema is irreversible, but medical treatment may relieve symptoms.

From Gordon (1993b).

Exercise and Asthma

EIA need not sideline your clients. Management of asthma is of particular importance to trainers, because one of the most prevalent triggers of asthma is exercise.

EIA is a temporary condition, not a chronic one. Most experts believe that nearly every asthmatic person should be able to participate fully in exercise and activity. This requires you, your client, and her physician to adequately understand EIA and be willing to treat it vigorously.

Causes of Exercise-Induced Asthma

The cause of EIA is still unknown. But two main theories stand out (Lacroix 1999).

Water loss theory. When air is taken in through the nose, the bronchi "condition" the air by warming it up to 98.6 degrees Fahrenheit (37 degrees Celsius) and saturating it with water vapor before the air reaches its endpoint in the respiratory track, which is at the site of the delicate alveolar membranes (i.e., alveoli, where carbon dioxide and oxygen are exchanged).

Ventilation rates increase greatly during exercise, and because most of the breathing takes place by breathing in and out of the mouth, the upper airway conditioning system is bypassed. Exactly how exercise leads to an asthma attack is not firmly established, but rapidly breathing and exchanging a lot of cool, dry air seems to be the most common cause. This may cause the lining of the airways in the lungs and respiratory tract to dry and set off the asthmatic episode, because the upper airways of the lungs must contribute water vapor from their surface liquid. It is generally recommended that the incoming air must be warmed and moistened before it reaches the alveoli (i.e., swim in a pool environment or wear a scarf or mask in cold or dry climates). Cool, dry air can sap the bronchi of heat and moisture, triggering bronchospasm, especially if breathing rate is increased and the air is taken in mostly through the mouth, which is likely to happen during vigorous exercise.

Heat-exchange theory. This theory, although more complex, may explain why EIA can occur after exercise. Increased ventilation during exercise cools the airways. After exercise is stopped, the bronchial vasculature dilates and engorges to rewarm the epithelium (lining of the respiratory system). Rebound hyperemia (increased blood resulting in distention) of the bronchial vascular bed impinges and narrows the airways. Engorged vessels can also leak, leading to bronchospasm (Lacroix 1999).

Defining Exercise-Induced Asthma

EIA develops when vigorous physical activity triggers airway narrowing in individuals who have heightened bronchial reactivity (i.e., their airways are hypersensitive to this and other triggers). EIA is a reversible airway obstruction that occurs during or after exertion. Note that EIA and chronic asthma are different.

What Happens During an Asthma Episode

During an "asthma attack," the bronchioles (small airways that branch off the bronchus, which is one of two larger airways that branch off the trachea or windpipe and distribute air throughout the lungs) narrow because the smooth muscles surrounding them go into spasm or contract. This narrowing of the bronchioles reduces air flow to the alveoli (the tiny grapelike cluster of air sacs deep in the lungs where oxygen and carbon dioxide are exchanged) and is referred to as bronchospasm. When bronchospasm occurs in these terminal branches (i.e., the alveoli) of the respiratory tract, individuals experience symptoms of an asthmatic attack to varying degrees.

The actual mechanism of EIA occurs during exercise when the demand for oxygen increases, breathing deepens and accelerates, and as a result moisture is lost to the air via exhaled air. In addition, airways cool. This change in the environment of the lungs and airways may cause cells to release histamines and other chemicals that cause an inflammatory or allergic response.

Designing the Exercise Program

Exercise is the most common of all the known asthma triggers after allergies, affecting 60 to

90 percent of people who have asthma (90 percent of those with chronic asthma). If a client exercises continuously for at least five minutes at about 70 percent of her aerobic capacity, she can trigger EIA. Generally, the reaction is triggered in the first 6 to 12 minutes of exercise, or 5 to 10 minutes after exercise is stopped (ACE 1999). A proper warm-up and cool-down are critical to limiting the likelihood of an exercise-induced asthmatic attack, as is working closely with the attending physician to ascertain how the patient's body reacts to progressive exercise.

Gathering information. Before you start your client on an exercise program, you must gather the necessary information from the asthmatic client and her physician. Have your client complete an asthma screening form (form 26.1) prior to designing her exercise program. The health care team will use this information to determine when and where she exercises, as well as the type, intensity, duration, and frequency of exercise.

Because most people who are asthmatic know of their condition, a trainer can learn information that is specific to the client through that person and her doctor. The response to exercise can vary greatly, so by learning how EIA and medications specifically affect her body, and working as part of an asthma management team, you will be better able to adjust your client's workouts to avoid asthmatic attacks.

Setting Up the Exercise Program

It has been demonstrated that regular exercise can be an effective and positive aspect of asthma therapy. Proper exercise can make the airways of asthmatics less susceptible to factors, such as common asthma triggers, that lead to bronchospasm and the ensuing asthmatic attack. But because exercise can sometimes cause such a response, you must work with your client and her physician to develop a safe and comprehensive exercise program. The box on page 499 offers guidelines to help ensure asthma-free workouts.

Generally, exercise programming for the person with asthma is simple if the disease is controlled. You must understand the impact of medication on the client's functional capacity,

be able to identify her current level of conditioning, and be prepared to modify the exercise program when necessary. The program is not written in stone, because many external and individual factors can affect the client's response to exercise.

Considering the Refractory Period

You have probably heard about athletes who perform exercises before an athletic competition with the intent to cause an exercise-induced asthmatic attack and take advantage of the refractory period (i.e., the period of time after an attack when another asthmatic attack is highly unlikely or any associated symptoms are fewer if activity is resumed). The refractory period can last from 30 minutes to three hours, depending on the individual (Bryant et al. 1998).

Generally, short bursts of exercise are used to bring on mild symptoms. A full-blown asthma attack is not the goal of this deliberate manipulation of symptoms. If this method is used with average clients or athletes, follow these steps:

1. Discuss the strategy with your client's physician.

2. Have the client medicate herself as usual.

3. Have the client warm up at about 50 to 60 percent of the heart rate maximum for about 10 to 15 minutes. This lower intensity usually does not induce bronchospasm.

4. Have the client stretch or cool down for about 10 to 15 minutes and stay hydrated.

5. Have the client work out at 70 to 85 percent of heart rate maximum. The hope is that the warm-up period will open your client's airways enough to allow exercise at this higher intensity, with no or milder asthmatic symptoms.

Adapted from Bryant et al. (1998, p. 37).

Managing an Asthmatic Attack

If your client should ever exhibit symptoms associated with an asthmatic attack or have difficulty breathing, take the following precautions:

FORM 26.1 Asthma Screening Form

Gather this information from both your client and medical professionals. (Don't underestimate the valuable information your client can contribute to the management approach, and administer this questionnaire in conjunction with your normal screening forms; see chapter 10 and the appendix.)

Client Asthma and Allergy History

1. Do you have, or have you ever had, asthma? Y N

2. Have you ever experienced wheezing? Y N

3. Do you have, or have you ever had, allergies to dust, pollen, or animal dander? Y N

4. Have you ever had a chronic cough? Y N

5. Have you ever had shortness of breath, difficulty breathing, cough, chest pain, or tightness during or after exercise? Y N

6. After sustained activity—for example, running or walking—of 5 to 10 minutes, do you have to stop to catch your breath or do you gasp for breath? Y N

7. Do you smoke? Y N

8. Does anyone in your family have asthma? Y N

9. What are the identified asthma triggers?

10. Are you currently taking any medications? If so, are they rescue or prophylactic?

11. When should medications be taken?

12. What are potential side effects associated with the medications being taken?

13. What is your previous exercise history and current involvement?

14. Do you have any known exercise or other physical limitations?

15. Are there any other medical conditions that may limit exercise or exacerbate the asthmatic condition?

Sources: Adapted from ACE (1999) and Lacroix (1999).

Activity Guidelines to Help Ensure Asthma-Free Workouts

To ensure safe, effective, and productive workouts that will keep your asthmatic clients successfully exercising for a lifetime, encourage them to take the following steps:

1. Avoid asthma triggers during exercise (i.e., cold, dry air or low humidity, fatigue, respiratory infections, air or other pollutants that include automobile or industrial pollutants, and allergens that include dust or other irritants).

2. Choose exercise that is relatively easy on the lungs (i.e., treadmill walking in an air-conditioned room or water-based exercise is good because the pool environment should be warm and humid; however, be sure the client is not allergic to any chemicals used to treat the pool). Resistance training rarely triggers EIA.

3. Check the quality of air before the client exercises outdoors, especially when pollutants and pollens or other airborne irritants are high. Avoid exposure to air pollutants and allergens whenever possible. For example, have your client exercise indoors when it's smoggy or in low traffic areas to avoid auto emissions.

4. Avoid exercise on cold and dry days. If the client must exercise or venture out on such a day, encourage her to wear a scarf or mask over her mouth to help warm and humidify the air and reduce the impact of the cold, dry air on her airways.

5. Keep well hydrated. Not only should the client with asthma hydrate before, during, and after exercise, but she should drink fluids regularly throughout the day.

6. A simple breathing resistance device provided by the physician can be used to condition the asthmatic's lungs. Breathing practice should be done outside of the training session. This small, palm-sized device won't increase cardiorespiratory fitness but can strengthen muscles related to inhalation and exhalation. It's also a good idea to practice diaphragmatic breathing.

7. Medicate on a regular basis. Usually, medication should be taken within about 30 minutes of exercising. Follow daily and preexercise medication schedules as dictated by your client's asthma and provided by her physician.

8. Inhalers and rescue medications (i.e., used in the event of an asthma attack) should always be available.

9. Perform a warm-up of at least 10 to 15 minutes using a cardiovascular activity. Gradually increase the exercise to about 50 to 60 percent of maximal heart rate. Warm-ups of this length or longer have been shown to reduce the probability of an asthmatic attack (Morton, Fitch, and Hahn 1981).

10. Perform a cool-down of at least 10 minutes. The second most likely period of time for an attack occurs 5 to 10 minutes after exercise has stopped. An extended cool-down will help prevent the onset of asthma-related symptoms.

11. Avoid intense activity for prolonged periods of time. For example, an intensity of up to 85 percent of maximum heart rate should not be maintained for longer than 10 consecutive minutes. (This guideline may not be true for every person with asthma and it errs on the side of being very conservative.) Use perceived exertion to help your client gauge proper exercise intensity.

12. Breathe through the nose (it helps humidify and warm the inspired air), not the mouth, as much as possible during activity. Although not always practical, breathing slowly through the nose can lessen the chance of EIA because nasal breathing reduces hyperventilation (rapid breathing) and humidifies and warms inspired air before it enters into the smaller airways of the lungs.

13. Consciously control the breathing rate to avoid hyperventilation. Focus on breathing that is controlled, deep in the diaphragm, and slow. It's a good idea to purse the lips (as if whistling) during exhalation and to keep the exhalation twice as long as the inhalation.

14. Constantly monitor your client's acute response to exercise. Watch for coughing, wheezing, or other signs of an impending asthmatic attack. Help your client discern between effort-induced symptoms like breathing hard and symptoms that are related to the client's asthma.

15. Learn as much as you can about the intricacies of EIA and asthma in general, as they apply to your client's special circumstances. This will help you develop effective, individualized strategies.

1. Have the client stop exercising, and make sure she is in an upright, comfortable position.

2. Loosen any restrictive clothing.

3. Comfort, calm, and reassure your client. Take control of the potential emergency situation by dictating corrective procedure. Ask the client where her rescue medication is, locate the medication, and allow the client to self-administer the medication. Unless you have the expertise or permission to assist in administration of medicine, generally, this is beyond the scope of a personal trainer's responsibilities.

4. If symptoms do not resolve after 30 minutes, it is prudent to seek medical aid. If you are ever in doubt about the seriousness of an attack, emergency procedures should be in place so that appropriate medical treatment and care can quickly be summoned. If symptoms subside, exercise can resume. Remember, an asthmatic may experience a refractory period after asthma symptoms are exhibited and is less likely to experience asthma symptoms in the following 30 minutes to three hours.

Asthma Medications

Asthma drugs are usually part of the treatment for EIA incidents. Like it or not, asthma usually is controlled through a combination of trigger avoidance and medication. Encourage your asthmatic clients to seek physician diagnosis and treatment, and let them know that drug therapy will likely be discussed. Most physicians allow the person with asthma to "medicate as necessary," although newer prophylactic drugs should be taken on a regular basis. Learn as much as you can about how your client's body reacts to exercise sessions and experiment with new program design so that your client can enjoy more asthma-free workouts.

As mentioned, medications generally are classified into two types: rescue and prophylactic. Both types reduce the frequency and severity of asthma attacks and minimize accumulated physical trauma to the respiratory tract over time.

Rescue or treatment medications. Rescue medications can be used before exercise, after exposure to any other trigger, or during an acute attack to alleviate symptoms. Common rescue medicines include medication that is administered via an inhaler. Inhalers work quickly to relax smooth muscles of the airways and are prescribed to be used when the user is in the midst of an attack. Some inhalers, when taken 15 to 30 minutes before exercise, can reduce the chance of an attack for up to two hours. The severity of side effects varies greatly from person to person and can decrease over time.

Prophylactic or long-term treatment medications. Taken over a period of time, prophylactic medications are used to reduce the sensitivity of the airways to triggers, and this results in fewer attacks and less physical damage of the airways. These medications are not designed to provide relief from an asthma attack or bronchospasm but instead block the specific mechanisms that precipitate an asthma attack, as caused, for example, by an allergen. This approach is an example of treating chronic asthma versus EIA.

Today's Treatment Approach

Anyone who has asthma, no matter how mild it seems, should be examined and treated by an allergy and asthma specialist. Seek a physician who understands your client's need to be active and acknowledges the importance of developing an asthma management team. Current research extols the benefits of fitness for the person with asthma and of treating the condition. Don't ignore asthma, because it generally doesn't "go away." If left untreated, it can become a serious health risk or limit the quality of life. On the other hand, controlled asthma contributes to a normal, active lifestyle.

The measure of treatment success can be gauged by whether your client can fully participate in physical activities and sports. One of my asthmatic clients coined the phrase, "No limits!" to foster this sense of attitude and goal attainment. Fortunately, the health, fitness, and psychological benefits of exercise are available to the majority of asthma sufferers. Work closely with your client and her physician. Progress the exercise program so your client can continue to enjoy the overall physical and mental health that is gained from participation in activity and sport on a regular, lifelong basis.

Asthma: Suggested Reading

In addition to those cited in this chapter, check into the following resources:

Disabella, V., and C. Sherman. 1998. "Exercise for Asthma Patients." *The Physician and Sportsmedicine* 26 (6): 75-85.

Morton, A., K. Fitch, and A. Hahn. 1981. "Physical Activity and the Asthmatic." *The Physician and Sportsmedicine* 9:51-64.

Arthritis: Osteoarthritis and Rheumatoid

The distinction of being the most prevalent chronic condition in the United States goes to arthritis and other rheumatic conditions (American Council on Exercise [ACE] 1999). Arthritis currently affects more than 40 million people (one in seven), and it is projected that 60 million will suffer from its effect by 2020 (Centers for Disease Control and Prevention, 1996, as reported in ACE 1999).

People with arthritis often are limited in daily activities because of disabling pain, fatigue, and fear of pain. To many who are afflicted with this disease, the idea of exercising with swollen, painful joints and weakened muscles is not always received with enthusiasm. But research increasingly shows that the vicious and crippling cycle of pain leading to immobility and loss of physical independence as a consequence of arthritis can be broken by adding exercise to the treatment approach (DiNubile 1997).

Arthritis is the most common cause of disability in the United States, and although the cause (etiology) of the disease remains hard to pinpoint, its occurrence greatly increases with age. Arthritis is a chronic disease and can last a lifetime. Early warning signs include pain, swelling, and limited movement that last for about two weeks. Your clients should heed this warning sign and embrace activity because exercise can improve mobility of osteoarthritic joints, increase strength, and lessen pain and stiffness and swelling around the affected joint or joints. If your older clients want to stay on the dance floor, remain socially active, and avoid the paralyzing consequences of inactivity, which leads to immobility and pain, they need to embrace a managed approach to arthritis, which includes a life filled with activity.

Promises and Hope

Arthritis is a disease that has no certain remedy, yet it wreaks havoc on lives. Your clients may grasp at any promise of help. Arthritis hurts; it can be crippling and can extremely limit one's lifestyle. Be on the lookout for unsafe or ineffective treatments or therapies and advise your clients accordingly. Because of the relentless pain and frustration caused by arthritis, clients may be tempted to take a chance on anything that promises relief, no matter how far-fetched, risky, or costly. Arthritic symptoms can come and go and are referred to as "flare-ups." Remission periods can bring a welcome reprieve.

The roller-coaster nature of this incurable, painful, and frustrating disease has led to widespread quackery. Almost a billion dollars per year is spent by hopeful people who have arthritis and have been driven to tears of despair. Don't let your client be lured by this fraud and become distracted from effective conventional therapy.

On the other hand, although you should avoid quack devices and unfounded nutritional or supplement approaches, you also should objectively evaluate new treatment approaches, including supplements, so that your client will have every effective option available. Research seems to support the contention that diet has little to do with most forms of arthritis other than gout (Strange 1996), but promising information exists regarding glucosamine and chondroitin sulfate supplements

(see section this chapter, "Using Supplements to Relieve Arthritis Pain"). Many experts question in some instances, for example, traditional approaches that treat arthritis with medication. An approach that centers on drug use is far from harmless and is not always effective. (See section this chapter, "Traditional Treatment Approach to Relieving Arthritis Pain.")

Understanding the Arthritis Umbrella

The term *arthritis* literally means joint inflammation and refers to more than 100 kinds of rheumatic diseases. (*Rheumatic disease* or *rheumatism* is a general term that indicates diseases of muscle, bone, tendon, joint, or nerve that have in common pain, inflammation, or stiffness that is related to the musculoskeletal system.) Osteoarthritis is the most common form of arthritis, followed by rheumatoid arthritis. Other common forms of arthritis include fibromyalgia, gout, ankylosing spondylitis, juvenile arthritis, psoriatic arthritis, and systemic lupus. Bursitis, tendinitis, and carpal tunnel syndrome are sometimes grouped under the arthritis cover. All are linked by the commonality of symptoms that include pain and limited movement in the joints.

Several factors seem to predispose individuals to arthritis and include heredity, excess weight, and sport- or work-related injuries or associated repetitive stress movements.

Osteoarthritis

Osteoarthritis (OA), the most common form of arthritis, affects 16 million Americans—two thirds of them women (Schardt 1998). OA affects an estimated one third of those older than 60 (DiNubile 1997). The disease process of OA can affect one joint or several, with weight-bearing joints such as the feet, knees, and hips most often involved, along with the finger joints.

What Causes OA?

OA starts with degeneration of articular or hyaline cartilage, which appears to be the primary cause of OA. This degenerative beginning is usually accompanied by other changes around the joint that include muscle weakness and growth of new bone (i.e., bone spurs), which can lead to loss of mobility, function, and pain. When the cartilage that cushions the joints in the hands, hips, knees, or back breaks down faster than your client's body can replace it, this results in OA and its symptoms. Without this protective tissue covering the bones, bone rubs against bone, causing pain, tenderness, swelling, and stiffness. Arthritis typically sets in as your clients reach their late 40s and can be joint specific or can involve several joints.

What's the Cure?

There is no cure for OA, and though it isn't fatal (although associated symptoms can be related to premature death), there are few effective treatments (ACE 1999). Exercise, medication, and supplements can all be part of the management approach.

How Can One Avoid OA?

Avoiding or improving symptoms associated with OA can be as simple as helping your clients keep their weight down, keep their muscles strong, and keep themselves in overall good shape. Losing as little as 10 to 15 pounds can greatly reduce a client's risk for developing arthritis, especially in the knees. Jobs that require kneeling, squatting, and climbing stairs increase the risk of OA in the knees. Jobs that require heavy lifting increase risk at the hip. However, this does not give your client a license to avoid strenuous exercise or appropriate resistance training programs. Physical activities such as stair stepping, swimming, jogging, and walking do not seem to subject the joints to repetitive stress injuries and exacerbate arthritis unless the joint is already damaged. Additionally, strength training can stabilize and strengthen joint musculature, tendons, ligaments, and other supportive soft tissues.

Rheumatoid Arthritis

Sometimes called "the other arthritis," rheumatoid arthritis (RA) is the second most common form of arthritis. This potentially crippling disease affects more than 2.5 million Americans and affects three times more women than men. RA can strike people at any age but is more common between the ages of 20 and 50. The

disease is variable in its effect, and some RA sufferers can run marathons whereas others are bedridden (ACE 1999).

RA is classified as a systemic autoimmune disease, although a body of research seems to support an etiology by microorganisms or bacteria. (If true, this could greatly change treatment approaches.) Current theory states that the body's immune system, which normally protects the body, inadvertently produces antibodies that attack the joints of the hands, feet, hips, wrists, elbows, shoulders, or neck. Systemic means the condition can involve the entire body and pain can occur at different spots, disappear, and reoccur. RA is more often associated with severe complications and decline in function, with many patients dying 10 to 15 years earlier than those who are not afflicted (ACE 1999).

Treatment of Arthritis

Because there is no known cure for arthritis, the most effective treatment approach is prevention and early detection. Arthritis therapy has at least five goals (ACE 1999; ACSM 1995, 1997, 1998; DiNubile 1997; Gordon 1993a):

1. Ease pain
2. Decrease joint inflammation
3. Increase function (i.e., physical capabilities) by using exercise
4. Prevent and lessen joint damage
5. Increase patient education and ability to manage pain

Management of arthritic conditions consists of trying to relieve the symptoms, halt the inflammatory process and thereby avoid long-term joint damage, help individuals come to terms with their disease, and promote the idea of self-management.

You must consider and implement all of the previously mentioned factors when designing an exercise program. Most comprehensive treatment programs use a combination of patient education, medication, exercise, rest, heat and cold application, joint protection techniques (i.e., strength training), awareness training, and sometimes surgery (e.g., hip replacement).

Your client should understand that he will probably have some level of discomfort during exercise, because he probably has the same type of sensations during his normal, daily routine. Don't lead the client to believe exercise will be pain-free, but help the individual understand the difference between discomfort and injury.

Traditional Treatment Approach to Relieving Arthritis Pain

It is not uncommon for doctors to recommend nonsteroidal anti-inflammatory drugs (NSAIDS) such as aspirin or ibuprofen to relieve arthritis pain. However, these over-the-counter drugs—and stronger prescription medications—can cause serious side effects. NSAIDS account for an estimated 7,600 deaths and 76,000 hospitalizations each year (Tamblyn et al. 1997, reported in Schardt 1998). Drug therapy is far from harmless and should be carefully scrutinized and monitored for each individual prescription. OA is generally not lethal, whereas drugs can be.

Using Supplements to Relieve Arthritis Pain

Beware! Because people are grasping for solutions to take away their pain, discomfort, and limited movement capabilities, alternative therapies must be scrutinized. When scientific literature is analyzed, only two products stand out: glucosamine and chondroitin sulfate. Several studies indicate that both help to relieve the pain of arthritis in many people (Schardt 1998), although it should be noted that 40 percent of the people taking a placebo felt better, too.

Both drugs stimulate growth of cartilage and are building block molecules of cartilage. Both appear to be safe, but long-term safety has not been studied. Twenty to 50 percent of the people who try these drugs receive no relief. Many doctors tell their patients that glucosamine is worth a try. The side effects of glucosamine are minimal, and one study showed that glucosamine matched the effectiveness of

ibuprofen. If patients are interested, rheumatologist Marc C. Hochberg of the University of Maryland School of Medicine in Baltimore recommends that the patient take 500 mg three times a day for a month. If an improvement in symptoms is noticed, the patient continues the supplementation as long as it seems to work and there are no uncomfortable side effects. If no relief is gained after four weeks, the patient is encouraged to stop taking glucosamine (Schardt 1998). Arthritis sufferers are claiming amazing results and singing the praises of over-the-counter glucosamine and chondroitin and, according to research, they may not be imagining the relief. Regardless, professionals and arthritic experts alike should remain open to such information and fully understand what the research does, and does not, show.

Exercise Rx: Designing an Effective Program

As was true for many other degenerative diseases, in the past doctors often advised arthritis patients to rest and avoid exercise. Rest and avoidance of exercise are sometimes appropriate, but inactivity can quickly lead to a chronic pain cycle that can sentence the arthritic patient to physical immobility, an unhealthy, extremely limiting state. Routine advice today includes a balance of activity and rest that is individualized to each patient. Although exercise does not retard, improve, or cure arthritis, research typically supports that exercise does not worsen arthritis either, and exercise does improve many areas of the arthritic person's life.

Exercise Training Benefits for the Client With Arthritis

Literature supports the following benefits of exercise training (ACE 1999; DiNubile 1997; Gordon 1993a; Hoffman 1993):

1. Enhances development and maintenance of a functional range of motion.

2. Improves joint function and decreases pain (i.e., relief of physical discomfort).

3. Improves muscular strength, endurance, and aerobic capacity, which directly affects capacity to participate in an active lifestyle.

4. Increases or maintains bone mass or density, which can help your client avoid osteoporosis and immobility.

5. Enhances weight control; losing weight or maintaining a desirable weight can minimize the likelihood of excessive stress being placed on weight-bearing joints, like the knees and hips.

6. Decreases risk for other chronic diseases such as heart disease, hypertension, and diabetes.

7. Enhances self-esteem and mood state.

8. Increases neurohormones (i.e., painkillers), which play a role in general physiological stress reactions; they seem to reduce pain and enhance a general feeling of well-being and are linked to the improved mood observed in those who exercise.

9. Decreases risk for premature death and disability.

10. Improves financial status (i.e., arthritis is costly not only in terms of emotional and physical stress but literally in terms of money spent for treatment and money lost because some arthritic clients are unable to work).

Physical Decline of the Arthritic Client

Inactivity alone does not fully explain a decrease in physical capacity and self-esteem in arthritic clients. You have to question, "Why is this outcome common?" The answer is often pain. Pain can precipitate impaired muscle strength and is related to inflammation of joints and surrounding tissues, which further reduces range of motion capabilities and pushes the client into a vicious cycle of chronic pain and ultimately inactivity. Joint swelling even can limit the ability of your client to contract muscles. Additionally, when physical capacity begins to diminish, it is common that self-esteem simultaneously erodes and depression often sets in. A decrease in physical ability often increases one's anxiety level, possibly associated with the

fear of not being able to participate in activities of daily life. This syndrome can lead to sleep disruptions, greater fatigue, and increased musculoskeletal pain.

Because many types of arthritis can lead to a chronic condition, exercise needs to be a lifelong commitment, especially for those in pain or psychological ruin. Exercise must be fun, relevant, motivating, and effective if it is to be continued over a lifetime. This is a tough mandate and no easy task, even for healthy people!

Exercise Program Goals

The physical abilities of people diagnosed with arthritis vary immensely. Common goals of an exercise program for the person with arthritis include joint mobility improvement, joint protection, weight control, maintaining functional movement capacity, and increasing overall fitness (DiNubile 1997).

The exercise pyramid. A stepwise introduction of physical programming often begins with range of movement and stretching and is followed in order by isometric exercise, dynamic exercise, aerobic activities, and recreational activities (Hoffman 1993). This progression can be thought of as an exercise pyramid for clients with arthritis, the base of which is range of motion, stretching, and joint mobility.

Joint mobility improvement. Loss of mobility forces the arthritic joint to work at a mechanical disadvantage, which increases mechanical stress and promotes fatigue. Stretching in both active and passive ranges of motion is highly effective in maintaining desirable movement capabilities (see chapters 11 and 20 for posture exercises and a stretching program).

Joint protection. Resistance training strengthens the muscles and other connective tissue surrounding affected joints and protects the joint by increasing its shock-absorbing capabilities and by improving stabilization at the joint, all of which reduce stresses that can accelerate cartilage degeneration and immobility.

Weight control. Researchers have consistently identified obesity as a risk factor associated with OA. This is not surprising, because the knee, for example, is subject to impact equal to three times body weight during walking and

five times body weight when going up or down stairs or when running.

Functional capacity maintenance. Resistance training, especially training targeted at the lower body, likely plays a role in maintaining functional capacity (e.g., the ability to stand from a seated position) in older persons. Strength training, along with training that improves gait and balance, is appropriate when (or before!) arthritic clients show decline in these areas.

Combating the chronic pain cycle with exercise. Help your client understand this cyclical feature of arthritis:

1. If moving a joint causes pain, you stop moving the joint.
2. Pain leads to stiffness and loss of flexibility (contracture).
3. Loss of motion leads to disability and loss of function.
4. Proper exercise can break this cycle, along with other aspects of treatment, although it's not necessarily an easy road to follow. However, failure to break the cycle can reduce one's quality life and eventually lead to premature death.

Individualizing the program. Exercise for the arthritic person should involve programming that is geared to the individual's physical and mental capability to endure discomfort. Progress should balance challenge and comfort. Exercises should be modified accordingly and to accommodate individual limitations.

"Wearing Out"

Some clients are concerned that repetitive activity might promote or accelerate the disease. Most data suggest that in the absence of joint abnormalities, physical activity that remains within the limits of comfort and normal range of motion does not lead to joint injury (Bouchard, Shephard, and Stephens 1993).

Exercise for Clients With Arthritis

When training the arthritic client, identify what is tolerable to the client and remind her that the consequence of inactivity is worse!

Joint Mobility, Active Flexibility, and Range of Motion Exercise

Preserving joint mobility and functional range-of-motion (ROM) movement patterns that are used in your client's daily routine is critical. This form of exercise is the foundation of an exercise program for people with arthritis.

Have your client exercise when stiffness and pain are at their lowest, which is often midmorning. Focus on gentle ROM movement every day, if not several times per day. Target all of the major muscle groups, especially the front of the shoulders and chest, calves, hamstrings, and pelvis, as well as affected joints if acute flare-ups are not present or limiting. Aggressive or improper stretching can harm any joint, especially one that is inflamed. Use active, active-assisted, or passive stretching techniques (chapters 15 and 20). Start slowly and gradually increase repetitions, sets, and duration of stretching. Initially, encourage the client to hold the stretches for 6 to 8 seconds and progress to 8 to 20 seconds, or whatever is tolerable. As the client progresses, several sets and repetitions may be used daily.

Resistance Training

Strength training helps keep muscles strong, protects and stabilizes joints, helps promote fat loss, and preserves physical independence (e.g., getting out of a car or chair).

Isometric strength training is a good starting point because strength can be developed at a joint with no or little movement, and this training is less likely to irritate an inflamed joint (realize that functional or stabilization training incorporates isometric force production to sustain a desired body or joint position). Instruct the client to hold contractions for about six seconds and continually breathe. Maximal effort is generally not desired, or required, and it increases the risk of injury to the skeletal system or cardiovascular system (e.g., unnecessary and sometimes dramatic increases in heart rate and blood pressure can occur).

Most arthritic clients can progress to dynamic strength training that involves both concentric and eccentric phases when pain and joint inflammation are controlled. With any type of comprehensive exercise plan, the client should warm up and cool down, exercise within a pain-free ROM, perform functional and balance exercises as well as traditional or isolated movements, and modify exercises according to need, tolerance, and progression.

ACSM recommends that clients build to two to three sessions per week, with at least a day of recovery between sessions. A balance should be struck between all of the major muscle groups and between affected and unaffected joints. Affected joints may require lighter loads and can be exercised more often to increase conditioning benefit if you observe no adverse effects. To optimize strength gains, provide a load to which the muscles are unaccustomed, such as 8 to 20 repetitions to fatigue, if tolerable. Note that high-repetition (which can result in overuse stress to the joint), high-resistance (e.g., low reps and heavy loads), and high-impact strengthening exercises are not recommended. Simple (tubes, bands) or sophisticated resistance training equipment (machines) is acceptable, as both work! It is never too late for strength gains, and because chronic inflammation and associated inactivity target muscles for breakdown, strength training is paramount.

Cardiovascular Conditioning

Aerobic exercise for clients with OA has been shown to improve cardiovascular fitness, reduce symptoms, and improve functional exercise (DiNubile 1997). Improved fitness means less pain and improved function for the person with arthritis.

Treatment of arthritis often has excluded aerobic exercise for fear of exacerbating arthritic symptoms and accelerating the disease process. It has been proven that if clients are not experiencing acute flare-ups, aerobic exercise is safe and effective. Low-impact activity is the preferred choice, which includes walking, cycling, water-based exercise (water should be about 83-88 degrees Fahrenheit), low-impact dance aerobics, and rowing. In some clients with arthritis, stair climbing, running, fast dancing, and other high-impact activities should be avoided. Low-impact activity choices decrease risk for orthopedic complications and increase exercise compliance.

Start clients with 5 to 15 minutes of moderate to somewhat challenging activity every other day and progress to daily aerobic exercise

that lasts 30 to 45 minutes. Consider having the client participate in shorter sessions done more frequently, because exercise accumulated throughout the day will be more easily tolerated for some arthritic clients and yet still provides similar health benefits compared with continuous training. Begin each aerobic session with an extended warm-up that includes ROM exercises, and end each exercise session with an extended cool-down and ROM exercises.

Beyond ROM, Strength, and Aerobic Exercise

Incorporate posture, balance, and coordination activities in your client's program. Poor posture, misaligned body positions, and an inability to correct a slip or fall can be as disastrous as injury; decreased joint mobility and decreased strength can destroy movement patterns that were once efficient, controlled, and integrated. Test functional fitness too. You need to find out whether your clients can get into and out of chairs and cars and can maintain an erect sitting posture. Flexibility, ROM, mobility, functional movement patterns, balance, and strength go hand in hand. When these elements are combined with body awareness, this is a winning formula for getting results and teaching arthritic clients that exercise is a realistic, lifelong pursuit that positively affects their well-being.

Two-Hour Rule

If a client's pain level is greater than it was before exercising and the pain persists more than two hours after the session, the client has done too much. Modify the next session so that the client reduces volume or intensity of effort. Follow the exercise guidelines found in the box on this page for clients with arthritis.

Individualized Health Screening

Besides filling out a complete health history form and having a medical release from your client's doctor, you can individualize your client's program by having the client answer the questions in the box on page 510. Obtain additional information from your client's doctor by using the questionnaire as a template to discuss your client's condition.

Exercise Guidelines for the Client With Arthritis

1. Warm up (extend the warm-up if in doubt) and engage in ROM exercises before a workout, and cool down at the end of a workout.

2. Your client's doctor may suggest a pain-relieving medication or supplement for greater comfort and for increased exercise tolerance.

3. Applying ice to any arthritic joint for 15 to 20 minutes after a workout will reduce soreness and help prevent swelling. (Always check with your client's doctor before applying heat or cold.)

4. Some muscle ache or tolerable joint discomfort after exercise is normal. However, if joints are significantly more painful that night or during the next few days than before exercise, suspend the workouts until symptoms subside. Use the two-hour rule as a guide to whether your client has done too much.

5. Exacerbated symptoms warrant changes in programming, and small changes will usually get your client back on the right track.

Health Screening for the Arthritic Client

1. What type of arthritis do you have?

2. What specific joints or body areas are affected, most painful, or unstable?

3. Do you have any days when your joints are red, hot, or more swollen than usual? Do you experience any other symptoms?

4. How do your joints feel during and after exercise?

5. Do any activities or movements cause unusual pain or discomfort?

6. Are there days when you feel more fatigue than usual because of arthritis?

7. Is there a certain time of day when you feel more comfortable exercising?

8. What medications or supplements do you use? What are the side effects?

9. Are there any restrictions or recommendations from your physician or yourself or other medical conditions that might limit physical activity?

10. Can you engage in a total fitness program that emphasizes range of motion training, balance training, resistance training, and aerobic conditioning?

Perfect Setup for Success

Ultimately, a client should be motivated not only to exercise with a trainer but to accept the responsibility for exercising on his own. The trainer must delegate responsibility and the client must be willing to accept it! Help your arthritic client become more aware of steps he can take to help improve his situation.

Results, relief from or improvement in chronic pain, and personal independence will make clients feel self-motivated, confident, and successful. Fostering such a relationship empowers the arthritic client to live a fuller life that is more independent of his chronic condition.

Arthritis: Suggested Reading

Arthritis Foundation. 1996. *Arthritis Fact Sheet.* Arthritis Foundation. Available: www.arthritis.org. [Accessed May 30, 2003.]

Centers for Disease Control and Prevention. 1994. "Prevalence of Disabilities and Associated Health Conditions—United States, 1991-1992." *Journal of the American Medical Association* 272 (22): 1735-36.

Rizzo, T. 1997. "Exercise and Arthritis." *IDEA Today* (Feb.): 25-29.

U.S. Department of Health and Human Services. 1996. *Physical Activity and Health: A Report of the Surgeon General.* Atlanta: Department of Health and Human Services, Centers for Disease Control and Prevention, National Center for Chronic Disease Prevention and Promotion.

Resources

Arthritis Foundation: www.arthritis.org

CHAPTER 28

Working With Older Adults

Pablo Picasso once noted, "Age matters only when one is aging." Most older adults would agree with a slight nod of acknowledgment and a wry, knowing smile. Aging can be thought of simply as the passage of time. However, when it is your client's body (or yours) that is passing time, it becomes a more personal and important matter!

The attention and interest of older adults in the aging process and what can be done about it have made them the fitness industry's most captive audience. Millions of older adults are concerned about aging gracefully and maintaining vitality. You can be part of the solution that helps older clients age gracefully while simultaneously maintaining a positive self-esteem and a productive, vigorous, and healthy lifestyle.

It is no secret that America is aging. The over-65 age group is the fastest growing age group in our society and since the 1960s has grown twice as fast as the general population. By the year 2030, the number of individuals 65 years and over will increase to 70 million in the United States alone (Mazzeo et al. 1998). Persons 85 years and older (defined as the "oldest old") are now classified as the fastest growing segment of the American population (Schnirring 2000).

The result of unprecedented success in health promotion and maintenance is that more and more individuals are approaching the upper limits of the human life span. The average American (and individuals from other countries who lead a similar lifestyle and have comparable health care) lives a long life, but he or she is often sedentary, fat, unfit, and chronically ill. Any adult who has accumulated such a lifetime of comfort and inactivity has (by choice or by being uninformed about the positive impact of activity and proper diet) inherited an ultimately disabling lifestyle. Medical intervention that includes advanced medicines and other procedures prolongs life, but a breathing existence is far from a high quality of life.

Disability Zone

According to experts on aging, rest is precisely what aging people do not need. Starting in middle age, people begin to gain fat and lose muscle, strength, bone, and aerobic capacity. Their risk of heart disease, diabetes, high blood pressure, and osteoporosis climbs. They're headed for the "disability zone" (Evans and Rosenberg 1991).

The disability zone is the time span from the point at which a person no longer leads a quality life (i.e., because of disease) to his or her death. The distinction is made by comparing "health span" to lifetime. The two are very different. Your client's health span is the time in which she is functional, healthy, and otherwise capable of performing everyday tasks for herself. In other words, functional capacity is high because she is self-reliant and capable of independent living in her preferred home environment. On the other hand, the disability zone is usually that period of time (often 10-15 years) that occurs near the end of a person's life when she becomes increasingly dependent on others (Evans and Rosenberg 1991). For your clients and loved ones to finish the race of life strong, you would like to see the time they spend in the disability zone significantly shrink or disappear. Let the knowledge of the disability zone serve as your client's motivator!

Who Is the Older Adult?

The over-50 population is a diverse and mixed community. This target market includes older adults who are free from diseases and fit, healthy and unfit, unhealthy (they have some kind of disease) and fit, unhealthy and unfit, or physically limited, as well as numerous other categorizations that don't fit into these molds. The message here is to not stereotype or label older adults as to their needs or physical status until a thorough history has been performed. Then, and only then, will you have a good idea as to the individual's special and unique needs. It is clear that one-size-fits-all programming is inappropriate for older adults.

Making Physical Activity Meaningful and Fun for the Older Adult

A properly designed and implemented exercise program for older adults can have many physical and emotional benefits. Of course, one of these benefits is that older persons can maintain an independent, active lifestyle. Additionally, you must make exercise fun and meaningful for older adults not only by focusing on their physical needs but by also taking into account social and emotional needs.

Fact and Fiction for the Over-50 Exerciser

As people grow older, they often worry about having enough money to live their golden years in a fashion they are accustomed to or as they anticipate retirement. Older adults should be as concerned about having enough muscle and energy left to move, function properly, and maintain their physical independence. Exercise is a blueprint for aging more slowly. People of any age can slow much of the physical decline associated with aging by exercising on a regular basis. If your older clients are ever encouraged to "take it easy," have them prepared with the retort, "Rest is precisely what I do not need!" Bust any misconceptions they have about their ability to engage in an active, healthy lifestyle by educating them about the following myths and facts:

Myth 1. I'm too old to exercise.

Fact.

The body is incredibly resilient. People 70, 80, and 90 years young show huge improvements in fitness. Your clients are never too old to begin. In fact, they cannot afford not to exercise. Muscle strength, dense bones, and a strong heart are essential for a quality older life. Exercise is medicine!

Myth 2. I have no energy, so I can't exercise.

Fact.

If your client is out of shape and exhausted before the day begins, it seems ludicrous to consider the possibility of adding exercising to his schedule. However, if he starts slowly, he'll build stamina and strength quickly. Before long, he'll have enough energy at the end of the day to carry over and provide an energy margin so that he can play with his grandkids or enjoy personal recreation. Once he feels the energy, he'll never want to be without it again, so he needs to get started and don't quit.

Myth 3. I need to get in shape before I begin a resistance training program.

Fact.

A resistance training program can be the first step and the most important part of one's training (Buckwalter and DiNubile 1997; Mazzeo et al. 1998). Your client should not wait to

Continued ➤

➤ *Continued*

strength train until he's in shape. He can start building muscle today and change his posture, change his appearance, speed up his metabolism, build strong bones, lose weight, and maintain physical independence.

Myth 4. I can lose weight through diet alone.

Fact.

The combination of sensible calorie restriction and exercise is the best solution for losing weight and keeping it off. Many older people who gain weight are eating fewer calories than previous years but continue to gain fat weight because they are losing muscle. Aerobic exercise and diet alone are not the answers. Your client has to strength train, too.

Myth 5. Middle-age spread and aging are natural, so why bother with exercise?

Fact.

Middle-age spread is normal but far from natural. Getting out of shape, gaining pounds, and being more susceptible to a host of life-threatening illnesses are common too, for most Americans and others who live in modernized societies. But, no one wants to be average in a largely unhealthy world. Exercise will help your client keep the weight off, avoid degenerative diseases like diabetes and heart disease, handle stress better, and feel good too. Being inactive has more to do with aging than any inevitable physiological reasons. Most physiological decline stems from inactivity and is therefore reversible (Schwenk 1999, p. 3).

Myth 6. Exercise is all or none. You either do it all the time or you don't.

Fact.

Don't let your client set himself up with a perfection scenario. The goal of perfection is the perfect setup for failure. Exercise done consistently, over time, is the winning formula. If he gets off track, he should hop back on as soon as possible. This race goes to the tortoise, not the hare.

Myth 7. I don't have time to exercise.

Fact.

Your client can't afford not to exercise. Exercise will increase his energy and vitality. He should schedule exercise as an appointment not to be missed and set a planned course of action. It's simple. At a minimum, he should eat right, walk three to five times per week, and strength train two times per week for 20 to 25 minutes.

The Fountain of Youth: Exercise Is the Aging Antidote

Don't let your client buy into the myth that aging is an inevitable, unstoppable process. Although your client's overall function will certainly decline compared with what she was capable of doing when she was 20, the most severe aspects of aging are related to inactivity and muscle loss. In fact, an active and fit 70-year-old can have the same maximal aerobic capacity as a sedentary and unfit 25-year-old (Schwenk 1999, p. 3).

Oliver Wendell Holmes captured this idea of comparing chronological age to functional age accurately when he said, "To be 70 years young is sometimes far more cheerful and hopeful than to be 40 years old." I encourage my clients to avoid the rocker with a battle! They do so by choosing an active lifestyle. The goal: to die young as late as possible!

General Program Recommendations

1. Choose exercises that are familiar and enjoyable.
2. Repeat specific activities to improve coordination, skill, and confidence.
3. Make sure the individual possesses the requisite skill to safely perform the activity.
4. Avoid or modify activities that are high impact and may involve trauma to joints and muscles, as appropriate to a client's specific situation.
5. Avoid or modify activities that require a high level of coordination and balance, as is appropriate to a client's specific situation.
6. Include adequate, gradual warm-ups (i.e., at least 10-15 minutes) and cool-downs (i.e., at least 5-10 minutes). These recommendations are especially appropriate for older adults who have known cardiovascular or orthopedic concerns or arthritis.

Program Design for the Older Adult: A Balancing Act

The use of a variety of training strategies is your best approach to training the older adult. Not only should cardiorespiratory, strength, and flexibility fitness be evaluated, but posture and walking gait should be trained and improved, too. Additionally, balance and functional training can help older adults improve balance and decrease their chances of falling or becoming disabled.

General Exercise Guidelines for Working With the Older Adult

When older clients request personal training, what can you do to guide them safely?

Use reliable information. In general, many of the basic guidelines that have been developed by ACSM (1997, 1998) for apparently healthy adults are appropriate for older populations, as well as specific recommendations set forth for older adults (ACE 1998; Mazzeo et al. 1998). The older participant can be more fragile or have a variety of chronic diseases that can make him more susceptible to fatigue, temperature extremes, orthopedic injury, and cardiovascular problems. Guidelines should also be adapted to the older adult's specific capabilities, limitations, and goals. Strength training should be a primary training goal.

Conduct a thorough preexercise assessment of the individual's health, capabilities, and limitations. The assessment must include a general medical evaluation with special attention given to the cardiovascular, pulmonary, musculoskeletal, and neurologic systems. In addition, the assessment should identify disorders and limitations that (a) preclude physical activity or require treatment and stabilization before exercise or (b) require modification of the exercise program. Use the assessment to determine whether you are qualified to work with this client based on the client's special needs and your background. In most instances you will have the capabilities if you're willing to ask questions and get answers to the ones you don't know.

Understand and clarify training goals. For most older adults, the primary health goal is to maintain an independent lifestyle that allows participation in the activities and social environment they enjoy. Stress to clients that the physical program is a supplement to—and not a substitute for—proper diet, adequate rest, and a positive outlook.

Use a comprehensive training approach. Older adults require individualization of their exercise programs. Balance, functional training, cardiovascular conditioning, muscular strength, muscular endurance, posture, and flexibility should be promoted.

Adjust cardiovascular training. In addition to formal cardiovascular exercise (i.e., regimented and planned), encourage an increase in everyday and recreational activities such as strolling, stair climbing, light housework, and gardening.

The generally recommended frequency for cardiovascular conditioning for adults is three to seven times per week, with 15 to 60 minutes of exercise per session, for a minimum of three nonconsecutive days. Many older adults—especially those who were previously sedentary—prefer and tolerate low- to moderate-intensity exercise for longer periods. If longer durations are not well tolerated, use intermittent activity. Balance compliance with training effect, intensity, and duration.

Cardiovascular fitness improvements have been documented with lower intensity exercise (i.e., 40 percent of $\dot{V}O_2$max). ACSM recommends a training intensity range between 40 and 85 percent of $\dot{V}O_2$max or heart rate reserve. For the previously inactive older adult, attaining a high exercise intensity is the least important factor in a successful program and, if emphasized early on, can lead to injury and exercise dropout. The program should match up with the client's fitness and tolerance levels (ACSM 1997; 1998; U.S. Department of Health and Human Services 1996).

Include strength training in the program. Many researchers believe the single most critical step in countering the aging process is strength training. A number of influential scientific papers (Feigenbaum and Pollock 1997; Fiatarone et al. 1990; Fiatarone, O'Neill, and Ryan 1994; Frontera, Meredith, and O'Reilly 1988; Mazzeo et al. 1998; Westcott 1995) provide persuasive information that has shaped current thought on optimal strength training programs for the older adult. It is inaccurate to believe that the older adult loses his ability to respond to exercise or a strength training stimulus as he ages. Studies have shown that strength can triple in older adults.

Strength training is the only way to stop muscles from wasting away (atrophy). It doesn't matter if your client runs every day or is 40 years old or 75 years young—if he doesn't build muscle with strength training he will lose it. Between the ages of 25 and 40, individuals commonly lose about four percent of their muscle

per decade. After age 50, a person can lose about 10 percent per decade, or about 1 percent per year. An approximate 30 percent reduction in strength between 50 and 70 years of age is typical in older adults. Muscle strength continues to dramatically decline by approximately 15 percent per decade in the sixth and seventh decade and 30 percent thereafter (Mazzeo et al. 1998). Bottom line: Strength train or lose it!

Emphasize flexibility and posture. Although science cannot precisely define the dose (how much)–response (result) training guidelines for flexibility training, basic programming parameters include stretching that is static in nature, rather than bouncing. Stretching can be performed two to seven days per week using sustained holds of 5 to 40 seconds, although I find 20 to 30 seconds more tolerable for older clients. Stretches can be repeated several times per body part, and intensity can be characterized as muscular tension that is comfortably uncomfortable but is not progressed to a point of pain. Range of motion progression cannot occur too slowly (see also chapters 11, 15, and 20).

Individualize older adults' exercise programs. A huge diversity exists among the physical and mental capabilities of older adults. There are completely inactive seniors and very active seniors. What works with one client or group may not work with another.

Importance of Resistance Training for Older Adults

The message is loud and clear. Strength training keeps muscles stronger, preserves physical independence, limits the likelihood of several chronic diseases (e.g., diabetes), and helps keep aging bodies physiologically younger than chronological age.

Research (ACE 1998; ACSM 1995, 1997, 1998; Evans and Rosenberg 1991; Mazzeo et al. 1998; Pollock et al. 1998) suggests that the single most important step to not just retard but to reverse the aging process is strength training. It is a myth that the elderly entirely lose their ability to respond to a strength training stimulus. Early studies seemed to support this view, but erroneous study design—too little

resistance was used—doomed the "strength response" theory to failure. It was not that older adults could not respond to a strength stimuli, as some studies indicated; simply, they were not presented one! Strength levels have tripled in well-controlled and designed strength studies using older adults, and other studies have shown strength improvements as high as 200 percent (Evans and Rosenberg 1991; Mazzeo et al. 1998). However, as is true for a person of any age, the older adult must work at sufficient intensity to optimize the strength training response and to see significant strength training gains.

Movement mechanics. Strength training can increase strength and associated functional capacity in aging adults. Improved gait, leg power, and balance are a few of the associated benefits.

Strength training, energy expenditure, and metabolic rate. Daily energy expenditure declines progressively throughout adult life. The main factor in sedentary individuals that leads to this decline in energy expenditure is a loss of fat-free mass. Loss of muscle contributes to a significantly lowered basal metabolic rate in older adults.

In addition to muscle's role in energy metabolism (i.e., calorie expenditure, weight control, and weight loss), loss of muscle can result in reduced bone density, reduced insulin sensitivity (i.e., increases insulin action), and reduced aerobic capacity (Mazzeo et al. 1998).

For these and many other reasons, programs that increase muscle mass can increase functional independence and capacity in previously sedentary older adults and can decrease the older adult's risk for incurring many age-associated chronic diseases.

➤ Note: Inadequate protein intakes can hinder the anabolic (hypertrophy) response to strength training in the older adult. The current Recommended Dietary Allowance (RDA) in the United States of 0.8 gram of protein per kilogram of body weight per day seems to be inadequate for older adults. Recent data suggest that the safe protein intake for older adults is 1.25 grams per kilogram per day (Mazzeo et al. 1998).

Strength training guidelines. The key to effective strength training is to select an intensity (resistance or load) that will fatigue the targeted muscles in 8 (about 85 percent of 1-repetition maximum or 1RM) to 20 reps (about 50 percent of 1RM), which presents an effective training stimulus. Endless repetitions can lead to overuse injuries and won't produce significant strength gains. However, during the first 12 weeks of a strength training program you don't need to encourage the older adult to attain voluntary muscle failure. Plenty of fitness benefits will accrue in these early stages of training without attaining voluntary muscle failure.

Muscle strength has been shown to increase in response to training between 60 and 100 percent of the 1RM (Mazzeo et al. 1998), which roughly equates to between 1 and 16 repetitions. (A 1RM load is the most amount of weight the client can lift and safely control one time with good form. A 20RM is a resistance that can be lifted 20 times during a given exercise. Low RMs, e.g., 1-7, are usually not recommended for older adults.)

Start with higher reps (e.g., 20) and less weight with deconditioned clients, and progress them accordingly. In previously sedentary adults, this conservative starting point will increase muscular strength and endurance while simultaneously minimizing the risk of injury. At a minimum, have your client perform two sessions per week with at least 48 hours between sessions, have him perform one set to failure (after about 12 weeks of training) or fatigue (the last rep is challenging to do and the client can still maintain good form), and choose 8 to 10 exercises that challenge all of the major muscle groups. Use a controlled movement speed that has each rep lasting between six and nine seconds (ACE 1998). I find that many clients tolerate a four- to seven-second repetition much better. The issue of course, is to control the movement speed. Recovery between repetitions and sets is determined by individual capacity, response, tolerance, and training goal, as is true for range of motion. Generally, a full recovery between each set is prudent.

General guidelines recommend a training intensity of between 70 and 80 percent of 1RM with a goal of 8 to 15 repetitions (ACE 1998). Err on the side of being conservative, and progress carefully to this lower rep range and relative greater intensity. Voluntary muscle failure becomes increasingly important after about 12 weeks of training, in terms of continued training result.

➤ Note: A 1RM, in terms of absolute weight or resistance used, can be quite low in deconditioned older adults. It does not necessarily involve a lot of weight or a heavy resistance. Make certain that the load the client is lifting—whether in the form of tubing, machine, or body weight—can be completed enough times so that it falls within the recommended repetition guidelines of 8 to 20 reps. For example, a modified bent-knee push-up can be a 1RM for some deconditioned older adults (they can only do one or no push-ups!) and is inappropriate for that individual at that point in his program if the appropriate rep goal is 15 to 20.

Research strongly documents that the rewards of strength training are plentiful:

- One advantage is a leaner body. Maintaining or increasing muscle mass preserves your client's ability to burn higher numbers of calories. Your client's body operates at a higher metabolic rate, and it's easier for her to maintain or lose weight.

- Another key argument in favor of resistance training is strong bones. Bones and muscle deteriorate with age and especially inactivity. The best way to strengthen bones is to stimulate the muscles that pull on them, eat a healthy diet, and participate in weight-bearing or low-impact activity.

- Improved posture is yet another plus of resistance training. Strong muscles help to maintain an erect posture and could eliminate many orthopedic problems associated with the back, hips, and knees.

- Resistance training can also provide good "armor" for your client's body during aerobic or cardiovascular workouts. Strong and resilient muscles, bones, tendons, ligaments, and cartilage protect the joint from potential injury, especially when the client is performing weight-bearing activities or after a fall.

The rewards of resistance training are indeed plentiful. Many older adults comment that they get a kick out of their new body: their abdomens flatten, something walking never did for them; their arms are firm; they stand straight up; and they can lift heavy objects and play with their grandkids. Being independent in itself may be reason enough for everyone, at any age, to begin strength training.

Individualizing Programming Approaches

As with all populations, there is diversity within the older adult population. There are completely inactive older adults and very active 70-, 80- and 90-year-olds. Some still run marathons, while others can't walk a flight of stairs or lift a bag of groceries.

What works with one person or group may not work with another. It is obvious that no single best program exists for training older adults. Program design involves integrating sensible and realistic goals and using an educational approach to explain what exercise can and cannot do in terms of health, fitness, and performance. This must be balanced with what the client wants and needs, what he can tolerate, and what he will participate in regularly.

Starting slowly. I fear that many exercise programs are too hard, intimidating, or complicated. An injury or other setback incurred early in the program is often the end of the program. The message for many older adults is to do something. Any active participation that is above what the older adult is doing currently is positive. Sometimes you have to forget textbook-perfect applications so that you can be successful in the real world. In this case, something is truly better than nothing. Emphasize joy, fun, and play. Older adults love to laugh and are like children in this sense. If it's not fun and doesn't feel good, they won't come back for more!

Working with older adults is rich with the opportunity for business and personal reward. Exercise works and, without doubt, greatly improves the quality of life for most older adults.

Growing Old

"Youth is not entirely a time of life . . . it is a state of mind. It is not wholly a matter of ripe cheeks, red lips or supple knees. It is a temper of will, a quality of the imagination, a vigor of the emotions. Nobody grows old by merely living a number of years. People grow old only by deserting their ideals. You are as young as your self-confidence, as old as your fears, as young as your hope, as old as your despair.

In the central place of every heart there is a recording chamber; so long as it receives messages of beauty, hope, cheer and courage . . . you are young. When the wires are all down and your heart is covered with the snows of pessimism and the ice of cynicism, then, and only then, have you grown old."

Anonymous quote sent to me by my mother, who is 73 years young.

Secret of Aging Well

We need to give older adults for whom we care and love positive messages and identify and communicate their worth and value. And there is a flip side. Older adults must exude an enthusiasm for life that, although it can be encouraged by all who interact with them, is ultimately the responsibility and choice of all who grow old. In conclusion, active living (there is no age limit to the benefits of exercise) and a positive outlook are keys to aging well!

Aging: Suggested Reading

Bouchard, C., R.J. Shephard, and T. Stephens. 1993. *Physical Activity, Fitness, and Health Consensus Statement.* Champaign, IL: Human Kinetics.

Centers for Disease Control and Prevention. 1994. "Prevalence of Disabilities and Associated Health Conditions—United States, 1991-1992." *Journal of the American Medical Association* 272 (22): 1735-36.

Kravitz, L. 1996. "The Age Antidote." *IDEA Today* (February): 28-35.

Spirduso, W.W. 1995. *Physical Dimensions of Aging.* Champaign, IL: Human Kinetics.

U.S. Department of Health and Human Services. 1996. *Physical Activity and Health: A Report of the Surgeon General.* Atlanta: U.S. Department of Health and Human Services, Centers for Disease Control and Prevention, National Center for Chronic Disease Prevention and Promotion.

VanNorman, K. 1995. *Exercise Programming for Older Adults.* Champaign, IL: Human Kinetics.

Westcott, W.S., and T.R. Baechle. 1998. *Strength Training Past 50.* Champaign, IL: Human Kinetics

Resources

American Association of Retired Persons: 202-434-2277 or www.aarp.org

American Senior Fitness Association: 800-243-1478 or 904-427-0613

National Institutes on Aging: 800-222-2225

A directory for Web sites of agencies, organizations, and advocacy groups related to aging can be found at www.aoa.dhhs.gov/aoa/webres/craig.htm

Training the Pregnant Client: A Special Healthy Population

Attitudes have changed significantly in recent decades with regard to women exercising during pregnancy. In fact, the difference between the guidelines of the 1950s and the initial American College of Obstetricians and Gynecologists (ACOG) guidelines that were released in 1985 is rather marked—and these recent recommendations were followed by further revised ACOG guidelines in 1994 and 2002. Information continues to mount that most pregnant women can exercise in a manner that keeps the developing fetus as well as the mother safe.

In the 1950s, the prevailing standard of care "allowed" a pregnant woman one mile of walking daily, and it was preferable that the mile be broken up into several sessions (Artal and Sherman 1999). In 1985, ACOG endorsed very specific limits on continuous duration (15 minutes) and heart rate (140 beats per minute). These guidelines were based on empirical observation and were designed to ensure the safety of the majority of pregnant women because clear-cut scientific research was not available to answer all of the questions related to exercise and pregnancy. Nine years later, and because many experts believed these initial recommendations were too restrictive for very fit pregnant women or highly trained athletes, the organization issued exercise recommendations for uncomplicated pregnancies that paralleled those used with nonpregnant women (ACOG 1994). The previous restrictions on exercise duration and heart rate were eliminated, and the recommendation was modified to indicate that most women can begin, or continue to exercise moderately to maintain cardiorespiratory and muscular fitness throughout pregnancy and the postpartum period (Artal and Sherman

1999). This recognition of individual differences allowed the fitness prescription to more readily match the activity patterns, fitness levels, and exercise capacities of women who continue to exercise while pregnant. In fact, the most recent ACOG (2002) guidelines state that healthy pregnant women can adopt the activity recommendation for the general population, which is 30 minutes or more of moderate exercise on most, if not all, days of the week. Raul Artal, principal author behind ACOG recommendations, believes that pregnancy offers a unique time for behavior modification and that healthy behaviors maintained or adopted during pregnancy can influence a woman's health for the rest of her life (Schnirring 2002).

Many women of childbearing age exercise regularly and often desire to continue to do so throughout their pregnancy and postnatal period. This reflects not only the evolving role of women in society but also advances in scientific understanding related to the effects exercise has on the fetus (Artal and Sherman 1999). Scientific knowledge helps a mother exercise with confidence and contributes to an accurate programming approach that keeps both mom and unborn child safe.

Moving Beyond Misconceptions and Outdated Guidelines

Misinformation and bad advice are still rampant when it comes to exercise advice for pregnant women. To follow are common myths, followed by facts, regarding pregnancy and exercise:

Myth 1. Exercise should never last longer than 15 minutes.

Fact. Although it's never a bad idea to use the concept of intermittent exercise—a number of minutes exercising followed by recovery and hydration—the black-and-white 15-minute limit arose in the initial attempt to set conservative and safe guidelines for women who exercised throughout their pregnancies (ACOG 1985). More current guidelines—buoyed by research that says women with uncomplicated pregnancies can exercise with virtually the same safeguards as nonpregnant women—support that women can exercise for longer periods of time (30 minutes or longer, most if not all days of the week) as long as they remain well-hydrated and perceive the exercise as mild to moderate (ACOG 1994, 2002). ACOG guidelines even encourage women who did not exercise prior to their pregnancy not only to adopt healthy behavior changes related to nutrition and other lifestyle choices but to also begin a progressive and moderate exercise program (ACOG 2002).

Myth 2. Exercising heart rate should never exceed 140 beats per minute.

Fact. This definite limit on heart rate also stems from the 1985 ACOG guidelines. Although deemed appropriate in 1985, this recommendation is now outdated. Research has revealed that a blanket recommendation like this was very limiting for women who found a heart rate of 140 beats per minute barely more taxing than a warm-up level of effort. New guidelines tell women they can engage in regular, mild to moderate exercise on most, if not all, days of the week (ACOG 2002). This change in wording is significant because it allows each pregnant woman to gauge her own fitness level and perceived level of effort, which can better match individual fitness needs.

Myth 3. Exercise causes low birth weight babies.

Fact. Research findings have been inconsistent with regard to fetal weight in women who exercise (Artal and Sherman 1999). Some studies of exercising pregnant women show lower birth weight, no difference, and heavier babies at birth (Artal and Sherman 1999). One review (Pivarnik 1998, quoted on p. 54 of Artal and

Sherman 1999) concluded that "current evidence appears to indicate that participation in moderate to vigorous activity throughout pregnancy may *enhance* birth weight," although the study cautioned that more severe regimens could result in lighter offspring. According to Pivarnik (1998), sufficient calorie quantification (i.e., is caloric intake sufficient?) is critical to evaluate before definitive conclusions can be made regarding exercise and birth weight. This key, calorie quantification, is missing from most studies. James Clapp (1998) found that vigorous and regular exercise throughout pregnancy decreases fetal fat without decreasing overall growth. In other words, women who exercise don't have low birth weight babies (less than 5 pounds 8 ounces) but may have lighter and leaner babies. *166*

Myth 4. Vigorous exercise causes miscarriages or premature labor, and pregnant athletes who exercise hard compromise maternal and fetal health (Kardell and Kase 1998; Bailey, Davies, and Budgett 1998; Hale and Milne 1996).

Fact. Anecdotal reports have led many people to believe that exercising during pregnancy leads to a higher incidence of miscarriages. A normal rate of miscarriage is between 15 and 20 percent. The incidence of miscarriage for pregnant exercisers and pregnant nonexercisers is 16 to 17 percent (Clapp 1998). Continuing exercise throughout pregnancy does not lead to a higher incidence of miscarriage or birth defects.

As for premature labor, the concern is that increased norepinephrine and prostaglandin output during exercise (or prolonged standing) could stimulate uterine activity and premature labor. One study concluded, "The observed reduction in risk of preterm delivery in a general obstetrical population is evidence of the safety, as well as the potential benefits, of exercise during pregnancy" (Artal and Sherman 1999, p. 57).

But what about vigorous exercise? Although a moderate exercise training regimen is generally recommended during pregnancy, some highly conditioned pregnant athletes appear able to train safely at very demanding levels of physical exertion (Bailey, Davies, and Budgett 1998; Hale and Milne 1996; Kardel and Kase 1998). Kardel and Kase (1998) found that an

intense exercise protocol that was continued nearly to term had no adverse effect on fetal growth. Moderate to vigorous training appears to have no adverse effect on maternal and fetal health, although this type of training certainly pushes the limits of exercise during pregnancy. More research is needed in the area of vigorous exercise and its impact on fetal growth and core temperature during pregnancy (Schnirring 2002).

Myth 5. If you've never exercised, don't start an exercise program during pregnancy. You'll do more harm than good.

Fact. Years ago this statement reflected a commonsense attitude toward women who were inactive prior to pregnancy and who considered starting an exercise program during pregnancy. Pregnancy should not be an excuse to remain sedentary or a reason to gain unnecessary weight (ACOG 2002). Exercise potentially can reduce the likelihood of gestational diabetes (ACOG 2002; Schnirring 2002), especially in obese pregnant women (Artal 1998). Exercise has the potential to reduce insulin resistance and increase insulin action (effectiveness).

Once your pregnant client has physician approval to start an exercise program, it is appropriate to do so. Additional benefits include improved postnatal recovery time, appropriate weight gain, and decreased fatigue. Have your client start slowly, listen to her body, and otherwise use common sense with regard to exertion levels and discomfort. Pregnancy, and the heightened awareness of self-care and fetal care that naturally comes with it, might be an excellent time to begin an exercise program that can positively affect a mother's health for a lifetime (Schnirring 2002; ACOG 2002)!

Myth 6. Running is contraindicated or never advised during pregnancy.

Fact. Recommended exercise regimens should emphasize low-impact activities such as stationary bicycling, swimming, walking, or low-impact aerobics. However, running is not off-limits and is very much a self-limiting exercise. Your pregnant client should be in touch with her body enough to be able to honestly discern when running no longer feels good. Generally, this occurs around the third trimester as the fetus increases in size. Note that one elite marathon runner continued to train an average of 66.5 miles (107 kilometers) weekly up to three days before the birth of healthy twins (Bailey, Davies, and Budgett 1998).

Myth 7. Strength or resistance training is inappropriate during pregnancy.

Fact. Participation in a full range of activities is generally safe. But, contact sports or those that have a high risk of falling or could cause abdominal trauma (ice hockey, soccer, basketball, and downhill skiing) and scuba diving (puts baby at higher risk for decompression sickness) should be avoided.

Until quite recently, resistance training during pregnancy was seldom recommended. But it is now known that women can continue their strength routines with an emphasis on correct exercise mechanics. Generally, moderate to light loads that maintain muscular fitness while minimizing the potential for ligament or joint injury are encouraged. Heavy loads should be avoided unless appropriately prescribed and simultaneously supervised.

Myth 8. A woman can eat anything she wants during pregnancy, and nutritional supplements are not necessary during pregnancy because so many calories are being consumed.

Fact. Although it is beyond the scope of most certified personal trainers to design meals or make nutritional recommendations, you should have a general knowledge base regarding nutritional supplementation and nutrition because nutrition is so important during pregnancy. First, some of your clients will overeat and some will undereat. Others will make poor food selections, miss out on nutrients, and not drink enough fluids. Generally, 200 to 300 extra calories should be added to daily intake by the middle of the second trimester to help ensure a healthy weight gain of 25 to 35 pounds and adequate caloric intake. Excessive weight gain is not encouraged (ACOG 2002). Protein needs are about 75 to 100 grams per day, calcium 1,000 to 1,200 milligrams, and iron 30 milligrams; the B vitamins become increasingly important because they help facilitate maternal and fetal energy metabolism (energy needs increase greatly during pregnancy). Folic acid (folate) needs double during pregnancy to 800 micrograms per day and can help prevent

neural tube defects (e.g., spina bifida) or anencephaly (an often fatal condition related to the brain not fully developing) in the fetus. Folate supplementation before and during the first few weeks of pregnancy is critical. Good nutritional habits should start before an anticipated pregnancy and continue for the rest of your client's life.

Myth 9. Exercise will harm your baby.

Fact. Because knowledge in this area is far from complete, concerns remain about the well-being of the developing fetus when the mother participates in exercise during her pregnancy. Until definitive answers are available, guidelines will continue to err on the side of being conservative. Ultimately, encourage your pregnant client to heed her own common sense. Most pregnant women who exercise through pregnancy see this as a time to maintain some degree of fitness and to bring their newborn safely into the world.

Myth 10. Science proves that concerns about exercise during pregnancy have been laid to rest.

Fact. The next section discusses what science can tell us and what areas need further research. In facilitating a client's exercise during her pregnancy, form a close alliance with her physician and err on the side of using conservative protocols.

Physiological Concerns, Adaptations, and Changes During Pregnancy

Why do controversy and concern surround the issue of exercise during pregnancy? Physiological changes occur in the cardiovascular, respiratory, musculoskeletal, and gastrointestinal systems and affect the maternal response to exercise. Anatomic changes of pregnancy alter balance, flexibility, joint stability, and coordination (Araujo 1997). Finally, exercising during pregnancy is of concern because of the fear that activity can harm a woman's unborn child.

Cardiovascular Changes

The cardiovascular system quickly jumps into overdrive in early pregnancy and remains there through the third trimester. When compared with prepregnancy levels, cardiac output during pregnancy increases up to 50 percent, and a 45 percent increase in blood volume can take place by the third trimester (Artal and Sherman 1999). Cardiac output (heart rate times stroke volume) increases primarily by an increased stroke volume (the amount of blood pumped per beat of the heart). However, there is a gradual increase of resting heart rate of about 15 beats per minute by the third trimester. Maximum work capacity (i.e., $\dot{V}O_2$max) is decreased dramatically by a combination of decreased cardiac reserve (i.e., because of increased cardiac output and blood volume) and increased oxygen cost of weight-bearing exercise (because of increases in body weight). These changes are offset to a degree by an increased capacity of the veins to reduce blood pressure and have greater vasodilation at the skin to help dissipate heat and lessen the likelihood for hyperthermia (Artal and Sherman 1999).

The cardiovascular impact related to the double stress of exercise and normal changes caused by pregnancy (discussed previously) has been the focus of much research. When the demands of exercise divert fetal blood flow to the working muscle, the theoretical risk of fetal hypoxia exists. However, it seems that during exercise, compensatory mechanisms are in place that limit the threat of insufficient blood flow and oxygen to the fetus.

Because the supine position is associated with decreased maternal cardiac output after the first trimester, this has led to the often recommended caveat against exercise in this position. Following this recommendation can prevent the theoretical diversion of blood flow from the uteroplacental unit and potential risk of fetal hypoxia. Until research is definitive in this area, this guideline should be followed.

Respiratory Changes

The respiratory system is affected anatomically by the enlarging uterus and physiologically by hormonal influences. A resting hyperventilation occurs in pregnant women (in response to increased plasma progesterone; Araujo 1997). In the third trimester, "deeper breathing" becomes more difficult because the enlarging fetus pushes the diaphragm up. Additionally, it takes more energy to breathe because inhalation causes the

diaphragm to lower and it is resisted physically by the enlarged uterus, which it must push down during each inspiration.

Gastrointestinal Changes

The gastrointestinal system is affected anatomically by the enlarging uterus and physiologically by increased plasma progesterone, a smooth muscle relaxant. The combined effects of these changes contribute to constipation and a slowing of gastrointestinal mobility. The hormonal influence also promotes relaxation of the lower esophageal sphincter, which leads to increased gastric reflux or heartburn (Araujo 1997).

Metabolic Changes

Hyperthermia is of concern because both exercise and pregnancy increase metabolic rate and raise maternal core temperature. Core temperature in excess of 102.6 degrees Fahrenheit (39.2 degrees Celsius) is potentially teratogenic (i.e., causing maldevelopment in the embryo) in the first trimester. Adaptive changes help to offset core temperature increases and include increased minute ventilation and skin blood flow, which help to augment heat dissipation and somewhat offset the potential hyperthermic effects of exercise (Artal and Sherman 1999).

Musculoskeletal Changes

Significant changes occur in the musculoskeletal system of the pregnant client and could increase her risk of injury while exercising. Growth of the breasts, uterus, and fetus increases lumbar lordosis and shifts the center of gravity forward, putting strain on the low back and altering normal balance. To compound these influences, hormonal changes increase joint laxity and mobility. Relaxin and progesterone soften the ligaments surrounding the joints, and the effect is systemic. This means that all joints of the body are affected, although the importance of the hormone release is related to pelvic relaxation and symphyseal widening (i.e., at the base of the pelvis), which allows vaginal delivery (Araujo 1997). Although research has not directly linked this with an increased injury rate, caution and moderation are appropriate (Artal and Sherman

1999). It makes sense that your client should maintain strength to help stabilize the joints, avoid contact sports, limit weight-bearing exercise if appropriate, and use caution with complex strength training exercises and stretching that is forced or emphasizes extreme range of motion (ROM).

Exercise Guidelines

Experts agree that during a normal, healthy pregnancy, moderate to vigorous exercise is safe for the baby and can provide benefits to the pregnant exerciser. Pregnant women who exercise are less likely to experience back pain, fatigue, varicose veins, and hemorrhoids. Exercise can enhance maternal well-being and self-esteem and make labor more tolerable. The bottom line is that pregnant moms feel better and stay fit when they exercise.

Reported Benefits of Maternal Exercise
- Provides physical and mental benefits
- Feels good and renews energy
- Helps maintain fitness
- Helps avoid excessive weight gain
- Improves posture
- Decreases incidence of back pain
- Prepares body for extra weight load
- Facilitates circulation
- Decreases incidence of varicose veins and hemorrhoids
- Helps with recovery
- Helps reduce pregnancy-related stress
- Improves self-esteem
- May lower perception of pain during labor and delivery
- May facilitate postpartum recovery

Commonsense Guidelines for Exercising During Pregnancy

Following sensible and research-based guidelines, like these from ACOG (1994, 2002), can help you ensure that your pregnant clients' programs are on the right track.

Always get approval from your client's obstetrician before beginning or continuing an exercise program. Some medical conditions make exercise during pregnancy inadvisable or justify modifications so that the program will be safe.

Plan a program of mild to moderate intensities and avoid exercise to the point of exhaustion. Common sense and perceived exertion rule here. If your client is already fit, she'll only need to make small changes as her pregnancy advances. If your client is new to exercise, begin with a low-level program and progress her slowly.

Use regular and moderate duration exercise sessions. The client should exercise at least three days per week, because regular activity is safer and more beneficial than intermittent or on-again, off-again exercise protocols. This holds true in nonpregnant populations as well.

Use recommended types of exercise. Recommended exercises include low-impact activities like swimming, walking, stationary cycling, stretching, and resistance training. Use impact activities like running as individual tolerance and enjoyment allow. Change activity choices when needed and as the pregnancy progresses.

Avoid jerky, ballistic, bouncy, and extreme ROM movements as well as exercise that involves severe straining, jumping, or sudden changes in direction. Balance and hormonal changes during pregnancy make activities with these types of movements higher risk. Avoid stretching to the limits or end ROM.

Avoid supine exercise after the first trimester. After the first trimester, the client should avoid exercise for prolonged periods of time while lying on her back. In the supine position, the growing fetus can compress the vena cava, which is a major vein that runs up the back side of the abdomen and returns blood to the heart. Compression of the vein causes less blood to flow back to the heart. Theoretically, this could decrease blood supply to the uterus, affecting fetal growth and development.

Avoid exercise in hot, humid environments, and encourage the client to drink plenty of water. Instruct your client not to exercise in excessively hot and humid environs. Your client should drink six ounces of water every 10 to 15 minutes during exercise, especially during the first trimester, when increases in maternal temperature can put the fetus at risk for neural tube defects.

Tell clients to increase calorie intake. Have your client talk to her doctor about an appropriate weight gain. Average weight gain is between 25 and 35 pounds. Pregnancy is not a time to lose weight, control weight (although excessive gain is not healthy for the mother), or restrict calories. It is common for your client to gain about two to four pounds during the first trimester, 10 to 11 pounds during the second trimester, and 12 to 13 pounds during the third trimester. Generally, an extra 200 to 300 calories can be added to the diet by the middle of the second trimester by gradually increasing caloric intake.

Suggest that clients eat small and frequent nutritious snacks and meals. Caution clients that cutting calories during pregnancy puts the fetus at risk (Andrew 1998). Your client can obtain the extra calories she needs by planning simple additions to her diet. Carbohydrates are the mother's primary caloric energy source and the best source of placental and fetal glucose. Without adequate carbohydrates, protein and other nutritional sources will be depleted. Adding a half bagel or half cup of rice, beans, or pasta adds 80 to 150 calories to your client's diet (Andrew 1998).

Teach your clients to use rating of perceived exertion (RPE). The RPE technique (refer to chapter 17) should be used during exercise—along with heart rate if you wish—so your client can monitor her individual tolerance and physiological response to exercise. Using RPE helps your client learn how to listen to her body and trust her intuition about acceptable exercise stress or intensity.

Trainer Guidelines Checklist

❏ Gain physician approval prior to any program.

❏ Encourage moderation and "listening to your body."

❏ Stress importance of adequate hydration and avoidance of overheating.

❏ Avoid aerobic or vigorous exercise in hot, humid weather or during a period of febrile illness (i.e., with fever).

❏ Encourage appropriate duration and intensity.

❏ Encourage adequate caloric intake to meet not only the increased energy needs of pregnancy but also of any exercise performed.

Cardiovascular Exercise

The type of activity should be familiar and not too skill dependent. General activities should graduate to nonballistic, nonjumping, and low-impact or non-weight-bearing activities. It is smart to avoid rapid or abrupt directional changes. Activities such as running are often self-limiting. Toward the end of the first trimester, many women report that running or similar activities no longer feel good. At this time, it makes good sense to switch to activities such as stationary biking, swimming, and walking.

Resistance Training

Many pregnant women do not want to give up any part of their fitness routine. Your client needs to know how to continue or begin a strength training program safely.

Lower weights and higher repetitions (i.e., 12-20) will maintain tone and strength with less risk of damaging ligaments. Hormonal changes create laxity in ligaments throughout the body, not just in the pelvic region. Lifting heavy resistance should be avoided in view of the resultant joint instability and the likelihood of performing a Valsalva maneuver in heavy training. This momentary or sustained breath holding (Valsalva) could divert blood from the womb to the working muscles, potentially compromising the fetus, or could unnecessarily increase the mother's heart rate and blood pressure to high levels.

When developing your client's resistance training program, you should focus on the following:

1. Maintain muscular strength and endurance.

2. Strengthen muscles to help prevent injuries or discomfort associated with postural changes, weight gain, and postpartum activities (e.g., carrying newborn, performing recovery workouts).

3. Promote comfort and safety through use of proper body mechanics and alignment.

Exercises or Positions to Avoid

1. Exercises performed in the supine position after the third month of pregnancy.

2. Exercises that use the Valsalva maneuver.

3. Long lever exercises or any requiring extreme ROM.

4. Multijoint exercises (i.e., squats) because these require more skill, balance, and stability.

5. Exercises requiring high levels of balance, especially in a weight-bearing position.

6. Exercises requiring abdominal strength for proper control. (The ability to produce force in the abdominal area decreases as the fetus grows.)

7. Any exercise requiring unsupported forward flexion of the spine (seated or standing).

Recommended Exercise Protocol and Modifications

1. Ensure that the client performs a thorough warm-up before engaging in any exercise. Emphasize good posture and ROM exercise that targets the back, pelvis, and hip joints.

2. Decrease ROM or cease exercise if any discomfort or pain is experienced by your client.

3. Use seated, side-lying, and supported standing exercises as much as possible.

4. Strengthen the upper back to help compensate for postural changes (i.e., increased breast size attributable to fluid increases).

5. Strengthen the abdominal muscles with pelvic tilts in standing or hands-and-knees position or using a stability ball in a supine incline position (when the head is higher than the hips the risk associated with a supine position is largely minimized).

6. Generally, use lower resistance in all exercises than would be used in a nonpregnant state.

7. Emphasize breathing during all exercises to prevent the Valsalva effect and resultant increase in blood pressure, which could compromise blood flow to the fetus.

8. Use single-joint isolation exercises as opposed to multijoint exercises.

9. Use shorter lever exercises (keeping elbows and knees slightly bent).

10. When performing adduction exercises, keep ROM small (use side-lying position rather than seated or supine full ROM).

11. Momentum should play no role in the exercise movement.

12. ROM should be determined by how far the contracting muscle (agonist) can take the body part through its specific range (i.e., establish the active ROM) and level of comfort perceived by the client.

Stretching Guidelines

Exercise programs during pregnancy should probably be directed toward muscle strengthening to minimize the risk of joint and ligament injuries because of increased connective tissue (i.e., ligament) laxity, as opposed to a goal of increasing flexibility. Deep flexion or hyperextension of joints should be avoided. Stretches should not be taken to the point of maximum stretch because connective tissue laxity increases the risk of injury. Try to avoid "strain" and an endpoint of extreme or forced ROM.

Flexibility goals might include these:

1. Relax through gentle stretching.

2. Improve ROM and decrease discomfort attributable to various posture changes.

3. Facilitate circulation and recovery.

Stretches or Positions to Avoid

1. Any extreme stretches

2. Any stretches involving forward flexion of the spine, especially if neutral lumbar posture cannot be maintained

3. Extreme adduction or long lever adduction

4. Stretches with a hinge joint such as the knee or elbow placed in a hyperextended or hyperflexed position

5. Extreme hip extension (e.g., that which can occur during lunges)

6. Sustained supine positions after the third month

Recommended Stretches

1. Lower back stretching in a side-lying or hands-and-knees position

2. Upper back, chest, and shoulder stretches in standing, seated, or hands-and-knees position

3. Neck ROM stretches (no excessive hyperextended positions)

4. Leg and hip stretches in seated, side-lying, or supported standing positions

Postnatal Exercise Return

Prepregnancy fitness levels, labor and delivery complications, each client's recovery time clock, postpartum fatigue, and physician approval will determine when your client is ready to return to exercise.

Cardiovascular and musculoskeletal changes return to a prepregnancy state in about four to six weeks. Discourage an obsessive focus with regard to returning as quickly as possible to the prepregnancy body. Consistency and patience are the rule here.

Following is a recommended progression of exercises for postpartum:

1. General body movement (e.g., walking).

2. Kegel exercises and pelvic tilts. The pubococcygeal muscle literally forms a hammock of support for the pelvic organs and uterus, in addition to providing sphincter control of the vagina, urethra, and anus. The easiest way to do "vaginal weight training" is to have your client stop the flow of urine midstream the next time she is urinating and then to practice this sphincter control once it is mastered during posterior pelvic tilts and other abdominal exercises.

3. ROM exercises (initially, little or no resistance) and gentle stretches.

4. Progress gradually to supine abdominal work (pelvic tilts first combined with Kegels, then adding traditional and stabilizing abdominal exercises).

5. Low-impact or nonimpact cardiovascular activities.

6. After approximately six weeks, with physician's approval and following this progression, the client can resume the prepregnancy program following principles of progressive adaptation and good common sense.

Overall Impact of Exercise

Exercise and child-birthing classes undoubtedly have an educational role and a major psychological and physical impact on your pregnant client. However, there is no scientific evidence that any exercise or birthing program results in shorter labors, easier labors, less complications, or benefit to the baby. Many of the programs followed may actually have more benefit after the birth to simply speed mother's recovery. Consistency, moderation, and appropriate exercise modification are the most important factors in any exercise regimen.

Point out to your pregnant clients that a sedentary lifestyle in pregnancy does not in any way affect the outcome of that pregnancy as related to the health of the fetus.

Although not ideal for a mother's well-being, doing nothing is okay for the developing fetus if the desire or interest to exercise is not present. However, if your client exercised with you before pregnancy or is not currently exercising but wants to improve her fitness and nutritional choices, the desire to exercise is probably there! In fact, my biggest concern with pregnant clients is to temper their enthusiasm for exercise and modify accordingly.

Pregnancy should not be considered a state of confinement, and your pregnant clients should be encouraged to lead a normal life and continue their prepregnancy activities. Recognizing physiological limitations and anatomical changes can limit the risk for injuries or complications to both the mother and fetus. This is certainly a time in any woman's life to maintain her fitness; if there is any question about risk to her baby, she should eliminate that question mark by being sensible and following established guidelines. This relatively short and remarkable nine-month journey, in my opinion, is not about fitness and workouts but about bringing a healthy child into the world.

Pregnancy Case Study: A Healthy Client With Special Concerns

Allison is a 31-year-old first-time mother-to-be who is 6 weeks into her pregnancy. She has no complications and with the approval of her doctor continues to be active.

History. Prior to her pregnancy she was rather rigid in her exercise regimen. She hints of her concerns about what "toll" her pregnancy will have on her fitness and body shape.

Her prepregnancy routine consisted of five to six 55-minute aerobic sessions and three 40-minute strength training sessions per week. Whenever possible, she adds one- to three-hour hikes to her weekly fitness routine.

She would like your help in combating weight gain. She commented, "I know I'll have to slow down, so I guess I'll just have to eat less." What would you do with this client?

Mapping out your strategy. Before you look at how I handled this client, map out your own strategy by keeping in mind the following questions:

1. On what basis did you plan her program?
2. What were your initial concerns?
3. What guidelines did you follow for cardio-vascular training?
4. Would you encourage Allison to resistance train?
5. Is flexibility fitness an appropriate focus?
6. As the pregnancy advances, what modifications will you make?
7. What kind of program will you follow post-partum?

Exercise guidelines. For the most part, pregnant women who engage in exercise programs are healthy, but very few are aware of the ana-tomical and physiological changes that might predispose them to injuries, and many are not aware of the potential harmful effects maternal exercise might have on the developing fetus.

As with all of my fitness programming, I base my initial plan on well-documented scientific information, a thorough medical history ques-tionnaire, and communication with the client and her health care practitioner (i.e., obstetri-cian). I also follow accepted industry standards set for pregnant women who exercise during their pregnancy.

Initial impression. My initial concerns with Alli-son centered on her rigid approach to exercise, her focus on minimizing weight gain, and the "toll" that she mentioned pregnancy would have on her body. Her request that I might help mini-mize her weight gain encouraged me to first approach her with the psychology, necessity, and reality of weight gain during pregnancy.

I believe that a woman should feel beautiful with the incredible changes that take place in her body and that allow birth to occur. However, many pregnant women feel the trauma of "ruin-ing" their bodies. Besides sharing information about recovery postpartum and the fantastic resilience the body has, you should also define what a healthy weight gain is. I also explain what this weight gain actually consists of. It is not all fat! Allison needs this comforting information.

All recommendations for weight gain and total calorie and protein intake should be decided upon with your client's doctor. A maternal weight gain of 26.4 pounds is average during pregnancy. About 11 pounds (41 percent) consists of the fetus, placenta, and amniotic fluid. Maternal tissues directly affected by pregnancy (uterus and breasts) along with fluid gain account for about 9.5 pounds (36 percent). The rest (6.1 pounds or 23 percent) is believed to be fat fuel storage.

This stored energy increase seems to be necessary for the birthing process. Also, post-partum energy needs increase, especially if the mother continues to breast-feed. Too little weight gain may first affect the mother's well-being and potentially that of the fetus. Exces-sive weight gain and inactivity probably have little effect on the fetus and quite an effect on the mother, especially her postpartum recovery and sense of self-esteem.

The energy cost of pregnancy is estimated at about 80,000 calories or 300 additional calories per day. This covers the growth and develop-ment of the fetus, increased metabolism of vari-ous body systems, and the buildup of maternal tissue such as the uterus, breasts, and fat.

These increased energy costs of pregnancy can be met by an increased intake of food or a reduction in expenditure (activity). The average pregnant woman increases her calorie intake by 200 to 300 calories attributable simply to increased appetite. Furthermore, it is common for your pregnant client to reduce her physical activity because of the demands imposed by the growing fetus (physically, it may be uncomfort-able), balance issues (mechanical instability), and laxity of joints, as well as feelings of nausea (especially early in the pregnancy), lassitude, and fatigue, which are sometimes caused by a surge of hormones and the significant increase in metabolic demands.

The dietary intake must meet the caloric and nutrient needs of the expectant mother or her body protein will be broken down. This may occur whether there is inadequate calorie intake or restricted protein or carbohydrate intake.

There is no evidence that high-protein diets, greater than 100 grams per day, are beneficial during pregnancy. An intake of about 75 to 100 grams of protein per day should be appropriate for pregnancy.

The trainer's role. My role was obvious. Besides following accepted exercise guidelines (discussed in previous sections) for exercise during pregnancy, I had to motivate Allison to eat calories that were nutritionally rich (no empty calories) and low in saturated fats and encourage her to consume a much greater protein intake than that to which she was accustomed.

After Allison and I talked about the reasons for and benefits of her weight gain, we came up with a plan for exercise through and after her pregnancy and then regularly monitored the progression and her feelings. Armed with this knowledge, most expectant mothers are excited about this new insight and nutritional challenge and are motivated to achieve a healthy weight gain. This is a special time for the mother to maintain optimal health for herself and her baby.

Time to Exercise Judgment

In recent years, pregnancy experts and related research have focused on comparing theoretical concerns to observed outcomes in exercising women who are pregnant. Many researchers have come to believe that many of the adaptations to exercise during pregnancy ensure fetal protection. It seems the body's highest priority is to protect and provide a margin of safety for the developing baby. It is clear that for a normal, healthy, and developing pregnancy, a moderate and sensible approach to exercise is not only safe for the fetus but extends many benefits to the mother.

Newer guidelines and further understanding of the effect that exercise has on the mother and unborn baby challenge the personal trainer to pay close attention to individualization of the exercise program for pregnant women, because no precise protocol fits all. Pregnancy is a time to help your client exercise confidently when that is her desire and to move beyond misconceptions and outdated guidelines.

Because the physical and hormonal makeover that occurs during pregnancy can affect self-esteem, trainers should support, encourage, and motivate their pregnant clients. Don't think you have to have a solution for every physical complaint or mental struggle of the client. In fact, maybe the best way to deal with what my pregnant clients call the "hormonal crazies" is to be an excellent listener. Be careful to acknowledge (not "fix") her feelings and to encourage her to work at her own pace and rest when needed.

Using Common Sense

Help your client become attuned to the tremendous changes that occur in her body during pregnancy. Help her understand the impact they have on her body, her mind, and the fetus. If her body is telling her to curtail a specific activity (i.e., running) because it doesn't feel good or to otherwise modify her workouts, she should heed these warnings. I like to instill in my pregnant clients the philosophy that although gains in fitness can be made during pregnancy, in general, this is a time to maintain fitness and personal well-being while simultaneously presenting a healthy child to her family and the world. Help your pregnant client to exercise intelligently and accurately and to enjoy this unique and relatively short period of time in her life.

Pregnant Clients: Suggested Reading

For information in addition to those works cited in the chapter, look up these resources:

American College of Obstetricians and Gynecologists. 1985. *ACOG Home Exercise Programs: Exercise During Pregnancy and the Postnatal Period*. Washington, DC: ACOG.

American College of Obstetricians and Gynecologists. 1994. "Committee on Obstetric Practice: Exercise During Pregnancy and the Postpartum Period, Committee Opinion No. 189, February." *International Journal of Gynaecology and Obstetrics* 45 (1): 65-70.

American College of Obstetricians and Gynecologists. 2002. "Committee on Obstetric Practice: Exercise During Pregnancy and the Postpartum Period, Committee Opinion No. 267, January." *International Journal of Gynaecology and Obstetrics* 77 (1):79-81.

Artal, R., and R. Wisell. 1986. *Exercise in Pregnancy*. Baltimore: Williams & Wilkins.

Huff, Dale. 2000. "Training the Pregnant Client." *ACE Certified News* 6(1): 8-10.

Pollock, M.L., G.A. Gaesser, J.D. Butcher, J. Despres, R.K. Dishman, B.A. Franklin, and C.E. Garber. 1998. "The Recommended Quantity and Quality of Exercise for Developing and Maintaining Cardiorespiratory Fitness and Flexibility in Healthy Adults." *Medicine and Science in Sports and Exercise* 30 (6): 975-91.

U.S. Department of Health and Human Services. 1996. *Physical Activity and Health: A Report of the Surgeon General.* Atlanta: Department of Health and Human Services, Centers for Disease Control and Prevention, National Center for Chronic Disease Prevention and Promotion.

Westcott, W.S. 1995. *Strength Fitness: Physiological Principles and Training Techniques.* 4th ed. Dubuque, IA: Brown.

Resources

American College of Obstetricians and Gynecologists (ACOG): 409 12th St. SW, Washington, DC 20024-2188; 800-673-8444; 202-863-2518.

Exercise clothing for the active mom: www.mothers-in-motion.com

Women's Sports Foundation: www.lifetimetv.com

Women's health site: www.herhealthonline.com

PART V

THE FINAL EDGE

CHAPTER 30

Keep Your Personal and Professional Desire Burning Brightly

You don't want to be stuck in a rut where you play the same song again and again. If your programming is the same and you play the same tune every day, you need to make some changes. If you're bored with your training or have ever secretly hoped that your next client will cancel, your business approach and attitude need an upgrade. Among other things, you've probably overscheduled yourself and are on the fast track to burnout as well as a failed business. At the least, you will never realize your full service potential if you've lost your energy, enthusiasm, and passion.

The challenge of personal training and any service business is to "keep playing the music" that made you successful in the first place while simultaneously maintaining training, programming, and business policy that are fresh, new, original, stimulating, and effective. You need to continually grow professionally and individually. Then, you have a chance to deliver the best possible service to your clientele and maintain a thriving business.

Why Do Trainers Burn Out?

Personal training is emotionally and physically draining. Even though most trainers love what they do and are passionate about their profession, hour-by-hour toil in the personal training trenches can take its toll. Although 88 percent of trainers report that they are "satisfied" or "highly satisfied" with their work (IDEA 1998), trainers still must meet the physical demands of the job and work with the emotional state of each client. Trainers need to take care of themselves and balance their business life with a personal life, or they run a high potential for experiencing job dissatisfaction.

Stress Causes Burnout

Stress can come in many forms but is often personal or environmental. Personal sources include your own expectations, wants, goals, attitudes, perceptions, and values. Environmental stress is created by situations, circumstances, or other people. Job responsibilities, family obligations, social support or lack thereof, reward, and conflicting demands fall into this category.

Often, a trainer can be his or her own worst enemy when it comes to stress. If your goals are unrealistic or become too great of a burden, you can experience a lot of frustration trying to fulfill them. For example, our commitments can sometimes clash with our values or what is truly important. Let's say a trainer wants to spend more time with her family during evenings but she schedules clients during this time. This classic conflict pits business growth, success, and income against personal life commitments. Experience and maturity, learning to say no, and being able to "let go" will help you to find the right balance. Ultimately, be honest about your feelings and emotions and look for the causes of stress in your life, and you will be

able to limit unnecessary stress and pressure in your life.

Playing Too Many Roles

As a personal trainer and business owner, you will have to wear plenty of different hats. Each role you play can detract from or enhance your business as well as the quality and balance of your life. Try this "quick check" exercise to assess how wearing all the hats of business owner, personal trainer, friend, or family person affects your life. Take a sheet of paper and divide it into three columns:

1. In the first column, write out all of the roles you play. Include trainer, business owner, spouse, parent, presenter, self-promoter, community leader or related involvement, coach, or taxi driver (i.e., you ferry your kids around). Note that you do, in fact, play many roles and wear many hats that can contribute to or detract from a balanced life.

2. Title the second and third columns "Energizing Role" and "Draining Role." Briefly explain why each role either steals your energy or gives back to you or why some roles can have both effects.

This written drill will help you realize how many aspects of your personal and business lives you have to constantly juggle and strive to balance. After identifying tasks or roles as energizing, draining, or both, you will have a better idea of which roles work for you and which aren't working in terms of positive energy. Roles that place undue strain or drain on you should not necessarily be eliminated but can be modified or relegated to the back burner. The goal is to find a healthy balance between roles that drain you and roles that create synergistic energy that builds you up and makes life fun, productive, and rewarding. This drill should also make apparent to you that you have choices and the power to change the flow of life, especially if you are aware of potential danger areas that are dragging you down. Choose not to be a victim of your circumstances, because you can change your work and personal environments.

Strategies to Avoid Burnout

The following are simple strategies that can help you "flag," deal with, or prevent personal burnout:

- Build a strong social support system made up of family, friends, and peers. Be careful that time requirements required to maintain close ties do not become an unwelcome burden (e.g., long phone calls on a regular basis). As always, the issue is balance, communication, and mutual understanding.

- Get adequate sleep, eat right, and work out on a regular basis.

- Plan restoration or down time in your working day, and take at least one day off per week.

- Establish goals to help you prioritize and wisely use your time. Don't let technology run your life. You should not be available 24 hours per day. Set clear-cut time boundaries that differentiate between personal and family time and business hours.

- Identify positive and negative stress (i.e., "energizers" and "drainers") in your life, and take steps to limit or eliminate negative stress.

- Learn to say no to new business and other requests for your finite time.

- Establish time for yourself. Not only should you regularly work out, but you should schedule time to study, relax, and otherwise occasionally pamper yourself.

- Pace yourself and realistically schedule your day to balance business and personal life.

- Do not compromise your values and morals, even if it means losing a client. Not holding your ethical line quickly produces wear and tear on you that is intolerable and can crush your spirit.

- Build a management style that includes assertiveness, fairness, listening, decision making, and time management.

Balance Prevents Burnout

The leading causes of personal trainer burnout are directly related to working long hours, meeting client needs and expectations, and taking on difficult clients or ones you are not qualified to train. Overscheduling is a leading culprit. Symptoms of burnout are easy to identify and include physical exhaustion, detachment (you may not say it but you're expressing through your behavior that you don't care anymore), and little self-fulfillment or apparent job dissatisfaction.

The solution to a balanced approach is often related to the problem. Many trainers need to reduce the number of hours they work, refer clients to other trainers if their schedule is too busy or they don't have the expertise to work with a particular client, and be more discriminating when it comes to taking on clients.

Maintain balance by correcting these and other factors that contribute to burnout. Keep training fresh and diversified by continued learning and personal growth, increased activity in the profession, and reestablished contact with friends and family. No one can thrive on business and day-to-day training alone!

Do You Still Love Your Job?

It is likely that every trainer at one time or another will experience personal burnout. How can you avoid personal burnout or climb back from the position of hating or being overwhelmed by your profession? You will have to provide the answers that allow you to return to a position of joy and passion, but the following questions may help you recover sooner.

Do you believe your services are special and valued? Part of the answer related to loving what you do lies in believing that your services are special and valued. Do you believe that? If not, your passion will drain and your business will flounder.

Why do you personal train? You need to reevaluate why you train. Are you in it for the money? Do you take on all comers? Or, have you simply made some mistakes and been unrealistic with your schedule? If the joy of training is gone, consider these and other issues. Identify where the pain and misery come from. Don't be afraid to investigate other business opportunities. This may help you realize how much you really love training or, on the other hand, it could tell you personal training is not the profession you should be in.

Do you maintain a personal life that is separate from business? Trainers cannot survive on personal training alone. Don't forfeit a balanced lifestyle for one that only revolves around your clients and business. The survival rate is low and the richness of life is limited.

What attracts you to personal training? Next, consider what attracts you to personal training. Some aspects of training that spur me on are these:

- Allows me to thrive as an individual
- Allows me to explore my personal limits
- Allows me to make a difference in individual lives
- Allows me to own and direct a business
- Is exciting, well paid, demanding, tedious, and challenging

Early in my professional career, I found that personal training had no limits with regard to what I could accomplish professionally. Initially, I thought my training as an exercise physiologist would confine me to a clinical setting where I would perform one stress test after another, or I would be relegated to a university teaching position. Neither of these situations is necessarily bad, but I knew that to thrive I needed diversity, options, change, and stimulation. Also, as a physiologist in an institutional setting, I realized that most of my diagnoses and exercise plans never made it into activation. Many of the people I tested understood what they needed to do based on the test results and consultation, but the missing factor was someone who would help them carry out the "exercise orders." It was then that I realized personal training would be my profession. The only parameters that were created stemmed from my desire, hope, and enthusiasm, or lack thereof. Personal training has offered me a rich profession that continually challenges me and fulfills my professional needs. I can write books, produce educational videos, carry out client training programs to fruition and life-changing end results, and otherwise pursue any health and fitness direction I choose if I remain sufficiently motivated and attain the proper credentials or necessary education.

How to Keep Personal Training Fresh

Here are some ideas to keep personal training fresh and stimulating.

Advancing professional growth. When you stop learning, a part of you has hit a dead-end. I have found that the more knowledge and application skills I gather, the more I realize I don't know. However, every day I go to work to train or lecture or conduct a workshop, I am content that

I am teaching the most current and accurate information because I constantly pursue new information and updates. Yet, because of the necessity of constant renewal, it also means that what I teach today may change tomorrow!

Striving for professional diversity. Early in a career, it makes sense that most trainers should start marketing themselves based on what they do well (current expertise) and are excited about (passion). As you grow and mature, additional training and experience allow you to branch into new areas of professional content. The ability to train a variety of special populations and other individuals with special needs defines the new marketplace. Knowledge is specialized and copious today. You might want to get your message across, in addition to training clients, by training other instructors, writing books, producing educational videos, designing corporate or home gyms, or hosting a television or radio talk show. Your degree of diversity must match your personality as well as your professional desire and need.

Attempting to meet the emotional and psychological needs of each client. At each workout, I strive to match my client's mental state and other emotional needs. In a sense I "chameleon" or change colors to meet my clients where they are each day. Although I try not to compromise accomplishment and attempt to keep the workout goal oriented, the challenge becomes one of maximizing the workout based on the client's capacity that day, as defined by his or her emotional and physical reserve at that moment.

Preserving your personal life. Early in this book I spoke of the "greed/ego syndrome." Trainers must differentiate and preserve personal life from business life. A steady diet of training with no relief is a sure setup for failure. The key to personal training is consistent service that is of high quality and oriented to the client on a very personal level. If you're exhausted, unfulfilled personally, or otherwise distracted, you cannot keep the necessary service edge.

The Final Edge

How do you renew your energy for each workout? Many trainers who work in the day-to-day training "jungle" struggle with keeping the demand of daily workouts from crushing their physical and emotional spirit. Training sessions with clients can be extremely physically and mentally draining. Besides realistically scheduling your day with an appropriate balance between work and restoration (i.e., self-time), use the following points to reevaluate what you are trying to accomplish daily, at the one-on-one level.

- **Present an attitude that you care.** Without my saying it, my clients know that I care, because I listen to them and follow up.

- **Present an attitude of service.** Constantly ask yourself what you can do for your clients, not what they can do for you or what the client can bring to the workout. For example, it's tempting to think that your client could use an attitude makeover, but it's you who creates, directs, and controls the workout environment. Do so with an attitude of service.

- **A lack of patience or condescending behavior is unacceptable.** Every trainer has probably, at one time or another, wanted to give a client a "good shaking." Of course, professional conduct (and lawsuits) rule out this type of behavior, but if you often have these feelings, it's probably not the client who is at fault. Clients will be who they are. Maybe you are not suited to assist this client, and a mature decision on your part might be to refer this person to a trainer who can successfully work with him.

- **The workout is always the client's.** Client sessions are not a time to get in a few crunches or set of dumbbell presses, to see how good you look in the mirror as your client exercises, or to take phone calls or otherwise be interrupted or distracted. You must intently focus on facilitating your client's workout. This is her time, and all efforts should recognize this.

- **Maintain hands-on correction and verbal and visual cues, and otherwise "stay involved."** This is your chance to use hands-on spotting and verbal and nonverbal cues to communicate to your client that he has 110 percent of your focus and commitment. This type of intensity is valuable to the client.

Develop a Style That Is Honest and Sincere and That Is You

What is style? The idea of different styles, of personalities and character traits, may conjure up images of enthusiasm, yelling (that's not always positive), care, dependability, and unrelenting service.

Develop your own style. Everyone has a style, whether you know it or not. I was told by a client one day that I was "firm, but easy." The client had just come from an intense all-night business negotiation, and just when the deal was to be consummated, the negotiations fell apart. All efforts were for naught and there was little hope of revitalizing the negotiations. My client had drug herself into this early morning workout feeling exhausted, irritated, and extremely frustrated. Because I recognized the physical symptoms of a night without sleep, she quickly apprised me of the mess she had just left. I quickly complimented her on her commitment to exercising and doing something positive in lieu of her recent business disaster. Without hesitation, I changed the planned workout to accommodate where she was that day. I dropped from the agenda a high-intensity strength workout. The new focus was a moderate cardiovascular warm-up and workout followed by an emphasis on stretching and balance training. After the workout, she thanked me for adjusting to her and keeping the workout productive. I am "firm" in my belief that something worthwhile can be accomplished in every workout but was "easy" enough this day to be able to change the planned workout to match the client's need. One key to successful training is being able to remain flexible to the client's mood yet still maintaining direction toward and accomplishing specific goals.

Your own style will develop over time and, very likely, your clients will help you to identify it. Let your style represent who you are. It's not important to clone another professional, and rarely will imitation come off as honest, sincere, real, and trustworthy.

Bringing Personal Training Back to One on One

Bringing training back to one on one means, in a word, service. A training business succeeds, regardless of whether it is a sole proprietor business or one that has hundreds of employees, because of personal service. A business is no better than the relationship between the trainer and client. Revisit chapters 1, 2, 3, 4, and 7, especially if you believe your business has moved away from the "personal" of personal training. Client relationships and service are your business foundation.

What a Successful Personal Training Business Looks Like

The qualities that make up a successful personal training business are often subtle, are not always easily taught or learned, and can't be bought (see chapters 1-9). Yet certain tangible aspects are evident in numerous successful businesses. Remember that thriving personal training businesses of today are the same businesses that made mistakes yesterday. However, they corrected erroneous direction, and you can learn from these mistakes by identifying businesses and inherent qualities that can serve as your model for success. Successful businesses rely on the trainer's individual personality in accomplishing high-level customer satisfaction, care, and service.

Recognize Shortcomings

It is essential to identify not only what you do well but what your business is doing poorly.

Otherwise, you will fail and never have the opportunity to rectify the situation. You must seek feedback and act on it when appropriate. It could save your business or, at the least, greatly improve the services you provide (refer to chapter 7 for a discussion about getting and using client feedback). You must remain proactive regarding any aspect of your business that affects service. Don't let your business move from being "well" to being "sick."

Be Mindful of Client Retention

I'm surprised, as are other veterans, when we hear trainers state that a high attrition rate is normal because people cannot continue to afford sustained training over a long period or because once base fitness is attained, the average adult does not need a trainer. If you agree with this view, I suggest taking a close look at how creative and progressive your program design is as well as your ability to identify new training goals, not to mention customer service. Value establishes the degree of need or desire for personal training service. Retention rates and the number of clients you serve are the keys to earning and often reflect the level of care and service your business is providing, as viewed by the customer. Your clients no longer need you if you don't make a difference in their lives. If value is not apparent, they will go elsewhere!

Define Success

Personal trainers often define success by personal job satisfaction, client attainment of goals, and lastly income (IDEA 1998). Why isn't money mentioned first? According to the

trainers surveyed, the money will follow if they dedicate themselves to customer service.

Does it seem simple to attain the look of a successful personal training business? It should. Success comes back to service at the one-on-one level. Of course, you've got to be progressive and understand the technical and business aspects of training, but your success largely relies on how much you affect people personally and individually and whether you make a difference in lives.

What Successful Trainers Look Like

Successful trainers take ownership of and have an unshakable commitment toward their clients, initiate and anticipate client needs, follow up on requests, are able to adapt to different personalities, and present themselves in a professional manner.

Successful trainers are able to do the following:

- Run a business, rather than allowing the business to run them
- Exhibit a high level of technical expertise and professionalism
- Have a marketing and business presentation plan
- Develop and present a professional image that is an individual and accurate expression of who they are and what they want their businesses to represent
- Remain passionate about fitness and deeply care about the individuals with whom they work
- Never stop learning, and use preparation and continued professional study to complement their intense passion and love of personal training
- Generate word-of-mouth referrals by providing excellent service
- Develop their business image and marketing approach in accordance to need and opportunity in an ever-changing marketplace
- Separate their business lives from their personal lives
- Conduct each training session at a personal

level, while simultaneously maintaining a professional boundary between the client and trainer

Conducting Outstanding Personal Training Sessions

Training sessions that connect on a personal level must unequivocally communicate to the client that the program design is special and individualized to the client's unique personality and training needs. Programs like this identify what the client wants and needs, and then realistic expectations are developed and managed. Identify some goals that can be accomplished in a short time frame and combine short-term goal setting with long-term goal setting as well.

Keep the client informed as to what is being accomplished, what is not, and why the program is or isn't working. Honesty and knowledge go a long way! The client must pitch in and be part of the planning process. Successful trainers invite clients to be an integral part of the planning process, because they realize this is important to developing a team approach and mutual accountability.

Because most people prefer pleasure over pain, keep the exercise session enjoyable and results oriented. Regularly introduce productive and planned variety that is goal oriented. This is in contrast to variety for the sake of variety. Additionally, periodize level of effort over specific time periods to keep the mind and body fresh and the results coming. Remember that pain can be both physical (i.e., inappropriate or hard workout) and mental (i.e., unrealistic expectations and the associated frustration or disappointment).

Any goal-oriented and planned programming approach should also provide a time to discuss and evaluate progress along the way. Acknowledge accomplishments, set new goals, and rewrite outdated or unrealistic goals.

Finally, set a positive mood for each training session. It is not the client's issue if your life is imploding or if you're exhausted because this client is your tenth one-hour session that day. You still must provide a quality session. Your clients will notice your lack of focus and professionalism and see through a fake smile or forced attitude. Patience and professional

control must dominate your personality during each training situation, regardless of personal circumstances.

Timeless Essentials for the Successful Personal Trainer

Mentioned in chapter 1, these essential qualities are a must for successful trainers of today and into the future:

Formal education and nationally recognized industry certifications. This educational base helps you establish credibility with licensed professionals and an increasingly educated consumer.

Continuing education. Continuing education is not an option; it is a requirement. Continuing education can be attained through home-study programs and by attending industry educational conferences. This involvement is critical to your continued growth and crucial to providing accurate information to clients, because exercise science is always changing.

Depth and diversity in education. Education and more education will allow you to expand your client base, provide the best programming to your clients, and remain interested and enthusiastic about your job.

An ability to identify the ever-changing needs of our population. This unique ability will allow you to become part of the cutting-edge group of professionals who are prepared to meet the constantly evolving and changing needs of society.

Interest in identifying and growing with fitness and health trends. Understanding and being able to deliver on newly identified health and fitness needs as they evolve will allow you to be among the first to fill consumer needs with appropriate service.

The capability of bringing your skills and training back to a personal level. If it isn't personal, your business isn't as special as it could be, and you're not taking advantage of a perfect learning environment—one on one.

Maintaining an ongoing dialogue with your clients. Communication between you and your client can never stop, and you must exhibit people skills that communicate to the client,

"I care about you." This is best shown by your attention to detail in regard to your clients' needs, your professional growth and behavior, and delivery of impeccable service.

All trainers should have the ability to charm, cajole, educate, motivate, and prod when necessary, while remaining sensitive and caring toward the client. You should not only convince your clients to reach for certain goals and assist them in achieving their exercise goals, but you must also help them sustain a level of enthusiasm and commitment to health-related lifestyle changes and regular exercise. The prized and intangible skill that goes well beyond necessary technical competency is your unique and special personality. Although the perfect personality probably does not exist, the right combination of qualities leads to success for you and all of your clients and truly does keep them coming back for more! Personal training success and the client–trainer relationship are like a boomerang: Success depends on service always coming back to this personal level and critical starting point! A well-thrown boomerang hits its mark every time—do you?

Master Trainer: Beyond Ordinary Training

How do you communicate that your services are special and personal? You can't advertise these special characteristics by attaching your credentials and the services you offer to your back. Although fitness enthusiasts have come to realize they do really need personal trainers, many are ill equipped to differentiate between superb, good, adequate, and poor trainers. Anyone can call him- or herself a personal trainer. What can a safe, conscientious, and knowledgeable trainer do to differentiate herself from the crowd?

Clients choose to work with trainers because they are personable, motivating, pleasurable to be around, and in good shape; because the trainer charges an affordable fee and can schedule the client at his desired time; and, yes, because the trainer is certified or otherwise qualified. Sometimes trainer competency criteria are not high on the list of reasons of why people hire trainers. A master trainer meets the client where he is and can differentiate herself from other trainers by pointing out the

value she brings to the table and by keeping the workouts personal and client oriented.

Master Trainers Stand Out in the Crowd

Top trainers who stand out go beyond simply knowing how to work out a client or how to advertise their businesses. This type of trainer runs a business that exudes professionalism. Business and personal skills lead the way. Add to this creative energy, fun, playfulness, and results-oriented planning and workouts. The following suggestions can help your business shine with professionalism and exhibit exemplary personal service:

10 Ways to Stand Out As a Master Trainer

1. Be yourself. The genie in a popular Disney movie said it best: "Beeee yourself." This bit of wisdom helps you realize that you cannot be everything to everybody. If you attempt this, not only can you spread yourself too thin, but your inconsistent actions may confuse your clients. In fact, you may even come across as insincere, patronizing, hollow, and fake. Follow your passion and enthusiasm, and stick to your business policies to help you make consistent, fair, and sensible business and programming decisions. Although you must be able to adjust to client needs, whims, and interests, you still need to set standards and demand compliance to policy. It might be best to exhibit excellence and fairness, rather than being a jack of all trades and master of none. Sticking with who you are and what you do best presents you as an honest, capable, and competent trainer and businessperson.

2. Maintain technical competence and know your client. Technical competence is a given requirement. Additionally, extensive and thorough, although not necessarily time consuming, verbal and written interviews and ensuing feedback must be obtained from each client. Although this process takes some diligence, record keeping, and effort, the dividends are huge with regard to perception of personalized service. Clients see the results of a trainer who acts upon client needs and wants concerning health and fitness.

3. Give your clients 100 percent of your attention. Giving 100 percent is true not only during the workout but regarding client followup. Any questions or concerns that a client may have raised should be promptly answered on the spot if the trainer has the requisite knowledge, or the necessary investigative work needs to be done in a timely manner. The workout session is your client's time. Unnecessary interruptions, including phone calls and pages, should be eliminated. Engage the client verbally and with hands-on correction if appropriate. Keep conversation professionally oriented, be a good listener, and keep your personal problems and life to yourself!

4. Communicate to your clients in simple language. The mark of a master trainer is one who can speak fitness on a variety of levels that are simultaneously intelligible, independent of the audience. One of my most respected peers is a PhD who has such a mastery of fitness information that he can simply communicate ideas and concepts to the lay consumer but can switch gears quickly to challenge and converse with leading scientists across the world. I am always impressed with his intention to communicate information versus a lame attempt to be unnecessarily complex or verbose to impress. No one likes someone who is self-impressed with his or her knowledge, especially if no one knows what he or she is babbling about! Master trainers check self-importance and personal insecurity at the door and focus on educating, being approachable, demystifying fitness, and motivating clients to exercise for a lifetime.

5. Be caring and respectful of each client. A lot of success in training comes from the heart. That last sentence doesn't have any research to support it, but my personal experience, in addition to that of many other successful trainers, says that care and respect for clients are keys to continued success. In a successful personal training business, there is no room for cookie cutter approaches to training, flippant and careless remarks (even just a one-time slip-up), impatience, or a condescending attitude. If you're upbeat and ready to "rock," remain sensitive to the client and her day and make sure your enthusiasm matches her need. Is impatience creeping into your attitude? Remember what it is like to learn a new skill, realize that many

of your clients have not yet learned to truly love exercise, and remember that events and circumstances that happen throughout the day will greatly affect your time with your clients. Keep your feedback positive and individual. Honest and sincere comments develop trust.

6. Provide service excellence. Service must be extraordinary and beyond the call of duty! The image of the service you provide can be enhanced by, for example, personalizing record keeping that uses high-tech photo and video images. Computer programs can enhance client compliance through better kept diaries, training logs, and records. However, nothing is more important to your business than the day-to-day interactions between trainer and client. New equipment and other bells and whistles will never replace respectful and personalized attention that is sincere and communicates that you care! You know clients recognize extraordinary training because they tell you, let you know they appreciate you, and stick with your organization for a long time.

7. Offer rewards and recognize client achievement. Complementary sessions and free T-shirts recognize consistency and other personal accomplishment. Use e-mail, faxes, and personal hand-written notes to let your clients know that you are aware of and appreciate their personal success, as well as their business.

8. Expand your toy box. Although new exercise toys don't replace any of these steps, they can certainly enhance and complement the training environment. Stability balls, weighted balls, cones, Bosu Balance Trainers, balance boards, steps, and slides and elastic resistance, as well as new training environments (like the out of doors), are just a few of my clients' favorite diversions. Yet, these diversions should not provide variety for the sake of variety. They should be effective training methods that accomplish your client's training goals.

9. Set professional boundaries. The professional boundary between client and trainer should be firmly established and communicated. Set business policy for cancellation procedures, difficult clients, and those who want to get too intimate or overly involve you in their personal or social lives. Although invitations like these can be tempting, you should generally avoid

them like a plague. Of course, social invitations, for example, to honor the client or other family member, can be considered on an individual basis. However, when the pattern becomes the norm, as opposed to the exception, it's time for a professional self-check. You can simultaneously be close to and caring of your client and still keep your professional edge without becoming too involved or intimate. Trainer after trainer will tell you that getting unprofessionally close to your client or otherwise overly involved in personal affairs leads to pain and more pain.

10. Model and teach commitment and excellence by example. Notice that I didn't say perfection. Your professional image should be one of humility and humanness. Although you should present a good example of healthy living and a balanced life, you are not perfect and should not attempt to posture yourself with this burden. Exercise, diet, and success should be pleasurable. After all, if you and your clients can't embrace an approach to wellness over a lifetime, everyone is set up for failure. Consistency wins over time, and your clients, as well as you, need space to succeed and have fun.

If you get these and other important messages across to your clients, you're well on your way to becoming a master trainer!

Master Trainers Are Different

The master trainer exhibits an attitude of positive thinking and relentless client support. A master trainer possesses the following qualities: intelligent, likes to help others, wants to understand people, respects individual differences, superb at delegating tasks, honest, of high integrity, unique, special, genuine, real, caring, nonjudgmental but able to confront differences and conflict, empathetic, action oriented, calm, recognizes improvement, and offers nonpatronizing and honest praise. The master trainer is a good teacher, an excellent facilitator, a good listener, and a steady, guiding, and inspiring force.

These qualities are revealed after a client has spent time training with a top trainer, or you could think of it as time spent mentoring under the sensitive master. The master trainer takes focus away from herself and doesn't need to proclaim her superiority. She practices the art of being, letting her actions, words, and demeanor speak for her; by demonstrating

strong character traits in action, she allows clients and peers to shape their opinion of her character. The master trainer demonstrates humility and humbleness in serving, caring for, and helping others. Someone once said, "Humility is not thinking less of yourself, but thinking of yourself less." (Church 1996, pg. 11).

The spirit of a master trainer allows her to create a good attitude even when it's hard to do. Personal conflict, tragedy, or exhaustion are not good excuses for having a bad day. On the other hand, master trainers are human and know when to let clients see that side of their lives, too. Master trainers know that they aren't and should not be expected to be perfect, but they also know how and when to separate business from personal life and when to let the guards of professionalism down and bare their human and vulnerable sides without becoming a burden to their clients.

Trainer's Dream List

Although fairly odd, to follow is a list of some of the top fantasies of fitness professionals. Part of the trick of keeping fresh and keeping training personal is to have hope and remain positive. The last intangible piece that must be put in place for the master trainer who's in this profession for the long haul is to possess a sense of humor . . . to dream . . . and to have hope!

■ A piece of home exercise equipment that trains the whole person on every component of fitness and converts into a robot housekeeper that cleans the house, drives the kids to school, and cooks dinner. You'll be sure to get more clients who will be ready to invest in a home gym like this.

■ A hand-held fitness computer that organizes personal training sessions, schedules group exercise classes, remembers your appointments, can repair a broken down car or go to the rest room for you, and warns you when you are about to call a client or family member by the wrong name.

■ Training shoes that automatically change colors like a chameleon to let your client know her exercise intensity level.

■ A workout bag big enough to hold everything and that doubles as a washer and dryer so you never have to waste time washing exercise apparel.

■ A water bottle that not only automatically appears when you or a client needs it and chills the drink but fills itself with the right replenishment fluid, empties itself when you're finished, and disinfects the inside so you never treat yourself to the sickening sight of growing fuzz inside your bottle.

■ A briefcase that holds the latest fitness research, reads it all, and tells you just what you need to know—and no more. A chip is provided with this purchase that can be inserted in your brain to help you retain and apply the information.

■ Adjustable steps for small-group sports conditioning class that walk to the proper spot and are always positioned so each client can see you and observe his form in a mirror. Better yet, all equipment should be preprogrammed to self-position and set itself up.

■ A prerecorded tape that changes songs every two weeks and automatically adjusts beats per minute based on your telepathic thought, pays for licensing rights, and plays top 10 music. This would especially be helpful for workout background music, stationary cycling classes, and small-group formats.

■ A headband that relaxes your client, fills his head with positive thoughts, gives him confidence, and reminds him to prioritize exercise and healthy food selection daily. Occasionally, the trainer should borrow the headband from the client and use it.

■ A wish that all of your clients would thank you after every workout, have an enthusiastic, positive, and infectious personality; and insist on a 10-year training commitment that is prepaid and pays you seven figures. (Keep dreaming and hoping!)

The day you stop improving, learning, listening, caring, and dreaming and the day you no longer have hope and a sense of humor is the day you die. Progressive and successful trainers are humbled by what they do not know and still have to learn, yet this reality does not hinder passion and enthusiasm but instead drives a desire for personal growth and continued top-notch client service.

Understanding the Client's Perspective

A master trainer is excellent at all aspects of training. This includes programming and business skills. Technical competency is required and expected. Master trainers know how to motivate, understand the importance of good communication skills, and know how to work with individual personalities.

If I perceive that my business is off track, I figuratively fix my gaze on client perspective. The client–trainer relationship should include this empathy, which leads to communication and understanding between trainer and client.

Many clients have had little success with their personal fitness goals until hooking up with a personal trainer. They understand and appreciate your value and "need" you in a good way. For many clients, nothing has worked in terms of health and fitness programming until they committed to a trainer and regular, guided, results-oriented programming.

Many of my clients have told me that they, at one time or another, believed they were the last person who'd ever go to a personal trainer. However, the realization that not caring and maintaining poor health was a vanity worse than any other, along with understanding the value a trainer brings to the table, swayed them to experience training at its best. I believe there is no better potential training experience than the one-on-one approach, especially if you strive to take your training to a personal and master level.

Clients look for trainers who will progress them safely, inform and educate them about new trends and controversies, and care for them on a personal level. Trainers should be prepared, arrive on time, and maintain a consistent level of motivation and enthusiasm as well as empathy for the client in this service-oriented business. Clients pay for convenience, quality, and results in a workout program and should get nothing less.

We influence lives most effectively, one at a time, starting with ourselves. We can begin to make the world a healthier place by building a better self in our personal lives and extending this into our professional lives. Then, and only then, can we significantly and positively influence each of our clients. One personal training client shed some light on the very personal effect training has had on her by saying, "After a workout, when I take a deep breath, I sense it down to the bottom of my lungs, and I feel—for the first time in my life I feel! I live here now, and it's not too bad a place to live." If you can lead your clients to a perception of self-success and self-acceptance, your work matters, has impact, and is powerful.

Yes, we can influence self-acceptance and encourage clients to engage in a healthy lifestyle—helping one person and making one impression at a time. Keep your training at the one-on-one level and believe that you make a difference! This simple reality encompasses the importance of a high-level, service-oriented, and comprehensive approach that successful master trainers use worldwide. The master trainer never lets the importance of one-on-one service move beyond sight.

APPENDIX:
Client Introductory Packet Overview

CLIENT INTRODUCTORY PACKET OVERVIEW

Place the information in a clear binder with a plastic, slide-on spine. This creates an inexpensive presentation that looks pulled together and is easy to edit when documents need to be updated or information sheets added to the packet, especially if the documents are stored on your computer.

The following is how I organize my client introductory packet. Samples, where applicable, follow this outline sketch.

1. Cover page: business logo and name; appropriate contact information
2. 8 × 10 head shot or action-type photo
3. Personal biography (one page or less)
4. Resume (maximum of one page)
5. Copy of degrees and certification
6. Copy of professional liability insurance
7. Brooks . . . The Training Edge Philosophy
8. What to expect during your first visit with us
9. Basic program and business policies
10. The Training Edge approach: balanced fitness
11. Medical history, activity, and eating habits questionnaire and forms

This is an optional insert, depending on for whom the packet is intended. New clients get the whole packet, whereas those interested in my services or the media get a shortened version.

12. Books written by Douglas Brooks

Insert copies of book covers.

13. Informational articles

Insert articles written by, or about, Douglas Brooks and The Training Edge, or articles where the trainer or business is recognized and quoted as or referred to in an "expert" capacity. If you've written or been featured in numerous articles, consider inserting a list of titles. If you've written one or just a few articles, include part or all of the articles.

14. Personalized gym design in commercial, corporate, or home settings

Insert pictures of gym designs and satisfied customer quotes (obtain permission to print quotes).

15. Character and service references

List a number of people or organizations that would bolster your credibility in the eyes of others who are considering your service. If you list contact numbers, you must obtain permission from the individuals or businesses. You can also simply state that the references are available on request. In this case, be prepared to provide the list at a moment's notice.

➤ *Note:* Included in this packet is a map detailing The Training Edge business locations.

For discussion about how you can maximize the packet's clout for client recruitment and marketing strategies, refer to chapters 2, 3, and 4. This packet is a good example of written communication. If questions or conflicts arise in the future, you can always refer to your written policies. Make sure that you walk through the entire packet with the client, highlighting key areas.

Introductory Packet Content (Sample)

You most certainly will want to adapt the format and some of the content you see next. After all, who wants to reinvent the wheel if you see what you like? If you're new to training, you probably haven't written too many books, appeared on "Good Morning America," or been written about in *USA Today*. Don't worry. More is not better. Keep your packet to the point and pertinent to what you have to offer today. About 20 years ago I created my first resume. It was seven pages long, it told you nothing, and no one read it. If in doubt, go the way of concise, bite-size tidbits of information! Beyond these suggestions, it is appropriate to develop the packet so that it directly matches your style and business practices and beliefs.

Personal Bio (Sample)

DOUGLAS BROOKS, MS, EXERCISE PHYSIOLOGIST

Acknowledged as one of the country's premier personal trainers by numerous publications, Douglas Brooks is truly the "trainer's trainer." As an author, lecturer, trainer, and video personality, he is recognized by professionals and the public worldwide.

Douglas, who holds a master's degree in exercise physiology, is the author of the best-selling *Going Solo—The Art of Personal Training* and *Program Design for Personal Trainers . . . Bridging Theory Into Application*, as well as numerous educational manuals. His latest books in print are *Your Personal Trainer,* which is being sold in bookstores nationwide, *Effective Strength Training; Bosu: Integrated Balance Training;* and *The Complete Book of Personal Training*. He frequently conducts lectures and workshops on exercise physiology, kinesiology, strength training, and personal training throughout the United States and internationally.

Douglas is the consulting exercise physiologist for product research and development for several fitness companies and is currently the head physiologist and strength and conditioning coach for Mammoth Mountain Ski and Snowboard Team.

Douglas was a three-term member of the advisory board for IDEA and has provided program consulting services to numerous organizations. Douglas also sits on the editorial advisory board for the *ACE: FitnessMatters* publication. Douglas is an IISA-certified in-line skating instructor and an ACE gold certified personal trainer.

His counsel and input are sought on an international basis. He currently serves on the advisory boards of Sweden's and Belgium's most respected training and educational organizations. Most recently, Douglas was appointed as vice president of the International Sports Trainers Association, based in Buenos Aires, Argentina.

A personal trainer for 19 years and counting, Douglas is no stranger to video and TV production. He has been the featured talent in over 20 videos. Douglas regularly appears on cable television as a fitness expert and the Health Club Cable Network. His Airofit™ infomercial ran number one in early 1997 national cable rankings. Viewing audiences during these live and taped appearances can exceed 7 million. He recommends and endorses fitness products that are scientifically proven and deliver the results that he promises.

Douglas owned and operated The Training Edge, a personal training facility, for nine years; directed a 5,000-member health facility; participated in and coached college-level gymnastics; and was an assistant professor at the University of Michigan Health Science Department. A person who enjoys fitness activities of all kinds, Douglas is an avid sports enthusiast. He is a serious cyclist, marathon runner and Ironman® triathlete, as well as a devoted downhill alpine and cross-country skier, in-line skater, rock climber, and mountaineer. Douglas lives near the top of a mountain in Mammoth Lakes, California, with his wife, Candice, and their two sons and cross-trains with all the toys according to the season.

➤ *Note:* A short biography, about a paragraph and no longer than a page, helps to establish your credentials and highlight your accomplishments. This can complement your resume and generally is easier to read than a resume format.

Resume (Sample)

DOUGLAS S. BROOKS

Exercise Physiologist and Personal Fitness Trainer

EMPLOYMENT:

1987 to present:	Co-owner of Moves International Fitness, a provider of educational resources, continuing education and live workshops to fitness professionals and fitness products
1983 to present:	Self-employed personal fitness trainer
1982 to 1983:	Assistant Professor, University of Michigan -- Department of Health Sciences
1981 to 1982:	Fitness Director and Coordinator of the Cardiovascular Health and Fitness Program, YMCA of Flint, Michigan
1980 to 1981:	Assistant Professor, Central Michigan University (CMU) -- Department of Physical Education -- Assistant Women's Gymnastic Coach (CMU)

EDUCATION:

1980-81:	Master's in Physical Education (CMU) -- Area of concentration, exercise physiology -- G.P.A. of 4.00
1979:	B.S., Magna cum laude, Secondary Physical Education (CMU) -- Area of concentration, exercise physiology -- Minor in health education

CERTIFICATIONS / SPECIAL RECOGNITION:

- American Council on Exercise (ACE)
- Gold certified personal trainer
- IISA certified in-line skating instructor
- American Heart Association, CPR, and First Aid Training

PROFESSIONAL MEMBERSHIP (PARTIAL LIST):

- IDEA--The Health and Fitness Source
- The American College of Sports Medicine (ACSM)
- International Sports Trainers Association (vice-president of ISTA)

AREAS OF SPECIALIZATION / INTEREST:

Special populations that include obese clients, deconditioned individuals, those undergoing out-patient back and cardiac rehabilitation, pregnant clients, clients with diabetes or asthma, those interested in weight control, youth, and clients who desire sports conditioning

Resistance training and biomechanics

Instruction and performance in running, cycling, swimming, stretching, tennis, cross-country and skate-skiing, downhill alpine skiing, and in-line skating

PERSONAL ATHLETIC HISTORY:

- Mountaineering: climbed 20,000-foot Imja Tse, Nepal Himalayas
- Ironman® Triathlon/Hawaii
- Marathons including Boston, London, New York, Los Angeles, San Francisco, and Detroit
- Men's Collegiate Gymnastic Team (CMU)
- Men's Collegiate Baseball Team (CMU)

PERSONAL DATA:

Birthdate: 6-15-57 Height: 5' 10" Weight: 157 lbs. Body Fat Percentage: 8%

Author's note: Besides listing employment credentials and education background, include any other applicable or related experiences that will enhance your credibility as a personal trainer.

Brooks . . . The Training Edge Philosophy
(sample program philosophy)

The pursuit of health and fitness can be confusing. It seems there is always a special program or some type of magical equipment that is being touted as the solution to your wellness needs. You start to realize it's not so easy to decipher contradictory information and conclude with confidence which approach is the truth, or what piece of equipment will really improve your personal well-being and work for you. A television show or infomercial expounds about the latest great new diet, which is surely destined to set up for failure anyone who happens to follow it. A newspaper article reports the latest exercise trend. Then there's the promise of the four-minute, total body workout. Another promotion attempts to lure you to a program that promises immediate results, with magical new technology that is "research" proven. Will these or any other hooks finally give you the success you've dreamed about, send you to the emergency room, or just leave you disappointed and frustrated one more time?

Quite often, attempts at enticement are driven by a marketing plan that doesn't consider your real needs and best interest. And, regardless of how wacky or unsafe the program or equipment might be, the irony is that it could work for a while. That is, until you get bored, dissatisfied, or injured.

Personalized fitness training gives you an alternative to this mass market, impersonal approach to your fitness and health. My colleagues and I, at Brooks . . . The Training Edge, will provide you with a sound program that is specifically tailored to your needs now, and we'll amend it so that it grows with you as you progress and your needs change down the road.

The programs at Brooks . . . The Training Edge are a comprehensive lifestyle plan. Training includes instruction in resistance training (weights, dumbbells, tubes, bands, machines), flexibility (stretching), nutrition (eating sensibly without hopping on the diet bandwagon), cardiovascular conditioning, and functional training. You will learn proper technique and the reasons why each of these areas of fitness is important. You'll cross-train (change activities),

and we'll periodize (change how hard you work over specific time periods) your fitness training so you'll stay interested, have fun, and keep the results coming. Rather than performing a flurry of mindless activity that gets you little more than sweaty, you will get a program that provides the maximum return for the goals that you set for yourself.

Although we at The Training Edge know what we want to accomplish with your program, it would not be complete or as effective unless we also consider your thoughts, feelings, and opinions as we develop our individualized approach for you. Your input is critical in helping us design an ever-changing program that can meet your fitness, health, and nutritional needs.

Brooks . . . The Training Edge will give you results that go further than cosmetic. Sure, you'll look good and obtain a healthy ratio of body fat to lean muscle, which is a key measurement of health, but you'll also get that "feel good" glow that comes from increased energy and a heightened state of overall health. You will become more agile and skilled in the sports in which you choose to participate. As you increase your fitness you will reduce your chance of heart disease and be much better equipped to manage stress.

To get these results, we will need your cooperation, enthusiasm, and steady attendance commitment. We must work as a team, giving 100 percent effort. (This doesn't mean going all out during every workout!) Throughout your workouts, be straightforward and forthcoming. Tell us how you feel, voice your concerns, and ask whatever questions you might have. This is your personal training program, and the whole process works much better when you are actively involved.

To become highly fit you should schedule at least two training sessions per week. Eventually, you'll progress to doing some type of activity most days of the week. You'll be encouraged to do several of these activity sessions on your own. We'll help you plan and schedule these workouts so that it's easy for you to complete

Continued ➤

them on your own. And, don't worry, we'll never progress you too fast and will always meet you at your pace! After four to six weeks of training, if not sooner, you should start seeing some great results.

To sharpen the edge you get from efficient training, we will also periodically reevaluate your program. Constant supervision and adjustment are essential features of responsible fitness training.

In addition to discussing your situation, needs, and preferences, we pledge to work so that these needs and desires are satisfied. That way, Brooks . . . The Training Edge's major objective—your physical fitness and personal wellness—becomes the edge you can live with.

➤ *Note:* Sharing your philosophy with new or potential clients allows you to state your objectives, views, and goals regarding the programs you plan to provide for them. This can help the interviewing client establish to some degree whether his or her goals can be met by the training organization and whether the individual could be comfortable training within your organization.

What to Expect During Your First Visit With Us (sample introductory letter)

INITIAL GET-TOGETHER

We've probably already chatted for a few minutes in person or by phone, and you have the client introductory packet in hand. Before any workouts occur at The Training Edge, we require you to fill out the medical history questionnaire as well as the activity and nutritional profiles found in your packet. Also, read and sign the Consent and Release form. If your written medical history responses indicate we need to do further follow-up, this could delay your first workout with us. But, we're in this for the long haul and your safety is our highest concern. Not only does this requirement follow professional protocol, but we can't create the safest and most effective program for you until this information is obtained. We won't let you start with our services—although we're as excited as you are to begin the program—until we're confident you can progress safely.

It should take about 20 minutes to fill out your paperwork. It's fun and introspective and may fuel your thinking toward the goals and expectations you have and that we can accomplish together.

Our initial get-together is provided at no charge. We'll finish up any paperwork that is necessary and schedule your first workout when we have cleared up any questions related to your medical history, activity, or nutritional forms. Our thoroughness and safety record are highly respected. Your best interest and well-being are at the top of our agenda!

THE FIRST WORKOUT . . . NOT TO WORRY!

We're so confident in being able to make a huge difference in your workouts and health that we believe this first workout will be the beginning of a long-term relationship. This workout is the beginning of an ongoing process where we work as a team (client and trainer) to define your goals, interests, and desires. Over time, we'll outline your program plan to achieve the results you are looking for.

Many first timers worry that they need to be in shape before coming to us. It's our job to progress you slowly and meet you where your health and fitness needs are today. Your first session will be a workout, not a wipeout.

Generally, we will not put you through a gauntlet of fitness tests during your initial visit. Fitness testing and assessment are optional motivational tools that we'll use with you when appropriate to your conditioning level and program. By having you fill out the medical history questionnaire form and carefully evaluating your answers and seeking additional counsel if necessary, we are certain we can safely and accurately begin training. Fitness assessment can be a double-edged sword that can straddle

Continued ➤

➤ *Continued*

personal encouragement or humiliation. Some tests can even put you at risk for injury if not properly and timely administered. Fitness testing at The Training Edge is not diagnostic. It doesn't evaluate whether you have health risks. This should be done in a medical setting. Fitness testing at our facilities is an optional tool we use with discretion, to motivate you and further tailor your program to meet your individual workout needs.

WORKOUT APPAREL

There are no crowds or "prime time" at our personal training facilities or your home. "Dress to impress" is out. Wear workout attire that is comfortable. Clean T-shirts, shorts, tights, sweats, and track suits are the rule. Athletic shoes should be supportive and functional. Please be considerate of others with regard to your personal attire. If you have questions about the appropriateness of your workout gear, ask us!

GEAR

Shower and changing facilities, towels, water, and music are provided. Bring toiletries and shower sandals or other personal items if you wish.

TRAINER AND CLIENT PERSONAL HYGIENE

Personal training, by its nature, creates an environment that is personal, up-close, and professionally intimate. Simply, we will work closely with one another. Dental hygiene, clean exercise clothing and shoes, and overall body cleanliness are requirements. You'll observe that our trainers will brush their teeth, change clothing, and shower several times on any given day. This consideration and respect of others are a must.

The Training Edge Program and Business Policies (sample program policies)

BASIC PROGRAM POLICIES

We believe that the following policies clarify basic business policies and help to develop a relationship that is based on a reciprocation of responsibility. Our commitment to you runs deep!

Training session length.

Each training session is based on a 55-minute hour, although longer and shorter options are available.

Trainer–client ratio.

Individual (one-on-one) training, small-group training, and phone consultations are options. Most of our clients choose the specialized attention and focus that one-on-one training provides. However, our role is to meet you where your interest, needs, and desires fall.

Promptness.

To get the most out of your time and efforts, please be ready to exercise at the appointed time. Because clients are usually scheduled before and after you, or your trainer may have scheduled a meeting or personal development time immediately after your session, workout times cannot be extended.

If a trainer is late for your session—late is defined as one minute after your scheduled starting time—the training session will be extended if possible, and regardless, you will be credited with a complimentary workout. We want your commitment and you have ours!

Cancellation of your scheduled workout and missed sessions.

You will not be charged for sessions that you cancel with more than 24 hours notice. You are allowed one late cancellation per every four scheduled workouts. For example, if you work out 12 times per month, three late cancellation notices would be allowed. If you workout four times per week, one late cancellation notice would be allowed each week.

The full session fee will be charged to clients who cancel with less than 24 hours notice, or if late cancellations exceed one per every four

Continued ➤

scheduled workouts. Excessive cancellation, regardless of notice time and resultant payment, will be discussed between the client and trainer or program director. Your program will not be as successful—obviously, even if you pay for missed sessions—if your attendance is not consistent. We want the best for you and want to earn the money you invest toward your health.

If a trainer misses a session with you, regardless of his or her reason, a sincere apology will be forthcoming immediately. Although crises do occur, even for a trainer whom you may consider above reproach, we believe that missing sessions is not acceptable. We respect and value your time commitment too much. The missed session—if you were not provided with at least a 24-hour notice—will immediately be rescheduled at your convenience, with no charge. Additionally, you will be credited with a complimentary session at our expense. We don't take our commitment and service to you lightly!

RESCHEDULING APPOINTMENTS

If you would like to reschedule an appointment with less than 24 hours notice, The Training Edge and its trainers will do their best to accommodate your request. Although they check for messages regularly, our trainers are booked well in advance and often consecutively. Our professionals also have obligations that include attending scheduled meetings and preserving self-development time. If The Training Edge cannot accommodate your request and the request comes in with less than a 24-hour lead time, you (the client) will be charged for the scheduled appointment.

If a trainer must reschedule or cancel an appointment with you, and does so with less than 24 hours notice, the scheduled session will immediately be rescheduled at your convenience, with no charge. Additionally, you will be credited with a complimentary session at our expense. Responsibility is a two-way street.

PAYMENT FOR SERVICES

All training sessions are guaranteed 100 percent, unconditionally. If for any reason you are not satisfied with your training session, your entire session fee will be refunded. We appreciate your positive criticism and the chance to correct any problems.

If you have not entered into an agreement where your training sessions are paid for in advance, all fees are due upon receipt of The Training Edge invoice. When invoices are overdue two weeks, it is Training Edge policy to suspend training services until your outstanding invoice is current. In cases of repeated delinquency, for example, a number of outstanding invoices, we require that all services be paid for in full in advance of the services being fulfilled. Prompt payment of your training fee, or fees related to other services rendered, saves us administrative cost and time, which allows us to better meet your health and fitness goals.

The Training Edge accepts Visa and Master-Card, personal checks, and cash as payment.

TRAINING LOCATION

Training sessions will take place in the privacy of your home, at one of The Training Edge's private facilities, or at a mutually agreed upon training location (i.e., outdoor training challenge or public facility, provided we can gain admittance).

PARTNERING

Partnering is a unique concept we use at The Training Edge to ensure a well-rounded and consistent service for you. This training concept has your best interest at heart. Although you will develop a relationship with a "primary" trainer, and this trainer will train you the majority of the time, one or two other trainers should become familiar with your program and personality. Creating a dependence on one trainer sets you up for potential failure. From time to time, trainers will leave The Training Edge for a variety of reasons; others will take time for vacation or become injured or ill. Any of these scenarios could interrupt your program. That is why we encourage multiple client–trainer partnerships. You'll help us choose at least one, if not two, other trainers with whom you think you might be comfortable training. Periodically, you'll have the opportunity to train with another "partner." These relationships need to be developed before a bump occurs in the road of progress. In the event your primary trainer is not available for a short period of time or, for example, the trainer moves to another state, your interests are covered and your program will not be interrupted. Our trainers and clients generally embrace this concept. It provides the trainer a guilt-free change of scenery (Yes, even your trainer needs a vacation!) and you—our prized client—get new perspective and expertise from other Training Edge pros.

The Training Edge Approach: Balanced Fitness
(sample training principles and program components)

CARDIOVASCULAR FITNESS

A strong heart is a cornerstone of any fitness program. Aerobic workouts burn a lot of calories and fat, increase the flow of oxygen to the body's muscles and vital organs (increased "energy"), help you cope with daily stress, and help protect you from heart attacks and many other degenerative diseases.

Cardiovascular fitness can be achieved through any activity that uses continuous and rhythmic movement. Walking, hiking, running, and swimming are good examples. You must find activities you love to do, or you won't stick with your program. To maximize results, you also need to exercise hard enough, yet not too hard. We'll help you understand how to use heart rate and perceived exertion to optimize your level of effort, fun, and enjoyment. An eventual goal will be to engage in cardio effort three to six times per week. How hard, how often, and how long you work out will be influenced by initial fitness level, your rate of progress, and your feedback.

The aerobic portion of your workout usually follows the same basic pattern, whether you choose walking, running, cycling, swimming, rowing, cross-country skiing, aerobic dance, or some other form of aerobic activity. You'll always warm up for at least 5 to 10 minutes, and then, generally, you'll gradually build your effort toward a target heart rate range or level of perceived exertion, which we call RPE. The cardiovascular portion of your workout will always end with a cool-down of at least three to five minutes.

To optimize cardiovascular fitness and maximize calorie burning, we use a form of interval training that most of our clients can safely participate in. This fun form of cardio training encourages you to work a little harder than you're used to, after you've acquired a base level of fitness. Because it's more interesting than always plodding along at the same old pace, interval training makes it easier for you to stick to your program. If you want to fully develop this area of fitness, interval training is the way to go.

RESISTANCE TRAINING

Contrary to popular belief, resistance training (or strength training) is not a mindless, unfocused activity that is for "muscle heads" only. When performed correctly, it is a focused effort. Superb results don't require hours per day. Significant strength gains can be realized with two 25-minute strength workouts per week. Additionally, strength training done right is probably the most important component of fitness—bar none—in terms of its impact on weight maintenance, weight loss, and overall health.

Many people are reluctant to train with weights because they mistakenly believe that toned muscle will turn to fat if they stop their program. This simply is not true. Just as a broken leg will atrophy while in a cast, a muscle that is not challenged will shrink . . . not turn to fat.

Some women don't want to strength train because they are afraid of building bulky muscle and looking "muscle bound." Rest assured that the average woman will likely not be able to attain an overly muscular body as a result of a normal strength training program. Usually, this holds true because of the hormonal influence—females generally lack significant amounts of testosterone—that prevents most women from building excess bulk or size.

We will develop a strength program that will reshape your body. You'll learn to concentrate, isolate muscle groups, train functionally, and appreciate the changes in your body. It has been reported that Michelangelo believed that inside every piece of marble was a statue waiting to be uncovered. If you've never strength trained, you will think the same way about your body as it starts taking on the look it was meant to have. To achieve this type of result means a consistent commitment to strength training.

FLEXIBILITY

More so than any other aspect of fitness, flexibility is generally misunderstood or pursued improperly. Stretching is the most likely area

Continued ➤

of fitness that will be left out of a program or given inadequate time, even though most people know they should stretch. And, even if they stretch with the best of intentions, they sometimes stretch incorrectly.

Although people often blame running or some other activity for their back problems or other injuries, the real culprit may be the stretches they do before the activity. You need to warm up first. Stretching is not a warm-up! Stretching is performed most effectively and safely when the joints have been limbered and the muscles are warm.

Hard-to-hold stretches that result in joints being forced beyond their normal range of motion—and may cause your eyes to bulge from their sockets—do not always increase flexibility and can cause injury. You will be encouraged to never move a joint further than you can actively control it. We do not encourage bouncing or forcing movement to painful or uncomfortable limits. If you stretch like this, you may be overstretching muscles and ligaments around the joint, which can be more harmful than not stretching at all. We'll use a variety of stretching approaches that will get you ready for recreational activity or competitive sports performance or give you the necessary suppleness you need for a busy and full life. When done correctly, stretching feels good.

CROSS-TRAINING AND PERIODIZATION

A program that has you complete the same workout day in and day out is a recipe for failure. Adding variety (cross-training) and cycling how hard you work out over specific time periods (periodization) are essential to top results as well as avoiding injury and burnout. We'll make this planned training and results-oriented program easy by suggesting and organizing the changes you need.

EATING AWARENESS

Regular exercise cannot compensate for improper nutrition. To get the most from your training program you have to pay the same amount of attention to your diet. This may be a challenge at first, but once you realize how poor eating habits can negatively affect your health and fitness, you will be motivated to follow our fun and easy "eating awareness" plan. We don't

like the word *diet*. We'd rather you eat smart, enjoy food, and put into action an approach that will work long term for you!

Good nutrition is not a sacrifice but a choice and a matter of knowledge and common sense. The following basic principles will keep you on track:

1. Calories do count. Exercise can burn off some, but not all, of your excess food intake. Exercise alone won't protect you from heart disease. Most men should consume at least 1,800 to 2,000 calories a day, whereas most women need about 1,500.

2. Carbohydrates in complex, whole, natural forms (rice, potatoes, whole grains, breads, fruits, and vegetables) should form the center of your diet. Our past reliance on proteins, fats, and refined foods has resulted in unprecedented levels of cardiovascular disease, obesity, cancer, and other life-threatening conditions.

3. Limit your intake of sugar, alcohol, high-fat dairy products (including cheese, milk, and butter), refined desserts, candies, red meats, any fats (including oils, butter, margarine, and mayonnaise), and salt. With the exception of salt, these foods are dense in calories while simultaneously being low in nutrients and natural fiber. Avoid preservatives and chemical additives.

4. Drink plenty of water before, during, and after exercise. By the end of the day, you should have consumed at least six eight-ounce glasses of water. Although this sounds cliche, drinking lots of water makes a positive difference.

5. Eat when you are hungry. Each day you could have up to six small meals or nutritious snacks that are high in complex carbohydrates and natural fibers, as opposed to fewer fat-laden meals that are dense in calories and low in fiber.

➤ *Note:* These explanations give new clients basic information about each area of fitness and nutrition that they will experience as part of their total program. Additionally, it creates anticipation and excitement about the knowledge, support, and motivation that are awaiting them. It also communicates a long-term commitment to personalize the program because clients know that variety (cross-training) and a planned approach (periodization) to their training program are part of our overall plan of attack.

Sample Short Form Medical History Questionnaire

Personal Health and Fitness Medical History Questionnaire

BROOKS
THE TRAINING EDGE

Name: _____

Age: _____

Date: _____

Primary health care provider: _____

Provider's contact number: _____

Other health care specialists: _____

Health History

1. Do you smoke? Yes No

 If you answered yes, how much do you smoke?_____

2. Has your doctor ever said your blood pressure was too high or low? Yes No

3. Have you (or a family member) ever been told that you have diabetes? Yes No

4. Do you have any known cardiovascular problems (e.g., heart disease, previous heart attack, atherosclerosis, abnormal electrocardiogram)? Yes No

 If you answered yes, please describe: _____

5. Has your doctor ever told you your cholesterol level was high? Yes No

6. Are you overweight? Yes No

 If you answered yes, how much are you overweight? _____

7. Do you have any injuries or orthopedic problems (e.g., bad back, bad knees, tendinitis, bursitis)? Yes No

 If you answered yes, describe: _____

8. Are you taking any prescribed medications or dietary supplements? Yes No

 If so, please describe: _____

9. Are you pregnant or postpartum less than six weeks? Yes No

10. Date of last physical examination: _____

11. Do you have any other medical conditions or problems not previously mentioned? Yes No

 If you answered yes, please describe: _____

12. Describe your current exercise program: _____

13. List the goals of your program: _____

From *The Complete Book of Personal Training,* by Douglas S. Brooks, 2004, Champaign, IL: Human Kinetics.

Continued ➤

➤ *Continued*

Consent Form (Sample Short Form)

I acknowledge, to the best of my ability, that I am in good health and have no known medical problems that would restrict my ability to participate in this exercise program.

Signed: _____ Date: _____

➤ *Note:* This form would be appropriate to use with low-risk clients or short-term clients (i.e., consulting). If you are not comfortable using an involved medical history questionnaire, a short form like this is sufficient.

From *The Complete Book of Personal Training*, by Douglas S. Brooks, 2004, Champaign, IL: Human Kinetics.

Medical History Questionnaire

(History, health, smoking, diet, exercise, risk factor, and stress analysis)

Douglas S. Brooks, MS
Exercise Physiologist

This is your medical history form, to be completed prior to your first training session with Brooks . . . The Training Edge. All information will be kept confidential. This information will be used for the evaluation of your health and readiness to begin our exercise program. Your answers will help us design a comprehensive program that meets your individual needs. You will want to make it as accurate and complete as possible, yet free from meaningless details. Please fill out the form carefully and thoroughly, then review it to be certain you have not left anything out.

Name: _____

Date: _____

From *The Complete Book of Personal Training,* by Douglas S. Brooks, 2004, Champaign, IL: Human Kinetics.

Continued ➤

Medical History and Screening Form

General Information

Participant

Name _____

Address _____

Contact phone numbers _____

Birthdate _____

Family Physician and/or Primary Health Care Provider

Doctor/other _____ Phone _____

Address _____ City _____

May I send a copy of your consultation to your physician or primary health care provider? ❏ Yes ❏ No

Marital Status

❏ Single ❏ Married ❏ Divorced ❏ Widowed

Sex

❏ Male ❏ Female

Education

❏ Grade School ❏ Jr. High School ❏ High School ❏ College (2-4 years)

❏ Graduate School ❏ Degree _____

Occupation

Position _____ Employer_____

Address _____

Phone _____

What is (are) your purpose(s) for participation in this fitness program?

❏ To determine my current level of physical fitness and to receive recommendations for an exercise program.

❏ Other (please explain) _____

From *The Complete Book of Personal Training,* by Douglas S. Brooks, 2004, Champaign, IL: Human Kinetics.

Continued ➤

Present Medical History

Check those questions to which your answer is yes (leave the others blank).

❏ Has a doctor ever said your blood pressure was too high?

❏ Do you ever have pain in your chest or heart?

❏ Are you often bothered by a thumping of the heart?

❏ Does your heart often race like mad?

❏ Do you ever notice extra heartbeats or skipped beats?

❏ Are your ankles often badly swollen?

❏ Do cold hands or feet trouble you even in hot weather?

❏ Has a doctor ever said that you have or had heart trouble, an abnormal electrocardiogram (ECG or EKG), heart attack, or coronary?

❏ Do you suffer from frequent cramps in your legs?

❏ Do you often have difficulty breathing?

❏ Do you get out of breath long before anyone else?

❏ Do you sometimes get out of breath when sitting still or sleeping?

❏ Has a doctor ever told you your cholesterol level was high?

Comments: _____

Do you now have or have you recently experienced:

❏ Chronic, recurrent, or morning cough?

❏ Episode of coughing up blood?

❏ Increased anxiety or depression?

❏ Problems with recurrent fatigue, trouble sleeping, or increased irritability?

❏ Migraine or recurrent headaches?

❏ Swollen or painful knees or ankles?

❏ Swollen, stiff, or painful joints?

❏ Pain in your legs after walking short distances?

❏ Foot problems?

❏ Back problems?

❏ Stomach or intestinal problems, such as recurrent heartburn, ulcers, constipation, or diarrhea?

❏ Significant vision or hearing problems?

❏ Recent change in a wart or a mole?

❏ Glaucoma or increased pressure in the eyes?

❏ Exposure to loud noises for long periods?

Comments: _____

From *The Complete Book of Personal Training,* by Douglas S. Brooks, 2004, Champaign, IL: Human Kinetics.

Continued ➤

Women only answer the following. Do you have:

❑ Menstrual period problems?

❑ Significant childbirth-related problems?

❑ Urine loss when you cough, sneeze, or laugh?

Date of last pelvic exam and/or Pap smear _____

Comments: _____

Are you on any type of hormone replacement therapy? _____

Men and women answer the following:

List any prescription medications you are now taking: _____

List self-prescribed medications or dietary supplements you are now taking: _____

Date of last complete physical examination: _____

❑ Normal ❑ Abnormal ❑ Never ❑ Can't remember

Date of last chest X-ray: _____

❑ Normal ❑ Abnormal ❑ Never ❑ Can't remember

Date of last electrocardiogram (EKG or ECG): _____

❑ Normal ❑ Abnormal ❑ Never ❑ Can't remember

Date of last dental checkup: _____

❑ Normal ❑ Abnormal ❑ Never ❑ Can't remember

List any other medical or diagnostic test you have had in the past two years: _____

List hospitalizations, including dates of and reasons for hospitalization: _____

List any drug allergies: _____

From *The Complete Book of Personal Training,* by Douglas S. Brooks, 2004, Champaign, IL: Human Kinetics.

Continued ➤

Past Medical History

Check those questions to which your answer is yes (leave the others blank).

❏ Heart attack If so, how many years ago? _____

❏ Rheumatic fever

❏ Heart murmur

❏ Diseases of the arteries

❏ Varicose veins

❏ Arthritis of legs or arms

❏ Diabetes or abnormal blood-sugar tests

❏ Phlebitis (inflammation of a vein)

❏ Dizziness or fainting spells

❏ Epilepsy or seizures

❏ Stroke

❏ Diphtheria

❏ Scarlet fever

❏ Infectious mononucleosis

❏ Nervous or emotional problems

❏ Anemia

❏ Thyroid problems

❏ Pneumonia

❏ Bronchitis

❏ Asthma

❏ Abnormal chest X-ray

❏ Other lung disease

❏ Injuries to back, arms, legs, or joints

❏ Broken bones

❏ Jaundice or gall bladder problems

Comments: _____

From *The Complete Book of Personal Training,* by Douglas S. Brooks, 2004, Champaign, IL: Human Kinetics.

Continued ➤

Family Medical History

Father:

❏ Alive Current age _____

My father's general health is:

❏ Excellent ❏ Good ❏ Fair ❏ Poor

Reason for poor health:

❏ Deceased Age at death _____

Cause of death: _____

Mother:

❏ Alive Current age _____

My mother's general health is:

❏ Excellent ❏ Good ❏ Fair ❏ Poor

Reason for poor health:

❏ Deceased Age at death _____

Cause of death: _____

Familial Diseases

Have you or your blood relatives had any of the following? (Include grandparents, aunts and uncles, but exclude cousins, relatives by marriage and half-relatives.)

Check those to which the answer is yes (leave others blank).

❏ Heart attacks under age 50

❏ Strokes under age 50

❏ High blood pressure

❏ Elevated cholesterol

❏ Diabetes

❏ Asthma or hay fever

❏ Congenital heart disease (existing at birth but not hereditary)

❏ Heart operations

❏ Glaucoma

❏ Obesity (20 or more pounds overweight)

❏ Leukemia or cancer under age 60

Comments: _____

From *The Complete Book of Personal Training,* by Douglas S. Brooks, 2004, Champaign, IL: Human Kinetics.

Continued ➤

Other Heart Disease Risk Factors

Smoking

Have you ever smoked cigarettes, cigars, or a pipe?

❏ Yes ❏ No

(If no, skip to Diet section)

If you did or now smoke cigarettes, how many per day? _____ Age started _____

If you did or now smoke cigars, how many per day? _____ Age started _____

If you did or now smoke a pipe, how many pipefuls a day? _____ Age started _____

If you have stopped smoking, when was it? _____

If you now smoke, how long ago did you start? _____

Diet

What do you consider a good weight for yourself? _____

What is the most you ever weighed (including when pregnant)? _____

How old were you? _____

My current weight is: _____

One year ago my weight was: _____

At age 21 my weight was: _____

Number of meals you usually eat per day: _____

Average number of eggs you eat per week: _____

Number of times per week you usually eat the following:

Beef _____ Fish _____ Desserts _____

Pork _____ Fowl _____ Fried foods _____

Number of servings (cups, glasses, or containers) per week you usually consume of:

Homogenized (whole) milk _____ Buttermilk _____ Skim (nonfat) milk _____

2% (low-fat) milk _____ 1% (low-fat) milk _____ Coffee _____

Tea (iced or hot) _____ Regular or diet sodas _____ Glasses of water _____

From *The Complete Book of Personal Training,* by Douglas S. Brooks, 2004, Champaign, IL: Human Kinetics.

Continued ➤

Do you ever drink alcoholic beverages?

❏ Yes ❏ No

If yes, what is your approximate intake of these beverages?

Beer:

❏ None ❏ Occasional ❏ Often If often, _____ per week

Wine:

❏ None ❏ Occasional ❏ Often If often, _____ per week

Hard liquor:

❏ None ❏ Occasional ❏ Often If often, _____ per week

At any time in the past, were you a heavy drinker (consumption of six ounces of hard liquor per day or more)?

❏ Yes ❏ No

Comments: _____

Do you usually use oil or margarine in place of high cholesterol shortening or butter?

❏ Yes ❏ No

Do you usually abstain from extra sugar usage?

❏ Yes ❏ No

Do you usually eat salt at the table?

❏ Yes ❏ No

Do you eat differently on weekends as compared to weekdays?

❏ Yes ❏ No

Comments: _____

From *The Complete Book of Personal Training,* by Douglas S. Brooks, 2004, Champaign, IL: Human Kinetics.

Sample Overview and Consent/Release Form

This program consists of various phases designed to determine your readiness to engage in physical activity, measure your functional fitness capacity in several areas, record active data in relation to your current fitness levels; and on an ongoing basis, regularly use and evaluate your current health and fitness status.

During the first phase you will undergo a **screening evaluation** process designed to identify risk factors that are associated with increased risk for incurring cardiovascular disease. This will include having you fill out a written medical history/questionnaire form and an informal interview. This written form of assessment and verbal interaction will assist the evaluation of your overall health. Several major risk factors related to coronary heart disease will be evaluated. These include smoking; blood cholesterol and lipids; blood pressure; obesity or extreme over-fatness; and inactivity.

To complement these factors, blood pressure, percent body fat, height and weight, and resting heart rate will be determined.

Additionally, self-evaluation of stress levels, activity levels, and diet and a summary of overall risk to injury and ill health will be determined by questionnaire.

To determine blood lipid (i.e., cholesterol, HDL, and LDL) levels, it is necessary to get blood samples taken. If you have already been tested, these results, with your consent, will be requested from the appropriate medical facility and attending health care provider. Both lipid profiles are extremely useful in helping motivate you to improve dietary habits and decrease your risk of coronary heart disease.

Upon successful completion of the screening phase, you may elect to go through a second or **fitness-evaluation phase.** After consultation with your trainer and/or quality health care specialist, fitness evaluation may, or may not, initially be encouraged. The fitness-evaluation phase is certainly not necessary for you to begin an effective, safe, and exciting program. A thorough and honest approach to phase-one screening sets the stage for a safe starting point.

Fitness evaluations are administered to measure fitness levels and not to be confused with medical diagnostic tests. Their purpose is to evaluate your starting point with regular to current level of fitness, develop an individual exercise plan, provide incentive, and note progress in the following months. Fitness evaluations should be an optional complement of phase-one screening. Fitness evaluations can include:

A. A series of evaluations to measure and assess flexibility, posture, muscular strength, and muscular endurance.

B. A series of evaluations to measure and assess flexibility, posture, strength, and tone of key postural muscles that are important in helping prevent orthopedic pain and discomfort associated with chronic misalignment. The low back and neck are examples of areas of the body that will be evaluated.

C. Skinfolds to measure body fat, and various tape measurements to record girth and circumference of specific body sites. Both measurements serve as a base for future reference and reflect changes in body composition, such as increases in muscle mass and losses of body fat. This may be performed in phase one.

D. Blood pressure assessment to determine resting systolic and diastolic pressures. Blood pressure is the force of your blood pushing against the walls of arteries. It is important to monitor on a regular basis to screen for hypertension or high blood pressure. It is easy to perform, painless, and takes only seconds to administer.

E. Using a bike ergometer, treadmill, adjustable step platform, or walking/running course, a heart-rate response to increased work (speed or resistance) will be determined. This submaximal cardiorespiratory test may be used to predict a maximal oxygen uptake and can help in determining an appropriate heart-rate training range.

The cardiorespiratory test is often described by my clients as the most physically demanding. The exercise intensity begins at a level of effort that is easily sustained. It may or may not progress in intensity. This is dependent on fitness level, personal response, and the cardiorespiratory test chosen.

Continued ➤

The test involves measuring heart rate and observing breathing (respiratory) responses to steady or increased submaximal work load. In other words, you will have the option to work increasingly harder.

Not only does this establish your present level of cardiorespiratory fitness, but it also provides a baseline for measuring future improvements. This final workload will have you working at approximately 85 percent or less of predicted (or actual maximal heart rate if available) maximal heart rate. The test may be stopped at any time due to signs of fatigue, strain, physiological response, or other contraindications to exercise. You may also choose to stop due to personal feelings of fatigue, discomfort, or any reason you deem appropriate.

During any of these fitness evaluations (A through E) there exists the possibility of heart disorders, fainting, abnormal blood pressure response, and in rare instances heart attack, stroke, or death. Every effort has been made to minimize these risks by gathering preliminary information relating to your current health and fitness, and by observations during testing.

At best, all of these fitness-testing evaluation procedures are a general measure of your degree of fitness, but they do NOT state whether or not you have heart disease. Furthermore, you agree to look to your physician or qualified primary health care provider for any medical care. It is generally recommended, though not always necessary, to have both a physical exam and diagnostic fitness evaluation conducted by qualified personnel on an annual basis. Discuss this with your health care provider(s).

A short period of time must pass before the appropriate data can be compiled. At this point, a meeting between you and your trainer will occur. All pertinent information will be explained with an accompanying personal exercise prescription or exercise plan. You may then elect to enter (or continue) our personal training program, which is valuable in motivating and helping you adhere to your exercise plan. Reevaluation and assessment of your progress and program plan is encouraged, and performed on a regular basis.

Any questions you have about the procedures, risks, or benefits to be expected are welcome. If you have any reservations or doubts, please voice these concerns and ask for an explanation or clarification.

Participation in any tests and this program is voluntary. You are free to deny consent or withdraw consent at any time after consenting. However, it is important that you promptly report any unusual feelings and/or other information that can assist the testing staff with any difficulties you perceive or are experiencing. It is your responsibility to fully disclose such information as relegated by your feelings and as requested by questionnaire or staff.

I, the undersigned, being aware of my own health and physical condition, and having knowledge that my participation in this program and fitness testing procedures may be injurious to my health, am voluntarily participating in The Training Edge program, which has been explained to me verbally, as well as presented in written form.

Having such knowledge, I hereby release Brooks . . . The Training Edge, its representatives, agents, employees, and successors from liability for accidental injury or illness, which I may incur as a result of participating in said fitness program or in the testing and/or screening procedures. I hereby assume all risks connected therewith and consent to participate in said program.

Signature _____ Date _____

Personalized Gym Design in Commercial, Corporate or Home Settings

Commercial gym design.

Home gym design.

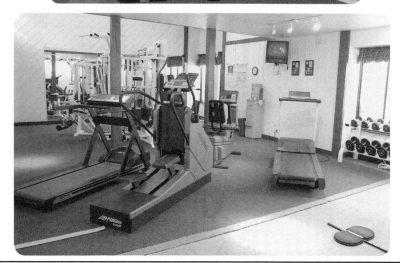

Condo gym design.

➤ *Note:* Because I believe that the client introductory packet establishes instant credibility with a prospective or first-time client, or with the media, I regularly update it with press clippings, new information, and photographs of home gyms that I have designed for some of my clients. The basic package, however, is still the same, and editing is simple if you use a computer.

RECOMMENDED READING AND USEFUL HEALTH AND FITNESS RESOURCES

A wealth of information is available on health and fitness topics—good news for personal trainers! The bad news is that the amount of info out there can make it difficult to find exactly what you need. The following list is my attempt to categorize the key resources I use into useful segments. All Web sites and phone numbers are accurate at the time of this printing, but be aware that URLs and numbers do change. If a specific address doesn't work, try typing key words into any search engine.

Certification Organizations

It is important to research each organization(s) with which you choose to certify. Talk to representatives of the company, acquaintances who have been certified by the group, and read critical reviews regarding the pros and cons of each organization. Literally, there are several hundred certifying organizations. Do your homework!

Recommended Reading:

Ryan, P. 1995. "How Can We Judge Quality?" *IDEA Personal Trainer* (July/Aug.): 27-34.

Ryan, P. 1996. "Certifications: Which One is Right for You?" *IDEA Personal Trainer* (Mar./Apr.): 18-31.

Educational Resource and Equipment Companies

Desert Southwest Fitness (high-quality continuing education courses)
602 East Roger Road
Tucson, AZ 85705
(800) 873-6759 or (520) 292-0011;
Fax: (520) 292-0066
E-mail: dswf@azstarnet.com
www.dswfitness.com

Fitness Quest (home exercise equipment)
1440 Raff Road SW
Canton, OH 44750
(800) 348-5890 or (330) 478-0755
Fax: (330) 478-9797
www.fitnessquest.com

Fitness Wholesale (health and fitness resources)
895-A Hampshire Rd.
Stow, OH 44224
(800) 537-5512 or (330) 929-7227
Fax: (330) 929-7250
E-mail: fw@fitnesswholesale.com
www.fitnesswholesale.com

Lifeline International (sports, rehabilitation, and fitness equipment)
3201 Syene Rd.
Madison, WI 53713
(800) 553-6633 or (608) 288-9252
Fax: (608) 288-9294
E-mail: lifeline@inxpress.net
www.lifeline-usa.com

Moves International Fitness (books, videos, fitness products, and continuing education courses)
P.O. Box 4083
Mammoth Lakes, CA 93546
(800) 272-5055 or (760) 934-0312
Fax: (760) 934-2535
www.MovesIntFitness.com

Perform Better
Contact for product catalog for functional and sport training.
(800) 556-7464
www.power-systems.com

Power Systems
Contact for product catalog for functional and sport training.
(800) 321-6975
www.power-systems.com

Sharper Image Look, Inc. (fitness training products and educational courses/materials)
1115-A Industrial Parkway
Bricktown, NJ 08724
(800) 824-9652 or (908) 206-1200

SPRI Products, Inc. (fitness training products and educational courses/materials)
1026 Campus Dr.
Mundelien, IL 60060
(800) 222-7774 or (847) 680-7774
E-mail: TEAMSPRI@aol.com
www.fitnessonline.com

Useful Internet Addresses

Are you tired of the hassle of running down information on the Internet? Here are some of the Internet site addresses I find helpful for locating information efficiently.

American Dietetic Association: www.eatright.org

American Heart Association: www.amhrt.org/news

American Medical Association (provides abstracts from JAMA and links to other peer-reviewed scientific journals): www.ama-assn.org

Asthma Information Center: www.mdnet.de/asthma

BioMedNet: www.biomednet.com/db/medline/new

Center for Science in the Public Interest (publisher of *Nutrition Action Healthletter*): www.cspinet.org

Centers for Disease Control and Prevention: www.cdc.gov

Department of Health and Human Services Healthfinder (links to online professional journals and provides follow-ups to health news in the media): www.healthfinder.gov

Fitness Link (get the latest fitness news, along with tips on nutrition, exercise, and health; links to many other sites, too): www.fitnesslink.com

Global Health and Fitness (offers training programs, instruction and motivation): www.global-fitness.com

Go Ask Alice (a highly rated Q & A site by Columbia University Health Service): http://www.columbia.edu/cu/healthwise/

Healthclubs.com (You or a client thinking about joining a gym?; get information about clubs across the nation): www.healthclubs.com

Healthfinder (government-managed Web site that helps users find reliable health resources and advice): www.healthfinder.gov

Healthgate (includes many sub sites that are health related): www.healthgate.com/HealthGate/home.hmtl

Human Kinetics Publishers: www.humankinetics.com

IDEA: The Health and Fitness Source (membership organization publishes two highly rated magazines (*IDEA Personal Trainer* and *IDEA Health and Fitness Source*) and provides many educational opportunities): www.ideafit.com

International Food Information Council Foundation (food safety and nutrition information): www.ificinfo.health.org

International Health, Racquet and Sportsclub Association or IHRSA (world-wide club listings and exercise-related research): www.ihrsa.org

The Journal of the American Medical Association's Asthma Information Center: www.ama-assn.org/special/asthma

Mayo Clinic (features "Headline Watch," which gives details on the week's top medical stories covered in the media): www.mayohealth.org

National Heart, Lung and Blood Institute: www.nhlbi.nih.gov

National Institutes of Health: www.hih.gov and a subdivision of this site links to abstracts from major medical and scientific journals at www.ncbi.nlm.nih.gov/PubMed

National Institutes of Health has launched the "International Bibliographic Information on Dietary Supplements" database at http://odp.od.nih.gov/ods/databases/ibids.html.

National Institutes of Health (information on dietary supplements): http://dietary-supplements.info.nih.gov

National Library of Medicine: http://igm.nlm.nih.gov/

Personal Fitness Training Referral Network (the aim of this site is to unite trainers' clients with trainers when they travel away from home): www.teamfit.com

Personal Training on the Net (provides a plethora of health and fitness information; membership required): www.personaltraining.com.au/

The Physician and Sportsmedicine Journal: www.physsportsmed.com

PubMed: http://www.ncbi.nlm.nih.gov/PubMed/

Quackwatch, Inc. (nonprofit organization provides accurate information about dietary supplements): www.quackwatch.com

The Road Runners Club of America (highly respected national running group): http://rrca.org/

Shape Up America (was started by former surgeon general C. Everett Koop; learn about the benefits of keeping active and maintaining a healthy weight): www.shapeup.org

Stanford University Medical Center's Health Library: http://www-med.stanford.edu/healthlib/

Tufts University (provides links categorized by interest group and rates site): www.navigator.tufts.edu

U.S. Food and Drug Administration: www.fda.gov

The Washington Running Report (training and running tips): http://www.runningnetwork.com/members/washington/tips/index.html

Research Journals for Fitness Professionals

The exercise research journals and publications listed below are peer reviewed and well respected. Many are available at medical bookstore outlets or university libraries, and most publish current tables of contents on the Internet. Many of these sources also offer free abstract service through their Internet sites.

A good, free, user-friendly starting point for finding articles is MEDLINE. MEDLINE search sites (BioMedNet, PubMed, and the National Library of Medicine) allow you to access medical literature citations and abstracts in any language. Their Web sites are listed in the Internet resources section.

Other excellent journals and publications are listed here. To find the Web site of a journal or publication, enter the title of the journal in your favorite search engine (like Google, Alta Vista, Lycos, or Yahoo!):

Acta Physiologica Scandinavica

Adapted Physical Activity Quarterly

Advances in Motor Research

American Journal of Health Behavior

American Journal of Health Promotion

American Journal of Sports Medicine

Applied Research in Coaching and Athletics

Archives of Physical Medicine and Rehabilitation

Australian Journal of Physiotherapy

British Journal of Sports Medicine

Canadian Journal of Applied Physiology

Canadian Journal of Health, Physical Education, Recreation & Dance

European Journal of Applied Physiology

Exercise Immunology Review

Exercise Physiology

International Journal of Physical Fitness

International Journal of Sport Nutrition

International Journal of Sport Psychology

Isokinetics and Exercise Science

Journal of Aging and Physical Activity

Journal of Applied Biomechanics

Journal of Applied Physiology

Journal of Applied Sport Psychology

Journal of Athletic Training

Journal of Cardiopulmonary Rehabilitation

Journal of Motor Behavior

Journal of Nutrition Education

Journal of Orthopaedic and Sports Physical Therapy

Journal of Physical Education, Recreation and Dance

Journal of Sport and Exercise Psychology

Journal of Sport and Social Issues

Journal of Sport Behavior

Journal of Sport Rehabilitation

Journal of Sports Sciences

Journal of Strength and Conditioning Research

Journal of Teaching in Physical Education

Journal of the American Physical Therapy Association

Measurement in Physical Education and Exercise Science

Medicine and Science in Sports and Exercise

Motor Control: The International Journal for the Multidisciplinary Study of Voluntary Movement

Palaestra: Forum of Sport, Physical Education and Recreation for Those With Disabilities

Perceptual and Motor Skills

Physical Educator

Physical Therapy

Quest

Research Quarterly for Exercise and Sport

Scholastic Coach and Athletic Director

Sports Medicine

Sports Medicine, Training and Rehabilitation

The Sport Psychologist

Sport Science Reviews

Strength and Conditioning Journal

Year Book of Sports Medicine

See also "Researching the Research" by Ralph La Forge, 2000, *IDEA Health & Fitness Source* (March): 26.

REFERENCES AND SUGGESTED READING

Refer to various chapters for additional and specific references pertaining to a chapter's particular content.

Albright, A., M. Franz, G. Hornsby, A. Kriska, D. Marrero, I. Ullrich, and L.S. Verity. 2000. "American College of Sports Medicine Position Stand. Exercise and Type 2 Diabetes." *Medicine and Science in Sports and Exercise,* 32: 1345-60.

Alter, M.J. 1988. *Science of Stretching.* Champaign, IL: Human Kinetics.

Alter, M.J. 1996. *Science of Flexibility.* Champaign, IL: Human Kinetics.

American Association of Cardiovascular and Pulmonary Rehabilitation. 1999. *Guidelines for Cardiac Rehabilitation Programs.* 3rd ed. Champaign IL: Human Kinetics.

American College of Obstetricians and Gynecologists. 1985. *ACOG Home Exercise Programs: Exercise During Pregnancy and the Postnatal Period.* Washington, DC: ACOG.

American College of Obstetricians and Gynecologists. 1994. "Committee on Obstetric Practice: Exercise During Pregnancy and the Postpartum Period, Committee Opinion No. 189, February." *International Journal of Gynaecology and Obstetrics* 45 (1): 65-70.

American College of Obstetricians and Gynecologists. 2002. "Committee on Obstetric Practice: Exercise During Pregnancy and the Postpartum Period, Committee Opinion No. 267, January." *International Journal of Gynaecology and Obstetrics* 77 (1):79-81.

American College of Sports Medicine. 1990. "Position Stand: The Recommended Quantity and Quality of Exercise for Developing and Maintaining Cardiorespiratory and Muscular Fitness in Healthy Adults." *Medicine and Science in Sports and Exercise* 22 (2, Apr.) 265-74.

American College of Sports Medicine. 1995. *ACSM Guidelines for Exercise Testing and Prescription.* 5th ed. Philadelphia: Williams & Wilkins.

American College of Sports Medicine. 1997. *Exercise Management for Persons With Chronic Diseases and Disabilities,* ed. L. Durstine. Champaign, IL: Human Kinetics.

American College of Sports Medicine. 1998. *ACSM Resource Manual for Guidelines for Exercise Testing and Prescription.* 3rd ed. Baltimore: Williams & Wilkins

American College of Sports Medicine (ACSM) and American Heart Association (AHA) Joint Position Statement. 1998. "Recommendations for cardiovascular screening, staffing and emergency policies at health/fitness facilities." *Medicine and Science in Sports and Exercise* 30 (6): 1009-2028.

American Council on Exercise. 1996. *Personal Trainer Manual.* San Diego, CA: ACE.

American Council on Exercise. 1998. *Exercise for Older Adults: ACE's Guide for Fitness Professionals,* ed. R. Cotton. Champaign, IL: Human Kinetics

American Council on Exercise. 1999. *Clinical Exercise Specialist Manual: ACE's Source for Training Special Populations.* Eds. R. Cotton and R. Andersen. San Diego, CA: ACE.

American Diabetes Association. 2003. "Facts and Figures." Accessed June 2003. <www.diabetes.org>.

American Heart Association. 2003. "Cardiovascular Disease Statistics." Accessed June 2003. <www.americanheart.org/presenter.jtml?identifier=4478>.

Andersen, R. 1999. "Exercise, an Active Lifestyle, and Obesity." *Physician and Sportsmedicine* 27 (10, Oct.) 41-50.

Anderson, O. *Running Research News,* Lansing, MI.

Andrew, L. 1998. "Pregnancy and Diet." *IDEA Health and Fitness Source* (May): 59-66.

Araujo, D. 1997. "Expecting Questions About Exercise and Pregnancy?" *The Physician and Sportsmedicine* 25 (4, Apr.): 85-93.

Artal, R., and C. Sherman. 1999. "Exercise During Pregnancy: Safe and Beneficial for Most." *The Physician and Sportsmedicine* 27 (8, Aug.): 51-75.

Ashton, A. 1998. "Building Bridges with the Healthcare Community." *ACE Certified News* 4 (3): 1-3.

Baechle, T., and B. Groves. 1992. *Weight Training— Steps to Success.* Champaign, IL: Human Kinetics.

Bailey, D.M., B. Davies, and R. Budgett. 1998. "Endurance Training During a Twin Pregnancy in a Marathon Runner." *Lancet* 351 (9110): 1182.

Basmajian, J., and C. DeLuca. 1979. *Muscles Alive—Their Functions Revealed by Electromyography*. 4th ed. Baltimore: Williams & Wilkins.

Beniamini, Y., J.J. Rubenstein, A.D. Faigenbaum, A.H. Lichtenstein, and M.C. Crim. 1999. "High-Intensity Strength Training of Patients Enrolled in an Outpatient Cardiac Rehabilitation Program." *Journal of Cardiopulmonary Rehabilitation* 19 (1): 8-17.

Bernardot, D., ed. 1993. *Sports Nutrition—A Guide for the Professional Working With Active People*. Chicago: American Dietetic Association.

Blakiston's Medical Dictionary. 1980. Blakiston's Pocket Medical Dictionary. 4th ed. New York: McGraw-Hill.

Bompa, T. 1965. "Periodization of Strength." *Sports Review* 1: 26-31.

Bompa, T. 1983. *Theory and Methodology of Training*. Dubuque, IA: Kendall-Hunt.

Bompa, T.O. 1999. *Periodization Training for Sports*. Champaign, IL: Human Kinetics.

Borg, G. 1982. "Psychophysical Bases of Perceived Exertion." *Medicine and Science in Sports and Exercise* 14 (5): 377-381

Bouchard C., R.J. Shephard, and T. Stephens. 1993. *Physical Activity, Fitness, and Health Consensus Statement*. Champaign, IL: Human Kinetics.

Brooks, D. 1990. *Going Solo—The Art of Personal Training*. 2nd ed. Mammoth Lakes, CA: Moves International.

Brooks, D. 1994. "Which Way Do We Go?" *IDEA Personal Trainer* (Feb./Mar.): 25-33.

Brooks, D. 1995a. "Planning Your Strength Program." *IDEA Today* (Sept.).

Brooks, D. 1995b. "Shaping the Shoulder." *IDEA Today* (Oct.).

Brooks, D. 1995c. "Training the Upper Back." *IDEA Today* (Nov./Dec.).

Brooks, D. 1996a. "Sculpting the Chest." *IDEA Today* (Jan.).

Brooks, D. 1996b. "Strengthening the Upper Arms." *IDEA Today* (Mar.).

Brooks, D. 1997a. *Program Design for Personal Trainers*. Mammoth Lakes, CA: Moves International; Champaign, IL: Human Kinetics.

Brooks, D. 1997b. "Targeting the Buttocks." *IDEA Today* (Mar.).

Brooks, D. 1997c. "Targeting the Hips." *IDEA Today* (May).

Brooks, D. 1997d. "Targeting the Inner and Outer Thigh." *IDEA Today* (Apr.).

Brooks, D. 1997e. "Targeting the Lower Leg." *IDEA Today* (Sept.).

Brooks, D. 1997f. "Targeting the Upper Leg." *IDEA Today* (June).

Brooks, D. 1999. *Your Personal Trainer*. Champaign, IL: Human Kinetics.

Brooks, D. 2001. *Effective Strength Training*. Moves International: Mammoth Lakes, CA and Human Kinetics: Champaign, IL.

Brooks, D., and C. Brooks. 2002. *Integrated Balance Training*. Fitness Quest: Canton, OH.

Brooks, D., and C. Copeland Brooks. 1993. "Uncovering the Myths of Abdominal Exercise." *IDEA Today* (Apr.): 42-9.

Brooks, D., and C. Copeland Brooks. 1995. *Stability Ball Programming Guide for Fitness Professionals*. Mammoth Lakes, CA: Moves International Publishing.

Brooks, D., C. Copeland Brooks, P. Francis, L. Francis, E. Sternlicht, and K. Stevens. 1995. *Reebok Interval Program Manual*. Stoughton, MA: Reebok International.

Bryant, C.X., J.A. Peterson, and B.A. Franklin. 1998. "Training Clients With Asthma." *IDEA Personal Trainer* (October): 33-38.

Buckwalter J.A. and N.A. DiNubile. 1997. "Decreased Mobility in the Elderly: The Exercise Antidote." *Physician and Sportsmedicine* 25 (9): 127-136.

Byrne, K. 1991. *Understanding and Managing Cholesterol*. Champaign, IL: Human Kinetics.

Cailliet, R. 1988. *Low Back Pain Syndrome*. 4th ed. Philadelphia: Davis.

Cantwell, S. 1997. *Policies That Work for Personal Trainers*. San Diego, CA: IDEA Press.

Carter Center. 1988. *Healthier People: Health Risk Appraisal Program*. Atlanta: The Carter Center of Emory University.

Church, M. 1996. *Mastering Personal Fitness Training*. Watsons Bay, NSW, Australia: Fast Books.

Clapp, J.F. 1998. *Exercising Through Your Pregnancy*. Champaign, IL: Human Kinetics.

Clark, J. and C. Sherman. 1998. "Congestive Heart Failure: Training for a Better Life." *The Physician and Sportsmedicine* 26 (8, Aug.): 49-57.

Clark, N. 1997. *Sports Nutrition Guidebook: Eating to Fuel Your Active Lifestyle*. Champaign, IL: Human Kinetics.

Colberg, S., and D. Swain. 2000. "Exercise and Diabetes Control." *Physician and Sportsmedicine* 28 (4, Apr.): 63-81.

Cotten, D.J. 1998. "Strategies for Managing Risk." *IDEA Personal Trainer* (Mar.): 49-54.

Costill, D. 1988. "Detraining: Loss of Muscular Strength and Power." *Sports Medicine Digest* (May): 4.

Couzens, G. 1992. "Personal Trainers: A Formula for Fitness?" *The Physician and Sportsmedicine* 20 (11, Nov.): 131-140.

Dalleck, L. and L. Kravitz. 2002. "The History of Fitness." *IDEA Health & Fitness Source* (Jan.): 26-33.

Davis, P. and K. Davis. 1999. "Editorial. Blazing New Paths in Personal Training." *IDEA Health and Fitness Source* (Apr.): 6.

deVries, H.A. 1961a. "Prevention of Muscular Distress After Exercise." *Research Quarterly* 32 (2), 177-185.

deVries, H.A. 1961b. "Electromyographic Observation of the Effect of Static Stretching Upon Muscular Distress." *Research Quarterly* 32 (4), 468-479.

Dickinson, A., ed. 1991. *Safety of Vitamins and Minerals: A Summary of the Findings of Key Reviews.* Washington, DC: The Council for Responsible Nutrition.

Dickinson, A., ed. 1993. *Benefits of Nutritional Supplements.* Washington, DC: The Council for Responsible Nutrition.

DiNubile, Nicholas A. 1997. "Osteoarthritis: How to Make Exercise Part of Your Treatment Plan." *The Physician and Sportsmedicine* 25 (7, July): 47-58.

Dishman, R.K. 1994. "Prescribing Exercise Intensity for Healthy Adults Using Perceived Exertion." *Medicine and Science in Sports and Exercise* 26 (9): 1087-94.

Dishman, R.K., R.P. Farquhar, and K.J. Cureton. 1994. "Responses to Preferred Intensities of Exertion in Men Differing in Activity Levels." *Medicine and Science in Sports and Exercise* 26 (9): 783-90.

Drought, J. 1995. "Resistance Exercise in Cardiac Rehabilitation." *Journal of Strength and Conditioning* 17 (2): 56-64.

Durrett, A. 1994. "IDEA Personal Trainer." *Time Management* (Feb./Mar.): 15-17.

Ebbeling, C.B., A. Ward, and J.M. Rippe. 1991. *Comparison Between Palpated Heart Rates and Heart Rates Observed Using the Polar Favor Heart Rate Monitor During an Aerobics Exercise Class.* Worcester, MA: Exercise Physiology and Nutrition Laboratory, University of Massachusetts Medical School.

Eichner, R. 1993. "Self Delusion: The Most Popular Indoor Sport." *Sports Medicine Digest* (Dec.): 5.

Ellison, D. 1993. *Advanced Exercise Design for Lower Body.* 2nd ed. Vista, CA: Movement That Matters.

Etnyre, B.R., and E.J. Lee. 1987. "Comments on Proprioceptive Neuromuscular Facilitation Stretching Techniques." *Research Quarterly for Exercise and Sport* 58: 184-8.

Evans, W., and I. Rosenberg. 1991. *Biomarkers.* New York: Simon & Schuster.

Faigenbaum, A.D., G.S. Skrinar, W.F. Cesare, W.J. Kraemer, and H.E. Thomas. 1990. "Physiologic and Symptomatic Responses of Cardiac Patients to Resistance Exercise." *Archives of Physical Medicine and Rehabilitation* 70: 395-8.

Fair, E. 1992. "Fitness Software." *IDEA Today* (June): 27.

Feigenbaum, M.S., and M.L. Pollock. 1997. "Strength Training: Rationale for Current Guidelines for Adult Fitness Programs." *Physician and Sportsmedicine* 25: 44-64.

Fiatarone, M.A., E.C. Marks, N.D. Ryan, C.N. Meredith, L.A. Lipsitz, and W.J. Evans. 1990. "High-Intensity Strength Training in Nonagenarians." *Journal of the American Medical Association* 263: 3029-34.

Fiatarone, M.A., E.F. O'Neill, and N.D. Ryan. 1994. "Exercise Training and Nutritional Supplementation for Physical Frailty in Very Elderly People." *New England Journal of Medicine* 330: 1769-75.

Fisher, G., and C. Jensen. 1990. *Scientific Basis of Athletic Conditioning.* 3rd ed. Philadelphia: Lea & Febiger.

Fleck, S., and W. Kraemer. 1996. *Periodization Breakthrough!* Ronkonkoma, NY: Advanced Research Press.

Fleck, S., and W. Kraemer. 1997. *Designing Resistance Training Programs.* Champaign, IL: Human Kinetics.

Fletcher, A. 1994. *Thin for Life: 10 Keys to Success from People Who Have Lost Weight and Kept It Off.* Shelburne, VT: Chapters.

Florez, G. 1997. "Designer Gyms for Every Body (And Budget)." *ACE FitnessMatters* 3 (1, Jan./Feb.):1-3.

Florez, G. 1999. "Productive Partnerships for Personal Trainers." *IDEA Health and Fitness Source* (July/Aug.): 100.

Florez, G., and J. O'Hara. 1997. "Adding On: Hiring Trainers." *IDEA Personal Trainer* (Feb.): 36.

Foster, C. 1992. "Licensure—The Quest for the Holy Grail." *ACSM Certified News* 2 (3): 9.

Fowles, J.R., D.G. Sale, and J.D. MacDougall. 2000. "Reduced Strength After Passive Stretch of the Human Plantarflexors." *Journal of Applied Physiology* 89: 1179-1188.

Francis, P., and L. Francis. 1988. *If It Hurts, Don't Do It.* Rocklin, CA: Prima.

Frontera, W.R., C.N. Meredith, and K.P. O'Reilly. 1988. "Strength Conditioning in Older Men: Skeletal Muscle Hypertrophy and Improved Function." *Journal of Applied Physiology* 64(3): 1038-1044.

Fulghum, R. 1993. *All I Really Needed to Know I Learned in Kindergarten.* New York: Random House.

Gavin, J. 1992. "Relationship Traps: How to Keep Control in One-to-One." *IDEA Personal Trainer* (June): 1-3.

Gavin, J. 1997. "Coaxing Your Client to Change." *IDEA Personal Trainer* (Nov./Dec.): 31-38.

Gavin, J. 1998. "IDEA Personal Trainer Survey: Relationships Between Trainers and Their Clients." *IDEA Personal Trainer* (May): 37-46.

Gavin, J. and N. Gavin. 1999. "Create Opportunity From Conflict." *IDEA Personal Trainer* (Feb.): 35-37.

Gesing, B.F. 1990. "All for One: Client/Trainer/ Physician." *IDEA Today* (Nov./Dec.): 26-28.

Ghilarducci, L., R. Holly, and E. Amsterdam. 1989. "Effects of High Resistance Training in Coronary Heart Disease." *American Journal of Cardiology* 64: 866-70.

Giese, M. 1988. "Organization of an Exercise Session." In *American College of Sports Medicine Resource Manual for Guidelines for Exercise Testing and Prescription*. Philadelphia: Lea & Febiger.

Golding, L., C. Myers, and W. Sinning. 1989. *The Y's Way to Physical Fitness*. Champaign, IL: Human Kinetics, for the YMCA of the USA.

Gordon, N. 1993a. *Arthritis: Your Complete Exercise Guide*. Champaign, IL: Human Kinetics.

Gordon, N. 1993b. *Breathing Disorders: Your Complete Exercise Guide*. Champaign, IL: Human Kinetics.

Gordon, N. 1993c. *Diabetes: Your Complete Exercise Guide*. Champaign, IL: Human Kinetics.

Graves, J., and M. Pollock. 1993. "Understanding the Physiological Basis of Muscular Fitness." In *Stairmaster Fitness Handbook*. Indianapolis: Masters Press.

Haas, E. 1992. *Staying Healthy With Nutrition*. Berkeley, CA: Celestial Art.

Hale, R.W., and L. Milne. 1996. "The Elite Athlete and Exercise in Pregnancy." *Seminars in Perinatology* 20 (4): 277-84.

Hallo, B. "Warming Up." 1999. *FitPro* (Aug./Sept.): 3.

Handley, A. 1997. "Management Notebook: Employment Law." *Club Industry* (Oct.): 64-67.

Hardy, L., and D. Jones. 1986. "Dynamic Flexibility and Proprioceptive Neuromuscular Facilitation." *Research Quarterly for Exercise and Sport* 57 (2): 150-153.

Hartley O'Brien, S.J. 1980. "Six Mobilization Exercises for Active Range of Hip Flexion. *Research Quarterly* 51 (4): 625-635.

Helmrick, S.P., D.R. Ragland, R.W. Leung, and R.S. Paffenbarger. 1991. "Physical Activity and Reduced Occurrence of Non-Insulin-Dependent Diabetes Mellitus." *New England Journal of Medicine* 325: 147-52.

Hendler, S. 1990. *The Doctor's Vitamin and Mineral Encyclopedia*. New York: Simon & Schuster.

Herbert, D. 1997. "Insure Your Success." *ACE Certified News* 3 (3, Apr./May): 1-2.

Heyward, V. 1991. *Advanced Fitness Assessment and Exercise Prescription*. 2nd ed. Champaign, IL: Human Kinetics.

Hickson, R.C., C. Foster, M.L. Pollock, T.M. Galassi, and S. Rich. 1985. "Reduced Training Intensities and Loss of Aerobic Power, Endurance, and Cardiac Growth." *Journal of Applied Physiology* 58: 492-499.

Hill, A.V. 1927. *Living Machinery*. London: G. Bell and Sons.

Hoffman, D.F. 1993. "Arthritis and Exercise." *Primary Care* 20: 895-910.

Holland, G.J. 1968. "The Physiology of Flexibility: A Review of the Literature." *Kinesiology Review (I)*: 49-62.

Hunter, G.R., D. Seelhorst, and S. Snyder. 2003. "Comparison of Metabolic and Heart Rate Responses to Super Slow vs. Traditional Resistance Training." *Journal of Strength and Conditioning Research* 17 (1, Feb.), 76-81.

Hutton, R.S. 1992. "Neuromuscular Basis of Stretching Exercises." In Komi, P.V. (ed.), *Strength and Power in Sport* (29-38). Cambridge, MA: Blackwell Scientific.

Hyatt, G. [Owner/president, Desert Southwest Fitness]. 2002. Interview by Douglas Brooks. Mammoth Lakes, CA, Feb..

IDEA. 1989. *IDEA Today,* as reported in *Industry News,* July/Aug: 13.

IDEA. 1997. "IDEA Personal Trainer Survey." Accessed May 19, 2003. <www.IDEAFit.com>.

IDEA. 1998a. "IDEA Personal Trainer Survey." Accessed May 21, 2003. <www.IDEAFit.com/prptclientsurvey.htm>.

IDEA. 1998b. *Top Sales Mistakes*, What's New Section, *IDEA Personal Trainer* (Oct.): 8.

IDEA Personal Trainer. 1998. Client Handout: Staying Motivated.

IDEA Personal Trainer. 1999. "Trends." *IDEA Personal Trainer* (Oct.): 7

International Health, Racquet and Sportsclub Association. 2000. *American Sports Data Health Club Trend Report*. Boston: International Health, Racquet and Sportsclub Association.

Internet World. 1999. Accessed Mar. 2003. <www.internetworld.com>.

Jackson, A.S., and M.L. Pollock. 1985. "Practical Assessment of Body Composition." *The Physician and Sportsmedicine* 13 (5, May): 76-90.

Jacobson, M. 1995. [Editorial comment.] *Nutrition Action Healthletter* (May): 2.

Jacobson, M., ed. 1987. "The Right Dose". *Nutrition Action Healthletter* Washington, DC: Center for Science in the Public Interest (CSPI).

Johns, R.J. and V. Wright. 1962. "Relative Importance of Various Tissues in Joint Stiffness." *Journal of Applied Physiology* 17 (5), 824-828.

Kardell, K.R., and T. Kase. 1998. "Training in Pregnant Women: Effect on Fetal Development and Birth." *American Journal of Obstetrics and Gynecology* 178 (2): 280-86.

Keeler, L.K., L.H. Finkelstein, W. Miller, and B. Fernhall. 2001. "Early-Phase Adaptations of Traditional-Speed vs. Superslow Resistance Training on Strength and

Aerobic Capacity in Sedentary Individuals." *Journal of Strength and Conditioning Research* 15: 309-314.

Kendall, F., E. McCreary, and P. Provance. 1993. *Muscles—Testing and Function*. 4th ed. Baltimore: Williams & Wilkins.

Kibler, B. 1997. *Penn State Sports Medicine Newsletter* (June). Reported in "What's New," *IDEA Personal Trainer* Jan. 1998: 16.

Koeberle, B. 1990. *Legal Aspects of Personal Training*. Canton, OH: Professional Reports Corporation.

Komi, P.V., ed. 1992. *Strength and Power in Sport*. Champaign, IL: Human Kinetics.

Kraemer, W., and S. Fleck. 1993. *Strength Training for Young Athletes*. Champaign, IL: Human Kinetics.

Kravitz, L., and D. Kosich. 1993. "Flexibility: A Comprehensive Research Review and Program Design Guide." *IDEA Today* (June): 42-49.

Lacroix, V.J. 1999. "Exercise-Induced Asthma." *Physician and Sportsmedicine* 27 (12, Nov.): 75-92.

La Forge, R. 2000. "Training the Cardiac Patient." *IDEA Personal Trainer* (Feb.): 51-63.

Leger, L. and M. Thivierge. 1988. "Heart Rate Monitors: Validity, Stability, and Functionality." *The Physician and Sportsmedicine* 16 (5, May): 143-151.

Lichtman S.W., K. Pisarska, E.R. Berman, M. Pestone, H. Dowling, E. Offenbacher, H. Weisel, S. Heshka, D.E. Matthews, and S.B. Heymsfield. 1992. "Discrepancy Between Self-Reported and Actual Caloric Intake and Exercise in Obese Subjects." *New England Journal of Medicine* 327: 1893-98.

Lohman, T., A. Roche, and R. Martorell. 1988. *Anthropometric Standardization Reference Manual*. Champaign, IL: Human Kinetics.

Mahan, K., and M. Arlin. 1992. *Krause's Food, Nutrition and Diet Therapy*. 8th ed. Philadelphia: Saunders.

Manson, J.E., E.B. Rimm, M.J. Stampfer, G.A. Colditz, W.C. Willett, and A.S. Krolewski. 1991. "Physical Activity and Incidence of Non-Insulin Dependent Diabetes Mellitus in Women." *Lancet* 338: 774-78.

Manson J.E., H. Tosteson, P.M. Ridker, S. Satterfield, P. Hebert, G.T. O'Connor, J.E. Buring, and C.H. Hennekens. 1992. "Medical Progress: Primary Prevention of Myocardial Infarction." *New England Journal of Medicine* 326: 1406-1416

Marmot, M.G. 1986. "Epidemiology and the Art of the Soluble." *The Lancet* i: 897-900.

Mazzeo, R.S., P. Cavanagh, W.J. Evans, M. Fiatarone, J. Hagberg, E. McAuley, and J. Startzell. (1998). "ACSM Position Stand on Exercise and Physical Activity for Older Adults." *Medicine and Science in Sports and Exercise* 30 (6): 992-1008.

McAlpine, K. 1993. "The Minimalist's Maxim." *Outside*. (Apr.): 163-167.

McArdle, W., F. Katch, and V. Katch. 1991. *Exercise Physiology—Energy, Nutrition, and Human Performance*. 3rd ed. Philadelphia: Lea & Febiger.

McArdle, W., F. Katch, and V. Katch. 1996. *Exercise Physiology—Energy, Nutrition and Human Performance*. 4th ed. Philadelphia: Lea & Febiger.

McDonagh, M.J.N., and C.T.M. Davies. 1984. "Adaptive Response of Mammalian Skeletal Muscle to Exercise With High Loads." *European Journal of Applied Physiology* 52: 139-55.

McGill, S. 2002. *Low Back Disorders—Evidence-Based Prevention and Rehabilitation*. Champaign, IL: Human Kinetics.

Metveyev, L. 1981. *Fundamentals of Sports Training*. Moscow: Progress.

Molk, B. 1996. "Connecting with Physicians." *IDEA Personal Trainer* (Sept.): 29-33.

Monahan, T. 1989. "Is Fitness Reaching Only the Wealthy?" *The Physician and Sportsmedicine* 17 (2, Feb.): 201-211.

Moore, M., and R. Hutton. 1989. "Electromyographic Investigation of Muscle Stretching Techniques." *Medicine and Science in Sports and Exercise* 12 (5): 322-29.

Morton, A., K. Fitch, and A. Hahn. 1981. "Physical Activity and the Asthmatic." *The Physician and Sportsmedicine* 9:51-64.

Murphy, R.D. 1991. "A Critical Look at Static Stretching: Are We Doing Our Patients Harm?" *Chiropractic Sports Medicine* 5 (3): 67-70.

National Cholesterol Education Program. 1993. "Summary of the Second Report of the National Cholesterol Education Program (NCEP) Expert Panel on Detection, Evaluation and Treatment of High Blood Cholesterol in Adults." *Journal of the American Medical Association* 269: 3015-3023.

National Institutes of Health. 1994. "Weight Cycling: In Some, the Benefits of Weight Loss Outweigh the Risks." 18 Oct. press release: 1.

Nieman, D. 1997. "The Ups and Downs of Detraining." *ACE Certified News* 3 (5, Aug./Sept.): 1-2.

O'Brien, T. 1997. *The Personal Trainer's Handbook*. Champaign, IL: Human Kinetics.

Ornish, D., S.E. Brown, L.W. Scherwitz, J.H. Billings, W.T. Armstrong, T.A. Ports, S.M. McLanahan, R.L. Kirkeeide, R.J. Brand, and K.L. Gould. 1990. "Can Lifestyle Changes Reverse Coronary Heart Disease?" *The Lancet* 336: 129-33.

Osternig, L.R. 1990. "Differential Responses to Proprioceptive Neuromuscular Facilitation (PNF) Stretch Techniques." *Medicine and Science in Sports and Exercise* 22 (1): 106-11.

Ozolin, N. 1971. *The Athlete's Training System for Competition*. Moscow: Fizkultura i Sport.

Pate, R., M. Pratt, S. Blair, W. Haskell, C. Macera, C. Bouchard, D. Buchner, W. Ettinger, G. Heath, A. King, A. Kriska, A. Leon, B. Marcus, J. Morris, R. Paffenbarger, Jr, K. Patrick, M. Pollock, J. Rippe, J. Sallis, and J. Wilmore. 1995. "Physical Activity and Public Health: A Recommendation From the Centers for Disease Control and Prevention and the American College of Sports Medicine." *Journal of the American Medical Association* 273: 402-407.

Piccone, P.K. 1997. "Choosing an Accountant." *IDEA Personal Trainer* (Mar./Apr.): 17-20.

Pickering, R. 1999. "Understanding Retirement Plans." *IDEA Personal Trainer* (Apr.): 19-34.

Pivarnik, J.M. 1998. "Potential Effects of Maternal Physical Activity on Birth Weight: Brief Review." *Medicine and Science in Sports and Exercise* 30 (3): 400-406.

Plowman, S. 1992. "Physical Activity, Physical Fitness, and Low Back Pain." *Exercise and Sport Sciences Reviews* 20: 221-42.

Plowman, S. and D. Smith. 1997. *Exercise Physiology for Health, Fitness, and Performance.* Needham Heights, MA: Allyn and Bacon.

Pollock, M., and J. Wilmore. 1990. *Exercise in Health and Disease.* 2nd ed. Philadelphia: Saunders.

Pollock, M.L., G.A. Gaesser, J.D. Butcher, J. Despres, R.K. Dishman, B.A. Franklin, and C.E. Garber. (1998). "The Recommended Quantity and Quality of Exercise for Developing and Maintaining Cardiorespiratory Fitness, and Flexibility in Healthy Adults." *Medicine and Science in Sports and Exercise* 30 (6): 975-91.

Post, W.R. 1998. "Patellofemoral Pain." *The Physician and Sportsmedicine* 26 (1, Jan.): 68-78.

Reed, C. 1999. "The Evolution of the Personal Fitness Profession." *Personal Fitness Professional* (Mar./Apr.): 18.

Reeves, R.K., E.R. Laskowski, and J. Smith. 1998a. "Weight Training Injuries—Part I: Diagnosing and Managing Acute Conditions." *The Physician and Sportsmedicine* 26 (2, Feb.): 67-83.

Reeves, R.K., E.R. Laskowski, and J. Smith. 1998b. Weight Training Injuries—Part II: Diagnosing and Managing Chronic Conditions. *The Physician and Sportsmedicine* 26 (3, Mar.): 54-63.

Rhea, M., B. Alvar, S. Ball, and L. Burkett. 2002. "Three Sets of Weight Training Superior to One Set With Equal Intensity for Eliciting Strength." *Journal of Strength and Conditioning Research* 16 (4, Nov.): 525-529.

Roberts, S., ed. 1996. *The Business of Personal Training.* Champaign, IL: Human Kinetics.

Rubin, A. (Ed). 1998. "Put Exercise Advice in Writing." ["Highlights" section.] *Physician and Sportsmedicine* 26 (7, July): 22.

Rubin, A. (Ed.) 1999. "Strength Training Bolsters Cardiac Rehab." ["Highlights" section.] *Physician and Sportsmedicine* 27 (7): 20.

Ryan, P. 1995. "How Can We Judge Quality?" *IDEA Personal Trainer* (July/Aug.): 27-34.

Ryan, P. 1996. "Certifications: Which One Is Right for You?" *IDEA Personal Trainer* (Mar./Apr.): 18-31.

Safran, M.R., A.V. Seaber, and W.E. Garrett. 1988. "The Role of Warm-Up in Muscular Injury Prevention." *American Journal of Sports Medicine* 16 (2): 123-29.

Sapega, A.A., T.C. Quedenfeld, R.A. Moyer, and R.A. Butler. 1981. "Biophysical Factors in Range-of-Motion Exercise." *Physician and Sportsmedicine* 9 (12), 57-65.

Schardt, D. 1998. "Relieving Arthritis Pain: Can Supplements Help?" *Nutrition Action Healthletter* (Jan./Feb.): 3-5.

Schnirring, L. 2000. "Healthy Aging or Anti-Aging? Diverse Philosophies Emerge." "News Briefs." *Physician and Sportsmedicine* 28 (6): 15-20.

Schnirring, L. (Ed.) 2002. "New ACOG Recommendations Encourage Exercise in Pregnancy." "News Briefs." *Physician and Sportsmedicine* 30 (8, Aug.): 9-10.

Schwenk, T.L. 1999. "Rejuvenating Patients—One Step at a Time." "Editor's notes." *The Physician and Sportsmedicine* 27 (11): 3-8.

Selye, H. 1978 . *The Stress of Life.* New York: McGraw-Hill.

Sharkey, B. 1990. *Physiology of Fitness.* 3rd ed. Champaign, IL: Human Kinetics.

Sharkey, B. 1991. *New Dimensions in Aerobic Fitness.* Champaign, IL: Human Kinetics.

Sheehan, G. 1991. "Health Risk Appraisals." *The Physician and Sportsmedicine* 19 (5): 41.

Sherman, C. 1994. "Reversing Heart Disease: Are Lifestyle Changes Enough?" *The Physician and Sportsmedicine* 22 (1, Jan.): 91-94.

Shrier, I. and K. Gossal. 2000. "Myths and Truths of Stretching." *Physician and Sportsmedicine* 28 (8, Aug.): 57-63.

Siff, M. and Y. Verkhoshansky. 1993. *Super Training: Special Strength Training for Sporting Excellence.* Johannesburg, South Africa: School of Mechanical Engineering, University of the Witwatersrand.

Siff, M.C. 1990. *The Science of Flexibility and Stretching.* Johannesburg, South Africa: School of Mechanical Engineering, University of Witwatersrand.

Skinner, J. 1993. "Understanding the Physiological Basis of Cardiorespiratory Fitness." In *Stairmaster Fitness Handbook.* Indianapolis: Masters Press.

Sleamaker, R. 1989. *Serious Training for Serious Athletes.* Champaign, IL: Human Kinetics.

Sleamaker, R. and R. Browning, 1996. *SERIOUS training for endurance athletes.* (Champaign, IL: Human Kinetics)

Smith, B. 1993. *Advanced Fitness Teacher's Manual.* Loughborough, UK: Loughborough University–Ludoe.

Soukup, J.T., and J.E. Kovaleski. 1993. "A Review of the Effects of Resistance Training for Individuals With Diabetes Mellitus." *Diabetes Education* 19 (4): 307-12.

Spirduso, W. 1995. *Physical Dimensions of Aging.* Champaign, IL: Human Kinetics.

Stanforth, D., and M. Buono. 1989. "The Fat Burning Concept: Implications for Aerobic Dance." In Marks, C. (ed.), *International Symposium on the Scientific and Medical Aspects of Aerobic Dance—Exercise Manual* (105-109). San Diego: IDEA Foundation.

Stone, M., and H. O'Bryant. 1987. *Weight Training—A Scientific Approach.* Minneapolis: Burgess.

Strange, C.J. 1996. "Coping with Arthritis in Its Many Forms." *FDA Consumer* 3: 17-21.

Sullivan, M.G., J.J. Dejulia, and T.W. Worrell. 1992. "Effect of Pelvic Position and Stretching Method on Hamstring Muscle Flexibility." *Medicine and Science in Sports and Exercise* 24 (12): 1383-1389.

Tamblyn, R., L. Berkson, W.D. Dauphinee, D. Gayton, R. Grad, A. Huang, L. Isaac, P. McLeod, and L. Snell. 1997. "Unnecessary Prescribing of NSAIDs and the Management of NSAID-Related Gastropathy in Medical Practice." *Annals of Internal Medicine* 127: 429.

Taylor, D.C., J.D. Dalton, A.V. Seaber, and W.E. Garrett. 1990. "Viscoelastic Properties of Muscle-Tendon Units: The Biomechanical Effects of Stretching." *American Journal of Sports Medicine* 18 (3): 300-309.

Thompson, C. 1989. *Manual of Structural Kinesiology.* 11th ed. St. Louis: Times Mirror/Mosby.

Thorneycroft, D. 1995. "What Makes a Marketing Piece Work?" *IDEA Personal Trainer* (Jan.): 21

"Trans: The Phantom Fat." 1996. *Nutrition Action Healthletter* (Sept.): 10-13.

University of California at Berkeley. 1994. *Berkeley Wellness Letter* 8: 1-4.

U.S. Department of Health and Human Services. 1996. *Physical Activity and Health: A Report of the Surgeon General.* Atlanta: U.S. Department of Health and Human Services, Centers for Disease Control and Prevention, National Center for Chronic Disease Prevention and Promotion.

Vorobyev, A. 1978. *A Textbook on Weight Lifting.* Budapest: International Weightlifting Federation.

Westcott, W. 1991. *Strength Fitness.* 3rd ed. Dubuque, IA: Brown.

Westcott, W.S. 1995. *Strength Fitness: Physiological Principles and Training Techniques.* 4th ed. Dubuque, IA: Brown.

White, R. and C. Sherman. 1999. "Exercise in Diabetes Management: Maximizing Benefits, Controlling Risks." *Physician and Sportsmedicine* 27 (4, Apr.): 71.

Wichmann, S., and D.R. Martin. 1992. "Heart Disease: Not for Men Only." *The Physician and Sportsmedicine* 20 (8, Aug.): 138-48.

Wilmore, J., and D. Costill. 1988. *Training for Sport and Activity: The Physiological Basis of the Conditioning Process.* 3rd ed. Dubuque, IA: Brown.

Wilmore, J., and D. Costill. 1994. *Physiology of Sport and Exercise.* Champaign, IL: Human Kinetics.

Young, W., and D. Behm. 2002. "Should Static Stretching Be Used During a Warm-Up for Strength and Power Activities?" *National Strength and Conditioning Journal* 24 (6): 33-37.

INDEX

ABOUT THE AUTHOR

Douglas S. Brooks, MS, is an exercise physiologist and personal fitness trainer with more than 20 years of experience. He co-owns Moves International Fitness, a provider of educational resources, continuing education, and live workshops to fitness professionals.

Acknowledged as one of the country's premier personal trainers, Brooks is a well-known author, lecturer, trainer, and video personality. His counsel and input are sought on an international level, most recently by the International Sports Trainers Association, which appointed him vice president of the organization. He also is a member of IDEA and the American College of Sports Medicine (ACSM).

Brooks is a gold-certified personal trainer by the American Council on Exercise, and he is an IISA-certified in-line skating instructor. He previously operated a personal training facility for nine years, directed a 5,000-member health facility, participated in and coached college-level gymnastics, and was an assistant professor at the University of Michigan Health Science Department.

In his free time, Brooks enjoys fitness activities of all kinds. He is a competitive tennis player, a marathon runner and Ironman triathlete, an avid alpine and Nordic skier, an in-line skater, and a rock climber and mountaineer. He lives in Mammoth Lakes, California, with his wife and two sons.